BRITISH PAINTINGS

OF THE SIXTEENTH

THROUGH NINETEENTH CENTURIES

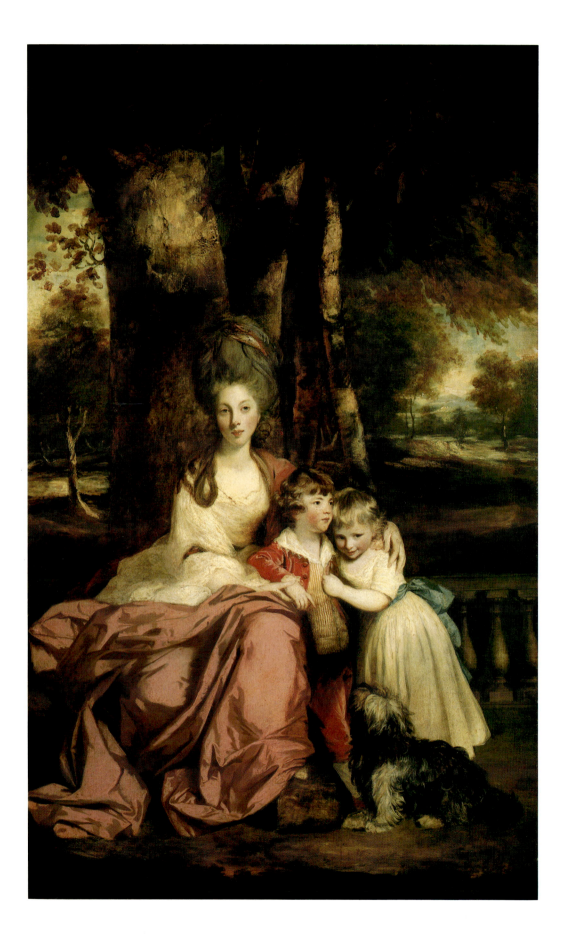

British Paintings

OF THE SIXTEENTH THROUGH

NINETEENTH CENTURIES

John Hayes

THE COLLECTIONS OF THE

NATIONAL GALLERY OF ART

SYSTEMATIC CATALOGUE

National Gallery of Art, Washington

Cambridge University Press

Edited by Barbara Anderman
Designed by Klaus Gemming, New Haven, Connecticut
Typeset in Plantin Light
by Monotype Composition Company, Inc., Baltimore, Maryland
Printed by Van Dyck/Columbia Printing, North Haven, Connecticut
on Quintessence Dull 80 lb. Text

COVER: John Constable, *Wivenhoe Park, Essex*, 1942.9.10
FRONTISPIECE: Sir Joshua Reynolds, *Lady Elizabeth Delmé and Her Children*, 1937.1.95

LIBRARY OF CONGRESS CATALOGING-IN-PUBLICATION DATA
National Gallery of Art (U.S.)
British paintings of the sixteenth through nineteenth centuries /
John Hayes.
p. cm.—(The Collections of the National Gallery of Art:
systematic catalog)
Includes bibliographical references and index.
1. Painting, British—Catalogs. 2. Painting, Modern—Great Britain—
Catalogs. 3. Painting—Washington (D.C.)—Catalogs. 4. National
Gallery of Art (U.S.)—Catalogs. I. Hayes, John II. Title. III. Title:
British paintings of the 16th through 19th centuries. IV. Series: National
Gallery of Art (U.S.). Collections of the National Gallery of Art.
ND464.N38 1992
759.2'074'753—dc20 90-19132
 CIP

ISBN 0-521-41066-5

CONTENTS

British paintings have held an important and valued place in the collection of the National Gallery of Art since its very inception. That this is so reflects both the general affection Americans have long felt for British social, political, and cultural traditions and the specific tastes and interests of the generous donors who have helped shape the Gallery's identity. Of the some 110 paintings presented to the nation by Andrew W. Mellon in 1937 as the foundation of the National Gallery collection, 20 were British. Only the Italian and Dutch schools were represented in greater numbers. Quantity was fully matched by quality, for in this core group were many key paintings—especially Reynolds' *Lady Elizabeth Delmé and Her Children* and *Lady Caroline Howard*, Gainsborough's *Mrs. Richard Brinsley Sheridan* and *Landscape with a Bridge*, Romney's *Miss Willoughby* and Turner's *Mortlake Terrace*—that remain cornerstones of the collection today.

When the Widener Collection came to the Gallery in 1942 it brought another eighteen British paintings that complemented perfectly those from the Mellon donation. Like Andrew Mellon, the Wideners particularly favored the Grand Manner portraiture epitomized by Reynolds and Gainsborough. But perhaps the most important aspect of their gift, at least as far as the British collection was concerned, was the addition of two Constables, *The White Horse* and the magically beautiful *Wivenhoe Park, Essex*, and three Turners, including our finest work by him, *Keelmen Heaving in Coals by Moonlight*.

In the years since the Mellon and Widener gifts, numerous other noteworthy donations, such as Stubbs' exquisite *Captain Pocklington with His Wife and Sister* donated by Mrs. Charles S. Carstairs in 1952, and Reynolds' grand *Squire Musters* given in 1961 by the Fuller Foundation, have greatly enriched the British collection. However, by far the most significant additions of recent years have come, once again, from the Mellon family. In 1970 the bequest of Ailsa Mellon Bruce brought us important works by Romney, Gainsborough, and Turner, and during the decade of the 1980s many generous gifts by Paul Mellon greatly amplified the range of artists and types of subjects represented in the collection—his special eye and taste-making passion for British art bringing here, with a new approach, conversation pieces, landscapes, and subject pictures.

Thanks to such sustained generosity, the National Gallery's collection of British paintings, though by no means a comprehensive survey of the field, now stands as a distinguished representation of the accomplishments of that great national school. In addition, it is worth remembering that the Gallery also owns several highly important works, which will be documented in another volume of our Systematic Catalogue, by American painters who spent long and profitable years on English soil: Benjamin West, John Singleton Copley, and Gilbert Stuart. Whether one properly considers such major pictures as Copley's *Watson and the Shark* and Stuart's *The Skater* American or English, they are eloquent reminders of the close artistic ties that have long endured between the two countries.

We are particularly fortunate that John Hayes, director of the National Portrait Gallery in London, agreed to take time from his busy schedule to write this volume, the third to appear in the series of systematic catalogues of the National Gallery's collection. Dr. Hayes, a well-known expert on British painting, has brought to this task an enormous wealth of knowledge and discernment, resulting in numerous discoveries concerning attributions, identifications of sitters, and more accurate dating of the pictures. For his thorough and conscientious scholarship, so evident in the pages that follow, we are most grateful.

As is true with the entire Systematic Catalogue, which has been ably and efficiently coordinated by Suzannah Fabing, managing curator of records and loans until her appointment this year as director of the Smith College Museum of Art in Northampton, Massachusetts, virtually every department in the Gallery has contributed to the realization of this catalogue. Each painting has been carefully examined in the

conservation laboratory, and valuable new information about the condition of the works has been incorporated into the entries. In short, all of the relevant information we have been able to gather about our British paintings has been assembled here. The result, we hope, will make our ever-expanding collection in this field better known and give further stimulus to the study of British art.

Earl A. Powell III
Director

ACKNOWLEDGMENTS

First of all, I wish to thank the board of trustees of the National Gallery of Art and the director, J. Carter Brown, for their flattering and welcome invitation to write this volume in the systematic catalogue, a volume that deals with one of the half dozen most important collections of British painting in America.

The attention given to the physical composition and condition of the objects in the collections is one of the most significant features of the new systematic catalogue. The detailed technical examination reports which form the basis of my technical notes have been prepared by the following past and present members, fellows, and interns of the Gallery's conservation department: Mary Bustin, Kristin Casaletto, Carol Christensen, Paula DeCristofaro, Sarah Fisher, Patricia Goddard, Charlotte Hale, Ann Hoenigswald, Cynthia Kuniej, Catherine Metzger, Susanna Pauli, Kay Silberfeld, Elizabeth Steele, Michael Swicklik, and Phil Young. The three paintings on loan to the American embassy in London were examined by Alan Cummings. Paula DeCristofaro and Catherine Metzger have borne the brunt of the work and, in addition, have been an immense help and stimulus to me. They have read and checked my technical notes, discussed them with me in front of the original picture in the case of nearly every work, and answered innumerable, sometimes I fear naïve questions, all with exemplary patience and clarity.

Denna Anderson undertook a great deal of detailed research relating to previous owners of the paintings; some of this, notably in respect of places of residence, has been incorporated into my provenance entries, the remainder is available in the curatorial files. Susan Davis has enthusiastically researched a number of problems, largely in connection with exhibition history.

My colleagues at the National Portrait Gallery in London, Malcolm Rogers and Jacob Simon, have made several suggestions about attribution, chiefly regarding portraits from the Clarke collection; where these are specific they are acknowledged in the appropriate entries. Sydney Freedberg (under whose benign direction it has been a pleasure to work) and Arthur Wheelock have both read the text in its entirety. I am indebted to two authorities in the field of British painting, Martin Butlin and Robert Wark, for their critical and constructive comments on the typescript; they have eliminated errors, suggested improvements (most of which I have been happy to adopt), and tightened the structure of the work. Other scholars and colleagues have provided much appreciated help or have answered specific queries: those not acknowledged in the appropriate places in the text include Brian Allen, Katharine Baetjer, Ann Chumbley, Judy Egerton, Richard W. Hutton, Evelyn Joll, Lowell Libson, Hugh Macandrew, Andrew Moore, A. G. Osler, Charles S. Rhyne, Erda Ryan, Lindsay Stainton, Duncan Thomson, Julian Treuherz, Neil Walker, and Stephen Wildman. Burton Fredericksen has generously provided printouts of the provenance of each painting from the resources of the Getty Provenance Index; and Aileen Ribeiro has supplied reports on the costume depicted in the Clarke pictures. The National Portrait Gallery archive and library has been an indispensable source of information; I am greatly indebted also to the staffs of the British Library, the British Museum Print Room, the Frick Art Reference Library, the London Library, the Paul Mellon Centre in London, the National Gallery library, the library of the National Gallery of Art, the Natural History Museum library, the Victoria and Albert Museum library, the library of the Warburg Institute, and the Witt Library, Courtauld Institute of Art.

The manuscript was impeccably typed by Mollie Luther, to whose efficiency, as always, I owe much. Since then the text has undergone numerous transformations on the Gallery's word processors. The final copyediting was undertaken, with admirable thoroughness, by Barbara Anderman, and the production was supervised by Frances Smyth, editor-in-chief of the National Gallery, and her staff. I am grateful also to Klaus Gemming for his tolerance and his skillful design. The index of subjects and the general index have been expertly prepared by Isabel Hariades. My principal debt, however, I have left to last. Over the course of the eight years during which

I have been engaged on the work, Suzannah Fabing, the coordinator of the systematic catalogue, has conducted a voluminous correspondence across the Atlantic, attending speedily to my every need. She also edited my initial typescript with the utmost tact, never presuming to press on me any of the hundreds of suggestions she made; in fact, I can scarcely think of one which did not improve immeasurably the sense and flow of the text. Her intelligent understanding and good-humored professionalism have been quite literally an inspiration. The friendliness and eagerness to help I have met with everywhere at the National Gallery have made the task of preparing this catalogue an exceptionally agreeable one.

John Hayes
London
January 1992

This volume contains entries for those paintings in the National Gallery that were produced from the sixteenth to the nineteenth century by British artists or by foreign artists who spent the greater part of their working lives in Britain. The latter definition excludes the name of Sir Anthony van Dyck, whose works will be treated in the volume devoted to the Flemish School. Nonetheless, it should be emphasized here that the eleven years Van Dyck worked at the court of Charles I, from 1629 to 1640, were of crucial importance for the history of British painting. Not only did his advent change the course of British portraiture at that time, but his European style and sophistication, his elegance, and his repertory of designs, poses, and accessories exercised a profound influence on British portrait painters and their patrons for two hundred years and more: both Reynolds and Gainsborough, so magnificently represented at the National Gallery, were inspired by his example and were influenced by his work.

Broadly speaking, the collection of British paintings in the National Gallery represents American taste of the last hundred years rather than incidental accession or Gallery policy. American collecting entered a new phase in the 1880s and 1890s, when there emerged a class of wealthy industrialists who sought to recreate in the New World collections of pictures and objets d'art that would have done honor to a Medici or a Habsburg. Among these men were Henry Clay Frick and his friend, Andrew Mellon, of Pittsburgh, and P.A.B. Widener of Philadelphia. Unlike the Medici or the Habsburgs, however, these collectors were less concerned with contemporary art (though Widener began his serious collecting with paintings of the Barbizon School and bought works by Manet and Degas) and surrounded themselves mostly with old masters; the objets d'art—the Persian carpets, the porcelain and the rock crystal, as well as the furniture—provided a sumptuous setting for the pictures they purchased for their palatial mansions and townhouses. Portraits by Gainsborough, Hoppner, Lawrence, Raeburn, Reynolds, and Romney were bought for their status in this context rather than because they were British.

Over half the paintings catalogued in the present volume are from the Mellon and Widener collections. Andrew Mellon's personal criteria in collecting were simple: "A painting must be by an outstanding artist; it must be in good condition; and it must be beautiful or pleasant to look at." As far as the British pictures were concerned, this meant works from the "golden age" of British painting, notably by the artists listed above. After his decision in about 1927 to provide a building for a National Gallery, and to present his own works of art as the nucleus for the national collection, Mellon widened the scope of his acquisitions to embrace other facets of Western painting and fine art. Perhaps he would not have bought the portrait then thought to be a Copley of Admiral Howe in the days when he was acquiring pictures for his own personal pleasure. Nor would he have purchased *en bloc* the Dreyfus collection of fifteenth-century Italian sculpture or the Thomas B. Clarke collection of American portraits. Clarke made early American portrait painters fashionable, and, at the time of its assembly, his collection was claimed as constituting an unparalleled nucleus for the formation of a national portrait gallery (a natural patriotic aspiration following participation in the First World War); unfortunately it proved to contain a number of spurious works—with false attributions, signatures, identifications, and pedigrees—many of which have turned out to be British portraits of middling or low quality; twenty-eight are catalogued in this volume. P.A.B. Widener was a far less discerning collector than Mellon, and his son, Joseph, worked with his father for some years on pruning the collection, discarding over four hundred heterogeneous pictures before inheriting responsibility for it in 1915; as a result, the hundred paintings bequeathed to the National Gallery in 1942 are mostly of the highest quality, although, as far as the British paintings are concerned, the taste they represent is similar to that of Mellon, Frick, and other millionaire collectors of the "Duveen" era.

Duveen's name is kept in quotation marks advisedly. He was a great self-publicist and made many spectacular sales to American collectors. But other firms were at least

equally active. Of the British pictures in the National Gallery acquired during the "Duveen" era, only ten—nearly all, however, of the first importance—were bought from the firm of Duveen. Almost as many came through Agnew or through Wallis & Son (who had a branch in New York). Thirty (excluding the Clarke pictures) were acquired from Knoedler.

The range of the British paintings in the National Gallery has been enlarged by subsequent gifts and bequests, most notably by the thirteen pictures presented by Paul Mellon. The huge collection of British paintings (and drawings) formed by Paul Mellon since June 1959, and now for the most part presented by him to the British Art Center at Yale, focused on aspects of British art quite different from those represented in his father's collection: conversation pieces, sporting painting, topographical pictures, works by lesser-known artists. Of the thirteen pictures presented to the National Gallery, five are conversation pieces, one, the Hogarth, is a theater scene, five are landscapes, and two, the Fuseli and a Wright of Derby, are subject paintings. Although these additions greatly enhance the holdings of British art, it should be stated here that the National Gallery's collection has never been intended as a representation of British painting. This is quickly apparent if its content is assessed. There is only one work dating to the sixteenth century, and three (excluding Clarke pictures) to the seventeenth. There is little rococo art, little history painting, and only two very minor works dating to after 1850. Indubitably, however, there are many masterpieces, the chief glory of the collection lying in the grand style portraiture and the group of Turners.

A list of changes of attribution (and of title) is included at the end of the volume. Nine or ten unattributed works have been newly assigned to specific artists; but, on the whole, the changes are simply refinements of existing views.

Entries are arranged alphabetically by artist. Each artist is given an introductory biography and bibliography, with individual entries following in chronological sequence.

The extended biographies are in keeping with the general plan of the systematic catalogue, and vary in length according to the importance of the artist. Each is divided into three sections: a biography proper, an assessment of style and artistic development, and a brief account of

followers and influence. The bibliographies are confined to the principal and most illuminating literature.

The following attribution terms are used:

Attributed to: Almost certainly by the named artist according to the weight of available evidence, although the available evidence stops short of reasonable certainty.

Studio of: Produced in the named artist's studio by assistants, possibly with some participation by the named artist. It is an important criterion that the creative concept is by the named artist and that the work was meant to leave the studio as his.

Style of: Produced by an unknown artist working more or less specifically in the style of the named artist, who may or may not have been trained by or assisted the named artist.

After: A copy of any date.

The following conventions for dates are used:

1790	Executed in 1790
c. 1790	Executed sometime around 1790
1790–1795	Begun in 1790, finished in 1795
1790/1795	Executed sometime between 1790 and 1795
c. 1790/1795	Executed sometime around the period 1790–1795

Dimensions are given in centimeters, height preceding width, followed by the dimensions in inches in parentheses.

The technical notes summarize the contents of the examination reports prepared by members of the Gallery's conservation department specifically for the systematic catalogue. The notes were written in consultation with individual conservators, and the pictures were reexamined jointly (where necessary in the laboratory) at that time. The notes describe the condition of each picture as of this time. The following procedure was employed for the original technical examinations:

Each picture was examined unframed. Visible light was used front and back, and a binocular microscope with a magnifying power of up to about 40x was employed. The pictures were examined under ultraviolet light; where applicable, areas of retouch or repaint were indicated on a photograph or photocopy (preserved in NGA curato-

rial files). If an x-radiograph was on file it was consulted; if there was evidence of a paint change, an x-radiograph was made. Although x-radiography is discussed in the technical notes only when significant changes were revealed, mention is made of the existence of an x-radiograph in the report in each case (if no mention is made, no x-radiograph exists). Infrared reflectography was not routinely employed, but on the rare occasions when it proved helpful in obtaining information its use is mentioned in the report. X-ray fluorescence was employed only when requested to solve specific problems; when this technique was used it is mentioned in the report.

The majority of the pictures were executed on plain-weave fabric supports that were estimated to be (but not analyzed as) linen. The type of weave is noted, but, in the absence of fiber analysis, the supports are described under the generic term *canvas*; similarly, wooden supports are described under the generic term *panel*. In most cases, paintings on fabric had been lined onto auxiliary fabric supports, again assumed to be linen. The lining adhesive employed was usually aqueous, such as glue or paste (or a combination), and original tacking margins were found to have been routinely removed as part of past lining treatment. Instances in which original tacking margins survive are noted. The paintings are normally mounted on nonoriginal stretchers. Stretchers estimated to be original are noted, as are those of unusual construction.

The ground layer in the majority of paintings consisted of an overall application of white, which was modified on occasion by an imprimatura layer. With few exceptions, paintings on fabric were executed in oil media, with occasional inclusions of mixed technique.

The condition of the paintings varied. Often pictures that had been lined exhibited flattened impasto and pronounced weave impression in the surface layers. Many of the paintings suffered from abrasion, particularly in dark, transparent glazes. All of the varnishes were presumed not to be original. The dates of restorations are noted where known, but restorers' names have been omitted.

Provenance information has been checked against original sources wherever possible. Dealers' names are given in parentheses to distinguish them from owners and collectors. Some modification of existing knowledge has been provided by the Getty Provenance Index, which possesses a microfiche of the stockbooks of Thomas Agnew & Sons and M. Knoedler & Co. Footnotes are provided where the source is not obvious or where the information relating to more recent transactions is not contained in NGA curatorial files. The date when a picture entered the collection is recorded in the accession number.

The exhibition history of each picture is given complete as far as it is known. Information has been checked from original exhibition catalogues wherever possible (only a few catalogues were untraced).

In the main text of the entries all studies and related works are described and illustrated, with the exception of reproductive prints, of which only the principal ones are noted. Material not germane to the elucidation of the Washington picture, including information relating to the subject of a work or to other pictures of the subject unrelated to the Gallery's painting, is kept to a minimum; for example, only summary biographies of sitters are supplied, and iconographies are selective, intended to give some idea of whether a sitter was a much painted subject or not. Costume analysis is only included in the case of undated pictures, and to the extent that it assists in dating. External visual evidence supporting an attribution or dating is described as well as cited, and, in so far as the budget has allowed, illustrated. Left and right refer to the viewer's left and right except in the case of persons or figures represented, where left and right refers to *their* left and right.

Contemporary or early references are all given, even if only a trivial notice in a newspaper; otherwise, only the principal references are cited. Newspapers and periodicals were published in London unless otherwise stated. The titles of works cited in the footnotes are abbreviated if the full title is given in the references or in the biography; the same applies to the references if the full title is given in the biography. References (and exhibition history) are complete as of 31 December 1990.

J. H.

Abbreviations for Frequently Cited Periodicals

AAm	Art in America
AB	The Art Bulletin
ArtN	Art News
AQ	The Art Quarterly
BurlM	The Burlington Magazine
Conn	The Connoisseur
IntSt	International Studio
MD	Master Drawings

Abbreviations for Books

Farington *Diary*	Farington, Joseph. *The Diary of Joseph Farington*. Edited by Kenneth Garlick and Angus Macintyre (vols. 1–6) and Kathryn Cave (vols. 7–16). 16 vols. New Haven, 1978–1984.
Mellon 1949	National Gallery of Art. *Paintings and Sculpture from the Mellon Collection*. Washington, 1949.
NGA 1970	National Gallery of Art. *American Paintings and Sculpture: An Illustrated Catalogue*. Washington, 1970.
NGA 1980	National Gallery of Art. *American Paintings: An Illustrated Catalogue*. Washington, 1980.
NGA 1985	National Gallery of Art. *European Paintings: An Illustrated Catalogue*. Washington, 1985.
Roberts 1915	Roberts, William. *Pictures in the Collection of P. A. B. Widener at Lynnewood Hall, Elkins Park, Pennsylvania. British and Modern French Schools*. Privately printed, Philadelphia, 1915.
Walker 1976	Walker, John. *National Gallery of Art, Washington*. New York, [1976].
Widener 1908	*Paintings Forming the Private Collection of P.A.B. Widener, Ashborne—near Philadelphia. Part I. Modern Painting*. N.p., 1908. Annotated copies in NGA library.
Widener 1923	*Paintings in the Collection of Joseph Widener at Lynnewood Hall*. Introduction by Wilhelm R. Valentiner. Elkins Park, Pennsylvania, 1923. Also 1931 edition.

CATALOGUE

Lemuel Francis Abbott

c. 1761 – 1802

ABBOTT was probably born in Leicestershire in about 1761 (though perhaps earlier, between 1755 and 1757), the son of the Reverend Lemuel Abbott, then vicar of Thornton in that county. He became a pupil of Francis Hayman in London in 1775, but returned to Leicestershire after Hayman's death the following year. He settled in London in about 1780 and married, probably between 1786 and 1787, a Roman Catholic of whom only the first names—Anna Maria—are known; his wife appears to have been a difficult person who wanted their son to become a priest, against his artistic inclinations. Abbott exhibited portraits at the Royal Academy of Arts in 1788, 1789, 1798, and 1800. His certain portraits are all of male sitters, many of them naval officers. Ben Marshall, later an accomplished sporting painter, was apprenticed to him for three years in 1791 (but remained only briefly).

In 1798, the year in which he was an unsuccessful candidate for Associateship of the Royal Academy, Abbott became insane, allegedly as a result both of his failure to keep up with his work—he was parsimonious in the running of his practice—and because of domestic disquiet. He was certified in 1801. He seems to have been attended by Dr. Thomas Monro, a specialist in insanity and patron of many young artists, whose portrait he exhibited at the Royal Academy in 1800. Abbott died in London on 5 December 1802.

At present Abbott's style is known chiefly from his later portraits; the first decade of his career has yet to be reconstructed. His touch in the 1790s was crisp, nervous, and sensitive, reflecting that of the early work of Lawrence. He had an ability to secure a good likeness, with an alert expression or turn of the head, and his best work (well represented in the National Portrait Gallery, London) is head-and-shoulders portraiture. On a large scale, when he was sometimes influenced by the drama of late Reynolds, he could be uncertain in stance and proportions. The hard, coarse touch evident in some of his works, notably in passages in the series of naval officers in the National Maritime Museum, Greenwich, suggests that canvases he had not finished at the time he became insane were completed by another hand.

Bibliography
Sewter, Albert Charles. "Some New Facts about Lemuel Francis Abbott." *Conn* 135 (1955): 178–183.

1954.1.8 (1192)

Captain Robert Calder

c. 1787/1790
Oil on canvas, 92.1 × 71.8 (36¼ × 28¼)
Andrew W. Mellon Collection

Technical Notes: The medium-coarse canvas is plain woven; it has been lined. The ground appears to be white; there may be layers of colored imprimatura. The painting is executed in rich, fluid, opaque layers applied in a somewhat fuzzy manner. X-radiographs show that the position of the sitter's left hand has been changed. A coat of arms at top right was painted out before the picture's export from England in 1920; there are also more recent retouches along the bottom edge, on the sitter's left shoulder, and scattered throughout the background. The impasto has been slightly flattened during lining. The work is otherwise in good condition. The natural resin varnish has discolored yellow slightly.

Provenance: Archibald Ramsden, Regent's Park, London (sale, Christie, Manson & Woods, London, 1–2 February 1917, 2nd day, no. 239, as by Gilbert Stuart), bought by (Frank T. Sabin), London, from whom it was purchased, 1920, by (G. S. Sedgwick) for Thomas B. Clarke [d. 1931], New York. Sold by Clarke's executors, 1935, to (M. Knoedler & Co.), New York, from whom it was purchased January 1936, as part of the Clarke collection, by The A. W. Mellon Educational and Charitable Trust, Pittsburgh.

Exhibitions: *Portraits Painted in Europe by Early American Artists*, Union League Club, New York, 1922, no. 15. *Portraits by Early American Artists of the Seventeenth, Eighteenth and Nineteenth Centuries Collected by Thomas B. Clarke*, Philadelphia Museum of Art, 1928, unpaginated and unnumbered.

SIR ROBERT CALDER (1745–1818), fourth son of Sir James Calder, Bt., a professional sailor, served in the Revolutionary and Napoleonic wars, was knighted after the Battle of St. Vincent, made a baronet in 1798, and rose to the rank of admiral. His active career was brought to an end shortly before the Battle of Trafalgar as a result of criticism of an abortive engagement with the French admiral Villeneuve, which culminated in a court martial

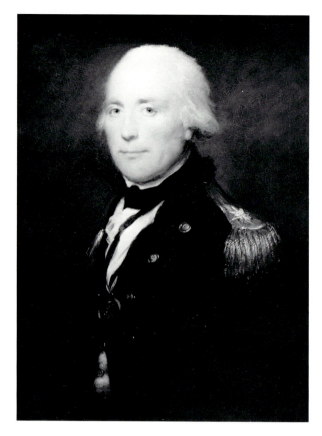

Fig. 1. Lemuel Francis Abbott, *Admiral Sir Robert Calder*, probably R.A. 1798, oil on canvas, London, National Maritime Museum

Calder is depicted in the full dress uniform of a captain (as it was worn between 1787 and 1795[5]), a rank he attained in 1780. The powdered wig with curls loosely frizzed out at the sides is characteristic of formal wear in the 1780s and early 1790s. The portrait was probably painted toward the end of the 1780s, when Calder was in his early forties (a three-quarter-length portrait by Richard Brompton[6] shows Calder, again in captain's uniform, several—perhaps ten—years younger). Abbott also painted Calder in rear-admiral's uniform when he was First Captain of the Fleet (fig. 1); this picture is almost certainly identifiable with Abbott's Royal Academy exhibit in 1798, and portrays Calder some ten years older than he is in the Washington picture. Abbott painted him once again when he was Vice Admiral of the White (this lost portrait is known only from the engraving by Henry R. Cook of 1807).

The picture is an excellent example of Abbott's crisp handling of paint, and, appropriately for a portrait in dress uniform, depicts Calder in a plain setting suggestive of the sea but without overt nautical associations.

Notes

1. Park 1926, 1, no. 135.
2. Alan Burroughs, note, 3 October 1939, in NGA curatorial files.
3. Edward H. H. Archibald, National Maritime Museum, Greenwich, letter, 23 January 1969, in NGA curatorial files.
4. Campbell 1970, 164; NGA 1980, 309.
5. Edward H. H. Archibald, letter, 17 February 1966, in NGA curatorial files.
6. Last recorded in the Mrs. Duff sale, Sotheby's, 22 June 1949, no. 88, bought by Montagu Bernard.

References

1926 Park, Lawrence. *Gilbert Stuart.* 4 vols. New York, 1926, 1: no. 135; 2:85, repro.
1970 NGA 1970: 164, repro. 165.
1980 NGA 1980: 309.

for error of judgment. He married Amelia Michell of Bayfield, Norfolk; there were no children.

An attribution to Gilbert Stuart, first proposed by Christie's at the time of the Ramsden sale in 1917 and accepted without question by Park,[1] was rejected in 1939 by Burroughs,[2] who thought the style close to that of Lemuel Abbott; this attribution, supported by Archibald,[3] is now accepted.[4]

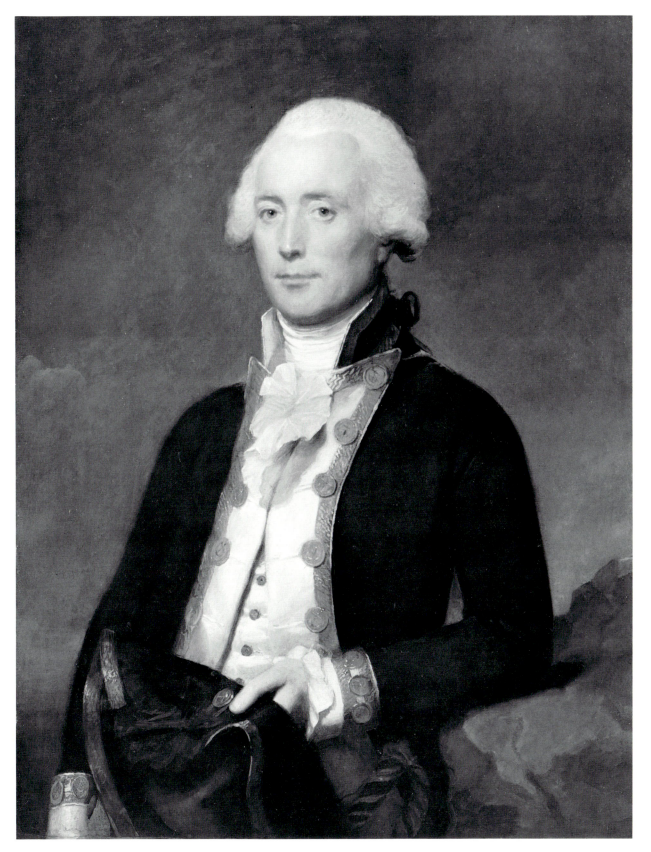

Lemuel Francis Abbott, *Captain Robert Calder*, 1954.1.8

Thomas Barker
1767 – 1847

THOMAS BARKER was born in Trosnant, Pontypool, in 1769, the eldest of the four sons of Benjamin Barker—a spendthrift who took to painting horses and who settled in Bath as a stable hand about 1783—and Anne, about whom nothing is known. Thomas' youthful talent for drawing figures and sketching landscapes attracted the notice of the predatory Charles Spackman, a wealthy coach builder and property developer—described by Farington as an "ignorant, forward fellow,"[1]—who had the boy educated at Shepton Mallet Grammar School and took him into his own home. At Spackman's Thomas copied and imitated landscapes of the Italian and Flemish schools as well as those of Gainsborough, who had lived in Bath from 1759 to 1774. Barker was entirely self-taught. Spackman (who deliberately brought forward the birth date of the young prodigy by two years) arranged an exhibition for his protégé in Bath in 1790; this proved profitable to them both. The celebrated *The Woodman and His Dog* (Torfaen Museum Trust, Pontypool, Gwent) was acquired by Thomas Macklin. Subsequently Spackman sent Barker to Rome for three years, where he became friends with Charles Lock Eastlake and John Flaxman and studied assiduously, learning the art of fresco painting. A second exhibition, including work sent back from Rome for Spackman to sell, was held in Bath in 1793.

Returning to England in 1793 to find Spackman on the verge of bankruptcy, Barker established himself in London, showing at the Royal Academy of Arts scenes based on his Italian sketchbooks. Achieving only a moderate success, he resolved to be a provincial painter and resettled in Bath in 1800. In 1803 he married Priscilla Jones, with whom he had eight children. Two of them, Thomas Jones and John Joseph, were to become accomplished painters. To the design of Sir John Soane's pupil Joseph Gandy, Barker built a fine house on Sion Hill with an art gallery where he held frequent exhibitions of his work. In 1824 he painted there an enormous fresco, *The Massacre of Scio*. He also assembled a fine art collection.

Barker specialized in rustic genre paintings, fancy pictures, studies of local characters, and landscapes; he executed few portraits. Such figure subjects as the woodman (a variant on Gainsborough's theme) were so popular that they were widely copied on pottery, china, and fabrics. He exhibited chiefly at the British Institution, was well patronized by local collectors, and amassed a considerable fortune; one collector alone, J. H. S. Piggott of Brockley Hall, near Bath, paid him seven thousand pounds over the years. As late as 1839 Benjamin Robert Haydon called him "a Man of great Genius."[2] Barker was generous and warm-hearted, but managed his own affairs badly; at the end of his life, as the prosperity of Bath declined, he fell on hard times. He died at Bath on 11 December 1847.

Barker was an eclectic. Though his Roman works are competent and more highly finished, he was generally a facile, prolific, and uneven painter, relying on bravura of handling to conceal deficiencies of drawing and design. His rustic figures, closer to those of George Morland and others of his generation than to those of Gainsborough, are often crude but, as Richard Dorment has pointed out, are remarkable in their candor: "they stare back at us, looking out of the pictures with vacant, sometimes menacing, eyes."[3] Claude, Cuyp, Jacob van Ruisdael, and Salvator Rosa are among influences evident in Barker's landscapes. He drew in pen in a broadly Guercinesque style. By the time of his death his popularity and that of his brother Benjamin (1776–1838), a landscape painter also resident in Bath, was on the wane; it has never revived.

Notes
1. Farington *Diary*, 4:868 (11 July 1799).
2. William Bissell Pope, ed., *The Diary of Benjamin Robert Haydon*, 5 vols. (Cambridge, Mass., 1960–1963), 4:545.
3. Dorment 1986, 10.

Bibliography
[Harington, Sir Edward]. *A Schizzo on the Genius of Man*. Bath, 1793.
Shum, Frederick. "Reminiscences of the late Thomas Barker." *Bath Chronicle*, 17 April 1862.
Hayes, John. *Barker of Bath*. Exh. cat., Victoria Art Gallery. Bath, 1962.
Hayes, John. *The Landscape Paintings of Thomas Gainsborough*. 2 vols. London and New York, 1982, 1:273–279.

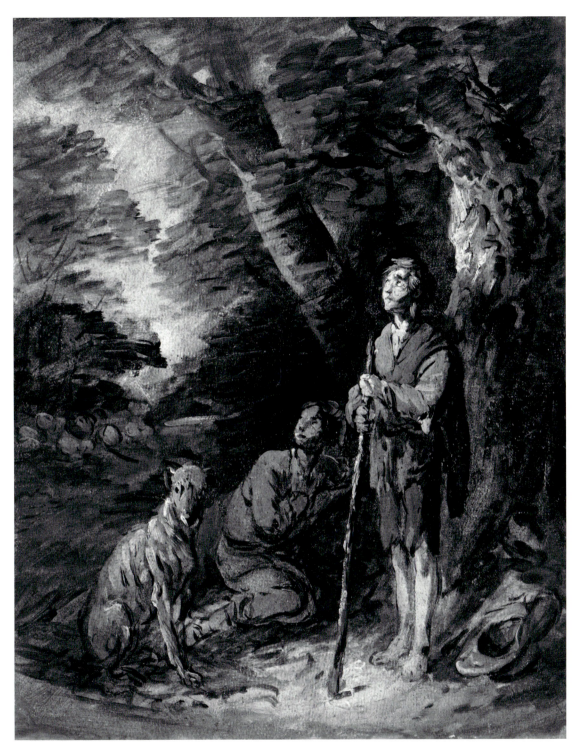

Thomas Barker, *Shepherd Boys and Dog Sheltering from a Storm*, 1956.9.1

Bishop, Philippa. *The Barkers of Bath*. Exh. cat., Victoria Art Gallery. Bath, 1986. (This publication has established the correct birth date.)

Dorment, Richard. "Barker of Bath." *British Painting in the Philadelphia Museum of Art*. Philadelphia and London, 1986:9–12.

1956.9.1 (1448)

Shepherd Boys and Dog Sheltering from a Storm

c. 1789/1790
Oil on paper mounted on canvas, 28.5 × 22.8
(11¼ × 9)
Gift of Howard Sturges

Technical Notes: Painted on white paper originally laid down on panel, the work was adhered to canvas in 1898.[1] The painting is executed in thin, fluid washes laying in the forms in the darks, with richer paint applied in overlapping hatched strokes in the lights. The painting is in good condition. The paint surface has been slightly abraded, but retouching is limited to small areas. The heavily applied varnish, natural resin beneath a glossy synthetic layer, has discolored yellow to a significant degree.

Provenance: Perhaps Philip Vandyck Browne [1801–1868], Shrewsbury; Philip Browne, Shrewsbury, as by Gainsborough.[2] (Bellas), France.[3] Howard Sturges [d. 1955], Providence, Rhode Island, as by Gainsborough.

THIS SMALL PAINTING is a variant of Gainsborough's celebrated *The Woodman*, painted in 1787 (destroyed by fire in 1810), which was engraved by Pierre Simon in 1791 (fig. 1); the picture was, until very recently, attributed to Gainsborough. The style is, however, unmistakably that of Barker. He frequently worked in oil on paper in the earlier part of his career, and the foliage is executed in his idiosyncratic hatching technique; the coarse modeling of the heads is comparable to the background figures, on a similar scale, in Barker's self-portrait of about the mid 1790s in the Tate Gallery.

Inspired by Gainsborough's *The Woodman*, which he must have seen when it was exhibited at Schomberg House, London, in 1789, Barker painted several full-scale variants on the woodman theme, of which the two most celebrated illustrated passages in William Cowper's poem *The Task:* one, showing a woodman returning from his labors on a winter's evening, was executed in 1790, and was purchased by Samuel Rogers; the other, depicting a woodman setting out for work on a winter's morning, was borrowed (and subsequently bought) by Thomas Macklin, causing a sensation when it was exhibited by him at his Poets' Gallery in London (this version was engraved by Bartolozzi in 1792).[4]

The National Gallery's picture, a less mature composition than these two, is an amalgam of Gainsborough motifs. The pose of the principal figure, with both hands clasping a rough stick and the head spotlit in a heavenward gaze, is clearly derived from Gainsborough's *The Woodman*, though the figure is a youth and not an old man. The boy is similarly standing under a tree on the right of the composition, and accompanied by a dog. But Barker has included an additional figure, reclining, also gazing upward, which is derived from Richard Earlom's mezzotint of 1781 (fig. 2) after Gainsborough's earliest fancy picture, *A Shepherd*, which also features a dog. The pose of this second figure emphasizes the principal diagonal of the composition.

Fig. 1. Thomas Gainsborough, *The Woodman*, from the mezzotint by Pierre Simon, 1791, London, British Museum

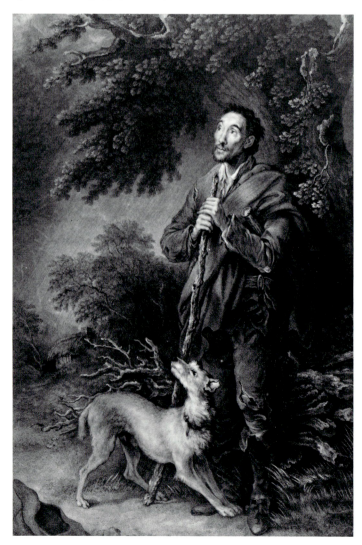

The subject of the woodman was one to which Barker returned throughout his life, and the style of the Washington painting corresponds with work done after the artist's return from Italy in 1793. On the other hand, Barker was preoccupied with the theme, and Gainsborough's interpretation of it, between 1789 and 1790. The heavy reliance on Gainsborough motifs suggests that this earlier dating is correct.

Notes

1. An ink label on the back of the stretcher only visible in infrared reflectography is inscribed: "relined/May 1898/originally/on panel." An ink label superimposed on this is inscribed: "lined May 1898/paper originally/laid down/on panel."

2. An ink label on the back of the stretcher is inscribed: "No 53 ['3' altered from '2'] by Gainsborough/on paper laid down/on canvas/Lent by/Philip Browne/Shrewsbury." The exhibition cannot be identified, but must have been subsequent to 1898, when the picture was adhered to canvas. Philip Browne may have been a descendant of the artist Philip Vandyck Browne, a prominent citizen of Shrewsbury (information about whom was kindly supplied by Mr. Nigel Gaspar, keeper, Shrewsbury Museums).

3. A Chenue label on the back of the stretcher is inscribed in ink: "Monsieur Bellas/pour Londres." Bellas was probably a dealer; the picture was exported as part of a consignment consisting of at least two cases.

4. *Bath Chronicle*, 17 April 1862; Bishop 1986 (see biography), 13–14, nos. 9, 10, repros. No. 10, the Macklin picture, is now owned by the Torfaen Museum Trust. Elizabeth Einberg kindly showed me her draft catalogue entry for the Tate Gallery's *The Woodman and His Dog in a Storm*, which she dates c. 1789.

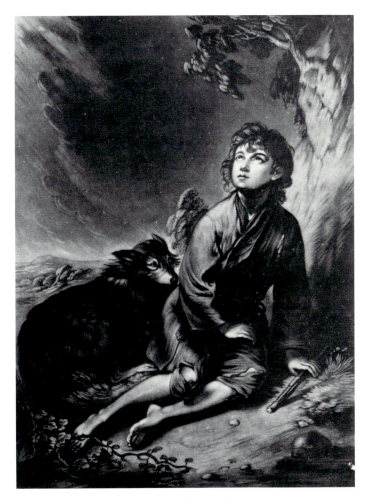

Fig. 2. Thomas Gainsborough, *A Shepherd*, from the mezzotint by Richard Earlom, 1781, London, British Museum

Sir William Beechey

1753 – 1839

BEECHEY was born in Burford, Oxfordshire, on 12 December 1753, one of the five children of William Beechey and Hannah Read. Both his parents died when he was young, and he was brought up by his uncle Samuel, a solicitor, who intended him for the law. While articled to a lawyer off Chancery Lane he became acquainted with a number of students of the Royal Academy of Arts, gave up his articles, and entered the Royal Academy in 1772, the same year as did John Bannister, the actor, who became a close friend, and Thomas Rowlandson. There is no evidence for assertions that he studied with Reynolds;

Dawson Turner, who knew Beechey, states more plausibly that he studied with Johan Zoffany, but this could only have been before July 1772, when Zoffany left England for seven years' sojourn in Italy.

Beechey first exhibited at the Royal Academy in 1776, and exhibited thereafter almost every year until his death more than sixty years later; he also exhibited regularly at the British Institution (founded 1805). In 1782 he moved to Norwich, where he remained until 1787; there he met his second wife (nothing is known about his first wife, who died sometime after 1784), Anne Phyllis Jessop, a

great beauty and talented draftsman and miniaturist, whom he married in 1793. They had fifteen children. Also in 1793 he was elected an Associate of the Royal Academy and became Portrait Painter to Queen Charlotte.

The 1790s marked the high tide of Beechey's professional success. Later eclipsed by Lawrence, he and John Hoppner were then still dividing the public honors in portraiture with that brilliant young star, and in 1795 Farington recorded in his diary George III's view that at the Royal Academy exhibition "Beechy [sic] was first this year, Hoppner second."[1] In 1798, after painting his huge canvas of the king at a review in Hyde Park (Royal Collection, Windsor Castle), Beechey was knighted and became a full Academician. Although he fell from favor at court for a while in 1804, he continued to paint royal portraits and was later Principal Portrait Painter to William IV. His prices, which in the 1790s were 30 guineas for a head and shoulders, 60 guineas for a half length, and 120 guineas for a full length, were increased twice in the 1800s and again in 1810, and by 1818 were 60, 125, and 250 guineas respectively. Beechey was a blunt but warm-hearted, generous, and convivial man, who entertained widely at his house on Harley Street. In 1836 he sold his collection of works of art and retired to Hampstead. There he died on 28 January 1839.

Up to and during his Norwich period Beechey concentrated, with ability and success, on portraits in little, a genre practised by Zoffany and Francis Wheatley; this experience probably accounts for the exceptionally precise delineation of features and almost Victorian preoccupation with detail that mark his later portraits and distinguish him from his contemporaries. In the 1790s he was close to Hoppner in style; he shared the romantic tendencies of the age and, although generally weak as a composer, emulated the rhythmical flow and swing of Lawrence in his groups. He also painted some romanticized landscapes and a number of fancy and mythological pictures in a sentimental vein, some of which look back to Reynolds and through him to Correggio. The Redgraves' judgment of 1866 still stands: "He excelled in his females and children; but his males wanted power. . . . His draperies [were] poor and ill-cast. . . . Yet he possessed much merit, and his portraits have maintained a respectable second rank."[2]

Notes
1. Farington *Diary*, 2:339 (5 May 1795).
2. Richard and Samuel Redgrave, *A Century of Painters of the English School*, 2 vols. (London, 1866), 1:341 (1981 ed.: 133).

Bibliography
Roberts, William. *Sir William Beechey, R.A.* London, 1907.
Millar, Sir Oliver. *The Later Georgian Pictures in the Collection of Her Majesty the Queen.* 2 vols. London, 1969, 1:5–10.

1961.5.1 (1654)

Lieutenant-General Sir Thomas Picton

1815/1817
Oil on canvas, 77 × 63.7 (30¼ × 25)
Gift of the Coe Foundation

Technical Notes: The medium-weight canvas is twill woven; it has been lined. The ground is off-white, fairly thickly applied, almost masking the weave of the canvas. The painting is executed in quite thick, opaque layers with impasto in the highlights; there is a transparent red glaze in the uniform. There is fairly extensive discolored retouching, principally in the glazed areas of the uniform, but also, most disturbingly, in the sitter's right cheek, to cover drying craquelure (suggestive of underlayers not having been allowed to dry properly before the upper layers were applied). The varnish has discolored yellow to a significant degree.

Provenance: Purchased from the artist February 1817 by Mr. Hall (?). Major Campbell. (John Levy Galleries), New York, 1934, from whom it was purchased by Mrs. Benjamin Franklin Jones, Jr., Sewickley Heights, Pennsylvania (sale, Parke-Bernet, New York, 4–5 December 1941, 1st day, no. 22, repro.), bought by William R. Coe [d. 1955], Oyster Bay, Long Island, New York; Coe Foundation, New York, 1955–1961.

SIR THOMAS PICTON (1758–1815), younger son of Thomas Picton of Poyston, Pembrokeshire, was a professional soldier. A stern disciplinarian whose governorship of Trinidad ended in his trial for sanctioning torture, he served with distinction and élan as Wellington's principal subordinate in the Peninsular War, becoming a national hero after his siege and heroic storming of Badajoz. He rose to the rank of lieutenant general, was created a knight grand cross of the Order of the Bath, and led the fifth division with extreme gallantry in the Waterloo campaign, where he fell in battle.

Picton was portrayed, in the main posthumously, by several artists. A posthumous full-length portrait by Sir Martin Archer Shee (now known only from the mezzo-

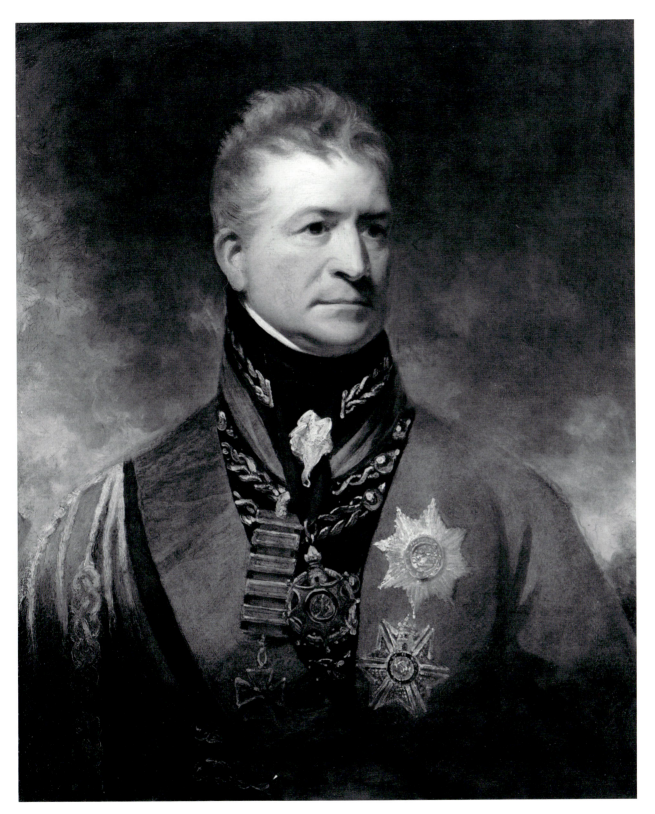

Sir William Beechey, *Lieutenant-General Sir Thomas Picton*, 1961.5.1

tint by Charles Turner, published in 1818)—in which the head was executed from Shee's earlier portrait now in the National Portrait Gallery, London—was exhibited at the Royal Academy in 1816. A monument by Sebastian Gahagan, who had also made busts of Picton, was later erected in Picton's memory in St. Paul's Cathedral.

Beechey painted his portrait of Picton in 1815, shortly before the latter left London for the Waterloo campaign.[1] The sitter is depicted in the uniform of a lieutenant general (epaulettes had been discontinued by an army order of 1811). He is wearing the sash of the Order of the Bath and on his left breast the star of the principal rank in that order (the GCB, awarded to him on 2 January 1815), with beneath it the star of a knight grand cross of the Portuguese Order of the Tower and Sword; hanging from his neck are the badge of the Order of the Tower and Sword and the Peninsula Cross with four campaign clasps.[2] Picton's expression is fiery and determined, descriptive of his dual qualities as an impetuous leader in action and a commanding officer of foresight, calm, and judgment; the Brutus crop hairstyle is in keeping with this image.

There are four recorded versions of this portrait.[3] One, exhibited at the Academy of 1815, was bought by a Mr. Picton, presumably a relative of the sitter, payment of fifty guineas being made in February 1816; this picture is no longer extant. One remained in Beechey's possession, and was purchased by the Duke of Wellington at the sale following the artist's death. This is now at Apsley House, London. A third was bought from Beechey, also for fifty guineas, the price of the original, by a Mr. Hall, who paid for it in February 1817. The fourth was acquired by a branch of the family, and is now at Ewenny Priory, Bridgend, Wales.[4] A copy by Thomas Brigstocke is at Cwmgwili, Bronwydd Arms, Dyfed, Wales.[5]

The Washington picture, which is fairly summary and lackluster in handling, is inferior in quality to the version at Apsley House, which is more solidly modeled and more firmly drawn, and it may well be the portrait acquired by Hall, probably painted to order.

Either the Picton or the Apsley House version (presumably the latter, as it was in the artist's studio) was engraved by Peltro William Tomkins in 1830.[6]

Beechey also executed a full-length portrait of Picton, now in the National Museum of Wales, Cardiff, in which the general is shown with a drawn sword in his right hand, an evocation of the storming of Badajoz beyond.

Notes
1. The Apsley House version is inscribed on the back, "painted a fortnight before his death."
2. I am grateful to Richard Walker for help in identifying the orders.
3. Three are listed in Roberts 1907 (see biography), 130–131.
4. This is described as a "replica of the painting at Apsley House" (John Steegman, *A Survey of Portraits in Welsh Houses*, 2 vols. [Cambridge, 1957–1962], 2 [South Wales]: 91).
5. Steegman 1957–1962, 2:46.
6. This was published in William Jerdan, *National Portrait Gallery of Illustrious and Eminent Personages of the Nineteenth Century*, 4 vols. (London, 1830–1833), 2:16.

William Blake
1757 – 1827

BLAKE was born near Golden Square, Soho, in London, on 28 November 1757, the third son of the five children of James Blake, a Nonconformist hosier, and his wife, Catherine. He entered Henry Pars' drawing school in the Strand at the age of ten, was writing poetry by the age of twelve, and by the time he was twenty had produced some of the finest lyrical poetry in the English language. In 1772 he was apprenticed for seven years to the successful engraver James Basire, who employed him between about 1774 and 1775 to draw medieval tomb sculpture in Westminster Abbey for Richard Gough's *Sepulchral Monuments in Great Britain*. In 1779 Blake was admitted to the Royal Academy Schools as an engraver; John Flaxman and Thomas Stothard, long to be close friends, were among his fellow students. He first exhibited at the Royal Academy in 1780 a painting of an historical subject, *The Death of Earl Goodwin* (sic).

In 1782 Blake married Catherine Butcher or Boucher,

the daughter of a market gardener in Battersea, who was to be a devoted wife; there were no children. The following year he published his *Poetical Sketches*, which were financed by Flaxman and the Reverend A. S. Matthew. After the death of his father in 1784 he set up a print shop next door to his birthplace with James Parker, a fellow apprentice of Basire. Unceasingly industrious and allowing himself no relaxation, Blake was obliged for long periods of his life to make his living as a reproductive engraver, and he was regarded as such by most of his contemporaries.

An avid reader, from his teens, of mystical writers such as Paracelsus and Jakob Böhme, Blake was a Nonconformist and political radical who became associated from about 1788 with the circle of Joseph Johnson, Fuseli, William Godwin, Mary Wollstonecraft, Joseph Priestley, and Thomas Paine; a man of natural goodness and humanity, he was at first an ardent supporter of the French Revolution, but was soon appalled by the increasing callousness and bloodshed.

In 1788 Blake developed a process of etching in relief that enabled him to combine illustrations and text on the same page and to print them himself, thus ensuring complete independence of thought and expression. The first of his illuminated books, *Songs of Innocence* and *The Book of Thel*, with their illustrations finished in watercolor, appeared in 1789. *The Marriage of Heaven and Hell* followed between 1790 and 1793, *Visions of the Daughters of Albion* and *America, a Prophecy* in 1793, and *Europe, a Prophecy*, *The Book of Urizen*, and *Songs of Experience* in 1794, when Blake turned to rich color printing. Many of his large independent color prints, or monotypes, were done in 1795. From 1795 to 1797 he produced, for a fee of twenty guineas, over five hundred watercolors for an edition of Edward Young's *Night Thoughts*, of which only one volume was published.

In 1799 Blake was commissioned by Thomas Butts, a minor civil servant, to paint, for one guinea each, fifty small Biblical subjects, which he executed in tempera; Butts, his single most important patron, seems to have bought the bulk of his output until at least 1810. In 1800, mentally exhausted, Blake moved to Felpham, near Chichester, at the invitation of the poet William Hayley, who offered him inconsequential employment for three years; there he regained a spiritual calm and was deeply affected by the study of Milton. Returning to London he began *Jerusalem* in 1804, a project he worked on continually until his death, and executed for Butts a large number of watercolors of Biblical subjects, including illustrations to the Book of Job. Between 1809 and 1810, enraged at being cheated by the publisher Cromek, Blake held an exhibition of his work, predictably a total failure with the critics and the public, at his brother's house in Soho, which had been his birthplace.

Neglected and in poverty, Blake was introduced in 1818 to John Linnell, who became his second major patron, commissioning a succession of works—including the engravings to the Book of Job (1823–1826), Blake's most popular work, and a set of illustrations to Dante's *Divine Comedy* (1824–1827)—and making regular payments to him until his death. Linnell introduced him to Constable and John Varley, and Blake later became acquainted with Samuel Palmer, George Richmond, and Edward Calvert. In spite of Linnell's patronage, Blake was in considerable financial distress during his later years; he was obliged in 1821 to sell his entire collection of prints to Colnaghi's, and in 1822, at Linnell's insistence, was the recipient of a grant from the Royal Academy. He died of gallstones at his home in Fountain Court, Strand, London, on 12 August 1827.

Blake was unusual in being a great poet as well as a great artist. His art was also intended primarily as an expression of his religious and philosophical ideas. His early style, already expressive, was flowing and linear, his subjects deployed on a narrow stage, influenced by medieval sculpture and the neoclassical aesthetic; the designs in his early illuminated books are lyrical, curvilinear, and delicately colored, reminiscent both of the rococo and of the age of *sensibilité*. It was his despair at the excesses of the French Revolution, the horrors of the slave trade, and the social effects of the Industrial Revolution—man's inhumanity to man—that precipitated the deeply visionary and more familiar style of the mid-1790s.

Blake had a profound sense of the irremediable corruption of the world in its fallen state, loathed organized religion, authoritarianism, reason, and materialism, and believed in redemption through Jesus Christ, less in the millenial sense preached by the Book of Revelation than as a state attainable by any individual. He developed his own complex mythology with a host of personifications: Los, for example, symbolized the imagination and the source of redemption; his offspring, Orc, revolutionary

energy; Urizen reason, law, materialism, and the vengeful Jehovah of the Old Testament. Blake believed that true art reflected the divine, that, by extension of Edmund Burke's enthusiasm for Hebrew as opposed to classical literature, the great works of classical antiquity reflected vanished Hebrew works of art, and that his own inspiration flowed from "Messengers from Heaven" who revealed to him his visions (after his uncreative years at Felpham he pronounced that "the Visions were angry with me"[1]).

Blake's visions were clear and precise, and more vivid to him than his perceptions of the natural world; it seems evident, however, that his extraordinary creative imagination was actually nourished by an exceptional visual memory, for it has been demonstrated that his imagery derived from a range of artistic sources unusually wide for the period, including not only the mannerist art of the sixteenth century, so much admired when he was a student, but also medieval and oriental art. Unconcerned with normal anatomy, draftsmanship, or perspective, and using more of the page than he had hitherto for his illustrations, Blake employed exaggerations of scale and posture and a new richness of color and texture to create the potent and harrowing imagery expressive of the deep pessimism of his Prophetic Books. Blake's most powerful works—intense in feeling, rich in texture, controlled and simple in design—are the great color prints of 1795.

The failure of political radicalism led Blake to place greater stress on Christ as man's salvation, and he reverted to Christian subject matter with his rich and somber tempera paintings for Thomas Butts. He also returned to neo-classical linearism and flat color washes in his Biblical watercolors for the same patron. Partly in response to his reading of Milton, Blake's later watercolors are more sensuous, and richer and subtler in their application of wash. In his last great but uneven masterpiece, the unfinished set of Dante drawings, executed in the serenity of his old age when he was inspired by a system of thought antithetical to his own, he achieved an astonishing new freedom of technique, working over his washes in small superimposed touches, and a new translucency and feeling for atmosphere.

Blake profoundly influenced the early style of George Richmond, the visionary work of Samuel Palmer, and the early engravings of Palmer and Calvert, notably through his exquisite woodcut illustrations of Robert John Thornton's *Pastorals of Virgil;* but his work remained little known outside a limited circle until the present century, when he became a cult figure and the subject of an increasingly copious literature.

Notes
1. Gilchrist 1863, 1:180.

Bibliography
Gilchrist, Alexander. *Life of William Blake, "Pictor Ignotus."* 2 vols. London and Cambridge, 1863.
Damon, S. Foster. *William Blake: His Philosophy and Symbols.* London, 1924.
Blunt, Anthony. *The Art of William Blake.* New York and London, 1959.
Wilson, Mona. *The Life of William Blake.* Ed. Sir Geoffrey Keynes. Oxford, 1971.
Clark, Sir Kenneth (later Lord Clark of Saltwood). *Blake and Visionary Art.* Glasgow, 1973.
Bindman, David. *Blake as an Artist.* Oxford, 1977.
Bindman, David. *The Complete Graphic Works of William Blake.* London, 1978.
Butlin, Martin. *William Blake.* Exh. cat., Tate Gallery. London, 1978.
Butlin, Martin. *The Paintings and Drawings of William Blake.* 2 vols. New Haven and London, 1981.
Bindman, David. *William Blake: His Art and Times.* Exh. cat., Yale Center for British Art, New Haven; Art Gallery of Ontario, Toronto. London, 1982.
Essick, Robert N. *The Separate Plates of William Blake.* Princeton, 1983.

1954.13.1 (1355)

The Last Supper

1799
Tempera on canvas, 30.5 × 48.2 (12 × 19)
Rosenwald Collection

Inscriptions:
Signed in monogram at lower left: *WB inv.*

Technical Notes: The exceptionally fine canvas is plain woven; it has been lined. The ground is white, thinly applied. The painting is executed in glue tempera (characteristic of Blake's technique), applied in thin, multiple glazes in the figures and in thicker, opaque layers in the dark background; the drapery and details of the figures are applied in stiff, textured paint modified by thin overlying glazes. The painting is very fragile. The canvas is dessicated and brittle; the lining is dry and stained on the reverse; there is minute cleavage throughout the ground and paint layers, caused by contraction of the brittle glue

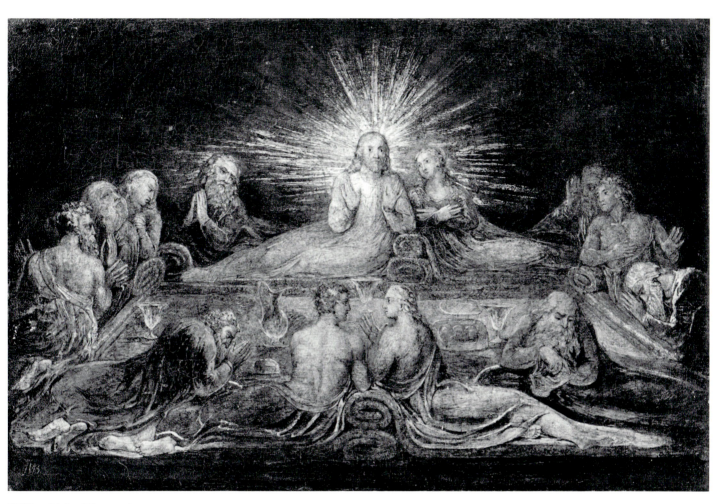

William Blake, *The Last Supper*, 1954.13.1

medium. The much darkened varnish was removed and flaking paint fixed with wax when the painting was restored, between 1949 and 1951, for the William Blake Trust. There is a considerable amount of overpaint throughout, applied with minute brushstrokes. The slightly toned natural resin varnish has discolored yellow to a moderate degree.

Provenance: Painted for Thomas Butts [1757–1845]; by descent to Thomas Butts, Jr. (sale, Messrs. Foster, London, 29 June 1853, no. 87), bought by J. C. Strange, Highgate. (B. F. Stevens & Brown), London. Graham Robertson [1866–1948]. (Anon. sale, Christie, Manson & Woods, London, 22 July 1949, no. 102), bought by the William Blake Trust, whose Trustees sold it 1951 to Lessing J. Rosenwald, Philadelphia.

Exhibitions: Royal Academy of Arts, London, 1799, no. 154. *The Tempera Paintings of William Blake*, Arts Council of Great Britain, London, 1951, no. 29, pl. 8. *The Art of William Blake*, National Gallery of Art, Washington, D.C., 1957, no. 1.

THIS IS one of over 135 illustrations to the Bible painted for Thomas Butts, a clerk in the office of the Commissary General of Musters (a department of the War Office), who was Blake's most important patron. The series marked a revival of the Christian element in Blake's thought, following the failure of political radicalism and Blake's revulsion at the bestiality of the later stages of the French Revolution. He referred to it in a letter of 26 August 1799 to George Cumberland: "I am Painting small Pictures for the Bible. . . . My Work pleases my employer, & I have an order for Fifty small pictures at One Guinea each."[1] Thirty temperas are known today. Unusual for

Blake in their dark and rich coloring, these works have further darkened (and cracked) owing to the use of carpenters' glue, instead of the usual size or egg medium, to bind the pigment.

The Last Supper, Blake's only representation of this subject, was exhibited in 1799 with a reference in the catalogue to Matthew 26:21 and the quotation: "Verily I Say unto you that one of you shall Betray Me." The disciples, carefully balanced and contrasted in pose on either side of a clear central axis, as in other paintings of the series,[2] are shown perturbed or in the act of prayer following this accusation. Judas is depicted oblivious of the others, counting the thirty pieces of silver (although it is implied in the Gospels that he was not paid until after the Betrayal).

Christ and his disciples are reclining on low couches at the table, in Roman style. It has been pointed out that Blake could have known Poussin's representations of the scene in which the Roman way of eating is adopted, since both the latter's series of the Seven Sacraments were exhibited in London at this time, in 1797 and 1798 respectively.[3] Moreover, Blake's lucid and balanced treatment of the theme is clearly in the tradition of Poussin's earlier rendering of the subject (fig. 1).[4] Blake's strong rhythmical sense is evident in his treatment of the foreground figures.

Notes
1. Butlin 1981 (see biography), 1:317.
2. Bindman 1977 (see biography), 128.

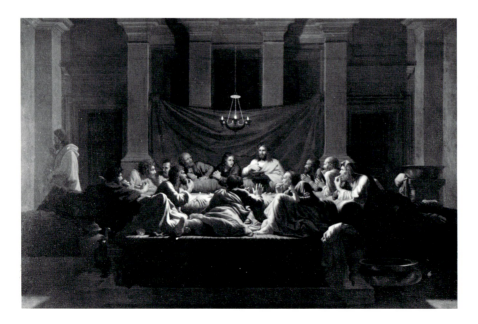

Fig. 1. Nicholas Poussin, *The Holy Eucharist*, 1647, oil on canvas, Mertoun, Duke of Sutherland, on long-term loan to the National Gallery of Scotland, Edinburgh

Fig. 1. William Blake, *Job and His Daughters*, pencil, pen,
and watercolor, Cambridge, Massachusetts, Fogg Art Museum

3. Bindman 1977 (see biography), 243, n. 54; Paley 1978,
55; Butlin 1981, 1:332.

4. Bindman 1982 (see biography), 38.

References
1863 Rossetti, William. *Annotated Catalogue.* In Gilchrist
1863 (see biography), 2: no. 23.
1957 Keynes, Sir Geoffrey. *William Blake's Illustrations
to the Bible.* Clairvaux (The Trianon Press), 1957: xiii, no. 132,
repro., pl. vi color repro.
1976 Rosenwald, Lessing J. *Recollections of a Collector.*
New York, 1976:100.
1977 Bindman 1977 (see biography): 124, 127, 128.
1978 Paley, Morton D. *William Blake.* Oxford, 1978:55,
pl. 80.
1981 Butlin 1981 (see biography), 1: no. 424; 2: color pl.
508.
1982 Bindman 1982 (see biography): 38, fig. 22.

1943.11.11 (763)

Job and His Daughters

1799/1800
Pen and tempera on canvas, 27.3 × 38.4 (10¾ × 15⅛)
Rosenwald Collection

Technical Notes: The medium-fine canvas is plain woven; it
has been lined. The ground is white, thickly applied in animal
glue and spongy in texture. There is a thin monochrome impri-
matura covered by a layer of glue. The painting is executed
thinly in glue tempera, a very thin layer containing the colored
elements of the design being covered with a brownish layer;
the linear details are added in black with a pen, with the final
touches of white in a low impasto. There is an original surface
coat of animal glue. The painting was described by William
Rossetti in 1863 as "fearfully dilapidated."[1] The paint is abraded
and is actively flaking and cleaving; the surface coat has discol-
ored to a very significant degree and has begun to delaminate
from the paint. Extensive watercolor inpainting was carried
out in 1938;[2] further watercolor inpainting was done in 1965,
1968, and in the early 1980s. The wax varnish has discolored
gray.

Provenance: Painted for Thomas Butts [1757–1845]; by descent
to Thomas Butts, Jr. (sale, Messrs. Foster, London, 29 June
1853, no. 86), bought by J. C. Strange, Highgate. (Harvey),
London, by c. 1865. William Bell Scott by 1876 (sale, Sotheby
& Co., London, 14 July 1892, no. 236), bought by (Bernard
Quaritch), London. Charles Eliot Norton, Cambridge, Mas-
sachusetts [d. 1908]. Gabriel Wells. George C. Smith, Jr., by
1930 (sale, Parke-Bernet, New York, 2–3 November 1938, 1st
day, no. 109, repro.), bought by (Rosenbach & Co.), Philadel-
phia, for Lessing J. Rosenwald, Philadelphia.

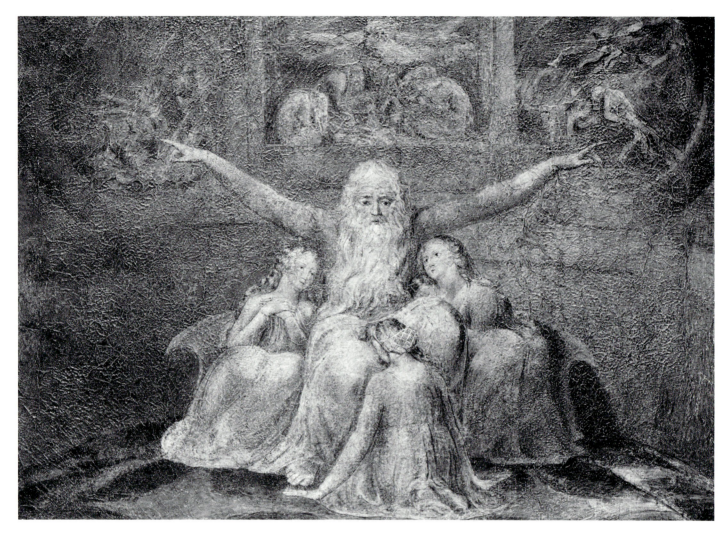

William Blake, *Job and His Daughters*, 1943.11.11

Exhibitions: *The Works of William Blake*, Burlington Fine Arts Club, London, 1876, no. 107. *International Exhibition of Industry, Science and Art: Pictures and Works of Art*, Edinburgh, 1886, no. 1442. *Works of William Blake*, Fogg Art Museum, Cambridge, Massachusetts, 1930, unnumbered. *William Blake 1757–1827: an Exhibition of the Works of William Blake selected from Collections in the United States*, Philadelphia Museum of Art, 1939, no. 148. *The Art of William Blake*, National Gallery of Art, Washington, 1957, no. 4.

THIS IS another of the series of over 135 illustrations to the Bible painted for Thomas Butts (see 1954.13.1).

The scene shows Job, shortly before his death, telling his three daughters of his afflictions and his salvation. Seated in an enclosed space, he is pointing to visions painted on the walls which depict, from left to right: the destruction of his servants by the Chaldeans, with Satan hovering overhead; God appearing in the whirlwind; and the destruction of his ploughmen by Satan himself, who is again seen hovering overhead.[3] Job's dramatic outstretched arms, badly drawn, are characteristic of Blake's expressionist narrative style and lack of concern for traditional academic values.

Blake depicted Job and his daughters on a number of occasions, both in sketches and in finished form, chiefly in the 1820s.[4] All these works differ in design from the Washington picture, although its figure composition is the starting point for his fresh invention (fig. 1), and most show the group in an outdoor setting usually with sheep grazing; but Blake reverted to the interior setting for his rendering of the subject in his engraved illustrations to the Book of Job, 1823–1826,[5] one of his late masterpieces. Lindberg, following Rossetti, maintained that the

Washington painting dates from this period: "The indoor scene is a great improvement which Blake is unlikely to have abandoned. The painting was certainly done after 1823, probably about 1825."[6] This view contradicts the clear evidence of the commission from Butts. Stylistically the work accords with the rich, deep harmonies and textures characteristic of Blake's work in the second half of the 1790s.

Notes

1. Gilchrist 1863 (see biography), 2:215.
2. Philadelphia 1939, 97, under no. 148.
3. Butlin 1981 (see biography), 1:417.
4. Butlin 1981 (see biography), 1: nos. 550 (20), 551 (20), 555, 556, 557 (49). Butlin sets out the order in which he believes these to have been done in his entry for no. 394.
5. The close resemblance in composition accounts for Rossetti's dating the Washington picture "1825?" (Gilchrist 1863 [see biography], 2:215).
6. Lindberg 1973, 23.

References
1863 Rossetti, William. Annotated Catalogue. In Gilchrist 1863 (see biography), 2: no. 99.
1935 Binyon, Laurence, and (Sir) Geoffrey Keynes. *Illustrations of the Book of Job by William Blake.* New York, 1935:46 (under no. 20).
1957 Keynes, Sir Geoffrey. *William Blake's Illustrations to the Bible.* Clairvaux (The Trianon Press), 1957:22, no. 74a, repro.
1973 Lindberg, Bo. *William Blake's Illustrations to the Book of Job.* Abo, 1973:23, 347, nos. xxvi, 20G.
1976 Rosenwald, Lessing J. *Recollections of a Collector.* New York, 1976:97.
1977 Bindman 1977 (see biography): 209.
1981 Butlin 1981 (see biography), 1: no. 394; 2: color pl. 500.

Richard Parkes Bonington

1802 – 1828

BONINGTON was born in Arnold, near Nottingham, on 25 October 1802, the only child of Richard Bonington, formerly governor of the county jail in Nottingham but by then a minor artist, drawing master, and printseller, and Eleanor Parkes, who ran a school for young ladies. Nothing is known of his schooling, but he is reputed to have been skilled at drawing from a young age and to have loved acting. In 1817, as a result of the social unrest

affecting business following the introduction of the factory system into the Nottingham lace and hosiery industries, the Boningtons emigrated to France and set up a lace manufactory in Calais, moving to Paris the following year. Bonington refined his watercolor technique, and acquired a taste for coastal scenes through his association with Louis Francia, a native of Calais, who had worked for over a quarter of a century in England;

he copied in the Louvre and studied in the atelier of Baron Gros at the Ecole des Beaux Arts, Paris, from 1819 to 1822, where he was taught precision in drawing.

In 1821 Bonington made an extended tour of Normandy, exhibiting at the Paris dealers Hulin and Schroth in the following spring watercolors that were admired by Corot, Delacroix, and Gros himself. He first exhibited at the Salon in 1822. Bonington toured Belgium in 1823 and spent much of 1824 at Dunkirk, exhibiting his first oils at the Salon that year. He contributed five subjects to the Normandy volume of Nodier's *Voyages pittoresques et romantiques dans l'ancienne France* (1820–1878), published in 1824, and produced his own set of lithographs, *Restes et fragmens* [sic] *d'architecture du moyen-age*, in the same year. In 1825 he visited London, where he studied the Meyrick collection of armor together with Delacroix, whose studio he shared for several months on his return to France.

Bonington traveled in Italy for eleven weeks in 1826 with Baron Rivet, a wealthy patron whom he had met through Delacroix, spending a month in Venice where he worked with feverish energy. The rest of his short life was taken up with handling a mounting pressure of work, much of it commissioned, in the face of increasing weakness induced by tuberculosis. At the end of 1827 he moved from his studio (which was drawn by Thomas Shotter Boys) in the house of Jules-Robert Auguste, a wealthy collector of oriental costume and armor, to a larger one in the rue Saint Lazare. Bonington made visits to London to see his dealers in 1827 and 1828, exhibiting at the Royal Academy of Arts in both years and first showing his courtly history subjects there and at the Salon in 1828. Obliged by ill health to cancel a summer sketching trip in Normandy with Paul Huet, he later returned to London and died there on 23 September 1828.

Bonington, striking in personal appearance, mild and generous in disposition, was a lyrical genius who worked charmingly and brilliantly, nearly always on a small scale, with complete assurance of touch. Although much of his work was done in the studio and Constable thought it superficial, Delacroix never ceased to wonder at his "marvellous understanding of effects, and the facility of his execution . . . that lightness of touch which, particularly in watercolours, makes his pictures as it were like diamonds that delight the eye."[1] Bonington had a command of every technique and nuance available in his media, especially in watercolor, an instinctive feeling for spatial relationships and significant detail, and a sense of construction and design perhaps largely attributable to his Beaux Arts training. He was thoroughly contemporary in his approach to subject matter. He devoured Walter Scott and French historical romances, sharing that sentimental feeling for the past and for medieval buildings characteristic of the post-Napoleonic age, and profited from the reviving artistic patronage of the Restoration period; he responded to French collectors' penchant for charming and sensuous works on a small scale, the taste for the exotic, and the demand for picturesque townscapes and country and coastal scenes (the seaside was becoming modish). He delighted in the immediacy of the new reproductive medium of lithography, and cultivated assiduously dealers and publishers both French and English.

At first dependent on pencil outline for his watercolors, which were restrained in tone, Bonington soon developed stronger and warmer color harmonies, a luminosity in his seascapes derived from his study of the Dutch, and a feeling for space, distance, and atmosphere especially evident in his superbly controlled panoramic views. His admiration for Turner, whose work he came to know in London in 1825, is evident; he was also influenced by Constable, Crome, and Joshua Cristall. That same year, 1825, he began painting historical genre scenes in the *style troubadour*, for which there was a vogue in the Salon; in these he was influenced by Delacroix, who also introduced him to Near Eastern subject matter. His mature figure studies were as brilliant as those of David Wilkie. Intimate interiors based on Dutch genre were another vein. Bonington developed a heightened expressiveness and feeling for drama, breadth, atmosphere, and intensity of color during and after his Italian tour; the painters he most admired at this period were, in addition to Delacroix, Titian and Veronese. At the end of his life his ambition was to embark on large-scale history painting (for which Delacroix realized he had no aptitude).

Bonington's fame was unaffected by his early death. Avid collectors of his work included Lord Lansdowne, John Lewis Brown (the Bordeaux wine merchant), and, later, Lord Hertford. Imitations and forgeries abounded, and his influence was widespread, both in France and England; his manner was taken up by Shotter Boys, Huet,

William Callow, James Holland, William Wyld, and others.

Notes

1. Delacroix to Théophile Thoré, Champrosay, 30 November 1861 (Jean Stewart trans., *Eugène Delacroix Selected Letters 1813–1863* [London, 1971], 371–372).

Bibliography

Dubuisson, A., and C. E. Hughes. *Richard Parkes Bonington*. London, 1924.
Spencer, Marion L. *R. P. Bonington 1802–1828*. Exh. cat., Castle Museum and Art Gallery. Nottingham, 1965.
Ingamells, John. *Richard Parkes Bonington*. Wallace Collection Monographs 3. London, 1979.
Peacock, Carlos. *Richard Parkes Bonington*. London, 1979.
Pointon, Marcia. *Bonington, Francia & Wyld*. Exh. cat., Victoria and Albert Museum. London, 1985:33–63, 125–153.
Cormack, Malcolm. *Bonington*. Oxford, 1989.
Noon, Patrick. *Richard Parkes Bonington* 'On the Pleasure of Painting.' Exh. cat., Yale Center for British Art, New Haven, Petit Palais, Paris. New Haven, 1991.

1982.55.1 (2863)

Seapiece: Off the French Coast

c. 1823/1824
Oil on canvas, 37.7 × 52 (14⅞ × 20½)
Paul Mellon Collection

Technical Notes: The medium-coarse canvas is plain woven; it has been lined. The ground is white, freely brushed. The painting is executed vigorously and opaquely; the primary layers are blended wet into wet, over which the ships and breakwaters are laid in with thinner paint and the rigging and figures richly and fluidly; there is broken impasto in the whites. The paint surface is slightly abraded and has been flattened during lining. The painting is otherwise in good condition. There is minute retouching throughout, resulting from the abrasion, and a quarter-inch band of reglazing along the bottom edge. There are residues of a pigmented natural varnish which have discolored yellow. The more recent, moderately thick synthetic varnish has not discolored.

Provenance: Baron Henri de Rothschild. John, 1st Baron Astor of Hever [1886–1971], Hever Castle, Kent, by 1951; by descent, through his wife, Lady Violet Nairne [d. 1965], to George, 8th Marquess of Lansdowne [b. 1912], who sold it 1979 to (Thos. Agnew & Sons), London, from whom it was purchased February 1980 by Paul Mellon, Upperville, Virginia.

Exhibitions: Perhaps Royal Academy of Arts, London, 1827, no. 373. *The First Hundred Years of the Royal Academy*, Royal Academy of Arts, London, 1951–1952, no. 208. *Bonington*, Guildhall, King's Lynn, 1961, no. 6. *Pictures, Watercolours and Drawings by R. P. Bonington*, Thos. Agnew & Sons, London, 1962, no. 6, repro. *R. P. Bonington*, Castle Museum and Art Gallery, Nottingham, 1965, no. 252. *Bonington: Les débuts du romanticisme en Angleterre et en Normandie*, Musée de Cherbourg, 1966, no. 46.

BONINGTON lived in Calais with his family from 1817 to 1818, and continued to be familiar with the northern French and Belgian coast from later visits, notably a long stay in Dunkirk in 1824. The coastline in this painting is too nondescript to be identifiable. As pointed out by Spencer, a watercolor in which the shipping is virtually identical but in which the breakwaters are not featured is in the Whitworth Art Gallery, University of Manchester (fig. 1).[1]

Fig. 1. Richard Parkes Bonington, *Shipping off the French Coast*, watercolor, Manchester, Whitworth Art Gallery, University of Manchester

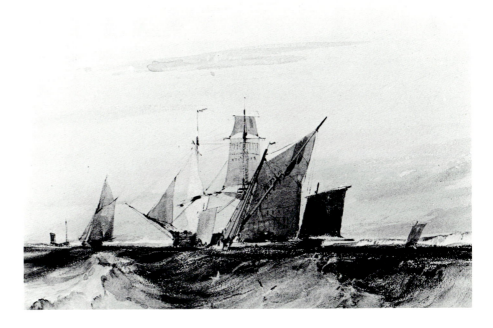

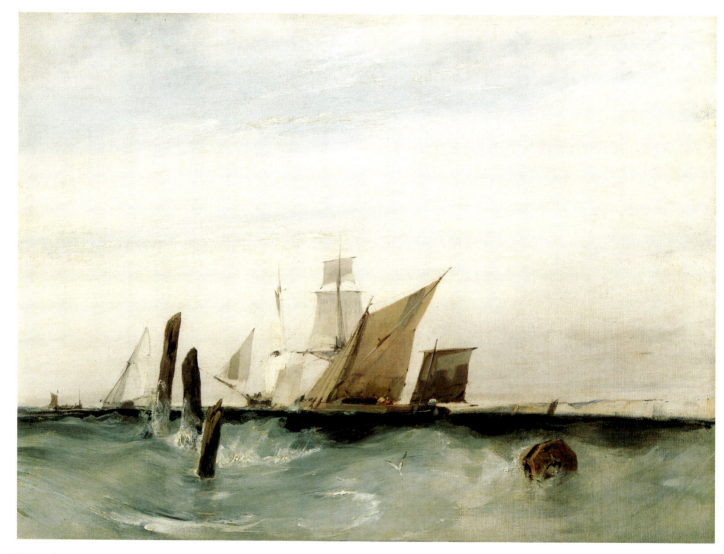

Richard Parkes Bonington, *Seapiece: Off the French Coast*, 1982.55.1

This little seascape, apparently artless but actually carefully controlled in design, is freshly and fluidly painted; the direct handling, almost as if in watercolor, of the waves that swirl around the breakwaters is especially brilliant. The tonality is subdued: browns, grays, and whites in the sails, the sea varying from gray-blue to inky black. The breakwaters are too far away from the shore to serve a functional purpose, and these and the buoy on the right have been placed where they are for compositional reasons.

The spontaneity of handling and subdued tones suggest that the picture was painted when Bonington was working in Belgium and northern France between 1823 and 1824.[2] In the summer of 1825 he was in England; later that year, he was in Paris, sharing an atelier with Delacroix and occupied with, among other genres,

grander and more spacious coast scenes. His style became more dramatic and his color richer and deeper following his visit to Italy in the spring and early summer of 1826.

Notes
1. Nottingham 1965, no. 252.
2. The Normandy beach scene in the Yale Center for British Art, which is identical to the Washington picture in its subdued grayish brown tonality, is dated to early 1824 by Patrick Noon (Noon 1991 [see biography], no. 25, color repro.)—a refinement on the date c. 1823 in Malcolm Cormack, *A Concise Catalogue of Paintings in the Yale Center for British Art* (New Haven, 1985), 24. Two other works comparable in execution and tonality are *A Distant View of St. Omer* in the Tate Gallery, London (2664), which is now dated c. 1824 (Noon 1991 [see biography], no. 26, color repro.), and a sea piece with a distant view of very similar low cliffs, and a similar buoy bobbing around on the right, in the Wallace Collection, London (P273), which is dated by that institution c. 1824–1825.

Carl Fredrik von Breda

1759 – 1818

CARL FREDRIK VON BREDA was born in Stockholm on 16 August 1759, the third of the five children of Lucas von Breda, the average adjuster of the maritime insurance company in Stockholm, who was also a great art collector, and Johanna Cornelia Piper. After receiving a thorough classical education Von Breda was trained at the Royal Academy in Stockholm, where he won his first medal in 1778; by then he was a pupil of the royal portrait painter, Lorenz Pasch the Younger. In about 1781 he married Inga Christina Enquist; they had several children, of whom two sons and a daughter survived. In 1784 Von Breda contributed nineteen paintings to the first public exhibition held in Stockholm, and was awarded the academy's gold medal. He was made a member of the academy in 1791.

After a period of successful practice in Stockholm, where he numbered the royal family among his patrons, Von Breda traveled to England in the summer of 1787, originally with the intention of going on to Italy, and worked for a time in Reynolds' studio. He exhibited at the Royal Academy annually from 1788 to 1796, and painted members of the Lunar Society in Birmingham

between 1792 and 1793. He remained in London until 1796.

Shortly after his return to Sweden Von Breda was appointed professor at the Royal Academy in Stockholm. In 1800 he was commissioned to paint the coronation of Gustav IV (Norrköping Museum, Östergotland), afterward becoming painter to the Swedish court. By now Von Breda had achieved a considerable reputation and was regarded as the most fashionable portraitist in Sweden, exhibiting regularly and painting a number of important groups; among his pupils were Per Krafft the Younger, A. Lauréus, and J. G. Sandberg. As a man he was amiable and unassuming. He died of a stroke in Stockholm on 1 December 1818.

Von Breda followed Lorenz Pasch and the Swedish culture of the day in his dependence on contemporary French art. His early style, rococo in color, was influenced by Fragonard, Greuze, and Louis Seize portraiture, with its meticulously rendered interior settings. In England he developed a more informal style, influenced by Reynolds and, to some extent, by Wright of Derby and by Gainsborough. Von Breda retained some of his

English manner and crisp handling of paint after his return to Stockholm; Giuseppe Acerbi, who thought his work "a little unnatural and overstrained," described many of his pictures then as nothing more than sketches.[1] But in about 1800 he changed his palette from the silvery grays and blues characteristic of his English period to warm reds and browns, and reverted to his former involvement with the French style, now exemplified by David (whose studio he had visited in 1796), Gérard, and Gros. He was the pioneer of romantic portraiture in Sweden but was an equally accomplished performer in the smooth and polished neoclassical grand manner. His history painting is little studied.

Von Breda, who has been called the last of the great masters from the golden age of Swedish art,[2] was the principal influence on the younger generation of Swedish painters at the beginning of the nineteenth century, notably the portrait and fresco painter J. G. Sandberg.

Notes

1. Joseph Acerbi, *Travels Through Sweden, Finland, and Lapland, to the North Cape, in the Years 1798 and 1799*, 2 vols. (London, 1802), 1:160.
2. Hultmark 1915, 121.

Bibliography

Hultmark, Emil. *Carl Fredrik von Breda: Sein Leben und sein Schaffen*. Stockholm, 1915.

1942.8.15 (568)

Mrs. William Hartigan

1787/1796
Oil on canvas, 77 × 64 (30⅜ × 25¼)
Andrew W. Mellon Collection

Technical Notes: The medium-weight canvas is plain woven; it has been lined twice. The ground is white, thinly applied. The composition itself is oval in format, and a brush-drawn line defines the arc of the oval; the area outside the oval is painted in dark brown. The painting is executed thinly, loosely in most areas except for the flesh, which is painted in careful, transparent glazes, with the features quite delicately applied. X-radiographs show a pentimento in the frilled collar, which was originally higher, revealing less of the sitter's bosom. The paint surface is slightly abraded; areas around two tears about five centimeters long to the right of the head have been heavily overpainted, and there is scattered, minor retouching. The fairly thick natural resin varnish has discolored to a moderate degree.

Provenance: Carlile Pollock [1749–1806], New Orleans and New York, the sitter's brother; by descent, through his daughter and grandson, to his grandniece, Mrs. Emma G. Terry Lull, who sold it by 1896 to George H. Story, New York, by whom sold to (Ehrich Galleries), New York, from whom it was purchased in 1913 by Jesse A. Wasserman, New York. (Ehrich Bros.), New York, who sold it to (Doll and Richards), Boston, from whom it was purchased 1916 by Mrs. David P. Kimball, Boston, who sold it 17 December 1918 to Thomas B. Clarke [d. 1931], New York. Sold by Clarke's executors 1935 to (M. Knoedler & Co.), New York, from whom it was purchased January 1936, as part of the Clarke collection, by The A. W. Mellon Educational and Charitable Trust, Pittsburgh.

Exhibitions: *Portraits Painted by Gilbert Stuart*, Museum of Fine Arts, Boston, 1880, no. 291. Long-term loan, Museum of Fine Arts, Boston, 1884–1886. Long-term loan, The Metropolitan Museum of Art, New York, 1896–1897. *One Hundred Early American Paintings*, Ehrich Galleries, New York, 1918, repro. 112. *Portraits Painted in Europe by Early American Artists*, Union League Club, New York, 1922, no. 17. *Portraits by Early American Artists of the Seventeenth, Eighteenth and Nineteenth Centuries Collected by Thomas B. Clarke*, Philadelphia Museum of Art, 1928, unpaginated and unnumbered. *Gilbert Stuart: Portraits Lent by the National Gallery of Art*, Virginia Museum of Fine Arts, Richmond, 1943–1944, no. 5. *Faces of America*, Inaugural Exhibition, El Paso Museum of Art, El Paso, Texas, 1960–1961, unnumbered.

ANNE ELIZABETH POLLOCK (b. 1758) was the daughter of John Pollock, of Newry, County Down, Northern Ireland, and the second wife of Dr. William Hartigan, surgeon and professor of anatomy at Trinity College, Dublin. Her husband's portrait, by Gilbert Stuart, is also in the National Gallery. Her three brothers, Carlile, George, and Hugh, emigrated to America, and were merchants in New York.

There are three (possibly four) other portraits of, or reputedly of, Mrs. Hartigan. A head-and-shoulders canvas, 20 by 15½ inches, attributed to Stuart, which had descended in the family, was owned by Dr. Alfred Bader, Milwaukee, in 1968;[1] this shows the sitter as prettier and more youthful than in the Gallery's picture, although the date, judging by the hair style and dress, must be much the same. A miniature by Walter Robertson, which also descended in the family, was formerly owned by Charles Lull, Washington.[2] A third portrait by or attributed to Stuart was reported as being in Philadelphia in 1924.[3] A fourth portrait by or attributed to Stuart is discussed below.

The identification has been questioned by Mount. On the basis of a portrait traditionally identified as Mrs. Hartigan by Stuart—but manifestly a different sitter—

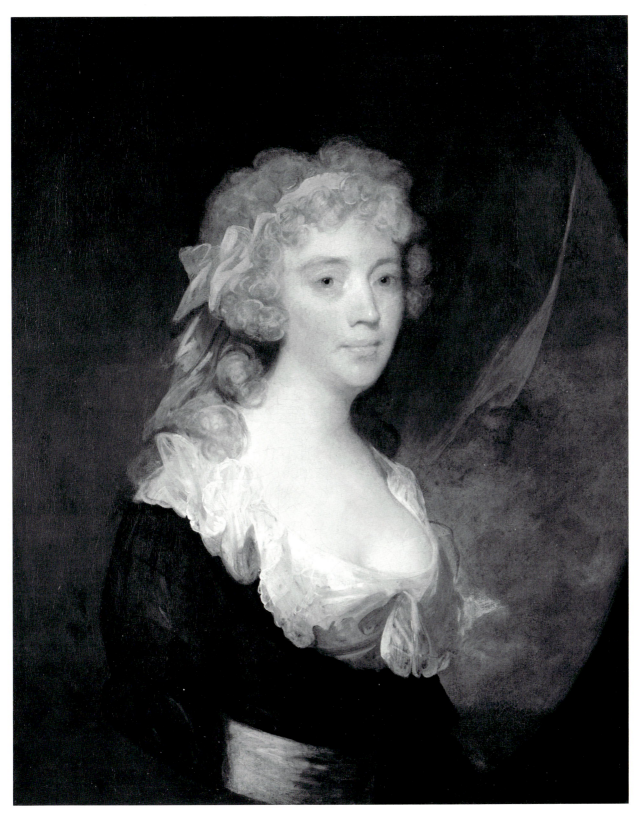

Carl Fredrik von Breda, *Mrs. William Hartigan*, 1942.8.15

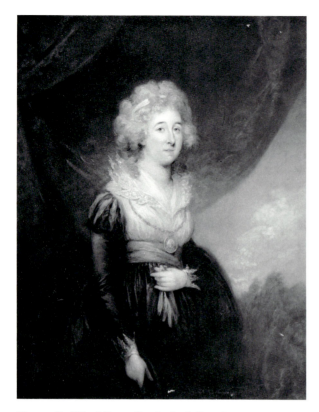

Fig. 1. Carl Fredrik von Breda, *Lady Jane James*, signed and dated 1794, oil on canvas laid down on panel, England, private collection
[photo: Sotheby & Co.]

which he discovered in the Pollock family home at Navan, Dublin, and convinced that the Gallery's picture was a work of Stuart's Philadelphia period and was not painted in Ireland, Mount argued that the Washington paintings of Dr. and Mrs. William Hartigan were portraits of Hugh Pollock and Stuart's cousin, Marthe Anthony, who were married in Philadelphia, 9 April 1795.[4] Without corroborative evidence this theory must remain surmise, and it rests, in any case, on the correct identification of the sitter in the portrait in the Pollock collection at Navan, Dublin.

The Gallery's portrait has been known as by Gilbert Stuart, who worked in Ireland from 1787 to 1792 or 1793, since at least 1879,[5] and has been accepted as such by scholars in the field.[6] As Mount pointed out, the pose is similar to those in the portraits of Mrs. Joseph Anthony and Mrs. James Greenleaf.[7] The picture is not, however, a pendant to the Stuart portrait of Dr. Hartigan: Mrs. Hartigan is painted in a standing position, with a curtain and sky behind, on a rectangular canvas, with painted spandrels, whereas he is painted seated, with a plain background, on an oval canvas.

In recent years the attribution has been questioned by Campbell[8] and Miles,[9] and comparison with signed works by Carl Fredrik von Breda, who worked in England from 1787 to 1796, shows that the portrait is actually by this artist (fig. 1). The modeling in the manner of late Reynolds, in whose studio Von Breda worked, which is unlike that of Stuart, and the idiosyncratic sketchy highlighting of the hair and costume, are characteristic of Von Breda's style.

The deliberately negligent hairstyle, and loose curls framing the face and reaching down to the shoulders, the ribbon bandeau encircling the hair, the frilled collar of the chemise, and the sash belt are all characteristic of English fashion in the late 1780s and in the 1790s. The evidence of costume would thus support an attribution of the portrait to Von Breda as much as to Stuart. The costume dating is consonant with the age of the sitter, who appears to be in her thirties.

Notes

1. Alfred Bader to Dorinda Evans, 10 September 1968 (wrongly describing the work as listed in Mason 1879 and included in the Ehrich Galleries exhibition 1918), and undated note, both in NGA curatorial files. Listed as attributed to Stuart in Park 1926, 2, 899.

2. Undated note, in NGA curatorial files.

3. Lawrence Park to Nathaniel C. Sears, 30 August 1924, copy in NGA curatorial files.

4. Charles M. Mount to William P. Campbell, 19 August 1972, in NGA curatorial files.

5. Mason 1879, 196. Mason presumably obtained the early history of the portrait from the then owner and descendant of the sitter, Commander Edward Terry.

6. Mason 1879, 196; Park 1926, 1:386–387; Sawitsky, undated note, in NGA curatorial files; Mount 1964, 369. The portrait was still accepted as by Stuart in 1980 (NGA 1980, 230).

7. Park 1926, 3:27, 212, repros.; Charles M. Mount to William P. Campbell, 27 September 1962, in NGA curatorial files.

8. Dorinda Evans, verbal information (Susan Davis to compiler, 30 January 1989, in NGA curatorial files). Nonetheless, Campbell included it without a question mark in his catalogue (NGA 1970, 104).

9. Ellen Miles, verbal information (Susan Davis to compiler, 30 January 1989, in NGA curatorial files).

References

1879 Mason, George C. *The Life and Work of Gilbert Stuart.* New York, 1879:196.

1886 Mudge, Alfred. *Catalogue of Works of Art* (Museum of Fine Arts). Boston, 1886:11, no. 206.

1926 Park, Lawrence. *Gilbert Stuart.* 4 vols. New York, 1926, 1:386–387, no. 380; 3:228, repro.

1927 Carroll, Dana. "Early American Portrait Painting." *IntSt* 86 (1927):65–66.
1928 Lee, Cuthbert. "The Thomas B. Clarke Collection of Early American Portraits." *American Magazine of Art* 19 (1928):304.

1964 Mount, Charles Merrill. *Gilbert Stuart: A Biography*. New York, 1964:369.
1970 NGA 1970:104, repro. 105.
1980 NGA 1980:210, repro.

John Constable

1776 – 1837

BORN IN East Bergholt, Suffolk, on 11 June 1776, Constable was the second son of the six children of Golding Constable, a prosperous mill owner, and Ann Watts. He was educated at a private school in Lavenham and at the grammar school in Dedham, subsequently joining the family business, of which it was intended he would succeed as manager. He learned the technique of painting from John Dunthorne (a local plumber and glazier who was an amateur painter), and was encouraged by Sir George Beaumont. Staying with relatives at Edmonton in 1796 he met John Cranch, a mediocre artist whose style he imitated, and John Thomas Smith, the antiquarian draftsman, with whom he made drawings of picturesque cottages. In 1799 his father gave him an allowance to enter the Royal Academy Schools, reluctantly consenting in 1802 to his becoming a professional painter. That same year Constable showed his first landscape at the Academy (where he was to exhibit nearly every year until his death), declared to Dunthorne his intention of becoming "a natural painter," and acquired a studio opposite the family house. He spent summers in East Bergholt, sketching from nature, until 1817; in the autumn of 1806 he made a two-month visit to the Lake District.

In 1809 Constable met and fell in love with Maria Bicknell, but he was unable to marry her until 1816 owing to the opposition of Maria's grandfather, Dr. Rhudde, rector of East Bergholt. After the marriage the couple lived in London, first on Keppel Street, then, after 1822, on Charlotte Street. The marriage, which was the prelude to Constable's finest work, was a deeply happy one, and there were seven children, to whom the artist was devoted; Maria's health was far from robust, however, and she died in 1828, a blow from which Constable never fully recovered.

In 1819 Constable exhibited *The White Horse* (Frick Collection, New York), the first of his so-called "six footers," a series of scenes of the banks of the river Stour, immortalizing the countryside in which he had grown up. In the same year, as a direct result of the success of this major step, he was belatedly elected an Associate of the Royal Academy, but did not attain full Academicianship until 1829, an injustice that rankled. Although Constable himself never left England, *The Hay Wain* (National Gallery, London) and two other works were shown in 1824 at the Paris Salon, where they were acclaimed by the French artists, especially Delacroix, and were awarded a gold medal. This led to the sale in France of over twenty works and to demands for replicas—previously in England Constable had sold few of his pictures except to patrons who were already his friends. He still depended on financial support, however, from the family concerns managed by his devoted brother, Abram. He exhibited the last of his six-foot canal scenes, *The Leaping Horse* (Royal Academy of Arts, London), in 1825.

Constable found a retreat in Hampstead in 1820 and began his studies of clouds (or "skying") there the following year; in 1827 he bought the house on Well Walk, which remained his country home until his death. After his marriage he returned to Suffolk less frequently, but became better acquainted with the south of England. He often visited his closest friend, John Fisher, archdeacon of Salisbury (whom Constable met on his visit to Fisher's uncle, the bishop, in 1811, and at whose vicarage in Osmington, Dorset, he had spent part of his honeymoon); he visited Brighton (where in 1824, 1825, and 1828 he sent Maria for her health), and stayed with George Constable at Arundel in 1834 and 1835 and with Lord Egremont at Petworth in 1834. All these visits, which

enabled him to become familiar with the surrounding country, were productive of pictures. In 1829, probably partly in emulation of Turner's *Liber Studiorum*, he embarked on the publication of *English Landscape Scenery*, with mezzotints by David Lucas, an enterprise upon which he bestowed an almost obsessive attention. In 1836 he delivered at the Royal Institution his celebrated series of lectures on the history of landscape painting. He died at Hampstead on 31 March 1837.

More is known about Constable from his letters, voluminous and self-revealing, than about any other artist prior to the twentieth century, with the exception of Delacroix and Van Gogh. He was companionable, warmhearted, and instinctively generous, observant, amusing, and witty, though often caustic and argumentative, deeply sensitive, and, in later life, prone to melancholy. In his approach to his art he was determined, stubborn, single-minded, and perpetually anxious, especially during the preparation of a major work for the Royal Academy. His life's work stemmed from family affection and fondness for local places (Flatford, Dedham, and Stratford Mills were all his father's property) and from pride in the prosperous scenes along the fertile and richly cultivated Stour Valley in which he grew up: "I had often thought of pictures of them before I had ever touched a pencil," he wrote to Fisher in one of his best-known letters.[1] He despised the bravura he found prevalent in landscape painting during his student days and, resolved to be "a natural painter," began that laborious process of sketching from nature as the essential preliminary to picture making that he continued, with ever-increasing precision and insight, all his life.

Unlike his predecessors and contemporaries in the field of landscape, Constable never (with the exceptions in his early career) went on seasonal sketching tours in search of subjects; he was totally absorbed in painting the particularities of his own countryside and with giving compositional weight and power to these modest scenes. Although his handling of paint conformed to the picturesque aesthetic, he disliked mountain scenery and nearly everything implied by the picturesque; the adjective *placid* was one of his favorite terms of praise. His interest in structure, evident from his study of astronomy on the one hand and his knowledge of agricultural machinery on the other, is reflected in the technical soundness of his paintings. He regarded the sky as the standard of scale

and chief organ of sentiment in any landscape. "Painting is but another word for feeling," he declared,[2] and the association between landscape and the artist's personal feelings was expressed in what he called the "chiaroscuro of nature": the enveloping atmosphere, "my 'light'—my 'dews'—my 'breezes'—my *bloom* and my *freshness*—no one of which qualities has yet been perfected on the canvas of any painter," as he wrote to his future biographer, Leslie.[3] His subject was as much the season and the weather as the view, and his most remarkable achievement was the union of form and light on this sophisticated level of observation. In his lectures on the art of landscape, which significantly he did not deliver until after he had been elected an Academician and it was safe to do so, he set out to demonstrate the moral and aesthetic significance of a genre hitherto regarded as far inferior to history painting.

Constable was a slow starter. After a long period of experimentation and stylistic uncertainty, during which he worked also as a portraitist, he produced from about 1809 a series of brilliant oil sketches of scenes in the Stour Valley that were the prelude to painstaking finished pictures, extensive and detailed, in which human activity was subordinate to the landscape featured. His magisterial six footers, upon which he staked his reputation, were increasingly bold and animated, the last two so vibrant and vigorously handled that, with *The Leaping Horse*, there is little to choose between the full-scale sketch which he habitually painted and the exhibited landscape itself. Rosenthal has argued that the changing character of the later six-foot pictures, involving a low viewpoint and less harmonious narrative, was a direct response to the disturbances then affecting rural society, but there is no evidence that this is so; Bermingham rightly stresses Constable's autobiographical perception of landscape. Constable's later style was increasingly turbulent and overcast, reflecting his depressed state after Maria's death, and this mood was embodied in Lucas' mezzotints. His last works, flickering in touch and rhythm, sought to capture ever more transitory effects.

Constable's only known assistant was John Dunthorne, Jr., employed from 1824 to 1829. Frederick W. Watts was strongly influenced by him. Although contemporary critics preferred artists such as Augustus Wall Callcott, William Collins, John Glover, and Thomas Christopher Hofland, and Constable's reputation in

England remained low until the latter part of the nineteenth century, his work, acclaimed in Paris in 1824, was influential on the Barbizon school of painters. By 1899, the date of the first exhibition devoted solely to Constable, the artist's oil sketches were widely admired, but the situation was confused by the imitations painted by his youngest son, Lionel, and by other members of the family, as well as by the prevalence of forgeries. Since that time Constable's work, notably as represented by *The Hay Wain*, has had a profound effect on the ordinary person's response to landscape; the exhibition at the Tate Gallery in 1976 was one of the most popular ever held in London.

Notes

1. Constable to John Fisher, 23 October 1821 (Beckett 1962–1968, 6 [1968]:78).
2. Constable to John Fisher, 23 October 1821 (Beckett 1962–1968, 6 [1968]:78).
3. Constable to Charles Robert Leslie, 1833 (Beckett 1962–1968, 3 [1965]:96).

Bibliography

Leslie, Charles Robert. *Memoirs of the Life of John Constable, Esq. R.A.* 2d ed., enlarged. London, 1845.

Beckett, R. B., ed. *John Constable's Correspondence.* 6 vols. London (Historical Manuscripts Commission), 1962; Ipswich (Suffolk Records Society, vols. 6, 8, 10, 11, 12), 1964–1968.

Reynolds, Graham. *Constable: The Natural Painter.* London, 1965.

Beckett, R. B., comp. *John Constable's Discourses.* Ipswich (Suffolk Records Society, vol. 14), 1970.

Taylor, Basil. *Constable: Paintings, Drawings and Watercolours.* London, 1973.

Parris, Leslie, Conal Shields, and Ian Fleming-Williams. *John Constable: Further Documents and Correspondence.* London (Tate Gallery) and Ipswich (Suffolk Records Society, vol. 18), 1975.

Parris, Leslie, Ian Fleming-Williams, and Conal Shields. *Constable: Paintings, Watercolours & Drawings.* Exh. cat., Tate Gallery. London, 1976.

Rosenthal, Michael. *Constable: The Painter and His Landscape.* New Haven and London, 1983.

Parris, Leslie, and Ian Fleming-Williams. *The Discovery of Constable.* London, 1984.

Reynolds, Graham. *The Later Paintings and Drawings of John Constable.* 2 vols. New Haven and London, 1984.

Bermingham, Ann. *Landscape and Ideology: The English Rustic Tradition, 1740–1860.* London, 1987:87–155.

Parris, Leslie, and Ian Fleming-Williams. *Constable.* Exh. cat., Tate Gallery. London, 1991.

1942.9.10 (606)

Wivenhoe Park, Essex

1816
Oil on canvas, 56.1 × 101.2 (22⅛ × 39⅞)
Widener Collection

Technical Notes: The medium-weight canvas is plain woven. It was added to by the artist on either side; the additional pieces are 10.5 cm wide on the left and 9 cm wide on the right; the canvases have been lined. The ground layer visible, a light warm brown, may be an imprimatura over a lighter ground. The painting is executed fluidly and fairly thickly with generally small brushstrokes, the highlights in low impasto. There are minor scattered paint losses. The painting was restored and revarnished with a synthetic resin in 1983.

Provenance: Painted for Major-General Francis Slater-Rebow, Wivenhoe Park and Alresford Hall, near Colchester, Essex; by descent to Hector John Gurdon-Rebow [b. 1846]. (Leo Nardus), Suresnes, Belgium, from whom it was purchased 1906 by P. A. B. Widener,[1] Elkins Park, Pennsylvania. Inheritance from the Estate of Peter A. B. Widener by gift through power of appointment of Joseph E. Widener, Elkins Park.

Exhibitions: Royal Academy of Arts, London, 1817, no. 85. *Constable's England*, The Metropolitan Museum of Art, New York, 1983, no. 27, color repro. *Constable*, Tate Gallery, London, 1991, no. 79, color repro.

THE VIEW is of Wivenhoe Park, the seat of General Rebow, built by Thomas Reynolds starting in 1758. The house is seen from across the lake, created when the park was landscaped in 1777. The general's young daughter, Mary (of whom Constable had painted a portrait in 1812), is included on the extreme left driving a donkey cart; a deer house is featured on the extreme right. The painting shows the general's home before it was extensively remodeled in 1846.

The commission, which was executed in August and September 1816, is described by Constable in a series of letters to his fiancée, Maria Bicknell.[2] "I am going to paint two small landscapes for the General, views one in the park of the house & a beautifull wood and peice [sic] of water, and another scene in a wood with a beautifull little fishing house,"[3] he wrote on 21 August. "They wish me to take my own time about them—but he will pay me for them when I please, as he tells me he understands from old Driffeild that we may soon want a little ready money." The next letter, written on 30 August, explains why he had to extend the canvas by over three inches on either side: "I am going on very well with my pic-

Fig. 1. John Constable, *Wivenhoe Park*, 1816, pencil,
New York, private collection

Fig. 2. John Constable,
Fishing with a Net on the Lake in Wivenhoe Park,
inscribed and dated 1816, pencil and gray wash,
London, Victoria and Albert Museum

Fig. 3. Richard Wilson, *Tabley House,
Cheshire*, R.A. 1780, oil on canvas,
England, private collection
[photo: Tate Gallery]

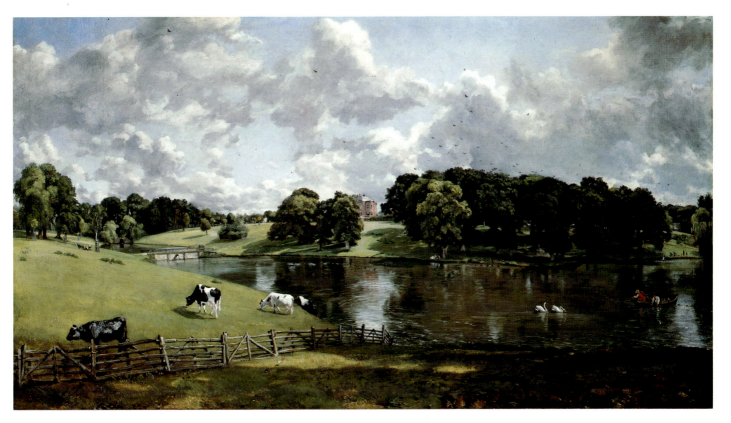

John Constable, *Wivenhoe Park, Essex*, 1942.9.10

tures . . . the park is the most forward. The great difficulty has been to get so much in as they wanted to make them acquainted with the scene. On my left is a grotto with some elms, at the head of a peice [sic] of water—in the centre is the house over a beautifull wood and very far to the right is a deer house, which it was necessary to add, so that my view comprehended too many [distances]. But to day I have got over the difficulty, and begin to like it *myself*. I think however I shall make a larger picture from what I am now about. . . . I live in the park and Mrs. Rebow says I am very unsociable." He reported on 19 September: "I have compleated [sic] my view of the Park for General Rebow." Constable received a payment of one hundred guineas for this picture.[4]

Constable's additions to the canvas, made at the patron's request, resulted in the inclusion of the fishing boat with men hauling in a net, which is painted across the seam on the right, and in the painting of an additional cow, which covers the seam on the left. The former was an operation of which he had made a drawing on 27 July[5] (fig. 2). The additional strips have been skillfully integrated into the composition to form a rhythmical whole.[6] From the evidence of Constable's letters it seems that the canvas was painted almost entirely, if not entirely, *en plein air*, which accounts for its exceptional freshness and sparkle. A composition sketch (fig. 1) shows a tree in the left foreground that Constable dispensed with, presumably because it would have appeared too much like a pictorial prop. The artist never executed the larger picture to which he refers.

Wivenhoe Park was painted during the period that marked the culmination of Constable's mastery of what he termed a "natural painture." Far more complex in design than his broad and sketchy *Malvern Hall* (Tate Gallery, London) of seven years earlier, it is executed with precision and a feeling for light most beautifully demonstrated in the reflections in the lake, although it has been pointed out that the latter are much more pronounced than they would be in nature.[7] Still, rocklike clouds dominate the scene, and the house, the ostensible subject of the picture, appears in the distance, half-hidden by trees. This aesthetic decision is at odds with the accepted tradition of country house portraiture, though Constable was anticipated in his approach by Richard Wilson (fig. 3), an earlier painter also concerned with the depiction of landscape as such.

Rosenthal has interpreted the work in terms of contemporary recognition of the social hierarchy: "Anyone with a modicum of taste would appreciate the estate's beauty, and be inclined to praise its cause. They would approve of the combination of beauty with utility (thus the juxtaposition of ornamental swan with toiling fishermen, or the cattle dotted around and about)."[8]

Notes

1. The date of purchase, approximate in Roberts 1915, is given in Edith Standen's notes, in NGA curatorial files.
2. Constable to Maria Bicknell, 21, 30 August, 15, 19 September 1816 (Beckett 1964, 196, 199, 203, 206).
3. The second painting is in the National Gallery of Victoria, Melbourne (Hoozee 1979, no. 219). A larger repro. is in Rosenthal 1983, 15.
4. Rosemary Feesey, *A History of Wivenhoe Park* (Colchester, 1963), 41 (where the source is not given). The payment cannot be traced in the Rebow Papers, which are deposited in the Essex Record Office, Colchester.
5. Graham Reynolds, *Catalogue of the Constable Collection in the Victoria and Albert Museum* (London, 1960), no. 146.
6. A diagram of the additions and an analysis of their effect on the composition is in Cooke 1968, 102.
7. Cooke 1968, 102.
8. Rosenthal 1983 (see biography), 110.

References

1915 Roberts 1915: unpaginated, repro.
1962–1968 Beckett 1962–1968 (see biography), 2 (1964):196, 199, 203, 206.
1968 Cooke, Hereward Lester. *Painting Lessons from the Great Masters*. London, 1968:42, fig. 28, 102, color repro. opposite.
1973 Taylor 1973 (see biography): 29, pl. 51.
1976 Walker 1976: no. 593, color repro.
1979 Hoozee, Robert. *L'opera completa di Constable*. Milan, 1979:108, no. 218, repro.; color pls. xx–xxi.
1983 Rosenthal 1983 (see biography): 16–17, 104, 108–110, 111, color pls. 12, 16 detail.
1984 Reynolds 1984 (see biography), 1:4–5, no. 17.4; 2: color pl. 6.

1942.9.9. (605)

The White Horse

1818–1819
Oil on canvas, 127 × 183 (50 × 72)
Widener Collection

Technical Notes: The medium-coarse canvas is tightly plain woven; it has been lined at least twice. The ground is white lead and chalk. There is a tan-colored imprimatura. X-radiographs made in 1984 reveal that the work is executed, comparatively thinly, over an unfinished (but fairly complete) painting of Dedham Vale from the Coombs (fig. 2); they also show penti-

menti in Willy Lott's cottage (fig. 8), which was originally positioned at the same angle as in the finished picture in the Frick Collection, and around the horse and barge. There is no lead white ground between the two paintings. Both paintings are executed broadly and sketchily with some passages in impasto. The paint layers have been compressed and the impasto flattened to an unusual degree in the course of linings, the last of which was in 1948. For a combination of reasons apparent from this summary the paint structure is hard to examine, but it seems likely that there was extensive damage and repainting at an early date. The gray-purple tone over most of the sky appears to be a later glaze applied over abraded paint; there is repainting in the white horse, the figure to its left, the cows, the foliage, and the water. Worn areas in the sky at right, numerous separation cracks, and an old tear in the foreground center were treated in 1949. There is a 34-cm. crack near the top edge, corresponding to the bottom edge of the top stretcher member. The unusually thick natural resin varnish has discolored yellow to an exceptional degree.

Provenance: Almost certainly retained in the studio by the artist until his death. John (later Sir John) Pender [b. 1816] by 1872. (E. Fox White Gallery), London, by 1882,[1] who sold it to (Wallis & Son), London, from whom it was purchased 1893 by P. A. B. Widener, Elkins Park, Pennsylvania. Inheritance from the Estate of Peter A. B. Widener by gift through power of appointment of Joseph E. Widener, Elkins Park.

Exhibitions: *Works of the Old Masters, together with Works of Deceased Masters of the British School*, Winter Exhibition, Royal Academy of Arts, London, 1872, no. 118.

THE ORIGINAL WORK painted on this canvas was a view of Dedham Vale from the Coombs, showing the river Stour, Stratford bridge with its buildings at either end, and the low hills of East Bergholt and Brantham toward the left, an elaboration of the oil study of about 1808 to 1812 in the Victoria and Albert Museum, London (fig. 1).[2] The most significant changes between this study and the painting beneath *The White Horse* are the more horizontal format and the additions of a diagonally placed tree trunk at lower left and a large tree mass on the right; these were prefigured in drawings and in another oil sketch.[3] As Rhyne points out, because of "the degree to which Stratford Bridge and the buildings on either side are detailed" it is "likely that what we see in the x ray is not a six-foot sketch but the rejected beginning of a painting Constable had expected to finish on the same canvas."[4] It seems probable that this work, insufficiently grand to sustain its scale, was painted subsequent to his largest landscape to date, the *Flatford Mill*, exhibited at the Royal Academy of 1817 (fig. 9), which was the forerunner of the six-foot canal scenes; the *terminus ante quem* is, of course, provided by the full-scale sketch for *The White Horse* painted over it (in other words, the Washington picture as now visible), which would have been executed in the winter of 1818–1819.

The White Horse is the first of Constable's full-scale sketches for his great canal scenes, pictures by means of which he hoped to attract more public attention than he had done hitherto; these sketches, for which there are no precedents in the history of art, are composition studies integrating the material from his drawings and sketches from nature that he regarded as entirely private and that are not mentioned in his correspondence. The view is taken from the right bank of the river Stour just below Flatford Lock, and shows, from left to right, the island known as the Spong, Willy Lott's house and the millstream leading to Flatford Mill, a thatched boathouse, and the farmhouse now called Gibbonsgate Farm. The incident depicted is the transit of a tow horse from one side of the river to the other as the tow path changes sides. The finished picture, exhibited at the Royal Academy in 1819 as *A scene on the river Stour*, was christened *The White Horse* by its purchaser, Archdeacon John Fisher.

It seems possible that the existence of the discarded canvas suggested to Constable the novel idea of a full-scale sketch; certainly the lack of an intermediate ground between the discarded painting and the sketch indicates that he never intended to paint a finished landscape for the Royal Academy on this already used canvas. As Rhyne has said: "Layered on this one remarkable canvas are the unfinished beginning of Constable's first six-foot landscape painting and, covering it, his earliest large, full-size oil sketch."[5]

The beginnings of Constable's design are recorded in a sketchbook that he used at East Bergholt in 1814 (fig. 3) and in two later oil sketches (figs. 4, 5); there also exists a pencil drawing of the boathouse (fig. 6) and of the boat moored nearby (fig. 7), which was used again for *The Hay Wain* (National Gallery, London), 1821.

In the finished painting, now in the Frick Collection (fig. 10), Constable followed his original sketches by moving the boathouse to the left to become the central focus of the composition and placing the gable of Willy Lott's house at right angles to the river (he had originally done this in the Washington sketch, as the x-radiograph shows [fig. 8], but then altered it). Among other changes he deleted the dovecote, lowered the tallest tree, included the stern of the barge with a man smoking a pipe, added a figure in a red jacket, inserted a cart and a plough in front of the barn, and altered the disposition of the cows

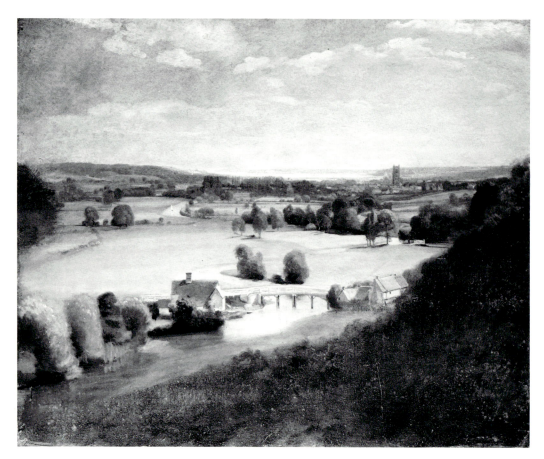

Fig. 1. John Constable, *The Valley of the Stour*, c. 1808–1812,
oil on paper laid down on canvas, London, Victoria and Albert Museum

Fig. 2. X-radiograph of the underlying discarded painting of 1942.9.9

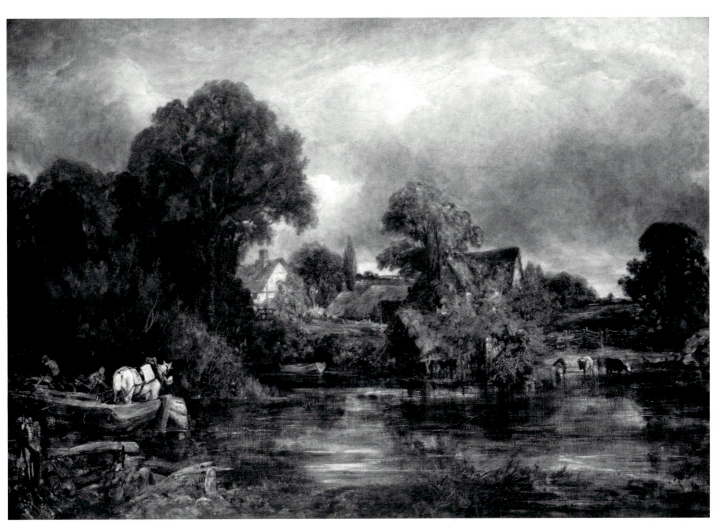

John Constable, *The White Horse*, 1942.9.9

Fig. 3. John Constable, *Willy Lott's House and Thatched Boat Shelter at a Confluence of the Stour*, 1814 sketchbook p. 66, pencil, London, Victoria and Albert Museum

Fig. 4. John Constable, *Willy Lott's House and Thatched Boat Shelter*, probably 1817, oil on board, Switzerland, private collection [photo: Yale University Press]

on the right, omitting the fence and open gate behind them. At the same time he transformed the breadth and vigor of the sketch—the foliage of the trees on the left no more than blocked in and the reflections in the water suggested by rough, dragged brushstrokes—into a masterpiece of well focused, carefully related, and meticulously rendered forms. One should note in particular the lovely reflected light in the water beneath the boathouse, a principal feature of the Frick picture. This large-scale finished work is a magisterial representation of the serenity and timelessness of the English countryside, as Constable intended it to be; he described it as "a placid representation of a serene grey morning, summer." The artistic development from the almost restless scatter of focus in his *Flatford Mill* of two years earlier (fig. 9) is immense.

Fig. 5. John Constable, *Willy Lott's House and Thatched Boat Shelter and Barn*, probably 1817, oil on canvas, Switzerland, private collection [photo: Yale University Press]

Fig. 6. John Constable, *A Thatched Boat Shelter*,
probably 1817, pencil, private collection
[photo: Yale University Press]

Fig. 7. John Constable, *A Boat*, probably 1817,
black chalk on blue paper, London,
Courtauld Institute of Art, Witt collection

Fig. 8. X-radiograph of Willy Lott's cottage in 1942.9.9

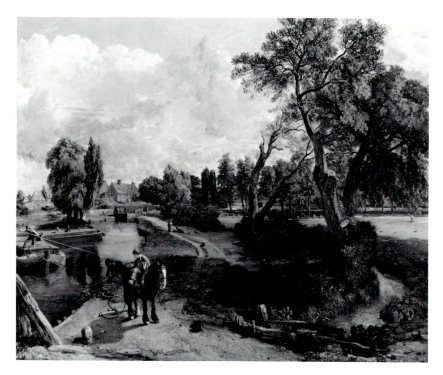

Fig. 9. John Constable, *Flatford Mill*, R.A. 1817, oil on canvas, London, Tate Gallery

Fig. 10. John Constable, *The White Horse*, R.A. 1819, oil on canvas, New York, Frick Collection

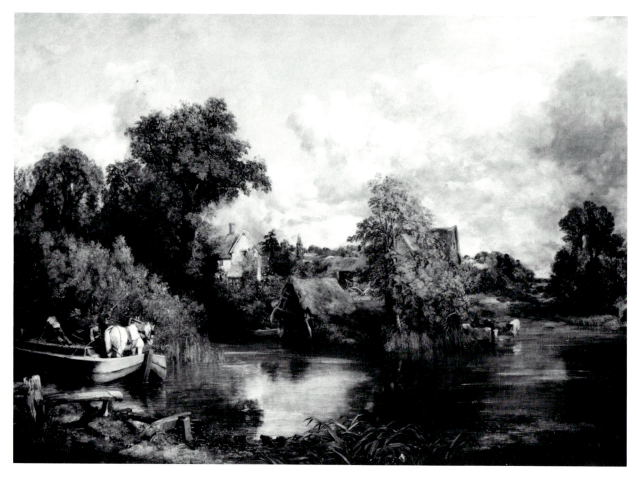

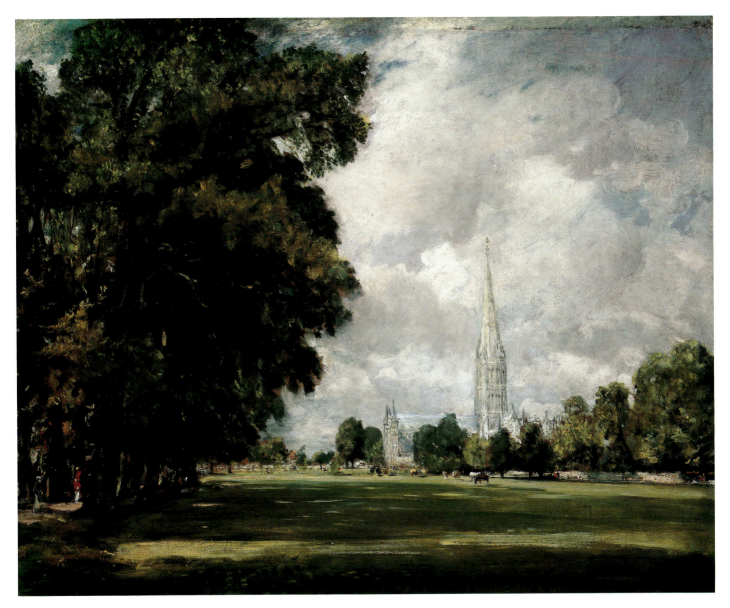

John Constable, *Salisbury Cathedral from Lower Marsh Close*, 1937.1.108

Francis Cotes

1726 – 1770

COTES WAS BORN in London on 20 May 1726. He was the eldest child of Robert Cotes, a well-known apothecary, and his second wife Elizabeth Lynn. At about the age of fifteen he entered the studio of George Knapton, who worked in pastel in the style of Rosalba as well as in oils. He began practice as a portraitist in his father's house on Cork Street, deriving from him an understanding of chemistry, the basis of his expertise in making pastels. The late eighteenth-century pastelist John Russell, in a treatise on the subject, *Elements of Painting with Crayons*, published in 1772, expounded what he had learned from Cotes. Cotes' reputation was assured by the pastels he did in 1751 of the beautiful Gunning sisters, then idolized by society and the populace. His practice in oils dates from the late 1750s.

In 1763 Cotes bought the large and elegant house on fashionable Cavendish Square later occupied by George Romney, took in pupils, of whom Russell was the principal, and employed Peter Toms as his drapery painter. No sitter books survive, but his prices at this date are known to have been twenty guineas for a head and shoulders, forty guineas for a half length, and eighty guineas for a full length, higher than Gainsborough (for a full length) but lower than Reynolds, of whom he was by then a recognized competitor. He exhibited each year at the Society of Artists, becoming a director in 1765, the year he married Sarah (whose parentage is unknown). Forced, as a result of intrigue, to resign along with fifteen other directors in 1768, he was responsible, with William Chambers, Benjamin West, and Mary Moser, for founding the Royal Academy of Arts. He exhibited there in 1769 and 1770. He was then at the peak of his career, patronized and highly regarded by the royal family. But he died in Richmond on 19 July 1770—as Russell said, "a man full of worldly honor and pride."[1]

Cotes was essentially a refined, decorative painter, concerned with surface qualities and preoccupied with detail, especially that of fashionable costume, at the expense of chiaroscuro and overall design. Pastel, with its soft colors and sparkling highlights, a typically rococo medium ideally suited to intimate portraiture and the capturing of a passing moment, was the perfect medium for him, and he was the finest British exponent of it, unique in his ability to obtain deep, rich tones. He often attained the level of Jean Etienne Liotard (active in England between 1753 and 1755/1756), by whose naturalism and use of simple, associative actions he was influenced, and of Quentin de la Tour. Turning to oils when Allan Ramsay was achieving a delicacy in this medium close to that of pastel, Cotes imitated Reynolds' style and poses but generally chose to avoid the Grand Manner. Except in a few full-length female portraits executed from 1767 onward, in which he exaggerated Reynolds' play of sculptural drapery, he eschewed idealization, heroic posture, and intellectual, classicizing content and retained his own conservative, decorative interests, casualness, sweetness, and sentiment. Horace Walpole's verdict was that "Cotes succeeded much better in crayons than in oils."[2] The artist also executed some competent topographical landscapes in watercolor in the manner of Paul Sandby, whose portrait (Tate Gallery) he painted in 1761.

Cotes' influence on his contemporaries, save through the perpetuation of the rococo medium of pastel in the work of his star pupil, Russell, was negligible. The future lay with Reynolds. His reputation only revived during the Duveen era, but, since his prices were low compared to those fetched by Gainsborough or Romney, there was less inducement for owners to sell and scarcity caused Cotes to become a generic name in the art trade.

Notes

1. John Russell, "Diary," 8 vols. (1766–1789, 1801–1802), Victoria and Albert Museum Library, 4:28.

2. Hugh Gatty, ed., "Notes by Horace Walpole, Fourth Earl of Orford, on the Exhibitions of the Society of Artists and the Free Society of Artists, 1760–1791," *The Walpole Society* 27 (1939):63.

Bibliography

Johnson, Edward Mead. *Francis Cotes*. London, 1976.

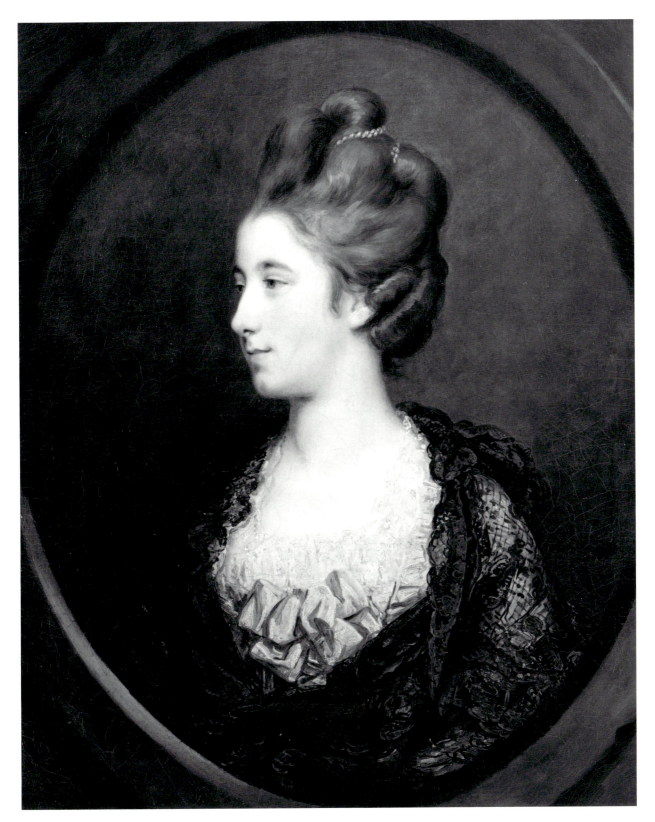

Francis Cotes, *Mrs. Thomas Horne*, 1961.5.2

1961.5.2 (1646)

Mrs. Thomas Horne

c. 1768/1770
Oil on canvas, 78 × 63.1 (30¾ × 24⅞)
Gift of the Coe Foundation

Inscriptions:
Signed at lower right: *F. Cotes ft* (FC in monogram)

Technical Notes: The medium-weight canvas is plain woven; it has been lined. The ground is off-white, fairly thickly applied. The painting is executed in smooth, opaque layers, blended wet into wet, except for the background and feigned oval, which are more thinly and translucently applied; the drapery is executed in a relatively rapid and painterly manner with pronounced brushwork and moderate impasto. The impasto has been severely flattened during lining, and there are scattered small retouchings; otherwise the painting is in excellent condition. The varnish has discolored yellow to a significant degree.

Provenance: Probably painted for the sitter's husband, Thomas Horne; by descent to Henry, Baron Horne of Stirkoke [1861–1929], Stirkoke House, Caithness. (Vicars Bros.), London, by 1919, by whom sold to (Thos. Agnew & Sons), London, 1919, who sold it to (John Levy Galleries), New York, 1919,[1] who sold it by 1925 to Benjamin Franklin Jones, Jr. [1868–1928], Sewickley Heights, Pennsylvania; passed to his wife (sale, Parke-Bernet, New York, 4–5 December 1941, 1st day, no. 34, repro.), bought by William R. Coe [d. 1955], Oyster Bay, Long Island, New York; Coe Foundation, New York, 1955.

Exhibitions: *Paintings by Old Masters from Pittsburgh Collections*, Carnegie Institute, Pittsburgh, 1925, no. 8.

NOTHING IS KNOWN about Elizabeth Crewe of Haddon Hall, Northamptonshire, except that she married Thomas Horne.

The loose, raised hair combed over rolls with ropes of pearls intertwined and stiff side curls is characteristic of the fashion of the late 1760s, as is the black lace shawl. The sitter seems to be about twenty, and the picture is probably a marriage portrait. The sweet expression, soft, smooth modeling, and finely drawn contours and features, together with the use of the old-fashioned concept of the feigned oval, are characteristic of Cotes. The gentleness of the image would originally have been counterbalanced by the lively impasted handling of the drapery.

Notes
1. Information from Agnew's stock books, kindly supplied by Evelyn Joll.

References
1931 Heil, Walter. "Portraits by Francis Cotes." *AAm* 20 (1931):2, 6, fig. 5.
1976 Johnson 1976 (see biography): 101, no. 293.

Style of Francis Cotes

1960.6.6 (1558)

Portrait of a Lady

c. 1765/1770
Oil on canvas, oval, 20 × 15.8 (7⅞ × 6¼)
Timken Collection

Technical Notes: The medium-fine canvas is plain woven; it has been lined and adhered to a wooden backing. The bottom of the lower curve of the oval is straight (not rounded), minuscule portions of the sitter's blue sleeves are visible at the lower edges, and the topmost portion of the oval is filled with recent paint to a depth of 0.8 cm above a horizontal line about 2 cm above the coiffure. It is probable, therefore, that the portrait was originally rectangular in format and has been cut down and added to at the top to form the present oval. The ground is white, smoothly applied and of moderate thickness. The painting is executed in very thin, rich, fluid layers, blended wet into wet, with light glazes in the cheeks. The painting is in good condition except for slight abrasion of the paint surface at the back of the neck and in the hair; there is very little retouching except for the top portion of the oval. The moderately thick dammar varnish, applied in 1960, has discolored yellow slightly.

Provenance: William R. Timken, New York [1866–1949]; passed to his wife, Lillian S. Timken [d. 1959].

Style of Francis Cotes, *Portrait of a Lady*, 1960.6.6

Style of Francis Cotes, *Portrait of a Lady*, 1960.6.7

1960.6.7(1559)

Portrait of a Lady

c. 1765/1770
Oil on canvas, oval, 20 × 15.8 (7⅞ × 6¼)
Timken Collection

Technical Notes: The medium-fine canvas is plain woven; it has been lined and adhered to a wooden backing. The topmost portion of the oval is filled with recent paint to a depth of 0.4 cm. above a horizontal line above the coiffure. It is probable, therefore, that, as in the case of the pendant, the portrait was originally rectangular in format and has been cut down and added to at the top. The ground is white, thickly applied. The painting is executed in thin, fluid layers, with the face and hair blended wet into wet; in the background the thin washes barely cover the ground. There are major areas of retouching at the top and bottom of the oval and in the sitter's chest, and scattered minor losses and retouchings elsewhere. The dammar varnish was applied in 1960.

Provenance: Same as 1960.6.6.

NOTHING IS KNOWN about these two sitters. The raised hair, combed over a roll and plaited into a knot at the top, and sleeves held up by laces looped around small buttons are fashions characteristic of the mid to later 1760s.

The traditional attribution to Cotes has been rejected, since the handling is coarser than his and he is not known to have worked on this small scale.[1] The design and contemplative expression of 1960.6.6 do, however, derive from him.[2] The technique indicates that the works are by the same hand, and the portraits are at present pendants, which suggests that the sitters are related; the facial characteristics do not, however, display any family resemblance, and the portraits may have been cut down at a later date to serve as pendants, possibly to fit the existing early nineteenth-century frames.

Notes
1. Edward Mead Johnson, letter, 20 May 1971, in NGA curatorial files.
2. Compare the portrait of Elizabeth, Duchess of Beaufort by Cotes, at Badminton in Gloucestershire (Johnson 1976 [see biography], no. 295).

John Crome

1768 – 1821

CROME WAS BORN in Norwich on 22 December 1768, the son of John Crome, a journeyman weaver and publican. He seems to have been uneducated, and became at the age of twelve an errand boy for Dr. Edward Rigby, a Norwich physician. In 1783 he was apprenticed for seven years to Francis Whisler, a house, coach, and sign painter. His first sketch in oil dates from 1790, and at about that date he set up a partnership with Robert Ladbrooke, sharing a garret with him; the young men sketched landscapes in and around Norwich and exhibited at the printsellers Smith and Jagger. In 1792 Crome married Phoebe Berney (Ladbrooke married her sister the following year); the couple had five daughters and six sons. On marrying, Crome prudently became a teacher.

One of Crome's earliest mentors was William Beechey, who worked in Norwich from 1782 to 1787; as a young man Crome visited him frequently in his London studio.

But the person who helped him most significantly at the outset of his career was Thomas Harvey of Catton House, whom he met in about 1790. Harvey, a wealthy master weaver, was an amateur artist, a generous patron, and a distinguished connoisseur. He was then in the process of building up a fine collection, notably of Dutch landscape paintings but also including works by Richard Wilson and Gainsborough. Crome was deeply influenced by the Dutch landscapes, is said to have copied a Hobbema in the collection, later copied Gainsborough's *The Cottage Door* (Huntington Art Gallery, San Marino, California), and in 1796 and 1798 painted compositions in the style of Wilson. He was also well acquainted with John Opie in Norwich from 1798.

Crome was largely instrumental in founding, in 1803, the Norwich Society of Artists (of which he became president in 1808), an institution at first primarily a forum

for biweekly discussions on art. The first exhibition of the society was held in 1805, and Crome contributed between ten and thirty works regularly every year until his death. He first exhibited at the Royal Academy of Arts in 1806, but only showed there at irregular intervals; as he grew older he was an infrequent visitor to London.

Crome's reputation was high throughout Norfolk, not only as a landscape painter but also as an enthusiastic drawing master. Among his earliest pupils were John Gurney of Earlham and his daughters Richenda and Elizabeth, whom he accompanied to the Lake District in 1802 and 1806; he also taught the Dawson Turner family at Yarmouth, and from 1813 was drawing master at Norwich Grammar School. Crome's principal pupils were his eldest son, John Berney Crome, who succeeded him in his practice, James Stark, and George Vincent.

Active also as a restorer and dealer, Crome had a shrewd business sense and made a comfortable living; Dawson Turner said that he earned from fifteen to fifty guineas for his pictures in the latter part of his life, when there was an increasing demand for his work. From 1801 until his death he occupied a good-sized house on Gildengate Street in Norwich, and collected pictures, prints, and books. He visited Wales and the Wye Valley with Ladbrooke in 1804, but he made only one journey abroad, to Paris in 1814.

Crome was independent-minded—he was a Nonconformist and Freemason—jovial, good tempered, engaging, a lively and witty conversationalist, and a welcome visitor in houses great and small throughout the county. He died in his home on Gildengate Street on 22 April 1821; an exhibition of his works was held that autumn.

Crome rarely signed or dated his paintings. Few are documented and few identifiable from the titles given in exhibition catalogues, so that the evolution of his style is difficult to chart. Apart from a few pictures based on his experience of Wales and the Lake District, and the major compositions resulting from his French trip—the *Boulevard des Italiens* and the *Fishmarket at Boulogne* (both R. Q. Gurney, Bawdeswell Hall, Norfolk)—his subject matter was local in inspiration, with numerous variations on the same theme: views in and around Norwich, of Mousehold Heath, and of Yarmouth Harbour and jetty; beach, river, and woodland scenes; and pictures in which magnificent oak trees, picturesque cottages, windmills, or watermills are prominent motifs.

Crome's early style is hardly known, but around the age of thirty he was still painting in the bold manner of a sign painter and was influenced by the generalized backgrounds in the portraits of Beechey and Opie, with massive forms, somber color, and unnaturalistic lighting. Gradually, under the influence of Dutch painting, notably of Jan van Goyen and Hobbema, his style became subtler, with greater naturalism in his treatment of buildings, trees, and skies, a greater feeling for light and atmosphere, and a greater fluidity and thinness of handling combined with rich impasto in the lighter passages. Crome's later style is characterized by an increasingly sophisticated feeling for light, air, shimmer, and movement. Always, however, he retained his feeling for breadth and his ability to concentrate attention on a pictorial motif. As he wrote to James Stark, "Breath [sic] must be attended to, if you paint but a muscle give it breath [sic]. . . . Trifles in nature must be overlooked . . . your composition forming one grand plan of light and shade."[1] His freedom of handling and lack of finish were the subject of contemporary criticism. Crome never attained the facility of John Sell Cotman or of John Thirtle in his watercolors, but, though lacking in technical skill, he achieved a remarkable luminosity in his etchings, which were chiefly of trees with an elaborate tracery of branches and foliage.

Crome's naturalism and rural subject matter were taken up not only by his pupils, John Berney Crome, Stark, and George Vincent, but by most of the second and third generation of Norwich School artists, who looked to him as the founder of the school. His work continued to be much imitated and was sometimes forged. In the late nineteenth century and until the 1920s he was regarded as the equal of Constable and Turner. Although his reputation has since declined, his work has never lost its appeal.

Notes

1. Crome to James Stark, January 1816 (Goldberg 1978, 1:17).

Bibliography

Turner, Dawson. Biographical memoir, preface to *Etchings of Views in Norfolk, by the late John Crome*. Norwich, 1838.

Dickes, William Frederick. *The Norwich School of Painting*. London and Norwich, n.d. [1905]:13–149.

Clifford, Derek and Timothy. *John Crome*. London, 1968.

Hawcroft, Francis W. *John Crome 1768–1821*. Exh. cat., Arts Council of Great Britain; Castle Museum, Norwich; Tate Gallery. London, 1968.

Goldberg, Norman L. *John Crome the Elder*. 2 vols. Oxford, 1978.

Hemingway, Andrew. *The Norwich School of Painters 1803–1833*. Oxford, 1979: particularly 10–17.

Moore, Andrew W. *The Norwich School of Artists*. Norwich, 1985:19–30.

1983.1.39 (2914)

Moonlight on the Yare

c. 1816/1817
Oil on canvas, 98.4 × 125.7 (38¾ × 49½)
Paul Mellon Collection

Technical Notes: The coarse canvas is plain woven; it has been lined. The absence of cusping except along the right edge suggests that the dimensions may be slightly altered; although the work is only a little smaller than a standard canvas size, 40 × 50 in., the original painting might have extended an inch or so farther at the top, where the tips of the branches are truncated. The ground is light beige. The painting is executed in rich, fluid, translucent scumbles with thicker wet into wet blending in the sky and whites, and some palette-knifelike passages in the tree trunk and interstices of the foliage on the left; the ground is used as a middle tone. The paint surface is slightly solvent abraded and has been very slightly flattened during lining; paint losses are minimal. The older natural resin varnish has been partially removed from the trees and foliage and completely removed in the sky. The moderately thick top layer of synthetic varnish has not discolored.

Fig. 1. Rembrandt van Rijn, *The Mill*, c. 1650, oil on canvas, Washington, D.C., National Gallery of Art

Provenance: Kirkman Daniel Hodgson [1814–1879], Ashgrove, Sevenoaks, Kent; by descent to his son, Robert Kirkman Hodgson [1850–1924], Gavelacre, Hampshire. H. Darell Brown, London, by 1908 (sale, Christie, Manson & Woods, London, 23 May 1924, no. 17), bought by (Thos. Agnew & Sons), London, by whom it was probably sold to the Hon. (later Sir) Arthur Howard [1896–1971] in the 1920s.¹ (Thos. Agnew & Sons), London, by 1973,² from whom it was purchased July 1974 by Paul Mellon, Upperville, Virginia.

Exhibitions: Probably Norwich Society, 1817, no. 14, as *Moon Rising*. *Franco-British Exhibition*, Fine Art Palace, White City, London, 1908, no. 73. *International Fine Art Exhibition*, British Fine Art Palace, Rome, 1911, no. 19. *English Eighteenth Century Pictures*, Thos. Agnew & Sons, London, 1919, no. 19. *Crome Centenary Exhibition*, Castle Museum, Norwich, 1921, no. 29. *British Art*, Royal Academy of Arts, London 1934, no. 447 (*Commemorative Catalogue*, no. 332, repro. pl. xcviiib). *Treasures from Sussex Houses*, Art Gallery, Worthing, 1951, no. 167. *Crome and Cotman*, Thos. Agnew & Sons, London, 1958, no. 52, repro. *John Crome*, Arts Council of Great Britain; Castle Museum, Norwich; Tate Gallery, London, 1968, no. 12. *William Wordsworth and the Age of English Romanticism*, New York Public Library; Indiana University Art Museum, Bloomington; Chicago Historical Society, 1987–1988, no. 280, 187 color repro., fig. 173.

THE RIVER YARE rises near East Dereham, Norfolk, runs south of Norwich and flows into the sea at Yarmouth. The exact location depicted is not identifiable.

The picture, which is one of Crome's masterpieces, was evidently intended as a nineteenth-century equivalent of the moonlight scenes of Aert van der Neer, but there seems little doubt that it was also inspired by the motif and massive chiaroscuro of Rembrandt's *The Mill* (fig. 1), which Crome could have seen in London either when it was exhibited for six months between 1798 and 1799 or in 1815,³ and which it would appear he greatly admired. The tree trunks and branches, painted with Crome's characteristic freedom of handling, are roughly conceived, according to the principles of the picturesque, but the moonlight effect, which permeates the whole canvas, is redolent of the romantic movement. The painting has been left largely in an unfinished state, only the central area being carried to a higher finish, but the image is fully realized and passages such as the thick gray smears accomplishing the effect of light breaking through the trees on the left suggest that Crome had completed the picture to his own satisfaction.

The picture has been variously dated c. 1808–1815 (with a preference for the earlier years), 1814, c. 1816 (on the assumption that it is the work exhibited in 1817),

John Crome, *Moonlight on the Yare*, 1983.1.39

and 1817.[4] The shimmering effect of the light supports a later rather than an earlier dating.

Notes

1. Sir Geoffrey Agnew to Paul Mellon, 9 April 1974, in NGA curatorial files.

2. Sir Geoffrey Agnew to J. Carter Brown, 8 August 1973, in NGA curatorial files.

3. Goldberg 1978 (see biography), 1, 41, n. 18. The owner, William Smith, was M.P. for Norwich between 1802 and 1826, so that Crome may well have had private access to the picture. Farington mentions the painting as being among those on the walls in the course of recording in his diary a dinner party given by Smith in London, 19 June 1801 (Farington *Diary*, 4:1563).

4. By, respectively, Clifford 1968 (see biography), 201; Dickes 1905 (see biography), 98; Baker 1921, 149; Goldberg 1978 (see biography), 1:218.

References

1905 Dickes 1905 (see biography): 98, repro.

1921 Baker, C. H. Collins. *Crome*. London, 1921:149, pl. xxxv.

1968 Clifford 1968 (see biography): 200–201, no. P43, pl. 88.

1978 Goldberg 1978 (see biography): 1:186, 218, no. 99; 2: pl. 99.

George Cuitt the Younger

1779 – 1854

CUITT was the only child of George Cuitt, a landscape and topographical painter, and his wife Jane; he was baptized in Richmond, Yorkshire, on 13 October 1779. Nothing is known of his education or training, but he assisted in his father's work and turned to etching as a result of his enthusiasm for Piranesi. In about 1804 he went to Chester as a drawing master, and from 1810 onward he published several series of etchings of ancient castles and abbeys, town houses, and picturesque cottages. A sketchbook dated 1821 documents travels in North Wales, Warwickshire, Derbyshire, Durham, and Yorkshire. Cuitt returned to Richmond perhaps in 1821 and built himself a house in Masham. He resumed view painting and published several more sets of etchings, including one of Yorkshire abbeys. His etchings were collected into one volume by Nattali, to whom he had sold the copyright, and published in 1855. Cuitt died in Masham on 15 July 1854.

Cuitt painted in a neat style close to that of his father (the work of the two is difficult to disentangle), a style which was evidently influenced by William Marlow, a late eighteenth-century topographical painter who also worked in Yorkshire, though intermittently. Cuitt's panoramic views are minutely detailed. Some of his paintings of picturesque scenery are more romanticized, following the taste for the sublime, and his etchings reflect the dramatic chiaroscuro of Piranesi.

Bibliography

Cust, Sir Lionel. In *Dictionary of National Biography*. Vol. 13. London, 1888:275–276.

1959.1.1 (1526)

Easby Abbey, near Richmond

c. 1821/1854
Oil on canvas, 65.9 × 91.6 (26 × 36)
Gift of Miss Harriet Winslow

Technical Notes: The medium-fine canvas is plain woven; it has been lined. The ground is white, fairly thinly applied. An extensive preparatory sketch of the composition has been drawn in with a red pencil or crayon and reinforced with liquid black paint applied with a brush; unlike the underdrawing of the trees, the underdrawing of the architecture is incorporated into the surface design and is clearly visible. The painting is executed in thin, opaque layers in the landscape, architecture, and sky; some of the foliage and areas of the foreground are applied in translucent glazes; the highlights are slightly textured. There is a pentimento in the tree on the right, which originally had a broader trunk. The paint surface is very slightly abraded throughout; apart from a damaged area of sky just beneath the lowest branches of the tree on the right, which has been retouched, the paint losses are minimal. The thin natural resin varnish has not discolored.

Provenance: Harriet Patterson Winslow, Washington, as *Fountains Abbey* by George Smith of Chichester.

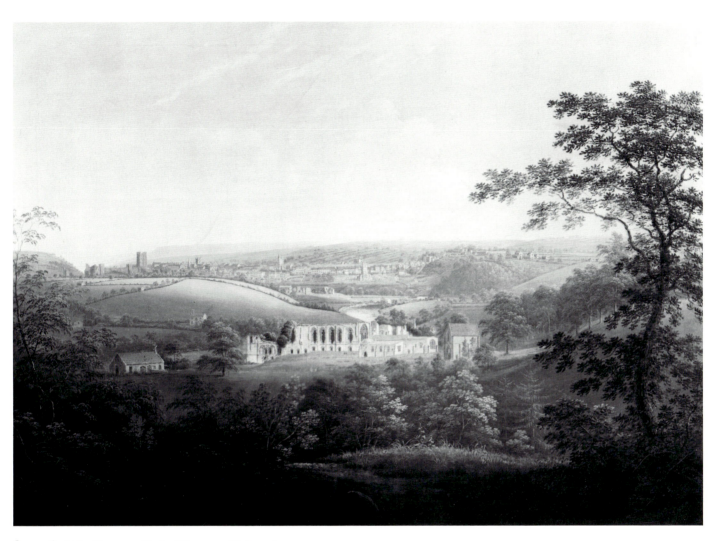

George Cuitt the Younger, *Easby Abbey, near Richmond*, 1959.1.1

THE VIEW is of Easby Abbey, Yorkshire, looking westward with a panorama of Richmond in the distance. Easby is one of the most picturesque monastic ruins in Yorkshire.

Traditionally attributed to George Smith of Chichester, the picture was rightly attributed to George Cuitt the Younger—who perhaps in 1821 resettled in Richmond—by Sir Ellis Waterhouse.[1] He compared it with a view of the same scene apparently signed and dated 1829 by Cuitt.[2] Another view, larger in size, with a similar framing tree and even more closely related in technique, was with Spink & Son in 1977 (fig. 1). A third, but with a different foreground, passed through the saleroom in 1983.[3]

The Washington painting is very carefully constructed in overlapping planes, and is executed for the most part in an exceptionally tight technique; the foreground is more painterly in handling, and the atmospheric shadowed areas relieve the precision. The exact rendering of the topographical distance is characteristic of an architectural engraver; the underdrawing revealed by infrared reflectography (fig. 2) is close in character to the draftsmanship of a long line of topographical artists from the early seventeenth century onward. The dark foreground with framing trees was a convention in British landscape art of the eighteenth century and, taken with the glowing light at the horizon, provides an echo of Claude.

Fig. 1. George Cuitt the Younger, *Easby Abbey, Yorkshire*, oil on canvas, private collection [photo: courtesy Spink & Son]

Not enough is known about the topographical features, or of any development in Cuitt's landscape style, to enable the picture to be dated to a particular period of his residence in Yorkshire.[4]

Notes

1. Letter, 17 March 1959, in NGA curatorial files.

2. M. H. Grant, *The Old English Landscape Painters*, 3 vols. (1 and 2: London, n.d. [1926]; 3: Leigh-on-Sea, 1947), 2: pl. 148a.

3. Sale, Christie, Manson & Woods, London, 18 November 1983, no. 64, color repro.

4. Two small, neat drawings of Easby Abbey were included in a sketchbook dated 1821 (Abbott and Holder, London, list no. 214, June 1983: nos. 99–118). Peter Boughton, keeper of art, Grosvenor Museum, Chester, kindly drew my attention to this reference.

Fig. 2. Infrared reflectogram of a detail of 1959.1.1

Jeremiah Davison

c. 1695 – 1745

JEREMIAH DAVISON was born in England in about 1695, of Scottish parentage. Nothing is known of his education or artistic training, but he is known to have copied works by Van Dyck and Lely in the Royal Collection; Vertue records that he copied many of Lely's pictures "with great attention & by such means formed from thence and nature a pleasant easy stile of Colouring."[1] Davison became acquainted at meetings of a masonic lodge with James, 2nd Duke of Atholl, whose portrait he painted and who took him to Scotland, recommending him widely. Davison worked in Edinburgh from about 1737 to 1740, painting the Scottish aristocracy, and maintained an equally prosperous practice after his return to London. He shared with Hudson, Ramsay, and Vanderbank the services of the drapery painter, Joseph Van Aken. His prices were moderate; he is recorded as charging thirty-two guineas for a full length in 1737. Davison died at his house in Leicester Fields, London, in December 1745.

In his earlier work Davison was slightly rhetorical in the Kneller tradition; his later three-quarter lengths were modeled on Hudson and were accomplished and often painterly. In his mature smaller portraits he achieved a robust directness, freshness, and feeling for texture characteristic of the age of Hogarth, though his modeling remained hard; in his large-scale work he was naturalistic in detail but derivative, stiff, and contrived in composition.

Never an original talent, Davison was superseded in the mid-1740s by Allan Ramsay. No pupils are recorded.

Notes
1. Vertue *Note Books*, 3:129.

Bibliography
Vertue, George. *Note Books*. In 6 vols. *The Walpole Society* 18 (1930), 20 (1932), 22 (1934), 24 (1936), 26 (1938), 30 (1955): (22 [1934]), 129.
Irwin, David and Francina. *Scottish Painters at Home and Abroad 1700–1900*. London, 1975:47–49, 54, 65.

1947.17.29 (937)

James, 5th Duke of Hamilton

1737/1740
Oil on canvas, 75.9 × 63.5 (29⅞ × 25)
Andrew W. Mellon Collection

Inscriptions:
Inscribed on reverse of canvas in ink, in a later hand: *Dundas* and: *Mat Brown*.

Technical Notes: The canvas is plain woven. It is unlined, and probably still attached to its original stretcher; the original tacking margins survive intact. The canvas was primed before being attached to the stretcher. The weft at the bottom is distorted upward, suggesting that a significant piece of canvas has been cut from the lower edge; since the tacking margin on the lower edge is unpainted (confirming that the painting has not been reduced in size), the probable explanation is that the canvas used for the picture was cut from a much larger pre-primed length. The ground is gray-green. The painting is executed fairly thickly, blended wet into wet, with considerable reworking of the costume. X-radiographs show that the painting was originally planned as an oval, and that the arm had been positioned twice before the present attitude was reached (see below). There is extensive retouching across the shoulder and in the foreground, and possibly elsewhere. The thick varnish has discolored to a significant degree.

Provenance: Painted for James, 5th Duke of Hamilton [1702/3–1742/3]; by descent to Alfred, 13th Duke of Hamilton (sale, Christie, Manson & Woods, 6–7 November 1919, 1st day, no. 7, as by Mather Brown), bought by (Tooth Brothers.), London, from whom it was purchased 4 February 1920 by (G. S. Sedgwick) for Thomas B. Clarke [d. 1931], New York. Sold by Clarke's executors in 1935 to (M. Knoedler & Co.), New York, from whom it was purchased January 1936, as part of the Clarke collection, by The A. W. Mellon Educational and Charitable Trust, Pittsburgh.

Exhibitions: *Portraits Painted in Europe by Early American Artists*, Union League Club, New York, 1922, no. 11. *Portraits by Early American Artists of the Seventeenth, Eighteenth and Nineteenth Centuries Collected by Thomas B. Clarke*, Philadelphia Museum of Art, 1928, unpaginated and unnumbered.

JAMES, 5th Duke of Hamilton, a Tory who intrigued with the exiled Stuart dynasty, was created a knight of the Order of the Thistle in 1723 by the titular James III.

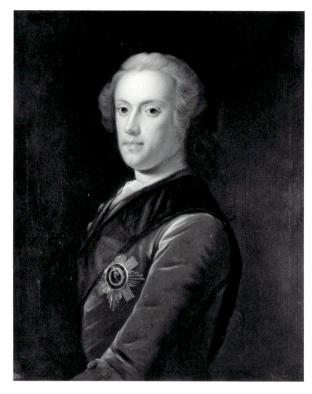

Fig. 1. Jeremiah Davison, *James, 5th Duke of Hamilton*, 1737/1740, oil on canvas, Lennoxlove, Duke of Hamilton [photo: Scottish National Portrait Gallery]

Invested with the Order of the Thistle in 1726 by George I, he was a lord of the bedchamber from 1727 to 1733, when he resigned on account of his opposition to Sir Robert Walpole. He was married three times, the third time in 1737 to Anne, daughter and wealthy co-heiress of Edward Spencer, of Rendlesham, Suffolk. Hamilton, said to have been "one of the handsomest and most graceful men of his time,"[1] was much portrayed: by Mignard as a young man, Rosalba, William Aikman (at least three times), Vanderbank, John Alexander, and William Hoare. He died in Bath, of jaundice and palsy, at the early age of forty.

This portrait was for long attributed to Mather Brown on the evidence of the old inscription on the back of the canvas, an inscription not of great antiquity but evidently placed there when the picture was still in the Hamilton collection. Sawitsky, for example, felt no reason to doubt that the work was an early Mather Brown.[2] In order to fit this attribution Sedgwick asserted at the time of the picture's purchase that the sitter was actually Alexander, 10th Duke of Hamilton (1767–1852),[3] a better known personality than the 5th Duke. This error was not corrected until 1952, when a photograph of the version of the portrait of the 5th Duke at Lennoxlove, Haddington, East Lothian (fig. 1), at that time attributed to William Aikman, was made available to the National Gallery by its owner, the then Duke of Hamilton. Lane and Rutledge at this point suggested that the Washington portrait was a copy of the Aikman by Mather Brown;[4] their view was supported by Clare and Davidson.[5] Campbell catalogued the work in 1970 (as did Wilmerding in 1980) as attributed to Mather Brown.[6]

The Hamilton inventory of 1759, however, which lists either the Gallery's or the Lennoxlove version of the portrait, documents the painter as being Jeremiah Davison.[7] The sitter wrote to James, 2nd Duke of Atholl, Davison's patron, in November 1737, mentioning that he would be glad to have a visit from the artist,[8] and the original portrait probably dates from soon thereafter and certainly before Davison's departure from Edinburgh in 1740. Davison shows him fuller in the face than in earlier portraits, close to the portrait by Hoare, which was painted after Hamilton's third marriage in August 1737.

The internal evidence of the reworking of the Washington picture suggests that it, rather than the Lennoxlove version, was the original portrait. In Davison's first concept the format was oval and the arm was held back so that the sitter's chest was turned more toward the spectator. In the second concept the arm was moved to the left, the two buttons on the cuff were included, and the star was shifted to its present position. Either then or in the original concept the cravat spilled out over the sash in a flutter of frills. Finally, in the pose now seen, the arm was positioned slightly farther back, between the postures previously adopted. Either at this stage, or at the second, the oval format was abandoned. In the Lennoxlove version, which is in precisely the same pose but is superior in quality—it is more softly and sensitively painted, with light brown paint in the highlights of the sash and a silvery sparkle to the star—Davison has included the lettering of the motto of the Order of the Thistle: NEMO ME IMPUNE LACESSIT, in the execution of the star. This version was presumably painted for the Duke of Hamilton either at the same time as, or soon after, the first and, by virtue of its more finished character, was likely to have been regarded by him as the prime version.

In spite of the social importance and apparent charisma of the sitter, and the trouble Davison took over the pose, the Gallery's picture is not one of the artist's best portraits. It lacks his customary Hogarthian directness.

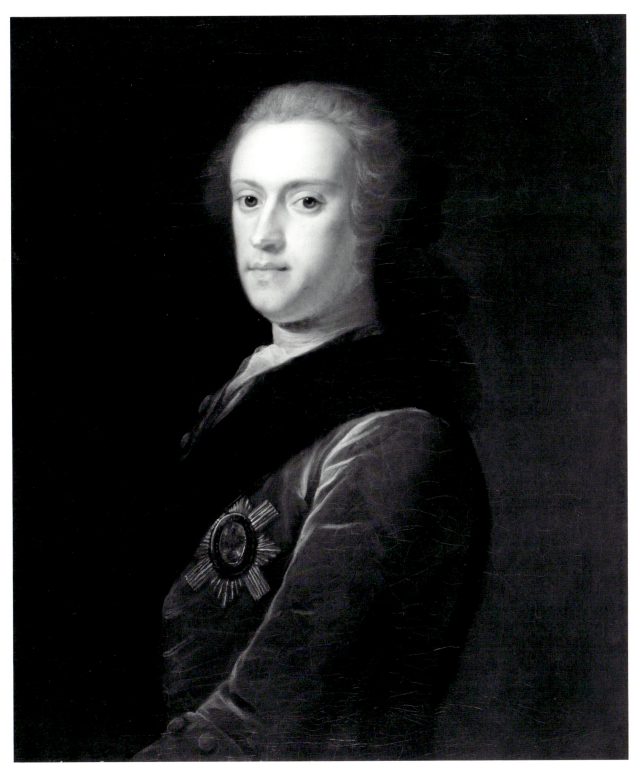

Jeremiah Davison, *James, 5th Duke of Hamilton*, 1947.17.29

On the other hand, in the Lennoxlove version, Davison was careful to paint a more sensitive portrait for the duke. Not enough is known at present about Davison and his studio practice to explain the puzzling difference in quality between the two works.

Six other versions of the portrait are known, all in the same pose: a version, coarser and more perfunctory, at Lennoxlove; one in the collection of Lord Templemore at Dunbrody Park, Arthurstown, Co. Wexford, which bore an attribution to Sir James Thornhill and is of good replica quality; one formerly in the Douglas collection,[9] which bore an attribution to Sir John Medina, and is also of good replica quality; one in the Godbold collection, Claremont, South Africa, which bore an attribution to Batoni; one in an oval format which appeared in a sale of pictures from the Marquess of Tweeddale's collection at Yester House, East Lothian, as school of Kneller,[10] and is now in the collection of the Duke of Hamilton at the palace of Holyroodhouse, Edinburgh; and one in the collection of Lord Home at The Hirsel, Coldstream, Berwickshire. None of these includes the lettering of the motto of the Order of the Thistle (photographs of numbers 2 through 5 are in the Witt Library, Courtauld Institute of Art, London).

Notes

1. *The Complete Peerage*, ed. H. A. Doubleday, Duncan Warrand, and Lord Howard de Walden, 13 vols. (London, 1910–1940), 6 (1926):270, n. (f).

2. William Sawitsky, undated note, in NGA curatorial files.

3. G. Stanley Sedgwick to Thomas B. Clarke, 1 January 1920, in NGA curatorial files.

4. James Lane and Anna Rutledge, report on the Clarke collection, 1952, quoted by William P. Campbell, memorandum, 4 May 1966, in NGA curatorial files.

5. Elizabeth Clare and William F. Davidson, notes, 15 and 16 May 1963, in NGA curatorial files.

6. NGA 1970, 18; NGA 1980, 30.

7. "In the Bed Chamber on the First Floor of the East Wing. 350. James Duke of Hamilton three quarters by Davidson [sic]" (Inventory of Pictures belonging to His Grace the Last deceased James Duke of Hamilton and Brandon 6 June 1759). Typescripts from the MS. in the Hamilton collection are deposited in the Scottish National Portrait Gallery, Edinburgh, and the National Portrait Gallery, London.

8. MSS, Blair Castle: Atholl MSS, 46 (11), 123; mentioned, and the reference cited, in Irwin 1975 (see biography), 48, 412.

9. Charles J. C. Douglas sale, Christie, Manson & Woods, London, 1–2 June 1927, 1st day, no. 123, bought by Barclay.

10. Peter Morris sale, Sotheby's, London, 20 December 1973, no. 29, bought by Dugdale.

References

1970 NGA 1970:18, repro. 19.
1980 NGA 1980:30, repro.

Arthur Devis

1712 – 1787

DEVIS WAS BORN in Preston, Lancashire, on 12 February 1712, the eldest son of Anthony Devis, a joiner who was later a town councillor, and Ellen Rauthmell. Perhaps through the influence of the Liverpool portrait painter Hamlet Winstanley he became the pupil in London of the sporting and topographical painter Peter Tillemans. After the latter's retirement in 1733 he returned to Preston, and his earliest dated work, of 1735, is a view painting. His earliest dated portraits are from 1741, and by the following year he is recorded as working in London. In that year he married Elizabeth Faulkner; the couple had twenty-two children. In 1745, well established as a painter of small-scale portraits and conversation pieces, he settled on Great Queen Street in Lincoln's Inn Fields. Little is known about Devis' prices (no sitter or account books survive), but by this date he was charging twenty-five guineas for a conversation piece including five figures. Many of his early commissions came from Lancashire Jacobite families, and were obtained through his father's local connections. In 1752 he took on an apprentice, George Senhouse, but was obliged to discharge him after three years for idleness; he had at least three other students.

From 1761 Devis exhibited irregularly at the Free Society of Artists, of which he became president in 1768. In this decade, however, his reputation was eclipsed by that of Zoffany, who was already charging twenty guineas a figure for his conversations. Devis never exhibited at the Society of Artists or the Royal Academy of Arts and never competed for Associateship of the latter body,

but he entered his son, Arthur William, at the Royal Academy Schools in 1774. Arthur William subsequently became a portrait and historical painter of note in Bengal.

In later life Devis was active more as a restorer; between 1777 and 1778 he was paid one thousand pounds for cleaning and repairing the Painted Hall at Greenwich, which he accomplished, as the minutes record, with "great Skill and care." In 1783 he sold his collection of pictures and retired to Brighton, where he died on 25 July 1787.

Apart from topography, self-portraits, and a not unaccomplished full length of a leading politician for Preston Town Hall, Devis' known output is entirely small-scale portraiture, generally small in size. It was Philip Mercier who, in the 1720s, created in England the related genres of the conversation piece and the small-scale portrait with landscape setting, and Hogarth who popularized these genres and made them fashionable for a short time even with patrons of the highest rank. Devis, in the 1740s and 1750s, was the acknowledged specialist in this field, catering to the middle ranks of society. Using a meticulous technique and gifted with a remarkable sensitivity to materials, notably fabrics, Devis created a life-like world in miniature in which the fashionable postures, gestures, and costume and the idealized settings (only one of his interiors is known to be of an actual room) reflected the social aspirations of his sitters: their appetite for possessions, gentility, and status.

The defects of Devis' manner were his artificial, contrived space, his stiff doll-like figures and the absence of visual relationships between them, and the lack of any rhythmic design to give rococo coherence to his bright colors. In the mid 1750s, stimulated by the advent of Reynolds and influenced by Benjamin Wilson, he tried to achieve a broader style, with more impressive figures, some use of chiaroscuro, and greater psychological subtlety, but his innate linearism and his conservatism were against him.

In the first decade of George III's reign Devis was superseded by the royal favorite, Zoffany, with his greater artistry and sophistication. Devis was scarcely noticed at his death and completely forgotten thereafter, until the revival of interest in Georgian life and manners in the 1920s and 1930s.

Bibliography
Pavière, Sydney H. *The Devis Family of Painters*. Leigh-on-Sea, 1950.
D'Oench, Ellen G. *The Conversation Piece: Arthur Devis & His Contemporaries*. Exh. Cat., Yale Center for British Art. New Haven, 1980.
Hayes, John, and Stephen V. Sartin. In *Polite Society by Arthur Devis 1712–1787*. Exh. cat., Harris Museum and Art Gallery, Preston; National Portrait Gallery, London. Preston, 1983:9–36.

1964.2.4 (1912)

Members of the Maynard Family in the Park at Waltons

c. 1755/1762
Oil on canvas, 138.5 × 195.6 (54½ × 77)
Paul Mellon Collection

Technical Notes: The medium-weight, plain-woven canvas is composed of two pieces of linen with a vertical seam to left of center; it has been lined. The ground is pinkish brown, thickly applied, masking the weave of the canvas. A thin white imprimatura has been applied locally beneath the red dress of the woman seated on the right. The painting is executed in thin, opaque, enamellike layers, with virtually no impasto and minimal texture; the brushwork is smoothly blended in the sky and grass, and loosely and fluidly applied in the costume, with light, delicate brushstrokes in the lace flounces and jewelry; the tonality of the ground layer shows through in areas such as the sky and passages in the trees. The painting has suffered heavily from losses and abrasion, and extensive areas in the sky, foliage, and landscape have been retouched; the face of the woman on the left has been traversed by a vertical line of damage. During conservation between 1934 and 1951 a horse standing in profile in the center left was painted out owing to damage in this area (fig. 1), and the face of the little girl on the right was repainted.[1] It is possible that a kite (removed before the picture was acquired by Paul Mellon) was added at the same time, as the little girl on the left is described in Christie's sale catalogues of 1951 and 1955 as flying a kite; the shape is evident to the naked eye in place of the flowers the girl is holding, but it is not revealed (as the horse is) by infrared reflectography or x-radiographs. The moderately thick natural resin varnish has not discolored significantly.

Provenance: Painted for Sir William Maynard [1721–1772], 4th Bt., of Waltons, Ashdon, Essex; by descent to Frances, Countess of Warwick,[2] who offered it as property of the Maynard collection (sale, Sotheby & Co., London, 21 November 1934, no. 34, repro., bought in); offered again, as property of the late Frances, Countess of Warwick, and of the Hon. Maynard and Mrs. Greville (sale, Christie, Manson & Woods, London, 28 May 1948, no. 25), bought by Hemming. Walter

Fig. 1. 1964.2.4, showing the horse originally included in the painting [photo: Barnes and Webster]

Fig. 2. Arthur Devis, *Cricketing Scene in the Grounds of Easton Lodge, Dunmow, Essex*, oil on canvas, last recorded in the Maynard collection sale, Sotheby's, London, 21 November 1934, lot 35 [photo: Barnes and Webster]

Arthur Devis, *Members of the Maynard Family in the Park at Waltons*, 1964.2.4

Hutchinson, London (sale, Christie, Manson & Woods, London, 20 July 1951, no. 87, bought in); (sale, Christie, Manson & Woods, London, 7 October 1955, no. 24), bought by (Betts) for (Montagu Bernard), who sold it to (Arthur Ackermann & Son), from whom it was purchased 1960 by Paul Mellon, Upperville, Virginia.

Exhibitions: *The First 618 Selected Pictures*, National Gallery of Sports and Pastimes, London, n.d. [1949], no. 14. *The Conversation Piece: Arthur Devis & His Contemporaries* (cat. by Ellen G. D'Oench), Yale Center for British Art, New Haven, 1980, no. 38, repro.

SIR WILLIAM MAYNARD, M.P. for Essex from 1759 until 1772, married Charlotte, second daughter of Sir Cecil Bishopp, in 1751. They had three sons and one

daughter. Harris has suggested that this conversation piece represents Charlotte, seated at the right, and her widowed mother-in-law in the center, "who sits in a Windsor chair of complex design," playing the guitar.[3] D'Oench has argued that "it is more likely that the reverse is the case, or that Charlotte is accompanied by one of her seven sisters . . . the youngest [son], Henry (1758–1801), may be the child on the left."[4] The central figure, on grounds of age, clearly cannot be Lady Maynard, who was in any case not widowed, and it seems most likely that the woman on the right is indeed Charlotte, who is playing a motherly role, and that the children are her two eldest; the small boy on the left would then be identifiable with Charles (1751–1824), later the fifth baronet and second Viscount Maynard, and the picture would be datable to

about 1755. On the other hand the low flounced petticoats of the elaborate sack dresses would seem to be more characteristic of fashion in the latter part of the decade. Devis, as always, depicts even country sitters in their country setting dressed at the height of fashion. A *terminus ante quem* is provided by Charlotte's death in 1762. Waltons, the house in the background, "rebuilt in an elegant manner, by Sir William Maynard,"[5] but with a plain red-brick front, still stands, and, with the exception of the attic story (removed during the restoration following severe damage to the house by fire in 1954), looks much as it did in Devis' day.

Both Pavière[6] and Harris have doubted the attribution to Devis, but the technique is fully consonant with his documented work. The schematic layout of the composition is typical, as are the stiffly painted trees and awkwardly rendered cattle. As a result of the painting out of the horse (see the technical notes), the left of the picture is now uncomfortably empty. A conversation piece of the same unusually large size, including in the distance a view of Easton Lodge, Dunmow, the nearby seat of Sir William's kinsman, Viscount Maynard, has always been a pair to the Washington picture (fig. 2);[7] this work is undoubtedly very damaged, but the handling is identical with the Washington painting and there is no reason to doubt its authenticity, as proposed by Pavière.[8]

Notes

1. The horse is seen in the illustration in the catalogue of the Maynard Collection sale, Sotheby's, London, 21 November 1934, no. 34.
2. She was the elder daughter and co-heir of Col. the Hon. Charles Henry Maynard, son of the 3rd and last Viscount Maynard (1786–1865).
3. Harris 1979, no. 234.
4. D'Oench 1980 (see biography), no. 38.
5. P. Muilman, *A New and Complete History of Essex*, 2 vols. (Chelmsford, 1769–1772), 2:311.
6. Pavière 1950 (see biography), 34, no. 141.
7. Traditionally thought to be a group portrait of the Hon. Greville Maynard and family, it seems to represent the patron, seated on the right, in conversation with a younger man, a boy—presumably his son—holding a cricket bat, and a servant approaching with a letter. It was no. 27 in the exhibition at the National Gallery of Sports and Pastimes, London, 1949, but its present whereabouts are unknown; the work was reproduced in the catalogue of the Maynard Collection sale, Sotheby's, 21 November 1934, no. 35.
8. Pavière 1950 (see biography), 34, no. 142. The attribution is fully accepted in D'Oench 1980 (see biography), 63 (see 64 for a description of its state and conservation).

References

1950 Pavière 1950 (see biography): 34, no. 141.
1976 Walker 1976: no. 518, color repro.

1979 Harris, John. *The Artist and the Country House.* London, 1979: no. 234.

1964.2.3 (1911)

Portrait of a Gentleman Netting Partridges

1756
Oil on canvas, 69.9 × 97.8 (27½ × 38½)
Paul Mellon Collection

Inscriptions:
Signed and dated at lower center: *Art: Devis fe/1756*

Technical Notes: The medium-weight canvas is plain woven fairly loosely; it has been lined. The painting appears to have been cut down along the left and bottom edges. The ground is cream colored, smoothly applied and moderately thick, masking the weave of the linen. There is a light brown imprimatura. The painting is executed in thin, smooth layers, mostly in opaque paint but with transparent glazes for the darkest greens and deep browns. The paint surface has been severely abraded, and there are numerous losses and heavy retouching, especially in the sky. The thick natural resin varnish has discolored yellow slightly.

Provenance: Miss P. A. Hatcher (sale, Christie, Manson & Woods, London, 29 June 1951, no. 132, as *Portrait of a Sportsman*, bought in); (sale, Christie, Manson & Woods, London, 18 June 1954, no. 142, as *Lord Brand, of Hurndall Park*), bought by (Edward Speelman), London, who sold it 1960 to Paul Mellon, Upperville, Virginia.

Exhibitions: *The Conversation Piece: Arthur Devis & His Contemporaries* (cat. by Ellen G. D'Oench), Yale Center for British Art, New Haven, 1980, no. 33, repro.

NOTHING IS KNOWN about the sitter. The evidence for Christie's identification of him in their catalogue of 1954 is unknown: no peer named Brand was created until 1946, and there is no such place as Hurndall Park. The sitter is shown with three partridges at his feet, which, as was a practice at the time, he had trapped in a net with the aid of a pointer. His pointer is seen at the lower left and his gun and tricorne hat lie at his feet; all are truncated by the edges of the canvas, suggesting that the picture may indeed have been cut down on the left side and along the bottom.[1]

As is common in Devis' work, the figure is strongly lit, stiffly painted, and visually unrelated to the landscape background; the landscape is conceived in two dis-

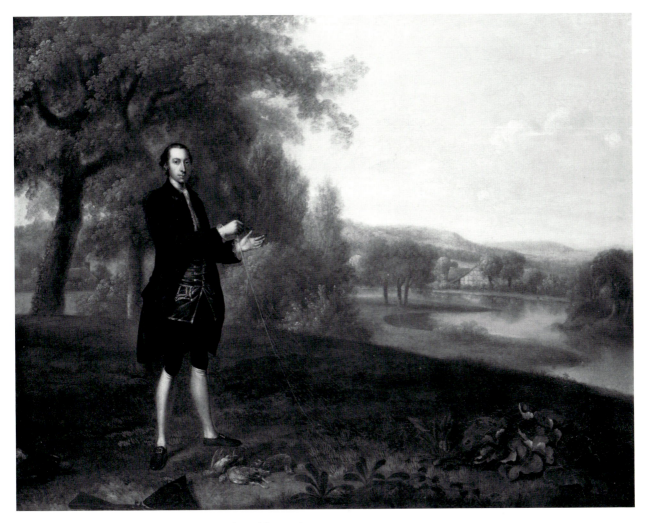

Arthur Devis, *Portrait of a Gentleman Netting Partridges*, 1964.2.3

tinct and arbitrary zones, the further one being soft and generalized in handling, close in style to that of the Smiths of Chichester, with a half-timbered cottage included beyond the river as a picturesque accent.

Notes
 1. As indicated by the conservation report. It should be noted, however, that the canvas is a standard size (kit-cat, 28 × 36 in.).

References
 1976 Walker 1976: no. 520, color repro.

1983.1.40 (2915)

Arthur Holdsworth Conversing with Thomas Taylor and Captain Stancombe by the River Dart

1757
Oil on canvas, 127.6 × 102.1 (50¼ × 40¼)
Paul Mellon Collection

Inscriptions:
Signed and dated at lower center: *Arth:* Devis fe 1757 (the last digit almost illegible)

Technical Notes: The medium-weight canvas is plain woven; it has been lined. The ground appears to be white, of moderate

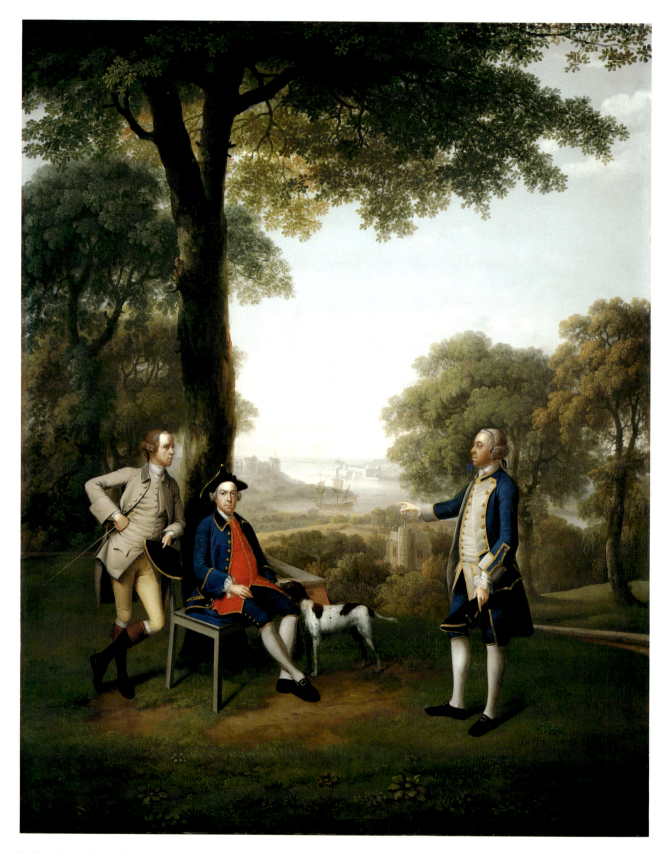

Arthur Devis, *Arthur Holdsworth Conversing with Thomas Taylor and Captain Stancombe by the River Dart*, 1983.1.40

thickness. The painting is executed thinly and very fluidly resulting in a smooth surface texture; there are minimal brushmarks and no impasto. There are scattered retouches chiefly in the sky; the entire canvas has a quarter-inch band of retouching at the edges. The moderately thin natural resin varnish has not discolored.

Provenance: Painted for Arthur Holdsworth [1733–1777], Mount Gilpin and Widdicombe House, Kingsbridge, Devon; by descent to Captain Frederick Holdsworth (sale, Christie, Manson & Woods, London, 22 April 1921, no. 2, bought in); by descent to his sister, Mrs. Cuthbert Lucas (sale, Christie, Manson & Woods, London, 6 November 1959, no. 71, repro.), bought by (Thos. Agnew & Sons), London, who sold it 1960 to Paul Mellon, Upperville, Virginia.

Exhibitions: *Painting in England 1700–1850*, Virginia Museum of Fine Arts, Richmond, 1963, no. 224, repro., pl. 71. *The Conversation Piece: Arthur Devis & His Contemporaries* (cat. by Ellen G. D'Oench), Yale Center for British Art, New Haven, 1980, no. 36, repro.

ARTHUR HOLDSWORTH, seated, who came from a merchant family, was governor of Dartmouth Castle, Devonshire, from 1760 to 1777. In 1755 he married Rebecca Taylor of Denbury, Devonshire. Her brother Thomas, who succeeded Holdsworth as governor, is standing behind him in the cross-legged pose then fashionable; he has evidently ridden over, as he is shown wearing spurs and holding a riding switch. Captain Stancombe, on the right, dressed in the uniform of an officer in the merchant navy, is pointing toward the merchantman sailing up the estuary of the River Dart. Dartmouth Castle and the fortifications of the harbor are seen in the distance. Holdsworth, for whom the picture was painted, is the principal figure: he alone is seated, he alone wears a hat, and he alone looks out at the spectator. It seems likely that the painting celebrates the safe return to England of one of his ships, of which Stancombe was the captain.

The informal grouping of the figures is characteristic of the conversation piece, but the lack of real communication between the three men demonstrates a basic weakness in Devis' art. The lighting is unified, however, and the greater unity between figures and background is characteristic of Devis' later work. The handling of the foliage is influenced by the style of George Lambert, then the doyen of British landscape painters.

References
1950 Pavière 1950 (see biography): no. 69.

Gainsborough Dupont

1754 – 1797

GAINSBOROUGH DUPONT was born in Sudbury, Suffolk, on 20 December 1754, the only son of Sarah, one of Thomas Gainsborough's elder sisters, and Philip Dupont. He was apprenticed to Gainsborough in January 1772 and was to work with him—so far as we know his uncle's only assistant—until Gainsborough's death in 1788. He was trained at the Royal Academy Schools, which he entered in March 1775; Hoppner (admitted on the same day as Dupont), Beechey, and Rowlandson were among his contemporaries. From 1779 on he made a number of mezzotints of Gainsborough's portraits. He took over the studio in 1788, and, after Mrs. Gainsborough's death in 1793, moved to Bloomsbury. Dupont was much employed by George III, who admired his work; to William Pitt he owed his principal commission, the large group portrait of *The Merchant Elder Brethren of Trinity House*. Thomas Harris, the proprietor of Covent Garden Theatre, engaged him to paint a series of portraits of actors (many of these are now in the Garrick Club, London). He also painted landscapes. On three occasions he tried, unsuccessfully, to secure election as an Associate of the Royal Academy. He died in London on 20 January 1797.

Dupont's style, and in landscape his subject matter as well, was entirely dependent on Gainsborough, but his technique is staccato and finicky, lacking in assurance. He suffered from the misfortune of working in the shadow of genius, of a great artist and technician who was also one of the most remarkable personalities of his age.

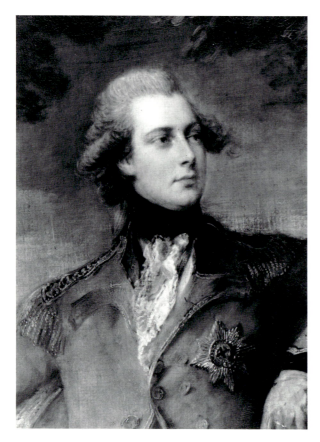

Fig. 1. Thomas Gainsborough, detail of *George IV as Prince of Wales*, R.A. 1782, oil on canvas, Buckinghamshire, Waddesdon Manor [photo: National Trust]

Dupont's forte lay in striking effects, and his most appealing works are his decorative and fluent landscape sketches in oil on paper.

Bibliography

Hayes, John. "The Trinity House Group Portrait." *BurlM* 106 (1964):309–316.

Hayes, John. "The Drawings of Gainsborough Dupont." *MD* 3 (1965):243–256.

Hayes, John. "Thomas Harris, Gainsborough Dupont and the Theatrical Gallery at Belmont." *Conn* 169 (1968):221–227.

Hayes, John. "The Problem of Gainsborough Dupont." In *The Landscape Paintings of Thomas Gainsborough.* 2 vols. London and New York, 1982, 1:187–236.

1937.1.98 (98)

George IV as Prince of Wales

1781
Oil on canvas, oval, 76 × 63 (29⅞ × 24¾)
Andrew W. Mellon Collection

Technical notes: The fairly fine canvas is plain woven; it has been lined. The ground is white, of moderate thickness. The painting is executed in thin washes that block out the composition and serve as a middle tone, followed by more heavily pigmented, richer colors, with the shading accomplished by blending wet into wet or by dragging a lightly loaded wide brush across a broad area. The final surface texture and detail is added in very fluid, rich paint. The thin, original glazes have been abraded and reglazed, and the impasto has been slightly flattened during lining. The darks have developed traction crackle. There are scattered retouchings. The natural resin varnish has not discolored.

Provenance: Painted for the sitter, who presented it to James, 2nd Earl of Courtown [1731–1810], County Wexford, treasurer of the household and lord of the bedchamber to the Prince of Wales; by descent to James, 5th Earl of Courtown [1823–1914], County Wexford. (Asher Wertheimer), London, who sold it to (M. Knoedler & Co.), London, by c. 1900, who sold it to (Henry Reinhardt & Son), New York.[1] John N. Willys [1873–1935], Toledo, Ohio.[2] (M. Knoedler & Co.), New York, from whom it was purchased January 1918 by Andrew W. Mellon, Pittsburgh, by whom deeded December 1934 to The A. W. Mellon Educational and Charitable Trust, Pittsburgh.

Exhibitions: *Arts, Industries, and Manufactures, and Loan Museum of Works of Art,* National Portrait Gallery, Dublin, 1872, no. 228.

GEORGE IV (1762–1830), who became Prince Regent in 1811 when his father was permanently affected by a mental disease, came to the throne in 1820. He was a distinguished connoisseur, collector, and patron of the arts, and was frequently portrayed by most of the leading artists of the day in the sumptuous uniforms in which he loved to dress up (he held no military appointment). Gainsborough painted him several times.

This portrait is a copy of the head and shoulders from Gainsborough's full-length portrait of the prince leaning against a charger, now at Waddesdon Manor, Buckinghamshire (fig. 1), which was exhibited at the Royal Academy of Arts in 1782. The style is closer to the sketchier version of this work in the collection of the Marquess of Zetland at Aske Hall, Yorkshire, which it would not be unreasonable to suppose was a studio replica and therefore the responsibility of Gainsborough Dupont,

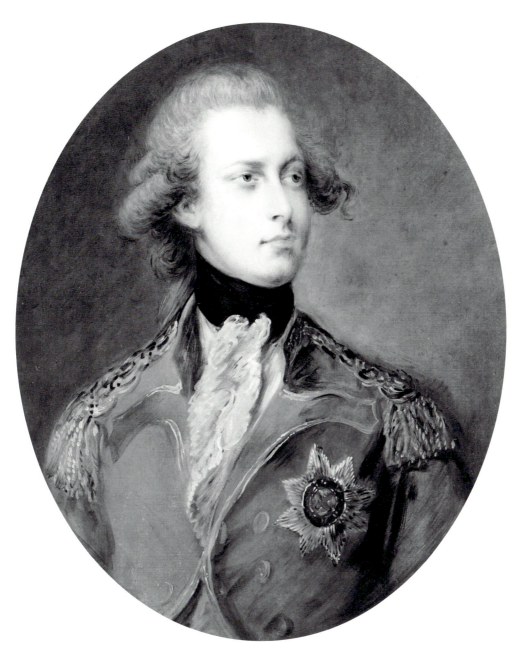

Gainsborough Dupont, *George IV as Prince of Wales*, 1937.1.98

who was Gainsborough's studio assistant from 1772 to 1788.

The loose handling of detail in the costume of the Washington picture, which lacks Gainsborough's unerring ability to suggest form and tends to float on the surface, is characteristic of Dupont. The head is also lacking in the vigor and thrust of the original. The work, which was given by the prince to Lord Courtown, who was his lord of the bedchamber from 1780 to 1784, was painted in 1781,[3] at the time the original Gainsborough was in hand. The price was thirty guineas, Gainsborough's standard charge at this date for a head-and-shoulders portrait.

Notes

1. Knoedler & Co. stock books, recorded by The Provenance Index, J. Paul Getty Trust, Santa Monica, California.

2. John N. Willys, President of Willys-Overland Motors, Inc., Toledo, Ohio, amassed a considerable art collection with part of which he later furnished his apartment at 820 Fifth Avenue, New York; he bought his British pictures from Agnew's and from Reinhardt & Son between 1910 and 1921. The Gallery's picture was not among those in his New York home in 1925 (Ralph Flint, "John N. Willys Collection," *IntSt* 80 [February 1925], 363–374).

3. "Head of His R: H: delivered by orders . . . to Lady Courtoun [sic]" (Georgian Papers 26791, Royal Archives, Windsor Castle, under 1781).

References

1949 Mellon 1949: no. 98, repro.
1953 Waterhouse, Sir Ellis. "Preliminary Check List of Portraits by Thomas Gainsborough." *The Walpole Society* 33 (1953):111.

1970.17.119 (2491)

Georgiana, Duchess of Devonshire

c. 1787/1796
Oil on canvas, 59.1 × 39.9 (23¼ × 15¾)
Ailsa Mellon Bruce Collection

Technical Notes: The fine canvas is plain woven; it has been lined. The picture has been very slightly enlarged by lining; there is a one-quarter-inch band of repaint along the left and bottom edges, and a thin border of retouching along the other edges. The ground is white, of moderate thickness. The painting is executed in very rich, fluid paint, applied first in thin washes, then increasingly opaquely, with some impasto in the highlights. The paint surface has been slightly flattened during lining. The large proportion of medium used resulted in traction crackle on drying, which has been retouched in the darks and in the face of the duchess. The recent natural resin varnish, lightly pigmented with black, has discolored yellow slightly.

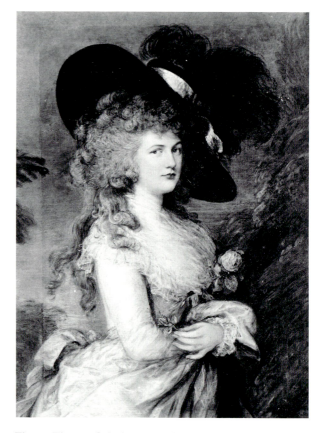

Fig. 1. Thomas Gainsborough, *Georgiana, Duchess of Devonshire*, late 1780s, oil on canvas, New York, private collection [photo: Frick Art Reference Library]

Provenance: George Agar-Ellis, 1st Baron Dover [1797–1833];[1] by descent to his granddaughter, the Hon. Lilah Agar-Ellis, later Lady Annaly [1862–1944], until c. 1922. (M. Knoedler & Co.), London, who sold it January 1922 to Andrew W. Mellon, Pittsburgh and Washington, who gave it to his daughter, Ailsa Mellon Bruce, New York, by 1937.

Exhibitions: *National Portraits*, South Kensington Museum, London, 1867, no. 470. *The Works of Thomas Gainsborough, R.A.*, Grosvenor Gallery, London, 1885, no. 40.

FOR BIOGRAPHICAL DETAILS about the sitter, see 1937.1.93, one of Gainsborough's portraits of the duchess.

This portrait is a reduced version, in grisaille, of what was probably Gainsborough's last portrait of the duchess, executed in the late 1780s. The latter (fig. 1), last recorded in the possession of Mrs. Mabel S. Ingalls, New York,[2] was cut down from full length to fifty by forty inches by Anne Maginnis, the then owner, sometime before 1841. The finicky handling, characteristic of the work of Gainsborough Dupont—an attribution first suggested

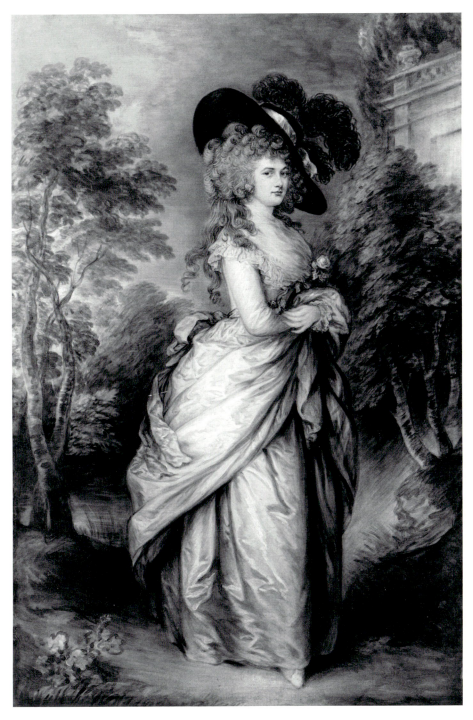

Gainsborough Dupont, *Georgiana, Duchess of Devonshire*, 1970.17.119

by Waterhouse[3]—is identical with that in Dupont's portrait of Mrs. Sheridan, 1970.17.122. The canvas seems likely, similarly, to have been a preparation for a mezzotint by Dupont; none, however, is recorded.

A mezzotint by T. L. Atkinson was published by Henry Graves in 1870.[4]

Notes

1. George Agar-Ellis was married to Lady Georgiana Howard, granddaughter of the sitter. His mother was Lady Caroline Spencer [d. 1813], eldest daughter of George, 4th Duke of Marlborough and cousin of the sitter. It is possible that Lady Caroline may have inherited the painting from Georgiana or her husband, William, 5th Duke of Devonshire [1748–1811], and bequeathed it to her son.
2. Ellis Waterhouse, *Gainsborough* (London, 1958), no. 195.
3. Waterhouse 1953, 29.
4. *Engravings from the Works of Thomas Gainsborough, R.A.* (London: Henry Graves & Company, c. 1880), no. 34.

References

1903 Gower, Lord Ronald Sutherland. *Thomas Gainsborough*. London, 1903: repro. opposite 66.
1953 Waterhouse, Sir Ellis. "Preliminary Check List of Portraits by Thomas Gainsborough." *The Walpole Society* 33 (1953):29.

1970.17.120 (2492)

William Pitt

1787/1796
Oil on board, 15.5 × 12.4 (6⅛ × 4⅞)
Ailsa Mellon Bruce Collection

Technical Notes: The support is a wood-pulp composition board composed of compressed layers. The ground is white, very thinly applied. The painting is executed in thin paint blended wet into wet. The painting is in good condition. The paint surface is not abraded, and there are few retouchings except in small paint losses below and to the left of the sitter's right eye. The thin, slightly pigmented varnish has not discolored.

Provenance: Perhaps purchased by (A. Betts) at an unidentified sale prior to 14 February 1930.[1] (M. Knoedler & Co.), New York, who sold it 1930 to Andrew W. Mellon, Pittsburgh and Washington, who gave it to his daughter, Ailsa Mellon Bruce, New York, by 1937.

WILLIAM PITT (1759–1806), second son of William, 1st Earl of Chatham, one of the greatest of British statesmen, was Prime Minister from 1784 to 1801 and again from 1804 to 1806. A supporter of Adam Smith and the concept of free trade, Pitt devoted the first years

Fig. 1. Thomas Gainsborough, *William Pitt*, 1787/1788, oil on canvas, New Haven, Yale Center for British Art, Paul Mellon Collection [photo: National Portrait Gallery]

of his administration to the restoration of the national economy following the American Revolution; the later years were dominated by his masterly conduct of the wars against revolutionary and Napoleonic France. He was painted by Gainsborough, Karl Anton Hickel, Hoppner, John Jackson, and Lawrence, drawn by Henry Edridge, and caricatured by Gillray. After Gainsborough's death in 1788 he was a patron of Dupont, who painted him at full length for Trinity House, London, of which he was master.

This portrait is a reduction of the oval portrait by Gainsborough in the Yale Center for British Art (fig. 1), of which Dupont made copies.[2] Dupont executed a number of small portraits on panel after Gainsborough, similar to this one; they included portraits of George IV (on the London art market in 1980), Lord Mulgrave (Cincinnati Art Museum), and Sir J. Bassett (private collection, England).

Notes

1. According to Knoedler's stock books, recorded by The Provenance Index, J. Paul Getty Trust, Santa Monica, California.
2. Ellis Waterhouse, "Preliminary Check List of Portraits by Thomas Gainsborough," *The Walpole Society* 33 (1953), 85;

Gainsborough Dupont, *William Pitt*, 1970.17.120

the Yale picture, formerly in the collection of Lord Amherst, is listed as no. 14 of the portraits of Pitt that emanated from Gainsborough and his studio.

1970.17.122 (2494)

Mrs. Richard Brinsley Sheridan

1787/1796
Oil on canvas, 59.4 × 39.7 (23⅜ × 15⅝)
Ailsa Mellon Bruce Collection

Technical Notes: The fine canvas is plain woven; it has been lined. The ground is white, of moderate thickness. The painting is executed in thin washes, followed by increasingly pigmented colors, with highlights applied in a fluid white impasto. The paint has been abraded in the thinnest background washes, and the impasto has been slightly flattened during lining. There is a good deal of retouching, notably in the rocks at lower right. The sitter's right wrist and index finger have been reinforced. The layers of varnish, one of them pigmented, have discolored yellow slightly.

Provenance: George Agar-Ellis, 1st Baron Dover [1797–1833]; by descent to his granddaughter, the Hon. Lilah Agar-Ellis,

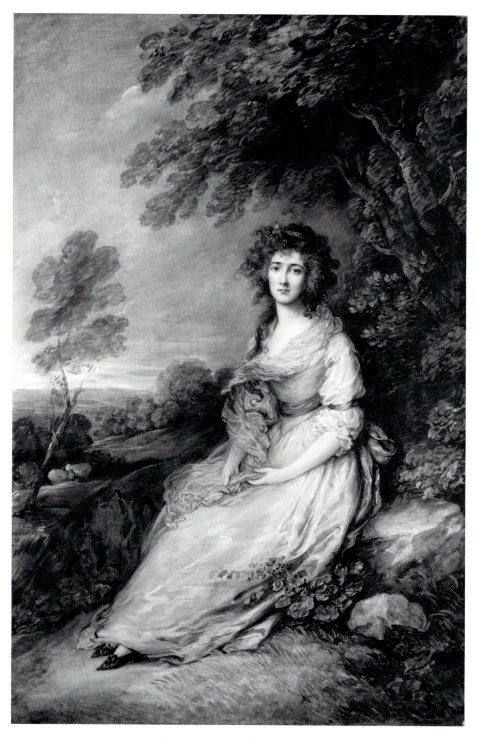

Gainsborough Dupont, *Mrs. Richard Brinsley Sheridan*, 1970.17.122

later Lady Annaly [1862–1944], until c. 1922. (M. Knoedler & Co.), London, who sold it January 1922 to Andrew W. Mellon, Pittsburgh and Washington, who gave it to his daughter, Ailsa Mellon Bruce, New York, by 1937.

FOR BIOGRAPHICAL details about the sitter, see 1937.1.92, Gainsborough's portrait of Mrs. Sheridan.

This portrait is a reduced version, in grisaille, of 1937.1.92. The finicky handling is characteristic of the work of Gainsborough Dupont, an attribution to whom was first suggested by Waterhouse,[1] and the canvas seems likely to have been a preparation for the mezzotint of Gainsborough's portrait, which Dupont executed but did not publish (fig. 1). *Georgiana, Duchess of Devonshire*, 1970.17.119, is a similar work.

Notes
 1. Waterhouse 1953, 98.

References
 1953 Waterhouse, Sir Ellis. "Preliminary Check List of Portraits by Thomas Gainsborough." *The Walpole Society* 33 (1953):98.

Fig. 1. Thomas Gainsborough, *Mrs. Richard Brinsley Sheridan*, from the mezzotint by Gainsborough Dupont, London, British Museum

John Ferneley

1782 – 1860

FERNELEY was born in Thrussington, Leicestershire, on 18 May 1782. His father was a master wheelwright, to whom he was apprenticed. In 1801, traditionally as a result of encouragement from the Duke of Rutland, who had admired and purchased his youthful picture of the celebrated "Billesdon Coplow Run" of 1800, Ferneley was apprenticed for three years to the sporting painter Ben Marshall. He may also have studied at the Royal Academy Schools, though he is not listed in the students' register. He first exhibited at the Royal Academy in 1806 and continued to exhibit there, at the British Institution, and at the Society of British Artists on Suffolk Street, but only sporadically. From 1804 onward he traveled extensively executing commissions, making several long visits to Ireland between 1808 and 1812.

In 1814 Ferneley settled in Melton Mowbray, traveling less widely thereafter. An industrious craftsman of sound technique with a steady flow of commissions, he never varied his prices throughout his career. His account books show him consistently charging ten guineas for a horse portrait, twenty guineas for a horse and mount, and one hundred guineas or more for large hunting pictures, depending on the numbers depicted. His clients included seven dukes and numerous members of the

aristocracy; Lord Cardigan was one of his principal patrons. In 1809 Ferneley married Sarah Kettle. The couple had seven children, two of them, John and Claude Lorraine, later following their father's profession. Ferneley's wife died in 1836, and in 1844 he married Ann Allan, by whom he had another son. He died at Melton Mowbray on 3 June 1860.

Ferneley was a prolific painter who specialized in posed portraits of horses and of immaculately dressed sportsmen on their mounts (often in groups) in which he achieved excellent likenesses, large group portraits of an entire hunt, such as *The Quorn at Quenby* (1823; Sir James Graham, Bt., Norton Conyers, Yorkshire), and hunting scenes, especially hunts in full cry, all painted with assurance and ease. The last-named pictures, known as *scurries*, a genre that can be traced back to watercolors by Rowlandson and Samuel Howitt but which Ferneley developed and popularized, were long—up to thirteen feet—narrow paintings, full of keenly observed incident. Ferneley's ten sketches of Count Sandor's hunting exploits in Leicestershire, a series of comic mishaps, were published in aquatint in 1833; fourteen aquatints of racehorses were published between 1828 and 1843. Ferneley also painted coaches, carriages in Hyde Park, prize cattle, dogs, game, sporting meetings in which—unlike James Pollard, the specialist in coaching scenes—he demonstrated a mastery in managing large numbers of figures, conversation pieces, and genre scenes. His sharp observation of detail and of characteristic human and animal behavior, and his feeling for space and atmosphere, were sustained throughout his career.

Sir Francis Grant took lessons from Ferneley in the 1820s but, though a painter of sportsmen and their horses and of hunt group portraits, concentrated largely on conventional portraiture. Ferneley's two painter sons were much less proficient than their father, but his range of sporting subject matter remained the staple of later sporting artists.

Bibliography

Paget, Guy. *The Melton Mowbray of John Ferneley.* Leicester and New York, 1931.
Paget, Guy. "Ben Marshall and John Ferneley." *Apollo* 40 (1944):30–37.
Ellis, Colin D. B. *John Ferneley 1782–1860.* Exh. cat., Leicester Museums and Art Gallery. Leicester, 1960.
Webster, Mary and Lionel Lambourne. *British Sporting Painting 1650–1850.* Exh. cat., Hayward Gallery, London; Leicestershire Museum and Art Gallery, Leicester; Walker Art Gallery, Liverpool. London, 1974:74–79.
Egerton, Judy. *British Sporting and Animal Paintings 1655–1867: The Paul Mellon Collection.* London, 1978:239–251.

1970.17.110 (2482)

Heaton Park Races

1829
Oil on canvas, 92 × 152.6 (36¼ × 60⅛)
Ailsa Mellon Bruce Collection

Technical Notes: The medium-fine canvas is plain woven; it has been lined. The smoothly applied white ground masks the weave of the canvas. The painting is executed in thin, smooth, opaque layers, with low impasto in the highlights. The broad traction crackle in many of the brown pigmented layers suggests the presence of bitumen. The impasto has been slightly flattened during lining, but otherwise the painting is in excellent condition; paint loss or damage is minimal. The moderately thick pigmented natural resin varnish has discolored yellow to a significant degree.

Provenance: Painted for Thomas Grosvenor, 2nd Earl of Wilton [1799–1882], Wilton Castle, Herefordshire, and Heaton Hall, Lancashire; by descent to Elizabeth, Countess of Wilton [d. 1919] (sale, Sotheby & Co., London, 16 May 1928, no. 155, as *A Country Race Meeting*, repro.), bought by (M. Knoedler & Co.), London, from whom it was purchased July 1928 by David K. E. Bruce, New York. Hamilton Bruce, Baltimore, by 1944.[1] Ailsa Mellon Bruce, New York [d. 1969.]

THIS PICTURE is one of Ferneley's most elaborate works. The scene is the annual race meeting at Heaton Park, near Manchester. A number of horses, with their jockeys up, are seen in the paddock, which is surrounded by spectators and their carriages; many of the figures are evidently portraits. Captain John White, who won five races at the meeting in 1829, is portrayed in the foreground on the right, mounted on his dark bay racehorse, Euxton, with his trainer leading the horse onto the course.[2] A marquee is seen in the distance at the left, and Heaton Hall—then a seat of Thomas, 2nd Earl of Wilton[3]—sketchily but recognizably depicted, stands on an eminence in the distance at the center.

Lord Wilton was the second son of Robert, 1st Marquess of Westminster, and married Mary, daughter of Edward, 12th Earl of Derby; both families were closely connected with the turf. Wilton wrote to Ferneley in August 1829: "We arranged some time ago that you were

John Ferneley, *Heaton Park Races*, 1970.17.110

to come down to Heaton at the time of the Races, to take portraits of several of the people who ride there. The picture is to be the same size as the *last* one painted for Lord Belgrave at Eaton.[4] You ought to be down ten days before the time in order to get in the drawing of the Course and the park. . . . Perhaps you could come down *before* the 8th when we might fix upon the spot from whence the picture is to be taken—and you might begin it *then*."[5]

A picture of Heaton Park races is listed in Ferneley's account books under the date of 1829.[6] The price was 120 guineas. The costumes, notably the wide-brimmed hats worn by the ladies, corroborate a date in the second half of the 1820s.

Characteristic of Ferneley's work, the groups of figures and horses are naturally and rhythmically composed. Scenes of such well managed complexity are rare in British sporting art.

Notes

1. Paget 1944 (see biography): 36, fig. xvi, where the cap-

tion describes it as in Hamilton Bruce's possession.

2. Egerton 1978 (see biography), 243. Ferneley painted a separate portrait of Euxton with John White up at the 1829 meeting (Mellon collection; Egerton 1978, 242–244, no. 264, color repro.).

3. Heaton Hall was built by James Wyatt in 1772 for Thomas' grandfather, Sir Thomas Egerton, created 1st Earl of Wilton in 1801.

4. *The Cheshire Hunt*, containing portraits of the noblemen and gentlemen of Cheshire, still in the family possession, is listed in Ferneley's account books under the date of October 1828 (Paget 1931 [see biography], 136). Richard, Viscount Belgrave (1795–1869), later 2nd Marquess of Westminster, was Lord Wilton's elder brother.

5. Letter, 18 August [1829] (Paget 1931 [see biography], 72).

6. "Earl Willton [sic] Sept. 1829 Picture of Heaton Park Races with Portrait 12600" (Paget 1931 [see biography], 138).

References

1931 Paget 1931 (see biography): 71, 72, 138, repro. opp. 70.
1976 Walker 1976: no. 597, color repro.
1978 Egerton 1978 (see biography): 243.

Henry Fuseli

1741 – 1825

FUSELI was born in Zürich on 6 February 1741, the second son of the five children of Johann Caspar Füssli, town clerk, portrait painter, and writer on art, and Elisabetha Waser. His godfather was the landscape painter and theorist Salomon Gessner. Although educated as a theologian and ordained as a Zwinglian minister in 1761, Fuseli pursued a wide range of humanist studies, developing an enthusiasm for classical philology under the influence of Johann Jakob Breitinger, and becoming proficient in English, French, and Italian. He was introduced by Johann Jakob Bodmer, the mentor whom he most revered, to Homer, the *Nibelungenlied*, Dante, Shakespeare, and Milton, later the principal sources of his art, and met as fellow students intellectuals such as Felix Hess, Johann Kaspar Lavater, and Johann Heinrich Pestalozzi. His associations with the Sturm und Drang movement were close. Forced, with Lavater, to leave Zürich in 1763 after publishing a pamphlet critical of the administration, he traveled in Germany, England, and France, embarking on a literary career. He produced an English translation of Winckelmann's *Reflections on the Painting and Sculpture of the Greeks* (1765), was deeply impressed by David Garrick's new expressive interpretations of Shakespeare, and met Rousseau in Paris and published *Remarks on the Writings and Conduct of J. J. Rousseau* (1767).

Encouraged by Reynolds in 1768 to become a painter, Fuseli traveled to Italy in 1770 in the company of John Armstrong (author of *The Art of Preserving the Health*, 1744—advice that Fuseli took), remaining there until 1778. Strongly opposed to Mengs and the fashionable artistic circles in Rome, he sought inspiration from classical sculpture, Michelangelo, and mannerist art, and, befriended by the Swedish sculptor Johan Tobias Sergel, became the leading spirit of a group of innovative young artists. Goethe wrote in 1775: "What fire and fury the man has in him!"[1] Returning to London in 1780 Fuseli established his reputation with *The Nightmare* (1781; Detroit Institute of Arts). Involved from the outset in 1786 with John Boydell's scheme for employing the most talented artists of the day on a Shakespeare Gallery, he devoted most of his time to paintings of Shakespearean

themes until the opening of the gallery in 1789. In emulation of this project, and supported by William Roscoe and the bookseller Joseph Johnson, he executed during the 1790s forty-seven paintings for a Milton Gallery in which the work was entirely his. Although many of these works were bought by his principal patron, Thomas Coutts, the exhibitions in 1799 and 1800 were not a public success.

Fuseli was elected an Associate of the Royal Academy of Arts in 1788, a full Academician in 1790, and professor of painting in 1799; he was obliged to relinquish the latter post after his election as keeper in 1804, the year in which Benjamin Robert Haydon became his pupil, but the statutes were altered to allow him to resume it in 1810. Popular with his students, he followed the tenets of Platonic and academic theory, preaching the superiority of genius to talent (which "arranges, cultivates, polishes, the discoveries of genius"[2]), of expression to beauty, and of drawing to color. "The aim of the epic painter is to impress one general idea," he wrote.[3] Like Constable he was deeply critical of what he saw at the annual exhibitions of the Royal Academy, the "present torrent of affectation and insipidity."[4] His historical approach to art was demonstrated in his revised edition of Matthew Pilkington's *Dictionary* (1805/1807).

Fuseli's relationships with and attitude to women were highly important for his art. His most passionate love was for Anna Landolt, a niece of Lavater, whom he met in Zürich in 1778; but her father refused his suit. He married in 1788 Sophia Rawlins, an attractive young model obsessed with hair and fashion, who was socially and intellectually his inferior; there were no children, but she appears to have satisfied her husband's fetishistic and other desires. Mary Wollstonecraft's passion for him in 1792 was firmly put down by Mrs. Fuseli. Timid, shy in unfamiliar society, and only five feet tall, Fuseli compensated with a Wagnerian frenzy and extravagance of manner, and with unpredictable violence; nonetheless, he was affectionate and kind to his friends. Methodical in his habits and frugal in his regime, he retained an exceptional vigor until extreme old age. He died suddenly on 16 April 1825, at the home on Putney Hill of

Coutts' daughter, Lady Guilford, and was buried in St. Paul's Cathedral.

Fuseli was neither a fluent painter nor an instinctive colorist, and he was well aware of his own shortcomings: "I see the vision of all I paint—and I wish to heaven I could paint up to what I see."[5] The bulk of his output was in the more spontaneous medium of drawing, and he intended his art to appeal largely to a select inner circle. From the start he was obsessed by dramatic, violent, macabre, and supernatural subject matter and adopted mannerist principles of design and techniques of drawing, reveling in mannerist complexities of space, contrasts in scale and chiaroscuro, and exaggerated foreshortening, poses, gestures, and anatomy. One of the most learned artists of his day, he had at his disposal an immense range of sources which he used with startling originality.

Fuseli upheld the academic theory of the sister relationship between literature and painting; for him the choice of subject was of primary importance. The visual embodiment of his ideas was always compelling if often strained. He devised striking compositional patterns, chiaroscuro, and attitudes, but employed symbolic gestures and generalized expression. His principal figures are clearly outlined against horizon or background; men may be shown almost nude, women in clinging garments. His work in the 1790s, when he was absorbed by the Milton gallery, became increasingly wild and demonic, and he more frequently pursued perverse and erotic subjects. After 1800 his range of thematic material widened still further to embrace subjects from Homer and the *Nibelungenlied*, William Cowper and Christoph Martin Wieland, while his eroticism became more pronounced and his style yet more nebulous, mysterious, and exaggerated.

Fuseli's personality, range of subject matter, and expressive style made a deep impact on the artists with whom he associated in Rome in the 1770s: Thomas Banks, John Brown, Prince Hoare, James Jefferys, George Romney, Alexander Runciman, and the Scandinavians Nicolai Abraham Abildgaard and Sergel. He was revered by Blake and strongly influenced James Gillray and William Etty. Lawrence, who was a warm admirer and imitated him closely in his historical pictures, bought twenty-one of his paintings and acquired all his drawings after his death. Theodor von Holst imitated his drawing style. Later in the century Fuseli was a strong influence on the development of European expressionism, particularly that of Munch.

Notes
1. Goethe to Johann Gottfried von Herder, 25 March 1775 (quoted by Schiff 1975, 40).
2. Knowles 1831, 3:63.
3. Knowles 1831, 2:157.
4. Knowles 1831, 3:57.
5. Fuseli to a student (quoted by Allan Cunningham, *The lives of the most eminent British painters, sculptors, and architects*, 2d ed., 6 vols. [London, 1829–1833], 2:331).

Bibliography
Knowles, John. *The Life and Writings of Henry Fuseli.* 3 vols. London, 1831.
Powell, Nicolas. *The Drawings of Henry Fuseli.* London, 1951.
Antal, Frederick. *Fuseli Studies.* London, 1956.
Tomory, Peter. *The Life and Art of Henry Fuseli.* London, 1972.
Schiff, Gert. *Johann Heinrich Füssli 1741–1825.* 2 vols. Zürich, 1973.
Schiff, Gert. *Henry Fuseli 1741–1825.* Exh. cat., Kunsthalle, Hamburg; Tate Gallery, London; Petit Palais, Paris. London, 1975.
Pressly, Nancy L. *The Fuseli Circle in Rome.* Exh. cat., Yale Center for British Art. New Haven, 1979.

1983.1.41 (2916)

Oedipus Cursing His Son, Polynices

1786
Oil on canvas, 149.8 × 165.4 (59 × 65⅛)
Paul Mellon Collection

Technical Notes: The medium-weight canvas is loosely plain woven; it has been lined. The thinly and smoothly applied white ground almost masks the weave of the canvas. The painting is executed in a variety of techniques. The figures are modeled in opaque paint ranging from thin to moderately thick (it is thickest in the figure of Polynices), with thin brown glazes in the surface layer and slight impasto in the highlights; there are layers of light gray underpainting beneath the flesh tones, and in the case of Polynices and Antigone the contours of the hands are defined by thin red glazes. The background is partly executed in thin brown glazes; where the paint is thicker, notably in the lower right quadrant, there is pronounced traction crackle which suggests the presence of bitumen. The canvas has been damaged by two major tears on the left and by smaller tears in the lower half of the picture, all of which have been restored. The brown glazes, in the figures as well as in the background, have been severely abraded. The fairly thin natural resin varnish has not discolored.

Provenance: Sold by the artist to William Roscoe, October 1791 (sale, Liverpool, 28 September 1816, no. 154, as *Oedipus*

Fig. 1. Henry Fuseli, *Oedipus Cursing Polynices*, 1777, pen and brown ink with gray and brown wash, Stockholm, Nationalmuseum [photo: Statens Konstmuseen]

Fig. 2. Henry Fuseli, *Oedipus Cursing Polynices*, f. 68 verso from the Roman Album, 1777–1778, pen and brown ink with gray and gray-black wash over pencil, London, British Museum

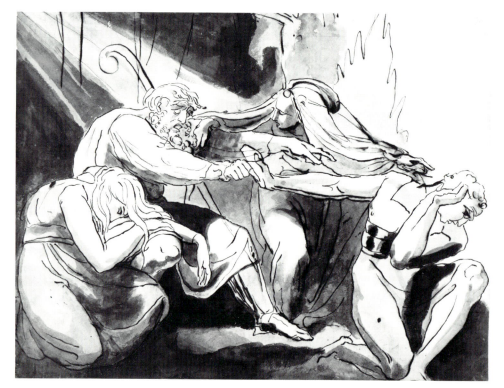

Henry Fuseli, *Oedipus Cursing His Son, Polynices*, 1983.1.41

Fig. 3. Henry Fuseli, *Oedipus Cursing Polynices*, f. 7 verso from the Roman Album, 1777–1778, pen and brown ink with gray wash over pencil, London, British Museum

Fig. 4. Henry Fuseli, *Death of Oedipus*, R.A. 1784, oil on canvas, Walker Art Gallery, Liverpool [photo: John Mills (Photography) Ltd.]

devotes to the Infernal Gods his son Polynices. . .), bought by Baxter.[1] (Maltzahn Gallery and Weiss Antiques), London and Zürich, 1973, from whom it was purchased 1974 by Paul Mellon, Upperville, Virginia.

Exhibitions: Royal Academy of Arts, London, 1786, no. 84.

THE SCENE is taken from Sophocles' *Oedipus at Colonus*, the second of his Theban plays. Oedipus, horrified at the discovery that he has married his own mother, Jocasta, forsakes the throne of Thebes, puts out his eyes, and eventually is banished from the city. Led by his devoted daughter, Antigone, he has come to the sacred grove of Colonus, on the threshold of Athens. His elder son, Polynices, driven from Thebes by his younger brother Eteocles (who has usurped the throne) and now married to the daughter of the king of Argos, has gathered together an army of vengeance but first seeks out Oedipus because the oracles have promised victory to whichever brother he supports. Oedipus is, however, disgusted by both his warring, power-seeking sons, so different in character from his daughters: "Listen, scoundrel!/You held the sceptre and the royal throne/Before your brother seized them, and it was you/That drove your father out of doors. *You* made him/A homeless vagabond." Fuseli has chosen the moment of his curse for the subject of the Washington picture: "Away! You have no father here, vile brute!/And take this malediction in your ears;/May you never defeat your motherland;/May you never return alive to Argos;/May you, in dying, kill your banisher,/And, killing, die by him who shares your blood./This is my prayer."[2]

Polynices is depicted in a vain attempt to shut out the sound of his hot-tempered father's words. Antigone is shown trying to restrain Oedipus, while her elder sister, Ismene, crouches, horrified, in the corner, bent over her father's knee.

Fuseli made several drawings of this subject during his sojourn in Italy, but he only translated his conception into a painting for public exhibition after a long interval.[3] In a vigorous pen and wash drawing now in Stockholm (fig. 1), inscribed as done in Rome in December 1777, the composition has already been adumbrated in its final form, but is looser in structure and arranged in reverse; Oedipus is shown with a shepherd's crook over his left shoulder, and there is a circular temple behind. A similar pen and wash drawing, dating between 1777 and 1778, more evenly lit, is in the Roman Album in the British Museum (fig. 2). A coarser pen and wash drawing in the

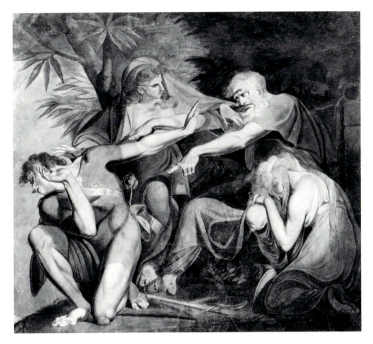

Fig. 5. After Henry Fuseli, *Oedipus Cursing Polynices*, pen and ink and watercolor, London, Victoria and Albert Museum

Fig. 6. After Henry Fuseli, *Oedipus Cursing Polynices*, pencil, Basel, Oeffentliche Kunstsammlung

Roman Album (fig. 3) shows the design in its final state, with Oedipus bearing down more savagely on Polynices, the outstretched arms of the two protagonists thrust out past each other in a more taut, histrionic way, and Antigone in strongly lit profile instead of half in shadow. A

larger watercolor in the Victoria and Albert Museum (fig. 5), which corresponds closely with the final design, and an unfinished pencil sketch for this watercolor in Basel (fig. 6) bear little relation to Fuseli's style.[4]

The choice of so tragic and violent a subject, the compact grouping of the figures on a narrow stage—compressed within the picture frame against a nebulous background without the relief of any view into distance—and the dramatic diagonals of the highlighted interlocking limbs and exaggerated gestures are characteristic of Fuseli's work of the 1780s.

The very slightly larger canvas of the *Death of Oedipus* (fig. 4), which Fuseli exhibited at the Royal Academy in 1784, is similar in style. Both pictures were sold to William Roscoe between 1791 and 1792; Fuseli wrote to him on 28 November 1791: "I think the Oedipus [perhaps the Washington picture] not dear at fifty guineas."[5] Later he wrote: "*make* the price of either or both for me, *yourself*—you know best *what you can give or what you can get*—my object is to enable myself to go on [with the Milton Gallery]."[6]

The Washington picture was rediscovered only in 1973, too late for inclusion in Gert Schiff's catalogue raisonné published that year.

A mezzotint was engraved by John Perry.[7]

Notes

1. Macandrew 1959–1960, 22–23, 35 (appendix 1, no. 6), as whereabouts unknown since the Roscoe sale in 1816.
2. Sophocles, *The Theban Plays*, trans. E. F. Watling (Harmondsworth, 1947), 112–113.
3. The date of exhibition is accepted as the date of the painting by Schiff and Viotto 1977, 88, no. 22; according to a prospectus, in NGA curatorial files, prepared by Maltzahn Gallery before the sale of the picture to Paul Mellon in 1974, Schiff at that time believed the work to date to c. 1776–1778.
4. The heads in the Victoria and Albert Museum watercolor (Schiff 1973, no. 398 as 1777–1780) are slightly lacking in life, there is little sense of chiaroscuro, and the shadows under Polynices' arm are awkwardly drawn; these considerations, and the fact that the watercolor is so highly wrought, suggest that this work, which corresponds so exactly with the finished picture, is not by Fuseli at all, but is a copy of his painting. The draftmanship in the Basel drawing (Schiff 1973, no. 399 as c. 1780) has no point of reference with even the most academic of Fuseli's drawings; a note on this sheet suggests the authorship of William Blake.
5. Macandrew 1959–1960, 23.
6. Macandrew 1959–1960, 21.
7. Date unknown. An unfinished proof is in the Victoria and Albert Museum (no. 18640).

References

1959–1960 Macandrew, Hugh. "Henry Fuseli and William Roscoe." *Liverpool Libraries, Museums and Arts Committee Bulletin* 8 (1959–1960): 21, 22, 23, 35 (appendix 1, no. 6).
1977 Schiff, Gert, and Paola Viotto. *L'opera completa di Füssli*. Milan, 1977: 88, no. 22, repro. 89.

Thomas Gainsborough
1727 – 1788

THOMAS GAINSBOROUGH was born in Sudbury, Suffolk, the youngest of the nine children of John Gainsborough, a prosperous cloth merchant and shroud manufacturer, and his wife, Mary Burrough, the sister of the Reverend Humphry Burrough; he was baptized in Sudbury on 14 May 1727. He attended Sudbury Grammar School, of which Humphry was the master. Of Non-Conformist descent, which encouraged his lifelong independence of mind and disinclination to "wear out a pair of Shoes in seeking after"[1] society patronage, he took to sketching at an early age, and when he was thirteen prevailed upon his father to send him up to London to become an artist. A pupil of the French illustrator and draftsman Hubert Gravelot, Gainsborough was intimately involved with avant-garde rococo art and design, and seems to have assisted Francis Hayman on his genre paintings for the decoration of Vauxhall Gardens.

After a short period on his own in London between about 1744 and 1748, during which he painted small-scale portraits and landscapes in the manner of Jan Wijnants and Jacob van Ruisdael, and married Margaret Burr, "a natural daughter of Henry, Duke of Beaufort, who settled £200 a yr. upon Her,"[2] Gainsborough returned to his native Suffolk. After a few years in Sudbury he moved, in 1752, to the larger seaport town of Ipswich. There is only one, uncorroborated, reference

(to a visit to Flanders in later life) to suggest that he ever traveled abroad, as was customary among his fellow artists.

By 1759, still finding it difficult to make ends meet and now with two daughters to support, he realized he had exhausted the possibilities of local patronage and moved to the fashionable spa town of Bath, where he achieved an instantaneous success. "Business came in so fast" that he was soon able to raise his prices from 8 to 20 guineas for a head and shoulders, and from 15 to 40 guineas for a half-length portrait; his charge for a full length, which he was now tackling for the first time, as there had been no demand for them in Suffolk, was 60 guineas. By the beginning of the 1770s he felt sufficiently established to raise his scale of fees to 30, 60, and 100 guineas respectively. He did not increase it again until 1787, this time to 40, 80, and 160 guineas, close to Reynolds' scale.

Unlike Reynolds, a man of reason, calculation, and evenness of temper, Gainsborough was an intuitive genius, a person of impulse and feeling without intellectual pretensions, fonder of landscape than of portraiture, and irregular in his application. He moved in musical and bohemian circles, and was a friend of the Linleys, C. F. Abel, and J. C. Bach. Also unlike Reynolds, he was a brilliant draftsman, the equal of any of his great European contemporaries, a master technician who loved the manipulation of oil paint, and a letter writer of wit and spontaneity. Garrick is reported to have said that "his cranium is so crammed with genius of every kind that it is in danger of bursting upon you, like a steam-engine overcharged."[3] "He had two faces," his daughter told Farington, "His studious & Domestic & His Convivial one;"[4] Gainsborough was modest and gentlemanly as well as intemperate, and Farington noted that he "maintained an importance with his sitters, such as neither Beechy [sic] or Hoppner can preserve."[5] Set back by a nervous illness in 1763, he later became a founding member of the Royal Academy of Arts, contributing to its first exhibition a scintillating female full-length portrait in the manner of Van Dyck. Unlike many of his contemporaries, Gainsborough—working fluently and directly, for the most part without the assistance of prepatory drawings—customarily painted his portraits entirely with his own hand; his only known assistant was his nephew, Gainsborough Dupont (q.v.), who was apprenticed to him in 1772.

In 1774 Gainsborough moved to London, where he settled in a wing of Schomberg House, Pall Mall. In 1777 he received the first of many commissions from the royal family (to whom Reynolds was antipathetic), and exhibited his glamorous full length of Mrs. Graham in Van Dyck dress (National Gallery of Scotland) and *The Watering Place* (National Gallery, London), which Horace Walpole acclaimed as "by far the finest Landscape ever painted in England, & equal to the great Masters."[6] In 1780 he exhibited a wide range of landscape compositions, and in 1783 made a tour of the Lake District in search of picturesque scenery. An original printmaker, he experimented in these years with soft-ground etching and aquatint; influenced by Philippe-Jacques de Loutherbourg's popular entertainment, the Eidophusikon, he also constructed a peep-show box in which transparencies were seen magnified and lit by candles from behind, producing a dramatic and colorful effect. After quarreling with the Royal Academy about the hanging of his pictures (he rarely participated in Academy affairs), from 1784 onward Gainsborough arranged annual exhibitions in his studio. He was by then comparatively well off. He died of cancer in London on 2 August 1788.

Both in portraiture and in landscape Gainsborough's art developed steadily. In the former, likeness was always his first consideration, "the principal beauty & intention of a Portrait."[7] Characteristic postures, glances, and movements contributed to this effect, as did Gainsborough's impressionistic handling and brilliant rendering of costume, notably the silks and satins of ladies' dresses. His most captivating portraits are of his family and close friends, of attractive girls of both the nobility and the demimonde, and of older women of character. Much of his earliest work was small-scale portraiture with landscape (though never interior) settings in the tradition of Arthur Devis, but of Devis raised to an infinitely higher level of accomplishment. Van Dyck was the principal influence on his mature style. In the 1780s, following his Watteauesque painting of *The Mall* (Frick Collection, New York), he developed what was recognized at the time as an original contribution to British portraiture, enveloping his sitters in their landscape setting so that they seemed to live and breathe in a romantic world of the artist's creation.

Gainsborough's landscapes followed a similar progression. At first imitative of the Dutch naturalist mas-

ters, he devised at Ipswich an artificial style that was a combination of the Dutch and of rococo rhythm and imagery, with an exquisite feeling for light and atmosphere. At Bath, where, as in portraiture, his most important work was on a larger scale, Gainsborough came strongly under the influence of the compositions of Claude, the chiaroscuro of Ruisdael, and the rhythmic energy, drama, and richness of effect of Rubens. Gradually he began to infuse his landscapes with sentiment, with a nostalgic feeling for the English countryside, notably in his "cottage door" compositions, of which the noblest is in the Huntington Art Gallery, San Marino. From these it was but a step to his fancy pictures, those affecting studies of beggar children that were his most popular works of the 1780s; Gainsborough eschewed history painting, which he considered as "out of his way,"[8] and inventions such as *The Woodman* (destroyed), an embodiment of honest labor, were his personal answer to the challenge of the Great Style.

Gainsborough's portrait style was too personal to be influential and, when the first retrospective of his work was held, at the British Institution in 1814, only fourteen of his portraits were included as against forty-five landscapes and almost all the fancy pictures. The tender quality of his landscapes profoundly affected Constable and, through him, had some influence on the nineteenth-century pastoral tradition. When Gainsborough's popularity revived in the later nineteenth century, it was through the medium of his most glamorous portraits; Gainsborough was one of the principal stars in Duveen's firmament. More recently, Gainsborough has been admired chiefly for the beauty of his handling of paint and for the brilliance and assurance of his many drawings of imaginary landscapes.

Notes

1. Gainsborough to the Hon. Constantine Phipps (later the 2nd Lord Mulgrave), 13 February 1772.
2. Farington *Diary*, 4:1152 (5 February 1799).
3. Ephraim Hardcastle [W. H. Pyne], *Wine and Walnuts*, 2 vols. (London, 1824), 2:215.
4. Farington *Diary*, 4:1152 (5 February 1799).
5. Farington *Diary*, 4:1130 (6 January 1799).
6. Annotation in his Royal Academy catalogue for 1777 (Lord Rosebery collection).
7. Gainsborough to William, 2nd Earl of Dartmouth, 13 April 1771 (Woodall 1963, 51).
8. Gainsborough to Philip Royston (later 2nd Earl of Hardwicke), c. 1764 (Woodall 1963, 42).

Bibliography

Whitley, William T. *Thomas Gainsborough*. London, 1915.
Waterhouse, Sir Ellis. *Gainsborough*. London, 1958.
Woodall, Mary. *The Letters of Thomas Gainsborough*. 2d rev. ed. London, 1963.
Hayes, John. *The Drawings of Thomas Gainsborough*. 2 vols. London and New Haven, 1970 and 1971.
Hayes, John. *Gainsborough: Paintings and Drawings*. London, 1975.
Hayes, John. *The Landscape Paintings of Thomas Gainsborough*. 2 vols. London and New York, 1982.

1961.2.1 (1602)

Master John Heathcote

c. 1771/1772
Oil on canvas, 127 × 101.2 (50 × 39⅞)
Given in memory of Governor Alvan T. Fuller by the Fuller Foundation, Inc.

Technical Notes: The medium-weight canvas is plain woven; it has been lined. The ground is white, thinly applied. There is a very thin pinkish-brown imprimatura that serves as the middle tone in the costume and hair and provides a vibrant contrast in the sky. The painting is executed fairly thinly with opaque paints freely blended wet into wet; this is followed, in the flesh tones, by glazes of red and by a very fine, distinct application of the details of the features, and, in the landscape, by slashing distinct highlights. There is limited impasto in such details as the bouquet of flowers. The painting is in good condition apart from slight abrasion; retouching is minimal. The moderately thick natural resin varnish, lightly pigmented with black, has not discolored.

Provenance: Painted for the sitter's parents, John [d. 1795] and Lydia [d. 1822] Heathcote, Conington Castle, Huntingdonshire; by descent to their great-grandson, John Moyer Heathcote [1834–1912]; purchased 1913 from his estate by (Thos. Agnew & Sons), London, who sold it the same year to (Duveen Brothers), London, who sold it c. 1913 to Herbert, 1st Baron Michelham [1851–1919], Hellingly, Sussex (sale, Hampton & Sons, on the premises, 20 Arlington Street, London, 23–24 November 1926, 2nd day, no. 292, repro.), bought by (Captain Jefferson Davis Cohn), Paris,[1] on behalf of (Duveen Brothers), London, who sold it March or April 1927 to Alvan T. Fuller [1878–1958], Boston.[2] The Fuller Foundation, Boston.

Exhibitions: *Pictures by Italian, Spanish, Flemish, Dutch, French, and English Masters*, British Institution, London, 1864, no. 184. *Paintings Loaned by Governor Alvan T. Fuller*, Art Club, Boston, 1928, no. 6. *Paintings Drawings Prints from Private Collections in New England*, Museum of Fine Arts, Boston, 1939, no. 48, pl. 26. *A Memorial Exhibition of the Collection of the Honorable Alvan T. Fuller*, Museum of Fine Arts, Boston, 1959, no. 22, repro.

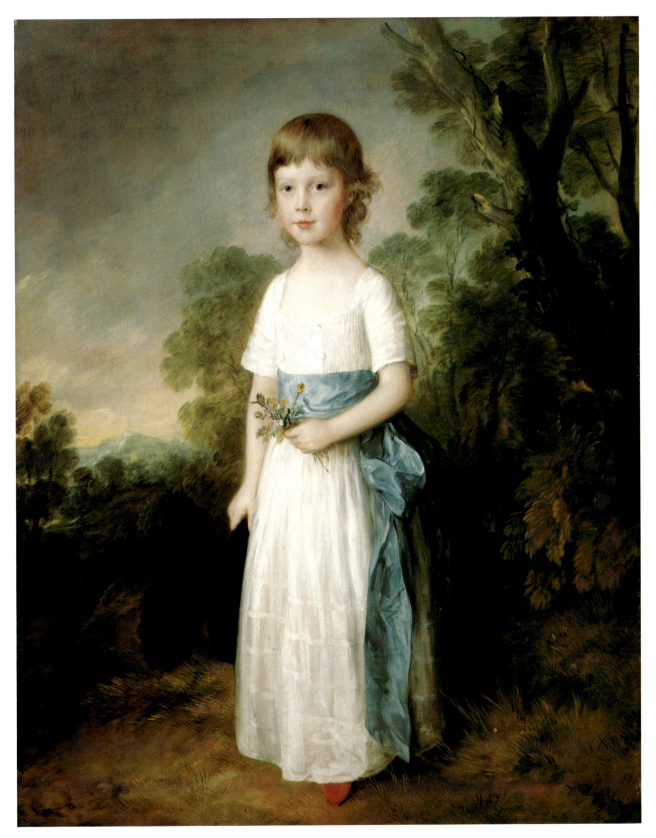

Thomas Gainsborough, *Master John Heathcote*, 1961.2.1

JOHN HEATHCOTE (1767–1838), M.P. for Ripon, was the great-grandson of Sir Gilbert Heathcote, one of the founders of the Bank of England and reputedly the richest commoner in England, who had bought Conington Castle, which became the family seat. John resided at the castle after his marriage in 1799 to Marie Anne Thornhill of Diddington.

The traditional account of the circumstances of the painting, which was evidently executed when John was about four or five years old, was first recorded in the mid-nineteenth century: "Gainsborough chanced to be on a visit to Bath when a destructive sickness was raging in different parts of the kingdom. The parents of Master Heathcote having lost their other children by the epidemic, were anxious to secure a portrait of the one yet spared to them. They applied to Gainsborough, who, however, refused, saying that he had visited Bath for the purpose of recreation; but, on hearing the circumstances of the case, he requested Mrs. Heathcote to let him see her son. The next morning, the boy, dressed in a plain white muslin frock with blue sash, was taken to Gainsborough. 'You have brought him simply dressed,' he said—'had you paraded him in a fancy costume, I would not have painted him; now I will gladly comply with your request.' "[3] There is no reason to discount this tradition, except for the circumstance that Gainsborough was still resident in Bath at the time (he moved to London in 1774).

In spite of the fact that it was only recently that he had painted, as a tour de force, Jonathan Buttall in Van Dyck costume (*The Blue Boy*, Huntington Art Gallery, San Marino, exhibited at the Royal Academy in 1770), Gainsborough normally preferred to paint his sitters in contemporary dress, which seemed to him a prerequisite for attaining likeness. Long frocks of the kind worn by John Heathcote were customary apparel in the eighteenth century for boys up to the age of about five; an identical frock was worn by Robert Charlton for the double portrait (also early 1770s; Virginia Museum of Fine Arts, Richmond) Gainsborough painted of him with his elder sister, Susannah, who is wearing a similar dress.

The pose is suitably simple, and the figure centrally placed. The head of the young boy is softly and delicately painted; the arms and dress are more fluently handled, while the bunch of wild flowers is brilliantly impressionistic. The elaborate landscape background, which effectively frames and sets off the figure, is unusually detailed if equally impressionistic in touch, and is exactly comparable with such Gainsborough landscapes of the early

1770s as the pastoral scene with distant mountains at the Yale Center for British Art.[4]

Notes

1. The Provenance Index, J. Paul Getty Trust, Santa Monica, California, records Cohn as the buyer at the Michelham sale. See also Colin Simpson, *The Partnership: The Secret Association of Bernard Berenson and Joseph Duveen* (London, 1987), 179–180, for an account of Cohn's part in the sale.

2. An undated note in the NGA curatorial files records a telephone conversation between Ross Watson and Peter Fuller, son of Alvan T. Fuller, who said that his father purchased this painting in England, probably at Thos. Agnew & Sons in July 1927. However, Sir Geoffrey Agnew, in *Agnew's 1817–1967* (London, 1967), 49, acknowledging that Governor Fuller of Boston was a faithful Agnew's client and that the firm acted on his behalf at many auctions, stated that the only picture he ever bought from Duveen was the Gainsborough that Agnew's had failed to buy for him at the Michelham sale.

3. Fulcher 1856, 228.

4. Hayes 1982 (see biography), 2: no. 108, repro.

References

1856 Fulcher, George Williams. *Life of Thomas Gainsborough, R.A.* 2d rev. ed. London, 1856:228.

1898 Armstrong, Sir Walter. *Gainsborough & His Place in English Art*. London, 1898:197; popular ed., London, 1904:269.

1951 Taylor, Basil. *Gainsborough*. London, 1951:22, pl. 10.

1958 Waterhouse 1958 (see biography): no. 358, pl. 148.

1968 Cooke, Hereward Lester. *Painting Lessons from the Great Masters*. London, 1968:208, repro. (two details), color repro. opposite.

1976 Walker 1976: no. 495, color repro.

1942.9.21 (617)

The Hon. Mrs. Thomas Graham

c. 1775/1777
Oil on canvas, 89.5 × 69 (35¼ × 27⅛)
Widener Collection

Technical Notes: The lightweight canvas is plain woven; it has been lined. An x-radiograph reveals cusping along the bottom edge, evidence that the painting has not been cut down. The ground, presently whitish brown possibly due to absorption of darkened media, may originally have been pure white and is exceptionally thin. The painting is executed in thin, translucent layers with more opaque paint in the lights of the flesh tones and sky and some areas of the foliage; thin layers of media-rich glazes have been applied in the costume and foliage. An area of original paint at the extreme bottom edge, which has been protected from the damaging effects of light by the rabbet of the frame, indicates that a rich deep red glaze was originally

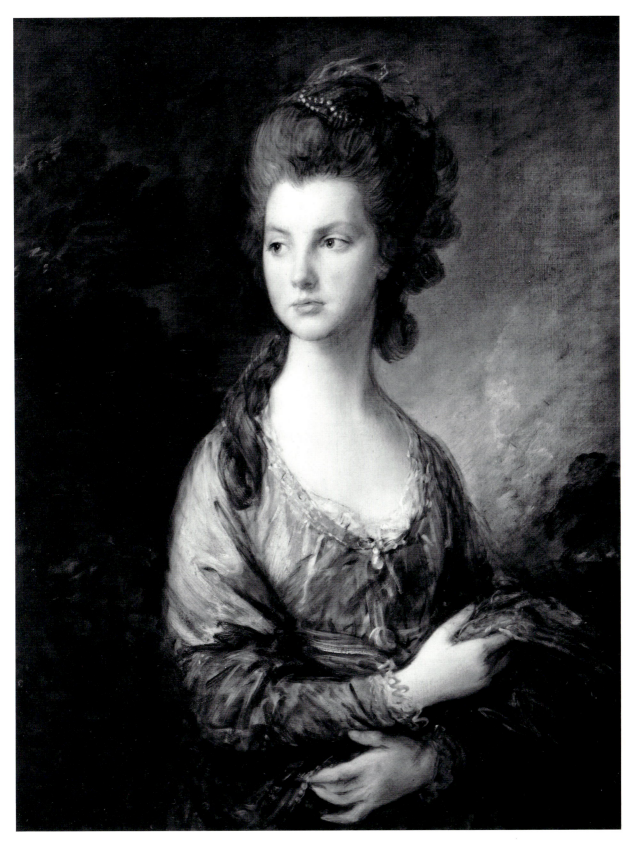

Thomas Gainsborough, *The Hon. Mrs. Thomas Graham*, 1942.9.21

employed in the drapery and has faded considerably; the red glaze was probably used in the flesh tones as well. There are moderate retouchings in the face and neck, perhaps as a result of abrasion damage. The natural resin varnish has discolored yellow to a considerable degree.

Provenance: Painted for the sitter's husband, Thomas Graham, later 1st Baron Lynedoch [1748–1843], Balgowan, Perthshire; by descent to his second cousin Robert Graham, 2nd Baron Lynedoch [d. 1859], who bequeathed it to his nephew, James Maxtone Graham [1819–1901]; by descent to his son, Anthony G. Maxtone Graham [1854–1930], Redgorton, Perthshire. (P. & D. Colnaghi & Co.), London, by 1909;[1] acquired the same year by (M. Knoedler & Co.), London, from whom it was purchased 21 March 1910 by Peter A. B. Widener, Elkins Park, Pennsylvania.[2] Inheritance from the Estate of Peter A. B. Widener by gift through power of appointment of Joseph E. Widener, Elkins Park.

Fig. 1. Thomas Gainsborough, *The Hon. Mrs. Thomas Graham*, R.A. 1777, oil on canvas, Edinburgh, National Gallery of Scotland [photo: Annan, copyright National Galleries of Scotland]

Exhibitions: *Pictures by Italian, Spanish, Flemish, Dutch, French and English Masters*, British Institution, London, 1860, no. 182. *National Portraits*, South Kensington Museum, London, 1867, no. 463. Recorded as Burlington Fine Arts Club, London, 1906 (if so, ex-cat.). *Works by the Old Masters and Deceased Masters of the British School*, Winter Exhibition, Royal Academy of Arts, London, 1907, no. 112. *Cent Portraits de Femmes*, Salle du Jeu de Paume, Paris, 1909, no. 5. *Old Masters*, M. Knoedler & Co., New York, 1912, no. 11. *Paintings by Thomas Gainsborough, R.A. and J. M. W. Turner, R.A.*, M. Knoedler & Co., New York, 1914, no. 12. *The Four Georges*, Sir Philip Sassoon's, 45 Park Lane, London, 1931, no. 52 (illustrated souvenir, repro. 7).

MARY SCHAW (1757–1792), second daughter of Charles, 9th Baron Cathcart, married Thomas Graham, a progressive farmer and fine sportsman, on 26 December 1774, the same day that her elder sister married the Duke of Atholl. Though a great beauty, her health was poor, and in 1780 the young couple traveled south, living for some years in Spain and Portugal; she died during a second visit to the Continent in search of health, in July 1792. Her husband, inconsolable, sought distraction in active service abroad; a gallant and resourceful soldier, he was later one of Wellington's generals and was rewarded with a peerage in 1814.

Gainsborough had a portrait of Mrs. Graham in hand in June 1775, six months after her wedding.[3] From his reported remark that he had "no thoughts of finishing it within the twelve month" but that he intended it to be "the compleatest of pictures,"[4] it is evident that this was the magnificent full-length portrait in Van Dyck dress now in the National Gallery of Scotland, Edinburgh (fig. 1), which was exhibited at the Royal Academy in 1777. The Washington portrait is a half length in the same pose, but Mrs. Graham wears informal contemporary dress with her hair falling in a fashionable plaited ringlet over her right shoulder and with her arms differently arranged. Judging by the age of the sitter, this portrait must be of a similar date to the Edinburgh picture, and was probably executed from the same sittings. Roberts described it as a study or sketch for the Edinburgh full-length version,[5] but there is no justification for this view, since it is equally highly finished. The costume was originally a deep red, but the fugitive red lake pigment employed has faded. Suspicions that the painting has been cut down are unfounded (see the technical notes). Waterhouse published it as "probably 1775: a little earlier than" the Edinburgh picture.[6] Not being able to bear the sight of either painting after his wife's death, Graham entrusted

them in about 1793 to a repository in Edinburgh, where they remained until his death in 1843.

A sketchier version of the Washington picture is in the collection of the Earl of Mansfield at Scone Palace, Perth.[7] A poor copy by Alexander Leggett was last recorded in the R. M. Graham sale, Sotheby's, London, 11 April 1979, lot 108. Other copies are extant.

The close similarity in the features and pose of the head and neck between Gainsborough's unfinished full-length picture in the Tate Gallery of a housemaid sweeping out a doorway[8] (fig. 2) and the portraits of Mrs. Graham have prompted the tradition that Mrs. Graham was the model for this fancy composition. The latter was painted a number of years later, and the head probably represents Gainsborough's concept of ideal beauty; the resemblance (created from memory) is probably not accidental.

A mezzotint by Charles Tomkins was published in 1868.[9]

Notes

1. The Provenance Index, J. Paul Getty Trust, Santa Monica, California, confirmed Colnaghi's ownership through Knoedler's records. The picture is reproduced in J. B. S. [James Byam Shaw] *Colnaghi's 1760–1960* (London, 1960), pl. 51.
2. Notes on Widener's purchases, recorded between 1929 and 1942 by Joseph Widener's secretary, Edith A. Standen, are in NGA curatorial files.
3. Mrs. Neale to Mrs. Graham, June 1775, in E. Maxtone Graham, *The Beautiful Mrs. Graham* (London, 1927), 57.
4. Maxtone Graham 1927, 57.
5. Roberts 1915, unpaginated.
6. Waterhouse 1958 (see biography), 322.
7. Not listed in Waterhouse 1958; possibly this was the "good and exact copy" Lord Mansfield intended to have made of the Washington portrait (letter to Thomas Graham, c. 1793, in Maxtone Graham 1927, 306). David, 2nd Earl of Mansfield, married Mary's sister, Louisa.
8. Waterhouse 1958 (see biography), no. 811.
9. Graves c. 1880, no. 64.

References

c. 1880 Graves, Henry, & Company. *Engravings from the Works of Thomas Gainsborough, R.A.* London, c. 1880: no. 64 (mezzotint by Charles Tomkins, published 1868).

1898 Armstrong, Sir Walter. *Gainsborough & His Place in English Art.* London, 1898:196; popular ed., London, 1904:268.

1915 Roberts 1915: unpaginated, repro.

1939 Tietze, Hans. *Masterpieces of European Painting in America.* London, 1939:324, repro. 223.

1958 Waterhouse 1958 (see biography): no. 322.

1976 Walker 1976: no. 499, color repro.

Fig. 2. Thomas Gainsborough, detail of *The Housemaid*, mid 1780s, oil on canvas, London, Tate Gallery

1942.9.20 (616)

Mrs. Paul Cobb Methuen

c. 1776/1777
Oil on canvas, 84 × 71 (33⅛ × 28)
Widener Collection

Technical Notes: The very fine, tightly plain-woven canvas was originally rectangular in format but was cut down to an oval size at a later date. Subsequently the painting was enlarged again, once more to a rectangular format, by means of lining onto a rectangular auxiliary canvas. Because the oval composition was slightly below the center point of this new rectangular format, the painting was later cut down along the bottom edge, and perhaps relined. The ground of the original canvas is white, thinly applied; a thicker white ground was applied to the added canvas, masking the weave. The original painting was executed thinly and fluidly with slight impasto in the highlights of the pearls and dress. The paint surface has been abraded overall, severely in the feathers, and the impasto has been flattened slightly during lining; there are no major losses. The thick natural resin varnish has discolored yellow to a considerable degree.

Fig. 1. Thomas Gainsborough, *Paul Cobb Methuen*, 1776, oil on canvas, Corsham Court, Lord Methuen [photo: A.C. Cooper]

Fig. 2. William Hoare, *Mrs. Paul Cobb Methuen*, 1776, oil on canvas, Corsham Court, Lord Methuen [photo: Courtauld Institute of Art]

Provenance: Probably intended for the sitter's husband, Paul Cobb Methuen [1752–1816], Corsham Court, Wiltshire, but possibly neither finished nor delivered. (Possibly Mrs. Gainsborough sale, James Christie, London, 10–11 April 1797, 1st day, no. 12[1]), bought by Caleb Whitefoord [1734–1810]. Paul, 3rd Baron Methuen [1845–1932], from whom it was purchased c. 1893 by (Wallis & Son), London, who sold it 1893 to P. A. B. Widener, Elkins Park, Pennsylvania. Inheritance from the Estate of Peter A. B. Widener by gift through power of appointment of Joseph E. Widener, Elkins Park.

MATILDA GOOCH (1752–1826), elder daughter of Sir Thomas Gooch, Bt., of Benacre Hall, Suffolk, married Paul Cobb Methuen on 20 April 1776. Their eldest son was created Baron Methuen in 1838. Matilda was also painted by William Hoare[2] and by Romney; a miniature by W. Allison, signed and dated 1825, is at Corsham Court.

Waterhouse has suggested[3] that this was probably a marriage portrait, companion to the three-quarter length of Matilda's husband in Van Dyck dress at Corsham Court (fig. 1),[4] and thus perhaps was cut down from fifty by forty inches, the size of that canvas. Since the Washington picture was at one time cut down to an oval format,

there is no means of telling whether the present rectangular format corresponds to Gainsborough's original size, though it should be noted that it is not a regular canvas size, and the awkwardness of the torso as it is at present supports Waterhouse's contention. The portrait is not recorded at Corsham Court until the mid-nineteenth century, which lends credence to the view that it was never delivered by Gainsborough. Paul Cobb Methuen did, however, secure a pendant to his own portrait, as Hoare painted a three-quarter length for him which was completed in 1776 (fig. 2); the presumption is that Gainsborough was dilatory, or the patron displeased, and that Methuen turned to a local artist who would oblige him quickly (Hoare worked in nearby Bath).

Part of the sleeve and the feather headdress were added by a later hand when the picture was restored to a rectangular format. The dress embellished with ropes and drops of pearls and the high-dressed hair, not yet sloping diagonally backward from the forehead, with a band of pearls and feathers, are characteristic of the fashion of about 1775 to 1776. The sitter appears to be much the same age as she is in the portrait by Hoare of 1776.

Thomas Gainsborough, *Mrs. Paul Cobb Methuen*, 1942.9.20

Notes

1. Waterhouse 1958 (see biography), no. 483, has suggested that this lot, one of a number of unfinished portraits in the sale, may be identical with the Washington picture, a view that is supported by the evidence of the change in format and the additions noted above and by the absence of documentation in the Corsham archives.

2. A receipt for payment dated 14 October 1776 is in the Corsham archives (Tancred Borenius, *A Catalogue of the Pictures at Corsham Court* [London, 1939], 109).

3. Waterhouse 1958 (see biography), no. 483.

4. For which a receipt dated 1776 is in the Corsham archives.

References

1856 Fulcher, George Williams. *Life of Thomas Gainsborough, R.A.* 2d. rev. ed. London, 1856:229.

1898 Armstrong, Sir Walter. *Gainsborough & His Place in English Art.* London, 1898:199; popular ed., London, 1904:273.

1915 Roberts 1915: unpaginated, repro.

1958 Waterhouse 1958 (see biography): no. 483.

1937.1.100 (100)

Mrs. John Taylor

c. 1778
Oil on canvas, oval, 76 × 64 (29⅞ × 25¼)
Andrew W. Mellon Collection

Fig. 1. Thomas Gainsborough, *John Taylor*, c. 1778, oil on canvas, Boston, Museum of Fine Arts

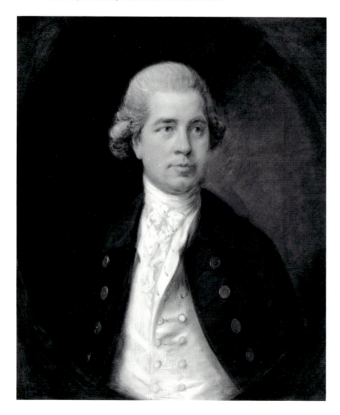

Technical Notes: The canvas is finely plain woven; it has been lined. The ground is white, of moderate thickness. A thinly painted imprimatura serves as a middle tone. The painting is executed thinly and fluidly, with rich translucent layers blended wet into wet in the flesh tones, and the features and details marked with thicker, deftly applied, multicolored strokes; shading is accomplished with diagonal hatching. The impasto has been flattened during lining; there are few paint losses. Traction crackle is evident in the darks. The natural resin varnish has discolored yellow slightly.

Provenance: Painted for the sitter's husband, John Taylor [1738–1814], Bordesley Park and Moseley Hall, Birmingham; by descent to George W. Taylor, Pickenhall Hall, Swaffham, Norfolk, who sold it sometime after 1903 (it was still in his possession when it was exhibited at Birmingham). (Trotti et Cie.), Paris. (M. Knoedler & Co.), from whom it was purchased September 1905 (?)[1] by Andrew W. Mellon, Pittsburgh, by whom deeded December 1934 to The A. W. Mellon Educational and Charitable Trust, Pittsburgh.

Exhibitions: *Loan Collection of Portraits*, City Museum and Art Gallery, Birmingham, 1903, no. 27.

SARAH SKEY (c. 1754/5–1838), daughter of Samuel Skey, of Spring Grove, Bewdley, Worcestershire, married John Taylor, son of one of Birmingham's leading manufacturers and cofounder of Lloyd's Bank, in 1778. John Taylor was high sheriff of Warwickshire in 1786.

The canvas is a companion to an oval of Sarah's husband, now in the Museum of Fine Arts, Boston (fig. 1),[2] and both are probably marriage portraits. The style accords with a date in the second half of the 1770s,[3] as does the dress, although the sitter is wearing her hair loosely and not high piled in the mode then fashionable. The sitter would have been in her early to mid-twenties. The work is loosely handled, and the diaphanous veil that falls over the right shoulder contributes to a lively sense of movement.

Notes

1. The Provenance Index, J. Paul Getty Trust, Santa Monica, California, whose source was M. Knoedler & Co., records Trotti et Cie., Paris, as owning this painting in 1906. The provenance card in NGA curatorial files records the work as having been purchased by Andrew Mellon in 1905. The notebook on Andrew Mellon's acquisitions, also in NGA curatorial files, records the painting as purchased from M. Knoedler & Co., without giving a date.

2. Alexandra R. Murphy, *European Paintings in the Museum of Fine Arts, Boston* (Boston, 1985), 110, repro.

3. The soft modeling of the flesh tones is close in handling to Gainsborough's portrait of Anne, Countess of Radnor, for which the receipt is dated 4 June 1778 (Waterhouse 1958, no. 571, pl. 195).

Thomas Gainsborough, *Mrs. John Taylor*, 1937.1.100

References

1898 Armstrong, Sir Walter. *Gainsborough & His Place in English Art*. London, 1898:203; popular ed., London, 1904:280.

1903 Wallis, Whitworth. *Catalogue of Loan Collection of Portraits*. Birmingham, 1903: nos. 26, 27.

1949 Mellon 1949: no. 100, repro. III.

1958 Waterhouse 1958 (see biography): no. 655.

1976 Walker 1976: no. 508, color repro.

1970.17.121 (2493)

Seashore with Fishermen

c. 1781/1782
Oil on canvas, 101.9 × 127.6 (40⅛ × 50¼)
Ailsa Mellon Bruce Collection

Technical Notes: The medium-coarse canvas is plain woven; it has been lined. The ground is white, probably composed partly of chalk, and smoothly applied. Infrared reflectography shows freely drawn underdrawing in parts of the picture, such as the cliff on the left. The painting is executed in broad brushwork, blended wet into wet, using glazes and scumbles, with slightly impasted white highlights. X-radiographs taken of the area including the figures do not reveal any pentimenti, but conservation in 1985 demonstrated that the foreground had been completely repainted to hide crackle; removal of the repaint revealed, beneath the thinly painted rocks on the right, two figures seated facing each other, the one on the left with his left arm upraised as if throwing a net. At the same time many of the more disturbing wider cracks, both the left and right sides approximately one inch in from the edges, and a number of areas of abrasion in the sky, were retouched. The heavily discolored varnish was removed in 1985 and replaced with a synthetic varnish.

Provenance: Possibly by descent to Margaret Gainsborough.[1] Probably Augustine Greenland (sale, James Christie, London, 25–28 January 1804, 4th day, no. 43), bought by Charles Birch. Probably with (William Dermer), who sold it in 1805 to Sir John Fleming Leicester, Bt., later 1st Baron de Tabley [1762–1827][2] (sale, James Christie, London, 7 July 1827, no. 27), bought by Smith[3] for Sir George Richard Philips [b. 1789], 1st Bt., Weston House, Shipston-on-Stour; bequeathed to his eldest daughter, who married Adam, 2nd Earl of Camperdown, Gleneagles, Perthshire; by descent to Robert, 3rd Earl of Camperdown [1841–1918] (sale, Christie, Manson & Woods, London, 21 February 1919, no. 134, repro.), bought by (M. Knoedler & Co.), London, who sold it 1920 to Andrew W. Mellon, Pittsburgh, who gave it by 1937 to his daughter, Ailsa Mellon Bruce.

Exhibitions: *Pictures by the late William Hogarth, Richard Wilson, Thomas Gainsborough and J. Zoffani*, British Institution, London, 1814, no. 30. *Pictures by Italian, Spanish, Flemish, Dutch, and English Masters*, British Institution, London, 1832,

Fig. 1. Thomas Gainsborough, *Seashore with Fishermen*, c. 1781/1782, gray and gray-black wash heightened with white chalk, England, private collection [photo: courtesy Sidney Sabin]

Thomas Gainsborough, *Seashore with Fishermen*, 1970.17.121

no. 66. *Pictures by Italian, Spanish, Flemish, Dutch, French and English Masters*, British Institution, London, 1863, no. 185. *Thomas Gainsborough*, Tate Gallery, London, 1980–1981, no. 144, repro. *Gainsborough*, Grand Palais, Paris, 1981, no. 67, repro.

GAINSBOROUGH, although skilled from an early age at the painting of water, whether calm or stormy, painted very few coastal scenes. Some, of the Suffolk coast, date to his residence in Ipswich in the 1750s, but the principal group was executed in the early 1780s. John Young, cataloguing in 1821 a work similar to the Washington picture in the possession of Lord Grosvenor, which was exhibited at the Royal Academy in 1781, wrote that it received "additional value, from the consideration that the Artist employed his pencil only on four subjects of the above description."[4] Acutely conscious of the astonishing variety of Reynolds' compositions, Gainsborough was at this time trying to demonstrate the range of his own invention. His seascapes—which may have been inspired partly by a sketching trip on the Devonshire coast that he had planned in 1779 in the company of his friend William Jackson, and partly by scenes in de Loutherbourg's Eidophusikon, which was first performed in London in February 1781—were one manifestation of this impulse. They were planned, like those of Claude-Joseph Vernet, as contrasting calms and storms.[5]

A study for the Washington painting, of which a less convincing version is owned by Eva Andresen, Oslo,[6] was with Sidney Sabin, London, in 1972 (fig. 1).[7] In the finished picture the composition is reversed, an extra figure is helping to push out the boat, the two fishermen with the net are differently arranged, and another figure is added; the two figures and an anchor on the left of the drawing were at first included, the figures seated facing each other, but were replaced in the course of painting by a large rock.[8]

The tonality and handling are similar to the Grosvenor coastal scene: the sea is grayish, with waves and foam similarly rendered, the air is full of moisture, and the sense of recession in the expanse of sea is equally masterly; the conception is broadly in reverse, but there is a similar *repoussoir* foreground. There is no evidence that the Washington picture was one of the seascapes exhibited at the 1781 Royal Academy, as stated by Waterhouse;[9] indeed it is most unlikely that Gainsborough would have exhibited two such similar works in the same year.

The scene is a turbulent one, but the forces thrusting in opposite directions are held in perfect balance. The squall and storm clouds are characteristic of such Dutch marine painters as Backhuyzen, one of whose sea pieces Gainsborough bought later in 1781;[10] and the rock forms that compose the artificial cliffs and are used to powerful and monumental effect were a recurrent motif in Gainsborough's style of the 1780s.

Small copies of this work and of the Grosvenor picture were in the C. H. C. P. Burney sale at Christie, Manson & Woods, London, on 20 June 1930, no. 129, where they were bought by Waters. Another small copy was in the Mr. and Mrs. G. Macaskill sale at Sotheby's, London, on 15 April 1981, no. 174 (repro.). A watercolor copy by Lady Farnborough, omitting the rowing boat, and with other differences in detail, is in the Huntington Art Gallery, San Marino.

Notes

1. Farington *Diary*, 4:1153 (8 February 1799).
2. Hall 1962, 70.
3. Possibly John Smith, the picture dealer of 137 New Bond Street, author of the catalogue raisonné of Dutch pictures.
4. John Young, *A Catalogue of the Pictures at Grosvenor House* (London, 1821), 4.
5. Hayes 1982 (see biography), 1:138–139.
6. Hayes 1970 (see biography), 1: no. 487, 2: pl. 151.
7. Hayes 1970 (see biography), supplement, no. 946 (*MD* 21 [1983], 386).
8. This pentimento was first recorded in Carey 1819, 13.
9. Waterhouse 1958 (see biography), 118. The other seascape exhibited that year was the coastal scene with a ruined castle in the Fairhaven collection (Hayes 1982 [see biography], 2:485–486, no. 126, repro.).
10. Edward Parker sale, James Christie, 14–15 December 1781, 2nd day, no. 75.

References

1799 Farington *Diary*, 4:1153 (8 February 1799); possibly the Washington picture.
1814 *Morning Post*, 6 August 1814.
1819 [Carey, William]. *A Catalogue of Pictures, by British Artists, in the Collection of Sir John Leicester, Bart.* London, 1819:4, no. 3. Also London 1819 [descriptive ed.]: 10–13.
1821 Young, John. *A Catalogue of Pictures by British Artists, in the Possession of Sir John Fleming Leicester, Bart.* London, 1821:18, no. 40, etched repro. opposite.
1856 Fulcher, George Williams. *Life of Thomas Gainsborough, R.A.* 2d. rev. ed. London, 1856:143–145, 198.
1898 Armstrong, Sir Walter. *Gainsborough & His Place in English Art.* London, 1898:160; popular ed., London, 1904:214.
1958 Waterhouse 1958 (see biography): 31, no. 954, pl. 224.
1962 Hall, Douglas. "The Tabley House Papers." *The Walpole Society* 38 (1962):70, 114, probably the Washington picture.

1976 Walker 1976: no. 501, color repro.
1982 Hayes 1982 (see biography): 1:139, 164, color pl.
11; 2:493, no. 129, repro.

1937.1.93 (93)

Georgiana, Duchess of Devonshire

1783
Oil on canvas, 235.6 × 146.5 (92¾ × 57⅝)
Andrew W. Mellon Collection

Technical Notes: The medium-coarse canvas is closely plain woven; it has been lined. Paint is visible on all four edges of the tacking margins, indicating that the canvas was originally stretched on a larger stretcher; the painting has been in this reduced state for a long period of time. The reduction in size, at most two centimeters, has taken place in a greater degree along the top and right edges, perhaps in an effort to place the figure very slightly more centrally in the composition. The ground is light in color and is a fairly dense substance. The painting is executed in layers blended wet into wet, using glazes and scumbles, with impasted highlights; the heaviness of the paint varies from thin washes to thick impasto; the brushwork is prominent in the paint film. Pentimenti are visible in the sash, the wrap, and the lower left area of the sitter's dress. There are scattered retouchings throughout the painting and drying cracks, particularly prevalent in the sitter's dress. The heavily applied natural resin varnish has discolored yellow to a significant degree.

Provenance: Painted for the sitter's mother, Georgiana, Countess Spencer [1737–1814], wife of John Spencer, 1st Earl Spencer [1734–1783], Althorp, Northamptonshire; by descent to John, 7th Earl Spencer [1892–1975], from whom it was purchased in 1924 by (Duveen Brothers), London; it was sold 13 April 1925 by (Duveen Brothers), New York, to Andrew W. Mellon, Pittsburgh and Washington, by whom deeded December 1934 to The A. W. Mellon Educational and Charitable Trust, Pittsburgh.

Exhibitions: Royal Academy of Arts, London, 1783, no. 78, as *Portrait of a lady of quality. The Works of Ancient Masters and Deceased British Artists*, British Institution, London, 1859, no. 149. *International Exhibition*, South Kensington, London, 1862, no. 72. *The Works of Thomas Gainsborough, R.A.*, Grosvenor Gallery, London, 1885, no. 145. *Loan Collection of Pictures*, Corporation of London Art Gallery, 1892, no. 92.

GEORGIANA SPENCER (1757–1806) made the acquaintance of William, 5th Duke of Devonshire, during one of her parents' visits to the health resort of Spa. They married in 1774 and settled in London the following year. Celebrated alike for her beauty, her charm, and her unusual kindness, Georgiana was a gifted hostess who made Devonshire House the brilliant focus of fashionable Whig society. She was a close friend and supporter of Sheridan and Charles James Fox, and the young Prince of Wales came deeply under her influence. Impetuous as well as vivacious, she was an addict of the gaming table and accumulated vast debts; Charles-Alexandre de Calonne, Louis XVI's former finance minister, was among those who lent her money. Inevitably, she was much painted. Reynolds and Gainsborough both painted her as a child and were to paint her several times again.[1]

As Whitley was the first to point out,[2] the Washington picture may plausibly be identified, from the evidence of contemporary press notices, with the portrait of the duchess exhibited by Gainsborough at the Royal Academy in 1783, which was catalogued anonymously there (as was the practice until 1798). Bate-Dudley, in the *Morning Herald*, wrote, "The portrait of the *Duchess of Devonshire* is after Mr. Gainsborough's best manner; the attitude she is shown in, is graceful and easy."[3] The *St. James's Chronicle* described it as "a very elegant picture of the Duchess of Devonshire, who in our opinion is by no means an elegant woman. There is a hoydening affability about her, sanctified by her rank and fortune, which has rendered her popular. Mr. Gainsborough has given her as she might have been if retouched and educated by the Graces."[4] These comments do not accord with the portrait in an American private collection (see note 1), nor with the lost full length once owned by Hoppner, which was painted from three brief sittings and was reported as characterized by freedom in handling.[5] Moreover, Horace Walpole's note against the portrait of the duchess—"too greenish"[6]—in his Royal Academy catalogue for 1783 may convincingly apply to the Washington picture. The comment by the *Morning Post* that the picture was "painted in the same style" as that of Mrs. Sheridan[7] confirms that the latter work was not the portrait now in Washington, 1937.1.92, which is in a quite different style.

The design is simple, generalized, and traditional, with columns and draped curtain; the emphasis on diagonals is characteristic of Gainsborough's late style but seems to presuppose a particular position for the eventual hanging of the picture. The attitude, with its gentle inclination of the head and sweet expression, together with the muted tonality and handling and soft, broad modeling of the flesh tones, reflects the aesthetic of the age of *sensibilité*. Bate Dudley's comments notwithstanding, the execution does not show Gainsborough at his best. The sitter's mouth protrudes awkwardly, the drapery lacks

Thomas Gainsborough, *Georgiana, Duchess of Devonshire*, 1937.1.93

brilliance of handling, the right thigh is shapeless, and the columns and the sitter's relationship to their plinths are not properly understood.

A mezzotint by Whiston Barney was published by T. Palser in 1808.

Notes

1. Reynolds' full-length in the Huntington Art Gallery, San Marino (exhibited at the Royal Academy in 1776), and his dramatic baroque portrait of the duchess holding her three-year-old daughter, Georgiana, at Chatsworth, in Derbyshire (exhibited 1786), are among his acknowledged masterpieces. What may have been Gainsborough's last portrait of her, now in an American private collection, achieved notoriety as "The Stolen Duchess," being stolen from Agnew's in 1876 and not recovered until twenty-five years later, in Chicago (1970.17.119 is a reduced version of this portrait by Gainsborough Dupont). Other portraits of note were executed by Angelica Kauffmann, Maria Cosway, John Downman, and Daniel Gardner; Downman's large watercolor of 1787, at Chatsworth, is perhaps the most enchanting representation of all. Rowlandson drew her more than once, and introduced her as the principal focus of attention in the most famous of all his watercolors, *Vauxhall Gardens*, now in the Victoria and Albert Museum, London (exhibited at the Royal Academy in 1784).

2. Whitley 1915, 198–199.
3. *Morning Herald*, 29 April 1783.
4. *St. James's Chronicle*, 1 May 1783.
5. *Morning Herald*, 29 December 1788. This may have been the full-length for which the duchess sat to Gainsborough in 1781, said to have been intended as a gift for Queen Marie Antoinette (*Morning Herald*, 13 July 1781).
6. Whitley 1915, 199.
7. *Morning Post*, 1 May 1783. A full length of Mrs. Sheridan by Gainsborough was no. 78 in the exhibition.

References

1783 *Morning Herald*, 29 April 1783.
1783 *Morning Post*, 1 May 1783.
1783 *St. James's Chronicle*, 1 May 1783.
1822 Dibdin, Thomas Frognall. *Aedes Althorpianae*. London, 1822:275.
1880 Graves, Henry, & Company. *Engravings from the Works of Thomas Gainsborough, R.A.* London, c. 1880: no. 33 (mezzotint by R. B. Parkes, published 1870).
1898 Armstrong, Sir Walter. *Gainsborough & His Place in English Art.* London, 1898:194; popular ed., London, 1904:263.
1915 Whitley 1915 (see biography): 197–199 (citing the contemporary descriptions quoted above).
1928 Whitley, William T. *Artists and Their Friends in England 1700–1800.* London, 1928, 1:396–398.
1941 *Duveen Pictures in Public Collections of America.* New York, 1941: no. 284, repro.
1949 Mellon 1949:93, repro. 109.
1958 Waterhouse 1958 (see biography): no. 194, pl. 206.
1975 Paulson, Ronald. *Emblem and Expression.* London, 1975:216, pl. 148.
1976 Walker 1976: no. 496, color repro.

1937.1.107 (107)

Mountain Landscape with Bridge

c. 1783/1784
Oil on canvas, 113 × 133.4 (44½ × 52½)
Andrew W. Mellon Collection

Technical Notes: The medium-fine canvas is plain woven; it has been lined. The ground is dark pinkish brown; although thinly applied it contributes substantially to the overall tonality, especially in areas of the sky and background mountains, where the overlying paint has been applied very thinly. The painting is executed in thin, fluid layers except in the highlights, with fairly short, pronounced brushstrokes. The sky has been extensively repainted except in the clouds, probably due to severe abrasion. The thinly applied natural resin varnish has discolored yellow to a considerable degree.

Provenance: Mrs. Thomas Gainsborough (sale, James Christie, 10–11 April 1797, 2nd day, no. 69[1]), bought by Sir John Fleming Leicester, Bt., later 1st Baron de Tabley [1762–1827], Tabley House, Cheshire. Lady Lindsay,[2] from whom it was bought by (Asher Wertheimer), London. Sir Edgar Vincent, Bt., later 1st Viscount d'Abernon [1857–1941], Esher Place, Surrey, by 1912. (Duveen Brothers), London, by 1926, from whose New York branch it was purchased 26 April 1937 by The A. W. Mellon Educational and Charitable Trust, Pittsburgh.

Exhibitions: *The Second Loan Exhibition of Old Masters: British Paintings of the Late Eighteenth and Early Nineteenth Centuries*, Detroit Institute of Arts, 1926, no. 9, repro. *Exposition Rétrospective de Peinture Anglaise (XVIIIᵉ et XIXᵉ siècles)*, Musée Moderne, Brussels, 1929, no. 66. *Eighteenth Century English Painting*, Fogg Art Museum, Cambridge, Massachusetts, 1930, no. 23. *Landscape Painting*, Wadsworth Atheneum, Hartford, Connecticut, 1931, no. 61, repro. *Paintings and Drawings by Thomas Gainsborough, R.A.*, Cincinnati Art Museum, 1931, no. 22, pl. 42. *Century of Progress: Exhibition of Paintings and Sculpture*, Chicago World's Fair, Art Institute of Chicago, 1933, no. 192, repro. *Thomas Gainsborough*, Tate Gallery, London, 1980–1981, no. 148, repro. *Gainsborough*, Grand Palais, Paris, 1981, no. 71, repro.

IN THE LAST DECADE of his life Gainsborough was concerned not only to deepen his expressive powers in landscape, but also, as noted in connection with 1970.17.121 (page 93), to enlarge his range of subject matter in this genre. Thus the six landscapes he sent to the Royal Academy in 1780—to the first exhibition in the institution's new premises at Somerset House—were works which varied greatly in content and which created something of a sensation on its walls. Romantic mountain scenery now played a greater role in Gainsborough's invention. This new thrust in his work involved pursuit of the

Fig. 1. Thomas Gainsborough,
Rocky Landscape with a Bridge,
early 1780s, oil on canvas,
Cardiff, National Museum
of Wales

Old Masters with greater assiduity, and, in the late summer of 1783, he made a tour of Cumberland and Westmorland—whose spectacular mountains and lakes were by then highly fashionable among devotees of the picturesque—on purpose "to mount all the Lakes at the next Exhibition, in the great stile [sic]."[3] *Mountain Landscape with Bridge* was painted during this period,[4] and may well have been planned for the Royal Academy exhibition of 1784.

Though in its pronounced lateral rhythms and extreme fluency of handling the influence of Rubens is paramount, the concept, with distant mountains bathed in a sunset glow that permeates the landscape, derives from Claude. The picture is unfinished; the cliffs on the right, increased in height during the course of painting, are somewhat obtrusive, and their disturbing effect upon the balance of the design may account for Gainsborough's ultimate failure to complete the work.

The composition is adumbrated in the drawing formerly in the Spencer collection at Althorp, Northamptonshire,[5] and Butlin has argued persuasively[6] that one of Gainsborough's transparencies[7] and the small landscape with similar motifs in the National Museum of Wales, Cardiff (fig. 1), are antecedent, and must have played a part in Gainsborough's thought process.

Gainsborough Dupont imitated this style of mountain landscape in his canvas now in the Central Art Gallery, Wolverhampton.[8]

Notes

1. The description in the catalogue is printed in M. H. Spielmann, "A Note on Gainsborough and Gainsborough Dupont," *The Walpole Society* 5 (1917), 97.

2. Possibly Jeanne, Countess of Lindsay [d. 1897], Kilconquhar House, Fife, and Queen's Gate, London, who was married to John, 10th Earl of Lindsay.

3. Gainsborough to William Pearce, Kew Green, n.d. [1783] (Woodall 1963 [see biography], no. 64).

4. The handling is identical with that in the background of the portrait of Mrs. Sheridan, 1937.1.92, begun in 1785 (Hayes 1982 [see biography], 2:524).

5. Hayes 1970 (see biography), 1: no. 495.

6. Martin Butlin, review of Hayes 1982, *BurlM* 125 (April 1983), 234.

7. Hayes 1982 (see biography), 2: no. 154.

8. Hayes 1982 (see biography), 1: pl. 229.

References

1949 Mellon 1949: no. 107, repro. 122.
1958 Waterhouse 1958 (see biography): no. 1008, pl. 287. 2d ed., 1966: color repro.
1962 Hall, Douglas. "The Tabley House Papers." *The Walpole Society* 38 (1962):70, 114.
1968 Cooke, Hereward Lester. *Painting Lessons from the Great Masters.* London, 1968:46, fig. 32, 138, detail repro., color repro. opposite.
1976 Walker 1976: no. 498, color repro.
1982 Hayes 1982 (see biography): 1:145, 147, 171, 231, detail pls. 179, 203; 2: no. 151, repro.

Thomas Gainsborough, *Mountain Landscape with Bridge*, 1937.1.107

1942.9.22 (618)

John, 4th Earl of Darnley

1785
Oil on canvas, 76 × 63.5 (29⅞ × 25)
Widener Collection

Technical Notes: The lightweight canvas is plain woven; it has been lined. The ground is white and has a pebbly quality from agglomerations of white pigment. A pinkish-brown imprimatura has been applied beneath parts of the picture, especially the coat and hair, where it contributes to the tonality. The painting is executed thinly and broadly, blended wet into wet, with glazes and scumbles and slightly impasted white highlights. The paint surface is in good condition except for some abrasion in the more thinly painted passages, where there is some broadly brushed retouching. The natural resin varnish has discolored yellow slightly; residues of an older varnish that was unevenly removed add to the somewhat blotchy appearance of the surface.

Provenance: Painted for the sitter, John, 4th Earl of Darnley [1767–1831], Cobham Hall, Kent; by descent to Ivo, 8th Earl of Darnley [1859–1927], who sold it to (P. & D. Colnaghi & Co.), London, by 1909,[1] from whom it was purchased 1910 by (M. Knoedler & Co.), London, who sold it 21 March 1910 to P. A. B. Widener, Elkins Park, Pennsylvania. Inheritance from the Estate of Peter A. B. Widener by gift through power of appointment of Joseph E. Widener, Elkins Park.

Exhibitions: *Works by the Old Masters and by Deceased Masters of the British School*, Winter Exhibition, Royal Academy of Arts, London, 1877, no. 252. *The Works of Thomas Gainsborough, R.A.*, Grosvenor Gallery, London, 1885, no. 93. *Eleventh Annual Exhibition on Behalf of the Artists' General Benevolent Institution*, Thos. Agnew & Sons, London, 1905, no. 11. *Paintings by Thomas Gainsborough, R.A. and J. M. W. Turner, R.A.*, M. Knoedler & Co., New York, 1914, no. 6.

LORD DARNLEY, who succeeded to the title in 1781, was an Irish peer who took his seat in the House of Lords in 1789 and whose English estate was Cobham Hall, Kent, where he effected large-scale improvements. He was to a great extent responsible for the formation of the Darnley collection (dispersed at Christie's in 1925), which was open to the public; among other acquisitions he bought several works at the sale held at Schomberg House after Gainsborough's death, Reynolds' last subject picture, the *Calling of Samuel*, and about a dozen pictures at the sale of the Orléans collection in 1798. He took an active part in political life but was said to be "a very indifferent speaker;" the same source described him as "of an amiable temper and disposition."[2] He was a founding member

in 1787 of the Marylebone Cricket Club at Lord's. His portrait was painted by Reynolds (Eton leaving portrait, 1787), twice by Hoppner, and by Thomas Phillips.

This portrait is noted in the contemporary press in April 1785 as an excellent likeness.[3] The *Public Advertiser*, which then believed that Gainsborough "no longer holds aloof" from the Royal Academy—the artist had withdrawn his exhibits in 1784 after a quarrel about the hanging of them—intimated that "the young Lord Darnley" would be one of the exhibits that year;[4] but Gainsborough was not reconciled, and did not send any of his work to the Royal Academy of 1785.

The painting is in the characteristic Gainsborough format of a half length without hands in a traditional feigned oval surround. The handling is fairly summary, and the contours of the sitter's left shoulder and arm seem to have been modified in the course of execution; the right eye is out of plane. In contrast to Reynolds, Gainsborough has softened the sharpness of the sitter's nose; he has also given the expression a greater aristocratic hauteur than did Reynolds.

Notes

1. Knoedler & Co. records, cited by The Provenance Index, J. Paul Getty Trust, Santa Monica, California.
2. Anon., *Sketches of Irish Political Characters, of the Present Day* (London, 1799), 96.
3. "Lord Darnley's portrait . . . is admitted to be in *resemblance*, like the reflexion of a mirror.—the beauty of the coloring is beyond praise" (*Morning Herald*, 8 April 1785). The critic of the *Public Advertiser* agreed about the likeness but regarded such an aim as "specious" in comparison with Reynolds' "diving deep into character, and delineating the mind" (13 April 1785).
4. *Public Advertiser*, 13 April 1785.

References

1785 *Morning Herald*, 8 April 1785.
1785 *Public Advertiser*, 13 April 1785.
1898 Armstrong, Sir Walter. *Gainsborough & His Place in English Art*. London, 1898:194; popular ed., London, 1904:263.
1915 Roberts 1915: unpaginated, repro.
1915 Whitley 1915 (see biography): 238–239 (citing contemporary descriptions quoted above).
1958 Waterhouse 1958 (see biography): no. 184.
1969 Watson, Ross. "British Paintings in the National Gallery of Art." *Conn* 172 (1969):56, repro. 55.
1976 Walker 1976: no. 500, color repro.

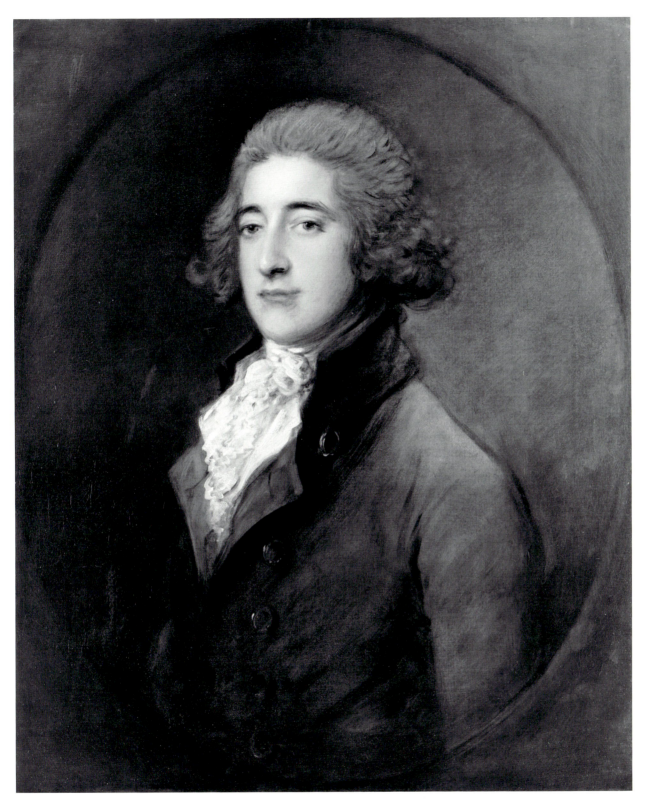

Thomas Gainsborough, *John, 4th Earl of Darnley*, 1942.9.22

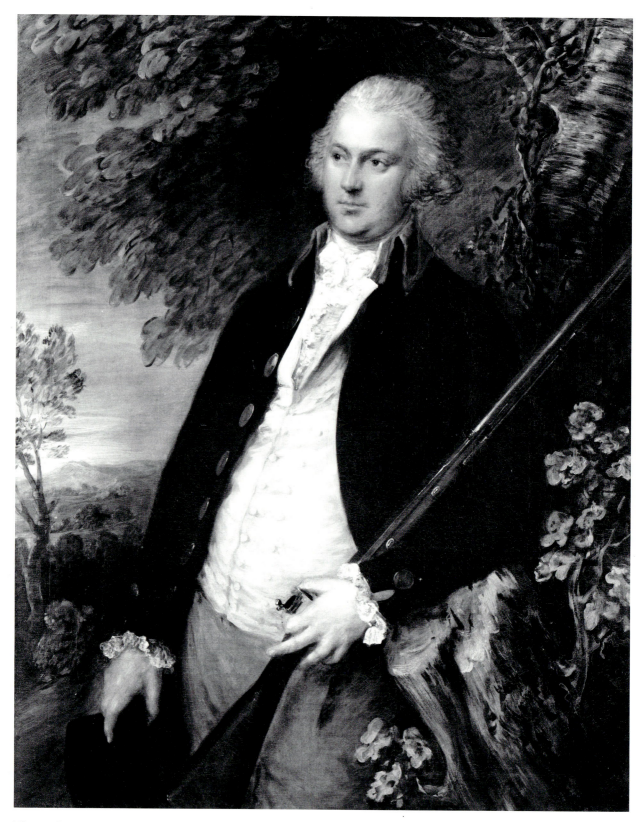

Thomas Gainsborough, *William Yelverton Davenport*, 1961.5.3

1961.5.3 (1647)

William Yelverton Davenport

c. 1785/1788
Oil on canvas, 127.3 × 101.9 (50⅛ × 40⅛)
Gift of the Coe Foundation

Technical Notes: The medium-weight canvas is plain woven; it was lined during conservation, 1980–1981. The ground or imprimatura is a pale pinkish brown (there may be a white or off-white layer underneath). The painting is executed very fluidly, generally in an exceptionally rapid and painterly manner, with the ground used as a middle tone. The hair and flesh tones are extremely thinly painted, with the details of the hair applied in feathery blues, blacks, and yellows, and the features indicated in strong tints of red and blue; by contrast, the hands are very richly modeled. There are slight pentimenti in the contours of the shoulders, especially the right shoulder. The paint surface gives the impression of having been abraded, but this is due to Gainsborough's technique. Apart from a fairly large area of retouching in the trees immediately to the left of the sitter's right shoulder, and scattered small retouchings, the painting is in excellent condition. The thinly applied synthetic varnish has not discolored.

Provenance: Painted for the sitter, William Davenport, Davenport House, Worfield, Shropshire; by descent to Mrs. Cuthbert Leicester-Warren, daughter of Edmund Henry Davenport, 1890. A. J. Finberg.[1] (M. Knoedler & Co.), New York. (John Levy Galleries), New York. Benjamin Franklin Jones, Jr. [1868–1928], Sewickley Heights, Pennsylvania, by 1925, from whom it passed to his wife[2] (sale, Parke-Bernet, New York, 4–5 December 1941, 2nd day, no. 23, repro.), bought by William Robertson Coe [d. 1955], Oyster Bay, Long Island, New York; Coe Foundation, New York, 1955.

Exhibitions: *Works by the Old Masters, and by Deceased Masters of the British School*, Winter Exhibition, Royal Academy of Arts, London, 1887, no. 29. *Paintings by Old Masters from Pittsburgh Collections*, Carnegie Institute, Pittsburgh, 1925, no. 17, repro. *Paintings and Drawings by Thomas Gainsborough, R.A.*, Cincinnati Art Museum, 1931, no. 6, pl. 30.

WILLIAM YELVERTON DAVENPORT (1750–1832/1834), the third son of Sharington Davenport, married Jane Elizabeth Crawley of Bath. A country gentleman and sportsman, devoted to coursing (already a member of three clubs, he founded the Morse Club in 1815), he took no part in political life, either national or local.

The portrait is composed on the baroque principles characteristic of some of Gainsborough's best portraiture in the early 1780s, but in which, unusually, head and hands, as well as body, gun, and tree, contribute to the prevailing diagonal emphasis. The exceptionally thin,

sketchy handling is characteristic of Gainsborough's style in the last few years of his life. The dark blue frock coat with large metal buttons and high collar, and double-breasted waistcoat cut straight across the waist, are typical of fashion in the 1780s. A dating in the mid to later 1780s is supported by the apparent age of the sitter; his jowls and embonpoint are not inconsistent with those of a well-living country squire in his mid- to later thirties.

Notes
 1. According to M. Knoedler & Co. records, entered in The Provenance Index, J. Paul Getty Trust, Santa Monica, California; presumably Alexander Joseph Finberg [1866–1936], the writer on Turner.
 2. It was lent to the exhibition in Pittsburgh in 1925 by Mrs. Jones.

References
 1898 Armstrong, Sir Walter. *Gainsborough & His Place in English Art*. London, 1898:194; popular ed., London, 1904:263.
 1941 Parke-Bernet, New York. *Sale Catalogue*. 4–5 December 1941:2nd day, no. 23.
 1958 Waterhouse 1958 (see biography): no. 189.

1937.1.92 (92)

Mrs. Richard Brinsley Sheridan

1785–1787
Oil on canvas, 220 × 154 (86⅝ × 60⅝)
Andrew W. Mellon Collection

Technical Notes: The medium-coarse canvas is plain woven; it has been lined. The ground, the color of which is difficult to determine, is moderately thick and masks the weave of the canvas. There is a light pink imprimatura evident beneath the sky and the sitter, which is used as a middle tone. The painting is executed in liquid paint, blended wet into wet, applied in many layers in order to create a rich and sumptuous effect, with thin washes in free-flowing brushstrokes for the details. The painting is in excellent condition. The natural resin varnish has discolored yellow slightly.

Provenance: Mrs. Edward Bouverie [1750–1825], a friend of the sitter, Delapré Abbey, Northampton; by descent to General Everard Bouverie [1789–1871]. Baron Lionel de Rothschild [1808–1879], Gunnersbury, Middlesex, by 1873 (it was lent by him to the Royal Academy of Arts exhibition; see below); by descent to Victor, 3rd Baron Rothschild [1910–1990], who sold it c. 1936/1937 to (Duveen Brothers), London, from whose New York branch it was purchased 26 April 1937 by The A. W. Mellon Educational and Charitable Trust, Pittsburgh.

Exhibitions: Gainsborough's studio, Schomberg House, London, 1786. *Works of the Old Masters, associated with Works*

of Deceased Masters of the British School, Winter Exhibition, Royal Academy of Arts, London, 1873, no. 35. *Works by the Old Masters, and by Deceased Masters of the British School*, Winter Exhibition, Royal Academy of Arts, London, 1886, no. 103. *Gainsborough*, Sir Philip Sassoon's, 45 Park Lane, London, 1936, no. 8 (illustrated souvenir, repro. 75). *Thomas Gainsborough*, Tate Gallery, London, 1980–1981, no. 129, repro., color repro. 125. *Gainsborough*, Grand Palais, Paris, 1981, no. 57, repro., color repro. 77. *A Nest of Nightingales: Thomas Gainsborough The Linley Sisters*, Dulwich Picture Gallery, London, 1988, no. 3, 14, repro., 37, color repro. 44.

ELIZABETH LINLEY (1754–1792), who in 1772 was escorted to France by Richard Brinsley Sheridan in order to escape the attentions of the blackguardly Major Mathews, married the playwright the following year. Mrs. Sheridan was a great beauty and a celebrated singer, appearing as the leading soprano at the Three Choirs Festival in 1771 and captivating London audiences in 1773; she was a member of a well-known musical family at Bath with whom Gainsborough was on intimate terms, and was painted by him on several occasions, three times at full length.[1]

As Whitley was the first to observe, the Washington picture was not the full length exhibited by Gainsborough at the Royal Academy in 1783,[2] but a work upon which he was employed in the spring of 1785. Bate-Dudley established the identification with the Washington picture, giving no hint that it might be a reworking of an earlier canvas, when he wrote in the *Morning Herald* in March 1785 that "Mr. *Gainsborough* is engaged on a portrait of Mrs. Sheridan; it is a full-length. She is painted under the umbrage of a romantic tree, and the accompanying objects are descriptive of retirement. The *likeness* is powerful, and is enforced by a *characteristic expression*, which equals the animation of nature."[3] Another critic described her as "resting under the trees."[4] Although until nearly the end of her life the sweet-natured Mrs. Sheridan loyally supported her ambitious but feckless and wayward husband, she was as constantly in the country as he was in town; delicate and consumptive, she declared, "God knows London has no Charms for me, and if I could draw the very few left to me that are Dear to my Heart around me, I should like to rest in some quiet Corner of the World and never see it again."[5] "Take me out of the whirl of the world, place me in the quiet and simple scenes of life I was born for," she implored her husband.[6]

The *Public Advertiser*, in the erroneous belief that Gainsborough was reconciled with the Royal Academy, included the portrait of "Mrs Sheridan sitting in a wood" in a list of works that would be exhibited "if they are well finished"[7] (a statement, incidentally, that rules out the possibility of it having been exhibited previously, in 1783). Gainsborough included the portrait in the exhibition held in his studio at Schomberg House at the end of 1786, but the picture was not quite finished to the artist's satisfaction as Bate Dudley, writing in the *Morning Herald*, said that the lambs in the background were still to be added, so that the picture would "assume an air more pastoral than at present it possesses."[8] The sitter's sister-in-law, Betsy Sheridan, saw the portraits in Gainsborough's exhibition, but "was not delighted with that of Mrs. Sheridan, tho' he has alter'd the idea of making her a Peasant, which to me never appear'd judicious."[9] Although admitting that "Gainsborough was certainly still working on it in 1785," Waterhouse maintained that the portrait was probably hung in the Academy exhibition of 1783 and that "it may have been begun as early as 1774."[10]

This portrait is a masterpiece in a style new to Gainsborough, marking the beginnings in British painting of a romantic approach to portraiture, which he continued in such works as *The Morning Walk* (National Gallery, London); Sir Thomas Lawrence was to take this romanticism to its furthest lengths. The abandon of Mrs. Sheridan's hair, which curls right down to her waist, and the restless figuration of the gauze wrap that is intertwined with it are matched by the sketchiness and animation of the brushwork throughout the dress; further, the character of the brushwork in the hair and costume is taken up in the foliage of the trees, so that trees and figure form a broad and natural compositional flow. In contrast to such apparently similar earlier works as *Mrs. Robinson* (1781–1782; Wallace Collection), where the sitter is posed *against* a landscape, Mrs. Sheridan is not only reclining *in* the landscape, perched somewhat hesitantly on some rocks, but seems to be at one with her setting and with its mood, a mood of heightened, indeed agitated pastoral sentiment conveyed most vividly by the dramatic rays of the setting sun. At the same time the figure is kept in the foreground plane of the picture through the strong lighting of the smoothly and firmly modeled head, a head sadly wistful in expression. Mrs. Sheridan is at once portrait, fancy picture, and part of a landscape.

Nicola Kalinsky has interpreted the work with great sensitivity. Mrs. Sheridan's "desire for conjugal retrenchment in the country was never fulfilled. The painting, with its restless movement agitating the dress

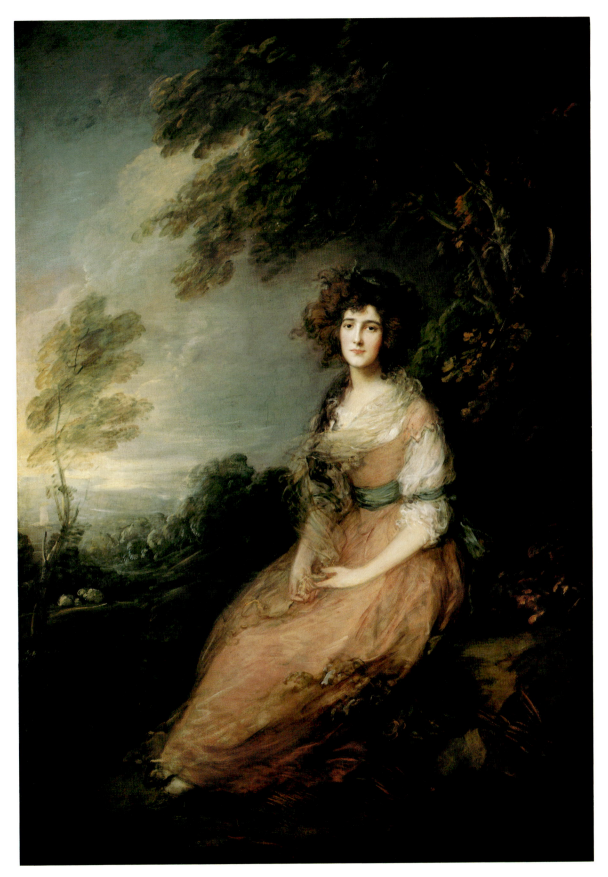

Thomas Gainsborough, *Mrs. Richard Brinsley Sheridan*, 1937.1.92

and hair of the still figure, seems to express this tension; it is not a scene, to requote Bate-Dudley, '*descriptive of retirement.*' The face that looks out is no longer that of the self-possessed innocent of *The Linley Sisters* [1772]."[11]

A mezzotint by Gainsborough Dupont was not published. A grisaille by Dupont, 1970.17.122, seems to be a preparation for the mezzotint. A lithograph by Richard Lane was included in his *Studies of Figures by Gainsborough*, published 1 January 1825.

Notes

1. "A large picture of Tommy Linley and his Sister," which Gainsborough began in 1786, does not survive (the early nineteenth-century tradition that the *Beggar Boy and Girl* in the Sterling and Francine Clark Art Institute, Williamstown, represents Miss Linley and her brother and may thus be the remains of that work is ill founded). A full-length portrait with her younger sister, Mary, is at the Dulwich Picture Gallery, London (exhibited at the Royal Academy in 1772). A small oval dating to the late 1770s is in the Philadelphia Museum of Art. The full length sent to the Royal Academy exhibition of 1783 has not come to light. For the same exhibition Reynolds executed a full length of Mrs. Sheridan as Saint Cecilia, now at Waddesdon Manor, Buckinghamshire; and she was painted by Richard Samuel as one of the *Nine Living Muses of Great Britain* (National Portrait Gallery, London).

2. Whitley 1915 (see biography), 201–202. A contemporary critic's description of this work could fit the National Gallery's portrait: "The piece is rich and well coloured and the drapery is finely touched" (*St. James's Chronicle*, 1 May 1783). However, the picture was not one of Gainsborough's portraits that attracted much critical attention at the Royal Academy exhibition of 1783, as the Washington canvas would surely have done.

3. *Morning Herald*, 30 March 1785.

4. Whitley 1915 (see biography), 238.

5. Mrs. Sheridan to Mrs. Canning, 7 October 1787 (quoted by Clementina Black, *The Linleys of Bath*, 2d rev. ed. [1926; London, 1971], 170).

6. Mrs. Sheridan to Richard Brinsley Sheridan, n.d. (quoted by Black 1971, 152).

7. *Public Advertiser*, 13 April 1785.

8. *Morning Herald*, 30 December 1786.

9. *Betsy Sheridan's Journal*, ed. W. Lefanu (London, 1960), 801 (16 April 1786).

10. Waterhouse 1958 (see biography), no. 613.

11. Exh. cat. London 1988, 77.

References

1785 *Morning Herald*, 30 March 1785.
1785 *Public Advertiser*, 13 April 1785.
1786 *Morning Herald*, 30 December 1786.
1856 Fulcher, George Williams. *Life of Thomas Gainsborough, R.A.* 2d rev. ed. London, 1856:226.
c. 1880 Graves, Henry, & Company. *Engravings from the Works of Thomas Gainsborough, R.A.* London [c. 1880]: no. 100 (mezzotint by James Scott, published 1878).
1898 Armstrong, Sir Walter. *Gainsborough & His Place in English Art.* London, 1898:202, pl. 31; popular ed., London, 1904:279, repro. opposite 164.
1915 Whitley 1915 (see biography): 201–202, 238–239,

257, 260, 265 (citing the contemporary descriptions quoted above), repro. opposite 265.
1928 Whitley, William T. *Artists and Their Friends in England 1700–1800.* 2 vols. London, 1928, 1:397.
1941 *Duveen Pictures in Public Collections of America.* New York, 1941: nos. 285, repro., 286, detail repro.
1949 Mellon 1949: no. 92, repro. 113.
1958 Waterhouse 1958 (see biography): no. 613, pl. 256.
1975 Paulson, Ronald. *Emblem and Expression.* London, 1975:218, 228, pl. 151.
1976 Walker 1976: no. 494, color repro.
1982 Hayes 1982 (see biography), 1:167, pl. 202.
1990 Shawe-Taylor, Desmond. *The Georgians: Eighteenth-Century Portraiture and Society.* London, 1990: 143, color fig. 97.

1937.1.99 (99)

Miss Catherine Tatton

1786
Oil on canvas, 76 × 64 (29⅞ × 25¼)
Andrew W. Mellon Collection

Technical Notes: The canvas, which is plain woven, was enlarged at the top and on the left side by 2 cm during the execution of the picture; it has been lined. The white ground is of moderate thickness. The painting is executed in thin, fluid layers, blended wet into wet. X-radiographs show that the blue sash had a strong highlight in the area now occupied by the third finger of the sitter's right hand, and blue paint can be seen through the traction crackle in the paint of the hand; it is evident, therefore, that the hand clasping the sash was added after the sash had been completely modeled. The thinnest areas have been abraded and the texture of the canvas has been strongly impressed into the paint surface during lining; there are fine retouchings, chiefly in the hair, but there are no major losses. The pigmented natural resin varnish has discolored yellow slightly.

Provenance: Painted for the sitter's father, the Reverend William Tatton, D.D., rector of Rotherfield, Sussex, and prebendary of Canterbury Cathedral; probably the Reverend William Drake-Brockman [1788–1847], the sitter's son; by descent to William Drake-Brockman [1882–1970], from whom it was purchased 1908 by (P. & D. Colnaghi & Co.), London, who sold it to Herbert, 1st Baron Michelham [1851–1919], Hellingly, Sussex (sale, Hampton & Sons, London, on the premises, 20 Arlington Street, London, 23–24 November 1926, 2nd day, no. 290, repro.), bought by (Duveen Brothers), London, who sold it 1927 to Andrew W. Mellon, Pittsburgh and Washington, who deeded it December 1934 to The A. W. Mellon Educational and Charitable Trust, Pittsburgh.

Exhibitions: *Old Masters*, Grafton Galleries, London, 1911, no. 37, pl. 27. *Paintings and Drawings by Thomas Gainsborough, R.A.*, Cincinnati Art Museum, 1931, no. 46, pl. 44.

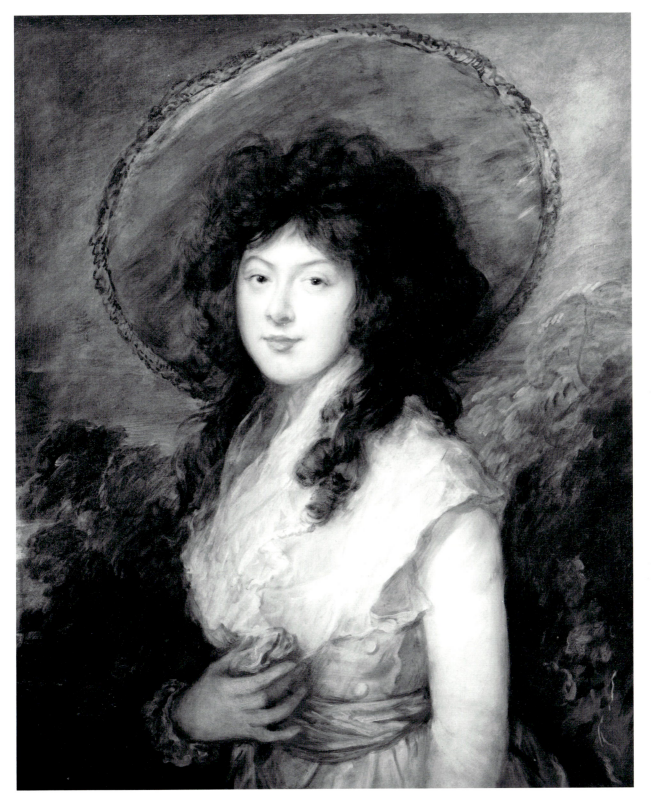

Thomas Gainsborough, *Miss Catherine Tatton*, 1937.1.99

CATHERINE TATTON (1768–1833) married James Drake-Brockman of Beechborough, Kent, high sheriff of the county in 1791, at Lambeth Palace chapel on 7 June 1786; the couple had thirteen children.

The portrait is documented from an entry in the Reverend Dr. Tatton's account book under 1786: "Pd Gainsborough for a Picture £34-2-6."[1] Thus the portrait was evidently painted as a commemoration of Catherine's marriage in that year. Thirty guineas (£31 10s.) was Gainsborough's fee for a portrait of this size from the beginning of the 1770s until 1787; the extra £2 12s.6d. was presumably for the frame and perhaps the packing case.

There is no mention of the painting in the contemporary press. The work is freely and freshly handled, and the sitter is wearing a large hat with platelike brim, tilted to one side, with her hair dressed loosely and ringlets falling over her shoulders, both fashions characteristic of the period. There is a pentimento in the placement of the hand clasping the sash.

A copy by Herbert L. Smith was in the Sir Robert Kirkwood sale, Sotheby's, London, 17 July 1985, no. 548 (repro).

Notes
1. Cited in a letter, 8 July 1976, from the then owners of the book, T & L Hannas, in NGA curatorial files.

References
1912 *Descriptive Catalogue of the Collection of Old Masters of the English School in the Possession of the Rt. Hon. Lord Michelham, K.C.V.O.* London, 1912:2, repro.
1941 *Duveen Pictures in Public Collections of America.* New York, 1941: no. 283, repro.
1949 Mellon 1949: no. 99, repro. 112.
1958 Waterhouse 1958 (see biography): no. 653.
1976 Walker 1976: no. 497, color repro.

Daniel Gardner

1750 – 1805

DANIEL GARDNER was born in Kendal, Lancashire, in 1750. His father was a master baker whose family had been highly respected for generations; his mother was a talented amateur artist, the sister of Alderman Redman of Kendal, who was a patroness of the youthful Romney. As a boy Gardner received some instruction from Romney, went up to London in 1767 or 1768, and was entered at the Royal Academy Schools in March 1770. In 1771 he was awarded the Academy's silver medal for a drawing of *Academy Figures* and exhibited there for the first and only time in his life, preferring, like Romney, to rely for patronage on his connections.

After Gardner left the Royal Academy Schools Reynolds invited him into his studio, where he remained for a short time. A hard-working artist, he started his career in London as a pastelist, painted his first oil in 1779 but worked rarely in that medium, and established his reputation with his gouache portraits. His account books have disappeared, and few of his works are datable; equally little is known about his life. He married Ann, the sister of Francis Haward, the engraver, in 1776 or 1777, but she died a few years later in childbirth and he seems to have developed into a lonely eccentric. One of his principal patrons was Sir William Heathcote, of whose family he painted at least twenty-five portraits. He visited Paris in 1802 or 1803 to study the sculpture in the Louvre, and died in London on 8 July 1805.

Gardner based his style on that of Reynolds, adopting the latter's practice of generalizing drapery and sometimes borrowing poses or gestures from his compositions; an accomplished artist, Gardner was able to group well and to vary his poses. Like Reynolds, he was enchanted by children. His masterpiece is his large oil and gouache of Mrs. Casamajor with eight of her children, painted in 1779. Although he was affected by the current fashion for sentiment in his treatment especially of women, and occasionally painted fancy pictures, his technique—in contrast to such contemporary pastelists as Downman and Russell—was broad and lively, with an effective play of chiaroscuro; he made an equally vigorous use of landscape backgrounds, which in his later works were somewhat messy and uncontrolled.

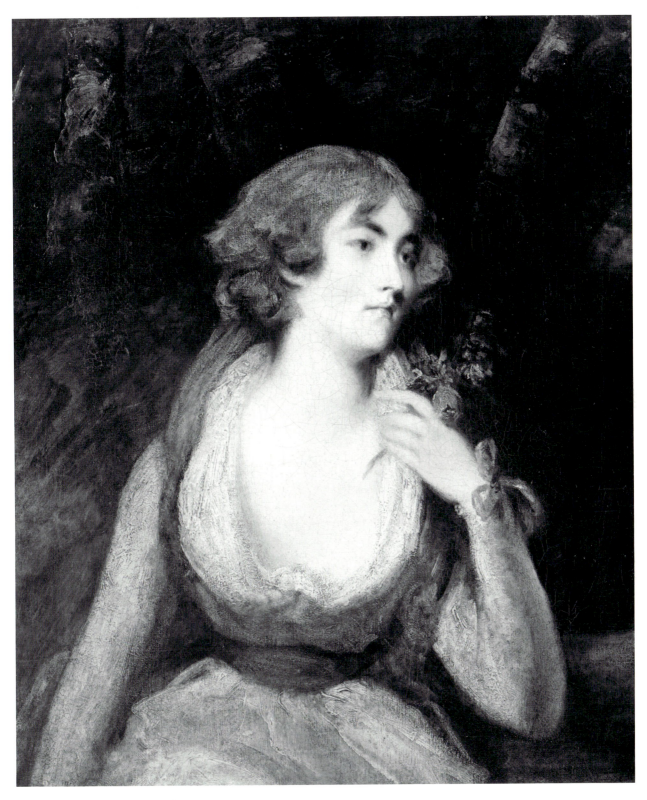

Daniel Gardner, *The Hon. Mrs. Gray*, 1942.9.73

Bibliography
Williamson, G. C. *Daniel Gardner*. London, 1921.
Kapp, Helen. *Daniel Gardner 1750–1805*. Exh. cat., Iveagh
Bequest, Kenwood. London, 1972.

1942.9.73 (669)

The Hon. Mrs. Gray

c. 1785/1790
Oil on canvas, 76 × 63.5 (29⅞ × 25)
Widener Collection

Technical Notes: The medium-weight canvas is plain woven;
it has been lined. The white ground is thickly applied, and
masks the weave of the canvas. The painting is executed in
thick, rich paint, blended wet into wet, with heavy brush-
strokes creating ridges and using impasted passages and a few
translucent glazes to create form and to color the cheeks; the
contours and features are blurred. The middle-tone glazes have
been abraded, and the impasto has been flattened during lining,
which was carried out with a great deal of pressure; there are
numerous retouchings in the flesh tones and there is probably
extensive retouching in the darker areas. The natural resin var-
nish, pigmented black, has discolored yellow to a significant
degree; residues of an older, deep amber varnish create a dis-
turbing, independent colored pattern.

Provenance: Philip Longmore [1799–1879], Stevenage,
Hertfordshire. (Wallis & Son), London, who sold it 1893 to P.
A. B. Widener, Elkins Park, Pennsylvania. Inheritance from
the Estate of Peter A. B. Widener by gift through power of
appointment of Joseph E. Widener, Elkins Park.

THERE IS no comparative visual evidence to support the
traditional identification of the sitter, but, on the
assumption that it is correct, she must be either Eliza-
beth Manwaring (d. 1823), daughter of Charles Man-
waring of Bromborough, Chester, who in 1782 married
the Hon. Booth Grey[1] (1740–1802), M. P. for Leicester
from 1768 to 1774; or Susannah, daughter of Ralph
Leycester of Toft, Cheshire, who in 1773 married the
Hon. John Grey (1743–1802). Both were younger sons
of Henry, 4th Earl of Stamford. The low-cut gown with
sash, the long, tight sleeves fastened at the wrist, and the
disheveled hairstyle with loosely dressed curls suggest a
date of about 1785 to 1790.

Traditionally this portrait has been ascribed to Rey-
nolds, but more recently Sir Alec Martin and Sidney Sabin
independently have suggested an attribution to Gardner.[2]

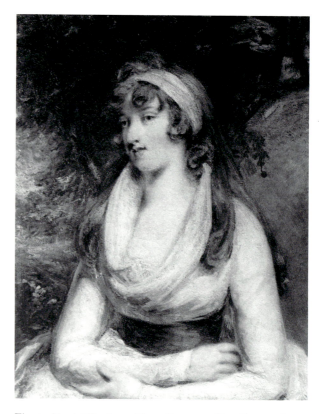

Fig. 1. Daniel Gardner, *Flora, Countess of Loudoun*, c. 1802,
oil on canvas, Mountstuart, Marquess of Bute
[photo: Paul Mellon Centre]

The treatment throughout—the rough impasto, the touch
in the hair, the chiseled modeling of such features as the
lips, and the roughly handled background—is indeed
consistent with a number of the comparatively few por-
traits in oils (fig. 1) executed by the gouache and pastel
painter and mixed media experimentalist, Daniel
Gardner, who was strongly influenced by Reynolds. There
is no doubt that this attribution is the correct one. It may
be noted also that Gardner was born and sought his
patronage in the northwest of England, and that both of
the supposed sitters came from Cheshire families.

Notes
1. *Gray* and *Grey* were interchangeable in the eighteenth
century.
2. Letter, 28 September 1957, and David Rust, memo-
randum, 22 April 1963, in NGA curatorial files. It was listed
simply as by a follower of Reynolds in NGA 1985, 350.

References
1915 Roberts 1915: unpaginated, repro.

Marcus Gheeraerts the Younger

c. 1561/1562 – 1636

MARCUS GHEERAERTS was born in Bruges in 1561 or 1562, and was brought to England in 1568 by his father, Marcus Gheeraerts the Elder, a painter of whose work hardly anything is known. Trained by his father and perhaps also a pupil of Lucas de Heere, Marcus produced his first surviving inscribed portrait in 1593; by this date, however, he was already under the powerful patronage of the royal pageant master, Sir Henry Lee, for whom he painted the celebrated full-length portrait of the queen standing on the map of England (National Portrait Gallery, London) to commemorate Queen Elizabeth's visit to Ditchley in 1592. In 1590 Gheeraerts married Magdalena, the sister of the painter John De Critz. The couple had six children, only two of whom seem to have survived. Marcus became the brother-in-law of the miniaturist Isaac Oliver when his sister married Oliver in 1602.

Gheeraerts was the most distinguished and most fashionable portraitist of the 1590s, and continued to be after Elizabeth's death, becoming the favorite painter of James I's queen, Anne of Denmark; he records himself in an Aliens Return of 1617 as "her Majesties painter." He received a grant of naturalization in 1618, and was still royal "picture drawer" in that year, when he received his last recorded payments for royal portraits. During the second half of the 1610s, however, Gheeraerts' position declined as the result of competition from a new generation of immigrants: Paul van Somer, who seems to have supplanted him in royal favor; Daniel Mytens, patronized by the Prince of Wales (later Charles I) and Thomas Howard, 2nd Earl of Arundel; and Abraham Blyenberch, patronized by the prince and William Herbert, 3rd Earl of Pembroke. For the last twenty years of his life he was supported chiefly by the lesser gentry and by academic sitters. Gheeraerts was a member of the Court of the Painter-Stainers' Company in the 1620s and had an apprentice, Ferdinando Clifton, who was made free of the Company in 1627. He died on 19 January 1636.

It has been possible to reconstruct for Gheeraerts the most extensive oeuvre of any Elizabethan painter. The limitations of insular patronage dictated that his practice should be entirely in the field of portraiture, and between Hans Eworth and Van Dyck he was arguably the most important portraitist on the scale of life active in England. Evidently influenced by Frans Pourbus, in forming his style Gheeraerts developed a new Flemish manner that superseded the iconic costume pieces characteristic of George Gower, the most fashionable painter of the 1570s and 1580s. For the first time since Eworth, sitters are set firmly but not always entirely convincingly in space that is often carefully constructed but sometimes awkwardly tilted forward, and for the first time they are portrayed in landscape surroundings. Sensitive and atmospheric in their modeling, Gheeraerts' portraits possess a quiet poetic charm; his sitters smile, their living presence accentuated by a sense of arrested movement. The details of the elaborate costume of the day are painted with distinction, fastidiously and lovingly. Although Gheeraerts occasionally painted allegorical portraits or used sophisticated masque costume, perhaps with accompanying sonnets, and his sitters are often shown fingering their pearls or other accessories, his works are distinguished by their poise and refinement rather than by props or symbolism.

Gheeraerts seems to have exerted some influence on Gilbert Jackson and on Cornelius Johnson, the latter of whom was akin to him in temperament; but Johnson, like Mytens and Van Somer, was able to set his figures much more confidently in space. The Elizabethan and Jacobean style, with its emphasis on dazzling costume and bright color, of which the works of Gheeraerts and William Larkin marked the zenith, was finally made obsolescent by Van Dyck, the most powerful influence on the future course of British portraiture.

Bibliography

Collins Baker, C. H. *Lely & the Stuart Portrait Painters.* 2 vols. London, 1912, 1: 21–35.

Poole, Mrs. Reginald Lane. "Marcus Gheeraerts, Father and Son, Painters." *The Walpole Society* 3 (1914): 1–8.

Strong, Sir Roy. "Elizabethan Painting: An Approach through Inscriptions—III. Marcus Gheeraerts the Younger." *BurlM* 105 (1963): 149–157.

Millar, Sir Oliver. "Marcus Gheeraerts the Younger: A Sequel through Inscriptions." *BurlM* 105 (1963): 533–541.

Strong, Sir Roy. *The English Icon: Elizabethan & Jacobean Portraiture.* London and New York, 1969: 21–24, 269–304.

Studio of Marcus Gheeraerts the Younger

1947.18.1 (1023)

Robert Devereux, 2nd Earl of Essex

1596/1601
Oil on wood, 114.7 × 87.7 (45⅛ × 34½)
Gift of Mrs. Henry R. Rea

Technical Notes: The wood panel is constructed of three vertical members; it has been cradled. The ground is cream colored, smoothly applied and of moderate thickness. There is a

thin, light-gray imprimatura, with a further thicker, overlying, reddish brown layer confined to the blue background. Infrared reflectography reveals some simple, slight contours delineating the eyes, nose, and mouth and in the region of the sitter's right arm and shoulder. The painting is executed in broad, smooth, opaque layers, thinly applied in the figure, more thickly and with some texture in the background, where the paint has the appearance of tempera; the brown hair and black cloak are painted in very thin glazes; the highlights in the belt, sword hilt, and medallion are slightly impasted. The ground and paint surfaces have suffered considerable losses along the two vertical seams and are worn and chipped along the edges. The paint surface has also been fairly severely abraded throughout, and the cloak and hat are now completely flat. There is a substantial amount of inpainting in the costume, the beard, and the edge of the brown hair. The thin natural resin varnish has not discolored significantly.

Provenance: Lt. Col. Richard Rouse-Boughton Orlebar [1862-1950], Hinwick House, Wellingborough, Northamptonshire. (M. Knoedler & Co.), London, by 1931.[1] (M. Knoedler & Co.), New York, by 1943.[2] Mrs. Henry R. Rea, Sewickley Heights, Pennsylvania, by 1947.

Exhibitions: *Development of Portraiture*, Walters Art Gallery, Baltimore, 1945, no cat.

ROBERT, 2nd Earl of Essex (1566-1601), was the eldest son of Walter Devereux, 1st Earl of Essex, of Chartley, Staffordshire, and Netherwood, Herefordshire. Placed under the guardianship of Lord Burghley, Queen Elizabeth's chief minister, he first appeared at court at the age of ten. When he was twenty he attracted the favor of the queen and was appointed master of the horse; after the death in 1588 of Robert Dudley, Earl of Leicester, he was Elizabeth's principal favorite. Vain, fiery, and temperamental, he had a short but stormy career as courtier, soldier, and naval commander, during which he crossed the queen on several occasions. His career culminated in his appointment as governor general of Ireland, with the task of pacifying the country. Arrested for returning without permission, he was involved in a plot against Elizabeth, tried, and executed. Essex was married to Frances, the widow of Sir Philip Sidney, wrote numerous sonnets, and was an active patron of literature. He was

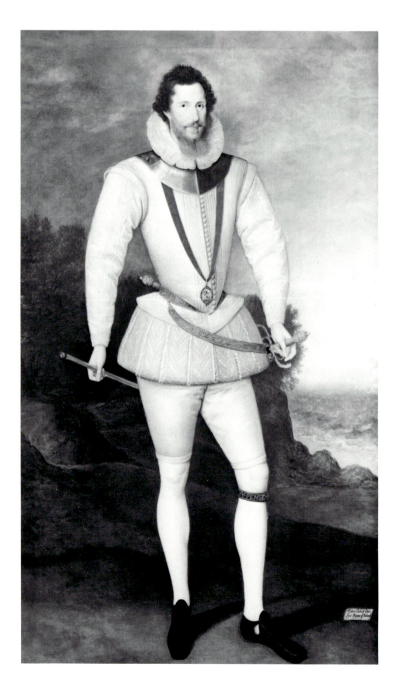

Fig. 1. Marcus Gheeraerts the Younger, *Robert Devereux, 2nd Earl of Essex*, c. 1596, oil on canvas, Woburn Abbey, Marquess of Tavistock [photo: National Portrait Gallery]

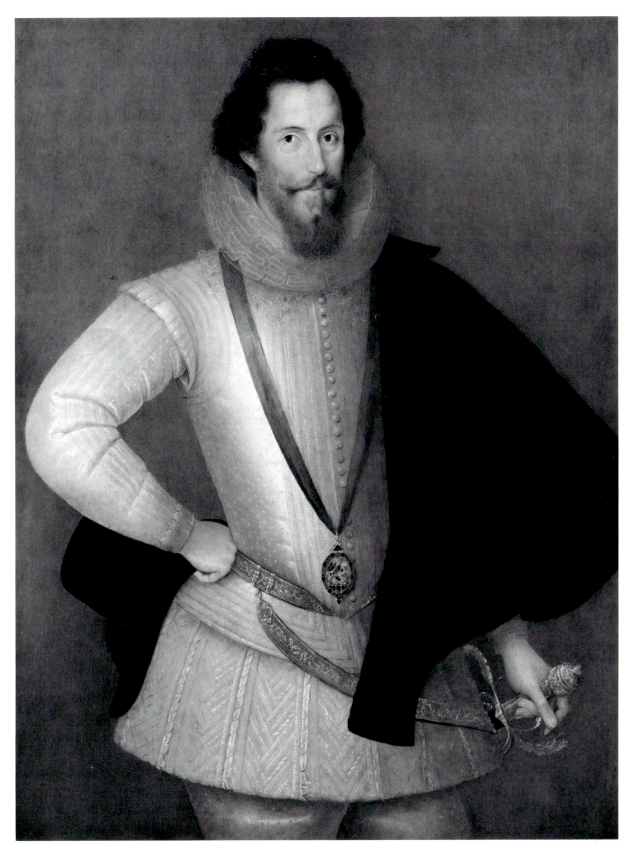

Studio of Marcus Gheeraerts the Younger, *Robert Devereux, 2nd Earl of Essex*, 1947.18.1

portrayed by Sir William Segar, Nicholas Hilliard, and Isaac Oliver as well as by Gheeraerts, whose studio disseminated his image widely.

Gheeraerts executed his portrait of Essex, almost certainly the full-length version at Woburn Abbey, Bedfordshire (fig. 1),[3] in about 1596, shortly after the sitter's return from his Spanish expedition; it shows in the background a town in flames, presumably Cadiz, which Essex had captured. Numerous versions exist, of which many are later works. A studio copy of the full-length portrait is at Longleat House in Wiltshire, and three-quarter-length portraits of the Woburn type, but with the baton held in front of instead of behind the body, include one sold at Christie, Manson & Woods, London, on 19 January 1945, no. 105, and others at Althorp, Northamptonshire, and Parham Park in Sussex. A similar three-quarter length, but including a black cape over the left shoulder, was with M. Adams Acton in 1956. The National Gallery's picture and a three-quarter length formerly in the Bullivant collection (Anderson Manor, Dorset) are modifications of the latter variant, with the right arm crooked and clasping a black hat at the waist instead of outstretched, holding a baton. A further three-quarter length variant is at Trinity College, Cambridge. Gheeraerts also painted Essex in the same pose as that at Trinity, full length in Garter robes (National Portrait Gallery, London).

The Washington picture is a work of good quality and some sensitivity in the modeling of the head, ranking with the versions at Althorp, Trinity College, the National Portrait Gallery, Christie's in 1945, and formerly with Adams Acton; it may be accepted as a product of Gheeraerts' studio rather than as a later work. Essex is shown wearing the Lesser George hanging from a blue ribbon around his neck. As in most Elizabethan portraiture, the image fills the picture plane.

Notes
1. Information from the mount of a photograph in the Witt Library, Courtauld Institute of Art, London.
2. Information from the back of a Knoedler photograph in the National Portrait Gallery, London.
3. This portrait is regarded by Sir Roy Strong as one of the two supreme works by Gheeraerts (Strong 1969 [see biography], 23).

References
1957 Piper, Sir David. "The 1590 Lumley Inventory: Hilliard, Segar and the Earl of Essex—II." *BurlM* 99 (1957): 299–303.
1969 Strong, Sir Roy. *Tudor and Jacobean Portraits*. 2 vols. London (National Portrait Gallery Catalogue), 1969, 1: 116.
1969 Strong 1969 (see biography): 297.

John Frederick Herring the Younger
before 1825 – 1907

HERRING was the eldest of the three sons of John Frederick Herring, a sporting and animal painter best known for his portraits of racehorses—he painted the winner of the St. Leger for thirty-three successive years—but who lacked Ferneley's gift for individual likeness. Nothing is known of the younger John's education or training, but from an early age he imitated his father's work, his father adding the suffix "Senr" to his signature from at least 1846, in order to avoid confusion. Herring first exhibited at the Royal Academy in 1863, showing there until 1873; but, like his father, he exhibited chiefly at the Society of British Artists on Suffolk Street, from 1860 to 1875.

His prices ranged from seven guineas to one hundred pounds. He died in 1907.

Herring specialized in fox-hunting scenes, animals—especially carthorses—and agricultural and farmyard subjects. The last, a genre to which his father had turned increasingly after settling at Meopham, Kent, in about 1847, were often sentimentalized. His style is much fussier and coarser than that of his father.

Bibliography
Sparrow, Walter Shaw. *British Sporting Artists from Barlow to Herring*. London and New York, 1922: 222–223.

Attributed to John Frederick Herring the Younger

1960.6.23 (1575)

Horses' Heads

c. 1845/1860
Oil on canvas, circular, 40.5 × 41 (16 × 16⅛)
Timken Collection

Technical Notes: The medium-weight canvas is tightly plain woven; it is unlined and remains attached to its original stretcher. The ground is white, thinly applied. The painting is executed in thin, semitransparent layers in the spandrels outside the tondo, more thickly and opaquely in the picture itself, with low impasto in the highlights. The canvas is dessicated and brittle, and has been damaged by two tears, one in the region of the nostrils of the horse on the left, which has been crudely repaired with wax or putty, and one in the cheek of the horse nearest on the right, which is unrepaired. The paint surface has been abraded throughout. The moderately thick natural resin varnish has discolored yellow to a significant degree.

Provenance: (Ferargil Galleries), New York. William R. Timken [1866-1949], New York, as by John Frederick Herring, Sr.; passed to his wife, Lillian S. Timken [d. 1959], New York.

Attributed to John Frederick Herring the Younger, *Horses' Heads*, 1960.6.23

Fig. 1. John Frederick Herring the Elder,
Two Mares and a Foal, signed and dated 1849, oil on canvas,
England, private collection [photo: Sotheby & Co.]

THIS STUDY of the heads of four horses, with their fodder, is painted in a small tondo shape within the canvas; the heads fill most of the design and the only background is sky.

The work was traditionally attributed to John Frederick Herring the Elder; the attribution to his son was suggested by Basil Taylor.[1] Herring the Elder painted a large number of groups of horses' heads, often sentimentalized by the inclusion of chickens or birds, bearing dates between 1846 and 1857 (fig. 1). The handling of the Washington picture is coarser and more finicky than these works. Given the fact that Herring the Younger closely imitated and followed his father's style and range of subject matter, Taylor's attribution may be accepted as probably correct. The painting is hard to date, but may perhaps belong to the period when Herring's father was executing subjects of this nature.

Notes
1. Basil Taylor to John Walker, 19 October 1964, in NGA curatorial files. Judging from a photograph, David Fuller, Arthur Ackermann & Son Ltd., London, supported this attribution (letter to the author, 22 June 1990).

Joseph Highmore

1692 – 1780

JOSEPH HIGHMORE was born in London on 13 June 1692, the third son of a coal merchant on Thames Street. He was educated at Merchant Taylors' School. His father failed to get him started as a painter as pupil of his uncle, Thomas, who had been appointed Serjeant Painter to Queen Anne in 1702, and he was articled to an attorney in 1707. In 1713 he enrolled in Kneller's Academy of Painting on Great Queen Street and, after his articles expired, set himself up in 1715 as a portrait painter in the City. In 1716 he married Susanna Hiller, with whom he had two children.

Highmore was a founding member of Chéron and Vanderbank's St. Martin's Lane Academy in 1720. In 1724 he moved to Lincoln's Inn Fields, began to paint sitters of greater distinction than City merchants, and executed drawings for a folio of engravings of the instal-lation of the Knights of the Bath, published in 1730, which led to aristocratic commissions. A great admirer of Rubens and Van Dyck, he traveled via the Low Countries to see the princely collections at Düsseldorf in 1732; he visited Paris in 1734, partly to study contemporary art. His most rococo production was a series of twelve paintings illustrating Richardson's *Pamela*, engraved in 1745, at which time he established a life-long friendship with the novelist. He also painted biblical subjects, including one for the decoration of the Court Room at the Foundling Hospital, London, and some landscapes.

Highmore maintained his busy portrait practice without studio assistance, executing the draperies himself and painting the hands from life; the heads were often completed in one sitting. He kept the same prices for most of his career: ten guineas for a head and shoulders,

twenty guineas for a half length, and forty for a full length, not much less than Hudson was charging in 1755. He exhibited at the first exhibition of the Society of Artists in 1760 but retired in 1762, selling his collection of paintings and going to live with his daughter and son-in-law in Canterbury.

A freemason and nonconformist, Highmore seems to have moved in learned and literary rather than artistic circles. He was himself a writer, chiefly in his retirement, of pamphlets and articles on varied subjects, including perspective. As a character he was urbane, genial, and compassionate; of temperate habits, he preserved a clear mind and strong constitution until the end of his life. He died in Canterbury on 3 March 1780, at the age of eighty-seven.

Little is known of Highmore's early style, which was evidently influenced by Sir Godfrey Kneller, but from 1728 on his portraiture can be studied almost year by year through dated works. He remained in the vanguard of artistic development. Watteauesque and light in tone following the arrival of Mercier in London, his work developed in the 1730s a remarkable lusciousness of handling owing something to Hogarth; he broadened his style in the 1740s under the influence of Jean-Baptiste van Loo, and followed Allan Ramsay and Reynolds in the succeeding decade. The hallmarks of his style are directness, informality and variety of pose, vivid likeness, a meticulous rendering of fabrics, and expressive, well-drawn hands; strongly individual studies of professional men are characteristic. Not wholly at ease with full-length portraits, of which he painted comparatively few, or in the composition of conventional group portraits, he took up portraits in little at the same time as he was working on his *Pamela* series; in both of these he exhibited a daintiness of pose and gesture and soft delicacy of color which are the equivalent of rococo porcelain. The twelve *Pamela* paintings (now distributed evenly among the Tate Gallery, London, the Fitzwilliam Museum, Cambridge, and the National Gallery of Victoria, Melbourne), illustrations less sensational than Richardson's novel, nonetheless display a gift for cogent narrative and may be reckoned Highmore's masterpiece.

Never an original artist, and without apprentices or students to carry on his style, Highmore soon faded in reputation after he gave up painting, and he attracted scant notice thereafter until the revival of interest in the Georgian little masters in the 1920s and 1930s.

Bibliography
Johnston, Elizabeth. *Paintings by Joseph Highmore 1692–1780*. Exh. cat., Iveagh Bequest, Kenwood. London, 1963.
Johnston, Elizabeth. "Joseph Highmore's Paris Journal, 1734." *Walpole Society* 42 (1970): 61–104.
Lewis, Alison Shepherd. "Joseph Highmore: 1692–1780." Ph.D. diss., Harvard University, 1975. Ann Arbor, Michigan (University Microfilms), 1979.

1942.8.5 (558)

Portrait of a Lady

c. 1730/1735
Oil on canvas, 91.6 × 71 (36⅛ × 28)
Andrew W. Mellon Collection

Inscriptions:
Falsely inscribed on ledge at lower left: *R F Pinx/1746* and on back of old stretcher (now replaced): *PORTRAIT OF WILLIA-MINA MOORE, WIFE OF DR. PHINEAS BOND AT THE AGE OF NINE-TEEN YEARS, 1746*

Technical Notes: The medium-fine canvas is tightly plain-woven; it has been lined. The ground is white, smoothly applied and of moderate thickness. There is a grey imprimatura beneath the figure, which is used for the shadows in the dress, and a reddish-brown imprimatura under the landscape on the right. The painting is executed richly, fluidly, and loosely except in the flesh tones; the flesh tones are more tightly painted, blended wet into wet, with red and reddish-brown shadows; the blue drapery is underpainted with white, glazed over with deep blue, with thinner glazes in the highlights; the dress is painted creamily, with pink and brown glazes; the landscape is very fluidly painted in what appears to be a single layer over the imprimatura. The "signature" has been shown to be false since it continues into cracks in the underlying paint film. The paint surface is abraded from heavy-handed cleaning, especially in the darks, and the impasto has been flattened during lining. There is major retouching in parts of the head; large losses in the right shoulder and between the left arm and torso are inpainted; and much of the deeper shadow in the blue drapery, and the lower left of the picture, are reinforced with glazes. The thick, natural resin varnish has discolored yellow to a significant degree.

Provenance: (Rose M. de Forest), New York, who sold it 12 October 1926 to Thomas B. Clarke [d. 1931], New York, as a portrait of Williamina Moore by Robert Feke. Sold by Clarke's executors 1935 to (M. Knoedler & Co.), New York, from whom it was purchased January 1936, as part of the Clarke collection,

by The A. W. Mellon Educational and Charitable Trust, Pittsburgh.

Exhibitions: (all as *Williamina Moore* by Robert Feke) *Paintings by Early American Portrait Painters*, Century Association, New York, 1928, no. 11. *Portraits by Early American Artists of the Seventeenth, Eighteenth and Nineteenth Centuries Collected by Thomas B. Clarke*, Philadelphia Museum of Art, 1928, unpaginated and unnumbered. *American Historical Paintings*, Golden Gate International Exposition, San Francisco, 1939, no. 10. *Twelve Portraits from the Mellon Collection*, Pack Memorial Library, Asheville, North Carolina, 1949, no. 1. *The Face of American History*, Columbia Museum of Art, Columbia, South Carolina, 1950, no. 6, repro. *American Portraits from the National Gallery of Art*, Atlanta Art Association, High Museum of Art, Atlanta, 1951, no. 2, repro.

THERE IS NO VISUAL EVIDENCE to support the identification of the sitter as Williamina Moore, who became Mrs. Phineas Bond (1727–1809), and the provenance from Colonel John Moore of New York, uncle of the supposed sitter, supplied by the dealer, de Forest, has been shown by archival research to be spurious.[1] Moreover,

Fig. 1. Joseph Highmore, *Mrs. Warren*, inscribed on reverse 1730, oil on canvas, last recorded in an anonymous sale, Christie, Manson & Woods, London, 6 April 1973, lot 85, bought by Harris [photo: National Portrait Gallery]

the costume depicted is earlier than 1746 and is almost certainly English; the lace-trimmed cap with pinned-up lappets is characteristic of English fashion in the 1720s and 1730s.[2]

The attribution to Robert Feke, based on the spurious inscription and upheld by Foote, who wrote that "none of his portraits is a more carefully studied or more beautiful work of art,"[3] has been generally discounted.[4] Sawitsky thought the portrait might be an early work by John Hesselius under the strong influence of Feke.[5] Questioned by Campbell as American in 1970,[6] the portrait was rejected by Wilmerding as such in 1980, but not reattributed.[7]

Elizabeth Clare,[8] supported by Sir Ellis Waterhouse,[9] correctly believed the work to be English. Both Ross Watson[10] and Ribeiro[11] have recognized affinities with the style of Charles Jervas (c. 1675–1739). The sophisticated technique, lively handling of paint, and essentially homely conception of the sitter, are, however, far removed from Jervas's stiffer, more rhetorical and less painterly style, and much closer to that of Highmore. The rich highlighting of the costume, the broad modeling of the head and treatment of the shadows in the sitter's right cheek, the gentle play of the hands and idiosyncratic open fingers, and the treatment of the landscape background are all characteristic of Highmore's style, especially in about 1730 (fig. 1), and the quality supports an attribution to Highmore himself.

The depiction of the sitter in a wrapping gown, fashionable *déshabillé* in the mornings, was typical of the early eighteenth-century English penchant for the undress portrait.

Notes
1. James Lane and Anna Rutledge, report on the Clarke collection, 1952, quoted by William P. Campbell, memorandum, 3 May 1966, in NGA curatorial files. Campbell sums up the provenance as "completely untenable."
2. Costume report by Aileen Ribeiro, February 1988, in NGA curatorial files. Ribeiro gives a date for the costume as probably late 1720s.
3. Foote 1930, 70, 170–171.
4. See William Campbell, memorandum, 3 May 1966, in NGA curatorial files.
5. Notes from a course on early American painting given by William Sawitsky at the Institute of Fine Arts, New York, c. 1940, typescript in NGA curatorial files.
6. NGA 1970, 158.
7. NGA 1980, 308. It was listed in the 1985 National Gallery catalogue of European paintings, but classified as of unknown nationality (NGA 1985, 408).
8. Opinion recorded in unsigned note, 15 May 1963, in NGA curatorial files.

Joseph Highmore, *Portrait of a Lady*, 1942.8.5

9. Opinion recorded by William P. Campbell, note, 29 April 1975, in NGA curatorial files.

10. Opinion recorded in unsigned note, February 1969, in NGA curatorial files.

11. Costume report by Aileen Ribeiro, February 1988, in NGA curatorial files.

References

1930 Foote, Henry Wilder. *Robert Feke, Colonial Portrait Painter.* Cambridge, Massachusetts, 1930: 70, 105, 170–171, 210, 213, repro. facing 70.

1970 NGA 1970: 158, repro. 159.

1980 NGA 1980: 308.

William Hogarth

1697 – 1764

HOGARTH WAS BORN in Bartholomew Close, near Smithfield Market, London, on 19 November 1697. He was the fifth (but eldest surviving) of the nine children of Richard Hogarth and Anne Gibbons. His father, a Latin teacher and textbook writer, opened a Latin-speaking coffeehouse when William was five. When the coffeehouse failed and his father was confined for debt, Hogarth lived with his family, from 1708 to 1712, within the jurisdiction of the Fleet prison, an experience he never forgot. Unable to aspire to anything higher, he was apprenticed in 1713 or 1714 to Ellis Gamble, a silver engraver. In 1720 he set up on his own as a print engraver, operating from home, and was an original subscriber to the academy off St. Martin's Lane founded by Louis Chéron and John Vanderbank.

Hogarth published his first satirical print, *The South Sea Scheme*, in 1721, and his first major series, twelve plates based on Samuel Butler's *Hudibras*, in 1726 (the year of publication of Swift's *Gulliver's Travels*). He began painting in about 1726 and achieved a rapid success, executing small genre and comic scenes, several versions of an episode from *The Beggar's Opera*, and conversation pieces, some with interior and others with outdoor settings. In 1729 he eloped with Jane Thornhill, the daughter of the eminent history painter Sir James Thornhill; the couple, forgiven, were allowed to move into Thornhill's house in the Great Piazza, Covent Garden, in 1731, but two years later they moved to the Golden Head, Leicester Fields, where Hogarth remained for the rest of his life.

In 1730 Hogarth painted his first series of "modern moral Subject[s],"[1] *A Harlot's Progress* (destroyed in a fire at Fonthill Abbey in 1755), launching a subscription for engravings the following year; he was characteristi-

cally original in dispensing with both engraver and printseller, performing these functions himself. Nearly two thousand sets were delivered to the subscribers in 1732, the year of his five-day peregrination to Kent with Samuel Scott and others. As a result of piracies of his engravings Hogarth instigated an Engraver's Copyright Act, delaying the publication of his second great moral series, *A Rake's Progress* (Sir John Soane's Museum, London), until the act became law in 1735. By this time, however, the *Rake* had already been pirated. Also in 1735 he founded the better known St. Martin's Lane Academy, where by all accounts he was an inspiring teacher; the academy quickly became the focus of avant-garde rococo art in Britain.

To forestall the commission's going to a foreigner, Jacopo Amigoni, Hogarth offered to paint without payment two large murals over the staircase of Saint Bartholomew's Hospital; he completed these in 1737. Enraged at the success of another foreigner, Jean-Baptiste van Loo, who had established himself in London in 1737, Hogarth turned to portraiture, and in 1740 presented his deliberately informal full length of Captain Coram to the Foundling Hospital, of which he was a founding governor. With the idea of creating a permanent exhibition where fashionable patrons could admire the best in contemporary British painting, he coordinated the donation by artists of paintings that would hang in the Foundling Hospital offices; the newly decorated Court Room was unveiled in 1747. He also promoted the pictorial decoration at Vauxhall Gardens, the most popular of London's many pleasure gardens, owned by his friend Jonathan Tyers.

In 1743 Hogarth traveled to Paris to hire engravers

for *Marriage à la Mode* (National Gallery, London), published in 1745. The twelve plates of *Industry and Idleness*, cheap engravings intended for a wide public, for which no paintings were produced, followed in 1747. The artist made a second trip to Paris in 1748 and was expelled from Calais, having been accused of spying. The following year he bought a country house in Chiswick (now a Hogarth museum). In 1753 he published his *Analysis of Beauty*, which was mostly favorably received; this appeared also in German, and was later translated into Italian (1761). Hogarth painted *An Election Entertainment* (Sir John Soane's Museum, London) in 1754 (engraved 1758) and completed the triptych altarpiece for Saint Mary Redcliffe, Bristol, in 1756. In 1757 he was appointed Serjeant Painter to the King. He resented Sir Richard Grosvenor's refusal to purchase *Sigismunda* (Tate Gallery, London), which in effect he had commissioned, and became increasingly embittered, a prey to persecution mania. He was ill for a whole year between 1760 and 1761. Although he contributed seven pictures to the Society of Artists exhibition in 1761, his health was in decline, and he died in Leicester Fields on 25 October 1764.

Hogarth held the stage for over thirty years; a diminutive, passionate, and combative man, alert, innovative, and boundlessly energetic, he was a sharp and sardonic observer of the foibles of mankind and keenly sensitive to the social evils of his time. Although intensely patriotic and xenophobic, especially toward the French, he was intimately acquainted with French art and became the principal exponent of the rococo style in Britain.

For his artistic training Hogarth relied upon a personal mnemonic system rather than waste time on an academic education. After a fumbling start he made his reputation as a painter with the conversation piece, a genre introduced into England by Philip Mercier in the mid-1720s. Although he was by far the most distinguished and varied painter in this vein before the advent of Zoffany, he soon gave it up, complaining that the work was "drudgery," since, unlike the common portrait, it "could not be made . . . a kind [of] manufacture."[2] With the example of Thornhill's history painting "running in his head,"[3] and determined to elevate his style, he devised the new genre of "modern moral Subject[s]." These pictures provided more scope for invention, and teemed with life and incident, much of it witty and amusing; they

were also inspired by a serious didactic intention—which led his friend Henry Fielding, in the celebrated preface to *Joseph Andrews*, to describe him as a "Comic History-Painter"—and could be reproduced and sold widely as prints.

Hogarth's style in this new vein was characterized by arresting asymmetrical and perspectival compositions, intricate figure groupings unified by an innate sense of rhythm, and searching psychological insight into the wide range of types from all classes who made up the increasingly complex society of the day. The narrative was heightened by an allusive commentary in the accessory detail extending even to the pictures represented on the walls. In these works Hogarth employed a dainty rococo handling of paint involving rich, gay colors, sparkling highlights, curvilinear contours, and lively arrangements of gently rippling drapery, the whole productive of an animated surface pattern. In his later work he developed a greater breadth of design, lighting, and grouping, with a preference for a single moral confrontation, larger figures, and less clutter in the accompanying detail. The same evolution can be traced in Hogarth's few religious or history paintings, which culminate in the neo-baroque *Sigismunda* (1759), an attempt to engage the passions of the spectator as in a tragedy on the stage.

For Hogarth, with his moral intentions and passionate desire to bring home to people, and to cure, the abuses of his time, reproductive engravings were at least as important as paintings. In the latter part of his career he abandoned the fine engravings offered on a subscription basis in favor of a coarser technique—*The Four Stages of Cruelty* (1751) were first conceived as woodcuts—that emphasized the characters and their expressions. Hogarth always insisted that he was not a caricaturist but was concerned with character. The change was also initiated to produce cheaper prints and wider sales.

Hogarth turned to portraiture in the late 1730s in combative riposte to the success of Van Loo. His smaller scale work, traditional in design, often employing the feigned oval, was fresh and direct in treatment, and characteristically responsive to personality traits especially in the case of sitters similar to himself in outlook. On a larger scale his rococo style, admirably suited to the conversation piece, was at odds with the need to achieve grandeur and dignity.

Hogarth's approach to art, and to the principles of the rococo style in general, were embodied in *The Analysis of Beauty* (1753). This wholly original treatise defined beauty in empirical terms, in opposition to the orthodox arguments of Platonic idealism and of the academic tradition, with its hierarchy of subject matter—arguments later enshrined in Reynolds' *Discourses*. Hogarth's reliance upon the study of nature led to his emphasis on movement and on novel aesthetic categories such as the serpentine line and intricacy, the latter of which, as he wrote in a memorable phrase, "leads the eye a wanton kind of chace."[4]

Hogarth's work and promotional activities had a profound effect on every aspect of art and the art world in Britain in the second quarter of the eighteenth century. Gawen Hamilton and Charles Philips imitated his conversation pieces; Ramsay and the young Gainsborough responded to the directness and psychological insight of his portraiture, his naturalism, painterliness, and informality of composition; paintings of the stage became a popular genre and continued so later in the work of Zoffany and others. But, except for the influence on Greuze of his modern moral subjects, Hogarth's reputation inevitably declined during the neoclassical period. His theory of art, castigated by Reynolds, was not taken up in England until the "rough" picturesque movement associated with Uvedale Price, later being reflected also in Constable's writings; influential in Germany from the 1750s, it prefigured the outlook of the romantic period.

It is, of course, his satiric engravings by which Hogarth has always been best known. Republished by Boydell in 1790, they were deeply influential in the revolutionary and Napoleonic era and were used as source material by artists such as Gillray, Rowlandson, Goya and, later, George Cruikshank. Hazlitt claimed that as a comic author Hogarth was equal to Shakespeare. Like the works of Rowlandson, his satires were shunned in the age of *Punch* and Victorian respectability, and although Hogarth was admired by Daumier and Whistler, his reputation did not revive until the middle of the present century.

Notes

1. *The Autobiographical Notes*, British Library Add. MS. 27,991 (Burke 1955, 216).
2. *The Autobiographical Notes* (Burke 1955, 202).
3. *The Autobiographical Notes* (Burke 1955, 205).
4. *The Analysis of Beauty* (Burke 1955, 42).

Bibliography

Oppé, Adolph Paul. *The Drawings of William Hogarth*. London, 1948.

Burke, Joseph, ed. *William Hogarth: The Analysis of Beauty*. Oxford, 1955.

Antal, Frederick. *Hogarth and His Place in European Art*. London, 1962.

Gowing, [Sir] Lawrence. *Hogarth*. Exh. cat., Tate Gallery. London, 1971.

Paulson, Ronald. *Hogarth: His Life, Art, and Times*. 2 vols. New Haven and London, 1971.

Bindman, David. *Hogarth*. London, 1981.

Einberg, Elizabeth, and Judy Egerton. *The Age of Hogarth*. London (Tate Gallery Collections, vol. 2), 1988: 74–148.

Paulson, Ronald. *Hogarth's Graphic Works*. 3d rev. ed. London, 1989.

1983.1.42 (2917)

A Scene from The Beggar's Opera

1728/1729
Oil on canvas, 51.1 × 61.2 (20⅛ × 24⅛)
Paul Mellon Collection

Technical Notes: The fine canvas is tightly plain woven; it has been lined, but the original tacking margins survive intact. The ground is warm gray and of moderate thickness. There is a thinly applied yellowish green imprimatura. The painting is executed in thin, rich, opaque layers that have an enamellike quality; the figures in the background are sketchily painted. There are pentimenti in the curtain: x-radiographs (fig. 1) reveal that Hogarth originally painted upper center a satyr's head set between swags of drapery—which, as in the Yale version of this subject (fig. 4), would probably have borne the motto of Lincoln's Inn Fields Theater: VELUTI IN SPECULUM UTILE DULCI— suspended on either side of what was presumably, although partially beneath the satyr's head, the royal coat of arms. The highlights of the curtain are executed with what appears to be gold foil toned with glazes. The edging of Macheath's pink coat was originally gilded. The paint surface is slightly abraded and has been slightly flattened during lining. The painting is otherwise in good condition. There are scattered retouches applied to abraded surfaces and some of the cracks. The thin natural resin varnish has not discolored.

Provenance: Edward Cheney[1] (possibly—although, if so, inaccurately described as a "Garden Scene with many figures, in *colours*"—sale, Sotheby & Co., 29 April 1885 et seq., 3rd day, no. 332), bought by (P. & D. Colnaghi & Co.), London. Francis Capel Cure [1854–1933], Badger Hall, near Bridgnorth, Shropshire, by 1905; by descent to his nephew, Nigel Capel Cure [b. 1908], Blake Hall, Ongar, Essex, by 1965.[2] (John Baskett), London, from whom it was purchased June 1975 by Paul Mellon, Upperville, Virginia.

Exhibitions: *Works by the Old Masters and Deceased Masters of the British School*, Winter Exhibition, Royal Academy of Arts, London, 1912, no. 150. *Hogarth*, Tate Gallery, London, 1971–1972, no. 46, repro.

THE SCENE represented is from act 3, scene 11, of *The Beggar's Opera*, a satire on cupidity and double-dealing by John Gay, first produced by John Rich at his Lincoln's Inn Fields Theatre in London in January 1728. Captain Macheath, a highwayman, betrayed by one of his wenches, stands manacled in a cell in Newgate prison between Lucy Lockit and Polly Peachum, rival charmers, both of whom suppose him to be their husband; they are appealing to their respective fathers, the jailer and the informer and fence—who stand to be rewarded for Macheath's hanging—to save him from the gallows. Macheath is standing in the pose of the choice of Hercules: "Which way shall I turn me?—How can I decide?" The central figures are portraits of those who appeared in the production, which Hogarth sketched in performance (fig. 2). Macheath was played by Thomas Walker, and Polly Peachum by Lavinia Fenton.[3] The spectators, privileged members of the audience with boxes on the stage, are also portraits: the man talking to the lady on the extreme left is Sir Thomas Robinson of Rokeby; the figure on the extreme right is Sir Robert Fagg, the noted racehorse breeder; and the slightly foppish figure next to him is Major Robert Paunceford.[4]

For his invention Hogarth responded to the remark in Gay's prologue: "I have a Prison Scene which the Ladies always reckon charmingly pathetick." He painted six small canvases of this scene, of which the Washington picture is the fourth, the most brilliantly handled, and the most expressive. In the first three, all dating to 1728, the cell is comparatively small, the actors dominate the scene, and the spectators to left and right are caricatures; the kneeling Polly Peachum, her head in profile lowered toward her father, who is moving forward, gestures toward Macheath with outstretched right arm and hand (fig. 3): "bring him off at his Tryal—*Polly* upon her knees begs it of you." In the last two—one dated 1729, which was commissioned by Rich, the other ordered in 1729 but still unfinished in 1731—the setting is grander, the figure arrangement is looser and more rhythmical, and the actors are less differentiated from the spectators, who are no longer caricatures but true portraits; Polly, further emphasized, is drooped on a ruffled carpet, imploring her father with both arms outstretched, her left hand

clutching at the hem of his coat, their relationship reminiscent of a *noli me tangere*[5] (fig. 4).

Einberg and Egerton rightly describe the Washington picture, intermediate between these two conceptions, as a "largely abandoned attempt to rethink the groups."[6] The somewhat awkward group of Polly and her father has been better resolved. Polly's arms are in the same positions as in the first design, but she clutches a handkerchief in her right hand (which she holds out toward Macheath, as does Lucy) and is looking upward at her father, her head in three-quarter view. Her father is no longer in motion and, like the jailer, holds up his left hand in refusal of her entreaties. This arrangement was to be changed again, and refined. Lucy's face is seen for the first time and her pose and dress altered, the whole figure constituting a far more affecting and potent image of distress; in the later versions Hogarth reverted to his original conception, presumably to avoid upstaging Polly. This is the only one of the series in which the figures are standing on flagstones, appropriate to a prison, rather than on boards, appropriate to a theater; also unlike the others, the curtain lacks the royal coat of arms, which was painted out. Of particular interest to the theater historian is the presence of an audience at the *back* of the stage as well as at the sides; the patterned pink covering of the "boxes" is continuous, completing a theater in the round.[7] Among the especially striking passages in Hogarth's sketchy treatment of the scene in the Washington version are the broken highlights in Lucy's blue dress and the crisp touch in her white mob cap.

In the late 1720s and early 1730s Hogarth produced a whole range of subjects painted on a small scale: reportage, moral tales, satires, conversation pieces. He was absorbed by the theater early, and *The Beggar's Opera* series, which afforded him unusual scope for invention, marked the swift maturing of his painting style—from the simple and prosaic to one richly rhythmical and expressive. Hogarth was the first English artist to paint theatrical scenes based on actual performance as well as on convention, creating a genre, later popularized by Zoffany, that was to flourish for over a century. But, typically, it was he alone who surrounded his scenes with a fashionable audience, making them, as Gowing remarked, "a profitable kind of conversation piece."[8] Many of Hogarth's narratives have the air of a performance on the stage. As he wrote in his autobiographical notes: "my Picture was my Stage and men and women my actors."[9]

Hogarth's interest in *The Beggar's Opera* was basically antiestablishment. He was clearly sympathetic to Gay's

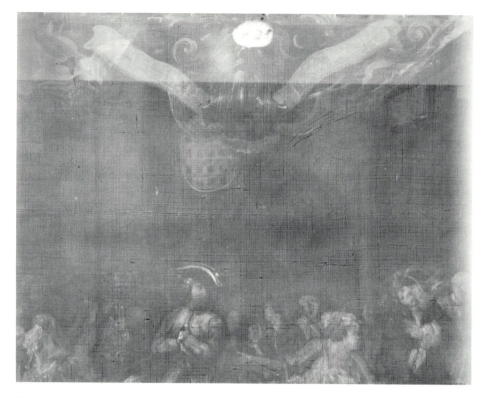

Fig. 1. X-radiograph of 1983.1.42, showing the original concept
for the upper part of the composition

Fig. 2. William Hogarth, *A Scene from* The Beggar's Opera, 1728, black chalk with touches of
white on blue paper, Windsor Castle, Royal Library [reproduced by gracious permission of
H.M. The Queen]

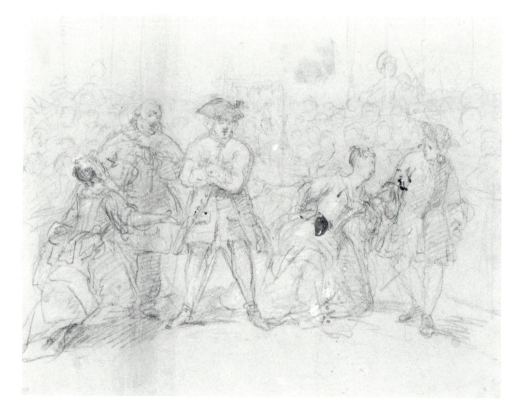

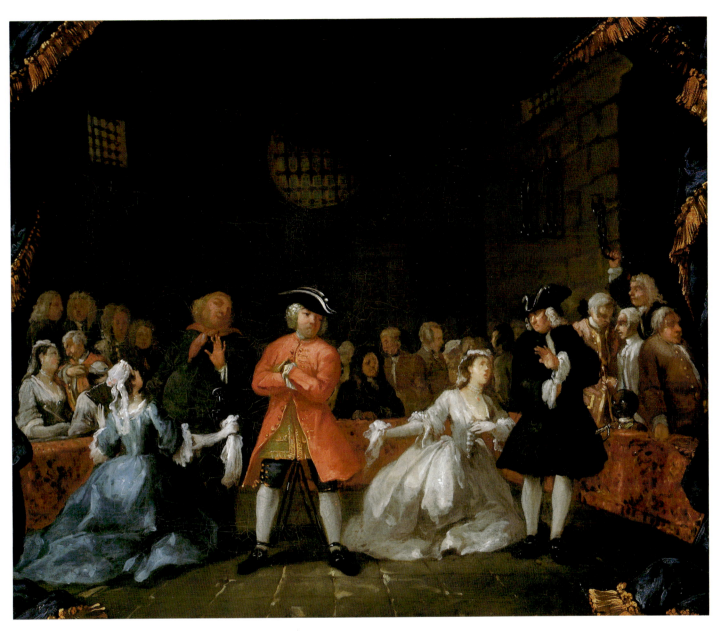

William Hogarth, *A Scene from* The Beggar's Opera, 1983.1.42

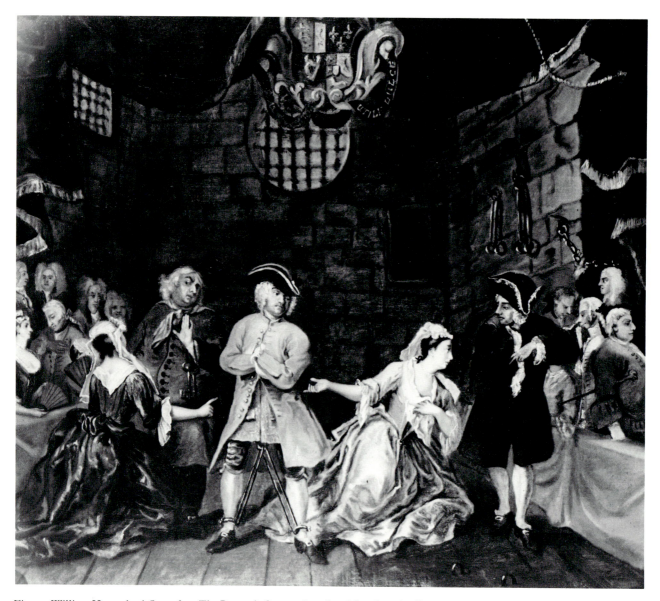

Fig. 3. William Hogarth, *A Scene from* The Beggar's Opera, signed and dated 1728, oil on canvas, Farmington, Connecticut, Lewis Walpole Library

mockery of the corruption of the Walpole administration ("every man has his price"), which resulted in *Polly*, the sequel to *The Beggar's Opera*, described by Hervey as "less pretty, but more abusive, and . . . little disguised,"[10] being banned.[11] No doubt, as a staunch defender of British art, he was stimulated by Gay's satirical view of contemporary Italian opera and his replacement of the foreign with the native British, arias with popular songs, and gods and goddesses with highwaymen and prostitutes. Like Gay he saw no difference in *mores* between the high and low born.

Hogarth frequently used the device of a curtain drawn back to reveal the events that were the subject of his satire, and the curtain in the Washington picture is strikingly close in the rhythms of its arrangement to that used in the print of *The Lottery* (1721). Its uncharacteristically lifeless appearance may be accounted for by the experimental nature of this canvas, especially in this area; Hogarth had originally painted a satyr's head upper center (fig. 1). In the later versions of the composition he included crouching satyrs on the left and right, the latter very prominent, as it were pulling back the curtains on the scene (fig. 4). The audience included in the picture is largely preoccupied with its own concerns rather than

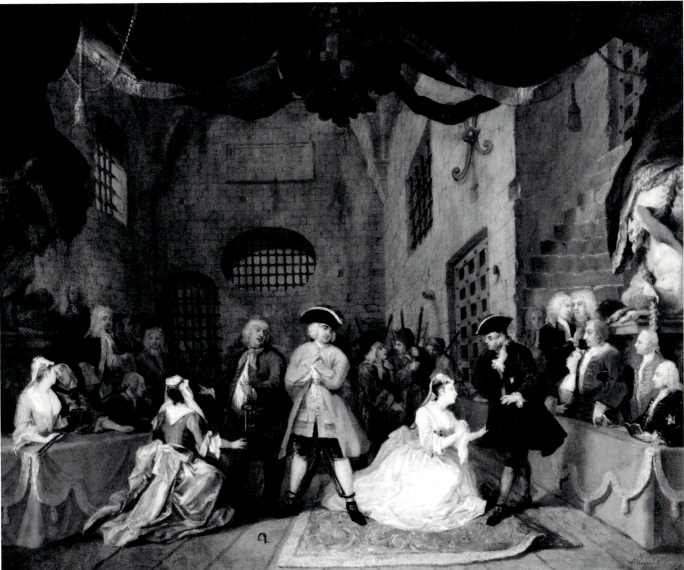

Fig. 4. William Hogarth, *A Scene from* The Beggar's Opera, signed and dated 1729, oil on canvas, New Haven, Yale Center for British Art, Paul Mellon Collection

with the low-life tragedy enacted on the stage; both its presence and its detachment blur the lines between real life and dramatic performance. The black page (who does not feature in any of the other versions) looks on with astonishment. In the last, the most sophisticated paintings in the series, Polly (Lavinia Fenton) is seen gesturing less toward her father than toward her real-life lover, the Duke of Bolton, seated in the audience. The spectators have now become part of the drama; fashionable noblemen are seen to be no better than their social inferiors.[12]

Notes

1. According to Lewis and Hofer 1965, under no. 5.

2. Lewis and Hofer 1965 list the six different versions of the composition, of which one then belonged to Nigel Capel Cure.

3. An old piece of canvas attached to the back of the frame is inscribed in ink: "Sketch by Hogarth of this Scene in the/ Beggars Opera; with the portrait of Walker,/the original representative of Captain Macheath—." The other players depicted are Jane Egleton as Lucy, John Hall as Lockit, and John Hippisley as Peachum (Lewis and Hofer 1965, 10).

4. Paulson 1971 (see biography), 1: 184, 527 (n. 23), following Horace Walpole. Robinson is wrongly identified as Anthony Henley in the key attached to William Blake's engraving of *The Beggar's Opera* (John and Josiah Boydell, *The Original*

Works of William Hogarth [London, 1790]).

5. Gowing 1971 (see biography), 27.

6. Einberg and Egerton 1988 (see biography), 76.

7. Iain Mackintosh, who drew my attention to the significance of this (letter, 24 April 1990), has pointed out how, in Hogarth's drawing (fig. 2), probably his original sketch done *ad vivum* at a performance (and the figure composition of which he broadly followed in the Farmington version, fig. 3), "there appears to have been almost an entire audience to the rear of the actors" ("The Rise and Fall of the Georgian Playhouse 1714–1830—A Cautionary Tale," *Annals of the Architectural Association* 4 [1983], 20, fig. 4). The on-stage audience began to be abolished in the 1750s.

8. Gowing 1971 (see biography), 26.

9. *The Autobiographical Notes*, British Library Add. MS. 27,991 (Burke 1955 [see biography], 109).

10. Romney Sedgwick, ed., *Some Materials towards Memoirs of the Reign of King George II by John, Lord Hervey*, 3 vols. (London, 1931), 1: 98.

11. For a discussion of Gay's political satire in *The Beggar's Opera*, see John Fuller, *John Gay: Dramatic Works*, 2 vols. (Oxford, 1983), 1: 47–48. The work was described at the time as "the most venomous *allegorical libel* against the *G——t* that hath appeared for many Years past" (from *A Key to The Beggar's Opera*, appended to the second edition of *Woman's Revenge*, a play by Christopher Bullock [London, 1728], 72).

12. Charles, 3rd Duke of Bolton (1685–1754), who married Lavinia Fenton after the death of his wife in 1751, was a profligate; he was a vain and troublesome courtier, not overburdened with intellect, who, in spite of holding official positions, was an inveterate opponent of the Prime Minister, Sir Robert Walpole. He won scant respect from any shade of political opinion.

References

1965 Lewis, Wilmarth Sheldon, and Philip Hofer. *"The Beggar's Opera" by Hogarth and Blake*. Cambridge, Massachusetts, New Haven, and London, 1965: no. 5, pl. 5.

1971 Paulson 1971 (see biography): 185, pl. 63.

1978 Webster, Mary. *Hogarth*. London, 1978: no. 6, repro., 13–14.

1981 Bindman 1981 (see biography): 32–36.

1988 Einberg and Egerton 1988 (see biography): 76, fig. 29.

John Hoppner

1758 – 1810

HOPPNER was born in London on 4 April 1758, the son of John Hoppner and Mary Anne, whose maiden name is unknown but who was of German extraction. His father was a surgeon who, according to Hoppner's son, had accompanied George II, as physician to the household, on one of the king's journeys from Hanover to England; Hoppner himself, however, encouraged the belief—rife in his lifetime—that he was a natural son of the king's grandson, the future George III. As a chorister of the Chapel Royal Hoppner would have received a sound education. He entered the Royal Academy Schools in 1775, and was awarded the Academy's silver medal in 1778 for a drawing from life, and its gold medal in 1782 for a painting from a scene in *King Lear*.

In 1781 Hoppner married Phoebe, the youngest daughter of a Mr. Wright, an American, whose wife, Patience (who emigrated to England after his death), was an ardent American patriot and a celebrated hostess and wax portraitist. There were five children. In 1784 he settled on Charles Street, between the Haymarket and St. James's Square, where he fitted up a handsome studio and gallery; he remained there, practising as a portrait painter, for the rest of his life. By 1784, in spite of the *froideur* caused by his marriage, he was working for Queen Charlotte; he was successively Portrait Painter (1789) and Principal Painter (1793) to the Prince of Wales, and was patronized by the Carlton House set. But for Lawrence, a brilliant young artist who became the talk of the town in 1790, he would have been the uncontested successor to Reynolds.

Hoppner became an Associate of the Royal Academy in 1793, and a full Academician in 1795, having been defeated by Lawrence in the previous year. He exhibited at the Royal Academy from 1780 until 1809, and from the early 1790s he, Beechey, and Lawrence were rivals in portraiture, competing at the annual Academy exhibition and dividing the favors of society among them. Farington noted in 1797: "Hoppner has a full tide of success. Has many Copies to make—money witht. trouble—G [possibly George Garrard] assists him—very bad—Owen also assists him."[1] Until this date Hoppner had worked without assistants; he took on a pupil, Henry

Salt, in 1800. There is no complete record of the prices Hoppner charged, but Farington noted in 1798 that "he has raised his price to that of Beechy [sic] & Lawrence—30 gs. head—120 whole length,"[2] and in 1802 that he was about to raise his price for a head and shoulders to thirty-five guineas, as Beechey had done. By 1808 he was charging fifty guineas for a portrait of this size, as Beechey was to do in 1810. Plagued with prolonged ill health, Hoppner seems to have been of an irritable and spiteful disposition. He wrote art criticism for the *Morning Post*, which was often vitriolic, and, one of the best-informed painters of his time, became a contributor to the new *Quarterly Review* in 1809. He died in London on 23 January 1810, his death hardly noticed; his first biographer was Allan Cunningham, in 1829.

Hoppner formed his style on those of Reynolds and Romney, and was at his best in the first half of his career. The firm drawing and characterization, detailed delineation of costume, and the unusually elaborate and particularized landscape backgrounds that are a distinctive feature of his earlier work subsequently gave way to a more facile and slipshod style. Farington reported Sir George Beaumont as saying in 1806 that Hoppner was "more remarkable for *peculiarity* than for *originality*, or any great power."[3] Hoppner never sought to emulate the sparkling facture of Lawrence, but his use of low viewpoints, the way he outlined figures against the sky, and his portraits of women in flowing white dresses, which elongated the figure and hid the absence of form beneath, demonstrate the influence of Lawrence. He was at his best on a small scale.

Hoppner followed Reynolds as an accomplished painter of appealing and sometimes animated groups of children. His fancy pictures are sentimental, in the tradition of Greuze and Francis Wheatley, and the nudes in his occasional mythological works graceful in conception; by contrast, his single commission for John Boydell's Shakespeare Gallery, a scene from *Cymbeline*, is melodramatic, and his *Gale of Wind* (Tate Gallery, London), exhibited at the Royal Academy in 1794, stormy and romantic. He also executed a number of imaginary pastoral landscape drawings in the manner of Gainsborough. Hoppner's work is in need of reassessment, and a study by John Wilson has recently been completed.[4]

Notes

1. Farington *Diary*, 3:868 (11 July 1797).
2. Farington *Diary*, 3:1017 (6 June 1798).
3. Farington *Diary*, 7:2735 (26 April 1806).
4. Dr. Wilson kindly read this and the succeeding Hoppner entries, and answered specific queries.

Bibliography

Monkhouse, Cosmo. In *Dictionary of National Biography*. Volume 27. London, 1891: 342–343.
McKay, William, and William Roberts. *John Hoppner, R.A.* London, 1909. Supplement, 1914.
Millar, Sir Oliver. *The Later Georgian Pictures in the Collection of Her Majesty the Queen*. 2 vols. London, 1969, 1: 50–55.
Wilson, John H. "The Life and Art of John Hoppner (1758–1810)." Ph.D. diss., Courtauld Institute of Art, 1992.

1979.65.1 (2770)

Lady Cunliffe

1781/1782
Oil on canvas, 76.7 × 64 (30¼ × 25¼)
Gift of Josephine Tompkins

Technical Notes: The canvas is twill woven; it has been lined. The ground is white, of moderate thickness. The painting is executed thinly and fluidly in opaque layers blended wet into wet; transparent glazes are used in the flesh tones. With the exception of the features and hat, contours are blended and imprecise. There is a pentimento in the ribbon descending from the left side of the sitter's hat, which originally extended half an inch lower. There is light abrasion of the glazes in the face, and the impasto has been slightly flattened during lining. There are no retouchings in the figure; there is extensive repainting in the bottom left corner, but it is uncertain whether the uniform appearance of the background is due to good condition or to extensive repaint. The thick natural resin varnish has discolored yellow; the residues of an earlier varnish are very dark.

Provenance: Painted for the sitter's husband, Sir Foster Cunliffe, 3rd Bt. [1755–1834], Acton Park, Wrexham, Denbighshire; by descent to Sir Robert Cunliffe, 7th Bt. [1884–1949]. (Lewis & Simmons), Paris, 1928. Mrs. Vivian B. Allen, New York; by descent to her granddaughter, Josephine Tompkins, New York.

Exhibitions: Royal Academy of Arts, London, 1782, no. 89, as *Portrait of a young lady*. *Works by the Old Masters, and by Deceased Masters of the British School*, Winter Exhibition, Royal Academy of Arts, London, 1877, no. 266. *Fair Women*, Grafton Galleries, London, 1894, no. 82.

HARRIOT KINLOCH (d. 1830), a woman of great accomplishment, daughter of Sir David Kinloch, Bt., of

Gilmerton, East Lothian, married Sir Foster Cunliffe in 1781. Sir Foster, noted as a picture collector, was best known for introducing the sport of archery into Cheshire and for founding, in 1787, the Society of Royal British Bowmen.

Lady Cunliffe sat to Hoppner twice, once in 1781 or 1782 for this portrait, and once in about 1787 for a grand full length (whereabouts unknown) in which she is depicted with pensive expression, holding a book. This is a companion to an equally grand full length of her husband holding a bow in his left hand and taking an arrow from a quiver with his right (with Leger Galleries, London, 1989).

Both portraits of Lady Cunliffe are, in their different ways, characteristic of the age of *sensibilité*. The National Gallery's picture is a marriage portrait, identifiable from the description in the *London Courant*[1] as the portrait exhibited at the Royal Academy of 1782. It soon acquired the status of a fancy picture, however, since, as pointed out by McKay and Roberts, two years later it was engraved under the name of *Sophia Western*, the heroine of Henry Fielding's novel *Tom Jones*[2]; this title was presumably acceptable to the sitter, who seems to have been of a literary disposition.

The firm modeling, direct gaze, and forward-leaning pose making contact with the spectator are characteristic of Hoppner's early, unsophisticated style. The gentle expression relates to the world of Wheatleyesque sentiment, while the lively handling of paint in the costume, the shadows cast over the forehead by the broad-brimmed hat, and the soft chiaroscuro derive from Reynolds' work of the previous years.

The mezzotint by John Raphael Smith, entitled *Sophia Western*, was published on 25 September 1784.

Notes

1. "A girl sitting; a full front face, drest in a yellow bonnet, trimmed with black gauze; a very good picture" (*London Courant*, 4 May 1782). The description of the gauze is incorrect; it is in fact cream colored.

2. McKay and Roberts 1909 (see biography), 310. John Wilson has recently argued that, as previously assumed, J. R. Smith's engraving of 1784 was actually made from the similar portrait of Miss Bailey exhibited at the Royal Academy that year (Wilson 1992, [see biography], 264). This portrait is now lost, but one of E. F. Burney's watercolors of the Royal Academy installation of 1784, an invaluable record (Huntington Art Gallery, San Marino), shows what the picture looked like. *Miss Bailey* differs from the engraving in several respects: her dress is not décolleté, she is not resting her arms on a ledge but at a table, and there are no folds at the lower left linking her with the spectator. However, her head *is* tilted to the left, as in the engraving, but not as in *Miss Cunliffe*. Possibly the idea of engraving the portrait of Miss Cunliffe, with a more wistful turn of the head, was stimulated (perhaps by Miss Cunliffe herself) by the exhibition of *Miss Bailey*, a work praised by the critics.

References

1782 *London Courant*, 4 May 1782.
1909 McKay and Roberts 1909 (see biography): 60, 310.
1992 Wilson 1992 (see biography): 133–134, 263–264.

1942.9.35 (631)

The Hoppner Children

1791
Oil on canvas, 152.5 × 127 (60 × 50)
Widener Collection

Technical Notes: The medium-coarse canvas is tightly twill woven; it has been lined, but the tacking margins survive intact. The ground is white, of moderate thickness. There is a fairly thin medium gray imprimatura. These two layers mask much of the weave of the fabric. The painting is executed in moderately thick opaque layers with no notable areas of impasto; thinner layers of more transparent glazes modify the foreground and background landscape and shadowed areas and details of the figures. There is a broad craquelure. The paint is abraded and damaged in the region of the sky and the figures, but areas of retouching are not apparent through the discolored varnish. The paint surface has been flattened slightly during lining. The moderately thick slightly toned natural resin varnish has discolored yellow to a significant degree.

Provenance: The artist's wife [d. 1827]; bequeathed to her eldest son, Catherine Hampden Hoppner; bequeathed to his brother, Richard Belgrave Hoppner [d. 1872] (sale, Christie, Manson & Woods, London, 25 March 1893, no. 358, as *The Hoppner Children*); bought by (Thos. Agnew & Sons), London, who sold it to (M. Knoedler & Co.),[1] from whom it was purchased 1893 by P. A. B. Widener, Elkins Park, Pennsylvania. Inheritance from the Estate of Peter A. B. Widener by gift through power of appointment of Joseph E. Widener, Elkins Park.

Exhibitions: Royal Academy of Arts, London, 1791, no. 151, as *Portraits of children. L'Art Rétrospectif*, Palais de Versailles, 1881, no. 861.

THE SITTERS are Hoppner's three eldest children, Catherine, Richard, and Wilson, then aged seven, five, and three respectively. Catherine is shown on the right, Richard on the left, and Wilson in the center. McKay and Roberts' assertion, based on family tradition, that the boy in the middle is Henry[2] is ruled out by the fact

John Hoppner, *Lady Cunliffe*, 1979.65.1

Fig. 1. Sir Joshua Reynolds, *The Lamb Children*, 1785, oil on canvas, Firle Place, Viscount Gage [photo: Edward Reeves]

that he was not born until 1795, several years after the picture was painted. Catherine Hampden (1784–1845) became a magistrate in the service of the East India Company; Hoppner later painted a separate portrait of him at half length in an Eton jacket (he was at Eton from 1796 to 1799). Richard Belgrave (1786–1872) entered the diplomatic service, was consul at Venice for just over ten years, and was an intimate friend and correspondent of Byron. Wilson Lascelles (1788–after 1827) became a painter, but did not distinguish himself.

The identification of this group portrait as of Hoppner's children is established in the family provenance.[3] None of the critics of the Royal Academy exhibition of 1791 made the identification, nor is the title of Ward's mezzotint of 1799 specific.

The portrait shows the three children preparing to bathe; Catherine is just unbuttoning his jacket. Richard is gazing up at his elder brother, and Catherine is looking out at the spectator, his relationship to his siblings similar to that of the boy on the right in *The Douglas Children* (private collection, England; repro. page 134), which Hoppner exhibited in 1795. John Wilson, noting the inspiration from Titian's *Concert Champêtre* (Louvre) of a picture of nude and clothed figures in a richly painted landscape, has pointed out that Wilson's head, with its odd downward gaze, is placed in exactly the same pose as that of the central figure on the grass in Titian's painting.[4] The grouping is somewhat static, the trees obvious compositional supports, and the principal light in the sky an equally obvious compositional device by comparison with the Reynolds group portraits of children in a landscape setting (fig. 1), from which the genre derives.[5] As so often with Hoppner, the landscape background is elaborate and finely rendered.

A mezzotint in reverse by James Ward, entitled *Children Bathing*, was published by Ward and Co., 1 April 1799.

Notes

1. M. Knoedler & Co. stock books, recorded by The Provenance Index, J. Paul Getty Trust, Santa Monica, California.
2. McKay and Roberts 1909 (see biography), 127.
3. See also J. Sewell, "Gainsborough's 'Blue Boy,'" *Notes and Queries*, 4th ser., 11 (21 June 1873), 505.
4. Wilson 1992 (see biography), 169.
5. A contemporary critic wrote: "The excellence of the late President in portraying the *infantine character* has been often admired, and we must do Mr. HOPPNER the justice of acknowledging that he follows his great predecessor, in this respect, with peculiar success" (*True Briton*, 13 May 1795, repeated in the *Sun*, 22 May 1795).

References

1909 McKay and Roberts 1909 (see biography): 127–128, 316, 336, repro. opposite 130.
1915 Roberts 1915: unpaginated, repro.
1939 Tietze, Hans. *Masterpieces of European Painting in America*. London, 1939: 325, repro. 233.
1976 Walker 1976: no. 519, color repro.
1992 Wilson 1992 (see biography): 169–170, 183–184.

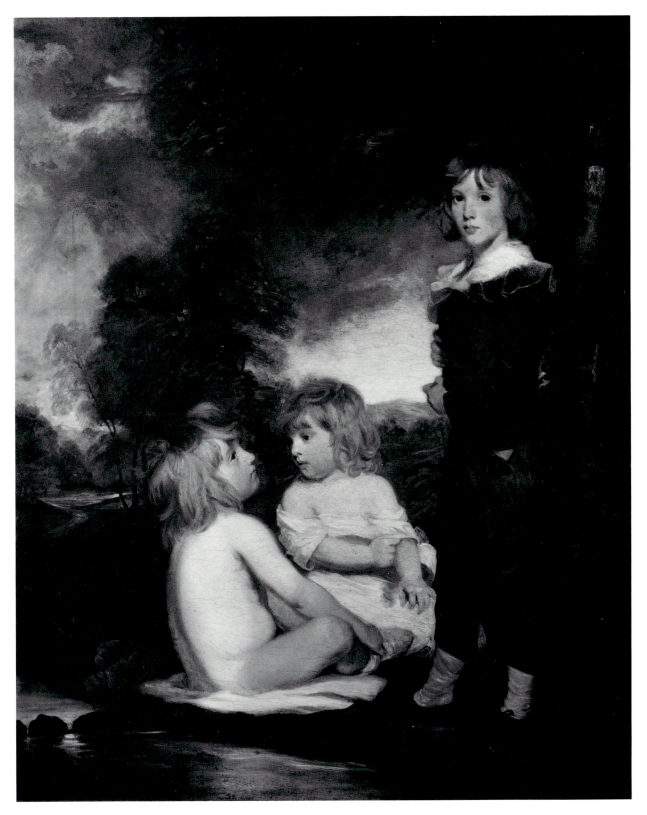

John Hoppner, *The Hoppner Children*, 1942.9.35

1937.1.111(111)

The Frankland Sisters

1795
Oil on canvas, 155 × 125 (61 × 49¼)
Andrew W. Mellon Collection

Inscriptions:
In a later hand, at lower left: *MARIANNE & AMELIA/DAUGHTERS OF SIR T. FRANKLAND OB* 1795 & 1800
at lower right: HOPNER [sic]

Technical Notes: The medium-lightweight canvas is twill woven; it has been lined. There are stretcher creases along the top, left, and bottom edges; the variance in distance between each crease and the edge of the painting, and the absence of a crease along the right edge, suggest that the painting has been cut down on these three sides. The ground is white, of moderate thickness, and almost masks the weave of the canvas. Layers of gray and pale-brown paint observed beneath the surface paint

of the clouds and sky suggest that an imprimatura has been selectively applied. The painting is executed in thin, multiple, opaque layers in the figures with some thicker brushwork but without high impasto; the foreground and background landscape is rendered in dark translucent layers with opaque touches for details of the foliage. The paint surface is moderately abraded and has been flattened slightly during lining. There is a considerable degree of traction crackle throughout, suggestive of the presence of bitumen; this has been extensively overpainted, and there are losses to the paint surface. There are also extensive retouchings in some of the principal features, such as the dog and details of the hands, drapery, and background. The natural resin varnish has discolored yellow slightly.

Provenance: Painted for the sitters' father, Sir Thomas Frankland, 6th Bt. [1750–1831], Thirkleby, Yorkshire; by descent to his granddaughter, Rosalind Alicia Frankland-Russell-Astley [d. 1900], Chequers Court, Buckinghamshire, who sold it c. 1896 to (Thos. Agnew & Sons), London, from whom it was purchased 1896 by John H. McFadden. Presumably sold back to (Thos. Agnew & Sons), London, from whom it was purchased 1898 by Sir Charles Tennant, Bt. [1823–1906], Glen,

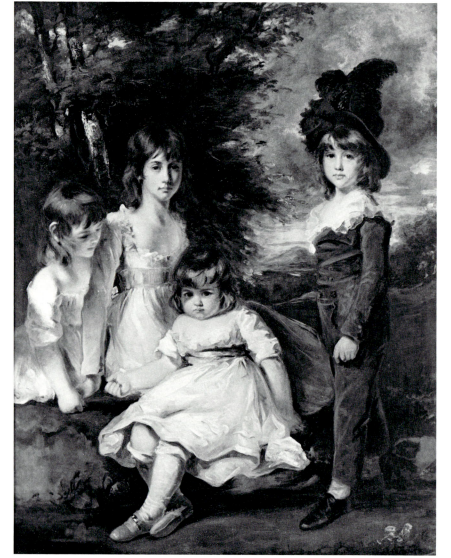

Fig. 1. John Hoppner,
The Douglas Children, R.A. 1795,
oil on canvas,
England, private collection
[photo: Anthony Hamber]

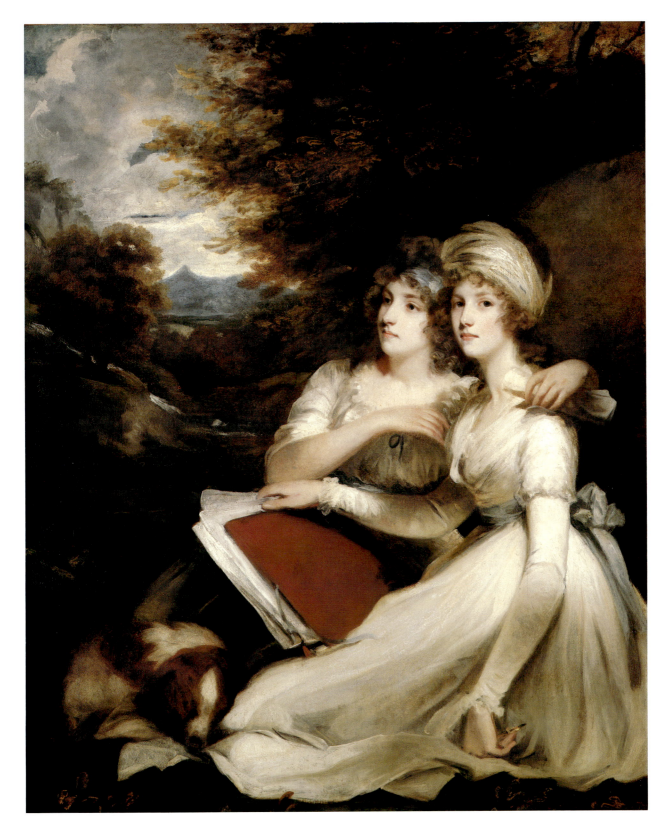

John Hoppner, *The Frankland Sisters*, 1937.1.111

Innerleithen, Peebles;[1] by descent to his grandson, Christopher, 2nd Baron Glenconner [1899–1983], who sold it July 1923 to (Charles Carstairs[2] for M. Knoedler & Co.), London, from whose New York branch it was purchased November 1923 by Andrew W. Mellon, Pittsburgh and Washington, by whom deeded December 1934 to The A. W. Mellon Educational and Charitable Trust, Pittsburgh.

Exhibitions: Royal Academy of Arts, London, 1795, no. 90, as *Portraits of young ladies*. *Twenty Masterpieces of the English School*, Thos. Agnew & Sons, London, 1896, no. 10. *Paintings by French and British Artists of the 18th Century*, Art Gallery and Museum, Glasgow, 1902, no. 109. *Loan Collection of Portraits*, City Museum and Art Gallery, Birmingham, 1903, no. 32. *Inaugural Exhibition of Pictures*, Laing Art Gallery, Newcastle-upon-Tyne, 1904, no. 20. *Works by the Old Masters and Deceased Masters of the British School*, Winter Exhibition, Royal Academy of Arts, London, 1906, no. 79. *Franco-British Exhibition*, Fine Art Palace, Wembley, London, 1908, no. 74 (illustrated review, repro. cover, 25). *Ten Paintings from the Tennant Glenconner Collection*, M. Knoedler & Co., New York, 1924, no. 1.

THE SITTERS ARE, on the right, Amelia (1777–1800) and, on the left, Marianne (1778–1795), the daughters of Sir Thomas Frankland, a descendant of Oliver Cromwell. Both daughters died of consumption, Marianne shortly after the portrait was painted; neither was married. Hoppner, in a letter of condolence to his patron in 1795, described Frankland's surviving daughter as one "whose talents, whose disposition, every way fits her to receive your undivided affection."

The critic of the *St. James's Chronicle*, who, among others, identified this work at the Royal Academy exhibition of 1795, wrote that it "does the Artist great credit: the Group is natural and graceful; the heads are sweetly painted; and there is a hue of colour and keeping in the effect that is charming."[3] The painting seems to have been exhibited as a companion to *The Douglas Children* (fig. 1).[4] The portrait is indeed idyllic in conception; Shawe-Taylor equates it with Gainsborough's *The Linley*

Sisters (1772; Dulwich Picture Gallery).[5] Amelia, who is looking out at the spectator, holds a portfolio of sketches in her right hand and a crayon for drawing in her left. Her sister, Marianne, leans affectionately toward her with her arm around her shoulder. A spaniel is asleep at their feet. The Titianesque landscape background, with its waterfall and its mountainous distance reminiscent of Claude, is overtly picturesque. The falling water is counterbalanced by the sweep of Amelia's dress. The work ranks as one of Hoppner's masterpieces.

A mezzotint by William Ward was published 1 March 1797.

Notes

1. Geoffrey (later Sir Geoffrey) Agnew, *Agnew's 1817–1967* (London, 1967), 36, pl. The plate records J. H. McFadden and Sir Charles Tennant as the owners in 1896 and 1898 respectively.

2. Dugdale 1971, 11–12. A group of ten paintings was purchased by Carstairs in July 1923 and was exhibited in 1924 at Knoedler's new headquarters in New York, from whence the Hoppner was purchased by Andrew Mellon shortly before the exhibition.

3. *St. James's Chronicle*, 5–7 May 1795; see also the *Morning Post*, 6 and 27 May 1795.

4. *Morning Post*, 27 May 1795.

5. Shawe-Taylor 1990, 137.

References

1795 *St. James's Chronicle*, 5–7 May 1795.
1795 *Morning Post*, 6 and 27 May 1795.
1909 McKay and Roberts 1909 (see biography): vii, 87–88, repro. opposite 86.
c. 1910 *Catalogue of Pictures in the Tennant Gallery 34 Queen Anne's Gate, S.W.* London, n.d. [c. 1910]: 7, 19, color frontispiece.
1949 Mellon 1949: no. 111, repro. 121.
1971 Dugdale, James. "Sir Charles Tennant: The Story of a Victorian Collector." *Conn* 178 (1971): 2, color repro., 6, 12.
1976 Walker 1976: no. 521, color repro.
1990 Shawe-Taylor, Desmond. *The Georgians: Eighteenth-Century Portraiture and Society*. London, 1990: 137, fig. 93.
1992 Wilson 1992 (see biography): 32, 185, 219.

Attributed to John Hoppner

1956.9.3 (1450)

Portrait of a Gentleman

c. 1810/1815
Oil on canvas, 76.5 × 63.3 (30⅛ × 24⅞)
Gift of Howard Sturges

Technical Notes: The canvas is plain woven; it has been lined. The ground is white, thinly applied. There is a very thin imprimatura of a warm golden brown. The placement of the head and coat is loosely sketched in very fluid, thinned paint. The painting of the head, cravat, and collar is executed in thicker, opaque layers, blended wet into wet. The paint surface has been flattened during lining. Paint loss is minimal; there are scattered retouchings. A deep reddish brown glaze applied throughout to cover cracks, probably during an early restoration, was removed in large part from the head and cravat and thinned elsewhere when the painting was lined, restored, and revarnished in 1956; a deep blue-black glaze similarly applied to cover cracks in the collar has been abraded. The synthetic clear resin varnish has not discolored.

Provenance: (Bellas), France.[1] R. M. Smith, who sold it 1924 to (Thos. Agnew & Sons), London, as a portrait of John Fawcett by Romney; sold 1925 to Howard Sturges [d. 1955], Providence, Rhode Island, as by Hoppner.[2]

THE TRADITIONAL identification as John Fawcett, the actor, is generally agreed to be untenable. More recently it has been suggested[3] that the sitter is Lord Brougham

Attributed to John Hoppner,
Portrait of a Gentleman, 1956.9.3

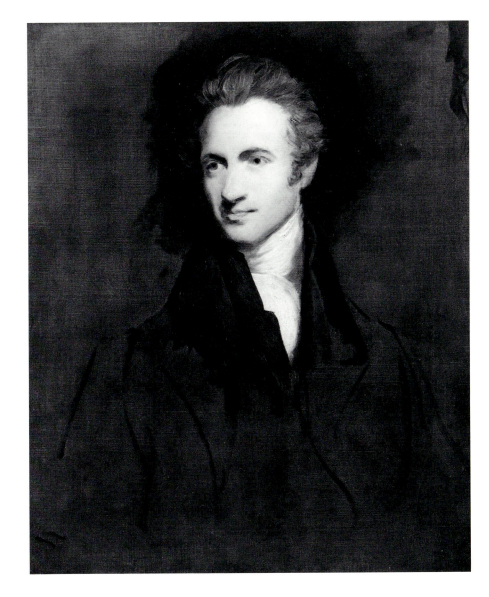

(1778–1868), the great lawyer, but the features do not bear any resemblance to him, either. The high stand collar and loosely dressed hairstyle with side whiskers in imitation of the military suggest a date for this portrait of about 1810 to 1815.

The traditional attribution to Romney, no longer accepted, is ruled out by the evidence of costume. Since the picture has been in Washington, attributions to a follower of Lawrence and to William Owen (1769–1825), Lawrence's contemporary, have been proposed by John Baskett and Graham Reynolds respectively.[4] Owen's style is, however, generally harder and less sensitive; and the technique does not resemble that of Lawrence. The portrait is more obviously within the orbit of Hoppner. Although the head and cravat have been brought to a high degree of finish, the imprimatura is largely unpainted and most of the costume no more than outlined; the work presumably, therefore, never left the artist's studio.

Notes

1. A Chenue label on the back of the stretcher is inscribed in ink: "Monsieur Bellas/pour Londres." Bellas was probably a dealer; the picture was exported as part of a consignment of at least two cases.

2. Information from Thos. Agnew & Sons, kindly supplied by Evelyn Joll. An old label on the back of the frame bears the implausible identification: "George Fawcett Esqe/G. Romney." "George" would seem to be an error for "John."

3. In a draft NGA catalogue entry by Ross Watson, 30 September 1968, in NGA curatorial files.

4. Verbal opinions, the latter with a question mark, recorded in a memorandum, 6 November 1964, by Perry B. Cott, in NGA curatorial files.

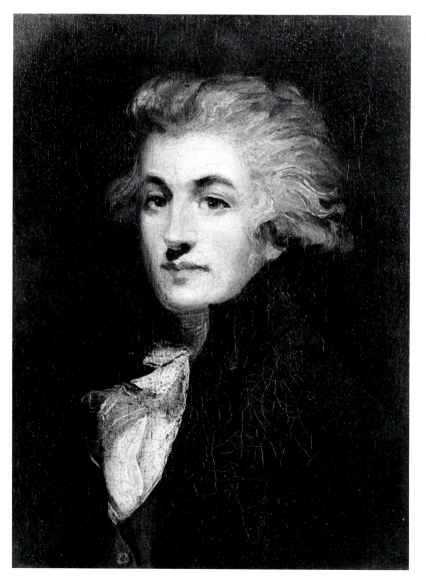

Style of John Hoppner,
Portrait of a Gentleman, 1970.17.106

Style of John Hoppner

1970.17.106 (2478)

Portrait of a Gentleman

c. 1790
Oil on canvas, 20.6 × 15.3 (8⅛ × 6)
Ailsa Mellon Bruce Collection

Technical Notes: The medium-thick canvas is plain woven; it has been lined, but the tacking margins survive intact. The proprietary ground is white, of moderate thickness. The background was blocked in, leaving open the area to be filled by the figure. The painting is executed in very fluid, opaque layers, blended wet into wet in the flesh tones and much of the hair, but with the features, details, and final highlights added over the dried base layer. The paint surface is heavily abraded and pitted. There are extensive retouchings and reglazing from at least two restorations. The natural resin varnish, pigmented with black, has discolored yellow; there are residues of an earlier deep brown varnish.

Provenance: Ailsa Mellon Bruce, New York.

NOTHING is known about the sitter. The type of high stand collar and the natural hair, loosely frizzed with tight side curls, suggest a date for the portrait of about 1790.

The portrait was attributed to John Downman when it was in Mrs. Bruce's collection, but Downman's technique is crisp and linear. The style is closest to that of Hoppner, though the execution is inferior and the technique uncharacteristic.

Joseph Bartholomew Kidd
1808 – 1889

KIDD WAS BORN IN 1808, perhaps in Edinburgh. Nothing is known of his parentage or education, but he became a pupil of the Reverend John Thomson of Duddingston. He was a founder Associate of the Royal Scottish Academy in 1826 and was elected a full Academician in 1829. In 1830 he was commissioned by John James Audubon to paint copies of one hundred of Audubon's drawings of birds, but his dilatoriness caused Audubon to terminate this undertaking in December 1833. Kidd practised as a landscape painter in Edinburgh until about 1835, when he sailed to Jamaica, remaining there on and off until 1843 (he visited New York in 1837 and traveled to London between 1839 and 1840).[1] His views of Jamaica were engraved between 1838 and 1840. He had resigned from the Royal Scottish Academy in 1838 and, after his return to Britain in 1843, he settled in Greenwich as a drawing master and lived there for the rest of his life. He died in Greenwich in May 1889.

Kidd's topographical views are tightly executed and crammed with detail. He painted romantic Highland scenes in a somewhat schematic style, but with a concern for effects of light and a roughness of touch influenced by Thomson of Duddingston. Very little of his work has been identified, however, and it is impossible to chart the development of his style in what was presumably a long career.

Notes
1. Information supplied by Mary Tyler Winters, a descendant of Audubon, who very kindly read and commented on the draft of this biography and the ensuing four entries (notes to the author, 2 April 1990).

Bibliography
Cust, Sir Lionel. In *Dictionary of National Biography*. Volume 31. London, 1892: 92.
Reynolds, Gary A. *John James Audubon & His Sons*. Exh. cat., Grey Art Gallery and Study Center, New York University. New York, 1982: 43–47.
Winters, Mary Tyler. *The Oil Paintings of the Audubon Family and Related Artists*. Princeton, forthcoming.

1951.9.7 (1075)

Orchard Oriole

1830/1832
Pencil and oil on canvas, 66.4 × 52.1 (26⅛ × 20½)
Gift of E. J. L. Hallstrom

Technical Notes: The light canvas is plain woven; it was lined in 1955. The ground is white, thinly applied. There is a light-colored imprimatura. The forms are underdrawn with a light pencil contour line. The painting is executed in thin, smooth layers ranging from opaque to translucent; the landscape is sketchily painted in thin, translucent glazes. There is extensive craquelure, and scattered retouching, now discolored, was carried out throughout the background and in the nest during restoration in 1955. The synthetic varnish has discolored to a moderate degree.

Provenance: Painted for John James Audubon [1785–1851]; by descent to Leonard Benjamin Audubon, Sydney, Australia, who sold it 1950 to Edward (later Sir Edward) Hallstrom, Sydney, Australia.

FIVE ORIOLES (adult males upper left and bottom, second- and third-year males upper right and left center, and a first-year female right center) are painted in the picture plane around a bird's nest among a pattern of branches and leaves, with a rhythmical hilly landscape beneath. The nest, which was drawn by Audubon in Louisiana, is supported only on the outer edges, and is set among the drooping branches of a honey locust, one of the trees favored by orioles.

In part, presumably, to enlist subscribers for his *Birds of America*, but in part for immediate profit, Audubon planned a perpetual exhibition of oil copies of his original drawings as early as 1828. At that time he seems to have had a pupil in mind for this task. On 26 November 1830 he made an agreement with J. B. Kidd, a young Scottish Academician whom he had first met in Edinburgh in 1827, conceivably the pupil of whom he had then spoken, "to copy some of my drawings in oil, and to put backgrounds to them, so as to make them appear like pictures. It was our intention to send them to the exhibition for sale, and to divide the amount between us. He painted eight, and then I proposed, if he would paint the one hundred engravings which comprise my first volume of the 'Birds of America', I would pay him one hundred pounds."[1] Although, eventually, ninety-four copies were completed, including some subjects from the second volume of *Birds of America*,[2] work did not proceed with the dispatch Audubon required. "Push

Jos. B. Kidd of Edinburgh if he *can* be pushed to paint copies of our drawings. I look on that series as of great importance to us all," Audubon wrote to his son Victor (whom he had sent to Edinburgh to supervise the printing and engravings for *The Birds of America*) from Boston in February 1833.[3] In September he was still imploring, but, after discovering that Kidd was working for other publishers,[4] he wrote to Victor from Charleston in December of that year, instructing him to terminate the enterprise: "*take all* the pictures from him, *by goodwill or otherwise*, and *give him no more originals to copy*."[5]

The National Gallery's study had traditionally been attributed to Audubon, but was correctly attributed to Kidd by Alice Ford[6] and Edward H. Dwight;[7] Waldemar H. Fries listed it as probably by Kidd.[8] The work was catalogued as Kidd by Campbell in 1970[9] and by Wilmerding in 1980.[10] The fluent, atmospheric treatment of the landscape is characteristic of Kidd and quite different from the schematic style of Audubon.[11] The canvas is one of the two sizes that in 1830 Audubon, writing from Edinburgh, had asked Robert Havell, the engraver,

Fig. 1. John James Audubon, *Orchard Oriole*, signed and dated 1822, pencil, watercolor, and gouache, New York, New-York Historical Society

Joseph Bartholomew Kidd, *Orchard Oriole*, 1951.9.7

to procure for him;[12] the stamps on the back of the original canvas[13] also indicate that it was of British origin.

The Washington picture would seem to have been executed by the beginning of 1832, as Kidd wrote to Havell on 24 January of that year listing the Orchard Oriole as among those drawings by Audubon that he had completed and stating that if these subjects were among those Havell required for engraving, he could "have them immediately."[14] Audubon's original watercolor, which he inscribed: *Louisiana April 12th 1822*, is in the New-York Historical Society (fig. 1).

The painting is almost identical (except for the inclusion of sky and landscape) with Audubon's watercolor and with plate 42 of *The Birds of America*,[15] engraved by Robert Havell, Jr., and printed and colored by Robert Havell, Sr., 1828. The underdrawing is very precise and was probably executed from Audubon's original drawing with some mechanical aid. As is shown by infrared reflectography, the underdrawing is identical in all four of the National Gallery's paintings after Audubon, providing corroborative internal evidence that the works are all by the same hand.

Notes

1. Journals, 20 March 1831; quoted in Lucy Bakewell Audubon, ed., *The Life of John James Audubon, the Naturalist* (New York, 1869), 206–207. The contract (Morris Tyler Gift, Beinecke Library, Yale University; published by Ford 1964, 438) was signed by Kidd on 26 November 1830. Winters (see biography) has pointed out that Lucy Audubon was obliged to rely heavily on her memory for her biography, as the materials she had sent to England to assist Robert Buchanan, Audubon's English biographer, were never returned. "There is no mention of profit sharing with Kidd in Audubon's writings. He paid Kidd 1 pound per picture and owned them outright after their purchase" (notes to the author, 2 April 1990).

2. Winters (see biography), notes to the author, 2 April 1990.

3. Audubon to Victor Audubon, 5 February 1833; Francis Hobart Herrick, *Audubon the Naturalist*, 2 vols., 2d ed. (New York and London, 1938), 2: 35.

4. Kidd to Victor Audubon, 4 October 1833, Houghton Library, Harvard University, bMS 1482, letter no. 361 (published by Fries 1963, 344).

5. Audubon to Victor Audubon, 24 December 1833 (Herrick 1938, 2: 62).

6. Ford 1964, 442.

7. Notes accompanying letter to William P. Campbell, 9 August 1966, in NGA curatorial files.

8. Fries 1963, 348, fig. 5.

9. NGA 1970, 164.

10. NGA 1980, 306.

11. The handling is identical with passages in Kidd's view of Weston Favel Estate, Trelawny, Jamaica, dating to 1835 (anon. sale, Christie, Manson & Woods, 31 March 1978, no. 17, repro.).

12. "20. Canvasses measuring when stretch [sic] precisely 26 inches by 20½ . . . the canvass . . . must be of the very best quality & PRECISELY the size mentioned" (Audubon to Robert Havell, Jr., 18 November 1830; Howard Corning, ed., *Letters of John James Audubon 1826–1840*, 2 vols. [Boston, 1930], 1: 124).

13. From top to bottom they are: a crown, the word *linens*, a long vertical rectangle subdivided into five rectangles containing numbers, and the letters *P & M*. These are identical with the stamps on the back of the canvas of 1951.9.6, except for the final letters; it is possible that either the *P* in this case or the *R* in the latter has been misread.

14. Fries 1963, 343.

15. This plate appears in John James Audubon, *The Birds of America*, 4 vols. (London, 1827–1838), vol. 1. (1827–1830). It is plate 219, as *Orchard Oriole or Hang-nest*, in the imperial octavo descriptive edition, 7 vols. (New York and Philadelphia, 1840–1844), vol. 4 (1842). That plate omits two of the birds, the three remaining being differently grouped; the foliage is also more summary.

References

1963 Fries, Waldemar H. "Joseph Bartholomew Kidd and the Oil Paintings of Audubon's *Birds of America*." *AQ* 26 (1963): 343, 345, 346, 348, fig. 5.

1964 Ford, Alice. *John James Audubon*. Norman, Okla., 1964: 442.

1970 NGA 1970: 164, repro. 165.

1980 NGA 1980: 306.

1951.9.8 (1076)

Yellow Warbler

1830–1833
Pencil and oil on millboard, 48.2 × 29.7 (19 × 11¾)
Gift of E. J. L. Hallstrom

Technical Notes: The support is a commercially prepared millboard,[1] primed recto and verso with a thin white proprietary ground coated on the verso with a thin dark gray layer. There is a very thin pinkish brown imprimatura. Infrared reflectography reveals a thin pencil underdrawing in the flowers and clouds. The painting is executed in smooth, thin, opaque layers, with thin, semitransparent glazes in the reds and yellows of the flowers and perhaps some of the yellows of the birds, and low impasto in the clouds. The paint surface is slightly abraded and there are a few scattered losses. The thin natural resin varnish has discolored yellow to a moderate degree.

Provenance: Same as 1951.9.7.

Fig. 1. John James Audubon, *Yellow Warbler*, signed and dated 1808, pencil, red chalk, watercolor, and some gouache, New York, New-York Historical Society

TWO YELLOW WARBLERS are supported on a trumpet vine and painted in the picture plane as though abstracted from the real world. The vine (bignonia) is characteristic of Louisiana and Mississippi. This warbler was a new species of which Audubon encountered only one pair, a male and female, engaged in searching for food among the Mississippi bignoniae in which he placed them; he never found a nest.

Like 1951.9.7, this study had traditionally been attributed to Audubon, but was correctly attributed to Kidd by Waldemar H. Fries,[2] Alice Ford,[3] and Edward H. Dwight.[4] The board is the size that Audubon, writing from Edinburgh, had asked Robert Havell, the engraver, to procure for him in 1830.[5] The work was catalogued as Kidd by Campbell in 1970[6] and by Wilmerding in 1980.[7]

Audubon's original watercolor, inscribed by him: *Drawn from Nature/Falls of Ohio—July 1st 1808*, is in the New-York Historical Society (fig. 1). The Washington picture is almost identical (except for the inclusion of clouds) with Audubon's watercolor and with plate 65 of *The Birds of America*,[8] engraved by Robert Havell, Jr., and printed and colored by Robert Havell, Sr., 1829, which is entitled *Rathbone's Warbler*.[9] The under-drawing is very precise, and was probably executed from Audubon's original with some mechanical aid.

Another version of this subject by Kidd is in the Audubon Memorial Museum, Henderson, Kentucky.[10]

Notes

1. The label reads: "R. Davey, Colourman to Artists, 83, Newman Street, London," who advertised himself as preparing "GENUINE FLEMISH GROUNDS."

2. Fries 1963, 345.

3. Ford 1964, 442.

4. Letter to William P. Campbell, 4 February 1964, and notes accompanying letter to same recipient, 9 August 1966, in NGA curatorial files.

5. "60 such past [*sic*] boards prepared for painting upon . . . 19 Inches by 11¾ . . . the . . . board must be of the very best quality & PRECISELY the size mentioned" (Audubon to Robert Havell, Jr., 18 November 1830; Howard Corning, ed., *Letters of John James Audubon 1826–1840*, 2 vols. [Boston, 1930], 1: 124).

6. NGA 1970, 164.

7. NGA 1980, 306.

8. This plate appears in John James Audubon, *The Birds of America*, 4 vols. (London, 1827–1838), vol. 1 (1827–1830). It is plate 89, as *Rathbone's Wood-Warbler*, in the imperial octavo descriptive edition, 7 vols. (New York and Philadelphia, 1840–1844), vol. 2 (1841). That plate omits the three separate groups of ramping trumpet flowers, but the central part of the design is otherwise almost identical.

9. Audubon named the bird after his friends the Rathbones of Liverpool.

10. Ford 1964, 444.

Joseph Bartholomew Kidd, *Yellow Warbler*, 1951.9.8

References

1963 Fries, Waldemar H. "Joseph Bartholomew Kidd and the Oil Paintings of Audubon's *Birds of America*." *AQ* 26 (1963): 345.

1964 Ford, Alice. *John James Audubon*. Norman, Okla., 1964: 442.

1970 NGA 1970: 164, repro. 165.

1980 NGA 1980: 306.

of the nest and grasses is suggestive of bitumen. The painting is otherwise in good condition; losses are minimal. The thinly applied synthetic resin varnish has discolored yellow slightly.

Provenance: Same as 1951.9.7.

THREE FINCHES (two males with a female in the nest) are painted in the picture plane among a pattern of branches and tendrils, above some water. This common species, which breeds along the coast from Texas to Massachusetts but spends the winter among the salt marshes of South Carolina, makes its nest a few feet above the high-water mark, and generally in a place resembling part of a new-mown meadow.

Like 1951.9.7 and 1951.9.8, this study was traditionally attributed to Audubon, but has been correctly attributed to Kidd by Waldemar H. Fries,[2] Alice Ford,[3] and Edward H. Dwight.[4] The board is the size Audubon had ordered from Robert Havell when he was in Edin-

Fig. 1. John James Audubon, *Sharp-Tailed Finch*, pencil, watercolor, and gouache over red chalk, New York, New-York Historical Society

Joseph Bartholomew Kidd, *Sharp-Tailed Finch*, 1951.9.5

1951.9.5 (1073)

Sharp-Tailed Finch

1831/1833
Pencil and oil on millboard, 48.3 × 29.9 (19 × 11¾)
Gift of E. J. L. Hallstrom

Technical Notes: The support is a commercially prepared millboard,[1] primed recto and verso with a proprietary ground of thin opaque white oil paint (on the verso the white is coated with a black layer). Infrared reflectography reveals a thin, dry, pencil underdrawing. The painting is executed in thin, opaque layers, carefully but fluidly applied, with some low impasto in the highlights and nest; there are some pentimenti in the rendering of the grasses. The craquelure in the dark brown paint

burgh in November 1830.[5] The painting was catalogued as Kidd by Campbell in 1970[6] and by Wilmerding in 1980.[7]

Audubon's original watercolor is in the New-York Historical Society (fig. 1). The Washington picture is almost identical with this watercolor and with plate 149 in *The Birds of America*,[8] which was engraved, printed, and colored by Robert Havell in 1832; in the watercolor there is neither sky nor sea, in the print there is no sky, the foreground extends to the left edge, and there are slight variations in the grasses and foreground detail. The underdrawing of Kidd's picture is flat and lifeless, with some overlapping forms misunderstood; it has the characteristics of a tracing, and must have been executed from Audubon's original with some mechanical aid.

Notes

1. The label reads: "Rowney & Forster, artists' colourmen, 51, Rathbone Place, London," who advertised themselves as preparing "IMPROVED/Flemish Ground Mill Boards." This was the firm Audubon favored. "I wish you to try first *Rowney & Forster* and purchase those (the whole I mean) as low and [on] as long a credit as you can" (Audubon to Robert Havell, Jr., 18 November 1830; Howard Corning, ed., *Letters of John James Audubon 1826–1840*, 2 vols. [Boston, 1930], 1: 124).

2. Fries 1963, 345.

3. Ford 1964, 443.

4. Dwight to William P. Campbell, 4 February 1964, and notes accompanying letter to same recipient, 9 August 1966, in NGA curatorial files.

5. Audubon to Robert Havell, Jr., 18 November 1830 (Corning 1930, 1: 124).

6. NGA 1970, 164.

7. NGA 1980, 306.

8. This plate appears in John James Audubon, *The Birds of America*, 4 vols. (London 1827–1838), vol. 2 (1831–1834). It is plate 174 in the imperial octavo descriptive edition, 7 vols. (New York and Philadelphia, 1840–1844), vol. 3 (1841). That plate contains no sea, the grasses are slightly different in detail and more massed, and the foreground is a generalized brown.

References

1963 Fries, Waldemar H. "Joseph Bartholomew Kidd and the Oil Paintings of Audubon's *Birds of America*." *AQ* 26 (1963): 345.

1964 Ford, Alice. *John James Audubon*. Norman, Okla., 1964: 443.

1970 NGA 1970: 164, repro. 165.

1980 NGA 1980: 306.

1951.9.6 (1074)

Black-Backed Three-Toed Woodpecker

1831/1833
Pencil and oil on canvas, 66.7 × 52.4 (26¼ × 20⅝)
Gift of E. J. L. Hallstrom

Technical Notes: The fine canvas is plain woven; it was lined in 1951. The ground is white, of moderate thickness and smoothly applied. There is a thicker light cream imprimatura which is used as the middle tone in the sky. The forms are drawn in pencil with a dry, careful contour line. The painting is executed in very thin, fluid washes with linear details. The paint surface is severely solvent abraded and was retouched throughout in 1958, not only in losses and in the cracks of the pronounced craquelure, but with a generalized glaze to consolidate abrasion. The thick synthetic varnish then applied has discolored yellow to a significant degree.

Provenance: Same as 1951.9.7.

Fig. 1. John James Audubon, *Black-Backed Three-Toed Woodpecker*, pencil, watercolor, and gouache, New York, New-York Historical Society

John Bartholomew Kidd, *Black-Backed Three-Toed Woodpecker*, 1951.9.6

THREE WOODPECKERS (two males right and a female center left) are perched on branches above a rhythmical, abstract landscape. The species was a common one in the northern part of Massachusetts and in all those parts of Maine covered with forests of tall trees; the birds lived in these forests, their nests bored into the tree trunks.

Like 1951.9.7, 1951.9.8, and 1951.9.5, this study was traditionally attributed to Audubon, but has been correctly attributed to Kidd by Waldemar H. Fries,[1] Edward H. Dwight,[2] and Alice Ford.[3] The stamps on the back of the original canvas,[4] which is the size Audubon had ordered from Robert Havell when he was in Edinburgh in November 1830,[5] indicate that the latter was of British origin. The work was catalogued as Kidd by Campbell in 1970[6] and by Wilmerding in 1980.[7]

Audubon's original watercolor is in the New-York Historical Society (fig. 1). The Washington picture is almost identical (except for the inclusion of sky and landscape) with this watercolor and with plate 132 in *The Birds of America*,[8] which was engraved, printed, and colored by Robert Havell in 1832. The underdrawing is very precise, and was probably executed from Audubon's original with some mechanical aid. Backgrounds of the kind painted here by Kidd would seem to have influenced the stylistic development of John Woodhouse Audubon (1812–1862).[9]

Notes
1. Fries 1963, 345.
2. Notes accompanying letter in response to William P.

Campbell, 9 August 1966, in NGA curatorial files. Campbell had previously written to Dwight: "I find this painting much better done than the others; furthermore, the background seems more like that in our *Arctic Hare* [1951.9.10], with background, you feel, by V. G. Audubon. Does this painting, in your opinion, fit neatly with other Kidds?" The background of *Arctic Hare* is, in fact, much more translucently handled. Winters (see biography) shares Campbell's query, observing that "There are striking dissimilarities between this background . . . and all other Kidd works known to" her (notes to the author, 2 April 1990). The dissimilarities are, however, due to the severe abrasion and subsequent restoration of the Gallery's painting. As already pointed out, the meticulous underdrawing (characteristic of a copyist) is identical in all four of the Gallery's paintings after Audubon, and is quite distinct from the free underdrawing only loosely followed in the paint layers employed, for example, by John Woodhouse Audubon.

3. Letter, 5 January 1968, in NGA curatorial files.

4. From top to bottom they are: a crown, the word *linens*, a long vertical rectangle subdivided into five rectangles containing numbers, and the letters *R & M*.

5. Audubon to Robert Havell, Jr., Edinburgh, 18 November 1830; Howard Corning, ed., *Letters of John James Audubon 1826–1840*, 2 vols. (Boston, 1930), 1: 124.

6. NGA 1970, 164.

7. NGA 1980, 306.

8. This plate appears in John James Audubon, *The Birds of America*, 4 vols. (London, 1827–1838), vol. 2 (1831–1834). It is plate 268, as *Arctic three-toed Woodpecker*, in the imperial octavo descriptive edition, 7 vols. (New York and Philadelphia, 1840–1844), vol. 4 (1842). That plate omits most of the foliage.

9. Compare the landscape setting for J. W. Audubon's *Black-Footed Ferret* (1951.9.1).

References

1963 Fries, Waldemar H. "Joseph Bartholomew Kidd and the Oil Paintings of Audubon's *Birds of America*." *AQ* 26 (1963): 345.

1970 NGA 1970: 164, repro. 165.

1980 NGA 1980: 306.

George Knapton

1698 – 1778

KNAPTON was born in London, one of four sons of James Knapton, a prosperous bookseller on Ludgate Street in the City. He was apprenticed to Jonathan Richardson from 1715 to 1722, and in 1720 was a founding subscriber to the academy off St. Martin's Lane established by Louis Chéron and John Vanderbank. He spent three years in practice on his own, and was one of the six young founders of the Roman Club in 1723. Thereafter he spent seven years in Italy, from 1725 to 1732, where he acquired a considerable knowledge of the old masters. He was a founding member of the Society of Dilettanti, formed in Rome in the early 1730s, and, as its official portrait painter, executed between 1741 and 1749 twenty-three portraits of members of the society in a variety of fancy dress (Brooks's Club, London); these are his principal claim to fame.

Although Knapton painted such large canvases as the group portrait of Augusta, Princess of Wales, and her children (1751; Royal Collection, Hampton Court Palace), he was best known for his work in pastel, of which he was the finest practitioner in Britain in the 1730s and 1740s.

He executed some of the portraits of historical worthies that were engraved for Thomas Birch's *Illustrious Persons of Great Britain*, whose two volumes were published by his brothers in 1743 and 1751; and, as a distinguished connoisseur, he was asked to catalogue the pictures at Althorp (1746) and survey the royal collection (1750). Knapton seems to have given up painting after about 1755. He succeeded Stephen Slaughter as surveyor of the king's pictures in 1765, and died in Kensington in December 1778.

Knapton acquired a firm sense of drawing from his apprenticeship with Richardson, but nothing is known of his work or style before 1736. His mature style shows him linked to the rococo movement. A penchant for informal poses and gestures—and for portraying domestic activities—is displayed in his Dilettanti Society portraits. He was capable of a Hogarthian directness, and painted with a softness and freshness of touch close to Highmore, derived from his feeling for pastel. He rarely painted full lengths, and his group portraits suffer from a certain incoherence of design, the product of his desire

to avoid conventional poses and figure arrangement. Knapton was the teacher of Francis Cotes, the most distinguished pastel portraitist of the next generation.

Bibliography

Vertue, George. *Note Books*. In 6 vols. *The Walpole Society* 18 (1930), 20 (1932), 22 (1934), 24 (1936), 26 (1938), 30 (1955); 1 (18[1930]): 12–13, 14; 3 (22[1934]): 62, 109, 117, 118, 154; 6 (30[1955]): 153–154, 170.

O'Donoghue, Freeman. In *Dictionary of National Biography*. Vol. 31. London, 1892: 236–237.

Lippincott, Louise. *Selling Art in Georgian London: The Rise of Arthur Pond*. New Haven and London, 1983: 14, 19, 22, 25, 26, 44, 66, 81.

Attributed to George Knapton

1942.8.1 (554)

Portrait of a Gentleman

c. 1750/1755
Oil on canvas, 71.1 × 55.7 (28 × 21⅞)
Andrew W. Mellon Collection

Technical Notes: The medium-weight canvas is plain woven; it has been lined. The ground is light gray, thinly applied. The painting is executed thinly in layers of opaque glazes with some impasto. There is scattered retouching, notably along the hairline in the right part of the sitter's forehead, in the lower part of the waistcoat, and in the upper right quadrant. The natural resin varnish has not discolored.

Provenance: Frank Bulkeley Smith, Worcester, Massachusetts (sale, American Art Association, New York, 22–23 April 1920, 2nd day, no. 122, repro., as a portrait of Gawen Brown by John Singleton Copley). Thomas B. Clarke [d. 1931], New York. Sold by Clarke's executors 1935 to (M. Knoedler & Co.), New York, from whom it was purchased January 1936, as part of the Clarke collection, by The A.W. Mellon Educational and Charitable Trust, Pittsburgh.

Exhibitions: *Portraits Painted in the United States by Early American Artists*, Union League Club, New York, 1922, no. 12. *Paintings by Early American Portrait Painters*, Century Association, New York, 1926, no. 4. *Portraits by Early American Artists of the Seventeenth, Eighteenth and Nineteenth Centuries Collected by Thomas B. Clarke*, Philadelphia Museum of Art, 1928, unpaginated and unnumbered.

THERE IS no visual evidence to support the identification of the sitter as Gawen Brown (1719–1801), the famous Boston clockmaker; both Burroughs and Sawitsky believed the portrait to be incorrectly identified,[1] and the title was officially dropped soon after the portrait entered the National Gallery's collection.[2]

The attribution to Copley, upheld by Hart,[3] Morgan,[4] and an anonymous reviewer of the Union League Club exhibition in 1922,[5] has been generally discounted,[6] and the portrait is not even mentioned in Prown's monograph on the artist.[7] Sawitsky proposed an attribution to

Fig. 1. George Knapton, *Sir Bourchier Wray, Bt.*, 1744, oil on canvas, London, Brooks's Club [photo: Courtauld Institute of Art]

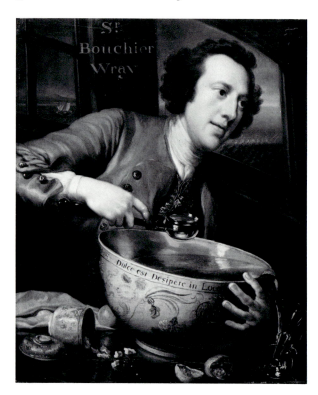

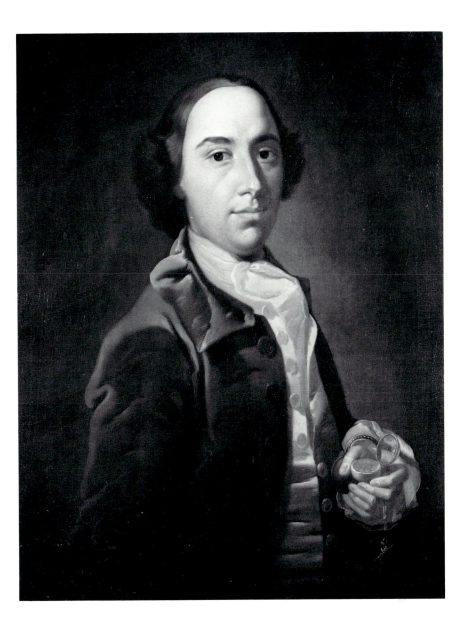

Attributed to George Knapton,
Portrait of a Gentleman, 1942.8.1

Lawrence Kilburn, an English artist active in New York from 1754 to 1775,[8] but Kilburn's known work is provincial and less painterly. Burroughs, although suggesting the possibility that the work might be one of the long-sought oil portraits by the miniaturist Henry Pelham, thought the modeling closest to the style of Allan Ramsay.[9] Questioned by Campbell as American in 1970,[10] the portrait was rejected by Wilmerding as such in 1980, but not reattributed.[11]

The fresh modeling of the head, the crisp delineation of the features, and the slight stiffness of conception are all close in style to the work of George Knapton (fig. 1),

and the treatment of the fingers is identical to that in Knapton's portrait of Francis Dashwood, 1742, in the series of Dilettanti Society portraits (Brooks's Club, London). The close interest in decorative-arts objects is also typical of Knapton.

The loose-fitting frock coat with a turned-down collar of velvet, and the wig made in imitation of real hair, typical of the English taste for informal clothes, are characteristic of English fashion in the 1750s and early 1760s.[12] The sitter holds a finely painted watch opened in his left hand with the key hanging on a cord below his fingers; he seems likely to be a watchmaker.[13]

Notes

1. John Walker to Donald Shepard, memorandum, 29 May 1943, in NGA curatorial files.

2. Minutes of Acquisitions Committee meeting, 6 April 1943, 4.

3. Charles Henry Hart, in a note included in an undated draft catalogue entry in NGA curatorial files, described the work as "a rarely fine example of Copley's best American straight portraiture."

4. John Hill Morgan, undated note, in NGA curatorial files.

5. Anon. 1922, 144.

6. William P. Campbell, memorandum, 7 February 1964, in NGA curatorial files.

7. Jules David Prown, *John Singleton Copley*, 2 vols. (Cambridge, Mass., 1966).

8. William Sawitsky, undated note, in NGA curatorial files.

9. Alan Burroughs, note, 3 October 1939, in NGA curatorial files.

10. NGA 1970, 158.

11. NGA 1980, 307.

12. Costume report by Aileen Ribeiro, February 1988, in NGA curatorial files.

13. The watch itself is of a type popular both in Britain and on the Continent from the late seventeenth century to the mid-eighteenth century and thus provides no information which would help in refining the date of the portrait (information kindly provided by Hugh Tait, British Museum).

References

1922 Anon. "Current Comment: Exhibitions." *AAm* 10 (1922): 144, repro. between 138 and 143.
1970 NGA 1970: 158, repro. 159.
1980 NGA 1980: 307.

1951.7.1 (1065)

A Graduate of Merton College, Oxford

c. 1754/1755
Oil on canvas, 127.7 × 102.1 (50¼ × 40¼)
Gift of Mrs. Richard Southgate

Technical Notes: The medium-fine canvas is plain woven; it has been lined. The ground is light gray, thinly and smoothly applied. The painting is broadly executed in fairly thin, smooth, opaque layers with only slight impasto in the highlights; the brown shadows and thin green paint of the background have a glazelike quality. The light-colored area to the left of the right arm may represent a pentimento, but the x-radiographs do not reveal an underpainted design. The painting is in good condition with only a few minor losses, chiefly in the sky. The natural resin varnish, evenly applied when the picture was surface cleaned in 1951, has not discolored.

Provenance: W. S. B. Grimson by 1930.[1] (M. Knoedler & Co.), London; probably purchased from (M. Knoedler & Co.), New York, by Mrs. Henry C. Lancashire; by descent to her daughter, Mrs. Richard Southgate, Manchester, Massachusetts.

Exhibitions: Long-term loan, Norfolk Museum of Arts and Sciences, Norfolk, Virginia, 1967–1972.

THE IDENTITY of the sitter is unknown, but he is shown wearing the gown and holding the mortar board of a master of arts of Oxford University. In the background is a view of the Fellows' Quadrangle of Merton College and the college chapel as seen from Christchurch Meadow.[2] The palings seen on the left may be linked with repair work agreed upon in 1754, when "the old wall," probably but not certainly to be identified with the old city wall seen in the picture, was to be pulled down and a new parapet wall erected.[3] The costume, notably the deep round cuffs, frilled lace, and absence of buttons in the lower part of the waistcoat, indicates a date in the 1740s or 1750s; the undulating rococo pattern of the exceptionally rich embroidery of the waistcoat suggests a date later rather than earlier in this bracket.

The traditional attribution to Highmore was questioned by Alison Lewis[4] and by Ross Watson, who pro-

Fig. 1. George Knapton, *Lucy Ebberton*, oil on canvas, London, Dulwich Picture Gallery

Attributed to George Knapton, *A Graduate of Merton College, Oxford*, 1951.7.1

posed Knapton as a more likely artist.[5] Aspects of the handling, notably the rococo delineation of the cuffs and the rich painting of the braid, are certainly characteristic of Highmore, and the two artists' work can be deceptively similar, but Highmore's modeling is usually crisper and more sculptural; he had a greater feeling for character than Knapton, and his heads are more vital and alert. The smooth modeling of the head and the treatment of the foliage in the background in the National Gallery's picture are typical of Knapton's handling of paint (fig. 1), and the particularized vignette of the college, with the sketchily painted couple outside the walls, the lady in a pink skirt, typical of his interest in detail. Fresh and silvery in color, the portrait may be accepted as an example of Knapton's mature style of the 1750s, before his retirement from painting in about 1755. Another three-quarter length of an unknown scholar, closer in modeling to Highmore but lacking his vitality, is signed and dated by Knapton 1753 (Graves Art Gallery, Sheffield).

Notes
1. A letter to Grimson about the picture, from the then Warden of Merton, in NGA curatorial files, is dated 20 March 1930.
2. Since the sitter is posed in front of the Fellows' Quadrangle of Merton College, it seems likely that he was a fellow of that college. I am greatly indebted to the librarian, Roger Highfield, for sending me a complete annotated list of the fellows elected 1742–1755, but identification has not proved possible.
3. Merton College Register 1: 4, 176 (information kindly supplied by Roger Highfield).
4. Lewis 1979, 638.
5. Letter, 29 November 1976, in NGA curatorial files. It was still listed as by Highmore in NGA 1985, 201.

References
1979 Lewis, Alison Shepherd. "Joseph Highmore: 1692–1780." Ph.D. diss., Harvard University, 1975. Ann Arbor, Michigan (University Microfilms), 1979.

Sir Thomas Lawrence
1769 – 1830

LAWRENCE WAS BORN in Bristol on 13 April 1769, the youngest of sixteen children of Thomas Lawrence, a customs official turned (unsuccessful) publican, and Lucy Reade. A boy prodigy without formal training, Lawrence was renowned, by the age of ten, for his profile drawings in pencil of the visitors to his father's hostelry, the *Black Bear* at Devizes in Wiltshire, an established coaching inn on the London-to-Bath road. After the family moved to Bath in 1780 he was taught by William Hoare and worked also in pastel; by 1786 he was charging three guineas a head. He received a prize from the Society of Arts in 1784 for a pastel copy of Raphael's *Transfiguration*. In 1787 he settled in London, taking lodgings in Leicester Fields not far from Sir Joshua Reynolds, who encouraged him to use his studio for studying and for copying. He spent three months at the Royal Academy Schools, chiefly drawing in the antique school; gradually abandoning his practice in pastel, he adopted in his oil painting the lively brushwork of his friend, William Hamilton.

Lawrence exhibited his first full-length portrait at the Academy in 1789, and his contributions the following year—*Queen Charlotte* (National Gallery, London) and *Miss Farren* (The Metropolitan Museum of Art, New York)—established his reputation. Reynolds is reported to have declared to him, "In you, sir, the world will expect to see accomplished what I have failed to achieve."[1] In 1791 he was elected an Associate of the Royal Academy, in 1792 he succeeded Reynolds as Principal Portrait Painter to the King, and in 1794 he became a full Academician, defeating Hoppner, who was eleven years his senior, by two votes. He was then twenty-five. From 1793 he had pupils and studio assistants; Samuel Lane joined him in 1800, George Harlow in 1802. His prices for a full length during this inflationary period rose steadily from 60 guineas in 1790 to 160 guineas in 1805. He raised them to 400 guineas in 1810 (after the death of Hoppner he no longer had rivals) and was charging 500 guineas by 1816 and 600 guineas at the time of his death. These were prices far in excess of those of any of his contemporaries.

In spite of his success, Lawrence was often in debt; generous and extravagant, though not personally so, he mismanaged his financial affairs and lived well beyond his means. He moved in professional and theatrical circles, and became emotionally involved with both the elder daughters of Sarah Siddons, Sally and Maria; but he never married. His closest friend and confidant was the artist and diarist Joseph Farington.

In 1814 Lawrence was commissioned by the Prince Regent to paint the allied heads of state and generals for what was to become the Waterloo Chamber at Windsor Castle, and in 1815 he was knighted. He worked on this scheme in Aix-la-Chapelle and Vienna between 1818 and 1819, and went on to Rome (his first visit to Italy) to paint the Pope. James Northcote compared this "high employment"[2] to that of Rubens and Van Dyck. He returned to England in 1820, after staying nearly three months in Florence, to find himself elected president of the Royal Academy in succession to West.

Lawrence worked unremittingly. In 1821 he complained to Farington of the pressing demand for portraits from distinguished persons. He was less sociable, more reserved, more solitary, than romantic legend would have us believe, but he was an able and much respected president of the Royal Academy, generous with his advice to students. He was an insatiable collector—one of the principal reasons for his financial difficulties—but, tragically, his unrivaled collection of Old Master drawings, offered after his death to the king (at a bargain price) and, failing his acceptance, to the government, was refused by both and subsequently dispersed. Lawrence died in London on 20 January 1830. About 150 unfinished works remained in his studio.

Obsessed from boyhood with the ideals of the Great Style, Lawrence always regretted that he had devoted so little time to historical painting, and thought his *Satan Summoning His Legions* (Royal Academy of Arts, London), exhibited at the Academy in 1797, a masterpiece superior to those of his contemporaries; in reality he was melodramatic in such works, confusing grandeur with size. His real achievement was to transform the Reynolds tradition in portraiture. He idealized his sitters, believing that a portrait should be more beautiful than appearance. Less intellectual but more committed than Reynolds, he sought, in Sir Michael Levey's words, "to distil on to canvas the essence of *his* response to the sitter."[3] Facture was a vital element in this endeavor, and Lawrence possessed a masterly brilliance in the manipulation of oil paint; he especially delighted in the details of costume, notably velvet, and, unlike Reynolds, habitually painted all the accessories of a major portrait himself. The bravura, glitter, crispness of touch, and sometimes nervous self-consciousness of pose in his early style gradually gave way to a greater breadth of treatment. He excelled in the portrayal of domesticity and children, and the range of his insight into character was never better displayed than in the last decade of his life. Drama, movement, and tense vitality are the essential ingredients of his compositions; low viewpoints, to bring the spectator into close contact with the sitter, romanticized landscapes, and turbulent skies were characteristic devices. His portrait drawings are delicate and refined.

Lawrence affected the work of his contemporaries as profoundly as did Reynolds. Beechey, Hoppner, Phillips, Sir Martin Archer Shee, and many others emulated the brilliance of his handling or the romanticism of his compositions. His influence on the next generation of British painters was all-pervasive. Later he was a star of the Duveen era: *Pinkie* (Huntington Art Gallery, San Marino) complemented Gainsborough's *The Blue Boy*. In more recent years his technical brilliance was dismissed as flamboyance, and his reputation declined.

Notes
1. William T. Whitley, *Artists and Their Friends in England 1700–1799*, 2 vols. (London and Boston, 1928), 2: 129 (the source of this quotation is given as the Somerset House Gazette in the Whitley papers, preserved in the British Museum Print Room, but the reference has not been traced).
2. Farington *Diary*, 15: 5309 (4 January 1819).
3. Levey 1979, 10.

Bibliography
Williams, D. E. *Life and Correspondence of Sir Thomas Lawrence, Kt.* 2 vols. London, 1831.
Garlick, Kenneth. *Sir Thomas Lawrence.* London, 1954.
Millar, Sir Oliver. *The Later Georgian Pictures in the Collection of Her Majesty the Queen.* 2 vols. London, 1969, 1: 59–79.
Levey, Sir Michael. *Sir Thomas Lawrence 1769–1830.* Exh. cat., National Portrait Gallery. London, 1979.
Garlick, Kenneth. *Sir Thomas Lawrence: A Complete Catalogue of the Oil Paintings.* Oxford, 1989.

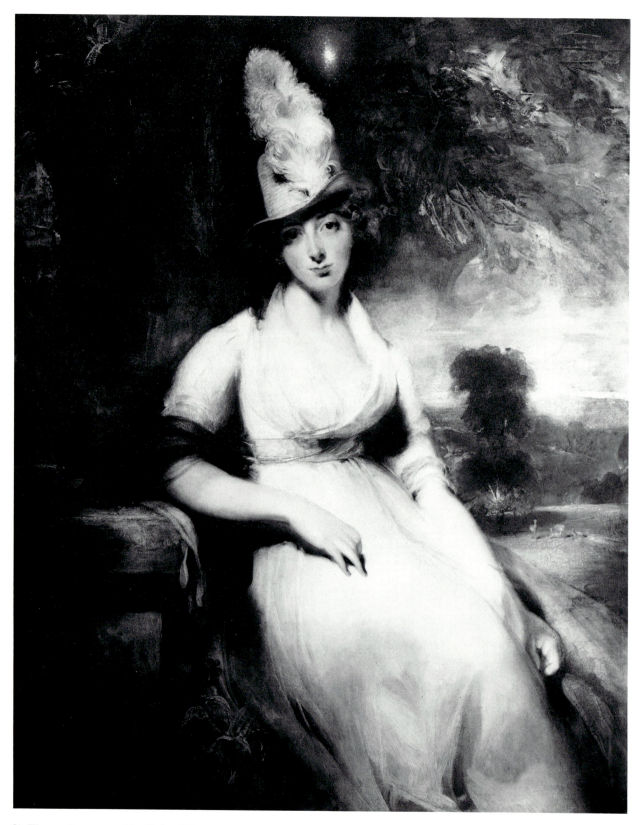

Sir Thomas Lawrence, *Mrs. Robert Blencowe*, 1942.9.37

1942.9.37 (633)

Mrs. Robert Blencowe

c. 1792
Oil on canvas, 127 × 101.5 (50 × 40)
Widener Collection

Technical Notes: The medium-weight canvas is twill woven; it has been lined. The ground is white, of moderate thickness. The painting is executed thinly and fluidly, blended wet into wet, with sweeping brushwork (the foliage at upper right has been worked with a palatte knife), except in the flesh, where the handling is more restrained; the whites and the yellow of the sash are more thickly painted in dry, dragged brushstrokes, with a low impasto. There is extensive traction crackle, due to the presence of a high proportion of medium, much of which has been retouched. Apart from this the painting appears to be in good condition. The paint surface seems not to be abraded or to have suffered loss, although there is retouching in the lips and right nostril, where small strokes of brilliant red have been added; the paint surface has been slightly flattened during lining. The thick natural resin varnish, pigmented with black, has discolored yellow to a significant degree.

Provenance: Probably Sir George Robinson, 5th Bt. [1730–1815], Cranford Hall, Northamptonshire; by descent to Sir Frederick Robinson, 10th Bt., who sold it to (Arthur J. Sulley & Co.), from whom it was purchased 12 September 1913 by P. A. B. Widener, Elkins Park, Pennsylvania. Inheritance from the Estate of Peter A. B. Widener by gift through power of appointment of Joseph E. Widener, Elkins Park.

THE PROVENANCE suggests that the sitter was a member of the Robinson family of Cranford. The tradition that she represents Emma Blencowe, who in 1827 married Sir George Stamp Robinson (1797–1873),[1] may be ruled out on grounds of age. It seems more likely that she represents one of the daughters of Sir George Robinson, the fifth baronet, either Frances Dorothea, who in 1790 married the banker Charles Hoare, or Penelope (Emma's mother), who in 1789 married Robert Willis Blencowe of Hayes, Middlesex.[2] A portrait of Penelope Blencowe, by Downman (fig. 1), signed and dated 1791, is so close in physical appearance to the National Gallery's picture that the identification of the latter as Penelope is virtually certain.[3] Lawrence's familiarity with the family is attested

Fig. 1. John Downman, *Mrs. Robert Blencowe*, signed and dated 1791, watercolor, last recorded with P. & D. Colnaghi, 1916 [photo: Prudence Cuming Associates Ltd., by courtesy of P. & D. Colnaghi & Co. Ltd.]

by references to his attending concerts at Mr. Blencowe's of Hayes in 1795 and 1796, on the latter occasion making a large drawing of the scene.[4]

The sitter is depicted with a soulful expression, redolent of the age of *sensibilité*. The landscape background with deer that drops away behind her, more of a vignette than a setting for the portrait, is executed in the agitated manner characteristic of Lawrence's style in the 1790s, a handling of paint that is distinctly at odds with the conception of the portrait. The picture seems thus to be slightly later than around 1789, the date of Emma's marriage, as suggested by Garlick,[5] and may be dated stylistically by comparison with the handling of the background in the full length of John Julius Angerstein and his wife (Louvre) exhibited at the Royal Academy in 1792.[6] This dating is supported by the evidence of costume: the low-cut chemise dress with sash and elbow-length sleeves, the loose curls of the coiffure, and the finely painted high-crowned hat trimmed with an ostrich feather. As so often with Lawrence, the drawing of the arms and hands is awkward and lacking in bone structure, the dress is shapeless, and it is difficult to know how the lady is seated.

Notes

1. Widener 1915, unpaginated. This identification was still retained in the last National Gallery catalogue; see NGA 1985, 222.
2. Garlick 1954 (see biography), 28, and Garlick 1989 (see biography), 154, where she is catalogued as Penelope, in the latter reference as "painted around the time of her marriage in 1789."
3. The Downman was exhibited as no. 25, and reproduced as the frontispiece, in the exhibition *Original Drawings by English Artists of the XVIII Century*, P. & D. Colnaghi & Obach, London, February 1916. The long nose and shape of the nostrils, and the shape of the mouth, are identical with the Lawrence, which also dates from the early 1790s.
4. Levey 1979 (see biography), no. 60, repro.
5. Garlick 1989 (see biography), 154.
6. Garlick 1954, pl. 13.

References

1915 Roberts 1915: unpaginated, repro.
1954 Garlick 1954 (see biography): 28.
1964 Garlick, Kenneth. "A Catalogue of the Paintings, Drawings and Pastels of Sir Thomas Lawrence." *The Walpole Society* 39 (1964): 169.

1937.1.96 (96)

Lady Mary Templetown and Her Eldest Son

1802
Oil on canvas, 215 × 149 (84⅝ × 58⅝)
Andrew W. Mellon Collection

Technical Notes: The medium-weight canvas is twill woven; it has been lined, but the tacking margins survive intact. The present stretcher is presumably larger than the original stretcher as there is an eighth of an inch of unpainted canvas visible along the top and right edges. The ground is slightly off-white, thinly applied. The painting is executed both thinly and thickly, with impasto especially evident in the whites; Lady Mary's gown and veil are broadly handled, but more worked than the background, with the shadows painted both under and over the white; much of the foliage is quickly and drily painted. The heads have been heavily reworked by the artist, and the smooth paint in these passages masks the prominent weave of the canvas. Lady Mary's right arm has been repositioned, as has the ribbon on her cap. The paint is abraded in places, and some of the impasto has been slightly flattened during lining. There is a prominent craquelure and discolored though not extensive retouching, especially disfiguring in the child's dress. The natural resin varnish has discolored to a moderate degree.

Provenance: Painted for the sitter's husband, John, 2nd Baron (later 1st Viscount) Templetown [1771–1846], Castle Upton, County Antrim; by descent to Henry, 4th Viscount Templetown [1853–1939], Castle Upton. Alfred Charles de Rothschild [1842–1918], Halton, near Tring; bequeathed to his daughter, Almina Victoria, Countess of Carnarvon, Highclere Castle, Hampshire; purchased by (Duveen Brothers), London after the death of Almina's first husband, George, 5th Earl of Carnarvon, in 1923, and sold through their New York branch June 1923 to Andrew W. Mellon, Pittsburgh and Washington, by whom deeded December 1934 to The A. W. Mellon Educational and Charitable Trust, Pittsburgh.

Exhibitions: Royal Academy of Arts, London, 1802, no. 5, as *Portrait of Lady Templetown. Sir Thomas Lawrence 1769–1830*, National Portrait Gallery, London, 1979–1980, no. 17, repro.

LADY MARY MONTAGU (d. 1824), only daughter of John, 5th Earl of Sandwich, married John Henry, 2nd Baron Templetown, in 1796. She had four sons: Henry, born in November 1799, who is depicted here; George, born in 1802; Arthur, born in 1807; and Edward, born in 1816. Her husband was created a viscount in 1806.

When the portrait was exhibited at the Royal Academy in 1802, Farington noted that it was among the five favorite pictures that year.[1] The *Monthly Mirror* described it as "a highly successful picture of a beautiful woman. It pos-

Sir Thomas Lawrence, *Lady Mary Templetown and Her Eldest Son*, 1937.1.96

sesses very eminent beauties of softness, clear and simple colour, natural grace, and bright effect."[2] The *True Briton* acclaimed it, together with two other of Lawrence's female full lengths, as "beautiful proofs of his taste in representing the female character,"[3] but observed in a later notice of the picture that although "the face of Lady Templeton [sic] is touched with admirable delicacy. We wish the Artist were not so fond of scattering *milky scintillations* about his Pictures, as they tend to give them a broken *frippery* aspect."[4]

In spite of awkwardnesses in the proportions of Lady Templetown's thigh and of her two-year-old son's head—emphasized in the case of the latter by the contrast between the heavy reworking of the head and the facility with which the body was completed—the portrait is elegantly conceived. The curvilinear pose, which flows rhythmically from the gently inclined head to the sharply expressive drapery folds falling over the knee, is taken up in the romanticized background, upon the details of which Lawrence has lavished much attention. This setting is no backdrop, but a sylvan world that the sitters seem to inhabit; Sir Michael Levey has suggested that: "Some echo of an old master religious composition may be behind the design; e.g. a treatment of the *Education of the Virgin* theme. The effect is not unlike that of a contented Hagar with her son in the wilderness."[5]

This portrait and two others were on loan to the artist from Lord Templetown at the time of Lawrence's death in 1830.[6]

Lawrence painted two other portraits of Lady Templetown. A miniature showing her in the same pose and costume, but at half length, is inscribed on the reverse as executed for Lady Templetown;[7] an unfinished head, finished by another hand, is in a different pose, facing the spectator.[8] A copy of the head of Lady Templetown, by Lawrence's pupil William Etty, is in the City Art Gallery, York.

Notes

1. Farington *Diary*, 5: 1773 (3 May 1802).
2. *Monthly Mirror*, 13 May 1802, 310.
3. *True Briton*, 3 May 1802.
4. *True Briton*, 2 June 1802.
5. Levey 1979 (see biography), 41.
6. Garlick 1964, 306.
7. Christie, Manson & Woods, London, 25 June 1968, under no. 55. The miniature was later sold with a firm attribution to Lawrence at Christie, Manson & Woods, London, 16 November 1976, no. 62.
8. Garlick 1964, 185.

References

1802 Farington *Diary*, 5: 1759 (21 March 1802), 1773 (3 May 1802).
1802 *Morning Chronicle*, 3 May 1802.
1802 *True Briton*, 3 May, 2 June 1802.
1802 *Monthly Mirror*, 13 May 1802, 310.
1804 Farington *Diary*, 6: 2291 (7 April 1804).
1913 Armstrong, Sir Walter. *Lawrence*. London, 1913: 166.
1949 Mellon 1949: no. 96, repro. 120.
1954 Garlick 1954 (see biography): 60, pl. 48.
1964 Garlick, Kenneth. "A Catalogue of the Paintings, Drawings and Pastels of Sir Thomas Lawrence." *The Walpole Society* 39 (1964): 185, 306.
1976 Walker 1976: no. 531, color repro.
1989 Garlick 1989 (see biography): no. 760, repro.

1968.6.2 (2348)

Francis Charles Seymour-Conway, 3rd Marquess of Hertford

c. 1825
Oil on canvas, 128.5 × 102.2 (50⅝ × 40¼)
Gift of G. Grant Mason, Jr.

Technical Notes: The medium-weight canvas is plain woven; it was lined in 1968. The ground is white. There is a very thin and transparent warm brown imprimatura. The painting is rapidly and deftly executed in fluid, opaque layers, blended wet into wet, the light passages in rich paint, the dark areas much thinner. X-radiographs show that the ring suspended from the sitter's waist has been shifted slightly to the left. The sitter's right hand is heavily retouched; the retouching lies over the remains of black, suggesting that the hand had been painted out by the artist, that the artist's black paint was removed during a subsequent restoration, and that the form then had to be reintegrated. The paint is somewhat solvent abraded in the background and in the pure blacks, and the impasto was very slightly flattened during lining. There is extensive retouching in the background, and scattered retouching carried out in 1968. The dammar varnish applied in 1968 has not discolored.

Provenance: Painted for the sitter; by descent to his son, Richard, 4th Marquess of Hertford [1800–1870]; bequeathed 1870 to his natural son and secretary, Richard Wallace [1818–1890], created Sir Richard Wallace, Bt., in 1871; by descent to Lady Wallace [1819–1897]; bequeathed to her husband's secretary, John Murray Scott, later a baronet [d. 1912] (sale, Christie, Manson & Woods, London, 27 June 1913, no. 109), bought by (E. M. Hodgkins for Blakeslee Galleries), New York (sale, American Art Association, New York, 21–23 April 1915, 3rd day, no. 221, repro.), bought by (Otto Bernet) for George G. Mason, New York; by descent to G. Grant Mason, Jr., Arlington, Virginia.

Sir Thomas Lawrence, *Francis Charles Seymour-Conway, 3rd Marquess of Hertford*, 1968.6.2

FRANCIS CHARLES SEYMOUR-CONWAY (1777–1842), who married Maria, daughter of the Marchioness Fagnani, succeeded his father as 3rd Marquess of Hertford in 1822. As Lord Yarmouth (his courtesy title) he was vice chamberlain to his intimate friend the Prince Regent and the latter's principal adviser on the purchase of works of art. A distinguished connoisseur principally interested in Dutch painting, he built up a superb collection of his own which, vastly augmented by the voracious collecting in Paris of the 4th Marquess and his constant companion, his own natural son, Richard Wallace, was destined to become the nucleus of the Wallace Collection. Lord Hertford was the original upon whom Thackeray modeled the character of the Marquis of Steyne in *Vanity Fair* and Disraeli Lord Monmouth in *Coningsby*.

Lord Hertford is shown wearing the star of the Order of the Garter, to which he was appointed in 1822. This provides a *terminus post quem* for the date of the portrait (there is no technical evidence to suggest that the star was added later, as is sometimes the case). The tight-fitting double-breasted frock coat with high rolled stand collar, black silk cravat, and side whiskers extending to the chin suggest a date of about 1825. The head is finely characterized, and, although the pose is somewhat stiff and static by comparison with other of Lawrence's three-quarter

lengths of this period—a deficiency emphasized by the plain background unrelieved even by traces of curtain—the handling is fluent and deft. The picture is an excellent example of Lawrence at the height of his powers and as a portraitist of deep psychological insight in the last decade of his life.

The picture was no doubt acquired by George G. Mason as a pendant to the portrait supposedly of Lady Hertford (by Thomas Phillips, 1968.6.1) that he had purchased in 1910.

A miniature copy in enamel of the head and shoulders only, signed and dated 1824 by Henry Bone, is in the Wallace Collection.

An engraving by William Holl, also of the head and shoulders, was published by Henry Fisher in 1833 as a plate for William Jerdan's *National Portrait Gallery* (1830–1833, vol. 4, 1833, no. 31).

References
1913 Armstrong, Sir Walter. *Lawrence*. London. 1913: 139.
1954 Garlick 1954 (see biography): 42.
1964 Garlick, Kenneth. "A Catalogue of the Paintings, Drawings and Pastels of Sir Thomas Lawrence." *The Walpole Society* 39: (1964): 105.
1989 Garlick (see biography): no. 404, repro.

Sir Peter Lely
1618 – 1680

LELY WAS BORN Pieter van der Faes in Soest, Westphalia, on 14 September 1618, the son of Johan van der Faes, an infantry captain in the service of the elector of Brandenburg, and Abigail van Vliet. As Pieter Lely (Lely being the name of the street in a fashionable quarter of The Hague where his forebears had settled, the house featuring a lily carved on the gable) he is recorded in the minutes of the Guild of Saint Luke in Haarlem for October–November 1637 as one of the pupils of Frans Pieters de Grebber. Unlike many of his contemporaries he never visited Italy.

When Lely came to London during the early years of the Civil War (the exact date is unknown), his bent was for subject pictures and historical compositions. He continued to paint such works and portraits of musicians

with their instruments, reminiscent of Terbrugghen, until the early 1650s. But from the start he accommodated himself to the native demand for portraiture, was espoused by aristocratic patrons who, supporting the Parliamentary cause, had remained in London, and thus succeeded to the mantle of Cornelius Johnson, who had returned to Holland in 1643, and of William Dobson (d. 1646). In 1647 he became a member of the Painter-Stainers Company and by 1654 was described as "the best artist in England."[1] A scheme to decorate Whitehall Palace with scenes commemorating the Civil War unfortunately came to nothing.

After the Restoration in 1660 Lely was recognized as Van Dyck's successor as court and society painter; he became Principal Painter to the King in 1661 and was

granted naturalization in 1662. With rapidly increasing demand he built up an elaborate studio organization and method by the early 1670s; a pose would be selected from an existing set of numbered postures, he would paint the head from life, chalk in the pose, and lay in the colors, leaving the rest to one of his many assistants, who included John Greenhill, Thomas Hawker, Prosper Hendrik Lankrink, and Willem Wissing. His output was immense and his prices, which in about 1647 were five pounds for a head and shoulders and ten for a three-quarter length, rose in the 1660s to fifteen pounds for a head and shoulders and twenty-five pounds for a half length, and were increased in 1671 to twenty and thirty pounds for these sizes, and sixty pounds for a full length.

Lely worked unremittingly and, emulating Van Dyck, led a grand and extravagant life in his house on the Great Piazza, Covent Garden; "a mighty proud man he is, and full of state," wrote Pepys.[2] A lover of music and close friend of poets such as Richard Lovelace, he also amassed a fine collection of paintings and sculpture, including twenty-five Van Dycks and a huge collection of drawings, all of which were sold after his death. Nothing is known of his mistress, Ursula, whom he married after the birth of two children and who died in childbirth, with her infant, in 1674. In the later 1670s his career was threatened by the increasing success of an ambitious young rival, Godfrey Kneller, who had come to England in 1674, but Lely remained in favor and was knighted in 1680. He died in London on 7 December 1680.

Just as Van Dyck's elegant and introspective style reflected the brittle fabric of the Caroline court of the 1630s, so Lely expressed to the full the exuberance and voluptuousness of Restoration society. The early awkwardness in his grouping, design, and posture was corrected by his study of Van Dyck, whose patterns, notably in group portraits, he absorbed into his own repertoire. Never as refined as Van Dyck, Lely developed a rich and lively sense of color, a feeling for the texture of materials, especially silks and satins, an ease of movement and placing, and a range of varied and graceful postures. His use of nightgowns, shifts, and vests rather than fashionable costume prevented his pictures from becoming dated. Lacking the consistent insight into character and personality of his neighbor, the great miniaturist Samuel Cooper, he depicted many of his sitters as types rather than individuals; Lely was fascinated by female beauty and feminine apparel, but Pepys pronounced the celebrated set of paintings of beauties of the court (Royal Collection, Hampton Court), expressive of a characteristic heavy-lidded languor, "good, but not like."[3] In his late style the draperies are more formalized, reflecting the greater participation of assistants, and the handling of paint correspondingly thinner and drier.

In the earlier part of his career Lely painted a number of subject pictures, many of them variations on the theme of nymphs in a landscape. These were executed in the style of such Dutch practitioners of the genre as Cornelis van Poelenburgh, with some Venetian influence through the agency of Van Dyck and Frans Wouters, and their elaborate landscape backgrounds, often containing decorative urns or figures, were carried over into his portrait style. He was also an accomplished draftsman.

Lely's influence on his contemporaries, many of whom had emerged from his studio, and on the next generation of painters—Kneller, John Riley, John Closterman and Michael Dahl—was extensive, not least in the studio organization he developed. He was also the first great artist collector of drawings in England, his most distinguished successor being Lawrence.

Notes
1. James Waynwright to Richard Bradshaw, 6 October 1654 (from the MS. of Miss ffarington of Worden Hall, county Lancaster; Appendix to the Sixth Report of the Royal Commission on Historical Manuscripts, 2 vols. [London, 1877–1878], 1: 437).
2. *The Diary of Samuel Pepys*, ed. Robert Latham and William Matthews, 11 vols. (London, 1970–1983), 8: 129 (25 March 1667).
3. Latham and Matthews 1970–1983, 9: 284 (21 August 1668).

Bibliography
Beckett, Ronald B. *Lely*. London, 1951.
Millar, Sir Oliver. *The Tudor, Stuart and Early Georgian Pictures in the Collection of H.M. The Queen*. 2 vols. London, 1963, 1: 119–129.
Millar, Sir Oliver. *Sir Peter Lely 1618–80*. Exh. cat., National Portrait Gallery. London, 1978.
Rogers, Malcolm. "Some Beauties of Sir Peter Lely." *Conn* 200 (1979): 106–113.

Probably chiefly studio of Sir Peter Lely

1960.6.26 (1578)

Barbara Villiers, Duchess of Cleveland

c. 1661–1665
Oil on canvas, 126.1 × 101.5 (49⅝ × 40)
Timken Collection

Technical Notes: The medium-fine canvas is plain woven; it has been lined. The ground is reddish brown, smoothly applied and of moderate thickness. The painting is executed in thin, fluid, transparent layers in the background with thicker, more opaque paint in the dress and flesh tones and low impasto in some of the details and highlights; certain passages are constructed by means of incorporating multilayered tonalities, such as the gray beneath the white edging of the dress, or the reddish shadows of the flesh paint. The paint surface has been moderately abraded overall, most prominently in the chin and neck, presumably due to overcleaning, and there are scattered retouchings. The face and white cuff were partially cleaned and the painting was revarnished with dammar in 1960; this moderately thick natural resin varnish, toned with dark-colored pigment, has discolored yellow slightly.

Provenance: Bethell Walrond [1820–1876], Dulford House, Devon (sale, Christie, Manson & Woods, London, 12–13 July 1878, 2nd day, no. 156), bought by (Algernon Graves). Sir Henry Hope Edwardes, 10th Bt., Wootton Hall, Ashbourne, Derbyshire (sale, Christie, Manson & Woods, London, 27 April 1901, no. 11), bought by Martin H. Colnaghi, London [d. 1908]; at his death it was sold to (Thos. Agnew & Sons), London, in joint account with (Wallis & Son), London, 1908, by whom it was sold 1909 to (Scott and Fowles), New York.[1] Frank Bulkeley Smith, Worcester, Massachusetts (sale, American Art Association, New York, 22–23 April 1920, 2nd day, no. 109, repro.), bought by Otto Bernet, probably as an agent for William R. Timken [d. 1949], New York; passed to his wife, Lillian S. Timken [d. 1959], New York.

Exhibitions: *Works by the Old Masters and Deceased Masters of the British School*, Winter Exhibition, Royal Academy of Arts, London, 1908, no. 184. Long-term loan, Norfolk Museum of Arts and Sciences, Norfolk, Virginia, 1967–1972.

BARBARA VILLIERS (1641–1709), daughter of William Villiers, 2nd Viscount Grandison, married Roger Palmer, shortly afterward created Earl of Castlemaine, in 1659. She became the mistress of Charles II at the time of his accession and in 1662 left her husband and was installed in official lodgings at Whitehall, becoming a lady of the bedchamber to the new queen. Extravagant as well as avaricious, she lived in increasing luxury and in 1670 was created Duchess of Cleveland. By then her days as the reigning royal mistress were numbered. Described as "at once the fairest and the lewdest of the royal concubines,"[2] she was by 1674 supplanted in the royal favors by Louise de Kéroualle, who had been made Duchess of Portsmouth. In 1677 she emigrated to France. She seems to have borne the king at least five children; three were created dukes—of Somerset (later also Cleveland), Grafton, and Northumberland. Inevitably she was much painted, repeatedly by Lely,[3] for whom she seemed to represent the ideal of female beauty; he is said to have remarked of her "that it was beyond the compass of art to give this lady her due, as to her sweetness and exquisite beauty."[4]

The Washington portrait seems to be a good variant of the type also represented by the portrait from the Bolingbroke collection at Lydiard Park (fig. 1).[5] In the latter

Fig. 1. Sir Peter Lely, *Barbara Villiers, Duchess of Cleveland*, c. 1661–1665, oil on canvas, Swindon, Lydiard Park [photo: Thos. Agnew & Sons Ltd.]

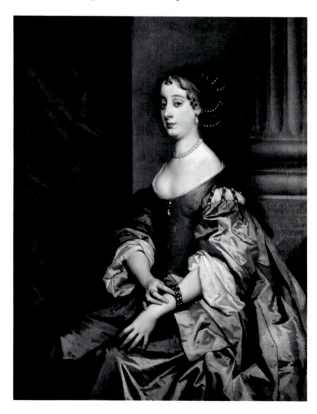

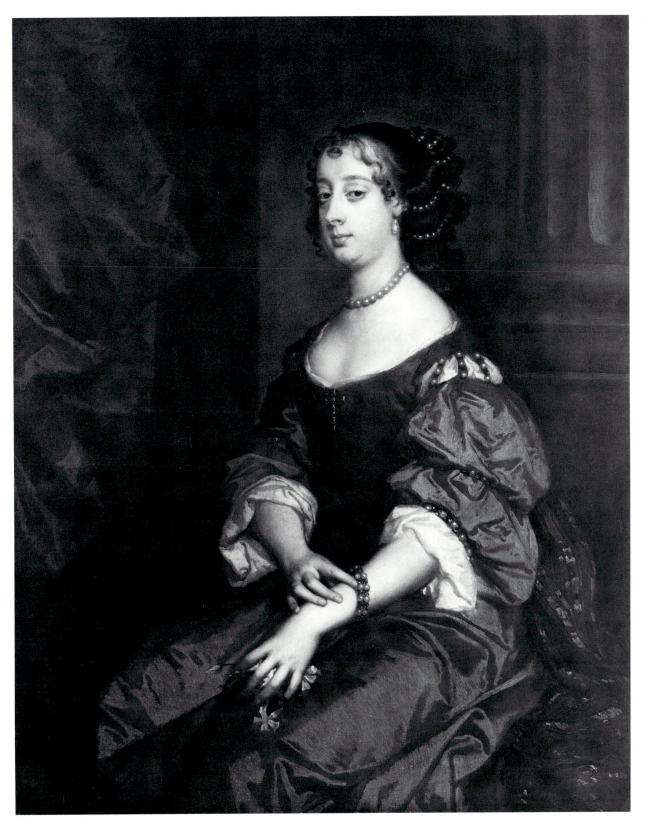

Probably chiefly studio of Sir Peter Lely, *Barbara Villiers, Duchess of Cleveland*, 1960.6.26

work the drapery is much more lively in arrangement, the sitter wears a pearl drop at her breast rather than a cross, and she is not shown with a pearl circlet on her left sleeve or holding a bunch of lilies (symbol of purity). In both versions, however, Barbara Villiers is depicted wearing a pearl necklace and festoons of pearls in her hair and, as in a number of Lely's portraits of women, fingering her pearls, in this case her bracelet. Malcolm Rogers has argued very convincingly that this motif relates to childbirth, since pearls, another emblem of purity, were the attribute of the virgin martyr, Margaret of Antioch, the extremely popular patron saint of childbirth.[6] The portraits were painted at the time Barbara Villiers was bearing the king's children, between 1661 and 1665, which suggests that they may commemorate one of these births, likeliest that of the first of her sons, Charles, the future Duke of Somerset (1662–1748).

The quality of the drawing and the relative liveliness of the handling throughout demonstrate the high standards maintained by Lely's studio. A drawing (fig. 2) which has come to light in recent years[7] may be a preparatory composition study or an aide-mémoire for the pattern prepared in the studio; in this the drapery is only very broadly defined, but the general pattern is clearly that adopted for the Bolingbroke rather than the Washington picture, supporting the primacy of the former work.

Replicas or copies of this design, all of which follow the drapery pattern of the Bolingbroke version rather than of the National Gallery's painting, are at Firle Place, Sussex, and in the North Carolina Museum of Art, Raleigh, and were in the possession of H. and P. de Casseres, London, 1932, and W. S. Ludington, Philadelphia, 1951.

A mezzotint by Edward Luttrell and Isaac Beckett was published, but is undated. This was executed from the National Gallery's painting, not from the pattern represented by the Bolingbroke version.

Notes

1. Thos. Agnew & Sons stock books, recorded by The Provenance Index, J. Paul Getty Trust, Santa Monica, California.

2. Thomas Seccombe, *Dictionary of National Biography*, vol. 58 (London, 1899), 317 (quoting John Oldmixon; reference untraced).

3. The range of Lely's designs includes a full-length version (showing in the background the Diana Fountain later set up at Hampton Court) at Goodwood House and other full-lengths at Knole and Aske Hall, three-quarter-length portraits as a Madonna (now lost), as Saint Barbara (formerly Colonel Palmer), as Saint Catherine (Earl Bathurst), as Minerva (Hampton Court), as a shepherdess (Althorp), in Turkish dress (Euston Hall),

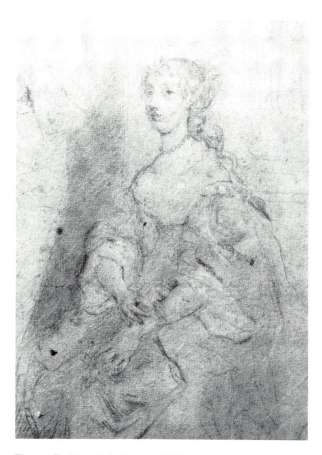

Fig. 2. Sir Peter Lely, *Barbara Villiers, Duchess of Cleveland*, c. 1661–1665, black and white chalks on buff paper, England, private collection [photo: National Portrait Gallery]

and others at Euston, Mertoun House, and in the Uffizi; there were twelve half-length pictures of her in the studio after Lely's death. J. M. Wright painted her when she became Duchess of Cleveland (National Portrait Gallery, London), Henri Gascars when she was living in France (collection of Lord Dillon); Kneller portrayed her in peeress' robes (Bank of England, London) and as a widow (National Portrait Gallery, London); Samuel Cooper (Royal Collection and Althorp) and Richard Gibson (Althorp) both made miniatures of her.

4. Thomas Hearne, diary, 27 February 1717/1718, in Philip Bliss, ed., *Reliquiae Hearnianae*, 2 vols. (Oxford, 1857), 1: 384.

5. Viscount Bolingbroke sale, Christie, Manson & Woods, London, 10 December 1943, no. 46, bought by Arnold; it was with Thos. Agnew & Sons in 1981 and repurchased for Lydiard Park, Swindon. It was exhibited in *Life and Landscape in Britain 1670–1870*, Thos. Agnew & Sons, London, 1981, no. 2, repro. Sir Oliver Millar, letter, 22 September 1961, in NGA curatorial files, doubted if the Washington picture was by Lely himself, and regarded the portrait now at Lydiard Park as "a better version." The latter opinion is certainly right, but with regard to the former, account should be taken of the fact that it was the National Gallery's painting that was engraved, presumably at Lely's request.

6. "Van Dyck's Portrait of the Seigneur D'Aubigny as a Shepherd," Van Dyck symposium, National Gallery of Art, Washington, 1991.

7. Sir M. R. Wright sale, Sotheby's, London, 17 February 1960, no. 87. The drawing is 10¾ × 7⅝ inches in size.

References

1951 Beckett 1951 (see biography): no. 100.

Benjamin Marshall

1768 – 1835

MARSHALL was born in Seagrave, Leicestershire, on 8 November 1768, the fifth of the seven children of Charles and Elizabeth Marshall. Nothing is known about the occupation of his parents or about his schooling. In 1789 he married Mary Saunders of Ratby, who bore him four sons (two of whom died young) and three daughters. Described in 1791 as being a schoolmaster, he left for London the same year to study painting with the portraitist Lemuel Francis Abbott, with whom, however, he stayed only briefly. He is reputed to have taken up animal painting as a result of his seeing Sawrey Gilpin's *Death of a Fox* at the Royal Academy of Arts in 1793.

Marshall first published an engraving of one of his pictures, a portrait of a sportsman, in the *Sporting Magazine* in 1796 (his work continued to appear there throughout his career, and sixty engravings had been published by 1832). In these early years he secured royal as well as aristocratic patronage. He first exhibited at the Royal Academy in 1800 and showed sporadically thereafter until 1819, chiefly portraits of racehorses and their owners; but he is reported to have despised the Royal Academy and its politics, and never became an Academician. In 1801 he took in John Ferneley as an apprentice for three years. In 1804 Farington noted Sir Francis Bourgeois' opinion of Marshall, "a Horsepainter as having extraordinary ability."[1] Although highly successful in London, from 1812 until 1825 Marshall lived in Norfolk, close to Newmarket, so that he could study the finest racehorses with greater ease. In 1819 he suffered severe injuries in a coaching accident; although it has been argued that this seriously impaired the quality of his later work, there is visual evidence that this was not so, and in 1820 he was sufficiently active to build a new painting room for himself at Newmarket. From 1821 he was racing correspondent of the *Sporting Magazine* under the pseudonym Observator. He returned to London in 1825 and settled in Bethnal Green, where he died on 24 July 1835.

Marshall's primary interest was in portraiture, whether of men or animals. He gave great presence to his horses, emphasizing their sheen, but often exaggerated their anatomical structure with a tendency to sculptural modeling. His portraits are chiefly of sportsmen, and mainly small full lengths; his oil sketches of jockeys and stable lads are as vital and down-to-earth as those of Stubbs. Marshall's earlier work is fluent and transparent in technique; later he painted more thickly to render varied textures. Otherwise he did not change his style markedly in the course of his career. His favored compositions show horse and figures at rest, mostly in profile, in the foreground, with the ground falling away sharply beyond; his backgrounds, preferred by Sawrey Gilpin to his own or to those of Stubbs, demonstrate an increasing feeling for atmosphere. He was less at home with hunting scenes than with single hunters or with racehorses—he was not a hunting man—and his hounds give the impression of being studied individually rather than of forming a pack. His grouping is often awkward and his crowd scenes wooden. Marshall also painted prize cattle, working at Windsor for George III, and fighting cocks; cockfighting was a sport that he seems to have enjoyed.

Marshall's style was continued by his son, Lambert Marshall. His pupils, John Ferneley and Abraham Cooper, took up and extended his range of subject matter; Cooper was influenced in his horse portraiture by Marshall's emphasis on anatomical structure.

Notes

1. Farington *Diary*, 6:2282 (28 March 1804).

Bibliography

Sparrow, Walter Shaw. *George Stubbs and Ben Marshall*. London and New York, 1929: 45–80.

Paget, Guy. "Ben Marshall and John Ferneley." *Apollo* 40 (1944): 30–37.

Benjamin Marshall. Exh. cat., Leicester Museums. Leicester, 1967.

Egerton, Judy. *British Sporting and Animal Paintings 1655–1867: The Paul Mellon Collection*. London 1978: 191–207.

Style of Benjamin Marshall

1970.17.125 (2497)

Race Horse and Trainer

c. 1820/1825
Oil on canvas, 33.3 × 43.5 (13⅛ × 17⅛)
Ailsa Mellon Bruce Collection

Technical Notes: The lightweight canvas is plain woven; it has been lined. The ground is white, thinly applied. The painting is executed in opaque layers, thinly and evenly applied except for some low impasto in the foreground, with a palette of mostly earth tones. The horse and trainer are painted in fairly delicate, small brushstrokes, the rest of the painting in broad, smooth strokes. The painting is in good condition. There is scattered but minimal retouching that has been well carried out and has

Fig. 1. Benjamin Marshall, *Mameluke with His Trainer, Mr. Edwards*, signed and dated 1827, oil on canvas, England, private collection [photo: Sotheby & Co.]

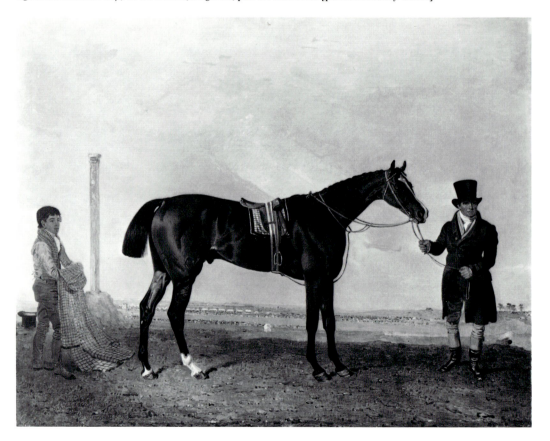

Style of Benjamin Marshall, *Race Horse and Trainer*, 1970.17.125

not discolored. The thin natural resin varnish has only discolored yellow slightly.

Provenance: (M. Knoedler & Co.), London, 1929. Ailsa Mellon Bruce, New York.

THE IDENTITY of the racehorse is unknown. The handling is too coarse throughout to sustain the traditional attribution to Benjamin Marshall, even in his more handicapped later years, but the style, with its exaggerated emphasis on anatomical structure, is unmistakably his (fig. 1). The costume worn by the trainer, notably the greatcoat of frock-coat length with fashionable rolled collar, indicates a date between 1820 and 1825. The generalized background, more devoid of features than is usual even with Marshall, represents some open racing country such as Newmarket Heath. Marshall may have had assistants or imitators during the thirteen years he had a studio near and in Newmarket.

Philip Mercier
1689 – 1760

MERCIER WAS BORN in Berlin in 1689, the son of Pierre Mercier, a Huguenot tapestry worker in the employment of the elector of Brandenburg (later Frederick I of Prussia), and of Marie Biendovienne. According to George Vertue, he studied under Antoine Pesne in Berlin, subsequently going on a tour of Italy and France. In 1716 he came to England, recommended by the court at Hanover, and settled on Saint Martin's Street, in the French quarter of London. There, in 1719, he married Margaret Plante, and they had two sons. After Margaret's death he married, in 1735, Dorothy Clapham, with whom he had a daughter. In the mid-1720s he introduced the conversation piece into England; the genre was taken up by Hogarth and rapidly became popular. He was a member of the Saint Luke's Club of Virtuosi, and was steward in 1728; he seems also to have been active as an art dealer.

Less than a month after the investiture in 1729 of Frederick, eldest son of George II, as Prince of Wales, Mercier was appointed Principal Painter to the prince, subsequently being appointed gentleman page of the bedchamber (1729) and library keeper (1730). Frederick, a cultivated connoisseur, patronized a number of living artists; Mercier was jealous of his own position, quarrels ensued, and in 1736 he was replaced by John Ellys. After a short period in Northamptonshire he took lodgings on the Great Piazza at Covent Garden from 1737 to 1739. Unable to compete with the new portraiture of Jean-Baptiste van Loo, Ramsay, and others, Mercier originated the genre of the fancy picture, sentimentalized figures engaged chiefly in domestic occupations, intended for a wide market through engraving in mezzotint. His first eight subjects were published by Faber in 1739.

In 1739 Mercier settled in York, where he was soon patronized by leading Yorkshire families and remained in respectable practice as a portraitist until 1751, visiting Ireland in 1747 and Scotland in 1750. In common with most provincial painters, he had to keep his charges low: five guineas for a head and shoulders, eight guineas for a three-quarter length, and twenty guineas for a large fancy picture. After a year in Portugal in 1752 he resettled in London, concentrating on fancy pictures; he exhibited two at the first exhibition of the Society of Artists in 1760. He died in London on 18 July of that year.

Mercier's early style was deeply influenced by Watteau. He painted *fêtes galantes*, used commedia dell'arte figures and Watteau poses, made etchings after Watteau, and drew in Watteau's manner; his early conversation pieces, of which the first known is dated 1725, are Watteauesque in elegance and lightness of color, a fusion of the Dutch group portrait with the *fête galante*. Never at his ease with formal portraiture and uncertain in spatial composition, Mercier developed an original portrait style in which he combined informality of pose and an easy naturalism with a rococo liveliness of touch comparable to that of Highmore; his portraits of children are especially engaging.

Mercier's early fancy pictures, with their Chardinesque domestic content and emphasis on still life, were equally influenced by French style, notably that of Boucher. Mercier was also influenced in choice of subject and in series such as *The Five Senses* by precedents in Dutch painting. Unlike Hogarth, who was motivated by moral and satirical intentions, Mercier was concerned solely to please; his subjects, derived sometimes from contemporary literature, notably that of Samuel Richardson, were innocent, anecdotal, affecting and sentimental in treatment, with a leaning to the languid and erotic, occasionally with a touch of humor. Some of his later portraits are almost fancy pictures in mood.

Mercier's conversation pieces and French rococo style were quickly taken up by Hogarth and were influential on the development of Francis Hayman and the young Gainsborough. The fancy picture, with its sentimental overtones, proved an immensely popular genre in the second half of the eighteenth century, the age of *sensibilité*, and was taken up both by Reynolds and by the later Gainsborough. Mercier's most specific influence was on Henry Robert Morland, who adopted his scenes of domestic occupations. Mercier's daughter, Charlotte, who executed lively pastel portraits in the French style, was his only known pupil.

Bibliography
Waterhouse, Sir Ellis. "English Painting and France in the Eighteenth Century." *JWCI* 15 (1952): 127–128.
Raines, Robert and John Ingamells. *Philip Mercier 1689–1760*. Exh. cat., City Art Gallery, York; Iveagh Bequest, Kenwood. London, 1969.
Ingamells, John, and Robert Raines. "A Catalogue of the Paintings, Drawings and Etchings of Philip Mercier." *The Walpole Society* 46 (1978): 1–70.

Attributed to Philip Mercier

1952.4.2 (1083)

The Singing Party

c. 1732/1760
Oil on canvas, 73.1 × 92.1 (28¾ × 36¼)
Gift of Duncan Phillips

Technical Notes: The medium-weight canvas is plain woven; it has been lined. The ground is white gesso, thinly applied. The painting is executed in fairly thick opaque paint for the heads, with low impasto in most of the foreheads, and in thin, translucent washes throughout the rest of the painting, with a palette of earth tones. There are numerous small losses along the top and bottom edges, and scattered but minimal retouching elsewhere. Otherwise the painting is in good condition. The moderately thick natural resin varnish has discolored yellow to a moderate degree.

Provenance: Painted for George Vernon, later 1st Baron Vernon [1709/1710–1780], Sudbury Hall, Derbyshire; by descent to Francis, 9th Baron Vernon [1889–1963]. (Arnold Seligmann, Rey & Co.), New York, from whom it was purchased 1940 by Duncan Phillips, Washington.

Exhibitions: *English Caricature 1620 to the Present*, Yale Center for British Art, New Haven; Library of Congress, Washington, D.C.; National Gallery of Canada, Ottawa, 1984, no. 35, pl. 13.

THE SCENE depicts four male singers, one of them a young boy, accompanied by a harpsichordist and a bassoonist; the last-named appears wigless, as does the player of the same instrument in Hogarth's engraving, *The Laughing Audience* (1733).[1] The theme, and to some extent the arrangement, derives from Hogarth's engraving, *A Chorus of Singers* (1732).[2] George Vernon, for whom the work was executed, was an amateur musician; comparison with portraits of him does not rule out the possibility that he may be included as the singer third from the left.

The painting was traditionally attributed to Hogarth but, with the exception of Baldini and Mandel,[3] this is no longer accepted by scholars. James Byam Shaw has suggested that the picture might be by Boitard; five other scholars have, with varying degrees of emphasis, proposed the name of Mercier.[4] Raines, however, a leading specialist on Mercier, did not accept this attribution, and the Washington picture was not included in the catalogue raisonné he published in collaboration with Ingamells.[5] Raines advanced three arguments, that the picture "is much more broadly painted than anything by Mercier of about this date. . . . Composition-wise, spatially this is better than Mercier's usual, and he seldom made use of a horizontal grouping like this. . . . There is hardly a picture by him where the figures are not aware of the audience."[6] It may be noted, too, that Vernon never employed Mercier as a portraitist, choosing to patronize Enoch Seeman and John Vanderbank.

Raines' counterarguments are unconvincing. The composition is, in fact, poorly organized spatially, the awkwardly placed bassoonist being typical of Mercier's uncertainty. The arrangement of figures horizontally across the canvas is not uncharacteristic, and, although there are often figures in Mercier's subject pictures who do gaze out and engage the spectator, there are many instances in which they do not. Further, the treatment is closely comparable to that of Mercier. The schematic modeling of the boy in shadow in the foreground is close in character to that of such figures as the lute player in *The Musical Party* in the Tate Gallery (fig. 1), a picture similarly uncertain in its spatial organization;[7] and the loose touch is paralleled in heads such as that of *The Drinker*, formerly in the Lee of Fareham collection.[8] Most of the costume is barely more than sketched, and the tonality is monochromatic.

In contrast to the elegant and mildly amorous music parties characteristic of the French rococo tradition in

Attributed to Philip Mercier, *The Singing Party*, 1952.4.2

which Mercier specialized, the scene is as expressive as one by Hogarth; at least three of the heads are caricatures. Richard Godfrey has suggested the possibility that the picture is connected with the campaign of Mercier's patron, Frederick Prince of Wales, against Handel and his followers.[9] The tradition of eighteenth-century musical caricature culminated in the work of Rowlandson. If the figure third from the left, who appears to be a youngish man, is indeed George Vernon, the picture could be dated to the 1730s, close to the appearance of Hogarth's engravings previously noted.

Notes

1. Ronald Paulson, *Hogarth's Graphic Works*, 3d rev. ed. (London, 1989): no. 130, repro. 298.
2. Paulson 1989: no. 127, repro. 296.
3. Baldini and Mandel 1967, no. 199. They dated it 1760.
4. Memorandum, Ross Watson to John Walker, 17 October 1968, in NGA curatorial files, citing the opinions of Sir Alec Martin, Edward Croft-Murray, Sir Oliver Millar, and Sir Ellis Waterhouse; Richard Godfrey in exh. cat. New Haven-Washington-Ottawa 1984, no. 35.
5. Ingamells and Raines (see biography). It was classified as anonymous British eighteenth century in NGA 1985, 21.
6. Letter, Basil Taylor to Perry Cott, 22 April 1968, in NGA curatorial files.
7. Ingamells and Raines 1978 (see biography), no. 256; Elizabeth Einberg and Judy Egerton, *The Age of Hogarth* (London [Tate Gallery Collections, vol. 2], 1988), no. 135, color repro.
8. Ingamells and Raines 1978 (see biography), no. 219, pl. 7a.
9. Exh. cat. New Haven-Washington-Ottawa 1984, 46.

References

1967 Baldini, Gabriele, and Gabriele Mandel. *L'opera completa di Hogarth pittore*. Milan, 1967: no. 199, repro.
1984 Exh. cat. New Haven-Washington-Ottawa 1984: no. 35, repro. pl. 13.

Fig. 1. Philip Mercier, *The Musical Party*,
c. 1737–1740, oil on canvas,
London, Tate Gallery

James Millar

c. 1740/1750 – 1805

MILLAR WAS BORN in the middle years of the eigh-
teenth century, probably in Birmingham, of unknown
parentage. His name is first documented in the Bir-
mingham Poor Law levy books in 1763. He first exhib-
ited in 1771, at the Society of Artists; after a gap of thir-
teen years he exhibited again, at the Royal Academy of
Arts, in 1784, 1786, 1788, and 1790. He lived in Bir-
mingham and was the leading portrait painter there in
the last quarter of the eighteenth century; six portraits
by him are in the City Museum and Art Gallery. His
range included portraits on the scale of life, portraits in
little, and conversation pieces. He may also have painted
subject pictures; one Shakespearean scene is recorded.
He died in Birmingham on 5 December 1805.

Millar painted neatly and crisply, in a slightly primi-
tive manner. His groups and outdoor portraits followed
the informal style of Francis Wheatley, one of the most
popular artists of the day, the handling of whose land-
scape backgrounds Millar imitated closely.

Bibliography
Waterhouse, Sir Ellis. *The Dictionary of British 18th Century
 Painters.* Woodbridge, 1981: 240.

1956.9.4 (1451)

Lord Algernon Percy

c. 1777/1780
Oil on canvas, 91.8 × 71.5 (36⅛ × 28⅛)
Gift of Howard Sturges

Technical Notes: The somewhat coarse canvas is plain woven;
it has been lined. The ground appears to be white, with a pinkish-
brown imprimatura. The painting is executed very fluidly in
opaque layers; the foliage and background are freely worked,
the foliage on the right in dragged paint; wet into wet blending
is used in these areas and in the face and legs of the sitter; the
rest of the figure is more tightly painted, with very slight impasto
in the highlights. The darks are solvent abraded, and the weave
of the canvas has been badly impressed into the paint surface;
there is major retouching in the breeches and to the right of the

coat. The synthetic varnish applied in 1956 has not discolored.

Provenance: E. Ledger; sold to (Arthur Tooth & Sons), London, 1923,[1] who sold it 1924 to (Thos. Agnew & Sons), London, as by Sir Martin Archer Shee; purchased from Agnew's by Howard Sturges [d. 1955], Providence, Rhode Island.

LORD ALGERNON PERCY (1749/1750–1830), second legitimate son of Hugh, 1st Duke of Northumberland, was M.P. for Northumberland from 1774 until 1786, when he succeeded his father as Lord Lovaine. He was created Earl of Beverley in 1790. Percy married Isabella Susanna (see the companion portrait, 1956.9.5), second daughter of Peter Burrell of Beckenham, Kent, in 1775. He took little part in political life, largely owing to indifferent health. He was a Fellow of the Society of Antiquaries, a friend of Sir George Beaumont, and was noted for the elegance and suavity of his manners. Living much of his life abroad, he was among the English who were detained as prisoners during the hostilities with France.

He died near Nice. There are portraits of Percy as a young man by Pompeo Batoni (Alnwick Castle), and by Hugh Douglas Hamilton (private collection), and a later one by Jacques-Laurent Agasse (Alnwick Castle); a portrait done in old age, by an unknown artist, also at Alnwick, was evidently intended as a pendant to the Reynolds portrait of his wife.

The original attribution to Sir Martin Archer Shee is untenable and has been rejected.[2] The style is close to that of Francis Wheatley,[3] but the handling of the foliage is looser than his. Comparison with the work of James Millar confirms that the correct attribution is to this artist; the portrait of an unknown sitter in the Fitzwilliam Museum, Cambridge, signed and dated 1769 (fig. 1), is posed in a similarly awkward fashion, with the arm scarcely resting on the plinth, and is also framed by foliage, in this case very artificially contrived.

The costume in the National Gallery's portrait, notably the close-fitting sleeves and the short waistcoat with angular lapels, is characteristic of the fashion of the 1770s

Fig. 1. James Millar, *Young Man in Red*, signed and dated 1769, oil on canvas, Cambridge, Fitzwilliam Museum

James Millar, *Lord Algernon Percy*, 1956.9.4

and 1780s. The sitter appears to be about thirty years of age, and a date of around 1780 is affirmed by the hairstyle in the companion portrait of his wife.

The pose is relaxed and the expression distant. There are certain weaknesses in drawing, notably in the left shoulder and arm, resting uncomfortably on a snapped branch, and the positioning of the left leg. The background, though including beyond the lake a temple and other features characteristic of a gentleman's park, is more like a photographer's backdrop than an actual scene, and Millar used it more than once in his work.[4]

Notes
1. Information from The Provenance Index, J. Paul Getty Trust, Santa Monica, California.
2. Anna Voris, memorandum, 29 October 1964, in NGA curatorial files. It was classified as anonymous British eighteenth century in NGA 1985, 21.
3. As was suggested by Sir Alec Martin (cited in Voris' memorandum).
4. His portrait of Sir William Pettit (with Leger Galleries, London, 1928, as by Zoffany; photograph in the Witt Library, Courtauld Institute of Art, London) is identical with the Gallery's picture both in pose and background.

1956.9.5 (1452)

Lady Algernon Percy

c. 1777/1780
Oil on canvas, 91.5 × 71.5 (36 × 28⅛)
Gift of Howard Sturges

Technical Notes: The medium-fine canvas is plain woven; it has been lined. The ground is light gray, smoothly applied and of moderate thickness. The painting is executed thinly and very fluidly, blended wet into wet in the lower layers, with highlights and definition supplied by linear, translucent accents. The weave of the canvas has been impressed into the paint surface. Paint loss is slight, and retouching is largely confined to the face and chest of the sitter and to the edges of the picture. The moderately thick and evenly applied synthetic varnish, dating from 1956, has not discolored.

Provenance: Same as 1956.9.4.

ISABELLA SUSANNA BURRELL (1750–1812), second daughter of Peter Burrell of Beckenham, Kent, married Lord Algernon Percy (see 1956.9.4) in 1775. Like her husband she was noted for her gracious manners. Her brother became the first Baron Gwydir, and one of her sisters married the Duke of Northumberland, another the Duke of Hamilton. A half-length portrait by Richard Cosway, dating to the early 1780s, which is at Alnwick Castle, shows her a little older than in the National Gallery's portrait; in June 1789 she sat to Reynolds for a portrait, also at Alnwick, which depicts her a good ten years older than in the Washington picture. The high-piled hair, swathed in broad ribbons and decorated with ostrich feathers, is characteristic of the fashion of about 1777 to 1780, confirming the date suggested by comparison with the later portraits.

The original attribution to Sir Martin Archer Shee is untenable and has been rejected.[1] As in the case of the companion portrait of Lord Algernon Percy, the treatment of the background, which is close in style to that of Francis Wheatley, can be compared with the work of James Millar; the handling of the trees in the middle ground is identical to that in the portrait of an unknown gentleman signed and dated by Millar in 1790.[2] The concept of the portrait, with the sitter in a mildly contrapposto attitude, her arm resting on a plinth, dressed in a loose-fitting wrapping gown trailing on the ground—a generalized, timeless costume broadly suggestive of the antique—is clearly derived from Reynolds. The particularized panoramic landscape background, a vignette not very successfully linked to the foreground, is incongruous in the context of such a grand manner design, and supports the attribution to a provincial painter.

Notes
1. Anna Voris, memorandum, 29 October 1964, in NGA curatorial files. It was classified as anonymous British eighteenth century in NGA 1985, 21.
2. Anon. sale, Sotheby's, 12 November 1980, no. 34, repro.

James Millar, *Lady Algernon Percy*, 1956.9.5

George Morland

1763 – 1804

MORLAND was born in the Haymarket, London, on 26 June 1763, the eldest of the five children of Henry Robert Morland, a well-known painter of genre subjects and fancy pictures, who was also a dealer and restorer, and of Jenny Lacam, daughter of a French jeweler on Pall Mall. Educated at home, he took to copying pictures and plaster casts, and first exhibited (chalk drawings) at the Royal Academy of Arts in 1773, at the age of ten. Apprenticed to his father in 1777, when he began copying in earnest, Morland was worked hard for his father's profit, but was encouraged to advertise his talents. His first picture to be engraved was published in 1780, he exhibited his first painting at the Royal Academy in 1781 (exhibiting sporadically thereafter, for the last time in the year of his death), and showed no fewer than twenty-six works at the Free Society of Artists in 1782.

At the expiry of his apprenticeship in 1784, Morland refused an offer to join Romney's studio and entered the Royal Academy Schools; but after six months he left home and took lodgings close to a rapacious Drury Lane publisher, for whom he painted a large number of pictures. In the summer of 1785 he worked in Margate as a portraitist and paid a short visit to northern France. In 1786 he married Anne Ward, the sister of James Ward, whose early style he influenced, and of William, the engraver of many of his works; tragically, since he loved children as much as he did animals, there was only one child, a still-born son. He established his reputation in the late 1780s as a painter of sentimental genre, a field popularized by Francis Wheatley (with whom he collaborated on a series entitled *Progress of Love*) and of childhood subjects, a new theme associated with the cult of Rousseau and the age of feeling. He turned to rustic subject matter in 1791. Exhibitions of his work were held at Orme & Co. in 1792 and 1793, and at John Raphael Smith's gallery on King Street, Covent Garden, in 1793. Morland did not normally work on commission, as his contemporaries did, but sold his paintings, which were mostly small in size, through an agent. He had at least five pupils at different times, the principal ones facilitating his prolific production.

As a reaction against a strict upbringing and the drudgery of his apprenticeship, Morland, handsome and charming, associated with the demimonde and soon acquired a reputation for recklessness and hard drinking. After his marriage and early professional success he became more extravagant and more addicted to low and sporting company: among the fish porters of Billingsgate "I hear jolly good straight language, and see some first rate fights."[1] By 1789 he was seriously in debt and had to dodge creditors; in 1790 he settled in Paddington. In 1793 he was warned by John Hunter, the physician, of the dangers of further debauchery. He was congenitally restless, and from 1794 on his debts compelled constant changes of address and greatly increased productivity. In 1799 he visited the Isle of Wight; on his return, still in debt, he was arrested at his lodgings in Vauxhall and committed to the King's Bench, living within the rules of the prison until his release in 1802. Morland spent his last years with his brother Henry, who had a picture shop on Dean Street in Soho. Both his work and his health deteriorated—Benjamin West told Farington in 1804 that Morland's pictures could only be received at the Royal Academy on account of his former merit. Worn out by his dissolute life, he died of brain fever in a spunging house in Coldbath Fields, London, on 29 October 1804.

Morland is principally noted for his painting of English rural life: hunting and shooting scenes, gypsy encampments, anecdotal cottage and alehouse-door pictures, farmyards and stables, donkeys, dogs, and pigs, as well as winter landscapes, and coastal and smuggling scenes. All were subjects adaptable "to common comprehensions," most of them of a restful nature, and without any pronounced personal vision. A prolific painter with a remarkable visual memory, he displayed a considerable knowledge of Dutch seventeenth-century and contemporary French painting—derived from the copying he had done as an apprentice, for he had no collection of prints. He worked with assurance and facility, though without the benefit of sound drawing, painting directly onto the canvas and often improvising his compositions. Knowledgeable about pigments and materials, and gen-

erally eschewing the unstable but fashionable asphaltum (bitumen), he used the best colors when he could afford them and possessed a sound technique.

Morland's earlier style was greatly influenced by Wheatley and William Redmore Bigg; his later imagery was much less sentimentalized, reflecting his independence of the requirements of contemporary patrons and the experiences of his own social life. Early biographers spoke of his objectivity, fidelity to nature, and delineation of "the vulgar and coarse manners of the lowest part of society;"[2] Joseph Burke has described him as "the leading exponent of the rustic picturesque."[3] His chalk drawings were admired by Hoppner. Morland's work was consistently praised until 1794, when Farington described him as "indifferent this year."[4] At his best a refined painter fresh in handling, tonally sensitive and subdued in coloring, with a "picturesque" feeling for textures, Morland grew increasingly careless and repetitious. In the last decade of his life much of his work suffered from his need for ready money.

Morland's subjects were popularized through a constant flow of engravings, and the prices of his pictures rose considerably even before his death. Forgeries were commonly produced (his brother Henry seems to have been the dealer most active in this traffic), and his work was widely imitated. Dean Wolstenholme the Elder took up the style of his hunting scenes. Acclaimed again at the end of the nineteenth century, when he was still regarded as an unaffected and straightforward interpreter of rural life, Morland has since been relegated to the position of a "little master."

Notes

1. Williamson 1904, 53 (source unspecified).
2. Dawe 1807, 185.
3. Joseph Burke, *English Art 1714–1800* (Oxford, 1976), 391.
4. Farington *Diary*, 1:177 (9 April 1794).

Bibliography

Collins, William. . . . *Biographical Sketch of . . . George Morland*. In *Memoirs of a Picture*. 3 vols. London, 1805, vol. 2.
Dawe, George. *The Life of George Morland*. London, 1807.
Williamson, George C. *George Morland: His Life and Works*. London, 1904.
Gilbey, Sir Walter, and E. D. Cuming. *George Morland: His Life and Works*. London, 1907.
Thomas, David. *George Morland*. Exh. cat., Arts Council of Great Britain, Tate Gallery. London, 1954.
Winter, David. "George Morland (1763–1804)." Ph.D diss., Stanford University, 1977.
Barrell, John. *The Dark Side of the Landscape*. Cambridge, 1980: 89–129.

1942.9.43 (639)

The Death of the Fox

c. 1791/1794
Oil on canvas, 142 × 188 (55⅞ × 74)
Widener Collection

Inscriptions:
Signed at lower right: *G Morland Pinx!*

Technical Notes: The medium-heavy canvas is twill woven; it has been lined. The ground is white, thickly and smoothly applied. The painting is executed richly and fluidly, progressing from thin to thicker layers, small details often being painted with some texture; there are glazes in passages such as the red coats of the huntsmen and the distant hills. There are pentimenti in the hind legs of the dog in the foreground and the two dogs on the left, which were originally outstretched, and in the right arm of the whipper-in, originally held downward. The paint surface is solvent abraded and the impasto has been flattened during lining. The traction crackle in the richer areas suggests the presence of bitumen. There is extensive retouching over flake losses in the sky at upper left. The residual older varnish is very darkened, and the more recent pigmented natural resin varnish has discolored slightly.

Provenance: John Page-Darby by 1882 (sale, Christie, Manson & Woods, London, 18 July 1892, no. 89), bought by (Vokins), who sold it to (Wallis & Son), London, from whom it was purchased 1893 by P. A. B. Widener, Elkins Park, Pennsylvania. Inheritance from the Estate of Peter A. B. Widener by gift through power of appointment of Joseph E. Widener, Elkins Park.

Exhibitions: *Works by the Old Masters, and by Deceased Masters of the British School*, Winter Exhibition, Royal Academy of Arts, London, 1882, no. 267.

THE ATTRIBUTION to Morland was first weakened in 1922 when Shaw Sparrow, an authority on sporting painting, suggested that "there are points . . . which do not look like Morland's; they suggest a collaborator."[1] More recently the attribution has been generally doubted,[2] and both Peter Johnson and Sidney Sabin have proposed Dean Wolstenholme the Elder.[3] However, comparison with similar works by Wolstenholme[4] reveals the latter's

style to be altogether more finicky and primitive; his figures are less substantial and closer to artists of the next generation—such as the coaching painter, James Pollard—while the treatment of the trees is more overtly picturesque.

The Washington picture is identical in handling and in the rhythmic concept of the design, especially evident in the autumnal foliage, to the even larger *Death of the Fox* signed by Morland in the North Carolina Museum of Art (fig. 1).[5] Both are among Morland's most ambitious works. They thus probably date to between 1791, when Morland began painting rural subjects, and 1794, when his work began to deteriorate;[6] certainly before 1799, when he was committed to the King's Bench Prison. The pentimenti in the National Gallery's painting are evidence of the care that he took with this composition.

The hounds in the Washington picture were reputed to be "Mr. Mellish's celebrated pack."[7] If this is correct, the figure on the left could be William Mellish (1764–1838) or his younger brother, Thomas, born about 1769, both of whom were sportsmen and patrons of Benjamin Marshall. However, neither of them are known to have had a "celebrated pack." The better known Colonel Henry Francis Mellish, friend of the Prince Regent, the eldest son of Thomas Mellish's half-brother, Charles, of Blyth

Hall, Nottinghamshire, was not born until 1782. It is uncertain whether the distant village is intended to be an actual place.

The subject was a popular one in British art of the period. John Nost Sartorius' rendering of the theme, in about 1800,[8] is similar in its rhythmical treatment of the foliage but is less convincing and substantial.

Notes

1. Shaw Sparrow 1922, 162.
2. The picture is not included in the catalogue in Winter 1977 (see biography), but the attribution to Morland was sustained in NGA 1985, 288.
3. Their opinions are cited in memoranda by David E. Rust, 22 April 1963 and 28 April 1970, in NGA curatorial files.
4. Such as *The Kill*, anon. sale, Sotheby's, London, 18 June 1976, no. 41, repro.
5. 52.9.80; North Carolina Museum of Art, *Catalogue of Paintings, 2, British Paintings to 1900* (Raleigh, 1969), 96, repro.
6. Farington *Diary*, 1:177 (9 April 1794).
7. According to the catalogue entry in the Darby sale at Christie, Manson & Woods, London, 18 July 1892, no. 89.
8. Virginia Museum of Fine Arts, Richmond, Paul Mellon Collection 85.469.

References

1915 Roberts 1915: unpaginated, repro.
1922 Shaw Sparrow, Walter. *British Sporting Artists from Barlow to Herring*. London and New York, 1922: 161–162.
1976 Walker 1976: no. 596, color repro.

Fig. 1. George Morland, *The Death of the Fox*, oil on canvas, Raleigh, North Carolina Museum of Art

George Morland, *The Death of the Fox*, 1942.9.43

Joseph Paul

1804 – 1887

JOSEPH PAUL was born in Norwich in 1804. Nothing is known of his education or artistic training. He exhibited at the Norwich Society of Artists in 1823, 1829, and 1832, on the last two occasions as a portrait painter. Sometime after 1832 Paul seems to have run up against the law and fled from Norwich. He acquired a studio in or near London, where he and his assistants turned out forgeries of Constable, Crome, and other East Anglian painters, and of Samuel Scott and other painters of old London views. A Yarmouth friend described him thus: "He was a great actor, a great singer, a great gambler, a great rogue, and a great fool."[1] He is said to have been married five times. At the time of his sudden death of syncope, early in May 1887, he was living at 53 William Street, St. Pancras.

Paul's style, even in his occasional original work, which was lacking in invention, is marked by coarse handling, with thickly and broadly applied impasto, and harshness of tone.

Notes
1. Theobald 1906, 10.

Bibliography
Theobald, Henry Studdy. *Crome's Etchings*. London, 1906: 10.
Rajnai, Miklos. "Robert Paul the Non-Existent Painter." *Apollo* 87 (1968): "Notes on British Art," 2–3, 10.
Goldberg, Norman L. *John Crome the Elder*. 2 vols. Oxford, 1978: 1, 101–103.

Attributed to Joseph Paul

1942.9.14 (610)

Landscape with Picnickers and Donkeys by a Gate

c. 1830–1880
Oil on canvas, 123 × 99 (48⅜ × 39)
Widener Collection

Technical Notes: The fine canvas is twill woven; it has been lined. The ground is light colored, possibly white, and is thinly applied. The painting is executed in thick, rich layers with high texture and impasto throughout; some fine traction crackle in the layers of thin brown glaze, especially at lower right, suggests the presence of bitumen. There is a slight pentimento in the positioning of the gate. The paint texture has been slightly flattened during lining. The lower left and the entire bottom edge have been retouched, there are scattered retouches chiefly in the foreground, and a large area of the sky to the left of the upper branches of the center tree has been heavily overpainted; the dark trunk of the tree on the extreme right has been reinforced with overpaint, as have the red branches in the trees top

center. The thick natural resin varnish has discolored to a moderate degree.

Provenance: The Hon. Mrs. James (?) Byng. (Wallis & Son), London, from whom it was purchased 1892 by P. A. B. Widener,[1] Elkins Park, Pennsylvania, as by Crome. Inheritance from the Estate of Peter A. B. Widener by gift through power of appointment of Joseph E. Widener, Elkins Park.

THIS LANDSCAPE has traditionally been entitled "Harling Gate." However, if the painting by John Crome in the Goldberg collection (St. Petersburg, Florida)[2] is correctly identified as representing Harling Gate, near Norwich—a matter that cannot be verified (the title seems in any case to have been proposed at a later date[3])—the Washington picture, which is a variant of another Crome composition (fig. 1),[4] must depict a different locality.

The National Gallery's painting was traditionally attributed to Crome,[5] but it has been omitted from the literature and the attribution is correctly doubted by

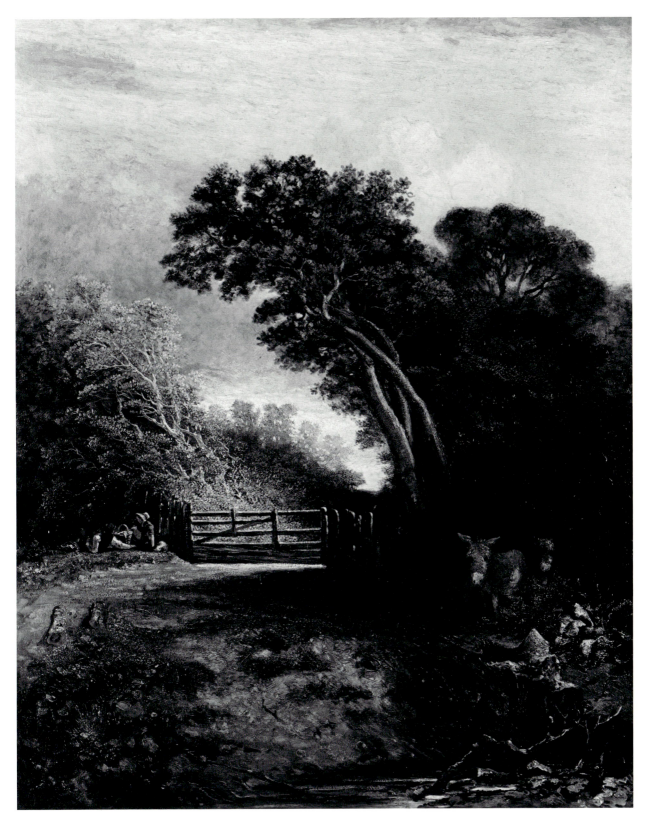

Attributed to Joseph Paul, *Landscape with Picnickers and Donkeys by a Gate*, 1942.9.14

Fig. 1. John Crome, called *Harling Gate*, oil on canvas, Norwich, Castle Museum [photo: Norfolk Museums Service]

scholars in the field.[6] Goldberg considered the work to be "an adaptation [of no. 83 in his catalogue: *The Gate*] by an imitator, a Norwich School artist other than Crome . . . his gate becomes a much more rigid structure and harsher in its values. . . . The cluster of large trees . . . also fails to show the natural, pliant quality of a Crome tree. The imitator's version is stylized and is as dense as a silhouette instead of being animated and airy."[7] His attribution is to Crome's brother-in-law and partner between 1790 and 1792, Robert Ladbrooke.[8] Ladbrooke's oeuvre is, however, difficult to establish, and none of his certain works is related closely to the style of the Washington picture.

Sir Geoffrey Agnew proposed an attribution to George Vincent.[9] Vincent usually signed and dated his paintings, so that his style is not hard to evaluate. The silhouetting of the trees, the handling of the tree trunks, the fuzzy treatment of the foliage, and the touch in the highlights in the Washington picture are certainly closer to the work of Vincent than to that of any other of the leading

painters of the Norwich School, but the coarseness of the facture, which is the dominant feature of the National Gallery's painting, is quite uncharacteristic of his style. This coarse, encrusted facture, especially marked in the treatment of the sky, is, however, typical of the work of the copyist Joseph Paul[10] (fig. 2), as are the deep tonality, the rough highlighting of the foliage, and the staccato handling of the branches in the right foreground. Paul has transmuted the beautiful, silvery style of the Crome from which he derived his composition into his own heavy and somewhat clumsy idiom.

A version of the Washington picture, smaller in size and varying in detail, again traditionally attributed to Crome, may also be ascribed to Paul (fig. 3).[11]

Notes
1. Information from P. A. B. Widener, "The Widener Collection, February 1st, 1908" in the NGA Library.
2. Goldberg 1978, 1: no. 92; 2: pl. 92.
3. It is unclear when the title first became attached to Crome's painting of a gate. It was not one of his exhibited titles,

Fig. 2. Joseph Paul, *Trees and Pool*, oil on canvas,
Norwich, Castle Museum [photo: Norfolk Museums Service]

Fig. 3. Attributed to Joseph Paul, *Landscape with Picnickers
and Donkeys by a Gate*, oil on canvas, England, private
collection [photo: Barnes and Webster]

nor was a painting of that title ever exhibited at one of the Norwich Society annual exhibitions (information kindly supplied by Andrew W. Moore, keeper of art, Castle Museum, Norwich).

4. Goldberg 1978, 1: no. 83; 2: pls. 83–84.

5. Widener 1915, unpaginated (as Crome).

6. Derek and Timothy Clifford, *John Crome* (London, 1968), 225; Francis Hawcroft to Ross Watson, 18 March 1969, in NGA curatorial files.

7. Goldberg 1978, 1: 94–95.

8. Goldberg 1978, 1: 213.

9. After inspecting the painting on 4 December 1973 (memorandum in NGA curatorial files). It was still listed simply as "follower of Crome" in NGA 1985, 108.

10. I am grateful to Andrew Moore for leading me toward this more convincing attribution.

11. An ink label on the back of the stretcher gives the earliest provenance as the Robert Hillier sale, Woodbridge, Suffolk, 19 August 1887, no. 66 (I am indebted to the present owner for allowing me to inspect and publish this painting).

References

1915 Roberts 1915: unpaginated, repro.

1978 Goldberg, Norman L. *John Crome the Elder*. 2 vols. Oxford, 1978, 1: 94–95, 213; 2: pls. 85–86.

Thomas Phillips

1770 – 1845

THOMAS PHILLIPS was born in Dudley, Warwickshire, on 18 October 1770, of well-to-do parents. After an apprenticeship with Francis Eginton, a Birmingham glass painter, he came to London in 1790 with an introduction to Benjamin West, who employed him on his painted-glass windows for St. George's Chapel, Windsor. Phillips entered the Royal Academy Schools in 1791. His first exhibits at the Royal Academy, between 1792 and 1794, were a view of Windsor Castle and history, religious, and mythological pictures, but he subsequently specialized in portraiture.

After a period of comparative obscurity in an age dominated by Lawrence, Hoppner, and Beechey—during which, however, he began his long association with Lord Egremont of Petworth—Phillips was elected an Associate of the Royal Academy in 1804 and a full Academician in 1808. In 1818 he told Farington that *"Owen, Shee & Himself had 50 guineas for a three quarter portrait, & 200 guineas for a whole length, & that He wd. not raise His price, having, He said, only business enough to keep Him employed."*[1] From about 1804 until his death he lived on George Street, Hanover Square. He married Elizabeth Fraser of Fairfield, near Inverness, who was noted for her beauty and accomplishments.

In 1825 Phillips was elected professor of painting at the Royal Academy in succession to Henry Fuseli. He held this post until 1832, and, in order to qualify himself for his duties, visited Italy, where he traveled in the company of William Hilton and Sir David Wilkie. His *Lectures on the History and Principles of Painting* were published in 1833. A man of wide learning, he was a Fellow of the Royal Society and of the Society of Antiquaries. He is best known for his portraits of scientists and literary figures, many of the latter painted for John Murray, the publisher. He died in London on 20 April 1845.

Phillips' style was formed on that of Lawrence, but though he evinced much of the latter's freshness and fluency he lacked Lawrence's bravura, vigor, and nervous vitality, and there is a certain stiffness in his work. He did not possess any real instinct for effective grouping or large-scale design, in which again he depended upon Lawrence, and most of his full lengths and his few subject pictures are unsuccessful. He was at his best with half-length portraits. His style showed no appreciable development.

Notes

1. Farington *Diary*, 15:5300 (13 December 1818).

Bibliography

Graves, R. E. In *Dictionary of National Biography*. Vol. 45. London, 1896:216–217.
Miller, Charlotte. "Thomas Phillips, R.A., F.S.A., 1770–1845. Portrait Painter." M.A. report, Courtauld Institute of Art, London, 1977.

Attributed to Thomas Phillips

1968.6.1 (2347)

Portrait of a Lady

c. 1830
Oil on canvas, 126.3 × 102 (49¾ × 40⅛)
Gift of G. Grant Mason, Jr.

Technical Notes: The fine canvas is plain woven; it was lined in 1968. The ground is white. The painting is executed in rich, fluid layers, blended wet into wet, with the features, jewelry, and horizon crisply defined in distinct, unblended layers. The paint has been severely abraded during successive restorations, and the impasto was badly flattened during lining. There is heavy retouching, chiefly in the hair, the foliage above, and the landscape lower left; the back of the neck has been entirely reglazed. The face has not been retouched. The thick dammar varnish applied in 1968 has not discolored.

Provenance: James Henry Smith, New York (sale, on the premises, American Art Association, New York, 18–22 Jan-

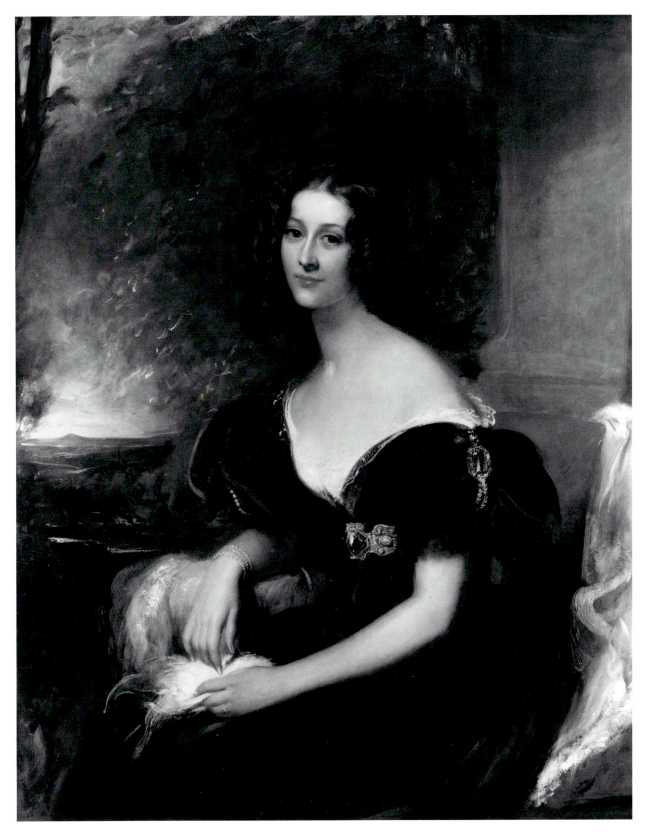

Attributed to Thomas Phillips, *Portrait of a Lady*, 1968.6.1

Fig. 1. Thomas Phillips, *Miss Hodges with a Landseer Newfoundland*, signed and dated 1801, oil on canvas, England, private collection
[photo: Thos. Agnew & Sons Ltd.]

uary 1910, no. 10, as *Lady Hertford* by Lawrence, repro.). George G. Mason, New York; by descent to G. Grant Mason, Jr., Arlington, Virginia.

IN THE CATALOGUE of the Smith sale the sitter was described as Lady Hertford. On grounds of age, however, the portrait cannot represent the wife of the third Marquess, née Maria Fagnani, who married in 1798 and died in 1856 aged eighty-five; the fourth Marquess did not marry. The identity of the sitter remains uncertain.

In 1910 the portrait was attributed to Lawrence, but this was correctly rejected by Garlick.[1] The dress, cut low off the shoulders with short double beret sleeves, and the loosely dressed hair style with center part and long ringlets indicate a date of about 1830. The modeling of the head and arms and very idiosyncratic handling of the landscape background suggest that the artist is Thomas Phillips, a contemporary and follower of Lawrence.[2]

Phillips' meticulous record of his work (referred to in note 2) indicates that he painted six female portraits of this size between 1825 and 1835, all of them exhibited works: Mrs. L. Hartopp and Lady de Dunstanville (1830), Lady Janet Walrond (1831), Mrs. Fitzgibbon and Mrs. Williams (1832), and Lady Pollock (1835). Of these six portraits, only that of Lady de Dunstanville is at present known; but Beechey's portrait of Lady Pollock rules her out also as the sitter in the Washington picture. This leaves four possible candidates, for none of whom is there any visual identification.

The loosely handled foliage with its broken highlights, and the dramatic lighting at the horizon contribute toward the gently romantic image suggested by the appealing glance and the slightly disheveled hair.

Serious deficiencies in drawing are evident in the unnaturally long neck, the elongated left arm, and the positioning of the right shoulder, the structure of which and its relationship to the right arm are concealed by the costume.

Notes
1. Kenneth Garlick, letter, 13 January 1969, in NGA curatorial files. It was listed as "follower of Lawrence" in NGA 1985, 222.
2. Comparison may be made with Phillips' portrait of a young lady, signed and dated 1801 (identifiable from the artist's list of pictures, a transcription of which is in the National Portrait Gallery, London, as Miss Hodges), which was with Thos. Agnew & Sons in 1976 (*Master Paintings*, no. 59) (fig. 1).

Sir Henry Raeburn

1756 – 1823

RAEBURN WAS BORN at Stockbridge, near Edinburgh, on 4 March 1756, the younger of the two sons of Robert Raeburn, a prosperous mill owner, and of Ann Elder. He was educated at George Heriot's Hospital, Edinburgh, and at the age of sixteen was apprenticed to the goldsmith James Gilliband. He met David Deuchar, a seal engraver and etcher, who encouraged his talent for drawing and of whom he painted a miniature (his earliest known work); he also met David Martin, the first Scot to make a living from portraiture in his native Edinburgh, who lent him paintings to copy. He never entered Martin's studio or attended an academy, and he was largely self-taught, a circumstance that accounts for his highly personal technique. His early work seems to have been entirely in the field of miniature painting. In about 1780 he married Ann Leslie, daughter of the factor of the Earl of Selkirk; they had two sons. Ann was a widow some twelve years older than he, with a comfortable income and property in Stockbridge; he thus became a painter of independent means.

In 1784 Raeburn spent two months in Reynolds' studio on his way south to travel abroad. He was away for three years, of which time little is known; James Nixon told Farington he was "2 years from Scotland one of which in Italy."[1] His earliest dated work, a miniature of the second Earl Spencer, was executed in Rome in 1786. Although he was manifestly influenced by the portrait patterns of Raphael and Velázquez, his period of study abroad seems to have had little other effect on his subsequent style; he was chiefly interested in sculpture, and thought of becoming a sculptor.

In 1786 Raeburn settled in Edinburgh New Town to practice as a portrait painter, achieving an instant success; his repertory of poses was influenced by those of Ramsay, Reynolds, and Romney. He worked first on George Street, then, after 1798, in a new studio with a single north light that he had built for himself on York Place; Martin had died in 1797, and from now on Raeburn was undisputed as the first portrait painter in Edinburgh. No sitter or account books survive, but it is known that by 1798 he was charging 18 guineas for a head and shoulders and 75 for a full length; by 1801 his prices for

half-length and full-length canvases were 50 and 100 guineas respectively, by 1818, 70 and 140 guineas, and by 1822, 100 and 200 guineas. Though he was able to command rising fees in the last decade of his career, they remained less than those of Beechey and a fraction of those levied by Lawrence.

Raeburn's contacts with London were at first limited; after exhibiting there in 1792, when his masterly *Sir John and Lady Clerk of Penicuik* (Sir Alfred Beit, Bt., Russborough) was well received, he did not do so again (save for single portraits in 1798, 1799, and 1802) until 1810, when—perhaps as a result of financial straits following the failure of his son's business in 1808—he considered moving south to fill the void left by the death of Hoppner. Although, after a visit in which he was received with great respect, he rejected the idea of establishing himself in the sophisticated society of the metropolis, he now began to exhibit regularly at the Royal Academy, becoming an Associate in 1812 and a full Academician in 1815.

Raeburn was knighted during George IV's visit to Scotland in 1822 and subsequently appointed King's Limner and Painter for Scotland. Modest, genial, and good natured, with a breadth of interests, both learned and sporting, he was popular in Edinburgh society, now increasingly vigorous and intellectual in outlook, and later among his fellow artists, with whom earlier he had associated little; a friend of Wilkie, he was active in encouraging young painters, offered the use of his own showrooms in York Place for annual exhibitions, and helped to form a Royal Scottish Academy (founded in 1826). He died in Edinburgh on 8 July 1823.

Raeburn's bold, direct style, which may have owed something to the example of Alexander Runciman, was well suited to the independent, innovative society he painted. Requiring four or five sittings for a head, he worked straightaway with the brush without preliminary drawings, often using square, flat touches, which were a personal characteristic; no drawings certainly by him are known, and his lack of training in draftsmanship accounts for weaknesses in anatomy and in the drawing of hands. His backgrounds were usually shadowy, so as not to divert attention from the figure. Raeburn's exe-

cution was lively, like that of Frans Hals, often disregarding form (Duncan Macmillan has suggested analogies with the theories of perception of the artist's friends, Alexander Reid and Dugald Stewart), and he was much criticized for lack of finish.

In his early post-Italian works Raeburn modeled firmly, delineated with care details such as plants or the frogging on military uniforms, painted in a low key, and showed a marked interest in silhouette. His likenesses were gentle or forthright according to sitter, but always perceptive and unaffected; he was at his best with men and women of intelligence and character. As his style developed he customarily described tone in terms of color, now high in key, and made an increasing use of dramatic effects of light. At first *contre-jour* effects, illuminating part of the face, were used to bring out character; by the end of the 1790s he was employing a high, concentrated light source to produce stronger modeling.

After 1810 Raeburn was more conscious of London styles, notably that of Lawrence, and, in his more ambitious exhibited works, strove after effect with a London audience in mind. Certain of his later portraits are charged with a high romantic quality, exemplified by heroic poses, dramatically low viewpoints, brilliant lighting, or overlarge luminous eyes; others display a noble simplicity. Effective in his postures, he was not an elaborate composer, and his double and group portraits tend to be awkwardly constructed. Neither was he successful when, occasionally, he tried to idealize his sitters with an overemphatic setting. Unlike Lawrence, he never essayed history or Shakespearean painting. His forte lay with the individual and, though his handling could be much softer in his late work, he also studied Rembrandt and experimented with strong broken color that sharpened physical presence. His characterization of his lively fellow Scots remained penetrating and sure.

Inevitably Raeburn influenced the next generation of Scottish portrait painters: his pupil John Syme, Colvin Smith, and, most notably, Sir John Watson Gordon. After a long period of neglect in the second half of the nineteenth century, he became a star of the Duveen era, his superb full-length portrait of Mrs. Robertson Williamson (Columbus Museum of Art, Ohio) establishing a record price in 1911 for a picture of any school sold in Britain. The directness of his portraiture made him especially popular in the United States, where, in the 1920s,

his work was more in demand than that of any other British painter. His true stature has yet to be assessed; several studies of his work and a major exhibition are in hand.

Notes
1. Farington *Diary*, 3:1011 (23 May 1798).

Bibliography
Cunningham, Allan. *The Lives of the Most Eminent British Painters, Sculptors, and Architects.* 6 vols. London, 1829–1833. 2d ed., 1837, 5:204–241.
Greig, James. *Sir Henry Raeburn, R.A.: His Life and Works.* London, 1911.
Baxandall, David. *Raeburn.* Exh. cat., National Gallery of Scotland. Edinburgh, 1956.
Harris, Rose. *Sir Henry Raeburn.* (The Masters series, no. 46.) Paulton, near Bristol, 1966.
Irwin, David, and Francina Irwin. *Scottish Painters at Home and Abroad 1700–1900.* London, 1975:146–164.
Thomson, Duncan. In *The Treasures of Fyvie.* Exh. cat., Scottish National Portrait Gallery. Edinburgh, 1985:54–61.
Macmillan, Duncan. *Painting in Scotland: The Golden Age.* Exh. cat., Talbot Rice Art Centre, University of Edinburgh; Tate Gallery, London. Oxford, 1986:74–136.

1948.19.1 (1024)

Captain Patrick Miller

1788/1789, altered later (date unknown)
Oil on canvas, 167.2 × 132.8 (65⅞ × 52¼)
Gift of Pauline Sabin Davis

Technical Notes: The heavy canvas is plain woven; it has been lined. The ground is white and contains white lead; it is possible that there are two layers, of which the white lead represents a priming over another, white chalk ground. The paint is applied in opaque layers, with thin, fluid washes, blended wet into wet in the darks, and with thick impasto in the lights; the final details are added crisply over dried lower layers. X-radiographs (fig. 1) show that some minor changes were made in the frogging, notably at the sitter's right shoulder above the armpit, where the V-shaped braid was originally filled with decorative trim, and that the necktie was originally higher and more elaborate; also, and this is visible to the naked eye, that the sitter originally held his hat (then adorned with a large rosette) in his left hand against the rump of his charger. The object he then held in his right hand is difficult to identify. Craquelure in the uniform reveals that its color was originally blue. The thinner washes are slightly abraded and the impasto has been flattened by lining.

Provenance: (Wallis & Son), London, 1910, from whom it was purchased by Sir Edgar Vincent, Bt., later Viscount d'Abernon [1857–1941], Esher Place, Surrey, who sold it c. 1917

Fig. 1. X-radiograph of the upper part of the figure of 1948.19.1

to (Duveen Brothers), London,[1] from whose New York branch it was purchased 1919 by Mr. [d. 1933] and Mrs. Charles H. Sabin, Southampton, Long Island, New York. (Mrs. Sabin [neé Pauline Morton] married Dwight F. Davis, Washington, in 1936.)

Exhibitions: *Pictures by Sir Henry Raeburn, R.A.*, French Gallery (Wallis & Son), London, 1910, no. 18. *Inaugural Exhibition*, Duke University Art Museum, Durham, North Carolina, 1969, no cat. *Styles in Portraiture*, Northern Virginia Fine Arts Association, Alexandria, 1972, no cat.

PATRICK MILLER was the eldest son of Patrick Miller of Dalswinton House in Dumfries, Scotland, friend of Robert Burns and James Nasmyth, a wealthy banker best known for his experiments in steam navigation. Young Miller was present with Burns at the trial on the Solway Firth of the first steamship in Great Britain. He appears as a boy of about fifteen in the center of the family group painted by Alexander Nasmyth in 1782. A regular army

officer for seven years, he became M.P. for Dumfriesshire in 1790.

The question of the uniform in which Miller is depicted—brown with silver lace and yellow facings—has been a subject of inconclusive debate among historians of military uniforms and other experts.[2] The recent technical examination revealing that the color beneath the present paint surface is blue to some extent clarifies the matter. The traditional identification with the Dumfries Yeomanry[3] remains unacceptable, since research in the army lists has shown that Miller was not commissioned in that regiment.[4] Miller served in the army from 1783 until 1790, when he resigned. He was successively an ensign in the Thirteenth Foot, a lieutenant in the Tenth Foot, a lieutenant in the Twelfth Light Dragoons, and a captain in the Fourteenth Light Dragoons.[5] Both the latter regiments had blue uniforms with silver lace and yellow facings, primrose yellow in the case of the Twelfth and lemon yellow in the case of the Fourteenth; the Twelfth

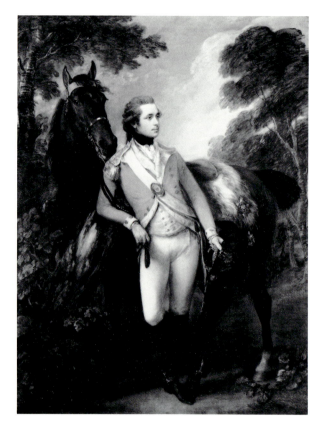

Fig. 2. Thomas Gainsborough, *Colonel John Hayes St. Leger*, R.A. 1782, oil on canvas, London, Royal Collection [reproduced by gracious permission of H.M. The Queen]

are known to have been unusual in retaining black horse furniture until 1792.[6] The facings in Miller's uniform are pale yellow, and the horse furniture black, so that the uniform as originally painted by Raeburn may be identified as that of the Twelfth Light Dragoons, in which Miller served as a lieutenant from February 1788 to May 1789.

This leaves unresolved the identification of the uniform in which Miller is actually depicted. Presumably the portrait was altered by Raeburn at a later date when Miller was serving in a different regiment as a more senior officer and wanted himself recorded in this new capacity. During the Revolutionary and Napoleonic Wars a considerable number of militia regiments were formed, the uniforms of which were often highly individual (officers in the same regiment sometimes wearing different uniforms) and are scantily recorded: it is likely that Miller served in one of these formations, though, as noted above, he was not an officer in the regiment he was most likely to have joined, the Dumfries-shire Yeomanry.

Miller is shown resting his arm on his charger in a manner employed by both Reynolds and Gainsborough (fig. 2), and which Raeburn adopted for his equestrian portraits, but the relationship between the sitter and his mount has not been satisfactorily resolved and the horse is somewhat wooden, as in Hoppner's rendering of the theme (John Curwen, painted 1782, delivered 1788). The relationship would have been even more awkward before Raeburn repositioned the hat, originally held against the horse's rump, unsupported by Miller's left hand (fig. 1).[7] The sitter is strongly lit and set in the extreme foreground, thus making close contact with the spectator, with the landscape falling away behind him, as so often in Raeburn's work. The loosely swept back hair with small side curls is characteristic of the 1780s and early 1790s.

Notes

1. Duveen Brothers to Mrs. John Shapley, 5 August 1948, in NGA curatorial files.
2. R. Gerard, Transvaal Museum, Pretoria, letters, 27 September, 23 October, 15, 16 December 1951, 17 January, 26 July 1952, in NGA curatorial files; R. G. Ball, Scottish United Services Museum, letter, 20 October 1969, in NGA curatorial files. Ball also stated that, according to a note in his museum's files, a version or copy of the Washington portrait in which the uniform was said to be green (apparently at one time the color worn by the Dumfries-shire Yeomanry) was owned by Major A. B. Cree, Cape Town; the existence of such a work is not borne out by the correspondence (which suggests rather that Major Cree was simply interested in the Washington picture), but is given some credence by the discovery already noted that the color of the uniform in the National Gallery's painting was originally blue and not brown (a discolored blue might appear to be green).
3. The portrait was captioned as such in exh. cat. London 1910, no. 18.
4. R. Gerard, letter, 17 January 1952, citing research by Haswell Miller, in NGA curatorial files.
5. A. S. White, Society for Army Historical Research, letter, 26 June 1951, in NGA curatorial files.
6. R. G. Ball, letter, 20 October 1969, in NGA curatorial files.
7. Compare Raeburn's more successful handling of the theme in later years in his full-length portraits of Harley Drummond (The Metropolitan Museum of Art) and Professor John Wilson (Royal Scottish Academy, Edinburgh; Greig 1911 [see biography], pl. 10a), in which the sitters are holding their hats against their mounts in a more sophisticated manner than in the original conception of the Washington picture.

References

1911 Greig 1911 (see biography): 53.
1976 Walker 1976: no. 528, color repro.

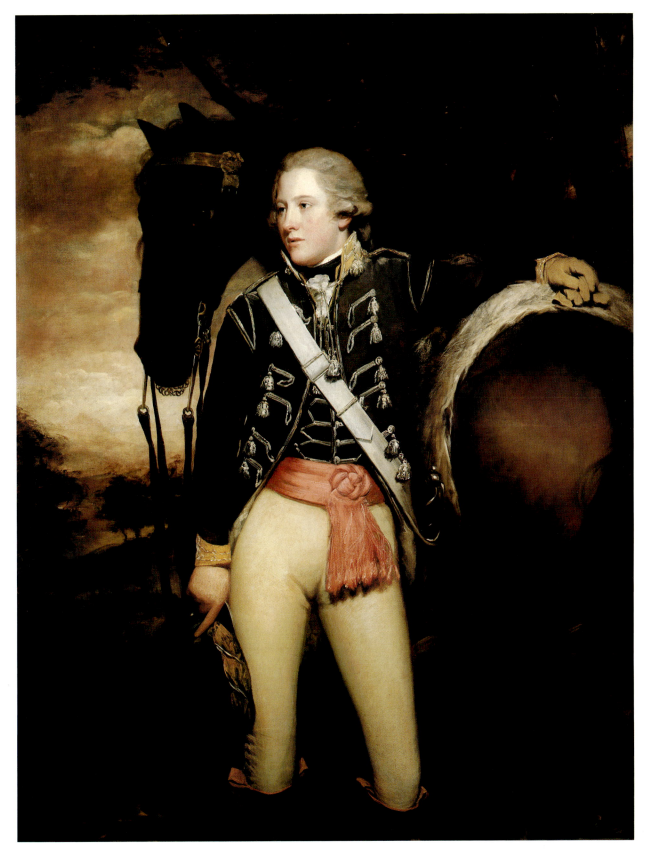

Sir Henry Raeburn, *Captain Patrick Miller*, 1948.19.1

Fig. 1. X-radiograph of 1942.9.56, showing the underlying double portrait

1942.9.56 (652)

David Anderson

1790
Oil on canvas, 152.5 × 107.5 (60 × 46¼)
Widener Collection

Technical Notes: The medium-heavy canvas is tightly twill woven; it has been lined. The ground is white, containing white lead, and is thinly applied. The painting is executed in thin layers, with little evidence of brushmarks, and in some areas the paint does not completely cover the ground. X-radiographs and an infrared reflectograph show a woman's body to the left of the figure (see below), and a thin but apparently bent implement depending from the man's left arm. There is some scattered unevenness in the paint surface, perhaps due to lumps in the lining adhesive. The paint surface has also been slightly abraded. The head and hair of the sitter are disfigured by shrinkage crackle in the darks. There are scattered small retouches, principally in the areas of pentimenti. The thick varnish has discolored yellow to a significant degree.

Provenance: Painted for Warren Hastings [1732–1818], Daylesford House, Gloucestershire, probably upon whose death it was returned to the sitter;[1] by descent to Captain David Anderson [1867–1944], Bourhouse, Dunbar, East Lothian.[2] (Aitken Dott & Son), Edinburgh, who sold it 1900 to (P. & D. Colnaghi & Co.), London,[3] from whom it was purchased October 1903 by Dr. Eissler [possibly Dr. Gottfried or Hermann Eissler, Vienna]. Purchased c. 1924 by Joseph E. Widener, Elkins Park, Pennsylvania. Inheritance from the Estate of Peter A. B. Widener by gift through power of appointment of Joseph E. Widener, after purchase by funds of the Estate.

DAVID ANDERSON (1750–1825), of St. Germains, near Tranent, East Lothian, served in India with Warren Hastings, the first governor-general. The two became lifelong friends, and when they returned to England in 1785 they agreed to exchange portraits of each other, Hastings choosing Reynolds to paint his.[4] Anderson wrote to Hastings on 7 July 1790 that he had begun sitting to Raeburn.[5]

The concept, with one side of the sitter's head in shadow and the other thrown into high relief by the rays of the setting sun, is typical of Raeburn's style of the 1790s. The highlighted passages are modeled in broad brushstrokes blocking out distinct planes. The shaded side of the face is very thinly painted, without modeling. The sitter is set high in the canvas, and the authority of the image is emphasized by his dominance over the generalized landscape. The foliage is autumnal in character.

Fig. 2. Infrared reflectogram of the underlying head of Mrs. Anderson in 1942.9.56

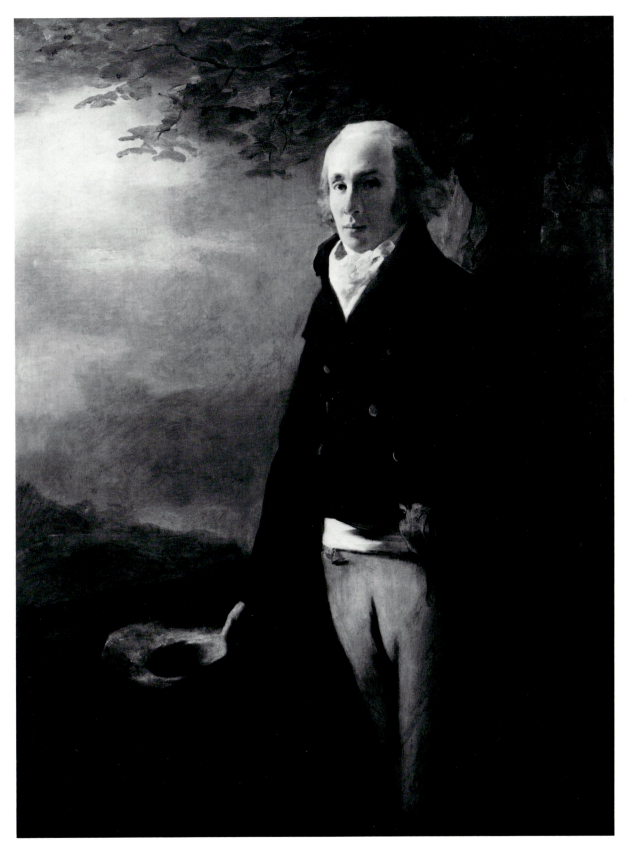

Sir Henry Raeburn, *David Anderson*, 1942.9.56

Sir James Caw stated that the canvas originally contained a portrait of Mrs. Anderson but that, as Anderson did not like it, it was painted out.[6] Pentimenti are indeed visible down the length of the sitter's right arm and in the sky, and x-radiographs (fig. 1) reveal the artist's original intention of including the sitter's wife in the picture. It has been suggested that the pentimenti may represent an earlier position for David Anderson himself,[7] but such a placement in the canvas would make very little sense from a compositional point of view, and an infrared reflectogram (fig. 2) shows that the head is that of a woman and also that the execution had been carried to an advanced stage, with the features clearly defined. The figures would have been awkwardly related, as so often in Raeburn's groups.

Notes

1. According to Kathleen Bliss, London, who was married to a direct descendant of David Anderson, the portrait was returned to David Anderson either after Warren Hastings' trial or after his death (Mrs. Bliss to John Walker, 16 April 1947, in NGA curatorial files).

2. The provenance from Captain Anderson to Dr. Eissler is recorded in Greig 1911 (see biography): 37.

3. Colnaghi's stock books (Roderic Thesiger, letter, 23 September 1969, in NGA curatorial files).

4. Hastings to Anderson, 19 September 1785 (British Library Add. MS. 45, 418: fols. 2–3). In the event Reynolds prevaricated and it was not until after his death, and after Warren Hastings' acquittal from his long drawn-out trial, that Hastings commissioned Lemuel Abbott, to whom he sat 1795–1796 (Hastings to Anderson, 13 January 1797, published in Sir Evan Cotton, "Warren Hastings' Favourite Portrait," *Bengal Past & Present* 44 [1932], 114). The portrait, now in the Victoria Memorial Museum, Calcutta, was delivered to Anderson in February (Anderson to Hastings, 3 February 1797 [British Library Add. MS. 29, 175, fol 26], published in Cotton 1932, 115). A portrait of Warren Hastings by John James Masquerier, now in the Art Gallery of New South Wales, Sydney, Australia (*Catalogue of British Paintings*, n.d. [1987], 26 repro.), also descended in the Anderson family.

5. Anderson to Hastings, 7 July 1790 (British Library Add. MS. 45,418: fol. 375).

6. In his catalogue published in Armstrong 1901, 95.

7. David Mackie suggested that the figure might not be a woman, but the infrared reflectography confirms that Raeburn's original intention was indeed to include Mrs. Anderson (Ann Hoenigswald and Catherine Metzger, memoranda, 10 December 1986, 2 October 1987, in NGA curatorial files).

References

1901 Armstrong, Sir Walter. *Sir Henry Raeburn.* London, 1901:95.
1911 Greig 1911 (see biography): 37.
1931 Widener 1931:172, repro.
1976 Walker 1976: no. 523, color repro.

1945.10.3 (884)

John Johnstone, Betty Johnstone, and Miss Wedderburn

c. 1790/1795
Oil on canvas, 101.5 × 120 (40 × 47¼)
Gift of Mrs. Robert W. Schuette

Technical Notes: The medium-weight canvas is twill woven; it has been lined. The ground is white, thinly and evenly applied. The painting is broadly executed, mostly in thin layers, but with several areas of low impasto. The painting is in good condition except for numerous small areas of discolored overpaint scattered throughout. The thinly applied natural resin varnish has discolored yellow to a significant degree.

Provenance: Painted for John Johnstone [1734–1795], Alva House, Clackmannanshire, fourth son of Sir James Johnstone, 3rd Bt., of Westerhall; by descent to his great-grandson, Major James Johnstone [1865–1906], Hangingshaw, Selkirk (sale, Christie, Manson & Woods, London, 26 May 1906, no. 92), bought by Wood. Mrs. P. Nelke, who sold it to (Lewis & Simmons), Paris, from whom it was purchased July 1928 by Mr. and Mrs. [d. 1945] Robert W. Schuette, New York.[1]

Exhibitions: *A Survey of British Painting*, Carnegie Institute, Pittsburgh, 1938, no. 37, repro. *Masterpieces of Art: European & American Paintings 1500–1900*, New York World's Fair, 1940, no. 146, repro.

AS A YOUNG MAN John Johnstone was in the service of the East India Company, serving in the artillery at the Battle of Plassey in 1757, and on the Council of Bengal from 1761 to 1765. An unscrupulous business man, he returned home in disgrace, but with a vast fortune. He purchased Alva and other large estates in Scotland, and sat as M.P. for Dysart Burghs from 1774 to 1780, voting with the Opposition and adopting a consistently pro-American stance.

According to family tradition,[2] the sitters in the National Gallery's portrait are John Johnstone, his sister, Betty, and his niece, Miss Wedderburn. The last named is reading or discussing a book; the others are attentive. The group is compressed in the front plane of the canvas and not very satisfactorily defined in space. It is a good deal more sophisticated, however, than the comparable portrait of Mr. and Mrs. James Harrower of Inzievar with their son reading.[3] Cunningham remembered seeing in Raeburn's studio "several family groups of ladies and children, with snatches of landscapes behind,"[4] but Mackie has pointed out that the only other conversation

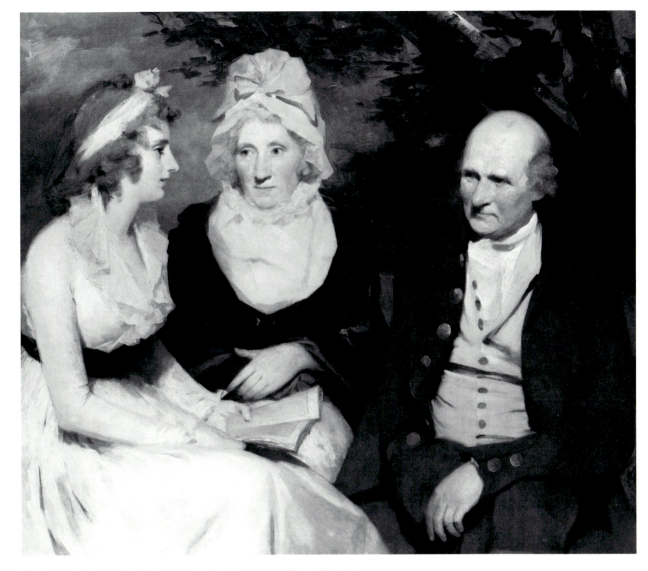

Sir Henry Raeburn, *John Johnstone, Betty Johnstone, and Miss Wedderburn*, 1945.10.3

piece by Raeburn known to him is the picture of General Francis Dundas and his wife playing chess (Mr. and Mrs. Aedrian Dundas Bekker, Arniston House, Gorebridge, Midlothian).[5]

Miss Wedderburn's hairstyle, loosely curled at the front and sides, secured with a ribbon-bandeau and dressed behind in a chignon, is characteristic of the fashion of the 1790s, as is Betty Johnstone's bonnet. The painting must, therefore, have been executed sometime in the last few years of Johnstone's life.

The work is broadly handled except for the heads, which are finely characterized. It is typical of Raeburn

that Johnstone should be depicted bald rather than wearing a wig, as Reynolds might have preferred. The even lighting is a characteristic of Raeburn's early style.

Notes

1. Gerald Donovan of Sullivan, Donovan & Heeneham, New York, counsel to Mrs. Robert Schuette, letter, 27 September 1945, in NGA curatorial files.

2. Armstrong 1901, 106.

3. Last recorded in the Norton Simon Foundation sale, Sotheby & Co., 27 June 1973, no. 21, repro.

4. Cunningham 1837 (see biography), 5:224.

5. David Mackie, memorandum, 11 August 1986, in NGA curatorial files.

References
1901 Armstrong, Sir Walter. *Sir Henry Raeburn*. London, 1901:106.
 1911 Greig 1911 (see biography): 50.
 1976 Walker 1976: no. 525, color repro.

1970.17.130 (2502)

Mrs. George Hill

c. 1790/1800
Oil on canvas, 96.9 × 76.6 (38⅛ × 30⅛)
Ailsa Mellon Bruce Collection

Technical Notes: The medium-weight canvas is twill woven; it has been lined. The ground is white, of moderate thickness. The painting is executed in very fluid and thin layers, blended wet into wet; the forms are vaguely blocked, only the features being crisply defined. Most of the picture surface has been solvent abraded; the texture has been flattened and the weave of the canvas impressed into the surface during lining. There is considerable retouching throughout the figure and lower background. The thickly and unevenly applied natural resin varnish, toned with carbon black, has discolored gray to a significant degree.

Provenance: Painted for the sitter's husband, the Reverend George Hill [1750–1819], St. Andrews, Scotland; by descent to John Sheriff Hill [d. 1900], Dingwall, Inverness (sale, Fraser, Inverness, 1900), bought by (Wallis & Son), London. (M. Knoedler & Co.), New York, by 1911,[1] from whom purchased by 1925 by Andrew W. Mellon, Pittsburgh, who gave it by 1937 to his daughter, Ailsa Mellon Bruce, New York [d. 1969].

Exhibitions: *Paintings by Old Masters from Pittsburgh Collections*, Carnegie Institute, Pittsburgh, 1925, no. 58.

HARRIET SCOTT, daughter of Alexander Scott, an Edinburgh merchant, married George Hill (fig. 1), later principal of St. Mary's College, St. Andrews, in 1782. Of their six or more children, one became professor of divinity at Glasgow University and another chief secretary of the East India Company at Madras.

The crisply modeled head and even lighting are characteristic of Raeburn's early style. The evidence of costume suggests a date in the 1790s: the casually curled hairstyle was fashionable in that decade (compare the similar coiffure in 1937.1.101, the next entry, datable to about 1793).

The concept of positioning the sitter in a dining armchair in an outdoor setting, common in Raeburn's work, and the even, frontal lighting of the figure give the twilit background the air of a photographer's backdrop.

Notes
1. Greig 1911 (see biography), 48.

References
1901 Armstrong, Sir Walter. *Sir Henry Raeburn*. London, 1901:104.
 1911 Greig 1911 (see biography): 48.
 1976 Walker 1976: no. 527, color repro.

Fig. 1. Sir Henry Raeburn, *The Reverend George Hill*, from the mezzotint, Edinburgh, Scottish National Portrait Gallery

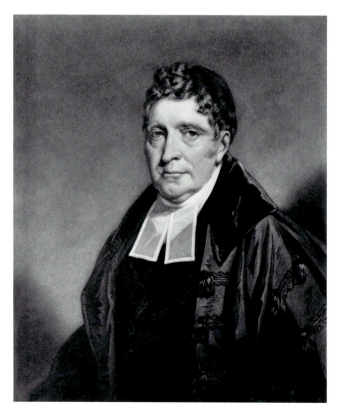

1937.1.101 (101)

Miss Eleanor Urquhart

c. 1793 (receipt dated 10 January 1794)
Oil on canvas, 75 × 62 (29½ × 24⅜)
Andrew W. Mellon Collection

Technical Notes: The coarse, heavyweight canvas is twill woven; it has been lined. The ground is white or off-white, evenly applied and of moderate thickness. The painting is executed boldly and spontaneously, using a wide brush; the paint layers are thin and sketchy, leaving the weave of the canvas clearly visible, and only the sitter's head is brought to a higher finish. The painting is in excellent condition. Retouching is minimal. The synthetic varnish applied in 1980 has not discolored.

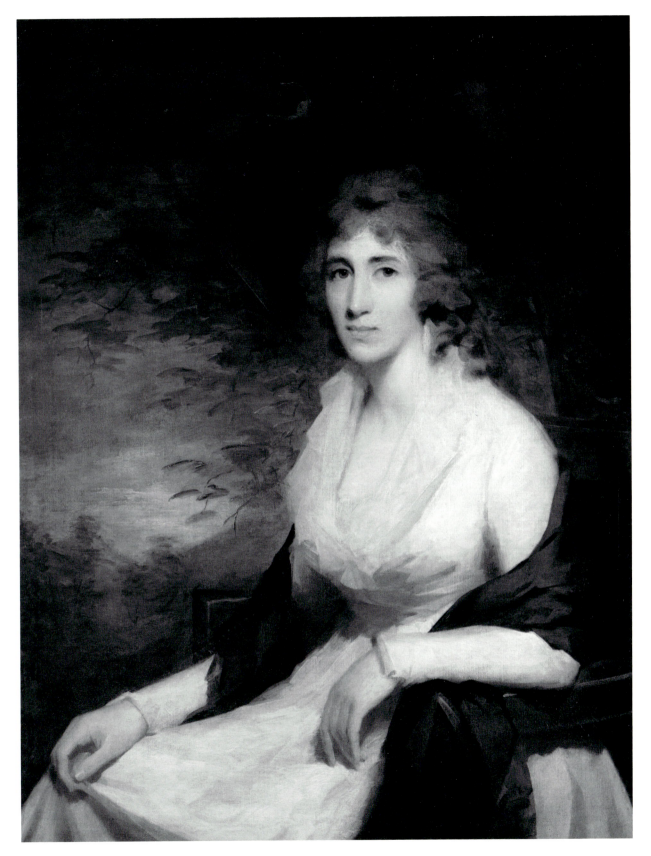

Sir Henry Raeburn, *Mrs. George Hill*, 1970.17.130

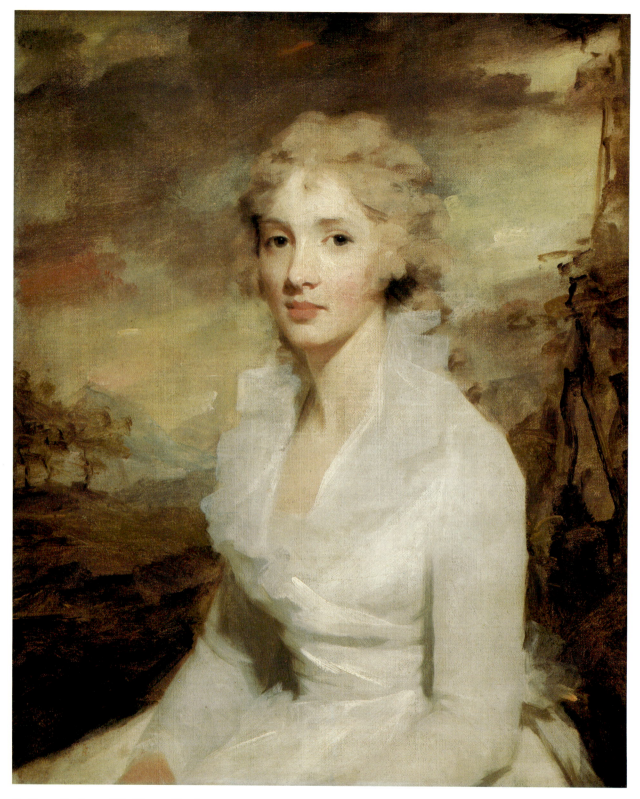

Sir Henry Raeburn, *Miss Eleanor Urquhart*, 1937.1.101

Provenance: Painted for the sitter's father, William Urquhart, 2nd Laird of Craigston, Craigston Castle, Turriff, Aberdeenshire; by descent to Captain Michael Bruce Pollard-Urquhart [1879–1940], Craigston Castle and Castle Pollard (sale, Christie, Manson & Woods, London, 20 December 1918, no. 144), bought by (Arthur J. Sulley & Co.), London. (M. Knoedler & Co.), London, probably from whose New York branch it was purchased 5 October 1920 by Andrew W. Mellon, Pittsburgh, by whom deeded December 1934 to The A. W. Mellon Educational and Charitable Trust, Pittsburgh.

ELEANOR URQUHART was the eldest daughter of William Urquhart of Craigston by his first wife, Margaret Irvine.[1] Nothing else is known of her life.

The receipt for this portrait, and for those of the sitter's parents, is dated 10 January 1794, the charge for each being fifteen guineas.[2]

The portrait is thinly, almost transparently painted, without preliminary drawing, and both costume and background are extremely sketchy in handling, accents of light and dark alike being executed in loose, free brushstrokes. The head itself is broadly modeled, the sitter's loveliness and freshness of appeal emphasized by the pale tonality of the canvas. The picture ranks as one of the masterpieces of Raeburn's direct, unaffected style of the 1790s. As the Irwins point out, the formula, "setting a half-length figure in white muslin with fashionably disordered curls, against an expanse of sky and landscape," is close to that of Romney.[3]

Notes
1. The sitter is identified, presumably on the basis of information provided by the family, in Christie's catalogue of the Pollard-Urquhart sale (see above). Corroborative evidence is provided by Mrs. Bruce Urquhart of Craigston to John Walker, 25 May 1953, in NGA curatorial files. The portrait has, in the past, mistakenly been identified as Eleanor Urquhart (d. 1883), the younger daughter of John Urquhart, the 3rd Laird of Craigston.
2. The receipt is or was preserved at Craigston Castle (Mrs. Bruce Urquhart to John Walker, 25 May 1953, in NGA curatorial files). The portraits of Mr. and Mrs. William Urquhart, the sitter's parents, have been identified as those in the City Art Gallery, Glasgow (nos. 903, 904), but these works are painted in a later style and the sitters are surely too young to have been Eleanor's parents.
3. David and Francina Irwin, *Scottish Painters at Home and Abroad 1700–1900* (London, 1975), 158.

References
1949 Mellon 1949:117 repro.
1966 Harris 1966 (see biography): 5, 7, color pl. 6.
1976 Walker 1976: no. 517, color repro.

1937.1.103 (103)

John Tait and His Grandson

c. 1793 (with addition c. 1800)
Oil on canvas, 126 × 100 (49⅝ × 39⅜)
Andrew W. Mellon Collection

Technical Notes: The medium-heavyweight canvas is twill woven; it has been lined. The ground is white, of moderate thickness. The painting is executed fluidly and thinly, blended wet into wet, except in the rendering of the child, where the coloration and shadows in the face are applied in glazes and the costume is painted thickly to cover the dark paint of an earlier composition. X-radiographs (fig. 2) show that the child was added later; the sitter was originally shown with his arm resting on the chair, holding a hat. The thinner areas are solvent abraded, and the impasto has been slightly flattened during lining. As a result of exposure to excessive heat, the paint has been damaged along the right edge in a strip approximately 2.5 cm. wide. Otherwise the painting is in good condition. The moderately thick natural resin varnish has discolored yellow to a significant degree.

Provenance: Craufurd Tait, Edinburgh [d. 1832], the sitter's only son; by descent through John Tait [d. 1877], the child in the portrait, to Mrs. Frederick Pitman, née Tait, Edinburgh, by 1901; her eldest son, Archibald Robert Craufurd Pitman, Edinburgh, who sold it October 1918 to (Robert Langton Douglas), London,[1] who sold it the same month to (M. Knoedler & Co.), London, from whose New York branch it was purchased February 1919[2] by Andrew W. Mellon, Pittsburgh, by whom deeded December 1934 to The A. W. Mellon Educational and Charitable Trust, Pittsburgh.

Exhibitions: *Works of Deceased and Living Scottish Artists*, Royal Scottish Academy, Edinburgh, 1863, no. 293. *Sir Henry Raeburn, R.A.*, Royal Academy, National Galleries, Edinburgh, 1876, no. 183. *Old Scottish Portrait Painters*, Grafton Galleries, London, 1895, no. 76. *Scottish National Exhibition*, National Gallery of Scotland, Edinburgh, 1908, no. 32. *Pictures by Sir Henry Raeburn, R.A.*, French Gallery (Wallis & Son), London, 1911, no. 8, repro. *Pictures by Raeburn*, M. Knoedler & Co., 1925, New York, no. 4.

JOHN TAIT (1727–1800) of Harviestoun, writer to the Signet and advocate, married a daughter of Murdoch of Cumloden, Galloway. His grandson, John Tait (1796–1877), also an advocate, was sheriff of Clackmannan, Kinross and Perth. Another grandson became archbishop of Canterbury. Tait was also painted by Raeburn some years earlier, at three-quarter length seated indoors (Fine Arts Museums of San Francisco).

The portrait was seen in Raeburn's studio in 1793 by Andrew Robertson, who made a miniature copy of it (fig.

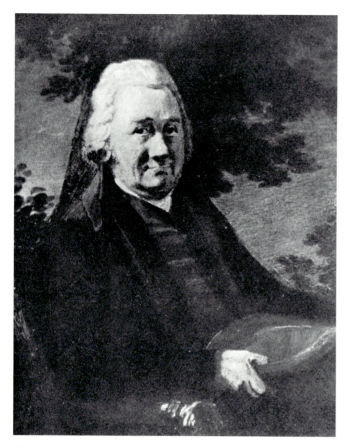

Fig. 1. Andrew Robertson, *John Tait*,
1793 (whereabouts unknown) [photo: Barnes and Webster]

1).[3] This copy shows Tait without his small grandson, holding a hat in his right hand and resting his arm on the side of the rustic chair. The child, who is about four, was included in the picture after Tait's death in 1800. There are awkwardnesses and inconsistencies in the altered portrait: the boy's costume spreads out in an amorphous way in order to fill the canvas, Tait remains looking at the spectator while dangling his watch in front of his grandson, and the hand introduced holding the boy's wrist is another right hand instead of a left one.

Both heads are strongly lit (not from the glowing sky but from studio top-lighting), a feature characteristic of Raeburn's style by 1800 and which Robertson toned down in his copy, thinking it injured the effect.[4] The lighting emphasizing the child's expression of wonderment as he holds up the watch chain and fob is reminiscent of Wright of Derby. The child's head is more broadly modeled than Tait's, marking a change in Raeburn's style in the intervening years.

Notes
 1. John S. Pitman (Archibald Pitman's brother), undated letter to Langton Douglas, in NGA curatorial files.

Fig. 2. X-radiograph of 1937.1.103, showing the composition before the inclusion of the child

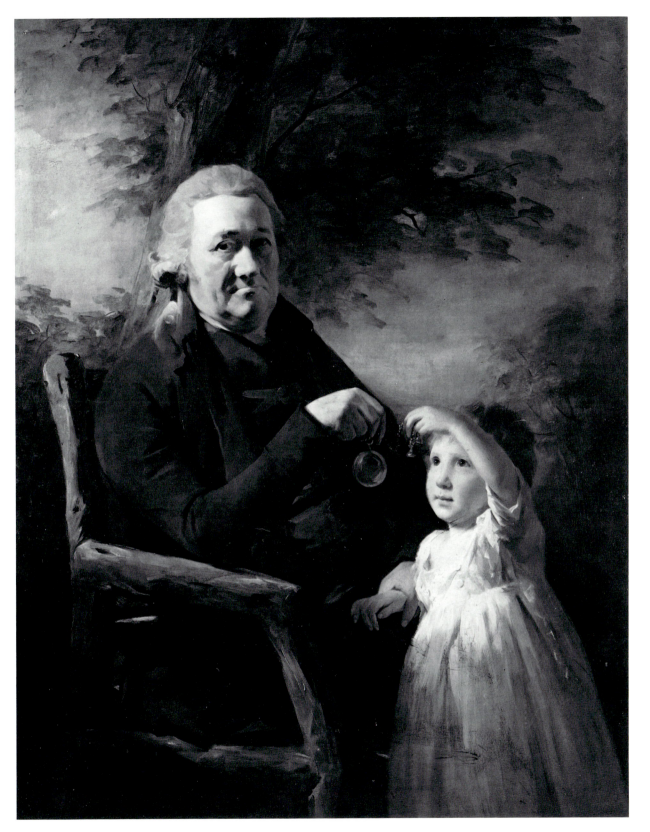

Sir Henry Raeburn, *John Tait and His Grandson*, 1937.1.103

2. M. Knoedler & Co. stock books (Helmut Ripperger to Ross Watson, 28 September 1969, in NGA curatorial files).

3. Greig 1911 (see biography), xxxiv–xxxv.

4. Greig 1911 (see biography), xxxv.

References

1901 Armstrong, Sir Walter. *Sir Henry Raeburn.* London, 1901:19, 113, repro. opposite 44.

1911 Greig 1911 (see biography): xxxv, 61, pl. 24.

1976 Walker 1976: no. 522, color repro.

1937.1.102 (102)

Colonel Francis James Scott

1796/1811
Oil on canvas, 128 × 102 (50⅜ × 40⅛)
Andrew W. Mellon Collection

Technical Notes: The medium-weight canvas is twill woven; it has been lined. The ground is white, thinly applied. The painting is executed fluidly, ranging from thin, sketchy brushwork in the background to thick impasto in the highlights. There is a pentimento in the upper part of the right arm, which was once wider. The impasto has been flattened, and the weave of the canvas impressed into the paint surface, during lining. Extensive traction crackle in the sky and hair has been retouched. The thick natural resin varnish has discolored yellow to a significant degree.

Provenance: Presented by the sitter to James Pillans, 1815.[1] Bequeathed to William Soltan Pillans, London.[2] (Anon. [Miss Pillans] sale, Christie, Manson & Woods, London, 1 July 1899, no. 100), bought by (Thos. Agnew & Sons), London, who sold it 1899 to Marcus Trevelyan Martin, London; passed to his wife, who sold it October 1921 to (M. Knoedler & Co.), London,[3] from whose New York branch it was purchased May 1922 by Andrew W. Mellon, Pittsburgh and Washington, by whom deeded December 1934 to The A. W. Mellon Educational and Charitable Trust, Pittsburgh.

Exhibitions: *Twenty Masterpieces of the English School*, Thos. Agnew & Sons, London, 1899, no. 10. *Works by the Old Masters and Deceased Masters of the British School*, Winter Exhibition, Royal Academy of Arts, London, 1906, no. 57. *Franco-British Exhibition*, London, 1908, no. 58A. *Pictures by Raeburn*, M. Knoedler & Co., New York, 1925, no. 3.

FRANCIS JAMES SCOTT (born c. 1745), of Horsely[4] was a regular soldier for twenty years. He served in the Sixth Foot from 1762 to 1782, rising from the rank of ensign to that of major, transferring to the Ninety-Second Foot in 1782; he left the army after the latter regiment was disbanded in the following year, at the time of the Treaty of Paris which ended the American War of Independence.

He took up arms again during the French Revolutionary wars, joining the Dumbarton Fencible Infantry as a major in 1796, and becoming lieutenant-colonel in 1797; this regiment, the uniform of which was red with black facings and, apparently, silver lace, was disbanded in 1802, at the time of the Peace of Amiens.[5]

Scott is depicted in a uniform that corresponds sufficiently with what is recorded of the Dumbarton Fencibles. This would date the portrait to between 1796 and 1802, which is consonant with the age of the sitter, who would then have been in his early to mid-fifties. It may be noted, however, that he is wearing the short "Brutus crop" hairstyle fashionable in the first decade of the nineteenth century; a *terminus ante quem* is provided by the epaulettes, badges of rank that were discontinued by an army order of 1811. The strong top-lighting and bold chiaroscuro are characteristic of Raeburn's style from the late 1790s.[6]

Scott is painted in a heroic pose, from a very low viewpoint, and set against a stormy sky appropriate to a military commander. The head is firmly and richly modeled, and the expression determined. The image is in every way suitable to the colonel of a volunteer militia regiment at a time when the country was threatened by invasion from France.

Notes

1. There is an inscription on the back of the lining canvas, presumably copied from the original canvas: "Colonel Francis James Scott to his Friend James Pillans Esq. 1815."

2. A label on the back of the lining canvas is inscribed: "Portrait of Colonel Francis Scott of Harsely [sic], my much regarded friend—to William Soltan Pillans—given for family preservation specially noted in my settlement J. Pillans."

3. M. Knoedler & Co. stock books (Helmut Ripperger to Ross Watson, 28 September 1969, in NGA curatorial files).

4. Perhaps Horsley Hall, Strontian, Argyllshire, the only "Horsely" in Scotland.

5. The foregoing information is derived from a letter from Ronald G. Ball, Scottish United Services Museum, 20 October 1969, in NGA curatorial files.

6. Robin Hutchison, former keeper of the Scottish National Portrait Gallery, dated the portrait c. 1805–1810 on stylistic grounds (Ronald G. Ball, letter, 20 October 1969, in NGA curatorial files).

References

1901 Armstrong, Sir Walter. *Sir Henry Raeburn.* London, 1901:111.

1911 Greig 1911 (see biography): 59.

1976 Walker 1976: no. 524, color repro.

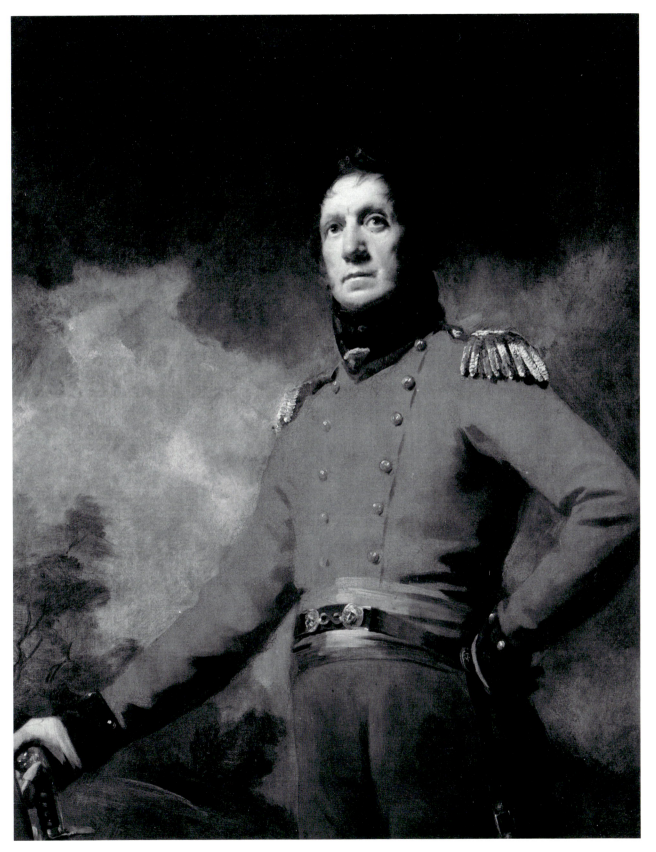

Sir Henry Raeburn, *Colonel Francis James Scott*, 1937.1.102

Sir Henry Raeburn, *The Binning Children*, 1942.5.2

1942.5.2 (553)

The Binning Children

c. 1811 (?)
Oil on canvas, 128.8 × 102.7 (50¾ × 40⅜)
Given in memory of John Woodruff Simpson

Technical Notes: The medium-weight canvas is twill woven; it has been lined. The ground is white, of moderate thickness. The painting is executed thinly, with smoothly blended brushwork in the heads and costume, fluid and sketchy brushwork in the hands, collars, and background, and low impasto in the highlights. The paint surface is slightly abraded, increasing the transparency in some of the darks and the sky, and has been severely flattened during lining. There is scattered retouching. The thick natural resin varnish has discolored yellow to a significant degree.

Provenance: Painted for the sitters' father, David Monro Binning of Argaty [1776–1843]; by descent to the elder son in the picture, George Home Monro Binning Home [d. 1884], thence to his nephew, George Home Monro Home; (anon. [Monro Home] sale, Christie, Manson & Woods, London, 3 May 1902, no. 97, repro.), bought by (Thos. Agnew & Sons), London, who sold it the same year to (M. Knoedler & Co.), London,[1] from whom it was purchased by John Woodruff Simpson, New York; passed to his wife, Kate Seney Simpson, Craftsbury, Vermont.

Exhibitions: Perhaps Associated Society of Artists, Edinburgh, 1811, no. 187.

NOTHING IS KNOWN about the two sons of David Monro Binning except the name of the elder, George, who died in 1884. Sir James Caw was the first to suggest[2] that the picture may have been the "Portrait of two boys" exhibited by Raeburn in Edinburgh in 1811; his dating was followed by Greig.[3] The portrait is certainly an example of Raeburn's mature work. The heads are broadly modeled, and the boys, dressed in identical suits, and holding identical fur-trimmed hats, are posed in a successful and uncontrived diagonal. The figures are gently lit, the glowing sky is softly handled, and the top of the canvas is filled out with wisps of twig and foliage. It is not clear whether the boy on the left is holding a riding crop for any but pictorial reasons; the two youngsters are absorbed with each other rather than with the adult world.

Notes
1. M. Knoedler & Co. stock books, recorded by The Provenance Index, J. Paul Getty Trust, Santa Monica, California.
2. In his catalogue published in Armstrong 1901, 96.
3. Greig 1911 (see biography), 38.

References
1901 Armstrong, Sir Walter. *Sir Henry Raeburn*. London, 1901: 96, repro. opposite 68.
1911 Greig 1911 (see biography): 38.
1976 Walker 1976: no. 526, color repro.

Attributed to Sir Henry Raeburn

1970.17.131 (2503)

Miss Davidson Reid

c. 1800/1806
Oil on canvas, 75.5 × 64 (29¾ × 25¼)
Ailsa Mellon Bruce Collection

Technical Notes: The medium-weight canvas is tightly twill woven; it has been lined. The ground is off-white, thinly applied. The painting is executed in thin, smooth, opaque layers which, in the shadows of the costume, barely cover the ground. The paint surface is slightly abraded, and the weave of the canvas may have been emphasized during lining. Retouching is min-

imal. The natural resin varnish, slightly toned with brown and black pigment, has discolored yellow to a significant degree.

Provenance: Probably painted for the sitter's father, David Reid, Edinburgh; by descent, through the sitter's daughter, Mrs. John Pryce, to Sir Henry Edward ap Rhys-Pryce [1874–1950][1] (sale, Christie, Manson & Woods, London, 18 July 1924, no. 84), bought by (M. Knoedler & Co.), London, from whose New York branch it was purchased 1924 by Andrew W. Mellon, Pittsburgh and Washington,[2] who gave it by 1937 to his daughter, Ailsa Mellon Bruce, New York.

Exhibitions: *Pictures by Raeburn*, M. Knoedler & Co., New York, 1925, no. 9.

MISS DAVIDSON REID (1778–1865), a noted beauty in the Edinburgh of her day, was the youngest daughter of David Reid, commissioner of customs for Scotland. In 1806 she married Lieutenant-General Alexander Beatson, who was in the service of the East India Company and one-time aide-de-camp to the governor-general, Richard, Marquess Wellesley; Beatson was the governor of St. Helena from 1808 to 1813.

The low-cut bodice and disheveled Titus-crop hairstyle are characteristic of the fashion of the first decade of the nineteenth century. The bold modeling in strong light and shade, typical of Raeburn's style in that decade, is comparable with such works by him as the portrait of Lady Charlotte Hope,[3] but the handling is coarse and the expression fixed. Hitherto the Washington picture has been regarded as the work of an imitator, but recently Mackie, though accepting that the painting is not of the highest quality and may be a secondary version, has sustained an attribution to Raeburn himself.[4] Mackie's dating of c.1812 is not, however, supported by the sitter's age; Miss Reid cannot be much above twenty in this portrait. Her marriage in 1806 provides a likely *terminus ante quem* for a portrait probably painted for her father; the wedding is unlikely, on grounds of age, to have been the occasion for the commission.

Notes

1. The early provenance is recorded in a dealer's prospectus, probably Knoedler's, in NGA curatorial files.

2. M. Knoedler & Co. stock books, recorded by The Provenance Index, J. Paul Getty Trust, Santa Monica, California.

3. Greig 1911 (see biography), pl. 21.

4. David Mackie, memorandum, 11 August 1986, in NGA curatorial files.

Attributed to Sir Henry Raeburn, *Miss Davidson Reid*, 1970.17.131

Style of Sir Henry Raeburn,
Miss Jean Christie, 1954.9.1

Style of Sir Henry Raeburn

1954.9.1 (1351)

Miss Jean Christie

c. 1810/1830
Oil on canvas, 76.9 × 64.2 (30¼ × 25¼)
Gift of Jean McGinley Draper

Technical Notes: The fine canvas is tightly twill woven; it was relined c. 1929. According to Greig, the original canvas was stamped with the name Middleton, Raeburn's usual color merchant in London.[1] The ground is dark gray, of moderate thickness, and almost masks the weave of the canvas. The painting is executed in rich, fluid, opaque layers, thickly in the figure, more thinly in the background. The painting is in good condition. The paint surface is somewhat abraded overall, especially in the darks, but retouching is minimal. The thick natural resin varnish, slightly pigmented, has discolored yellow to a significant degree.

Provenance: Elizabeth, Duchess of Gordon [1794–1864]; passed to the sitter's half brother, Lord Adam Gordon; thence through his widow, who married a Mr. Reid, to her grandson, Major Duggan [d. by 1918], Newton Garrie, Fochabers, Morayshire, Scotland;[2] sold 1929 by his widow to (P. Jackson

Higgs), New York,[3] from whom it was purchased December 1929 by Mrs. William H. Moore, New York; by descent to Edward S. Moore, thence to his wife, née Jean McGinley [d. 1954], who later became Mrs. Charles D. Draper, New York.

JEAN CHRISTIE was the daughter of a Mrs. Jane Christie, who later (1820) became the second wife of Alexander, 4th Duke of Gordon. The date of the painting does not suggest that she was one of the four illegitimate children the duke had with Mrs. Christie before their marriage (his first wife had died in 1812), unless their liaison was of very long standing. Nothing else is known of her life.

The high-waisted low-cut bodice with short puffed sleeves and the slightly disheveled hair with side curls and a part in the center are characteristic of the fashion of the second and third decades of the nineteenth century; the disheveled, rather than tight, curls suggest the second rather than the third decade. However, in the absence of any precisely datable feature in the costume, stylistic characteristic, or evidence as to the sitter's birth, it is difficult to propose more than a broad bracket for the date of this portrait.

The work is not of high quality. The costume is poorly painted, the right arm is limp, and the head seems awkwardly attached to the body; the head itself is somewhat lifeless. Recently the attribution has been doubted by Mackie.[4] Since, as noted above, the canvas was supplied by Raeburn's usual color merchant, likely alternative attributions would be John Syme (1795–1861), who was Raeburn's pupil, or Colvin Smith (1795–1875), who took Raeburn's house and studio in 1827. Neither, however, are convincing candidates. Colvin Smith, in his early Raeburnesque phase, is closer, but his handling is much firmer than in the Washington painting.[5]

Notes
1. James Greig, certificate, 4 September 1929, in NGA curatorial files.
2. The provenance from Lord Adam Gordon to Major Duggan is given in the expertise supplied to P. Jackson Higgs by William Roberts, 5 September 1929, in NGA curatorial files.
3. The picture was advertised as recently acquired by P. Jackson Higgs in *ArtN* (December 1929), 5.
4. David Mackie, memorandum, 11 August 1986, in NGA curatorial files.
5. There is no record in his sitter book (preserved in the Scottish National Portrait Gallery, Edinburgh) of Colvin Smith having painted a life-size portrait of Jean Christie, but he did execute a full-length miniature of her, for which payment is recorded on 11 October 1819 (information kindly supplied by Dr. Duncan Thomson, keeper of the Scottish National Portrait Gallery).

References
1929 *ArtN* (December 1929):5, repro.

Sir Joshua Reynolds

1723 – 1792

REYNOLDS WAS BORN in Plympton in Devonshire on 16 July 1723, seventh child in the large family of the Reverend Samuel Reynolds, master of the local grammar school, an unworldly but respected and loveable clergyman with a scholarly and scientific bent of mind, and Theophila Potter. Inspired to become an artist by Jonathan Richardson's elevated *Essay on the Theory of Painting*, Reynolds was determined that "he would rather be an apothecary than an *ordinary* painter."[1] In 1740 he was apprenticed to Thomas Hudson, the most fashionable portraitist of the day, a fellow Devonian who had married Richardson's daughter; he remained with Hudson until 1743.

After two years of independent practice in London and another two in his native Devonshire, Reynolds was introduced by his father's friend, Lord Edgcumbe, to Commodore Augustus Keppel, who was about to sail to the Mediterranean and invited him to join his expedition. After a stay in Minorca he spent over two years in Rome, from 1750 to 1752, returning through Florence, Venice and northern Italy, Lyons, and Paris. He brought back with him Giuseppe Marchi, whom he employed as an assistant until the end of his life. Although he never received any academic training, this experience of Italy, his reverence for Raphael, Michelangelo, and the Venetians, and the notebooks that he filled with drawings from

classical antiquity and from the Old Masters were the foundation of his ideals and practice as a painter.

Armed with introductions from Lord Edgcumbe to aristocratic sitters, and immediately establishing his reputation in London with his masterly and dramatic full-length portrait of Keppel in the pose of the Apollo Belvedere (National Maritime Museum, Greenwich), Reynolds soon supplanted Hudson as the capital's leading portraitist, his only serious competitor being Ramsay. In 1759 he had more than 150 sitters; the following year he bought a grand house on Leicester Fields, took on pupils, and ran a coach. His prices (formerly in line with Hudson's) were 20 guineas for a head and shoulders, 50 for a half length, and 100 for a full length; raised in 1764 to 30, 70, and 150 guineas respectively; and, in 1782, to 50, 100, and 200 guineas. (By comparison, Gainsborough's price scale in the earlier 1780s was 30, 60, and 100 guineas, Romney's 20, 40, and 80.)

Reynolds was an assiduous worker, Sundays included, never happier than when he was in his studio, reluctant to leave London. The press of business was so great, especially in the middle years of his career, that, as had been customary with a busy portraitist since the time of Lely, the drapery and subordinate parts of his portraits were usually largely executed by assistants—at first by Peter Toms (who received fifteen guineas for painting the drapery of a full length), and later by his own pupils. Ceaselessly ambitious and an able publicist for his work, he employed the finest engravers to publish his principal compositions in mezzotint, a medium in which British eighteenth-century printmakers excelled.

With little time for reading, Reynolds sharpened his mind through conversation, kept open table, and cultivated the acquaintance of his great contemporaries, Edmund Burke, David Garrick, Edward Gibbon, Oliver Goldsmith, and above all Dr. Samuel Johnson, for whom in 1764 he founded The Club (later The Literary Club). "His mind was active, perpetually at work."[2] An acute observer of character, he was equable in temperament and, seeming to lack passion, never married; his household was run first by his sister Frances, then by his niece, Mary Palmer. Though he was uninterested in politics and no courtier, his eminence was such that it was inevitably he who was appointed first president of the Royal Academy of Arts in 1768. He was then knighted.

In his annual *Discourses* to the Royal Academy stu-

dents, which are among the classics of critical writing, Reynolds elaborated his system of art education. He preached the importance of the Great Style, an idealized form of painting reflecting objective standards of beauty and based on a study of the great art and literature of the past. Cultivation of the Great Style would, he believed, raise the status of the painter to that of man of letters and bring the nascent British school into the mainstream of European art. He also preached the virtues of hard work: "Nothing is denied to well-directed labour: nothing is to be obtained without it."[3] Lacking the time and opportunity to develop his own creative powers, he was reluctant himself often to engage in history painting until the latter part of his life; his relaxation from portraiture took the form of fancy paintings of children, whom he loved, in various appealing attitudes.

In 1781 Reynolds visited Flanders and Holland, where he was greatly impressed by the work of Rubens. In 1784 he was appointed Principal Portrait Painter to the King in succession to Ramsay. The following year he was commissioned by Catherine II of Russia to paint an historical picture of his own choosing; *The Infant Hercules* (Hermitage, St. Petersburg) was his largest and most ambitious work. Apart from experiencing chronic deafness he had always enjoyed vigorous good health until he suffered a stroke in 1782; in 1789 he lost the sight of his left eye, and on 23 February 1792 he died in his home on Leicester Fields. He was given a quasi-state funeral and was buried in St. Paul's Cathedral.

The course of Reynolds' career is easy to chart: most of his sitter books survive for the period 1755 to 1789, and he contributed regularly to the exhibitions first of the Society of Artists, then of the Royal Academy. From the moment he returned from Italy his style, transformed by Venetian light and shade and richness of effect, possessed authority and breadth. He began to elevate his portraiture, most notably his exhibited work of the 1770s, with practices appropriate to the Great Style: idealized expressions; ennobling "quotations" from the art of the past; allegories, attributes, or accessories setting up an association of ideas; and for his female sitters, generalized classicizing drapery rather than contemporary fashionable dress, "something with the general air of the antique for the sake of dignity, and . . . something of the modern for the sake of likeness."[4] As he wrote: "The great end of the art is to strike the imagination. . . . The

general idea constitutes real excellence . . . each person should also have that expression which men of his rank generally exhibit. . . . It is the inferior stile that marks the variety of stuffs.''[5] Women were often portrayed as characters from mythology, and men as exemplars of their profession: a writer has a hand pressed to his forehead, an admiral an alert turn of the head, a general a cannon or storm clouds.

Reynolds' all-important contributions to the first Royal Academy exhibition of 1769 contained borrowings from, or were essays in the manner of, classical sculpture, Veronese, Correggio, Albani, and Guercino; his majestic *Mrs. Siddons as the Tragic Muse*, exhibited in 1784 (Huntington Art Gallery, San Marino), derives from Michelangelo. Nonetheless he knew, as Nicholas Penny has written, "that many of his fashionable ladies were less gracious, his mothers less loving, his princes less dignified, his bishops less wise, and his commanders less valiant than he makes us believe."[6] Reynolds' range was far greater than his public style. He portrayed women at their domestic occupations, his friends with candor; his portraits of children are playful, pert, and enchanting. He was endlessly original in pose, gesture, and design. "Damn him, how various he is," Gainsborough is reported to have declared.[7]

In the last decade of his life Reynolds leaned more toward the aesthetic relativity of Hume and Burke and his style became bolder, more informal, and more direct; he displayed greater expressiveness, richer chiaroscuro, more vigorous action—and the device of truncating the design above the knees gave greater immediacy.

Reynolds' weakness lay in deficiencies of technique. He was not trained as a draftsman and his sketches were simply *aides-memoire;* his knowledge of anatomy was imperfect, his foreshortening incompetent. Though the most experimental of British eighteenth-century portrait painters (he formed a collection of old master paintings partly to study the secrets of their technique), he lacked chemical knowledge and became more and more careless of methods and media, using asphaltum (bitumen), which never dried, to achieve the rich, Rembrandtesque effects he increasingly desired.

Reynolds' influence was profound. The leadership he gave to the Royal Academy as president, not least in the number and variety of the pictures he contributed to its annual exhibitions, made sure of that. He was not a good teacher to his own pupils, of whom the ablest was James Northcote, but gave his time freely to young artists, lending them pictures and pointing out their faults. Many of his younger contemporaries, such as Hoppner, who were able to study his exhibited pictures, adopted both his ideals and his manner. His effect on the style of the next generation of painters, of whom Lawrence was one, was no less great. He was the first British artist to be given a retrospective, at the British Institution in 1813, and he has continued to be respected if not always admired.

Notes
1. Samuel Reynolds to Mr. Cutcliffe, 17 March 1740 (quoted in Leslie and Taylor 1865, 1:16).
2. Northcote 1819, 2:94.
3. *Discourses:* Wark 1975, 35.
4. *Discourses:* Wark 1975, 140.
5. *Discourses:* Wark 1975, 59, 58, 61, 62.
6. Penny 1986, 17.
7. George Williams Fulcher, *Life of Thomas Gainsborough, R.A.*, 2d ed. (London, 1856), 154.

Bibliography
Northcote, James. *The Life of Sir Joshua Reynolds.* 2d. rev. ed. 2 vols. London, 1819.
Leslie, Charles Robert, and Tom Taylor. *Life and Times of Sir Joshua Reynolds.* 2 vols. London, 1865.
Graves, Algernon, and William Vine Cronin. *A History of the Works of Sir Joshua Reynolds.* 4 vols. London, 1899–1901.
Hilles, Frederick Whiley. *Letters of Sir Joshua Reynolds.* Cambridge, 1929.
Waterhouse, Sir Ellis. *Reynolds.* London, 1941.
Hudson, Derek. *Sir Joshua Reynolds.* London, 1958.
Reynolds, Sir Joshua. *Discourses on Art.* Edited by Robert R. Wark. 2d ed. New Haven and London, 1975.
Penny, Nicholas, ed. *Reynolds.* Exh. cat., Royal Academy of Arts. London, 1986.

1942.9.75 (671)

Lady Elizabeth Hamilton

1758
Oil on canvas, 117 × 84 (46 × 33⅛)
Widener Collection

Technical Notes: The canvas is plain woven; it has been lined, and was relined in 1944. The ground is thinly applied; its color is difficult to determine. The painting is executed thinly, with thicker paint in the flesh tones and impasto in the highlights of the dress and bouquet. The blue background was applied beneath the hair, and is revealed, through losses in this area, to have been intense in color; it is uncertain whether this was the

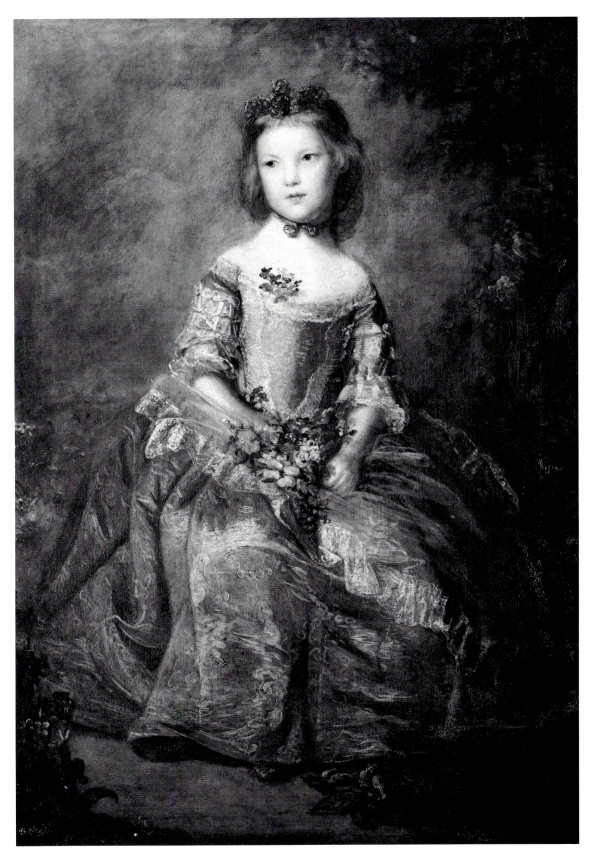

Sir Joshua Reynolds, *Lady Elizabeth Hamilton*, 1942.9.75

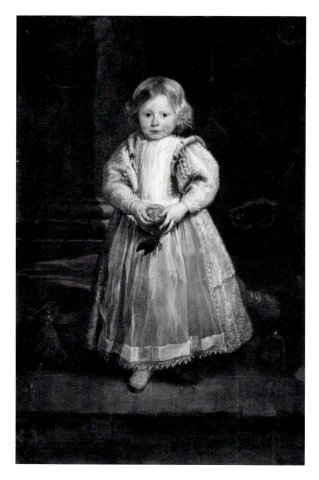

Fig. 1. Sir Anthony van Dyck, *Clelia Cattaneo*, inscribed 1623, oil on canvas, Washington, D.C., National Gallery of Art

intensity of blue intended by Reynolds for the sky, or whether it was to be toned or glazed to give the somber tone it has now. The paint surface seems to have been abraded. Some of the flesh tones may have faded. There is some retouching, but there are also scattered losses overall that have not been inpainted. The natural resin varnish has discolored yellow to a significant degree.

Provenance: Painted for the sitter's mother, Elizabeth, Duchess of Hamilton and Brandon [1734–1790]; by descent through her second husband, John, 5th Duke of Argyll [1723–1806], to George, 8th Duke of Argyll [1823–1900] (sale, Christie & Manson, London, 17 March 1855, no. 91), bought by (King) for Welbore Ellis, 2nd Earl of Normanton [1778–1868], Somerley, Hampshire; by descent to Sidney, 4th Earl of Normanton [1865–1933], who sold it 22 March 1909 to (Thos. Agnew & Sons), London, who sold it the same day to (Arthur J. Sulley & Co.), London,[1] from whom it was acquired in 1909 by P. A. B. Widener, Elkins Park, Pennsylvania. Inheritance from the Estate of Peter A. B. Widener by gift through power of appointment of Joseph E. Widener, Elkins Park.

Exhibitions: *Works by the Old Masters, and by Deceased Masters of the British School*, Winter Exhibition, Royal Academy of Arts, London, 1882, no. 33.

LADY ELIZABETH HAMILTON (1753–1797), only daughter of James, 6th Duke of Hamilton and Brandon (d. 1758, a month before Reynolds began this portrait), is seen in this portrait at the age of five. She grew up a great beauty (like her mother, one of the celebrated Gunning sisters) but was unhappily married in 1774 to Edward, 12th Earl of Derby. She separated from her husband and became the mistress of John, 3rd Duke of Dorset, by whom she had a son. She was portrayed as a young woman by Romney[2] and again by Reynolds (in a full-length of 1777, later destroyed by her husband and now known only from the mezzotint by William Dickinson), and, with her son, together with the artist playing the harp, by Angelica Kauffmann.[3]

Lady Elizabeth sat to Reynolds in February 1758.[4] Although she is shown seated out-of-doors, the pose, with its elegant slight turn of the head, is more formal than in Reynolds' groups with children or his later child portraits; the concept is closer to the world of Van Dyck's aristocratic children (fig. 1) or the Infantas of Velázquez and is in keeping with the earlier eighteenth-century perception of the child as a young adult. The fashionable ornamental dress is richly handled in the Venetian manner, in contrast to Ramsay's more exquisite and appealing treatment of costume in his portraits of this period. The awkward proportions of the child's neck are characteristic of Reynolds' weakness as a draftsman.

Notes
1. Agnew stock books, recorded by The Provenance Index, J. Paul Getty Trust, Santa Monica, California.
2. Now in The Metropolitan Museum of Art (Katharine Baetjer, *European Paintings in The Metropolitan Museum of Art* [New York, 1980], 1:158, repro.; 2:260).
3. Anon. sale, Christie, Manson & Woods, London, 18 June 1976, no. 96, repro.
4. Leslie and Taylor 1865 (see biography), 1:161.

References
1865 Leslie and Taylor 1865 (see biography), 1:161.
1899 Graves 1899 (see biography), 1: repro. opposite 224; 2:422–423.
1900 Armstrong, Sir Walter. *Sir Joshua Reynolds*. London, 1900:210.
1915 Roberts 1915: unpaginated, repro.
1941 Waterhouse 1941 (see biography): 11, 43–44, pl. 43.
1966 Roberts, Keith. *Reynolds*. (The Masters series, no. 31.) Paulton, near Bristol, 1966: pl. 3.
1976 Walker 1976: no. 503, color repro.

1937.1.95 (95)

Lady Elizabeth Delmé and Her Children

1777–1779
Oil on canvas, 239.2 × 147.8 (94⅛ × 58⅛)
Andrew W. Mellon Collection

Technical Notes: The light- to medium-weight canvas is twill woven; it has been double lined. The ground is not discernible through the discolored varnish and thick paint layers, but is probably white. The painting is richly executed in a complex of different layers and techniques. The lowest paint layer is gray; the middle layers are thickly applied, white in the lights, the drapery, and background, and dark in the tree trunks, foliage, and shadows; the final layers defining detail contain nonoil additives and include rich brown, red, and blue glazes in the foliage, sky, and landscape, and in parts of the figures. The painting seems to have been retouched and revarnished by Reynolds in 1789.[1] There are many shallow, overpainted losses throughout the painting. Broad craquelure marks most of the dark, rich browns, indicating the presence of bitumen. The varnish, which appears to be a natural resin, is difficult to distinguish from the final glazes and has discolored yellow to a significant degree.

Provenance: Painted for the sitter's husband, Peter Delmé [1748–1789], Titchfield Abbey, Hampshire; by descent to Seymour Robert Delmé, Cams Hall, Hampshire (sale, Christie, Manson & Woods, London, 7 July 1894, no. 63), bought by (Charles J. Wertheimer), London, from whom it was purchased c. 1900–1901[2] by J. Pierpont Morgan, Sr. [1837–1913], New York; bequeathed to his daughter, Mrs. Herbert L. Satterlee [d. 1946], who owned it until c. 1930. (Duveen Brothers), New York, who sold it 15 December 1936 to The A. W. Mellon Educational and Charitable Trust, Pittsburgh.

Exhibitions: *Works by the Old Masters, and by Deceased Masters of the British School*, Winter Exhibition, Royal Academy of Arts, London, 1895, no. 130. *Loan Collection of Pictures and Drawings by J. M. W. Turner, R.A. and of a Selection of Pictures by Some of His Contemporaries*, Corporation of London Art Gallery, 1899, no. 170. *Aeldre Engelsk Kunst*, Ny Carlsberg Glyptotek, Copenhagen, 1908, no. 29, repro. *Aelterer Englischer Kunst*, Königliche Akademie der Künste, Berlin, 1908, no. 68 (souvenir volume, 73, repro.). *Fifteen Masters of the Eighteenth Century*, Jacques Seligmann & Co., New York, 1928, no. 13. *Sir Joshua Reynolds*, Sir Philip Sassoon's, 45 Park Lane, London, 1937, no. 26 (illustrated souvenir, repro. 56).

LADY ELIZABETH HOWARD (1746–1813), third daughter of Henry, 4th Earl of Carlisle, married Peter Delmé in 1769 and, after his death in 1789, became the wife in 1794 of Captain Charles Garnier, R.N., who was drowned in 1796. Delmé, of wealthy Huguenot descent, was, through the influence of his wife's family, M.P. for Morpeth from 1774 to 1789. He inherited Titchfield Abbey (demolished 1781) and in 1771 built Cams Hall, Fareham, Hampshire, a few miles away. Their two eldest children, Isabella Elizabeth (d. 1794)[3] and John (1772–1809), are depicted on the right and in the center of the portrait respectively. The couple had three other children, all sons, born in 1774, 1775, and at a date unknown.

Lady Elizabeth sat to Reynolds in April 1777.[4] A sitting in June 1780, canceled on account of the Gordon riots,[5] seems unlikely to have been connected with any change to this portrait, by then finished and engraved. In June 1777 there were two sittings for "Master Delmé" and the "Delmé Children."[6] Payment was made in June 1780, when Reynolds recorded in his account book the receipt of three hundred pounds.[7]

The picture is one of Reynolds' noblest and most successful family portraits. The design is pyramidal and, although Lady Elizabeth is looking out at the spectator rather than at her children, it is strongly reminiscent of such Raphael Madonnas with the Christ Child and Saint John as the *Madonna in the Meadow* (fig. 1). The chiaro-

Fig. 1. Raphael Sanzio, *The Madonna in the Meadow*, dated 1505, oil on panel, Vienna, Kunsthistorisches Museum

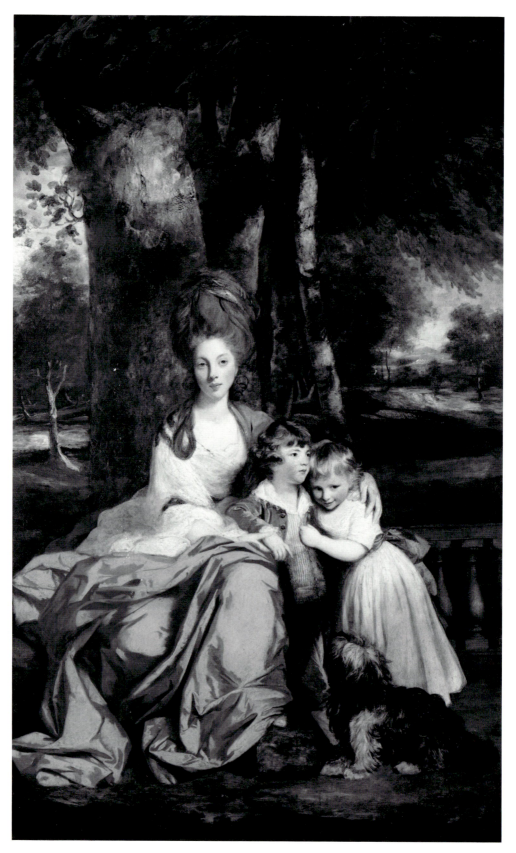

Sir Joshua Reynolds, *Lady Elizabeth Delmé and Her Children*, 1937.1.95

scuro is carefully contrived, and the swathes of drapery over Lady Elizabeth's knees, influenced in their elaboration by Bolognese seventeenth-century painting, give the composition a rhythmic sense of movement. The beech trees that support the figure group are more massive than was customary with Reynolds; these trees, suggestive of the canopy behind a Madonna in an Italian altarpiece, together with the Titianesque vista on the right, add to the impression of a work deliberately painted in emulation of the Old Masters. Lady Elizabeth's hair, high piled with a scarf intertwined and a ringlet falling over the right shoulder, is dressed in the height of fashion, and her two children are wearing contemporary dress. The intimate naturalism with which Reynolds has painted the children and their terrier serves as a perfect foil to his idealized representation of Lady Elizabeth, personifying the adult world, and to the high seriousness of the work as a whole.

A mezzotint by Valentine Green was published by him on 1 July 1779 and another, by Samuel William Reynolds, is undated.

Notes

1. A newspaper report dated 19 September 1789 stated that this and some other portraits "which for many years have been lodged in his *infirmary*" now "by the help of fresh varnish and a few vivifying touches from his pencil, again claim our notice" (Graves and Cronin 1899–1901 [see biography], 4:1296).
2. *Conn* 3 (1901), 206, notes this portrait as recently sold to Pierpont Morgan.
3. Isabella's birth date is not known, but, on the assumption that the child on the right of the picture is a girl, she must have been the eldest child, born in 1770 or 1771.
4. Leslie and Taylor 1865 (see biography), 2:202.
5. The entry is struck through in Reynolds' sitter book.
6. Graves and Cronin 1899–1901 (see biography), 4:1544–1545.
7. Malcolm Cormack, "The Ledgers of Sir Joshua Reynolds," *The Walpole Society* 42 (1970), 150.

References

1865 Leslie and Taylor 1865 (see biography), 2:202, 302.
1899 Graves and Cronin 1899 (see biography), 1:241; 4:1296, 1544–1545.
1900 Armstrong, Sir Walter. *Sir Joshua Reynolds.* London, 1900:202.
1907 Roberts, William. *Pictures in the Collection of J. Pierpont Morgan at Prince's Gate & Dover House, London: English School.* London, 1907: unpaginated.
1941 *Duveen Pictures in Public Collections of America.* New York, 1941: no. 264, repro.
1941 Waterhouse 1941 (see biography): 68, pl. 191.
1949 Mellon 1949: no. 95, repro. 106.
1976 Walker 1976: no. 504, color repro.
1990 Shawe-Taylor, Desmond. *The Georgians: Eighteenth-Century Portraiture and Society.* London, 1990: 192–193, color fig. 127.

1961.2.2 (1603)

John Musters

1777–c. 1780
Oil on canvas, 238.5 × 147.3 (93⅞ × 58)
Given in memory of Governor Alvan T. Fuller by the Fuller Foundation, Inc.

Technical Notes: The canvas is twill woven; it has been lined. The ground is white, of moderate thickness. What remains of the original paint in the face and figure is freely applied in thick, opaque layers, blended wet into wet. The sky and background are severely abraded and very heavily overpainted; the sitter's hair and neck are also overpainted. The costume was overpainted c. 1820; this overpaint was removed and the picture restored to its original state in 1872.[1] The coat is badly abraded and has been extensively retouched. The impasto has been flattened during lining. The heavy natural resin varnish has not discolored.

Provenance: Painted for the sitter, John Musters [1753–1827], Colwick Hall, Nottinghamshire; probably by descent to his son, John Musters [1777–1849], Colwick (sale, Pott, on the premises, 12 December 1850, no. 680, bought in); by descent to John Chaworth Musters [1838–1887], Annesley Park, Colwick Hall, and Wiverton Hall. (William Lockett Agnew), by 1895 (anon. [Agnew] sale, Christie, Manson & Woods, London, 27 April 1901, no. 101, bought in), but sold two days later to Charles, 9th Duke of Marlborough[2] (anon. [Marlborough] sale, Christie, Manson & Woods, London, 14 June 1907, no. 104, repro.), bought by Lane for Sir W. Hutcheson Poë, Bt.[3] (sale, Christie, Manson & Woods, London, 8 July 1927, no. 58, repro.), bought by (Thos. Agnew & Sons), London, who sold it the same month to Alvan T. Fuller [1878–1958], Boston. The Fuller Foundation, Boston.

Exhibitions: *Opening Exhibition of the Midland Counties Art Museum*, Castle, Nottingham, 1878–1879, no. 57. *Works by the Old Masters, and by Deceased Masters of the British School*, Winter Exhibition, Royal Academy of Arts, London, 1885, no. 189. *20 Masterpieces of the English School*, Thos. Agnew & Sons, 1895, no. 15. *Japan-British Exhibition*, Shepherd's Bush, London, 1910, no. 9. *Paintings Loaned by Governor Alvan T. Fuller*, Art Club, Boston, 1928, no. 24. *Paintings Drawings Prints from Private Collections in New England*, Museum of Fine Arts, Boston, 1939, no. 109, pl. 56. *A Memorial Exhibition of the Collection of the Honorable Alvan T. Fuller*, Museum of Fine Arts, Boston, 1959, no. 20, repro.

JOHN MUSTERS (1753–1827), high sheriff of Nottingham in 1777, who in July 1776 married Sophia Catherine Heywood of Maristow, Devon, was a keen sportsman. Stubbs painted three separate equestrian portraits of him the year after his marriage, one with his

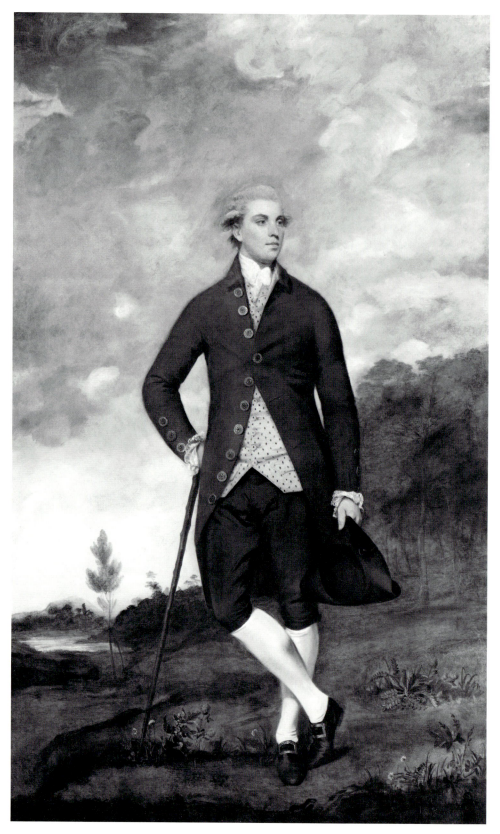

Sir Joshua Reynolds, *John Musters*, 1961.2.2

wife, one with the Reverend Philip Strong, and one of him on his own.[4] Fanny Burney noted in her diary in 1779 that Mrs. Musters, "an exceeding pretty woman," was "the reigning toast of the season."[5] Their son Jack, athletic and handsome, married the rich and beautiful Mary Anne Chaworth, the first love of the poet Byron.

John and Sophia Musters sat to Reynolds for full-length portraits in November 1777 and May 1780.[6] A half payment of 150 guineas, Reynolds' advance for starting a pair of full-length portraits from 1764 until 1782, was made in December 1777.[7] The portrait of Sophia (fig. 1) shows her with a sprig of flowers in her hand and a spaniel at her feet. Mrs. Musters sat several times to Reynolds, notably in May 1782 for a full length as Hebe, now at the Iveagh Bequest, Kenwood.

The portrait shows the sitter elegantly dressed, wearing a plain, tight-fitting frock coat and a yellow spotted waistcoat, holding a formal tricorne hat and standing in the cross-legged pose fashionable in British portraiture from the 1740s. The large buttons, which became fashionable from about 1775, support a dating in the second half of the 1770s.

The head is firmly modeled and displays the confident pride of the young aristocrat. The open landscape background, with enlivening groups of plants and flowers painted around the sitter's feet, can be paralleled in other portraits by Reynolds of the period, but the absence of any large tree form as repoussoir or support for the figure is exceptional; both landscape and sky are very heavily overpainted.

Notes

1. Graves and Cronin 1899–1901 (see biography), 2:682.
2. Agnew stock books, recorded by The Provenance Index, J. Paul Getty Trust, Santa Monica, California.
3. The Getty Provenance Index records Lane as the buyer for Poë.
4. These are still in the family possession (the first two were exhibited at *George Stubbs 1724–1806*, Tate Gallery, London; Yale Center for British Art, New Haven, 1984–1985, nos. 116–117, color repro.).
5. Charlotte Barrett, ed., *Diary & Letters of Madame D'Arblay*, 6 vols. (London, 1904–1905), 1:283.
6. Graves and Cronin, 1899–1901 (see biography), 2:682.
7. Malcolm Cormack, "The Ledgers of Sir Joshua Reynolds," *The Walpole Society* 42 (1970), 158.

References

1865 Leslie and Taylor 1865 (see biography), 2:203, 229, 313.
1899 Graves and Cronin 1899 (see biography), 2:681–682.
1900 Armstrong, Sir Walter. *Sir Joshua Reynolds*. London, 1900:221.
1941 Waterhouse 1941 (see biography): 69, pl. 192.

Fig. 1. Sir Joshua Reynolds, *Sophia Musters (Mrs. John Musters)*, 1777–1780, oil on canvas, Petworth House, National Trust [photo: Courtauld Institute of Art]

1969 Watson, Ross. "British Paintings in the National Gallery of Art." *Conn* 172 (1969):56, repro., 57–58.
1976 Walker 1976: no. 505, color repro.

1937.1.106 (106)

Lady Caroline Howard

1778
Oil on canvas, 143 × 113 (56¼ × 44½)
Andrew W. Mellon Collection

Inscriptions:
Bears inscription at lower right: *Lady Caroline Howard/Lady Cawdor*

Technical Notes: The medium- lightweight canvas is loosely plain woven; it has been lined. The ground is pinkish white, very thinly applied. The painting is broadly and fluidly executed in thick, opaque layers, with thin translucent glazes in the background. Underlying brushstrokes and an x-radiograph show that the composition has been modified slightly from an underpainted design: the blue sash, for example, was originally broader. There is moderate abrasion in the glazed shadows of the face and in the thinly applied green paint of the trees, and areas of impasto have been slightly flattened during lining. There is some retouching in the face. The medium thick natural resin varnish has discolored yellow to a moderate degree.

Provenance: Painted for the sitter's father, Frederick Howard, 5th Earl of Carlisle [1748–1825], Castle Howard, Yorkshire; by descent to the Hon. Geoffrey Howard [1877–1935], son of George, 9th Earl of Carlisle, who sold it February 1926 to (Duveen Brothers), London, from whose New York branch it was purchased 3 February 1926 by Andrew W. Mellon, Pittsburgh and Washington, by whom deeded December 1934 to The A. W. Mellon Educational and Charitable Trust, Pittsburgh.

Exhibitions: Royal Academy of Arts, London, 1779, no. 252, as *A young lady*. *Pictures of the Italian, Spanish, Flemish, Dutch and English Schools*, British Institution, London, 1824, no. 162. *Pictures by Italian, Spanish, Flemish, Dutch, French and English Masters*, British Institution, London, 1851, no. 118. *Ancient and Modern Paintings*, Irish Institution, Dublin, 1856, no. 20. *British Art*, Royal Academy of Arts, London, 1934, no. 315 (commemorative catalogue, 1935, no. 145, pl. 45). *Reynolds*, Royal Academy of Arts, London, 1986, no. 107, repro. 141, color repro.

LADY CAROLINE HOWARD (1771–1848), daughter of Frederick, 5th Earl of Carlisle (1748–1825) and niece of Lady Elizabeth Delmé (see 1937.1.95), is seen in this portrait at the age of seven; she was apparently a lively, headstrong child, "always a great favourite" of her father's. She married John Campbell (later 1st Earl of Cawdor) of Cawdor Castle, Nairn, in 1789.

Lady Caroline probably sat to Reynolds in 1778.[1] Final payment was not made until July 1783, when Reynolds recorded in his account book a payment of seventy guineas, his fee for a half-length portrait from 1764 to 1782.[2]

The young sitter is depicted informally, squatting on the ground in a simple white muslin dress and black silk hooded mantle. The critic of the *St. James's Chronicle*, whose review of the Royal Academy exhibition of 1779 identified the portrait as that of Lady Caroline, disapproved of the squatting pose: "She is plucking a Rose, but in what Attitude we cannot conceive; she seems to be curtseying to the Rose-Bush, or to be deprived of the lower Parts of her Limbs, and is a most unpleasing Figure."[3] As Mannings has pointed out, this criticism is ironic in view of Reynolds' belief that all the movements and gestures of children were graceful; it is unknown whether the pose is the child's own (as is certainly the case in some of Reynolds' portraits), or whether it was chosen by the artist. Mannings has suggested that the action of plucking a rose just starting to open "is a compliment to her own budding beauty," and Ribeiro has noted that girls "were encouraged to wear long mittens (which were more practical than gloves) in order that their hands and arms should remain soft and white."[4] Wheelock and Kreindler, noting that roses are symbolically related to Venus and the Three Graces, have suggested that "Reynolds may well have intended to allude to their attributes, Chastity, Beauty, and Love, as ideals to which Lady Caroline should aspire."[5] The unusual, cool, fresh tonality may be allusive, a reminder of childish innocence; but the fashionable net and lace cap and the serious expression give rather the impression of precocious adulthood. The foreshortening of the rim of the large gray urn containing the rosebush is misunderstood.

A mezzotint by Valentine Green was published by him on 7 December 1778, and another, by Samuel William Reynolds, is undated.

Notes

1. Reynolds' sitter book for 1778 is missing, but Valentine Green's mezzotint was published 7 December 1778, which gives a *terminus ante quem*.
2. Graves and Cronin 1899–1901 (see biography), 2:487. The portrait, though a full length, is painted on a canvas appropriate in size for an adult three-quarter length. The latter came within the category of half length as far as the fee was concerned. Reynolds' letter presenting his account, dated 4 July but with no year given, is at Castle Howard.
3. *St. James's Chronicle*, 24–27 April 1779.
4. David Mannings and Aileen Ribeiro in exh. cat. London 1986, 279.
5. Arthur K. Wheelock, Jr., and Alice Kreindler, *British Painting in the National Gallery of Art* (Washington, D.C., 1987), 20.

References

1779 *St. James's Chronicle*, 24–27 April 1779.
1865 Leslie and Taylor 1865 (see biography), 2:427.
1899 Graves and Cronin 1899 (see biography), 2:487–488.
1900 Armstrong, Sir Walter. *Sir Joshua Reynolds*. London, 1900:213.
1941 *Duveen Pictures in Public Collections of America*. New York, 1941: no. 266, repro., no. 267, detail repro.
1941 Waterhouse 1941 (see biography): 70, pl. 211.
1949 Mellon 1949: no. 106, repro. 107.
1976 Walker 1976: no. 502, color repro.

Sir Joshua Reynolds, *Lady Caroline Howard*, 1937.1.106

1937.1.97 (97)

Lady Elizabeth Compton

1780–1782
Oil on canvas, 240 × 149 (94½ × 58⅝)
Andrew W. Mellon Collection

Technical Notes: The medium- lightweight canvas is fairly tightly twill woven; it has been lined. The ground is white, of moderate thickness. The painting is boldly executed in fluid, broad layers, ranging from thick impasto in the lights, with some palette-knife applications, to thin, dry scumbling and glazes. The texture of the paint is buttery, and it may contain nonoil additives. There are pentimenti in the folds of the sleeves around the forearms, below the sitter's left shoulder, and in the contours of the hair, and a plume or decoration at the top center of the hair seems to have been painted out. The paint layers are in poor condition owing partly to Reynolds' experimental painting techniques and partly to insensitive past restoration. There is extensive abrading and the impasto has been flattened during the linings; there is extensive overpainting in the severe traction crackle in the darks, which was caused by the presence of bitumen. The natural resin varnish has discolored yellow to a significant degree.

Provenance: Painted for the sitter's husband, Lord George Cavendish [b. 1754], of Keighley; by descent to John Compton Cavendish, 4th Baron Chesham [1894–1952]. (M. Knoedler & Co.), London, from whose New York branch it was purchased October 1928 by Andrew W. Mellon, Pittsburgh and Washington, by whom deeded December 1934 to The A. W. Mellon Educational and Charitable Trust, Pittsburgh.

Exhibitions: Royal Academy of Arts, London, 1782, no. 204, as *Portrait of a lady. Sir Joshua Reynolds*, British Institution, London, 1813, no. 37. *Pictures by Italian, Spanish, Flemish, Dutch, French and English Masters*, British Institution, London, 1857, no. 139. *Works by the Old Masters, and by Deceased Masters of the British School*, Winter Exhibition, Royal Academy of Arts, London, 1880, no. 135. *Tenth Annual Exhibition on Behalf of the Artists' General Benevolent Institution*, Thos. Agnew & Sons, London, 1904, no. 11. *Sixteen Masterpieces*, M. Knoedler & Co., New York, 1930, no. 5, repro.

LADY ELIZABETH COMPTON (1760–1835), only daughter and heiress of Charles, 7th Earl of Northampton (1737–1763), married in 1782 Lord George Cavendish, third son of William, 4th Duke of Devonshire, who was created Earl of Burlington in 1831. George Selwyn described her as plain but not disagreeable; as a wealthy heiress she had had numerous suitors. She was painted twice by Romney and once by Hoppner.[1] A bust attributed to Paolo Bonelli is at Chatsworth.

Lady Elizabeth sat to Reynolds in November 1780[2]

and in May 1781.[3] Since the picture was painted for her husband, it was presumably an engagement portrait. It was exhibited at the Royal Academy of Arts in 1782. Payment was made in 1782, when Reynolds recorded in his account book the receipt of two hundred guineas,[4] the sum to which he had raised his fee for a full length that very year.

Lady Elizabeth is portrayed in a wrapping gown that trails along the ground, suggestive of classical costume—an example of the timeless kind of dress, impervious to changes in fashion, that Reynolds had introduced in the 1760s; the broadly painted drapery is, however, less lively in treatment than in most of his portraits in this manner. The anatomy of the lower part of the body is unconvincing, but, as with Romney (see p. 231), and in common with other works by Reynolds, the thigh has been exaggerated with intent, to enhance the power of the image. The motif of leaning against a plinth, usually with legs crossed, is common in British eighteenth-century full-length portraiture.

The critic of the *St. James's Chronicle*, who identified the picture shown at the Royal Academy of 1782 as that of Lady Elizabeth (then Lady George Cavendish), described the portrait as "a very elegant and striking likeness;"[5] Bate-Dudley in the *Morning Herald*, who also identified the sitter, called it "charming."[6]

An oval copy of the upper part of the figure, by Frederick Percy Graves, is at Hardwick Hall, Derbyshire.

A mezzotint by Valentine Green was published on 1 December 1781.

Notes

1. Duke of Northumberland collection; sale, Sotheby's, London, 7 July 1982, no. 30, color repro.; New York art market, 1927.
2. Graves and Cronin 1899–1901 (see biography), 4:1547.
3. Leslie and Taylor 1865 (see biography), 2:343.
4. Graves and Cronin 1899–1901 (see biography), 1:189.
5. *St. James's Chronicle*, 30 April 1782.
6. *Morning Herald*, 2 May 1782.

References

1782 *St. James's Chronicle*, 30 April 1782.
1782 *Morning Herald*, 2 May 1782.
1865 Leslie and Taylor 1865 (see biography), 2:343, 361.
1899 Graves and Cronin 1899 (see biography), 1:134, 188–189; 4:1285, 1547.
1900 Armstrong, Sir Walter. *Sir Joshua Reynolds*. London, 1900:200.
1941 Waterhouse 1941 (see biography): 74, pl. 230.
1949 Mellon 1949: no. 97, repro. 108.
1976 Walker 1976: no. 506, color repro.

Sir Joshua Reynolds, *Lady Elizabeth Compton*, 1937.1.97

1942.9.74 (670)

Lady Cornewall

c. 1785–1786
Oil on canvas, 127 × 101.5 (50 × 40)
Widener Collection

Technical Notes: The fine canvas is tightly plain woven; it has been lined. The ground appears to be white but is possibly covered by a dark, nearly black, imprimatura. The painting is executed in rich, fluid layers with extensive broadly applied glazes and impasto in the lights. Extensive traction crackle in the darks suggests the presence of bitumen. There are scattered discolored retouchings throughout the painting. The thick natural resin varnish has discolored yellow to a significant degree.

Provenance: Painted for the sitter's husband, Sir George Amyand Cornewall, 2nd Bt. [1748–1819], Moccas Court, Herefordshire; by descent to his grandson, the Reverend Sir George Cornewall, 5th Bt. (Arthur J. Sulley & Co.), London, from whom it was purchased 28 August 1909 by P. A. B. Widener, Elkins Park, Pennsylvania. Inheritance from the Estate of Peter A. B. Widener by gift through power of appointment of Joseph E. Widener, Elkins Park.

Fig. 1. Thomas Gainsborough, *Mrs. Sarah Siddons*, 1785, oil on canvas, London, National Gallery

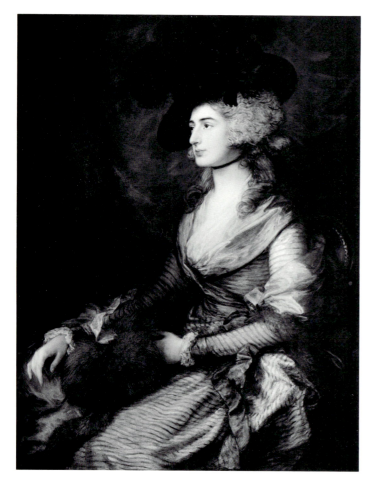

Exhibitions: *Works by the Old Masters, and by Deceased Masters of the British School,* Winter Exhibition, Royal Academy of Arts, London, 1883, no. 218.

CATHERINE CORNEWALL (1752–1835), only daughter and heiress of Velters Cornewall of Moccas Court, married Sir George Amyand, Bt., in 1771; her husband then assumed the surname and arms of Cornewall. Sir George had sat to Reynolds in 1761 as a boy of thirteen,[1] and was later painted by Romney at about the same time as the double portrait of their two children.[2]

Lady Cornewall sat to Reynolds in April 1779 and in March and May 1780.[3] Payment was not, however, made until June 1786, when Reynolds recorded in his account book the receipt of seventy guineas,[4] his fee for a half-length portrait from 1764 to 1782. It is clear that the commission dragged on for about six years. The sittings extended over a period of fourteen months. Reynolds painted two portraits. The first proved unsuccessful: an unfinished and presumably discarded canvas is extant, formerly in the possession of the Duff Gordon family.[5] Then the work lapsed. The National Gallery's portrait, on the evidence of costume, was not painted until about 1785, as Lady Cornewall is dressed at the height of fashion for that time: she is wearing a white muslin dress with black silk stole and a broad-brimmed black felt hat trimmed with ostrich feathers tilted at an angle, and has her hair frizzed out in a profusion of loosely rolled side curls. The picture was paid for as a work for which sittings had been given before Reynolds raised his prices in 1782. It is conceivable that fresh sittings were given in 1785, but there is no means of knowing, as Reynolds' sitter book for that year does not survive.

The portrait is very similar in pose to Gainsborough's famous portrait of Mrs. Siddons (fig. 1), executed in March 1785, but which of the two was painted first is a matter for conjecture. Unlike Zoffany, or French portraitists of the period, Reynolds rarely painted his sitters in interiors that were much more than the semblance of a room, perhaps containing associational features. In this case the setting is ambiguous; the curtain is drawn back to reveal what seems to be a low wall, beyond which are a strange kind of garden ornament and some trees, handled in a generalized and perfunctory manner.

Notes
1. Graves and Cronin 1899 (see biography), 1:17.
2. Humphry Ward and William Roberts, *Romney*, 2 vols. (London, 1904), 2:33. Last recorded in the Harald Peake sale, Sotheby's, London, 10 March 1965, no. 112A.

Sir Joshua Reynolds, *Lady Cornewall*, 1942.9.74

3. Leslie and Taylor 1865 (see biography), 2:281, 287, 297.

4. Malcolm Cormack, "The Ledgers of Sir Joshua Reynolds," *The Walpole Society* 42 (1970), 149.

5. Last recorded in the Sir Cosmo E. Duff Gordon sale, Christie, Manson & Woods, London, 23 June 1933, no. 62, bought by Freeman.

References

1865 Leslie and Taylor 1865 (see biography), 2:281, 287, 297, 312.

1899 Graves and Cronin 1899 (see biography), 1:194.

1900 Armstrong, Sir Walter. *Sir Joshua Reynolds*. London, 1900:200.

1915 Roberts 1915: unpaginated, repro.

1941 Waterhouse 1941 (see biography): 77, pl. 255.

1976 Walker 1976: no. 507, color repro.

1987 Simon, Robin. *The Portrait in Britain and America*. Oxford, 1987:66, pl. 47.

After Sir Joshua Reynolds

1942.9.76 (672)

Miss Nelly O'Brien

Early to mid-nineteenth century
Oil on canvas, 76 × 64 (29⅞ × 25¼)
Widener Collection

Technical Notes: The medium-weight canvas is plain woven; it has been lined. The ground is white, of moderate thickness. The painting is broadly executed in thick, opaque layers; the paint is blended wet into wet in the flesh tones, but more loosely and sketchily applied over dried underlayers elsewhere; the texture of the paint is not descriptive of the material depicted and the brushwork is generalized. The picture is abraded overall, apparently by overcleaning, and there is extensive retouching, notably in the flesh tones; the background darks are extensively reglazed. The thick, pigmented natural resin varnish has discolored yellow to a significant degree.

Provenance: William Angerstein [b. 1811], Woodlands, Blackheath, Kent (anon. [Angerstein] sale, Christie, Manson & Woods, London, 20 June 1874, no. 109), bought by (Henry Graves & Co.), London. William Stuart Stirling-Crawfurd [d. 1883], Milton, Lanark; bequeathed to his wife, the Hon. Caroline Agnes [c. 1816–1894], previously Duchess of Montrose (sale, Christie, Manson & Woods, London, 14 July 1894, no. 35, bought in); Montrose (sale, Christie, Manson & Woods, London, 4 May 1895, no. 84), bought by McLean,[1] who sold it to (Messrs. Shepherd Brothers), London. (Avery), from whom it was purchased 1895 by P. A. B. Widener, Elkins Park, Pennsylvania. Inheritance from the Estate of Peter A. B. Widener by gift through power of appointment of Joseph E. Widener, Elkins Park.

NELLY O'BRIEN (d. 1768) was a noted beauty and courtesan in London, a rival of Kitty Fisher; she is mentioned by Horace Walpole in a letter to George Montagu of 25 March 1763 as the mistress of Lord Bolingbroke. She sat frequently to Reynolds in the 1760s, "very often through the summer"[2] of 1764.

The portrait is a generalized copy of the upper part of the figure in the celebrated portrait in the Wallace Collection, London, exhibited at the Society of Artists in 1763. The smooth technique and loose, sketchy treatment of the costume and dog, undescriptive of form, are uncharacteristic of Reynolds or his studio; if the work is a contemporary copy, it did not emanate from the Reynolds circle. The provenance gives a *terminus ante quem* of 1874; the picture is likely to be early to mid-nineteenth century in date.

Notes

1. Probably Thomas McLean, London, the dealer, who dissolved his partnership in 1902 and sold his stock at Christie, Manson & Woods, 15 November 1902 and 21 November 1903.

2. Leslie and Taylor 1865 (see biography), 1:240, n. 3.

References

1915 Roberts 1915: unpaginated, repro.

After Sir Joshua Reynolds, *Miss Nelly O'Brien*, 1942.9.76

John Riley

1646 – 1691

JOHN RILEY was born in London in 1646, one of the sons of William Riley, Lancaster Herald and keeper of the records at the Tower of London. Nothing is known of his education. He studied painting with Isaac Fuller and Gerard Soest, but left them to set up his own practice as a portraitist when he was very young. Slow to acquire any great reputation, he was brought to the notice of Charles II after the death of Lely in 1680 but, diffident and uncourtierlike in temperament, did not achieve office until the accession of William and Mary in 1688, when he was appointed Principal Painter to the Court jointly with Kneller.

In about 1681 Riley engaged as his drapery painter and partner the immigrant German painter, John Closterman. At this time he was charging ten pounds for a head and shoulders (the bulk of his work), twenty pounds

for a half length, and forty pounds for a full length. The formal partnership was dissolved after a couple of years, but Closterman continued to work and to live with Riley, and finished several of his pictures after his death. Riley also employed Lely's drapery painter, John Baptist Gaspars. A brother who was a painter lived with him but was of little professional assistance. Riley's recorded pupils were Anthony Russell, Thomas Murray, Edward Gouge, and Jonathan Richardson Senior, who stayed with him four years, up to the time of Riley's death, and managed his affairs following this event.

Riley was a modest, courteous, kind-hearted but somewhat timorous man. Easily upset when his work was criticized by his sitters, he would never allow his pupils to stand by when he was painting from the life. Reference to a purchase of a Van Dyck in 1681 suggests that he may have been a collector; he was a member of the Saint Luke's Club of Virtuosi. Nothing is known of his married life except his wife's first name, Jacobed. After suffering several years with gout, he died of this disease in London in March 1691.

Nothing is certainly known of Riley's style before the death of Lely; our present knowledge of his work is confined to the last decade of his career. The contemporary art critic and biographer, Roger de Piles, wrote that Riley retained much of the manner of Soest, and the portraits in which Soest's influence is most pervasive probably date to the 1670s. Both artists eschewed the fashionable world. A diligent painter from life, Riley was a restrained but delicate colorist and an acute observer of character, at his best with professional, middle-class, and ordinary people, such as the housemaid of James II (Royal Collection, Windsor Castle). His men tend to be melancholy in disposition, his women gentle and withdrawn. Although he took over some of Lely's poses, he was not gifted as a composer, and his large-scale portraits tend to be dry and wooden. The baroque swagger and vigorous, masterly treatment of drapery in certain of his larger works must be attributed to the participation of Closterman.

Riley was eclipsed by the energy, bravura, and sheer fecundity of Kneller, but his sober style was taken up by those he taught and the sincerity and penetration of his portraiture deeply influenced his principal pupil, Jonathan Richardson, the master and father-in-law of Thomas Hudson, to whom Reynolds was apprenticed.

Bibliography

Vertue, George. *Note Books.* In 6 vols. *The Walpole Society* 18 (1930), 20 (1932), 22 (1934), 24 (1936), 26 (1938), 30 (1955); 1 (18 [1930]): 61, 106; 2 (20 [1932]): 11, 131, 135, 139, 140; 3 (22 [1934]): 23, 67, 75, 117, 120; 4 (24 [1936]):21, 28, 29, 43, 175.

Waterhouse, Sir Ellis. *Painting in Britain 1530 to 1790.* Harmondsworth, 1953:96–97.

Millar, Sir Oliver. In Margaret Whinney and Oliver Millar. *English Art 1625–1714.* Oxford, 1957:188–189, 191–192.

1988.20.1

John Eldred

c. 1670/1680
Oil on canvas, 76.2 × 63.5 (30 × 25)
Estate of John N. Estabrook

Technical Notes: The medium-weight canvas is plain woven; it has been lined. The ground is white, thinly and smoothly applied. There is a thin, pink imprimatura used to model the shadows in the face and which appears through the gray layers of the hair. The composition is painted within a bold gray-brown feigned oval. The painting is executed in thin layers, blended wet into wet, with boldly touched impasto in the highlights. Retouching is minimal, but some of the glazes may have become more transparent or have been thinned. The natural resin varnish is in very poor condition and is moderately discolored.

Provenance: By descent to Sir John Ruggles-Brise, Bt. [b. 1908], Spains Hall, Finchingfield, Essex (sale, Sotheby & Co., 21 January 1976, no. 87 [with a portrait of his grandson's wife, Susannah Rawston, wrongly described as his own wife], as Kneller, bought in). Purchased by private treaty after the sale by John N. Estabrook, Chicago.

JOHN ELDRED (1629–1717), of Olivers, near Colchester, Essex, was the son of John Eldred, M.P. (d. 1682), collector of the sequestrations for the county in 1645. He married an heiress in 1657, Margaret, half sister of Richard Harlackenden, of Earl's Colne Priory, Essex. A dissenter who was no friend of the restored monarchy, Eldred was a lawyer by profession and served as deputy recorder of Harwich; he was elected M.P. for Harwich in 1689. Portraits of his daughter-in-law, Mary, and of his granddaughter Dulcibella, were among the Eldred family portraits sold at Sotheby's in 1976.

An attribution to Gerard Soest was proposed by Arthur Wheelock at the time the portrait was offered to the National Gallery. The careful study of character, the direct

John Riley, *John Eldred*, 1988.20.1

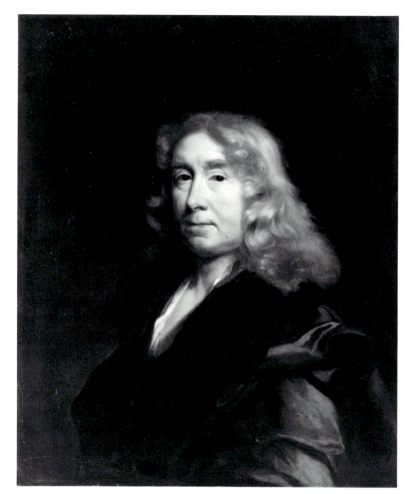

Fig. 1. John Riley, *William Chiffinch*,
c. 1670/1680, oil on canvas, England,
private collection [photo: Sotheby & Co.]

treatment, the full, fleshy modeling of the head, the idio-syncratic highlighting of the upper lip, and the slight stiffness of pose are, however, all characteristic of the work of Soest's principal pupil, John Riley (fig. 1).[1]

Eldred is depicted in legal dress, with gown and white bands. The soft, loosely curled wig, low over the forehead, is characteristic of fashion in the 1660s and 1670s. Allowing for the fact that Eldred was unlikely, as a country lawyer, to have followed the height of fashion, the closeness to Soest's manner of painting suggests that the por-

trait may be a rare example of Riley's early style, before the death of Lely in 1680 and his association with Closterman in about 1681.

Riley's forte was in painting from life, and the bulk of his work was on a small, head-and-shoulders scale, often using feigned ovals, as in the Gallery's picture.

Notes
1. My colleague, Malcolm Rogers, pointed me in this direction.

George Romney

1734 – 1802

GEORGE ROMNEY was born in Dalton-on-Furness, Lancashire, on 15 December 1734, the third of the eleven children of John Romney, a prosperous cabinetmaker, and Anne Simpson. Leaving school at the age of eleven, he worked for eight years in his father's workshop before being apprenticed to a local painter, Christopher Steele, with whom he served for two years, from 1755 to 1757, in Kendal, York, and Lancaster. He married a Kendal girl, Mary Abbot, on 14 October 1756, and painted at Kendal from 1756 to 1762, principally small full-length portraits close in style to those of Arthur Devis, for which he charged six guineas.

In 1762 Romney settled in London, leaving his wife and son behind, and henceforward saw them only on his few visits to the north. He won premiums for historical paintings from the Society of Arts in 1763 and 1765, and exhibited at the Free Society between 1763 and 1769 and with the Society of Artists from 1770 to 1772. During a visit to Paris in the autumn of 1764 he was deeply impressed by the classicism of Eustache Le Sueur. His portraits were chiefly influenced by Ramsay. In 1773 he traveled to Italy with the miniaturist Ozias Humphry, remaining there until 1775, chiefly in Rome. Humphry found him "a man of uncommon Concealment; in no way communicative. In what related to his Art He reserved his studies, refusing to let them be seen while He was in Italy."[1]

On his return to London Romney was patronized by the Duke of Richmond, in whose celebrated gallery of casts he had formerly studied, and took the grand house in Cavendish Square, with its large painting room, previously occupied by Francis Cotes. He achieved an instant success, and his unremitting application as a society portraitist is amply documented by his sitter books, which survive for the years 1776 to 1795. His prices rose steadily, from fifteen guineas for a head and shoulders in 1775 to twenty guineas in 1781, thirty guineas in 1787, and thirty-five guineas in 1793; his fees for half lengths were double these, and for full lengths double again. Though his prices were always lower than those of Reynolds and Gainsborough, he was recognized as their only rival. He was too sensitive to exhibit at the Royal Academy of Arts, though

this was partly due to an antagonism with Reynolds. His health affected by overapplication, he gave up portrait painting at the end of 1796 and retired to Hampstead. In 1798 he sold the lease of his London house to Martin Archer Shee and returned to Kendal, where he died insane on 15 November 1802.

Romney was the ideal fashionable portrait painter. Uninterested in the portrayal of character or in psychological subtleties, he delighted, as Sir Ellis Waterhouse has written, in rendering "all those neutral qualities which are valued by Society—health, youth, good looks, an air of breeding."[2] His patterns, his line, and his clarity of color were alike agreeable. His best period was between 1775 and 1780, when he was most under the influence of classical antiquity, notably the flowing draperies of classical sculpture; subsequently his style hardly changed, marked though it was by a gradual deterioration in quality. But Romney was a Jekyll-and-Hyde character. He never moved in the great world of his sitters, as did Reynolds; neurotic and introspective, distrustful and unsociable, he had few friends, spoke of "this cursed portrait-painting! How I am shackled with it!"[3] and spent his evenings sketching historical compositions (a large number of these drawings are now in the Fitzwilliam Museum, Cambridge, and the Yale University Art Gallery, New Haven).

In 1776 Romney met William Hayley, with whom he formed one of his few close friendships; as a member of Hayley's circle he came to know William Cowper and John Flaxman, who said that Romney "was gifted with peculiar powers for historical and ideal painting, so his heart and soul were engaged in the pursuit of it."[4] Romney's drawing style quickly developed from the neoclassical to the sublime and became increasingly free, rhythmic, and horrific, with subjects taken from Ossian, Aeschylus, and Homer; toward the end of his life his house was filled with casts of Greek sculpture. He completed few history paintings, however, and those he did were chiefly for John Boydell's Shakespeare Gallery. In 1782 he met the vivacious Emma Hart (later Lady Hamilton), with whom he became infatuated and who was the subject, until 1786, of some fifty paintings in which she displayed her delight in acting in various graceful and

sentimental attitudes in the guise of appropriate mythological and other characters; these were the equivalent, in Romney's oeuvre, of Gainsborough's fancy pictures, though in style they prefigured Hollywood taste.

Romney's influence over the next generation was eclipsed by that of Reynolds, but it is not surprising that, in the age of Duveen, and with the vogue for British portraiture in the United States, his glamorous portrait style and the sheer loveliness of his female sitters should have found particular favor. More recently it has been his sketches that have been most admired.

Notes
1. Farington *Diary*, 6:2117 (28 August 1803).
2. Waterhouse 1953, 222.
3. Romney to William Hayley, February 1787 (Hayley 1809, 123).
4. "Sketch of Romney's Professional Character, by Flaxman," in Hayley 1809, 310.

Bibliography
Hayley, William. *The Life of George Romney*. Chichester, 1809.
Romney, Reverend John. *Memoirs of the Life and Works of George Romney*. London, 1830.
Ward, Humphry, and William Roberts. *Romney*. 2 vols. London, 1904.
Waterhouse, Sir Ellis. *Painting in Britain 1530–1790*. Harmondsworth, 1953:222–225.
Crookshank, Anne. "The Drawings of George Romney." *BurlM* 99 (1957):43–48.
Johnston, Elisabeth. *George Romney, Paintings and Drawings*. Exh. cat., Iveagh Bequest, Kenwood. London, 1961.
Irwin, David. *English Neoclassical Art*. London, 1966:84–86, 160–161.
Jaffé, Patricia. *Lady Hamilton*. Exh. cat., Iveagh Bequest, Kenwood. London, 1972:11–24.
Jaffé, Patricia. *Drawings by George Romney*. Exh. cat., Fitzwilliam Museum. Cambridge, 1977.

Fig. 1. George Romney, *Mrs. Verelst*, 1771–1772, oil on canvas, Rotherham, Yorkshire, Clifton Park Museum [photo: P. & D. Colnaghi & Co. Ltd.]

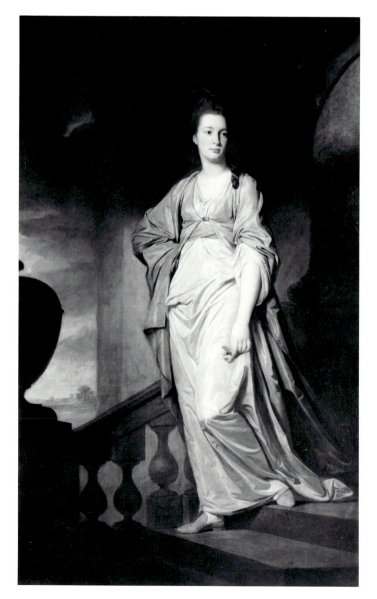

1937.1.94 (94)

Mrs. Thomas Scott Jackson

c. 1770/1773
Oil on canvas, 239 × 147 (94⅛ × 57⅞)
Andrew W. Mellon Collection

Technical Notes: The medium-weight canvas is twill woven; it has been lined. The ground is white, smoothly applied and of thin to moderate thickness. The painting is executed smoothly and fluidly, with transparent layers in the darks and low impasto in the highlights. X-radiographs have revealed slight pentimenti; the neckline of the dress has been moved about one inch to the right and is lower than it first was, the folds of the sleeve above the elbow originally followed more the curve of the arm, and the folds in the green drapery to the left of the sleeve were once more broadly curved. The painting was cleaned and restored by Romney in 1795. The painting is in good condition except for heavy retouching in the darks at lower right over fine traction crackle caused by bitumen. The natural resin varnish has discolored yellow moderately.

Provenance: Painted for the sitter's first husband, Thomas Scott Jackson [d. 1791]; by descent to the sitter's daughter, Maria [d. 1830], who married Sir John Grey-Egerton, 8th Bt., Oulton Park, Cheshire; by descent to Sir Philip Grey-Egerton, 12th Bt. [1864–1937], who sold it c. 1905 to (Thos. Agnew & Sons), London. (Robert Langton Douglas), London, from

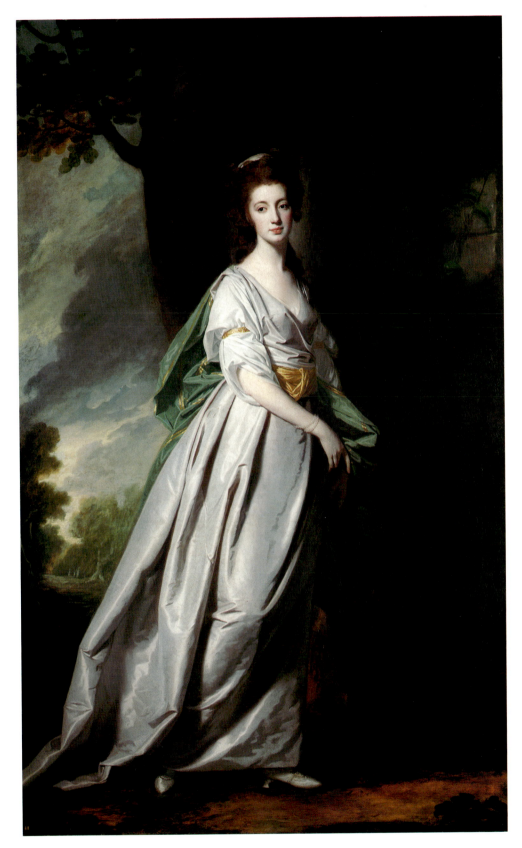

George Romney, *Mrs. Thomas Scott Jackson*, 1937.1.94

whom it was purchased by J. Pierpont Morgan, Sr. [1837–1913]; bequeathed to his daughter, Juliette (Mrs. William P. Hamilton), New York, who sold it December 1936 to The A. W. Mellon Educational and Charitable Trust, Pittsburgh.

Exhibitions: *Art Treasures of the United Kingdom*, Manchester, 1857, "Paintings by Modern Masters," no. 77. *Pictures by Italian, Spanish, Flemish, Dutch, French and English Masters*, British Institution, London, 1864, no. 97. *Eleventh Annual Exhibition on Behalf of the Artists' General Benevolent Institution*, Thos. Agnew & Sons, London, 1905, no. 21.

MARY KEATING (1751/1752–1813), daughter of Michael Keating of County Cork, was married to Thomas Scott Jackson, a director of the Bank of England. After Jackson's death in 1791 she married, in 1794, the Reverend Sir Thomas Broughton, Bt., of Doddington Park, Cheshire (hence the traditional title of this work as Lady Broughton).

On the basis of the appearance of Mrs. Jackson's name in Romney's diary for 27 October 1784 and in the Reverend John Romney's list of portraits upon which the artist was engaged in 1785 (the diary for that year is missing), Ward and Roberts initially dated the work to 1785.[1] This is patently wrong, as the sitter is not a woman in her early thirties but much younger, while the style of the portrait is that of Romney in the early 1770s, when Mrs. Jackson was, more plausibly, about twenty. Comparison may be made with the full length of Mrs. Verelst, dating to between 1771 and 1772, in which the relaxed, classical style, firm, rounded modeling of the head and arm, and sculptural handling of the draperies are similar (fig. 1). The backdrop landscape, with its stormy clouds and broadly handled foliage, relates closely to that in the full-length figure of Allegro or Mirth, exhibited at the Society of Artists in 1770.[2] This dating is supported by the evidence of costume, since the hair style, high piled but not yet towering or elaborate, with loosely dressed curls and tresses, is characteristic of the earlier part of the 1770s.

The references to work on the picture between 1784 and 1785 may be associated with restoration; the portrait was certainly restored by Romney ten years later, as there is a note in his ledger to this effect: "Lady Broughton, W.L., cleaned and varnished and sent to Oulton Park."[3] The sitter's daughter, Maria, married Sir John Grey-Egerton of Oulton Park, Cheshire, in 1795, and the picture must have been restored at that time, preparatory to its removal to the house in which it was to hang for the next century and more.

This portrait is an especially fine example of Rom-

ney's cultivation of the graceful attitude (at the expense of anatomical accuracy) in his pre-Italian period, a time when he must have been particularly conscious of the challenge of Reynolds (who had painted a deliberately varied group of portraits with poses borrowed from the antique and from the Old Masters for the first exhibition at the Royal Academy of Arts in 1769), and when he succeeded to the mantle of one of Reynolds' chief competitors in this decade, Francis Cotes, who died in 1770.

Notes

1. Ward and Roberts 1904 (see biography), 2:84. Roberts corrected this view in his entry in the Morgan catalogue (Roberts 1907): "It is clearly of a much earlier date than this, and was painted either just before or soon after his visit to Italy."
2. Reproduced in the catalogue of an anonymous sale, Christie, Manson & Woods, London, 13 July 1984, no. 122.
3. Ward and Roberts 1904 (see biography), 2:84.

References

1904　Ward and Roberts 1904 (see biography), 1:105, 106; 2:84.
1907　Roberts, William. *Pictures in the Collection of J. Pierpont Morgan at Prince's Gate & Dover House, London: English School.* London, 1907: unpaginated.
1949　Mellon 1949: no. 94, repro. 114.
1966　Henderson [later Jaffé], Patricia. *George Romney.* (*Maestri del colore* series, no. 250.) Milan, 1966: color pls. 10–11.
1969　Watson, Ross. "British Paintings in the National Gallery of Art." *Conn* 172 (1969):55–56, repro. 55.
1976　Walker 1976: no. 510, color repro.
1990　Shawe-Taylor, Desmond. *The Georgians: Eighteenth-Century Portraiture and Society.* London, 1990: 153, color fig. 103.

1954.14.1 (1356)

Mr. Forbes

c. 1780/1790
Oil on canvas, 76.4 × 63.5 (30⅛ × 25)
Gift of Pauline Sabin Davis

Technical Notes: The medium-weight canvas is plain woven; it has been lined, but the tacking margins survive intact. The light-brown ground is applied thinly and evenly. The painting is executed fluidly and thinly; the uniform remains flat and unfinished, only the head being modeled to a higher finish. The painting is in good condition. Retouching is confined almost exclusively to the edges. The thick natural resin varnish has discolored yellow slightly.

Provenance: (M. Knoedler & Co.), 1921, from whom it was purchased by Mr. and Mrs. Charles H. Sabin, Southampton,

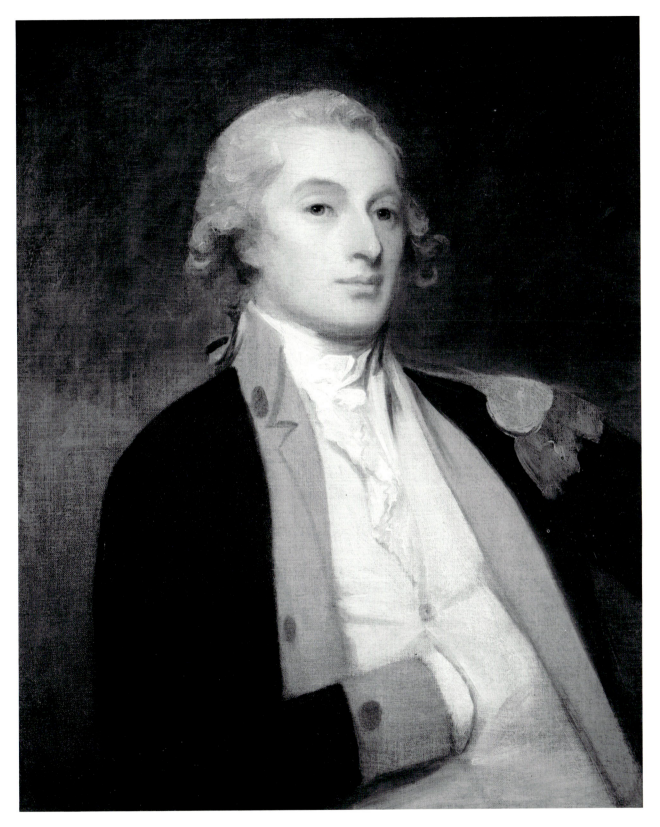

George Romney, *Mr. Forbes*, 1954.14.1

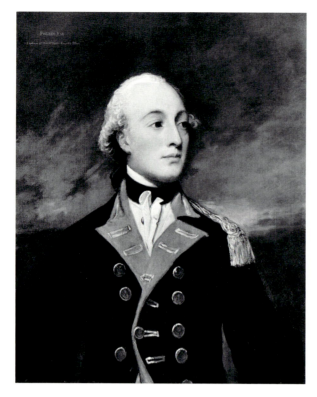

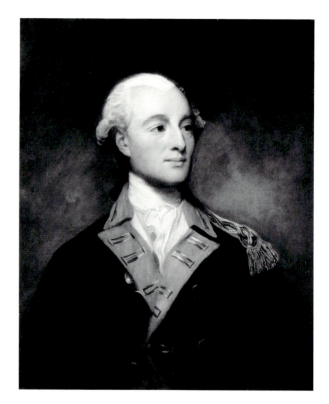

Fig. 1. George Romney, *Captain Alexander Forbes*, 1780s, oil on canvas, New York, private collection [photo: Thos. Agnew & Sons Ltd.]

Fig. 2. George Romney, *Captain Forbes*, 1780s, oil on canvas, Aberdeenshire, Fyvie Castle, National Trust for Scotland [photo: Scottish National Portrait Gallery]

Long Island, New York. (Mrs. Sabin, née Pauline Morton, later became Mrs. Dwight F. Davis, Washington [d. 1955].)

THE SITTER is depicted in a dark blue military uniform with scarlet facings, wearing only one epaulette, on his left shoulder, as was the custom in cavalry regiments in the British army at that time. The only regular cavalry regiment to wear a blue coat of this pattern with scarlet facings was the Royal Horse Guards.[1] The rank is uncertain. The hairstyle, with loosely dressed side curls, suggests a date in the 1780s.

A family resemblance to portraits by Romney of Captain Alexander and another Captain Forbes (figs. 1, 2),[2] also in the uniform of the Royal Horse Guards, suggests that the traditional identification is correct, but there is no evidence for any other Forbes but Alexander having served in the Royal Horse Guards (or in any of the irregular cavalry regiments that wore blue coats during the 1780s), and it is not possible to connect this portrait with documented sittings.[3] None of the three portraits represents a Forbes of Culloden, as has been thought,[4] but it is impossible to establish from family trees to which of

the innumerable branches of the Forbes family the sitters in the Romney portraits, who seem likely to be brothers, may have belonged.[5]

The head has been brought to Romney's customary degree of finish at this period, but the costume has only been laid in (the mustard yellow of the waistcoat and the red and green of the epaulette bear no relation to contemporary military uniform). The hand held in the waistcoat had been gentlemanly etiquette since the 1730s.

Notes

1. Information from Daphne Willcox, keeper of uniform at the National Army Museum, to whom I am greatly indebted for help with this entry.

2. The former, from the collection of P. B. Davies-Cooke, was with Thos. Agnew & Sons, 1978 (*Three Centuries of British Painting*, exh. cat., Agnew's, no. 9, repro.); the latter, with Agnew in 1904, was acquired by Lord Leith for his collection at Fyvie Castle. The tradition that the second portrait represents Arthur Forbes, 7th Laird of Culloden (see Ward and Roberts 1904 [see biography], 2:56; *Treasures of Fyvie* [exh. cat., Scottish National Portrait Gallery] [Edinburgh, 1985], no. 24) is unfounded, as authentic portraits of him make clear (*Albums of photographs and documents relating to Duncan Forbes of Culloden and the Forbes family*, 2 vols., Scottish Library,

Central Library, Edinburgh, no. XDA 758.3 F69). Moreover, although John Forbes, 6th Laird of Culloden, did serve in the Royal Horse Guards, there is no evidence to support the assertion in *Burke's Landed Gentry* that his son Arthur did. (Further, as there were no other surviving sons, the Romney cannot depict any other Forbes of Culloden.) An Arthur Forbes is recorded as an infantry officer, serving in the Ninety-Fourth Foot from 1780 and in the Sixth Foot from 1784 to 1796.

3. A Mr. Forbes had sittings with Romney on 16 March and on 29, 30 June 1780. On 29 June Romney described him in his sitter book as Captain Forbes. This portrait was paid for on 30 June. A Captain Forbes had sittings with Romney on 18, 19, 21 July 1782. This is likely to be the portrait sent to Mrs. Thornton in Dover Street in February 1783 (Ward and Roberts [see biography], 2:56). These two portraits are probably identifiable with those described in note 2, and are clearly not identifiable with the Washington picture, which is unfinished.

4. See note 2.

5. See Alistair and Henrietta Tayler, *The House of Forbes*, printed for the Third Spalding Club (Aberdeen, 1937).

References

1976 Walker 1976: no. 511, color repro.

1937.1.104 (104)

Miss Juliana Willoughby

1781–1783
Oil on canvas, 92.1 × 71.5 (36¼ × 28⅛)
Andrew W. Mellon Collection

Technical Notes: The medium-weight canvas is tightly twill woven; it has been lined. The light gray ground is applied smoothly and fairly thickly. The painting is executed in vigorously brushed thick paint with moderate impasto in the costume, while the darks are painted in thin, transparent glazes. X-radiographs show that the sitter originally wore a smaller hat and that her features then appeared younger (fig. 1); there are slight pentimenti in her right shoulder and the contour of the bow. The painting is in good condition. The paint surface has not been abraded and there are no major losses. The impasto was slightly flattened during lining and there is scattered but minor retouching. The synthetic varnish applied after conservation in 1985 has not discolored.

Provenance: Painted for the sitter's father, Sir Christopher Willoughby, 1st Bt. [1748–1808], Baldon House, Oxfordshire; by descent to Sir John Willoughby, 5th Bt., Fulmer Hall, Slough, Buckinghamshire, by whom it was sold 1906. (M. Knoedler & Co.), from whom it was purchased February 1907 by Andrew W. Mellon, Pittsburgh, who deeded it 28 December 1934 to The A. W. Mellon Educational and Charitable Trust, Pittsburgh.

JULIANA WILLOUGHBY was the only child of Sir Christopher Willoughby and his first wife, Juliana, daughter of the Reverend John Burville, whom he married in 1776. Juliana's mother died on 20 April 1777, probably in childbirth; 1777, at any rate, is likely to have been the date of Juliana's birth. Nothing further is recorded about her life, so that she probably died young and unmarried.

Miss Willoughby had two sittings with Romney in 1781, on 13 and 20 May.[1] She had two further sittings the following year, on 22 April and 29 June 1782, and four more a year later, on 24, 27, and 29 March, and on 10 April 1783.[2]

Miss Willoughby began to be painted when she was (probably) just four years old. At the time of her last sittings she was (probably) almost six. This difference in age accounts for the substitution, shown in x-radiographs (fig. 1), of a fashionable adult hat for the child's mob cap, which she had outgrown. The placement high in the canvas adds to this sense of sophistication. The positioning of her left forearm is echoed in the sweeping diagonal of the landscape background, executed in lively brushwork which, together with the agitated handling of the sky, enhances the vitality of this delightful image of childhood.

Fig. 1. X-radiograph of 1937.1.104, showing underlying hat

George Romney, *Miss Juliana Willoughby*, 1937.1.104

Notes

1. Ward and Roberts 1904 (see biography), 1:95–96.
2. Ward and Roberts 1904 (see biography), 1:98–99, 101.

References

1904 Ward and Roberts 1904 (see biography), 1:95–96, 98–99, 101; 2:172.
1949 Mellon 1949: no. 104, repro. 115.
1966 Henderson [later Jaffé], Patricia. *George Romney.* (*Maestri del colore* series, no. 250.) Milan, 1966: color pl. 14.
1976 Walker 1976: no. 509, color repro.

1937.1.105 (105)

Mrs. Davies Davenport

1782–1784
Oil on canvas, 76.5 × 64 (30⅛ × 25¼)
Andrew W. Mellon Collection

Technical Notes: The somewhat coarse canvas is plain woven; it has been lined. The ground is white, smoothly applied and of moderate thickness. There are thin layers of grey and brown imprimatura except in the area to be occupied by the head. The painting is executed in thick, opaque layers, blended wet into wet, with slight impasto in the whites; only the details of the features are defined crisply over a dried underlayer. Some change in the color of the satin cloak is suggested by the presence of deeper reds beneath the pink of the lower portion. An x-radiograph confirms slight pentimenti in the fall of the drapery folds. There is slight solvent abrasion and flattening of the impasto during lining, a large area of retouching in the neck, and pronounced traction crackle in the brown foliage caused by bitumen, which has been infilled. The slightly pigmented natural resin varnish has been applied over residues of a deeply discolored coating most marked over the bituminous foliage at lower right.

Provenance: Painted for the sitter's husband, Davies Davenport [1757–1837], Capesthorne, Macclesfield, Cheshire; by descent to Sir William Bromley-Davenport [1862–1949] (sale, Christie, Manson & Woods, London, 28 July 1926, no. 147, repro.), bought by (Duveen Brothers), London, from whose New York branch it was purchased April 1928 by Andrew W. Mellon, Pittsburgh and Washington, by whom it was deeded December 1934 to The A. W. Mellon Educational and Charitable Trust, Pittsburgh.

Exhibitions: *Works by the Old Masters, and by Deceased Masters of the British School,* Winter Exhibition, Royal Academy of Arts, London, 1878, no. 111. *Works by the Old Masters, and by Deceased Masters of the British School,* Winter Exhibition, Royal Academy of Arts, London, 1892, no. 17. *Meisterwerke Englischer Malerei aus drei Jahrhunderten,* Secession, Vienna, 1927, no. 15, repro.

CHARLOTTE SNEYD (died 1829) of Keele Hall, Staffordshire, married Davies Davenport, who became high sheriff of Cheshire in 1783 and was M.P. for Cheshire from 1806 to 1830, in 1777. According to family tradition she was the model for Margaret Dawson, the heroine in Mrs. Gaskell's short story, *Lady Ludlow,* published in 1858.

Mrs. Davenport gave seven sittings to Romney in 1782, on 24 and 29 March, 2, 8, 15, and 23 April, and 16 May.[1] She had a further sitting a year later, on 18 March 1783, and three more a year afterward, on 1, 8, and 24 March 1784.[2] It is not certain whether she was the same Mrs. Davenport who sat to Romney for a half-length portrait in 1780.[3]

The modeling of the head, notably the sweeping contour in halftones that outlines the form, is schematic. The resulting vacuousness in characterization, an image of a well-bred young lady rather than of an individual, may be compared with Reynolds' sensitivity in this type of female portrait. It is difficult to know why the artist required as many as eleven sittings. Romney has given Mrs. Davenport a background similar to the one he employed for Miss Willoughby (1937.1.104). The stormy sky and the rapidly painted landscape which, in its diagonal emphasis, echoes the neckline of the costume, complement the sense of youthful freshness in the portrait.

A mezzotint by John Jones was published by him, 29 May 1784.

Notes

1. Ward and Roberts 1904 (see biography), 1:98.
2. Ward and Roberts 1904 (see biography), 1:101, 103–104.
3. Ward and Roberts 1904 (see biography), 2:41.

References

1904 Ward and Roberts 1904 (see biography), 1:98, 101, 103–104; 2:41.
1939 Tietze, Hans. *Masterpieces of European Painting in America.* London, 1939: 325, repro. 229.
1941 *Duveen Pictures in Public Collections of America.* New York, 1941: no. 289, repro.
1949 Mellon 1949: no. 105, 116, repro.
1976 Walker 1976: no. 515, color repro.

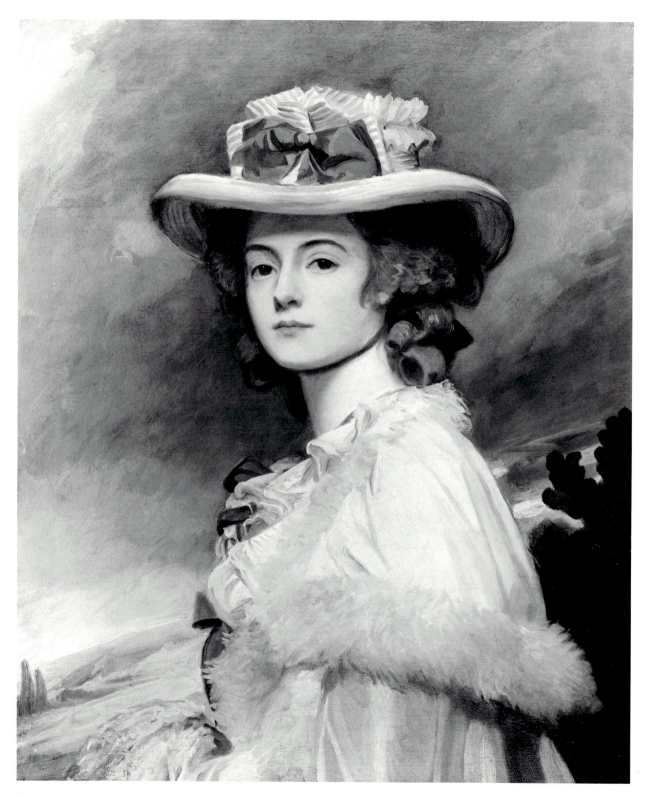

George Romney, *Mrs. Davies Davenport*, 1937.1.105

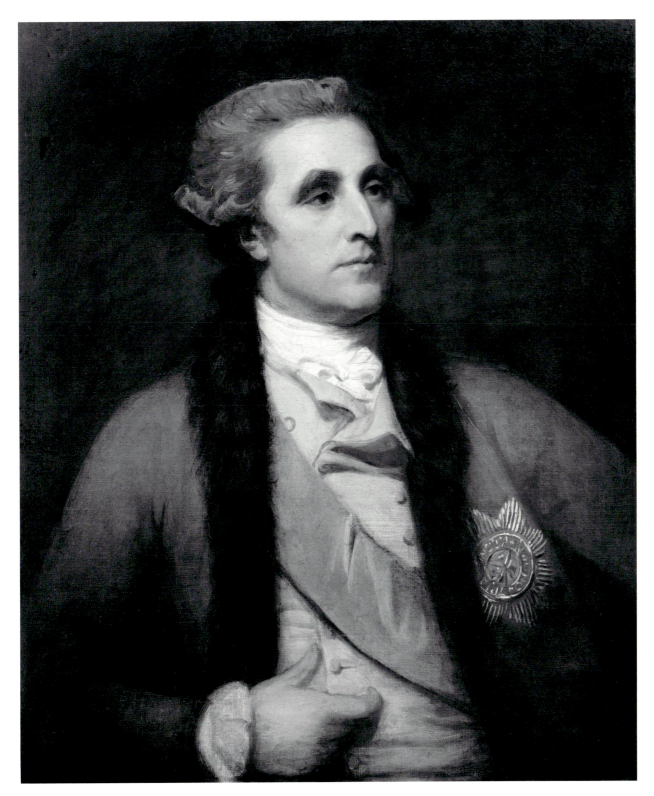

George Romney, *Sir William Hamilton*, 1970.17.133

1970.17.133 (2505)

Sir William Hamilton

1783–1784
Oil on canvas, 76.8 × 65.1 (30¼ × 25⅝)
Ailsa Mellon Bruce Collection

Technical Notes: The medium-weight canvas is twill woven; it has been lined. The ground is a light pinkish red, of moderate thickness. The painting is broadly executed in fairly thin, opaque layers with transparent red and brown glazes in the shadows. The glazes have been abraded. The moderately thick natural resin varnish has discolored yellow to a significant degree.

Provenance: Noted as given by the sitter in 1789 to his nephew, the Hon. Charles Francis Greville [1749–1809][1] (sale, James Christie, London, 31 March 1810, no. 41), probably bought on behalf of the Hon. Robert Fulke Greville [1751–1824],[2] brother of Charles Francis Greville; bequeathed to his wife, Louisa, Countess of Mansfield [d. 1843]; thence to their daughter, Lady Louisa Greville [d. 1883], wife of the Reverend the Hon. Daniel Hatton [1795–1866], rector of Great Weldon and chaplain to the queen; by descent to Nigel Hatton [1859–1937]. (Asher Wertheimer) by 1917,[3] who sold it to (M. Knoedler & Co.), London, the same year, from whose New York branch it was purchased 1918 by Andrew W. Mellon, Pittsburgh, who gave it by 1937 to his daughter, Ailsa Mellon Bruce.

SIR WILLIAM HAMILTON (1730–1803), fourth son of Lord Archibald Hamilton and grandson of William, 3rd Duke of Hamilton, was British envoy at the court of Naples from 1764 to 1800. Sociable, artistic, and a keen sportsman, he was renowned as an investigator of volcanic phenomena and as an antiquarian, forming two collections of Greek antiquities, the first of which he donated to the British Museum in 1772. Emma Hart, famed both for Romney's many paintings of her and as the inamorata of Nelson, was his mistress and later his second wife. Hamilton was much painted.[4]

Hamilton had eight sittings with Romney on his visit to London between 1783 and 1784, on 24 and 28 November, and on 2, 5, 7, 10, 15, and 31 December 1783.[5] He is shown wearing the star and sash of the Order of the Bath (he was created K.C.B. in 1772). The head is well characterized, but the treatment of the hand and costume is perfunctory and of the left arm awkward. This unusually rudimentary, small-scale image of so remarkable a sitter suggests that the requirement was for nothing more than a likeness. Nonetheless, the work was picked out by a contemporary critic as a fine example of Rom-

ney's painting in the Reynolds tradition of "delineating the mind."[6]

An engraving by William Sharp is undated.

Notes

1. According to a Knoedler prospectus dated 26 April 1913 given to Andrew Mellon, Sir William gave the portrait to his nephew on 8 May 1789.
2. Christie's marked copy of the catalogue records no. 41 as bought by "Col. Greville." Robert Fulke's son, also named Robert Fulke, was a captain; possibly he acted as buyer for his father, and was recorded as "Col."
3. M. Knoedler & Co. records, recorded by The Provenance Index, J. Paul Getty Trust, Santa Monica, California.
4. Full lengths by David Allan and from the studio of Reynolds are in the National Portrait Gallery, London. Hamilton features prominently in one of Reynolds' group portraits of the Society of Dilettanti, which now hangs at Brooks's Club, London; Batoni painted him in the company of Sir Watkin Williams-Wynn and Thomas Apperley (formerly in the Williams-Wynn collection); and Allan depicted him in a conversation piece with his first wife, Catherine, the daughter and heiress of Hugh Barlow (Duke of Atholl, Blair Castle, Perthshire). He was also the subject of a Gillray cartoon.
5. Ward and Roberts 1904 (see biography), 1:103.
6. "If from a cloud of witnesses for Romney's cause, we must select,—we would be content to take those first occurring—as Sir William Hamilton's head" (*Public Advertiser*, 13 April 1785).

References

1785 *Public Advertiser*, 13 April 1785.
1904 Ward and Roberts 1904 (see biography), 1:103; 2:69–70.
1976 Walker 1976: no. 512, color repro.

1942.9.78 (674)

Lady Arabella Ward

1783–1788
Oil on canvas, 76 × 63.5 (29⅞ × 25)
Widener Collection

Technical Notes: The medium-heavy weight canvas is twill woven; it has been lined. The ground is lead white over a layer of glue. There is a gray imprimatura. The painting is executed in fluid, thick, opaque layers, blended wet into wet. X-radiographs show substantial changes in the composition (noted below). The painting is in good condition. The full-bodied paint has resisted abrasion, but the impasto has been slightly flattened during lining. Retouching is minor, chiefly at the edges of the painting. The thick natural resin varnish has not discolored.

Provenance: Painted for the sitter's husband, the Hon. Edward

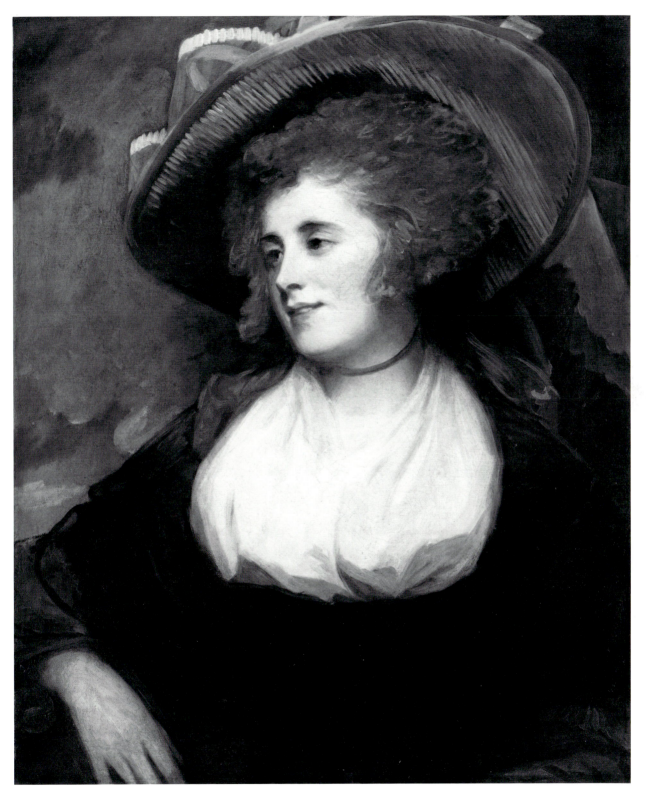

George Romney, *Lady Arabella Ward*, 1942.9.78

Fig. 1. X-radiograph of 1942.9.78, showing the underlying composition

Ward [1753–1812], son of Bernard, 1st Viscount Bangor; by descent to Maxwell, 6th Viscount Bangor [1868–1950], Castle Ward, county Down. (M. Knoedler & Co.), New York, from whom it was purchased 1921 by Joseph E. Widener, Elkins Park, Pennsylvania. Inheritance from the Estate of Peter A. B. Widener by gift through power of appointment of Joseph E. Widener, Elkins Park, after purchase by funds of the Estate.

Exhibitions: *Old Masters of the Early English and French Schools*, Royal Hibernian Academy of Arts, Dublin, 1902–1903, no. 18. *Eighth Annual Exhibition on Behalf of the Artists' General Benevolent Institution*, Thos. Agnew & Sons, 1903, no. 3.

LADY ARABELLA CROSBIE (1757–1813), third daughter of William, 1st Earl of Glandore, of Ardfert Abbey, County Kerry, married the Hon. Edward Ward, second son of Bernard, 1st Viscount Bangor, Castle Ward, county

Down, in 1783. Their eldest son, Edward, succeeded as the 3rd Viscount in 1827. Both families had been prominent in Irish life for several centuries.

Lady Arabella began to sit to Romney on 15 March 1783, the month after her wedding, and had further sittings on 21 and 24 March and on 21 May.[1] They were then discontinued. After a lapse of four-and-a-half years, during which time two of Lady Arabella's children were born, both she and her husband sat to Romney for their portraits. This second series of sittings numbered seven, and took place on 19, 24, and 30 November, 8, 20, and 28 December 1787, and on 12 January 1788.[2] Forty-five guineas were paid for the two portraits on 14 June 1788, and they were sent to Samuel Johnston, Liverpool, a forwarding agent, on 17 June.[3]

X-radiographs (fig. 1) show substantial changes

between Romney's original conception of 1783 and the finished portrait. Originally the body was inclined slightly to the right, emphasizing the turn of the head; the left rather than the right hand was included; the sitter wore a chemise dress with a low v-shaped neckline and had a ribbon in her hair; and the wrap was placed lower. The absence of the tying ribbon around the neck indicates that she was not, in 1783, shown wearing a hat. Between 1787 and 1788 Romney turned a lively, thrusting image of a girl in her mid-twenties, just married, into a more static and relaxed, softer, even matronly portrait in which the sitter envelops the picture space. In spite of the number of sittings at this time, the finished work is very perfunctory. The costume is sloppily handled without definition of form, the hat is unrelated to the hair, the eyes lack highlights, and the hand is flaccid.

Notes

1. Ward and Roberts 1904 (see biography), 1:101–102.
2. Ward and Roberts 1904 (see biography), 1:113.
3. Ward and Roberts 1904 (see biography), 2:165.

References

1904 Ward and Roberts 1904 (see biography), 1:101–102, 113, repro. opposite 8; 2:165–166.
1923 Widener 1923: unpaginated.
1966 Henderson [later Jaffé], Patricia. *George Romney. Maestri del Colore* series, no. 250. Milan, 1966: color cover.
1976 Walker 1976: no. 516, color repro.

1942.9.77 (673)

Mrs. Alexander Blair

1787–1789
Oil on canvas, 127 × 101.5 (50 × 40)
Widener Collection

Technical Notes: The medium-weight canvas is twill woven; it has been lined. The ground is white, smoothly applied. The painting is executed in very rich, obvious brushstrokes, thinly in the darks with relatively high impasto especially in the right sleeve; the background layers consist of a dark, cool red over a warmer vermilion. There appear to be some pentimenti in the hat and the papers on the table. There is marked traction crackle in the background, probably caused by the presence of bitumen, which has been infilled and has now discolored; retouching extends over much of the shadows in the arms and hands, and in scattered areas of the background, while the chair is extensively overpainted. The thick natural resin varnish has discolored yellow to a significant degree.

Provenance: Painted for the sitter's husband, Alexander Blair,

Castle Bromwich, Warwickshire. William Beckett-Denison [1826–1890], Nun Appleton, Yorkshire; by descent to his son, Ernest William Beckett [1856–1917], later 2nd Baron Grimthorpe (sale, Christie, Manson & Woods, London, 23 May 1903, no. 80), bought by (Charles Sedelmeyer, Sedelmeyer Gallery), Paris, who sold it to (Eugene Fischhof), from whom it was purchased 4 April 1907 by P. A. B. Widener, Elkins Park, Pennsylvania. Inheritance from the Estate of Peter A. B. Widener by gift through power of appointment of Joseph E. Widener, Elkins Park.

Exhibitions: *Paintings by Old Masters*, Sedelmeyer Gallery, Paris, 1906, no. 96, repro.

MARY JOHNSON (1750–1827), who married Alexander Blair, was a fashionable London hostess. In her youth she was an intimate friend of Kitty, Duchess of Queensberry (friend of Congreve, Swift, and Pope), of whom she wrote a memoir and whose letters to her were published with the memoir as preface.

Mrs. Blair gave seven sittings to Romney for this portrait—at the same time as did her husband—on 13, 21, and 28 April, 3 and 11 May, and 1 and 15 June 1787.[1] Two further sittings were given on 23 April and 4 May 1789.[2] Payment (of seventy guineas, part payment of thirty guineas having been made previously) was made for both portraits in December 1789, and both were delivered on 3 January 1790.[3] Mrs. Blair also sat to Romney in 1781 for a half length with her small daughter, but this portrait has not been traced.

Mrs. Blair is posed against a traditional background of column and draped red curtain. The books on the table and the music she holds in her right hand allude to her literary and musical interests. The head is finely rendered but, as so often with Romney, there are awkwardnesses in the design. The chair is unrelated to the sitter's body, the lower part of the dress, especially at the back, is unconvincingly modeled, and the hat, which completely lacks modeling, rests behind rather than upon the head and looks like an afterthought.

Notes

1. Ward and Roberts 1904 (see biography), 1:111–112.
2. Ward and Roberts 1904 (see biography), 1:118–119.
3. Ward and Roberts 1904 (see biography), 2:13. The slightly smaller (42 × 34½ in.) portrait of Alexander Blair, who is depicted seated in an interior, facing half left but also with his head turned to the spectator, was last recorded in the Lemle sale, Parke-Bernet, New York, 24 October 1946, no. 23, repro.

References

1904 Ward and Roberts 1904 (see biography), 1:111–112,

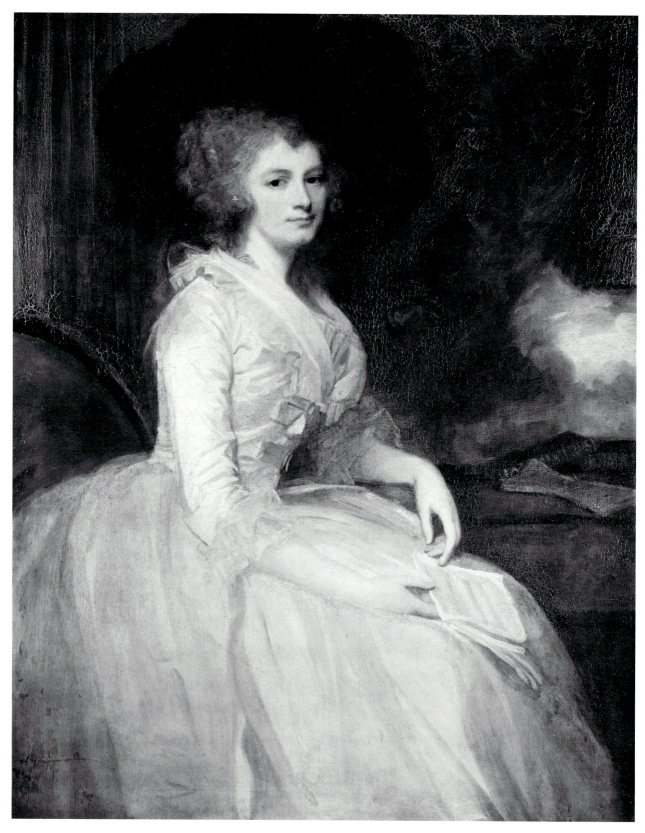

George Romney, *Mrs. Alexander Blair*, 1942.9.77

118–119; 2:13, repro. opposite 14.

1915 Roberts 1915, unpaginated, repro.
1976 Walker 1976: no. 513, color repro.

1960.6.31 (1583)

Major-General Sir Archibald Campbell

1790–1792
Oil on canvas, 153.4 × 123.9 (60⅜ × 48¾)
Timken Collection

Technical Notes: The canvas appears to be plain woven; it has been lined. The ground is white, thickly applied so that it masks the weave of the canvas. There is a warm brown imprimatura. The painting is executed in thick, opaque layers, blended wet into wet; the head was painted first. There are pentimenti in the black collar and cuffs, which were originally blue. The painting is in good condition. Abrasion and flattening are slight; retouching is confined to the extreme edges. The painting was surface cleaned and revarnished with dammar in 1960; the varnish has discolored yellow only slightly.

Provenance: Amelia Campbell [d. 1813], wife of the sitter, Inverneil, Scotland; probably by descent in the Campbell family. Thatcher M. Adams, New York (sale, American Art Association, New York, 14–15 January 1920, 2nd day, no. 154, repro.), bought by (John Levy Galleries), New York, from whom it was purchased by William R. Timken [d. 1949]; bequeathed to his wife, Lillian S. Timken [d. 1959].

Exhibitions: *Styles in Portraiture*, Northern Virginia Fine Arts Association, Alexandria, 1972, no cat.

SIR ARCHIBALD CAMPBELL (1739–1791), second son of James Campbell, of Inverneil, Argyllshire, served with distinction in the Seven Years War and the American Revolution, rising to the rank of major-general, and was successively governor of Jamaica and of Madras, where he ably seconded Lord Cornwallis, then the governor-general of India. He married the daughter of Allan Ramsay, the painter. He was portrayed several times by the miniaturist John Smart, who pursued a highly successful career in Madras; and there are three medallions of him by James Tassie.

Campbell had thirteen sittings with Romney in the first half of 1790, on 8, 12, 16, 19, 28, and 29 January, 11 and 23 February, 12 March, 9 and 24 April, 11 May, and 1 June.[1] He is shown in the uniform of a major-general, wearing the star of the Order of the Bath (he was created K.C.B. in 1785 on his return from Jamaica), with a view of Fort George, Madras, in the background.

Romney painted several versions of this portrait. The principal version, now in the National Army Museum, London, is that which was sent to Mr. Addison's, Surrey Street, Strand, a forwarding agent, on 8 April 1791 and paid for (seventy guineas) by Lady Campbell on 15 April 1791.[2] Another, from the collection of Harold O. Barker, New York, was sold at Christie, Manson & Woods, London, on 1 May 1959, lot 21; it was bought by Frost and Reed and subsequently acquired by John L. Campbell, a descendant of the sitter.[3] A third, originally in the possession of Lady Campbell, was once owned by the Springfield Museum of Fine Arts but, having been cut down and badly restored, was sold at auction by Tobias, Fischer and Co., Inc., in May 1947. A fourth was in the possession of T. J. Blakeslee, New York, in 1910.

The National Gallery's version may be the copy paid for by Lady Campbell on 26 March 1792 (70 guineas), and sent to her the following day,[4] or a version Romney intended to finish in mid-September,[5] presumably that sent to Mr. Addison's on 10 December 1792 and paid for on the same date (70 guineas).[6]

The image is a commanding one but, although it has

Fig. 1. Sir Joshua Reynolds, *Lord Heathfield*, 1787, oil on canvas, London, National Gallery

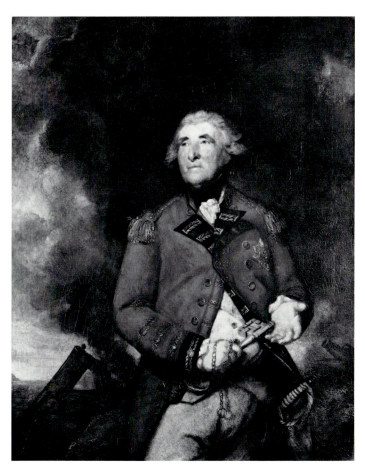

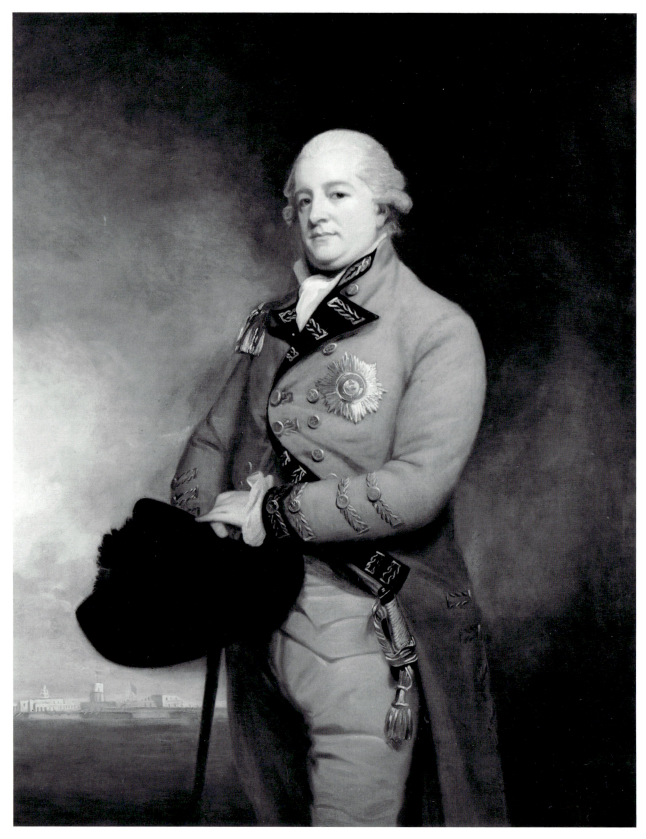

George Romney, *Major-General Sir Archibald Campbell*, 1960.6.31

the immediacy of Reynolds' late portraits seen from a low viewpoint with the figure cut above the knees (fig. 1), it is very formal in concept, with broad, even lighting; it is a portrait of a governor not a hero, and Romney has not sought to emulate Reynolds' overwhelming sense of physical presence against rolling clouds.

Notes

1. Ward and Roberts 1904 (see biography), 1:121–122.
2. Ward and Roberts 1904 (see biography), 2:24 (where this information, which applies to the principal version, is wrongly associated with a replica).

3. This is the version illustrated in Ward and Roberts 1904 (see biography), 1: opposite 16.
4. Ward and Roberts 1904 (see biography), 2:24.
5. Romney noted in his diary, 17 July 1792: "Sir A. C. to be finished in two months from this date;" see Ward and Roberts 1904 (see biography), 1:126.
6. Ward and Roberts 1904 (see biography), 2:24.

References

1904 Ward and Roberts 1904 (see biography), 1:121–122; 2:24.
1938 Borenius, Tancred. *English Painting in the XVIIIth Century*. London, 1938: pl. 60.
1976 Walker 1976: no. 514, color repro.

Enoch Seeman

1694 – 1744/1745

SEEMAN WAS BORN in Danzig in 1694, one of the four sons (all of whom became painters) of Isaac Seeman, a portrait painter. Brought to London by his father when he was young, he was in good practice as a portraitist by 1717, when he painted the full length of Elihu Yale (Yale University, New Haven). Seeman obtained patronage from the Graftons, Pembrokes, Rockinghams, and other aristocratic families, and maintained a respectable position in the second rank of painters in the age that bridged late Kneller and the mature Hudson, but he was never able to command high prices: he was only paid twenty guineas for a full length in 1732. He painted a number of portrait groups, of which the largest was that of Lady Cust and her nine children (1743; Belton House, Lincolnshire). Seeman lived on St. Martin's Lane, and died there in March 1744 or 1745. At his death George Vertue pronounced: "he had some years ago much business and his works were well esteemd—but generally neat finisht Labourd—his colouring not much variety—nor freedom. his price not much, but as he could get."[1]

Seeman was not an original talent and had few idiosyncracies. In his early years he painted in the style of Kneller, using traditional seventeenth-century poses and gestures. In the 1720s he developed a more informal style, with a softer handling of paint, closer to that of Charles Jervas. Later he followed the rising star of Hudson. His brother Isaac, who died in 1751, succeeded to his studio and business. His son, Paul, is recorded as a painter, but none of his work has been identified.

Notes

1. Vertue *Note Books*, 3 (22 [1934]): 125.

Bibliography

Vertue, George. *Note Books*. In 6 vols. *The Walpole Society* 18 (1930), 20 (1932), 22 (1934), 24 (1936), 26 (1938), 30 (1955); 3 (22 [1934]): 16, 54, 125, 155.
Cust, Sir Lionel. In *Dictionary of National Biography*. Vol. 13. London, 1897:1132.
Waterhouse, Sir Ellis. In *Dictionary of British 18th Century Painters*. Woodbridge, 1981:337.

Attributed to Enoch Seeman

1947.17.26 (934)

Portrait of an Officer

c. 1702/1730
Oil on canvas, 127.6 × 102.2 (50¼ × 40¼)
Andrew W. Mellon Collection

Inscriptions:
On the strainer replacing the original stretcher in brown ink:
Leu.ͭ Govn.ͬ William Gooch

Technical Notes: The medium-fine canvas is loosely plain woven; it has been lined, but the tacking margins survive intact.

The ground is warm ocher, of moderate thickness, masking the weave of the canvas. A deep reddish imprimatura is locally applied under the head as a basis for the flesh tones. The painting is broadly executed in thin, opaque layers with smoothly blended brushstrokes; there is thicker paint, with slight impasto, in the highlights. The painting is in excellent condition. The paint surface is not abraded and there are no significant losses. The natural resin varnish has discolored only slightly.

Provenance: (Rose M. de Forest), New York, who sold it 1929 to Thomas B. Clarke [d. 1931], New York, as a portrait of Sir William Gooch by Charles Bridges. Sold by Clarke's executors 1935 to (M. Knoedler & Co.), New York, from whom it was purchased January 1936, as part of the Clarke collection, by

Fig. 1. Enoch Seeman, *Edward Sheldon*, inscribed 1715, oil on canvas, England, private collection [photo: Sydney W. Newbery, courtesy Thos. Agnew & Sons Ltd.]

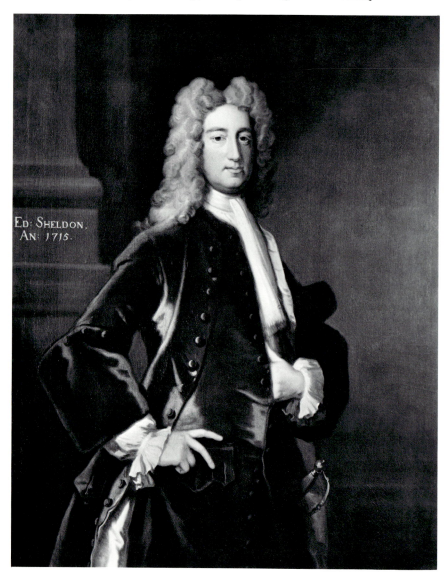

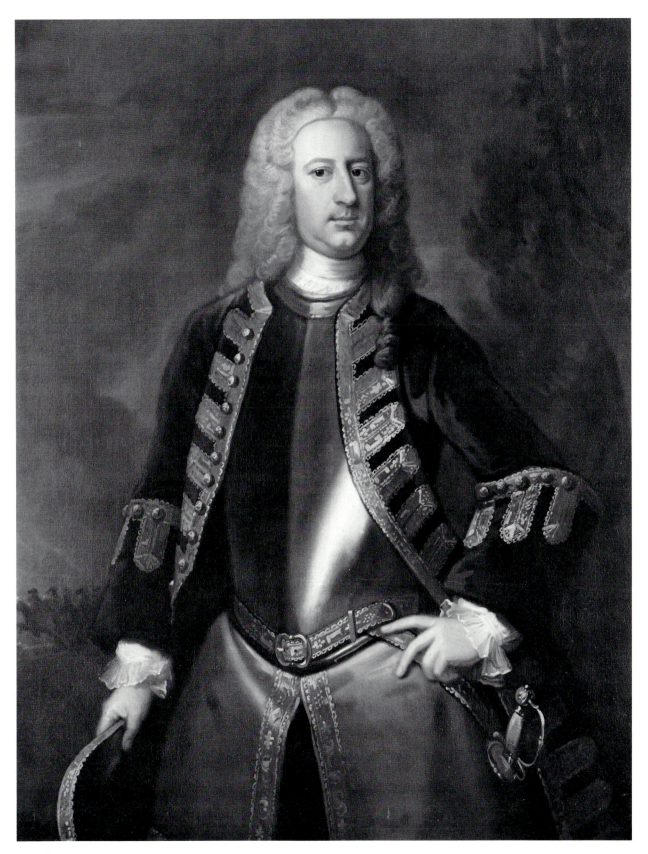

Attributed to Enoch Seeman, *Portrait of an Officer*, 1947.17.26

The A. W. Mellon Educational and Charitable Trust, Pittsburgh.

THERE IS no visual evidence to support the identification of the sitter as Sir William Gooch, Bt. (1681–1751), lieutenant-governor of Virginia from 1727 to 1749, and the provenance from Gooch's son supplied by the dealer, de Forest, is generally accepted as untenable. Bland recalled being informed by a minor New York dealer that he had brought "this picture of a nobody over from England, sold it to De Forest, and in a few weeks, who would have believed it, it is now known as a famous Governor called Gooch and the artist is called Bridges."[1]

The attribution to Charles Bridges was upheld by Burroughs[2] but otherwise has been unanimously discounted.[3] Sawitsky regarded the work as characteristic of the Lely-Kneller school of English portraiture, "either an original or an early copy."[4] Sir Ellis Waterhouse was equally convinced that the portrait was English and executed in England, and suggested Charles Philips as a possible attribution.[5] Ross Watson suggested a comparison with the work of John Wootton.[6] Rejected as American by Campbell in 1970, the portrait was reattributed by him to the European school;[7] Wilmerding catalogued it as unknown.[8] The style seems closest to that of Enoch Seeman (fig. 1), whose early work is in the Kneller tradition.

The sitter is wearing a royal blue military uniform with breast plate; his portrayal as a serving officer is emphasized by the suggestions of a cavalry engagement in the left background, where troopers also in blue uniform are seen firing as they charge. The scene is presumably related to the Marlborough Wars, a supposition supported by the type of wig the sitter is wearing, a campaign wig with one end tied in a knot, a fashion introduced during that period. This evidence indicates a date for the portrait subsequent to 1702.[9]

Notes
1. H. M. Bland, quoted by William P. Campbell, memorandum, 5 March 1964, in NGA curatorial files.
2. Alan Burroughs, note, 3 October 1939, in NGA curatorial files.
3. William P. Campbell, memorandum, 5 March 1964, in NGA curatorial files.
4. William Sawitsky, undated note in NGA curatorial files.
5. Opinion recorded by William P. Campbell, note, 29 April 1975, in NGA curatorial files.
6. Note, February 1969, in NGA curatorial files.
7. NGA 1970, 172.
8. NGA 1980, 306.
9. Aileen Ribeiro has suggested a date in the 1720s or early 1730s, but admits "the notorious difficulty of dating dress in this part of the 18th century" (letter to Suzannah Fabing, 23 March 1988, in NGA curatorial files).

References
1930 Weddell, Alexander Wilbourne, ed. *Virginia Historical Portraiture 1585–1830*. Richmond, 1930:168, repro. opposite 167.
1970 NGA 1970:172, repro. 173.
1980 NGA 1980:306.

Henry Singleton
1766 – 1839

SINGLETON was born in London on 19 October 1766, of unknown parentage. His father died when he was young, and he was brought up by his uncle, William, a painter of miniatures. Precociously talented, Singleton exhibited at the Society of Artists in 1780 a drawing he had done when he was only ten. He entered the Royal Academy Schools in 1783, winning a silver medal in 1784 and a gold medal in 1788; the painting that won the latter, an illustration of Dryden's *Alexander's Feast*, was specially commended by Reynolds. He exhibited at the Royal Academy first in 1784 and every year thereafter until his death; he also exhibited at the British Institution every year from its inaugural exhibition in 1806 until 1839.

Singleton was not only prolific but exceptionally versatile. He was noted for such battle scenes as *The Death of Captain Hood* (whereabouts unknown) and also painted religious, mythological, historical, Shakespearean, and other literary and theatrical subjects, many of them large and many of them subsequently engraved. Later he specialized more in sentimental, moral, and literary genre scenes, almost entirely destined for the engraver; both these and his conversation pieces were executed in the

style of Wheatley. He was also a book illustrator and a portraitist of some distinction. He was unsuccessful as a candidate for an Associateship of the Royal Academy in 1807, and did not allow his name to go forward again. He died, unmarried, in Kensington on 15 September 1839.

Singleton was an ambitious but somewhat superficial artist and became increasingly so, displaying a growing weakness in composition and looseness in painting the human figure. West summed up his attitude to art with the remark: "Propose to Singleton a subject, and it will be on canvass [sic] in five or six hours."[1]

Notes

1. Michael Bryan, *A Biographical and Critical Dictionary of Painters and Engravers*, rev. ed. by George Stanley (London, 1849), 452.

Bibliography

Cust, Sir Lionel. In *Dictionary of National Biography*. Vol. 52. London, 1897:314–315.

Attributed to Henry Singleton

1954.1.11 (1195)

James Massy-Dawson (?)

c. 1790/1800
Oil on wood, 74.1 × 59.3 (29⅛ × 23⅜)
Andrew W. Mellon Collection

Technical Notes: The wood panel is constructed of three vertical members; it has been thinned and marouflaged to a thick wooden support cradled on the reverse. The ground is white gesso, thinly applied. There is a warm imprimatura. The painting is generally broadly executed with a palette of earth tones; the face and hair are more delicately modeled; the application varies from dense, opaque layers to transparent glazes. There is little damage to the central section of the painting, but there is a considerable amount of discolored overpaint concealing the two vertical seams on either side of the actual portrait; there is a thin band of overpaint around the entire edge of the painting to compensate for the slightly larger size of the auxiliary wooden support. The thick natural resin varnish has discolored yellow moderately.

Provenance: Apparently John, 6th Baron Massy [1835–1915], Fetard, county Tipperary.[1] (B. F. Stevens & Brown), London, 1917.[2] (Tooth Brothers), London, 1919, from whom it was purchased 15 May 1919, through the agency of (G. S. Sedgwick), as by Gilbert Stuart, for Thomas B. Clarke [d. 1931], New York.[3] Sold by Clarke's executors 1935 to (M. Knoedler & Co.), New York, from whom it was purchased January 1936, as part of the Clarke collection, by The A. W. Mellon Educational and Charitable Trust, Pittsburgh.

Exhibitions: *Portraits Painted in Europe by Early American Artists*, Union League Club, New York, 1922, no. 14. *Portraits by* *Early American Artists of the Seventeenth, Eighteenth and Nineteenth Centuries Collected by Thomas B. Clarke*, Philadelphia Museum of Art, 1928, unpaginated and unnumbered.

JAMES MASSY-DAWSON (1736–1790) was the second son of Hugh, 1st Baron Massy, of Ballincourt, county Tipperary, Ireland, and married Mary, daughter of John Leonard, of Carha, county Galway, and Brownstown, county Kildare. The identification is traditional;[4] there are no other known portraits of Massy-Dawson for comparison.

The waistcoat with stand collar, double-breasted coat with wide, angular lapels, and the powdered natural hair with sideburns and pigtail were characteristic of fashion in the 1790s. Since the sitter seems to be about forty and certainly not much older, his identification as Massy-Dawson is highly doubtful. A possible candidate would be Hugh, 3rd Baron Massy (1761–1812), but there are no other known portraits of him either, so this hypothesis cannot be tested.

The traditional attribution to Gilbert Stuart, who worked in Ireland as a portrait painter from 1787 to 1792 or 1793, accepted by Park,[5] has since been unanimously rejected.[6] Sawitsky thought it was the work of a minor British painter;[7] Sir Ellis Waterhouse tentatively suggested Opie.[8] Campbell attributed the portrait to the British school,[9] an opinion supported by Wilmerding.[10] The crisp, fluent handling, sharp profile, and intensity of expression are characteristic of the idiosyncratic style of Henry Singleton (fig. 1).[11]

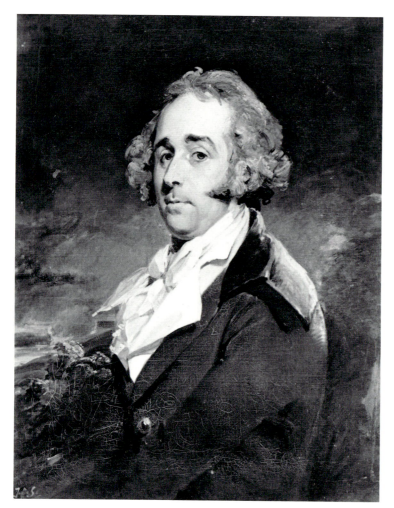

Fig. 1. Henry Singleton,
Charles, 2nd Viscount Maynard, R.A. 1794,
England, private collection
[photo: Barnes and Webster]

Notes

1. The dealer, G. S. Sedgwick, reportedly wrote to Thomas B. Clarke at the time of the latter's purchase of the picture that "he had seen the portrait about 1915 in Lord Massy's house near Dublin" (noted by William P. Campbell, memorandum, 10 January 1966, in NGA curatorial files).

2. B. F. Stevens & Brown to Charles Henry Hart, 13 September 1917, offering the portrait as from the Massey-Dawson [sic] family (in NGA curatorial files).

3. G. S. Sedgwick to Thomas Clarke, 14, 24 April 1919, in NGA curatorial files.

4. A label on the back of the stretcher is inscribed in ink: *Massy Dawson.*

5. Park 1926, 1: no. 223.

6. William P. Campbell, memorandum, 10 January 1966, in NGA curatorial files.

7. William Sawitsky, undated note in NGA curatorial files.

8. Opinion recorded by William P. Campbell, note, 21 May 1975, in NGA curatorial files.

9. NGA 1970, 166.

10. NGA 1980, 309. It was included as such in the last National Gallery catalogue of European paintings (NGA 1985, 21).

11. Compare, for example, the conversation piece dating from 1794 in the Jones-Mortimer collection, Hartsheath, Mold, Clwyd.

References

1926 Park, Lawrence. *Gilbert Stuart.* 4 vols. New York, 1926, 1: no. 223; 3: repro. 136.

1970 NGA 1970: 166, repro. 167.

1980 NGA 1980: 309.

Attributed to Henry Singleton, *James Massy-Dawson(?)*, 1954.1.11

Gerard Soest

c. 1601/1602 – 1681

SOEST WAS BORN of unknown parents in Soest, Westphalia, in the early part of the first decade of the seventeenth century (he was noted by Charles Beale as "neare 80 years old when he died"[1]). Nothing certain is known of his training or of his work in Holland, but his later style suggests links with the Utrecht school.

Soest may have come to London as early as 1644 and was certainly there by 1650. His studio was first near Lincoln's Inn Fields, then in Southampton Buildings, north of the Strand. He never attained the status or the vogue of Lely, his charge for a head in the 1660s being three pounds as opposed to Lely's fifteen, and seems never to have painted at court. He is described as being capricious, slovenly, and mean, was evidently temperamentally unsuited to the establishment of an effective studio, and, on account of his "ruff humour,"[2] was unpopular with fashionable female clients. He died in London on 11 February 1681.

Soest's career in England spans almost exactly the same period as that of Lely, but, like Jacob Huysmans and Michael Wright, he was entirely independent of the prevalent Lelyesque manner, his early portraits being closest to those of William Dobson. His very direct style is characterized by a strong and down-to-earth feeling for character accompanied by a certain quirkiness of expression, a luscious handling of paint, a very personal range of mainly cool colors, and an equally personal metallic treatment of swathes of drapery that have a life of their own. His work was chiefly on a head-and-shoulders scale; otherwise he seems to have specialized in three-quarter-length portraits, full lengths being less common. His portraits were generally of male sitters. In his female portraits he could be tender and he could be sensual. Soest also painted allegorical works, in some of which he indulged his taste for the erotic. A highly individual painter, he did work of a consistently high quality, and he ranks with Lely at his best. Vertue called him "so rare a Master."[3] His principal pupil was John Riley, a contemporary of Kneller.

Notes

1. Vertue *Note Books*, 4 (24[1936]): 175.

2. Vertue *Note Books*, 2 (20[1932]): 72.
3. Vertue *Note Books*, 2 (20[1932]): 11.

Bibliography

Cust, Sir Lionel. In *Dictionary of National Biography*. Vol. 53. London, 1898: 211–212.

Vertue, George. *Note Books*. In 6 vols. *The Walpole Society*, 18 (1930), 20 (1932), 22 (1934), 24 (1936), 26 (1938), 30 (1955); 2 (20 [1932]): 11, 72, 140–141; 4 (24 [1936]): 29, 166, 175; 5 (26 [1938]): 45, 50.

Waterhouse, Sir Ellis. *Painting in Britain 1530 to 1790*. Harmondsworth, 1953: 68–69.

Whinney, Margaret, and Oliver Millar. *English Art 1625–1714*. Oxford, 1957: 182–184.

1977.63.1 (2709)

Lady Borlase

c. 1672/1675
Oil on canvas, 127 × 103.2 (50 × 40⅝)
Gift of Mr. and Mrs. Gordon Gray

Technical Notes: The medium-weight canvas is plain woven; it has been lined. The ground is pinkish brown, smoothly and thinly applied, leaving the fabric pattern fairly pronounced. The painting is executed in rich, opaque, but thin layers overall with thicker, smoothly blended layers in the flesh tones and more textured paint in the highlights; the flesh tones and highlights are modified by thin, delicate glazes. The design is built up in a fairly specific sequence of paint layers locally applied over the ground; thus, the light colored bands of sky are constructed with a yellow ocher underlayer covered with a thin, dry layer of light blue, and the contours of the head are defined by a narrow band of dark blue underpaint covered with strokes of earth red, used also to model the shadows in the face. The thin glazes in the face and the darkest shadowed areas of the dress are moderately abraded; otherwise, the painting is in excellent condition. The thin natural resin varnish has discolored only slightly.

Provenance: Purchased London c. 1929 by Mrs. Bowman Gray as a portrait of Lady Warrender by Lely;[1] by descent to Gordon Gray, Washington.

ON THE BASIS of a portrait wrongly attributed to Lely so described,[2] the sitter was identified by William Roberts as Griselle or Grizel Blair, daughter of Hugh Blair, an Edinburgh merchant; she married George War-

Gerard Soest, *Lady Borlase*, 1977.63.1

render, a merchant who later became lord provost of Edinburgh and was created a baronet. The resemblance is, however, unconvincing. Another line of inquiry has proved more rewarding. A close copy of the Washington picture at Sudbury Hall, Derbyshire (fig. 1), is reputed to represent Ann Borlase, wife of Sir John Borlase, the first baronet.[3] Comparison of the National Gallery's picture with the Van Dyck portrait of Lady Borlase at Kingston Lacy (fig. 2), painted about 1638 when she was probably no more than twenty, confirms this identification.

In December 1637 Ann, eldest daughter of Sir John Bankes, lord chief justice of the Common Pleas, of Corfe Castle, Dorset, wed John Borlase, successively M. P. for Great Marlow, Corfe Castle, and High Wycombe, a staunch Royalist who was created a baronet in 1642 and died in 1672. She was converted to Roman Catholicism in her widowhood and died in Paris in 1683.

The traditional attribution to Lely was corrected by Sir Ellis Waterhouse, who described the portrait as "an entirely characteristic work of Gerard Soest, from about the middle of the 1660's."[4] The highly mannered contorted drapery, reminiscent of the sculpture of Tilman Riemenschneider or Veit Stoss, with which Soest would have been familiar, is indeed characteristic of Soest's style (fig. 3). The execution, with its richly diversified technique, is also as idiosyncratic as it is sound and assured.

The elaborate hairstyle, in the "en taureau" fashion with massed curls and long side tresses popularized by Louise de Kéroualle, Duchess of Portsmouth, in the 1670s, indicates a date in that decade rather than in the 1660s, as proposed by Waterhouse. The shell receiving

Fig. 1. Copy after Gerard Soest, *Lady Borlase*, oil on canvas, Derbyshire, Sudbury Hall [photo: National Trust]

Fig. 2. Sir Anthony van Dyck, *Lady Borlase*, c. 1638, oil on canvas, Kingston Lacy, National Trust [photo: National Portrait Gallery]

drops of water, which the sitter holds in her left hand, is a motif commonly found in Lely's portraits of women; since the receptacle used is sometimes a metal bowl, the shell does not seem to be significant as such, the constant being the flow of water, symbolic of the spiritual life and salvation. This suggests a date after 1672, when Lady Borlase was widowed. She would then have been in her mid-fifties, which is consonant with Soest's portrait.[5]

The Sudbury Hall picture lacks the crispness and vitality of the Washington painting. This is especially apparent in the modeling of the pale blue drapery beneath Lady Borlase's right hand. The Sudbury picture seems

likely, therefore, to be a competent early copy, perhaps by the artist who painted the copy of Van Dyck's portrait of Lady Borlase's husband, also at Sudbury Hall; Soest is not known to have had assistants.

Notes

1. Certificate by William Roberts, 29 April 1929, a copy of which is in NGA curatorial files.

2. Colnaghi sale, Robinson & Fisher, London, 16 June 1927, no. 111.

3. It bears an early inscription to this effect, together with an attribution to Lely.

4. Letter, 5 January 1978, in NGA curatorial files.

5. I am grateful to my colleague, Malcolm Rogers, for help with this part of the entry.

Fig. 3. Gerard Soest, *Countess of Cassilis*, c. 1670/1680, oil on canvas, Floors Castle, Duke of Roxburghe [photo: Scottish National Portrait Gallery]

George Stubbs

1724 – 1806

STUBBS WAS BORN in Liverpool in 1724, the son of John Stubbs, a prosperous currier and leather seller, and of his wife, Mary. At the age of fifteen he was apprenticed to Hamlet Winstanley, a former friend of Arthur Devis, but left him after only a few weeks. Apparently self-taught, he practiced as a portrait painter in various northern centers, settling in York about 1745. Obsessed with anatomy, which he studied at York Hospital and taught privately to medical students, he was commissioned to illustrate John Burton's *Essay towards a Complete New System of Midwifery*, 1751, which necessitated his learning to etch. In 1754 he traveled to Rome, where Richard Wilson was then working, allegedly "to convince himself that Nature is superior to all art,"[1] but nothing is known about his studies there.

After returning to Liverpool in about 1756, Stubbs began the studies that were to result in *The Anatomy of the Horse*, 1766. By then he was living with Mary Spencer, with whom he had a son, George Townley Stubbs; Mary was his companion until his death, but they were apparently never married. After completing his dissections and drawings, Stubbs came to London about 1758 to find a reproductive engraver; failing in this purpose, he eventually made the plates himself. He had settled on Somerset Street (where Selfridge's store now stands) by 1764.

During the 1760s Stubbs acquired an immense reputation as a painter. He painted in this decade racing, hunting, and shooting scenes, portraits of horses and wild animals, his first dramatic subjects on the theme of a horse attacked by a lion, and conversation pieces mostly including horses. He worked on all scales, occasionally producing huge works, as in the case of *Whistlejacket* (Trustees of the Rt. Hon. Olive, Countess Fitzwilliam's Chattels Settlement). His patrons were as distinguished as the Graftons, Grosvenors, Portlands, Richmonds, and Rockinghams. He exhibited from 1762 at the Society of Artists, of which he became president in 1772, but as an animal painter he was not made a founding member of the Royal Academy of Arts and did not switch to the exhibitions there until 1775. He was elected an Associate of the Royal Academy in 1780, but, though he was voted a full Academician in 1781, his election was not ratified since he never supplied a diploma picture. This was probably the result of his displeasure at the unfavorable hanging in 1781 of his enamel paintings, which, as Ozias Humphry said, did much to discredit them "and to defeat the purpose of so much labour and study."[2] In the 1770s Stubbs' reputation suffered. This was partly because of his categorization as a mere animal painter—a position that seems not to have been rectified by his use of classical sculpture as source material or by his essays into history painting at this time, with subjects, no longer extant, derived from the Hercules myths—and partly because of his absorption in experiments with enamel colors, a process that led to a fruitful association with Josiah Wedgwood, whose ceramic tablets he found the best support for larger paintings.

In the 1780s Stubbs turned to the fashionable genre of rural scenes and to a new technique based on mezzotint, but his products were too refined to be popular. In 1790 the *Turf Review* commissioned a series of portraits of famous racehorses, to be engraved by his son; sixteen were exhibited in 1794, but none was sold and the enterprise lapsed. In the early 1790s Stubbs also executed commissions for the Prince of Wales, but the ensuing last decade of his life seems to have been a period of financial difficulty. During this time he devoted himself to his most ambitious project, a study of the comparative anatomy of a man, a tiger, and a chicken. A person of strong will, determination, single-minded application, and immense physical vigor and stamina, distinguished as much for his scientific bent of mind as for his art, he died in London almost unnoticed on 10 July 1806.

Stubbs transformed the art of horse painting, his principal preoccupation, from the schematized and comparatively wooden imagery of the previous generation, represented by John Wootton, to a genuine aspect of portraiture. His works were based on his anatomical studies, his concern for the individuality of the animals, their grooms and jockeys, and his close observation of the everyday activities surrounding their lives. Yet, as Deuchar observes, his very objectivity idealized what that writer called the "unwholesome reality"[3] of the contemporary sporting scene. Stubbs' scientific curiosity and

exact scrutiny extended to the whole natural world; he drew and painted wild animals dispassionately and without a trace of the anthropomorphic concerns that were to dominate romantic animal painting. His portraiture was deeply searching. His rural scenes, executed in the heyday of Wheatleyesque sentiment, were meticulously observed. It was characteristic that he should seek to eliminate brushwork, one reason (longevity was another) for his using as supports panel, copper, and ceramic tablets, and for his experiments with enamel colors.

It was a corollary of Stubbs' preoccupation with detailed naturalism that his compositions should be dominated by their individual components. Imbued with a quality of stillness, these components are generally set across the foreground in a form of frieze, but the simplicity of the designs reflects a fastidious sense of pictorial order: in the Mares and Foals series the animals are linked in an elegant arabesque, generalized backgrounds are suited to and echo particular subject matter, and the use of such pictorial geometry as the golden section helps to unite disparate elements in different planes.

Stubbs' objectivity and absence of sentiment, his lack of interest in events or narrative—he hardly ever depicted races, never the Newmarket scene—and his independence of the picturesque or the conventional grand manner and its aesthetic values, account for the neglect from which he suffered in the latter part of his life and subsequently. Such specific genres as his shooting scenes influenced Samuel Alken and James Pollard, and his image of the horse was handed down to the Marshalls and the Ferneleys, but his genius remained generally unrecognized until comparatively recent years.

Notes

1. Ozias Humphry, MS Memoir of George Stubbs, Picton Collection, Liverpool Public Libraries.
2. Humphry, Memoir.
3. Deuchar 1988, 109.

Bibliography

Parker, Constance-Anne. *Mr Stubbs the Horse Painter*. London, 1971.
Taylor, Basil. *Stubbs*. London, 1971.
Egerton, Judy. *George Stubbs 1724–1806*. Exh. cat., Tate Gallery, London; Yale Center for British Art, New Haven. London and New Haven, 1984.
Deuchar, Stephen. *Sporting Art in Eighteenth-Century England: A Social and Political History*. New Haven and London, 1988:21, 105–126, 133, 145–148, 151–152, 164–165.
Lennox-Boyd, Christopher, Rob Dixon, and Tim Clayton. *George Stubbs: The Complete Engraved Works*. London, 1989.

1952.9.4 (1047)

Captain Samuel Sharpe Pocklington with His Wife, Pleasance, and His Sister (?), Frances

1769
Oil on canvas, 100.2 × 126.6 (39½ × 49⅞)
Gift of Mrs. Charles S. Carstairs in memory of her husband, Charles Stewart Carstairs

Inscriptions:
Signed and dated at lower right: *Geo: Stubbs/pinxit 1769*

Technical Notes: The medium-weight canvas is plain woven; it has been lined, but the tacking margins still survive intact. The lining and nonoriginal stretcher may be over one hundred years old; fabrics were mounted on the new stretcher slightly off center, so that original paint extends slightly onto the top edge of the stretcher and about half an inch of overpainted ground appears along the bottom edge. The ground is grayish white, of moderate thickness. The painting is executed smoothly, fluidly, and fairly thickly, with low impasto. Visible to the naked eye is an old, horizontal, retouched tear about 10 cm. long extending in from the right edge slightly above the rocks. The overall craquelure was inpainted in 1984; the abrasion in the horse's rump and in the dark foliage above the horse's tail was glazed over at the same time; although the original and lining fabrics are somewhat fragile, the restoration of 1984 did not include relining. The synthetic varnish has not discolored.

Provenance: Painted for Samuel Sharpe Pocklington [d. 1781], Chelsworth Hall, Suffolk; by descent through his elder son, Colonel Sir Robert Pocklington, who married Catherine Blagrave, to John Blagrave, Calcot Park, Berkshire (sale, Messrs. Foster, London, 28 June 1911, no. 102), bought by (Francis Howard for M. Knoedler & Co.), New York, from whom it was purchased by 1913 by Charles Stewart Carstairs [d. 1928], Lockport, New York; passed to Mrs. Charles S. Carstairs [d. 1949], New York.

Exhibitions: *Meisterwerke Englischer Malerei aus drei Jahrhunderten*, Secession, Vienna, 1927, no. 54, repro. *English Conversation Pieces*, Sir Philip Sassoon's, 45 Park Lane, London, 1930, no. 47 (illustrated souvenir, repro. 49). *British Art*, Royal Academy of Arts, London, 1934, no. 395 (commemorative catalogue, no. 165, repro.). Long-term loan, Tate Gallery, London, 1936–1947. *George Stubbs 1724–1806*, Tate Gallery, London; Yale Center for British Art, New Haven, 1984–1985, no. 107, color repro., color detail.

George Stubbs, *Captain Samuel Sharpe Pocklington with His Wife, Pleasance, and His Sister (?), Frances*, 1952.9.4

THE TRADITIONAL identification of the sitters as Colonel Pocklington and his sisters, first recorded in the catalogue of the Blagrave sale in 1911, has recently been corrected by Egerton.[1] The principal sitters are Captain Samuel Sharpe, who assumed the name and arms of Pocklington on his marriage in 1769, and his wife, Pleasance Pykarell, who had changed her name to Pocklington as a condition of inheriting the manor of Chelsworth, Suffolk, from her cousin, Robert Pocklington. The identity of the lady on the left has not been established; Egerton has suggested that she may be Samuel's unmarried sister, Frances.

The picture is a marriage portrait. Pleasance is dressed in her white wedding gown and is offering a posy of flowers to her husband's horse. Samuel, standing elegantly cross legged, is wearing the uniform of the Third Foot (later the Scots) Guards, in which he had served since 1760 and from which he seems to have resigned shortly after his marriage.

As so often with Stubbs, the figures and horse are contained within a gentle, rhythmical, horizontal design, equally characteristically echoed and continued in a further plane by the dark trees that fill the picture surface—what Praz calls a "screen of foliage."[2] The background is generalized and softly handled. The whole composition has an air of artificiality, underlined by Pleasance's pose; the *Melbourne and Milbanke Families*[3] in the National Gallery, London, of the same period, 1769 to 1770, with its very similar background, is even more artificial in its arrangement. Taylor has described the work as "conceived, perhaps with a deliberate professional intention, in the spirit of" Reynolds' informal portrait group of Henry Fane and his guardians (The Metropolitan Museum of Art) of three years earlier, Stubbs perhaps "hoping for opportunities to work on the larger scale expected from the leading portraitists of the Royal Academy."[4]

Notes

1. Egerton 1984 (see biography), no. 107.
2. Praz 1971, 134.
3. Taylor 1971 (see biography), pl. 55.
4. Taylor 1971 (see biography), 38; the Reynolds is reproduced in Ellis K. Waterhouse, *Reynolds* (London, 1941), pl. 117.

References

1971 Praz, Mario. *Conversation Pieces*. London, 1971: 134, color cover and color fig. 95.
1971 Taylor 1971 (see biography): 37–38, pls. 57–59.
1976 Walker 1976: no. 529, color repro.
1984 Egerton 1984 (see biography): no. 107, color repro., color detail.

Joseph Mallord William Turner

1775 – 1851

TURNER WAS BORN on Maiden Lane in Covent Garden, London, in 1775 (the actual day is uncertain, but Turner maintained it was Saint George's Day, 23 April), the only son of William Turner, a barber and wig maker, and of Mary Marshall. His mother, who was mentally unstable, was committed to Bethlem asylum for the insane in 1800, and died in 1804. During his only sister's fatal illness (she died in 1786) Turner was sent to live with his mother's brother in Brentford and attended Brentford Free School; this was his only formal education. His early artistic talent was encouraged by his father, who exhibited Turner's drawings in his shop window (the father remained a devoted supporter and, later, was his son's studio assistant and general factotum until his death in 1829). In 1789, the year of his first extant sketchbook from nature, Turner entered the Royal Academy Schools, also working at about this time in the studio of the architectural draftsman and topographer Thomas Malton. He exhibited his first watercolor at the Royal Academy in 1790 and his first oil in 1796; thereafter he exhibited nearly every year until a year before his death. He stayed with his father's friend, John Narraway, in Bristol in 1791, and from then on until the end of the Napoleonic Wars made frequent summer sketching tours in various parts of Britain. In 1794 he published his first two engravings for *The Copper-Plate Magazine*, and in 1798 began drawings for *The Oxford Almanack*. Probably beginning in 1794 he worked for three years at Dr. Monro's evening

"academy" in the company of Thomas Girtin, Edward Dayes, and others.

Turner's precocity led to his election as an Associate of the Royal Academy in 1799, and to full Academicianship in 1802. He revered the Academy (and its first President, Sir Joshua Reynolds) all his life, was assiduous as a member of the council and hanging committee and as auditor of the accounts, and was proud to be appointed its professor of perspective in 1807, from 1811 until 1828 giving lectures that ranged widely over the problems of landscape painting. He moved from Maiden Lane to lodgings on Harley Street in 1799, opening his own gallery in contiguous premises on Queen Anne Street in 1804; this he enlarged between 1819 and 1822. In 1805 he took a house at Isleworth, keeping a second home on the riverside at intervals for the rest of his life (Upper Mall, Hammersmith, from 1806 to 1811; Sandycombe Lodge, Twickenham, from 1813 to about 1825; Cheyne Walk, from about 1846 onward).

Turner made his first journey abroad in 1802, traveling through France to Switzerland, and studying in the Louvre on his return. He published his *Liber Studiorum* between 1807 and 1819. In 1817 he visited the Low Countries and subsequently traveled more frequently on the Continent (until 1845), less frequently in the British Isles (until 1831); no artist can have traveled so much. Between 1819 and 1820 he paid his first visit to Italy, staying principally in Venice and Rome; he revisited Venice in 1833, 1835 (probably), and 1840, the year in which he met the young Ruskin. He worked continuously for the publishers of illustrated books; his *Picturesque Views in England and Wales* appeared between 1827 and 1838, his illustrations to Rogers' *Italy* in 1830, and *The Rivers of France* between 1833 and 1835.

Turner was a tough, dedicated, and immensely industrious artist, highly professional and constantly concerned, even in old age, with reputation and fortune. Tight fisted only because money was a symbol of success, he was infinitely generous to fellow artists in need. Single minded, intelligent, and shrewd, but inarticulate, gruff, and unkempt, he formed his few close friendships with patrons: William Wells of Knockholt (d. 1836), Walter Fawkes of Farnley Hall (d. 1825), Lord Egremont of Petworth (d. 1837), and H. A. J. Munro of Novar (d. 1865), all countrymen with whom he was able to indulge his love of angling. In such company he was

affectionate, high spirited, and much loved. For some twenty years, from about 1798, he maintained a liaison with Sarah Danby, with whom he had two daughters, but he never married. In old age, following the death of his father and close friends, he became increasingly pessimistic and morose, allowed the house and picture gallery on Queen Anne Street to become dilapidated, and finally lived largely in his cottage on Cheyne Walk, cared for by his housekeeper, Mrs. Booth. There he died on 19 December 1851. He was buried in St. Paul's Cathedral.

Turner left his fortune to provide a charitable institution for indigent artists (in earlier life he had for a decade been a zealous chairman of the Artists' General Benevolent Institution) and bequeathed his finished pictures to the National Gallery, to be exhibited as a changing display in a separate Turner gallery. The former purpose was frustrated by his relatives, who successfully contested his will; the latter came to nothing—the entire contents of his studio passing, by agreement with his executors, into the custody of the National Gallery (1856)—until the recent provision of the Clore Gallery at the Tate, which opened in 1987.

Turner made his reputation, influenced by Dayes and J. R. Cozens, as a topographical watercolorist in the picturesque tradition; imbued with a feeling for the sublime, and affected by the theatricality of such contemporaries as Fuseli and de Loutherbourg, he developed a style in which dramatic chiaroscuro, massive or soaring forms, breadth and sweep of design, and scale all played their part. Turner sketched from nature, mainly in pencil, all his life; possessed of an intense visual concentration, he was able, in the leisure of his lodgings, to work up into watercolor the most cursory notation. His sketchbooks, nearly all now in the Turner Bequest, served him as a repository of ideas, of which he might make use months or even years afterward; for him art was not the servant of nature, nature was the springboard for art. Turner had a similar attitude toward the old masters, whom he sought both to emulate and to surpass: he transformed the rough seas and storms of Dutch seascape painting into elemental fury, the epic grandeur of Poussin into the sublime, the soft light of Claude, which permeated an extensive pastoral scene, into rich effects of sunlight dissolving the landscape. He was determined to raise landscape painting to the level of ideal art, closer in the hier-

archy of genres to history painting, as Reynolds had done for portraiture; and he demonstrated the wide range of possible landscape styles in the categories he evolved for his *Liber Studiorum*. Human beings, often ridiculous since figure painting was not his forte, were an essential referent.

From the start, in his efforts to translate into paint the overwhelming effects of nature, Turner had scant respect for the conventional vocabulary of representation, and he was criticized by connoisseurs like Sir George Beaumont and in the press for his idiosyncratic technique: in 1803 his sea was said to resemble soap and chalk, forty years later soapsuds and whitewash. Joseph Farington early recorded in his diary that "Turner has no settled process but drives the colours abt. till He has expressed the idea in his mind."[1] He replaced the stability, controlled design, and carefully constructed space of classical landscape painting with unstable, oval, and vortical compositions, dissolving space, masses, and forms in light and atmosphere; using a white priming from about 1805, he developed a greatly enhanced high key of color from the time of his first visit to Italy in 1819. Experimenting first in watercolor, then in oils which he kept private, he began to use arbitrary zones of color out of which his designs evolved; he employed grays and blacks as expressively as whites, yellows, and reds; he also used color to create his compositional emphases, notably in those sunset scenes in which light radiates across the canvas on either side of what Sir Lawrence Gowing has called "an incandescent central axis." In the 1840s the distinction between his exhibited and his unexhibited work diminished, and his technique in oils came close to his practice in watercolor. Critics were often bewildered, especially by his late works, but his paintings, sometimes commissioned, more often than not found buyers. The demand for his pictures grew appreciably after the publication in 1843 of the first volume of Ruskin's *Modern Painters*, which was conceived as a vindication of Turner—some purchasers paying a thousand guineas or more.

Many of Turner's late exhibited works were charged with brooding meaning. They were accompanied by verses—as indeed his exhibits had been since 1798—which were often taken from his own poem, *The Fallacies of Hope*, a work never, however, a complete entity. Fascinated by Goethe's theories concerning the emotional connotations of color, translated in 1840 (which he illustrated in two paintings he exhibited in 1843),

Turner used reds, blacks, and yellows to carry symbolic meaning: red, for example, symbolized fire, blood, and death. His images, often of natural disaster, became increasingly turbulent, and his figures, customarily teeming masses of people, became increasingly subservient to his vision.

Turner had always been absorbed by the fate of great empires: Carthage, Rome, Venice. Now he was preoccupied by a more universal state of flux; weather effects took on form, and the sea was his constant theme. His private paintings became more and more evanescent. Turner's mind was restless and searching; he was well acquainted with men of science, and a geologist friend remarked of him: "That man would have been great in any—and every—thing he chose to take up. He has such a clear, intelligent, piercing intellect."[2]

By virtue of his genius Turner had a pervasive influence on his contemporaries. In mid-career he was responsible for a school of landscape, the so-called "white painters," including Augustus Wall Callcott, William Havell, and others. As a result of his bequest to the National Gallery his pictures remained scarce and consequently much sought after following his death, and his work was forged as well as imitated; but in the later nineteenth century his reputation declined except among avant-garde artists like the impressionists and the symbolists, and it was not until the mid-twentieth-century revival of interest in the romantic era, and later the triumph of abstract expressionism, that Turner was acclaimed as the greatest and most universal of British painters. Since the large-scale retrospective at the Royal Academy in 1974 to 1975, the spate of exhibitions and scholarly publications relating to Turner has vastly accelerated; in one of the more recent, John Gage has challenged the modernist view of Turner as an artist concerned solely with pictorial values and emphasized his lifelong preoccupation with subject matter and verbal expression.

Notes

1. Farington *Diary*, 4:1303 (16 November 1799).
2. John Macculloch (quoted by Thornbury 1877, 236.)

Bibliography

Thornbury, Walter. *The Life of J. M. W. Turner, R.A.* 2 vols. London, 1862; 2d ed., 1877.

Finberg, A. J. *The Life of J. M. W. Turner, R.A.* Oxford, 1939; 2d ed., 1961.

Kitson, Michael. *Turner*. London, 1964.

Gowing, Sir Lawrence. *Turner: Imagination and Reality.* Exh. cat., Museum of Modern Art. New York, 1966.

Butlin, Martin, and Evelyn Joll. *The Paintings of J. M. W. Turner.* 2 vols. New Haven and London, 1977; 2d rev. ed., 1984.

Wilton, Andrew. *The Life and Work of J. M. W. Turner.* London, 1979.

Gage, John. *J. M. W. Turner: "A Wonderful Range of Mind."* New Haven and London, 1987.

Herrmann, Luke. *Turner Prints: The Engraved Work of J. M. W. Turner.* Oxford, 1990.

1942.9.87 (683)

The Junction of the Thames and the Medway

1807
Oil on canvas, 108.8 × 143.7 (42⅞ × 56⅝)
Widener Collection

Inscriptions:

On back of lining canvas in black ink: The Junction of the/ THAMES and MEDWAY, from the/NOREBUOY, with a distant view/ of SHEERNESS and the Isle of SHEPPY./Painted by J˙W˙M˙ [sic] TURNER Esq $\frac{r}{n}$ RA/In $\frac{o}{n}$ [sic] Newington Hughes Esq. $\frac{r}{n}$. Below: N$\frac{o}{n}$ 54

Technical Notes: The canvas has been lined. The ground is off-white, thinly and smoothly applied. There are traces of a buff-colored imprimatura above the ground in some areas. The painting is executed in very thin, transparent glazes in the darks; the sky is more opaquely rendered; moderate impasto is used in the highlights, especially in the waves. X-radiographs reveal pentimenti in the rowing boat (fig. 3): the boat was originally 2 cm. longer at the bow; the figure in the stern, now leaning over the side of the boat, originally sat with his back to the spectator; a rowing figure in the center of the boat has been painted out; the figure at the bow of the boat originally sat facing the spectator. The picture is very abraded in numerous thinly painted areas, and has been extensively retouched with small, feathered repaints that have darkened considerably. The moderately thick natural resin varnish has discolored yellow-brown to a significant degree.

Provenance: Purchased 1807, almost certainly from Turner's gallery, by Thomas Lister Parker [1779–1858], Browsholme Hall, Yorkshire (sale, 1808, bought in[1]). (Sale, James Christie, London, 9 March 1811, no. 29, bought in.) John Newington Hughes, Winchester, after 1826 (sale, Christie & Manson, London, 14–15 April 1848, 2nd day, no. 147), bought by (Thomas Rought), who sold it 3 May 1848 to Joseph Gillott, Birmingham (sale, Christie, Manson & Woods, London, 19–

20, 26–27 April 1872, 4th day, no. 306), bought by (Thos. Agnew & Sons), London, who sold it 1872 to Richard Hemming [d. c. 1892], Bentley Manor, Bromsgrove, and London; passed to his wife, who sold it 1892 to (Thos. Agnew & Sons), London, by whom sold 1893 to (Wallis & Son), London, from whom it was purchased, through (J. G. Johnson), 10 March 1894 by P. A. B. Widener, Elkins Park, Pennsylvania. Inheritance from the Estate of Peter A. B. Widener by gift through power of appointment of Joseph E. Widener, Elkins Park.

Exhibitions: Turner's gallery, 1807. *Modern Works of Art*, Birmingham Society of Artists, 1852, no. 37. *Art Treasures of the United Kingdom*, Manchester, 1857, "Paintings by Modern Masters," no. 288. *National Exhibition of Works of Art*, General Infirmary, Leeds, 1868, no. 1107. *Forty-First Annual Exhibition of Selected High-Class Pictures, by British and Foreign Artists*, French Gallery (Wallis & Son), London, 1894, no. 26.

THE VIEW is of the Thames estuary, showing the confluence of the river Medway with the Thames at the Nore buoy, seen on the left, and, in the distance, Sheerness and the Isle of Sheppey.

Turner was a painter of light but, above all, of light as it affected his principal love, the sea. His first exhibited picture (Royal Academy, 1796) was a sea piece, and in the ensuing years he exhibited a series of such works in which, initially partly under the influence of Willem Van de Velde, he gradually developed a mastery, unrivaled in the history of art, of rendering the sea in all its motions and under every condition of light and weather. The Washington picture is one of his early masterpieces depicting a storm at sea. The composition is dominated by the sunlight, which has broken through the rapidly moving storm clouds, and by the vigor of the foreground swell; as so often in Turner, the distant ships are silhouetted against a strip of light at the horizon, the frigate in the center forming the tranquil focus of an otherwise turbulent design.

A drawing in the Calais Pier sketchbook (fig. 1)[2] seems to be a preliminary idea for the right-hand part of the Washington picture; if the three boats, one with a darkened sail, drawn on the opposite page, were part of the original concept for this design, they were soon discarded. A brown pen-and-ink and wash drawing in the Hesperides sketchbook (fig. 2)[3] is a detailed study for the composition, which, with the significant exception of the figures in the rowing boat, Turner followed in its broad essentials (there are slight changes in the arrangement of the rigging and sails, and in the ships at the horizon). While Turner's initial disposition of the figures in the rowing boat in the Washington painting, as revealed in

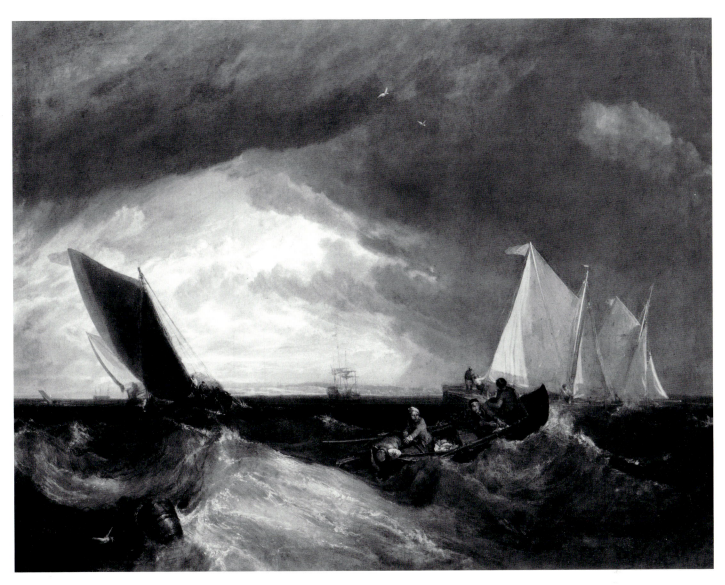

Joseph Mallord William Turner, *The Junction of the Thames and the Medway*, 1942.9.87

the x-radiographs (fig. 3), was not substantially different from that in his sketch, the final arrangement comes from a deeper level of the imagination. There are now four fishermen in the boat, contrasted in action as well as in pose; engaged (although one has succumbed) in an uneven struggle with the waves which threaten to engulf them, they have become a far more dramatic focal point in the composition.

The picture was purchased from Turner by Thomas Lister Parker for two hundred pounds.[4] Parker, a relative of Sir John Fleming Leicester (later Lord de Tabley), was among the first to follow the latter in concentrating upon collecting works of the British School.[5]

An engraving by J. Fisher was published, at an unknown date.

A full-scale copy by Sir Augustus Wall Callcott, painted for Parker at the time he was contemplating selling the Turner, is at Browsholme Hall.[6] A slightly smaller copy by him, and a small, more roughly handled sketch for this copy (pictures done earlier for his own instruction and not originally intended as preparatory to the full-scale copy) are in the Tate Gallery and at the Ashmolean Museum, Oxford;[7] both were accepted as original Turners in the nineteenth century, the latter in Turner's life-

Fig. 1. Joseph Mallord William Turner,
The Junction of the Thames and the Medway,
black and white chalks on blue paper,
London, Tate Gallery

Fig. 2. Joseph Mallord William Turner, *The Junction of the Thames and the Medway*,
pen and brown ink and brown wash on gray paper, London, Tate Gallery

Fig. 3. X-radiograph of the rowing-boat in 1942.9.87

time.[8] A small copy by an unknown artist, based on the left half of the National Gallery's picture, is also in the Tate Gallery.[9]

Turner painted two further canvases, both exhibited in 1808, showing Sheerness as seen from the Nore.[10]

Notes
1. Brown 1975, 721.
2. Turner Bequest LXXXI, sketchbook, 90–91 (D4992–4993). The rowing boat drawn on page 91 is offset on the opposite page.

3. Turner Bequest XCIII, sketchbook, 16 (D5791).
4. This figure is entered in a catalogue of Parker's collection compiled in 1808 (Butlin and Joll 1984 [see biography], 1: 49). The date of the purchase is established by a note about Parker's acquisitions in the *Morning Post:* "Mr PARKER has also purchased a fine *Sea Piece,* by TURNER, which is in his best manner" (6 May 1807).
5. Carey 1826, 115.
6. Brown 1975, 721–722. It was Brown's discovery of the Callcott that identified the Washington picture as the sea piece bought by Parker.
7. Brown 1975, 722.
8. Butlin and Joll 1984 (see biography), 1: nos. 542, 543.

9. Brown 1975, 722; Butlin and Joll 1984 (see biography), 1: no. 544.

10. Butlin and Joll 1984 (see biography), 1: nos. 75, 76.

References
1807 *Morning Post*, 6 May 1807.

1826 Carey, William Paulet. *Patronage and Progress of the Fine Arts*. London, 1826: 115.

1915 Roberts 1915: unpaginated, repro.

1968 Cooke, Hereward Lester. *Painting Lessons from the Great Masters*. London, 1968: 44, fig. 29.

1975 Brown, David. "Turner, Callcott and Thomas Lister Parker: New Light on Turner's 'Junction of the Thames and the Medway' in Washington." *BurlM* 117 (1975): 719–722.

1976 Walker 1976: no. 599, color repro.

1984 Butlin and Joll 1984 (see biography), 1: no. 62; 2: pl. 73.

1986 Chapel, Jeannie. "The Turner Collector: Joseph Gillott, 1799–1872." *Turner Studies* 6 (1986): 44–45.

1937.1.109 (109)

Mortlake Terrace

1827
Oil on canvas, 92.1 × 122.2 (36¼ × 48⅛)
Andrew W. Mellon Collection

Technical Notes: The fine canvas is plain woven; it has been lined. The ground is white, of moderate thickness, and masks the weave of the canvas. The painting is executed in a variety of complex techniques. Smooth, opaque layers are used for the sky and river; the background buildings are rendered in fairly thin, opaque paint, while the rest of the design is constructed in multiple layers of glazes, especially thin and liquid in the trees; there is stiff impasto in the highlights, and occasional sgraffito marks created with a blunt instrument are evident in the tree trunk and some of the foliage on the left side of the canvas. The dog standing on the parapet is constructed with brown paper cut in the shape of a dog, and adhered to the paint; the surface of the brown paper is either painted black or is covered with a thin layer of printer's ink. The parasol is not a paper collage element, but is applied in thick paint. There is retouching along the entire right edge, but otherwise the paint losses are minimal. The natural resin varnish has only discolored slightly.

Provenance: Painted for William Moffatt [c. 1754/1755–1831], "The Limes," Mortlake. With William Bernard Cooke, the engraver, c. 1831–1838. Harriott by 1838 (sale, Christie & Manson, London, 23 June 1838, no. 112), bought by Allnutt. The Reverend E. T. Daniell [1804–1842] (sale, Christie & Manson, London, 17 March 1843, no. 160), bought by M. E. Creswick, who sold it 1851 to (Thos. Agnew & Sons), London, from whom it was purchased the same year by Samuel Ashton; by descent to Captain Ashton, by whom it was sold 1920 jointly to (Thos. Agnew & Sons), London, and (Arthur J. Sulley & Co.), London, who sold it 1920 to (M. Knoedler & Co.), London, from whose New York branch it was bought 1 December 1920 by Andrew W. Mellon, Pittsburgh and Washington, by whom deeded 28 December 1934 to The A. W. Mellon Educational and Charitable Trust, Pittsburgh.

Exhibitions: Royal Academy of Arts, London, 1827, no. 300. *Art Treasures of the United Kingdom*, Manchester, 1857, "Paintings by Modern Masters," no. 256. *Pictures and Drawings by J. M. W. Turner, R.A., and a Selection of Pictures by Some of His Contemporaries*, Corporation of London Art Gallery, Guildhall, 1899, no. 23. *Works by Early British Masters*, City of Manchester Art Gallery, 1909, no. 30. *Turner 1775–1851*, Royal Academy of Arts, London, 1974–1975, no. 310, repro. *London and the Thames*, Somerset House, London, 1977, no. 48, repro. and color repro. *J. M. W. Turner*, Grand Palais, Paris, 1983–1984, no. 36, color repro.

THE VIEW IS TAKEN from the front ground-floor window on the west side of William Moffatt's riverside house, "The Limes," at Mortlake, looking westward over the garden and terrace with its splendid lime trees (which Turner has idealized), toward the village and toward Kew, with the evening sun shining over the Thames. The Lord Mayor's barge is introduced on the river.

The canvas was exhibited at the Royal Academy of 1827 as *Mortlake Terrace, the Seat of William Moffatt, Esq., Summer's Evening*, and was a companion to the picture exhibited the previous year as *The Seat of William Moffatt Esq., at Mortlake, Mortlake Terrace: Early Summer Morning*, now in the Frick Collection, New York,[1] which depicts the west side of the house, and the riverside looking north-eastward toward Chiswick, from the garden (fig. 3). The house, until recently number 123 Mortlake High Street, has been demolished and the site is now a public garden.

Thornbury stated that the dog on the parapet was cut out of an engraving and stuck onto the canvas, as was the parasol nearby[2] (but see the technical notes above). According to Thornbury, "it suddenly struck the artist that a dark object here would throw back the distance and increase the aerial effect."[3] It does indeed heighten the magical effect of dazzling light dissolving form.[4]

The tradition of painting a morning and evening view as companions goes back through Claude-Joseph Vernet to Claude. Turner followed Wilson, George Barret, and others in subordinating topographical to pictorial requirements. Canaletto, as well as Barret, painted views *from* houses, as, more recently, had Constable. The design, with its sharp perspective and dominating orthogonals, is at once reminiscent of Canaletto and typical of Turner's predilection for strong radial compositions.[5]

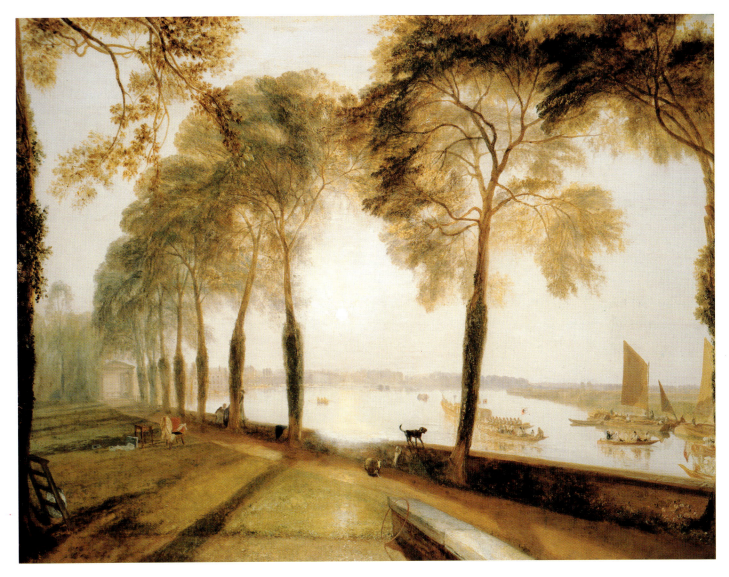

Joseph Mallord William Turner, *Mortlake Terrace*, 1937.1.109

Fig. 1. Joseph Mallord William Turner, *Mortlake Terrace*, pencil on gray paper, London, Tate Gallery

Two preliminary studies of the garden building and five of the adjacent lime trees, one of them very sketchy, are in the Miscellaneous Black and White sketchbook (fig. 1).[6] A further study of trees and a full composition sketch—including the distant trees, the foliage arching over the scene, and the parapet in the foreground—close to the picture as finally executed, are in the Mortlake and Pulborough sketchbook (fig. 2).[7]

When it was exhibited at the Royal Academy, the picture was abused on account of its yellowness. *John Bull* referred to "Mr. Turner's pertinacious adherence to yellow;" that trees, figures, grass and white copings "should be afflicted with the jaundice, is too much to be endured."[8] The *Morning Post* remarked that Turner had

been, at "each successive exhibition, getting worse and worse of what we may call a *yellow fever*, which promises if not soon checked, to be fatal to his reputation," and that this canvas was "desperately afflicted with this disease."[9] *John Bull*'s references to "so sad, so needless a falling off" is one of the earliest accusations of a decline in Turner's powers.[10] But Thoré, who saw the picture at Manchester in 1857, hailed it as a masterpiece, "absolument dégagé de toute l'influence des anciens maitres . . . Claude le suprême illuminateur, n'a jamais rien fait d'aussi prodigieux. . . . Pour moi, j'ai vu aussi, sur le bord de la Tamise, ces effets singuliers de la lutte du soleil contre le brouillard et la poussière."[11]

An engraving by W. J. Cooke was published in *The*

Fig. 2. Joseph Mallord William Turner, *Mortlake Terrace*, pencil, London, Tate Gallery

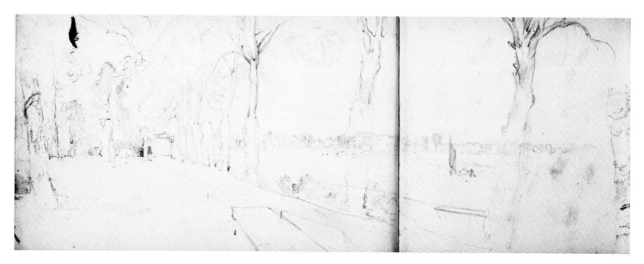

Fig. 3. Joseph Mallord William Turner, *Mortlake Terrace: Early Summer Morning*, R.A. 1826, oil on canvas, New York, Frick Collection

Book of Gems, 1836,[12] to illustrate Sir John Denham's *From Cooper's Hill.*

A copy either of the Washington or of the Frick picture was made by Edward William Cooke when both works were with his father, the engraver William Bernard Cooke, between Moffatt's death in 1831 and the sale of the pictures by auction in 1838.[13]

Notes

1. Butlin and Joll 1984 (see biography), I: no. 235.
2. Thornbury 1862 (see biography), I: 413. The painter

Frederick Goodall claimed that it was inserted as a practical joke by Landseer on varnishing day at the Academy, and that Turner, on appearing in the room, unconcernedly adjusted and varnished it (*The Reminiscences of Frederick Goodall* [London and Newcastle-on-Tyne, 1902], 124). This is extremely unlikely (see Shanes 1983, 49–50).

3. Thornbury 1862 (see biography), I: 305.
4. Gage 1987 (see biography), 11.
5. Martin Kemp discusses Turner's treatment of perspective in the Washington picture in the context of that artist's original analyses of this science: "Making obvious references to Canaletto's views from Somerset House, he has combined a particularly rhythmic use of perspective with his own special vibrancy of light and shade which both amplifies and competes with the linear effects. There is more than a hint of the curving

of the horizontal lines under the wide-angle view" (Kemp 1990, 159).

6. Turner Bequest CCLXIII (a), sketchbook, 1, 2 (D25516–25517).

7. Turner Bequest CCXIII, sketchbook, 16 (drawn sideways on the page), 15v–16(D18734)(Gerald Wilkinson, *Turner's Colour Sketches 1820–34* [London, 1975], 30, repro. 31).

8. *John Bull* 7, no. 337 (27 May 1827), 165.

9. *Morning Post*, 15 June 1827.

10. Butlin and Joll 1984 (see biography), 1: 148.

11. Bürger 1860, 425–427.

12. S. C. Hall, ed., *The Book of Gems* (London, 1836), 249, no. 42.

13. Butlin and Joll 1984 (see biography) 1: 148.

References

1827 *John Bull* 7, no. 337 (27 May 1827): 165.

1827 *Morning Post*, 15 June 1827.

1860 Bürger, W. [T. Thoré], *Trésors d'art en Angleterre.* Brussels and Ostend, 1860: 425–427.

1862 Thornbury 1862 (see biography), 1: 305, 413.

1902 Armstrong, Sir Walter. *Turner.* 2 vols. London, 1902, 1: 118–119, repro. opposite 120.

1930 Whitley, William T. *Art in England 1821–1837.* Cambridge, 1930: 131–132, 282.

1976 Walker 1976: no. 598, color repro.

1979 Wilton 1979 (see biography): 132, pl. 139 (color detail).

1983 Shanes, Eric. "The Mortlake Conundrum." *Turner Studies* 3 (1983): 49–50, repro. detail.

1984 Butlin and Joll 1984 (see biography), 1: no. 239; 2: color pl. 237.

1987 Gage 1987 (see biography): 9–11, fig. 12 (color).

1987 Wilton, Andrew. *Turner in His Time.* London 1987: 272, pl. 170 (color).

1990 Kemp, Martin. *The Science of Art.* New Haven and London, 1990: 159, pl. 317.

1970.17.135 (2507)

Rotterdam Ferry-Boat

1833
Oil on canvas, 92.3 × 122.5 (36⅜ × 48¼)
Ailsa Mellon Bruce Collection

Technical Notes: The medium-weight canvas is finely plain woven; it has been lined. The ground is light gray (warm in tone on account of brown admixtures), and is smoothly applied. There is thin dark gray brushed underdrawing in the two ships to the left of the ferryboat. The painting is executed in thick opaque layers with moderate impasto. The impasto has been flattened during lining. There is scattered retouching throughout the sky and along all the edges of the painting. The natural resin varnish has discolored yellow to a moderate degree.

Provenance: Purchased at the time of the Royal Academy of Arts exhibition in 1833 by Hugh Andrew Johnstone Munro [1794–1865], Novar, Ross and Cromarty, Scotland (sale,

Christie, Manson & Woods, London, 6 April 1878, no. 101), bought by (Thos. Agnew & Sons), London, for Kirkman Daniel Hodgson [1814–1879], Ashgrove, Kent; by descent to Robert Kirkman Hodgson, Gavelacre, Hampshire, who sold it 1893 to (Thos. Agnew & Sons), London, from whom it was purchased the same year by Sir Charles Tennant, Bt. [1823–1906], Glen, Innerleithen, Peeblesshire, Scotland; by descent 1920 to his grandson, Christopher Tennant, 2nd Baron Glenconner [1899–1983], London, who sold it July 1923 to (Charles Carstairs for M. Knoedler & Co.), London, from whose New York branch it was purchased November 1923 by Andrew W. Mellon, Pittsburgh and Washington, who gave it by 1937 to his daughter, Ailsa Mellon Bruce, New York.

Exhibitions: Royal Academy of Arts, London, 1833, no. 8. *Works by the Old Masters, and by Deceased Masters of the British School*, Winter Exhibition, Royal Academy of Arts, London, 1894, no. 103. *Works by British Artists Deceased Since 1850*, Winter Exhibition, Royal Academy of Arts, London, 1901, no. 82. *Ten Paintings from the Tennant Glenconner Collection*, M. Knoedler & Co., New York, 1924, no. 9.

THE WASHINGTON PICTURE was wrongly given the title of the picture in the Sir John Soane's Museum (*Admiral Van Tromp's Barge at the Entrance of the Texel 1645*)[1] in the catalogue of the Munro pictures drawn up after Munro's death without any manuscript material from the collector to assist identification.[2] At the time of the 1878 sale this error was compounded by the *Times*, which suggested that the painting was *Van Tromp's Shallop at the Entrance of the Scheldt*, Turner's exhibited picture of 1832,[3] and this title survived until the work was acquired by the National Gallery. The distant view is not, however, of Antwerp, and the foreground boat is not a shallop (a form of sloop with small mainmast and a foremast, commonly used as a tender upon men-of-war). More recently Turner's exhibit of 1832 has been convincingly identified as the picture now in the Wadsworth Atheneum, Hartford, which at least since 1889 had also borne the title of the National Gallery's picture,[4] traditional since 1878, and which does include a shallop.

Cunningham was the first to identify the Washington picture with Turner's exhibit of 1833, *Rotterdam Ferry-Boat*, otherwise hitherto unidentified,[5] a view supported, with additional evidence, by Joll.[6] Cunningham pointed out that the *Rotterdam Ferry-Boat* had been listed by Thornbury as in the Munro of Novar collection,[7] but seemed to have disappeared; that the boat in the foreground of the Washington picture was more like a ferryboat than a shallop; and that the church tower in the background, with its three broad, tapering stories was very similar to that of the Groote Kerk in Rotterdam, an

Joseph Mallord William Turner, *Rotterdam Ferry-Boat*, 1970.17.135

identification positively confirmed by Bachrach.[8] J. B. van Overeem, of the Maritime Museum "Prins Hendrik," Rotterdam, has doubted, however, whether the boat, which she regards as an inland vessel, could be intended to be the Rotterdam ferryboat.[9] Joll noted the connection with the views of Rotterdam in the Dort sketchbook and, in support of the identification of the Washington picture with the *Rotterdam Ferry-Boat*, pointed out that the very idiosyncratic orange ocher in the water was identical in hue with a color used extensively in the sky and water of *Mouth of the Seine, Quille-Boeuf*, also exhibited in 1833. He added that these last touches in the water were probably put in when Turner was working on both pictures on varnishing day, and that he knew nowhere else in Turner's work where this color occurs.[10]

The composition is generally lateral in concept, although the ships are set diagonally to give thrust to the design. The sea is conceived broadly in two planes—the foreground in shadow, the middle ground sunlit, rather as in a Van Goyen though less schematic—and the distance is closed by a view of Rotterdam which seems to arise out of a dramatic explosion of light. The ships are linked rhythmically by their motion on the force of the swell, and the effect of the gale is reinforced by the fitful light and the vigorous movement of the clouds, erupting like a volcano. The *London Literary Gazette* wrote that Turner "has exhibited those great powers which, in such subjects, place him above all competition."[11]

Notes

1. Butlin and Joll 1984 (see biography), no. 339.
2. Frost 1865, no. 40.
3. Redford 1888, 1: 272.
4. Cunningham 1952, 323–329.
5. Cunningham 1952, 326–329.
6. Butlin and Joll 1984 (see biography), 1: 199–200, no. 348.
7. Thornbury 1862 (see biography), 2: 400.
8. Bachrach 1974, 20.
9. Letter, 1 February 1972, in NGA curatorial files.
10. Letter, 24 May 1976, in NGA curatorial files.
11. *London Literary Gazette*, no. 851, 11 May 1833, 299.

References

1833 *Athenaeum*, no. 289, 11 May 1833: 297.
1833 *London Literary Gazette*, no. 851, 11 May 1833: 299.
1833 *Arnold's Magazine of the Fine Arts*, n.s., 1 (June 1833): 187.
1833 *Times* (London), 1 July 1833.
1862 Thornbury 1862 (see biography), 2: 400.
1865 Frost, William. Revised by Henry Reeve. *A Complete Catalogue of the Paintings . . . in the Collection of the late Hugh Andrew Johnstone Munro, Esq., of Novar, at the time of his death . . . 6 Hamilton Place, London; with some additional paintings at Novar.* London, 1865: no. 40.
1888 Redford, George. *Art Sales.* 2 vols. London, 1888, 1: 270, 272.
1952 Cunningham, C. C. "Turner's Van Tromp Paintings." *AQ* 15 (1952): 325–329.
1971 Dugdale, James. "Sir Charles Tennant: The Story of a Victorian Collector." *Conn* 178 (1971): 8, 12, repro.
1974 Bachrach, A. G. H. *Turner and Rotterdam 1817—1825—1841.* Deventer, n.d. [1974]: 20, repro. 21.
1976 Walker 1976: no. 602, color repro.
1981 Bachrach, A. G. H. "Turner, Ruisdael and the Dutch." *Turner Studies* 1 (1981): 26, pl. 13.
1984 Butlin and Joll 1984 (see biography), 1: no. 348; 2: pl. 351.

1942.9.85 (681)

Venice: The Dogana
and San Giorgio Maggiore

1834
Oil on canvas, 91.5 × 122 (36 × 48)
Widener Collection

Technical Notes: The canvas is finely plain woven; it was lined in 1971. The ground is white; it is thickly applied and masks the weave of the canvas. There appear to be layers of gray and beige imprimatura in some areas. The painting is executed in freely handled opaque layers ranging from rich, fluid glazes to thick paint; the strongest whites are thickly impasted. Glazes and scumbles are drawn, scraped, and dragged over the paint layers, and the scumbles of white and light-colored paint that create the luminous effect may be gouache or watercolor. The details of architecture and rigging are accomplished with very thin fluid paint occasionally reworked by scratching in with a blunt tool. The thinner paint seems to have been abraded. There is extensive craquelure. Retouching is largely limited to the corners and edges, and to the concealment of cracks. There are substantial residues of an earlier natural resin varnish, which has discolored yellow to a significant degree, beneath the dammar varnish applied in 1971.

Provenance: Painted for Henry McConnel [1801–c. 1874], The Polygon, Ardwick, Manchester, who sold it 1849 to John Naylor, Leighton Hall, Liverpool; passed to his wife, from whom it was purchased 1910 through (Dyer and Sons) by (Thos. Agnew & Sons), London, who entered into joint ownership with (Arthur J. Sulley & Co.), London, April 1910; purchased from (Arthur J. Sulley & Co.), London, 13 June 1910 by P. A. B. Widener, Elkins Park, Pennsylvania. Inheritance from the Estate of Peter A. B. Widener by gift through power of appointment of Joseph E. Widener, Elkins Park.

Exhibitions: Royal Academy of Arts, London, 1834, no. 175. *Modern Artists*, Royal Manchester Institution, 1834, no 53. *Pictures, exhibited at a Soirée, given by John Buck Lloyd, Esquire,*

Joseph Mallord William Turner, *Venice: The Dogana and San Giorgio Maggiore*, 1942.9.85

Mayor of Liverpool, Town Hall, Liverpool, 23 September 1854, no. 2. *Paintings by Thomas Gainsborough, R.A. and J. M. W. Turner, R.A.*, M. Knoedler & Co., New York, 1914, no. 35.

THE VIEW DEPICTS the church and campanile of San Giorgio Maggiore on the Isola di San Giorgio, with the customs house (the Dogana di Mare) at the mouth of the Canale Grande; in the distance are the Rive leading to the public gardens. For Turner, the Dogana (surmounted by the figure of Fortune), a monument to Venetian trading prosperity, was symbolic of a glory that had passed. The figure of Fortune is a prominent feature in this canvas.

Finberg stated that the viewpoint was the steps of the Grand Hotel Europa e Britannia (Ca' Giustinian), close to the Piazza San Marco, where Turner stayed during his later visits to Venice.[1] This cannot be sustained, however, as Ca' Giustinian is almost directly opposite the Dogana; the point is demonstrated by a view that Turner *did* paint from the steps of the Europa.[2] The perspective and relationships of the buildings indicate that the actual viewpoint must be a boat close to the south bank of the Canale Grande.

Turner has deliberately exaggerated the foreground and the extent of the lagoon in order to accommodate a mass of shipping and gondolas (the distance between San Giorgio and the Riva degli Schiavoni is actually no greater than that between San Giorgio and the Dogana). Although the cupola of San Giorgio should be larger in relation to the dome, the buildings themselves are in general accurately delineated; those on the extreme right no longer exist (or were invented for perspectival reasons: they do not appear in Canaletto's views). This combination of careful detailing with a distortion of the setting for pictorial purposes is characteristic of many topographical artists, including Canaletto. The composition is given added spaciousness and depth by the sharply receding diagonals of the buildings on the right. The luminous quality of the picture, exemplified by the exquisite shimmer of the water, is produced by the use of thin brushwork over a thick white ground, and is enhanced by the gaily colored costume of the figures; the center of the composition is marked by a gondola with a bright red bale stowed inside.

Turner almost certainly made a ten-day visit to Venice, his second, in September 1833,[3] and there is a study in the Venice: Miscellaneous sketchbook (fig. 1) that is surely a sketch for the Washington picture.[4] The viewpoint, the strong effect of light on San Giorgio, and the placing of the two principal groups of boats are similar (the foremost sail in the group on the left is identical). In this sketch the architectural detail is summarily, and to a large extent inaccurately drawn.

The picture was painted at the patron's "especial suggestion,"[5] and McConnel later wrote (in rebuttal of Thornbury's colorful but fabricated account of the transaction[6]) that "before it had hung one week on the walls of the Academy, I paid him [Turner], without the slightest objection or hesitation, 350*l*, the price which he had fixed for the picture."[7] Although Turner was alleged by the press to have painted the Venetian scene he exhibited at the Royal Academy in 1833 in rivalry with Clarkson Stanfield,[8] McConnel's prior "commission" of the National Gallery's picture refutes the accusation of the *Morning Chronicle* that he had done the same in 1834 out of spite "because the Marquess [of Lansdowne] gave Mr. S the commission, and did not give it to him."[9] Otherwise, in common with most of Turner's Venetian views, the picture had a good press, both at the Academy and at the Royal Manchester Institution, where it was shown immediately afterward. The *Manchester Guardian* was enraptured: "We stand transfixed, we ask no name—nor open we the catalogue, and as we look on the waters of peerless Venice, we confess by our enraptured, breathless attitude, the power of the unrivalled and gorgeous TURNER. . . . The fairy touch, the bright sunshine, the glowing colour, the transparency, the vividness, the poetry . . . surprise and delight us."[10] The *Manchester Courier* considered that "no artist, perhaps, ever shewed such a mastery over his colours, availing himself of the most brilliant, we had almost said glaring, and yet harmonizing them so charmingly that the eye is never offended though frequently dazzled."[11] Even the *Morning Chronicle* admitted that it was Turner's "best piece" at the Academy.

McConnel, acclaimed as "the pioneer of art collecting in Lancashire,"[12] subsequently commissioned a contrasting companion picture of an industrial scene at a seaport in the north of England (1942.9.86). In 1861 he tried, unsuccessfully, to buy back from John Naylor one or other of these canvases, which he had sold to him in 1849.[13]

Notes

1. Finberg 1961 (see biography), 347–348.
2. Butlin and Joll 1984 (see biography), 1: no. 396; 2: color pl. 400.
3. George 1971, 84. Lindsay Stainton, *Turner's Venice*

Fig. 1. Joseph Mallord William Turner, *Venice: The Dogana and San Giorgio Maggiore*, watercolor and gouache over pencil, with touches of red and black chalk, on gray paper, London, Tate Gallery

(London, 1985), 21–22, regards George's hypothesis as "not completely proven."

4. Turner Bequest CCCXVII, sketchbook, 22 (D32207). The connection was first pointed out by Jerrold Ziff, review of Butlin and Joll 1977 (see biography), *AB* 62 (1980), 170. The study is reproduced in Lindsay Stainton, *Turner's Venice* (London, 1985), pl. 35, where it is suggested, 26 and in the entry for no. 31, that the series of drawings on gray paper of which this forms part dates from 1840, when Turner was definitely in Venice. William Callow describes in his *Autobiography* how "one evening whilst I was enjoying a cigar in a gondola I saw in another one Turner sketching San Giorgio, brilliantly lit up by the setting sun" (quoted by Stainton, 22).

5. McConnel to John Naylor, 28 May 1861 (quoted in Butlin and Joll 1984 [see biography], 1: 205).

6. Thornbury 1862 (see biography), 2: 239–240.

7. Letter, *Athenaeum*, no. 1781, 14 December 1861, 808.

8. Butlin and Joll 1984 (see biography), 1: no. 349. Lindsay Stainton, *Turner's Venice* (London, 1985), 20, regards the smear as "very unlikely."

9. *Morning Chronicle*, 26 May 1834. Lord Lansdowne was, in any case, a patron of Stanfield and not of Turner.

10. *Manchester Guardian*, 30 August 1834.

11. *Manchester Courier*, 10, no. 512, 18 October 1834.

12. Review of "The Winter Exhibition at Burlington House," *Times* (London), 11 January 1887.

13. McConnel to John Naylor, 28 May 1861 (quoted in Butlin and Joll 1984 [see biography], 1: 205).

References

1834 *Athenaeum*, no. 341, 10 May 1834: 355.

1834 *London Literary Gazette*, no. 903, 10 May 1834: 331.

1834 *Spectator*, 7, no. 306, 10 May 1834: 447.

1834 *Morning Chronicle*, 26 May 1834.

1834 *Manchester Guardian*, 30 August 1834.

1834 *Manchester Courier and Lancashire General Advertiser*, 10, no. 512, 18 October 1834.

1861 *Athenaeum*, no. 1781, 14 December 1861: 808.

1915 Roberts 1915: unpaginated, repro.

1964 Rothenstein, John, and Martin Butlin. *Turner*. London, 1964: 52, pl. 98.

1971 George, Hardy. "Turner in Venice." *AB* 53 (1971): 84–87.

1976 Walker 1976: no. 603, color repro.

1984 Butlin and Joll 1984 (see biography), 1: no. 356; 2: color pl. 362.

1986 Treuherz, Julian. "The Turner Collector: Henry McConnel, Cotton Spinner." *Turner Studies* 6 (1986): 38–39, 40–41, 42, fig. 2.

1942.9.86 (682)

Keelmen Heaving in Coals by Moonlight

1835
Oil on canvas, 92.3 × 122.8 (36⅜ × 48⅜)
Widener Collection

Inscriptions:
Signed on the buoy at lower left: *JMWT*

Technical Notes: The medium-weight canvas is plain woven; it was lined in 1967. The ground is white; it is very thickly applied and virtually masks the weave of the canvas. The painting is executed very richly with vigorous brushwork and much use of scumbles; the highlights in the water are thickly impasted, and the moon almost stands out in relief. The sky is painted very thinly and fluidly, probably with some use of watercolor; the rigging on the boats, especially on the left, may also be done in watercolor. The paint surface seems to be slightly abraded, and some of the highest impasto has been flattened during lining. There is scattered retouching throughout. The thick natural resin varnish, which has discolored yellow to a significant degree, was not removed before the dammar varnish was applied in 1967.

Provenance: Same as 1942.9.85.

Exhibitions: Royal Academy of Arts, London, 1835, no. 24. *Modern Artists*, Royal Manchester Institution, 1835, no. 260. *Pictures, exhibited at a Soirée, given by John Buck Lloyd, Esquire, Mayor of Liverpool*, Town Hall, Liverpool, 23 September 1854, no. 21. *Works by the Old Masters, and by Deceased Masters of the British School*, Winter Exhibition, Royal Academy of Arts, London, 1887, no. 14. *Paintings by Thomas Gainsborough, R.A. and J. M. W. Turner, R.A.*, M. Knoedler & Co., New York, 1914, no. 36. *Turner 1775–1851*, Royal Academy of Arts, London, 1974–1975, no. 513, color repro. *J. M. W. Turner*, Grand Palais, Paris, 1983–1984, no. 61, color repro. *Turner*, National Museum of Western Art, Tokyo; Municipal Museum, Kyoto, 1986, no. 33, color repro.

THE CANVAS shows keelmen, or coal heavers, shoveling coal into colliers at South Shields on Tyneside, working by moonlight with the aid of braziers. The composition was based on an earlier watercolor and gouache drawing, *Shields on the River Tyne*, signed and dated 1823 (fig. 1),[1] which was engraved for *The Rivers of England*, but the difference in concept is significant. Whereas in the earlier work the ships and subject matter are brought close to the spectator and the figures are well defined—the nearest, a keelman and young lady conversing, are overtly picturesque—in the finished picture the ships are farther away and the channel between them has been

Fig. 1. Joseph Mallord William Turner, *Shields on the River Tyne*, signed and dated 1823, pen and black ink, watercolor, and gouache, London, Tate Gallery

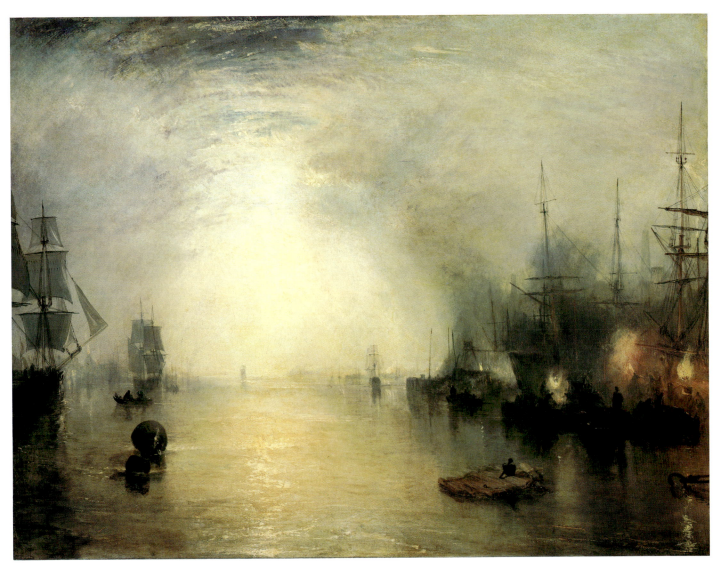

Joseph Mallord William Turner, *Keelmen Heaving in Coals by Moonlight*, 1942.9.86

widened, so that the moonlight forms the focal point of a tunnellike arch of light and clouds in which the ships play their part as spectral presences, the work of the keelmen silhouetted against the flaming braziers.

This work was painted as a companion to 1942.9.85, exhibited the previous year. McConnel, a Manchester textile manufacturer, may have suggested to the artist that he should paint a pair of pictures contrasting the fortunes of two great mercantile powers—the sunlit indolence of declining Venice with the smoke and bustling activity of an industrial seaport in the prosperous north of England.[2] But Turner hardly needed prompting; this was a theme that fascinated him. He had painted the building and the decline of Carthage and, as Gage has pointed out, was concerned that the British Empire should not go the same way as the empires of the past.[3] McConnel paid three hundred pounds for the canvas, "a larger sum than Turner has asked,"[4] but fifty pounds less than for the Venetian scene; Turner clearly took subject into account in pricing his pictures.

Critical opinion was divided. The *Times* called it "one of those masterly productions by which the artist contrives to convey very striking effects with just so much of adherence to nature as prevents one from saying they are merely fanciful. It represents neither night nor day, and yet the general effect is very agreeable and surprising."[5] *Fraser's Magazine* noted that it "is thought highly of; it is nevertheless a failure. The night is not night; and the keelmen and the coals are any thing."[6] The *Morning Chronicle* agreed that the sky was "in parts far too blue for a night scene,"[7] the *Spectator* adding: "but a year or two hence it will be as bright and true a night scene as ever—or rather *never* was painted."[8] Boths journals agreed that "the aerial perspective is beyond all praise."[9] The *London Literary Gazette* commented: "And such a night!—a flood of glorious moon-light wasted upon dingy coal-whippers, instead of conducting lovers to the appointed bower."[10] McConnel, who had been obliged to sell pictures at a time of business adversity, regretted selling his Turners to John Naylor, and in 1861 tried, unsuccessfully, to buy at least one of them back: "I cannot overcome my hankering after one of the Turners. I know, at least, I feel pretty certain, nothing would tempt you to part with the Venice; but are you irresistibly determined not to part with the Moonlight?"[11] The two pictures are not only magnificently contrasted, but united by broad similarities in the outer structure of the design; they rank among Turner's masterpieces.

Notes

1. Turner Bequest CCVIII-V (D18155); Eric Shanes, *Turner's Rivers, Harbours and Coasts* (London, 1981), 29, no. 49, color pl. 49.

2. Butlin and Joll 1984 (see biography), 1: 210–211.

3. Gage 1987 (see biography), 216.

4. Henry McConnel, letter, *Athenaeum*, no. 1781, 14 December 1861, 808. Turner wrote to McConnel in January 1836: "I write merely to say I received your letter *asking me for my account* which I left to you to decide upon for me *as to the amount*" (Gage 1980, 159, no. 198; quoted in Butlin and Joll 1984 [see biography], 1: 211).

5. *Times* (London), 23 May 1835.

6. *Fraser's Magazine* 12 (12 July 1835), 55.

7. *Morning Chronicle*, 6 May 1835.

8. *Spectator*, 8, no. 358, 9 May 1835, 447.

9. *Morning Chronicle*, 6 May 1835.

10. *London Literary Gazette*, no. 955, 9 May 1835, 298.

11. McConnel to John Naylor, 28 May 1861 (quoted in Butlin and Joll 1984 [see biography], 1: 205).

References

1835 *Morning Chronicle*, 6 May 1835.
1835 *London Literary Gazette*, no. 955, 9 May 1835: 298.
1835 *Spectator*, 8, no. 358, 9 May 1835: 447.
1835 *Times* (London), 23 May 1835.
1835 *Fraser's Magazine* 12 (12 July 1835): 55.
1915 Roberts 1915: unpaginated, repro.
1976 Walker 1976: no. 600, color repro.
1979 Wilton 1979 (see biography): 220, color pl. 217 (detail).
1980 *Collected Correspondence of J. M. W. Turner*. Edited by John Gage. Oxford 1980: 159, no. 198.
1984 Butlin and Joll 1984 (see biography), 1: no. 360; 2: color pl. 363.
1986 Treuherz, Julian. "The Turner Collector: Henry McConnel, Cotton Spinner." Turner Studies 6 (1986): 38–39, 40–41, 42, fig. 3.
1987 Wilton, Andrew. *Turner in His Time*. London, 1987: 186, repro. 253.

1951.18.1. (1080)

The Rape of Proserpine

1839
Oil on canvas, 92.6 × 123.7 (36½ × 48¾)
Gift of Mrs. Watson B. Dickerman

Technical Notes: The medium-weight canvas is very tightly plain woven; it has been lined. Because of the thickness of the paint it has not been possible to determine the color or composition of the ground. The painting is executed very freely and fluidly in a low to medium impasto, with thinner glazes and scumbles in a few areas of the sky. Some diagonal scraping in the underpaint before it had completely dried to create an atmospheric effect, and some palette-knife type application have also been used in parts of the sky. There is a disfiguring craquelure in the dark layer of underpaint in the foreground and middle

Joseph Mallord William Turner, *The Rape of Proserpine*, 1951.18.1

Fig. 1. Joseph Mallord William Turner, *Italian Landscape, probably Civita di Bagnoregio*, 1828, oil on canvas, London, Tate Gallery

ground, probably caused by bitumen. The paint layer has been somewhat flattened during lining. There is retouching along all the edges and in the craquelure, but there are no major paint losses and there is no severe abrasion. The thick, extremely uneven layer of natural resin varnish has discolored yellow to a significant degree.

Provenance: Possibly William Wethered [d. 1863], King's Lynn, Norfolk, and, by 1849, London.[1] John Chapman [1810–1877], Hill End, Cheshire, and Carlecotes, Yorkshire, by 1852;[2] by descent to his son, Edward Chapman [1839–1906]. (Arthur J. Sulley & Co.), London, in joint ownership with (Thos. Agnew & Sons), London; purchased 1912 from (Arthur J. Sulley & Co.), New York, by Watson B. Dickerman; passed to his wife, Florence E. Dickerman, New York.

Exhibitions: Royal Academy of Arts, London, 1839, no. 360, with *Ovid's Metam.* appended to the title. *Art Treasures of the United Kingdom*, Manchester, 1857, "Paintings by Modern Masters," no. 191. *Royal Jubilee Exhibition*, Fine Arts Galleries, Manchester, 1887, no. 609. *Loan Collection of Pictures*, Corporation of London Art Gallery, Guildhall, 1892, no. 112. *Works by the Old Masters, and by Deceased Masters of the British School*, Winter Exhibition, Royal Academy of Arts, London, 1896, no. 28. *Pictures and Drawings by J. M. W. Turner, R.A., and a Selection of Pictures by Some of His Contemporaries*, Corporation of London Art Gallery, Guildhall, 1899, no. 35. *Paintings Lent by George John Chapman, Esq. and the Executors of the Late Edward Chapman, Esq.*, City of Manchester Art Gallery, 1908, no. 020. *Paintings by Thomas Gainsborough, R.A. and J. M. W. Turner, R.A.*, M. Knoedler & Co., New York, 1914, no. 37.

THE SCENE DEPICTS Pluto's abduction of Persephone (Proserpine is the Roman equivalent), the daughter of Zeus (Jupiter) and Demeter (goddess of the corn and identified by the Romans with Ceres). As Proserpine was picking flowers with her companions in the meadows of Enna in the center of Sicily, she was carried off by Pluto

in his chariot and made his queen in the underworld. On the right, the snake on the stone fragment from a monumental building alludes to an occasion when Jupiter himself, enamored by Proserpine's beauty, descended to the earth disguised as a serpent and folded her in his coils. Turner regarded a snake (especially the brazen serpent) as a symbol of evil,[3] so that the motif may have had a double significance.

Although the setting is correctly shown as a high plateau, the scenery bears little resemblance to the center of Sicily, an island that Turner never visited, and the central mass with its town atop is clearly reminiscent of Tivoli, a view of which, after Wilson, he had painted forty years before.[4] Joll points out also the resemblance, both in scenery and composition, to another Italian landscape Turner had painted earlier (fig. 1).[5] The connections with the landscape around Rome have led to the suggestion that the Washington picture may have been painted, or at any rate started, some time before being exhibited,[6] though this would be an unusual practice for Turner. The bold, lumpish forms of the hills lend a primeval quality to the landscape, which is in keeping with the subject. Even the principal action, which takes place in the left foreground, is subordinated to these massive forms; as so often in Turner, the human beings are dwarfed by the majesty of their surroundings.

Turner's treatment both of the setting and of the theme was sharply criticized when the picture was exhibited. For Ruskin "the nature is not the grand nature of all time, it is indubitably modern, and we are perfectly electrified at anybody's being carried away in the corner except by people with spiky hats and carabines [sic]."[7] The *Spectator*, in its review of the Royal Academy exhibition, dismissed the Washington picture as "utterly unintelligible,"[8] and *Blackwood's Edinburgh Magazine* was scathing: "Here we have a red-hot Pluto frying the frigid Proserpine. Fire hissing in contact with ice. Why is all the ground (how unlike the plains of Enna) an iceberg? but that fire may blaze to represent the passion of the god, and that heaven and earth should personify the unmelting heart of the cold goddess. But here is something very miraculous. Here are red-hot stones, and clothes upon them unburnt. Turner's draperies are all asbestos: and here are figures that look like sulphureous tadpoles. It is really detestable and childish in colour, composition and in every thing belonging to it."[9] Thackeray, for whom Turner's exhibits in 1839 were "not a whit more natural, or less mad, than they used to be in former years, since he has foresaken nature," also found the picture incom-

prehensible, and wrote scornfully: "It is worth a shilling alone to go and see 'Pluto and Proserpine.' Such a landscape! such figures! such a little red-hot coal-scuttle of a chariot!"[10]

The *Athenaeum*, on the other hand, thought the picture "one of the best of his grand landscapes,"[11] and the *Art-Union* found it "a gorgeous piece of wild imagining—abounding in proofs of genius," adding ominously, though: "This picture, more than any other by the great master, gives us hints of the perishable nature of his materials. It seems as if part of it must peel off before the exhibition closes; we could almost fancy that portions of it have been painted in distemper."[12]

Notes

1. The evidence for Wethered's possible ownership of the picture is discussed in Butlin and Joll 1984 (see biography), 1: 232.

2. According to a note in the copy of the Royal Academy catalogue of 1839 in Agnew's library (Butlin and Joll 1984 [see biography], 1: 232).

3. John Gage, *Colour in Turner: Poetry and Truth* (London, 1969), 187.

4. Butlin and Joll 1984 (see biography), no. 44. The connection between the two compositions was first noted by Shanes 1981, 46. Joll notes also (Butlin and Joll 1984 [see biography], 1:233) that another of Turner's exhibits of 1839, *Cicero at His Villa*, was painted with Wilson in mind; however, Tivoli "was a favourite view with artists and Turner must have seen it himself when in Rome, so no direct copying of the Wilson motif by way of this oil painting (no. 44) seems necessary" (1:33).

5. Butlin and Joll 1984 (see biography), 1: 233.

6. Butlin and Joll 1984 (see biography), 1: 233.

7. Ruskin 1846, 129–130; Ruskin 1903–1912, 3: 242.

8. *Spectator*, 12, no. 567, 11 May 1839, 447.

9. *Blackwood's Edinburgh Magazine* 46 (September 1839), 313.

10. *Fraser's Magazine* 19 (19 June 1839), 744.

11. *Athenaeum*, no. 602, 11 May 1839, 357.

12. *Art-Union* 1 (15 May 1839), 69.

References

1839 *Athenaeum*, no. 602, 11 May 1839: 357.
1839 *Spectator*, 12, no. 567, 11 May 1839: 447.
1839 *Art-Union* 1 (15 May 1839): 69.
1839 *Fraser's Magazine* 19 (19 June 1839): 744.
1839 *Blackwood's Edinburgh Magazine* 46 (September 1839): 313.
1846 Ruskin, John. *Modern Painters*. 5 vols. London, 1843–1856, 1 (3d ed., 1846): 129–130. (*The Works of John Ruskin*. Edited by E. T. Cook and Alexander Wedderburn. 39 vols. London and New York, 1903–1912, 3: 242).
1857 Waagen, Gustav Friedrich. *Galleries and Cabinets of Art in Great Britain*. London, 1857: 419–420.
1980 *Collected Correspondence of J. M. W. Turner*. Edited by John Gage. Oxford, 1980: 297.
1981 Shanes, Eric. Review of Butlin and Joll 1977 (see biography). *Turner Studies* 1 (1981): 46.

1984 Butlin and Joll 1984 (see biography), 1: no. 380; 2: pl. 384.

1961.2.3 (1604)

The Dogana and Santa Maria della Salute, Venice

1843
Oil on canvas, 62 × 93 (24⅜ × 36⅝)
Given in memory of Governor Alvan T. Fuller by the Fuller Foundation

Inscriptions:
Signed at bottom right: *JMWT*

Technical Notes: The medium-weight canvas is somewhat coarsely plain woven; it has been lined. The gound is white, of moderate thickness. The painting is executed with white paint brushed onto the gound with thick strokes, and probably by palette knife, to create the impasted highlights; several layers of transparent washes were then applied, probably with some use of watercolor in the uppermost layers. The impasto has been flattened during lining; otherwise the painting is in excellent condition. The synthetic varnish applied when the picture was surface cleaned in 1976 has not discolored.

Provenance: Purchased 1843 at the Royal Academy of Arts by Edwin Bullock, Hawthorn House, Handsworth, Birmingham (sale, Christie, Manson & Woods, London, 21, 23 May 1870, 1st day, no. 143, bought by (Thos. Agnew & Sons), London, who sold it that same day to John Fowler (later Sir John Fowler, Bt.) [1817–1898], Thornwood Lodge, Campden Hill, London (sale, Christie, Manson & Woods, London, 6 May 1899, no. 79), bought by (Thos. Agnew & Sons), London, for James Ross, Montreal (sale, Christie, Manson & Woods, London, 8 July 1927, no. 28, repro.), bought by (Thos. Agnew & Sons, London) for Alvan T. Fuller, Boston [d. 1958]. The Fuller Foundation, Boston.

Exhibitions: Royal Academy of Arts, London, 1843, no. 144. *Modern Works of Art*, Birmingham Society of Artists, Athenaeum, Temple Row, Birmingham, 1843, no. 54. *Twenty Masterpieces of the English School*, Thos. Agnew & Sons, 1899, no. 19. *Loan Collection of Pictures and Drawings by J. M. W. Turner, R.A.*, City Museum and Art Gallery, Birmingham, 1899, no. 7. *Paintings Loaned by Governor Alvan T. Fuller*, Art Club, Boston, 1928, no. 46. *Paintings Drawings Prints from Private Collections in New England*, Museum of Fine Arts, Boston, 1939, no. 133, pl. 65. *Paintings Drawings and Prints by J. M. W. Turner, John Constable, R. P. Bonington*, Museum of Fine Arts, Boston, 1946, no. 17. *A Memorial Exhibition of the Collection of the Honorable Alvan T. Fuller*, Museum of Fine Arts, Boston, 1959, no. 33, repro. *Turner 1775–1851*, Royal Academy of Arts, London, 1974–1975, no. 533, color repro. *Turner*, National

Museum of Western Art, Tokyo; Municipal Museum, Kyoto, 1986, no. 50, color repro. *Discerning Tastes: Montreal Collectors 1880–1920*, Montreal Museum of Fine Arts, 1989–1990, 156–160, no. 57.

ONE OF THREE VIEWS of Venice of this size that Turner exhibited at the Royal Academy of 1843,[1] the National Gallery's picture depicts the customs house (the Dogana di Mare), the church of Santa Maria della Salute, and the opening of the Canale Grande from a point on the Riva degli Schiavone between the church of the Pietà and the Gabrielli Sandwirth hotel, some distance from Piazza San Marco.

Turner has indulged in a number of "improvements" to the scene. The prominent landing stage in the foreground is invention. As in 1942.9.85 he has emphasized the figure of Fortune surmounting the Dogana; in reality, from this viewpoint, the turret of the Dogana should be much lower and would not obscure the twin bell towers of the Salute (which should in any case be as high as the dome on their right). The buildings on the right have been thrust back and the width of the Canale Grande exaggerated (though less so than in 1942.9.85) for the sake of atmospheric effect.

The heavily encrusted highlights, white tonality of the sky, and atmospheric treatment, especially on the right of the canvas, combine to produce a beautiful effect of hot, shimmering light; at the same time the picture is a synthesis of massive forms within which figures and other detail are subsumed. The *Spectator* wrote of this and the two other Venetian views exhibited by Turner in 1843 that they "are beaming with sunlight and gorgeous colour, and full of atmosphere; though, as usual, all forms and local hues are lost in the blaze of effect."[2]

There are a number of studies of the Dogana and Santa Maria della Salute in Turner's sketchbooks, but none that corresponds to the National Gallery's painting.

The purchase of the Washington picture from the walls of the Academy by Edwin Bullock, one of the most notable patrons of contemporary art in the Midlands, is recorded in a letter to a potential customer written by Turner in November 1843: "I have no small picture in hand and indeed I have no wish to paint any smaller than Mr Bullocks and those all of Venice 200gns if painted by commission—250gns afterwards. This is the offer made to Mr B who thought of a companion picture to his bought last year out of the exhibition."[3] This is the only reference to Turner's practice of reducing his charges for a picture painted on commission. In the event, Bullock did not commission or purchase a companion picture. Finberg called the National Gallery's painting "the most serene, the noblest and most powerful of all Turner's Venetian paintings."[4]

Notes
 1. The others were *The Sun of Venice Going to Sea* and *Saint Benedetto, Looking towards Fusina* (both Tate Gallery, London; Butlin and Joll 1984 [see biography], nos. 402, 406).
 2. *Spectator*, 16, no. 776, 13 May 1843, 451. It is worth noting that the first volume of Ruskin's *Modern Painters* was published in May, coinciding with the opening of the Royal Academy exhibition.
 3. Turner, letter, 23 November 1843 (Gage 1980, 192–193, no. 261; quoted in Butlin and Joll 1984 [see biography], 1: 252).
 4. Finberg 1930, 148.

References
 1843 *Times* (London), 9 May 1843.
 1843 *Spectator*, 16, no. 776, 13 May 1843: 451.
 1843 *Athenaeum*, no. 816, 17 June 1843: 570.
 1930 Finberg, Alexander Joseph. *In Venice with Turner.* London, 1930: 148.
 1968 Cooke, Hereward Lester. *Painting Lessons from the Great Masters.* London, 1968: 232, details and color repro. opposite.
 1976 Walker 1976: no. 601, color repro.
 1980 *Collected Correspondence of J. M. W. Turner.* Edited by John Gage. Oxford, 1980: no. 261.
 1984 Butlin and Joll 1984 (see biography), 1: no. 403; 2: color pl. 409.

1960.6.40 (1592)

The Evening of the Deluge

c. 1843
Oil on canvas, 76 × 76 (29⅞ × 29⅞)
Timken Collection

Technical Notes: The support is composed of two canvases, both of medium weight and plain woven; it has been lined. There are shallow diagonal grooves cutting across each corner at approximately 14.5 cm. from the edge; these were scored either in the ground or in the paint layers before the painting was finished. Although, as confirmed by x-radiographs, the original canvas has always remained square in format, it is clear that Turner did consider an octagonal shape for the design; but it is difficult to know now if the roughly painted corners were meant to be seen or to be covered. The ground is white, probably calcium carbonate, and thickly applied. The painting is executed in thick paint, applied with both brush and palette knife, which is covered with thick and thin glaze washes, often blended wet into wet, probably with some use of watercolor, creating the details of the design. The uppermost paint layers filling the corners outside the grooves are sketchily applied.

Joseph Mallord William Turner, *The Dogana and Santa Maria della Salute, Venice*, 1961.2.3

Some of the impasto has been flattened during lining. There is one large, old, retouched loss above the tent; otherwise there are only a few scattered losses and little abrasion. The thick natural resin varnish has discolored yellow to a significant degree.

Provenance: The Reverend T. J. Judkin; passed to his wife (sale, Christie, Manson & Woods, London, 13 January 1872, no. 35, as *The Animals going into the ark-circle*), bought by (White). William Houldsworth, Mount Charles, Ayr, Scotland, by 1878 (sale, Christie, Manson & Woods, London, 23 May 1891, no. 59, as *The Deluge*, bought in), (sale, Christie, Manson & Woods, London, 16 May 1896, no. 54), bought by (Messrs. Shepherd Brothers), London. (Charles Sedelmeyer, Sedelmeyer Gallery), Paris, 1896. (Maurice Kann), Paris, who sold it 1900 to (Thos. Agnew & Sons), London, from whom it was purchased 1901 by H. Darell Brown, London (sale, Christie, Manson & Woods, London, 23 May 1924, no. 41, as *The Eve of the Deluge*, bought by (Carroll Galleries). (Howard Young Galleries), New York, by 1926. William R. Timken [1866–1949], New York, by 1933; passed to his wife, Lillian S. Timken [d. 1959].

Exhibitions: *Fine Art Loan Exhibition*, Corporation Art Galleries, Glasgow, 1878, no. 13. *Third Series of 100 Paintings by Old Masters*, Sedelmeyer Gallery, Paris, 1896, no. 98. *Seventh Annual Exhibition on Behalf of the Artists' General Benevolent Institution*, Thos. Agnew & Sons, 1901, no. 17. *English Eighteenth Century Pictures*, Thos. Agnew & Sons, 1919, no. 7. *Second Loan Exhibition of Old Masters: British Paintings of the Late Eighteenth and Early Nineteenth Centuries*, Detroit Institute of Arts, 1926, no. 48. *A Century of Progress: Exhibition of Paintings and Sculpture Lent from American Collections*, Art Institute of Chicago, 1933, no. 206. *A Survey of British Paintings*, Carnegie Institute, Pittsburgh, 1938, no. 56.

Fig. 1. Joseph Mallord William Turner, *The Evening of the Deluge*, R.A. 1843, oil on canvas, London, Tate Gallery

In 1843 Turner exhibited at the Royal Academy two canvases—probably influenced in their choice of subject by works exhibited by John Martin in 1840—entitled *Shade and Darkness—the Evening of the Deluge* and *Light and Colour (Goethe's Theory)—the Morning after the Deluge—Moses Writing the Book of Genesis* (both Tate Gallery, London).[1] Each was accompanied, in the catalogue, by lines from Turner's epic poem, *The Fallacies of Hope*. The reference to Goethe's theory is to the latter's concept of a color circle divided into "plus" and "minus" colors: the former, reds, yellows, and greens, were associated by Goethe with gaiety, warmth, and happiness, while the latter, blues, blue-greens, and purples, were seen as productive of "restless, susceptible, anxious impressions." Both works were regarded as "daubs" by contemporary critics.[2]

The authenticity of the National Gallery's picture has been doubted, for example by Luke Herrmann,[3] but it was accepted by Michael Kitson as "possibly a rejected first study"[4] for the Tate's *Evening of the Deluge* (fig. 1), and by Butlin and Joll, who describe it as "almost certainly a first version of the composition."[5] It is worth noting that T. J. Judkin, the first owner of the picture, an amateur landscape painter and friend of Bonington and Constable, was certainly known to Turner.[6]

The Washington picture is only a little over an inch smaller than the Tate canvases, and is an equally finished work. It seems less likely to be a study for the Tate picture than, as Joll suggests, a first version that was superseded because it did not provide such an effective contrast to *Light and Colour*.[7] The canvas is gray-green in tonality, with reds and yellows highlighting the figures in the tent. The Tate picture is considerably darker, better illustrating Goethe's polarities, and revealing "the sublimity of darkness," that Gage suggests was Turner's concern in painting the subject;[8] Turner was also anxious, according to Gage, "to restore the equality of light and darkness as values in art and nature, which Turner felt Goethe had unduly neglected."[9] Kemp prefers to see "the *Evening of the Deluge* as a dramatic exploitation of Goethe and Field's 'negative' polarities. The greens and purplish blues reside in the 'cold' sector. . . . They are associated with the negative power of darkness. The hollow, ruptured vortex stands in negative contrast to the implied sphericality of the *Morning*. But neither state is stable. A glow of light continues to compete with the advancing storm, just as the forces of darkness still threaten the new dawn. [Turner] has expressed Goethe's poles of power and colour in terms of his own sense of elemental flux."[10]

Joseph Mallord William Turner, *The Evening of the Deluge*, 1960.6.40

The vortical composition, typical of Turner's cataclysmic later paintings, is emphasized by the spiral of birds (a compositional device Turner had used ten years earlier, in a less developed form, in *Mouth of the Seine, Quille-Boeuf*[11]), illustrating the line from *The Fallacies of Hope:* "The roused birds forsook their nightly shelters screaming." The tent in the foreground, in which the couple is shown sleeping, and the distant ark, are much more clearly defined than in the Tate picture, and the arrangement of the animals wading out to the ark is different. Both the Tate canvases are octagonal in format (adding to the force of their strongly vortical compositions), a fact that supports Wilton's suggestion that Turner was influenced by the baroque cupolas he would have seen in Rome and Venice.[12] The incised diagonal lines at the corners, under the existing top layers of paint, indicate that, at some point in the evolution of the design, the Washington picture was also conceived as an octagon.[13]

Notes

1. Butlin and Joll 1984 (see biography), I: nos. 404, 405.
2. For example, by the *Times* (London), 11 May 1843, and the *Spectator*, 16, no. 776, 13 May 1843.
3. Opinion, 1974, recorded in NGA curatorial files.
4. Opinion, 1969, recorded in NGA curatorial files.
5. Butlin and Joll 1984 (see biography), I: 253.
6. Thornbury 1862 (see biography), I: 223, 316–317.
7. Butlin and Joll 1984 (see biography), I: 280.
8. John Gage, *Colour in Turner: Poetry and Truth* (London, 1969), 186.
9. Gage 1969, 185.
10. Martin Kemp, *The Science of Art* (New Haven and London, 1990), 303.
11. Butlin and Joll 1984 (see biography), I: no. 353; 2: pl. 357.
12. Wilton 1979 (see biography), 216.
13. Ann Hoenigswald, paintings conservator at the National Gallery, letter, 2 May 1983; Sarah L. Fisher, head of paintings conservation at the National Gallery, examination summary, 27 July 1987, in NGA curatorial files.

References

1902 Armstrong, Sir Walter. *Turner*. London and New York: 220, repro. opposite 180.
1984 Butlin and Joll (see biography), I: no. 443; 2: color pl. 405.

1937.1.110 (110)

Approach to Venice

1844
Oil on canvas, 62 × 94 (24⅜ × 37)
Andrew W. Mellon Collection

Technical Notes: The medium-weight canvas is finely plain woven; it was lined in 1971. The ground is off-white. The painting is executed with thick white impasto covered with very thin transparent glaze washes of intense colors which create a flickering effect in the highlights. The glazes have been abraded, or possibly, in the case of the red lakes beneath the city, have faded. The impasto has been slightly flattened during lining. There is extensive craquelure which significantly disrupts the composition. There are a great number of scattered small retouches in the sky and foreground. The dammar varnish applied in 1971 has discolored yellow slightly.

Provenance: William Wethered [d. 1863], King's Lynn, Norfolk, and by 1849, London. Benjamin Godfrey Windus [1790–1867],[1] Tottenham, after 1847[2] (sale, Christie & Manson, London, 20 June 1853, no. 5), bought by (Ernest Gambart), Paris, Brussels, and London. Charles Birch, Edgbaston and London (sale, Messrs. Foster, London, 28 February 1856, no. 57), bought by Wallis. Joseph Gillott [1799–1872], Edgbaston, by 1860. (Ernest Gambart), from whom it was purchased 1863 by (Thos. Agnew & Sons), London, who sold it 1863 to James Fallows, who exchanged it later that year (for pictures by Alfred Elmore and P. F. Poole) with (Thos. Agnew & Sons), London, who sold it to J. Smith.[3] Bought from the executors of Smith's estate 1870 by (Thos. Agnew & Sons), London, who sold it to W. Moir, 1871; passed to Mrs. Emma Moir, who sold it 1899 to (Thos. Agnew & Sons), London, from whom it was purchased that same year by Sir Charles Tennant, Bt. [1823–1906], Glen, Innerleithen, Peeblesshire, Scotland; by descent to his grandson, Christopher Tennant, 2nd Baron Glenconner [1899–1983], who sold it July 1923 to (Charles Carstairs for M. Knoedler & Co.), London, from whose New York branch it was purchased November 1923 by Andrew W. Mellon, Pittsburgh and Washington, by whom deeded 28 December 1934 to The A. W. Mellon Educational and Charitable Trust, Pittsburgh.

Exhibitions: Royal Academy of Arts, 1844, no. 356. *Modern Works of Art*, Birmingham Society of Artists, Birmingham, 1860, no. 64. *Loan Collection of Oil Paintings by British Artists Born Before 1801*, Art Club, Liverpool, 1881, no. 133. *Royal Jubilee Exhibition*, Fine Art Galleries, Manchester, 1887, no. 613. *Twenty Masterpieces of the English School*, Thos. Agnew & Sons, 1896, no. 5. *Works by the Old Masters and Deceased Masters of the British School*, Winter Exhibition, Royal Academy of Arts, London, 1903, no. 37. *Ten Paintings from the Tennant Glenconner Collection*, M. Knoedler & Co., New York, 1924, no. 10. *Venezia nell'Ottocento*, Ala Napoleonica e Museo Correr, Venice, 1983–1984, no. 14, color repro.

THE SCENE, depicted at sunset with the full moon rising, shows a number of barges and gondolas—of which the barge in the left foreground is inscribed *DOGE*—crossing the lagoon toward Venice, which is visible in the distance; the causeway between the mainland and the city is seen on the right. Gage's suggestion that the subject

Joseph Mallord William Turner, *Approach to Venice*, 1937.1.110

matter may be concerned with Dogal ceremony, and that there may be a link between the Washington picture and Turner's memories of the Canaletto drawings of Dogal ceremonies he had seen in his youth at Stourhead,[4] is rightly described by Joll as tenuous.[5]

As he had done in 1843, Turner exhibited three views of Venice of this size at the Royal Academy of 1844,[6] each, however, markedly more atmospheric in quality than those shown in the previous year. The principal motif of the Washington picture, the procession of boats, is characteristic of the last phase of Turner's perception of Venice; the distant city, over which the sun is setting, forms the focal point for the diagonals of the causeway (to be opened in 1845) and of the boats slowly moving toward her. The darkening sky is painted in very encrusted tones of brown. The painting was exhibited with the following quotations:

> "The path lies o'er the sea invisible;
> And from the land we went
> As to a floating city, steering in,
> And gliding up her streets as in a dream,
> So smoothly, silently"—Rogers' *Italy*

> "The moon is up, and yet it is not night,
> The sun as yet disputes the day with her"—*Byron*[7]

Although to some extent bewitched by the wizardry of Turner, the Victorian public was too imbued with the primacy of hard fact fully to respond to this treatment of topography. At the Royal Academy the Washington picture was praised, but grudgingly so, for its atmospheric beauty. The *Times* wrote that the painting, "with its rich greens in the foreground and the tints of the clouds and of the distant objects, all so delicately blended, presents a beautiful and fantastic play of colours to the spectator, who will take his station amid the benches in the middle room, and be content with the general impression," adding: "Whether Turner's pictures are dazzling unrealities, or whether they are realities seized upon at a moment's glance, we leave his detractors and admirers to settle between them."[8] The *Spectator* pronounced of the two other Venetian views that "his architecture . . . is too evanescent for anything but a fairy city," and of the Washington painting: "beautiful as it is in colour it is but a vision of enchantment."[9] In 1848 Ruskin wrote that the National Gallery's picture "was, I think, when I first saw it (and it still remains little injured), the most perfectly *beautiful* piece of colour of all that I have seen produced by human hands, by any means, or at any period."[10] Eight years later, however, he described it as "now a

miserable wreck of dead colours," while originally it had been "beyond all comparison the best"[11] of Turner's Venetian views. Ruskin was prone to exaggeration, but the picture must have deteriorated somewhat; as Joll points out, the "rich greens" noted by the *Times* are now no longer nearly so prominent.[12]

Probably in the autumn of 1844, William Wethered wrote to William Etty asking him to paint a picture with two figures "as *brilliant* as gold . . . [I] want it to hang over Turner's Approach to Venice which perhaps you will remember was a mixture of red and green . . . but by all means I must have a landscape . . . the fact is . . . (do not laugh) I wish thus to *overawe* and keep Turner in *subjection*."[13] He seems also to have requested from Turner another view similar to the one he had bought from that year's Academy, for in October 1844 Turner wrote to him: "On my return from Switzerland [whither he had gone in August] I found your note containing a commission to paint for you another approach to Venice. I beg to thank you for allowing me to make some change—tho I suppose you wish me to keep somewhat to the like effect."[14] This picture was never executed.

An engraving by Robert Wallis was published in 1859.[15]

Notes

1. Butlin and Joll 1984 (see biography) begin their provenance with Windus.

2. The picture is not mentioned by Thomas Tudor, who visited Windus on 21 June 1847, as being among the latter's collection of Turners at that time (Butlin and Joll 1984 [see biography], 1: 259).

3. Possibly John Smith, the picture dealer of 137 New Bond Street, author of the catalogue raisonné of Dutch pictures, who dealt frequently with Agnew's.

4. John Gage, "Turner and Stourhead: The Making of a Classicist?" *AQ* 37 (1974), 83–84.

5. Butlin and Joll 1984 (see biography), 1: 260.

6. The others were *Venice—Maria della Salute* and *Venice Quay, Ducal Palace* (both Tate Gallery, London; Butlin and Joll 1984 [see biography], nos. 411, 413).

7. Byron's second line (the quotation is from *Childe Harold*, canto IV, verse XXVII, lines 1–2) has been completely altered by Turner. The original reads: "Sunset divides the sky with her—a sea." Turner's close affinity with Byron was already noted by Ruskin.

8. *Times* (London), 8 May 1844.

9. *Spectator*, 17, no. 828, 11 May 1844, 451.

10. Ruskin 1848, 136; Ruskin 1903–1912, 3: 250.

11. Ruskin 1856, 74; Ruskin 1903–1912, 13: 166.

12. Butlin and Joll 1984 (see biography), 1: 260.

13. The letter is quoted, with reasons given for the dating, in Butlin and Joll 1984 (see biography), 1: 259.

14. Turner to William Wethered, 7 October 1844 (Gage 1980, 200, no. 270; reprinted in Butlin and Joll 1984 [see biog-

raphy], 1: 259). The possibility that this letter refers to Wethered having commissioned the National Gallery's picture (and that the latter was not thus the exhibited picture of 1844) is made less likely by the evidence of Wethered's letter to Etty, apparently written in the autumn of 1844 (and if later, probably not much later), as it is on paper watermarked 1844 and mentions an Etty exhibit at the Academy of 1844. The question is whether Turner could have painted another *Approach to Venice* between October 1844 and the date when Etty saw Wethered's picture (*The Approach to Venice* as described in Wethered's letter). If the Washington picture *is* the painting referred to by Turner, one would be obliged to posit a missing canvas as candidate for the Royal Academy of 1844, no. 356.

15. W. G. Rawlinson, *The Engraved Work of J. M. W. Turner, R.A.* (London, 1908–1913), 2: no. 679.

References

1844 *Times* (London), 8 May 1844.
1844 *Spectator*, 17, no. 828, 11 May 1844: 451.
1848 Ruskin, John. *Modern Painters.* 5 vols. London, 1843–1856, 1 (5th ed., 1848): 136. (*The Works of John Ruskin.* Edited by E. T. Cook and Alexander Wedderburn. 39 vols. London and New York, 1903–1912, 3: 250).
1856 Ruskin, John. *Notes on the Turner Gallery at Marlborough House.* London, 1856: 74. (*The Works of John Ruskin.* Edited by E. T. Cook and Alexander Wedderburn. 39 vols. London and New York, 1903–1912, 13: 166).
1878 Ruskin, John. *Notes by Mr Ruskin on His Collection of Drawings by the late J. M. W. Turner, R.A.* London, 1878: 10. (*The Works of John Ruskin.* Edited by E. T. Cook and Alexander Wedderburn. 39 vols. London and New York, 1903–1912, 13: 409).
1971 Dugdale, James. "Sir Charles Tennant: The Story of a Victorian Collector." *Conn* 178 (1971): 8–9, 12, color repro. 2.
1976 Walker 1976: no. 604, color repro.
1980 Gage, John. *Collected Correspondence of J. M. W. Turner.* Oxford, 1980: 200, no. 270.
1984 Butlin and Joll 1984 (see biography), 1: no. 412; 2: pl. 417.
1986 Chapel, Jeannie. "The Turner Collector: Joseph Gillott, 1799–1872." *Turner Studies* 6 (1986): 47.

Unknown British Artists

1947.17.91 (999)

Portrait of a Gentleman

c. 1650/1655
Oil on canvas, 55.5 × 48 (21⅞ × 18⅞)
Andrew W. Mellon Collection

Inscriptions:
Falsely inscribed on reverse of canvas in ink: *Gov^r. Ri./Bellingham Effigies* [sic]/*Delind Boston Anno Dom. 1641/Aetatis 49 W.R.*

Technical Notes: The medium-weight canvas is coarsely-plain woven; although it has not been lined, none of the tacking margins survives intact and an old canvas strip lining, covering about a quarter of an inch of each edge, is attached to the face of the painting. The ground is reddish brown. A dark gray to black imprimatura is applied locally under the head as a basis for the flesh tones. The painting is executed thinly with some low impasto in the highlights, in broad, primitive brush-strokes. The paint surface is severely abraded and extensively retouched throughout; there are large losses in the forehead. The natural resin varnish has discolored yellow to a significant degree.

Provenance: (Rose M. de Forest), New York, who sold it 29 December 1924 to Thomas B. Clarke [d. 1931], New York, as a portrait of Richard Bellingham by William Read. Sold by Clarke's executors in 1935 to (M. Knoedler & Co.), New York, from whom it was purchased January 1936, as part of the Clarke collection, by The A. W. Mellon Educational and Charitable Trust, Pittsburgh.

Exhibitions: *Earliest Known Portraits of Americans Painted in This Country by Painters of the Seventeenth and Eighteenth Centuries,* Century Association, New York, 1925, no. 6. *Portraits by Early American Artists of the Seventeenth, Eighteenth and Nineteenth Centuries Collected by Thomas B. Clarke,* Philadelphia Museum of Art, 1928, unpaginated and unnumbered.

THERE IS no visual evidence to support the identification of the sitter as Richard Bellingham (1592–1672), governor of Massachusetts, and the provenance from Captain Edward Pelham, nephew of Mrs. Bellingham, supplied by the dealer, de Forest, cannot be verified. There is, moreover, no reason why Bellingham should be wearing the scarlet gown of a doctor of divinity in the University of Oxford or Cambridge, as the sitter in this portrait is.

The attribution to William Read, an artist living in Boston who was selected in 1665 to draw up a map of the colony of Massachusetts, based on the initials W.R. in the inscription, which was upheld by Sherman,[1] has been

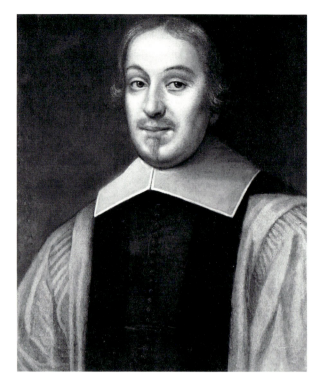

Unknown British Artist, *Portrait of a Gentleman*, 1947.17.91

unanimously discounted.[2] Although the portrait was described and illustrated in fashionable art magazines and elsewhere in the late 1920s,[3] both the attribution and the identification were doubted as early as 1930.[4] Bland said that he had been informed by a New York art dealer that he (the dealer) brought this and other portraits over from England as unknowns, and Morgan averred that the story was well known on Fifty-seventh Street that the inscription on this work (claimed to be the earliest known portrait painted in America) was put on after the portrait came to America.[5] Rejected by Campbell as American in 1970, the portrait was catalogued both by him and by Wilmerding as unknown European school.[6]

The English origin of the portrait, supported by Sawitsky,[7] is confirmed by the costume. The sitter, who is wearing a cassock beneath his scarlet gown, is presumably a clerical college fellow; the unfashionably short hair was characteristic of clergymen and scholars at that time. The white linen collar follows the fashionable line of the early to mid-1650s.[8] The picture is coarsely painted, and is evidently the work of a provincial painter.

Notes
1. Sherman 1932, 6.
2. See William P. Campbell, memorandum, 22 November 1965, in NGA curatorial files.

3. Dana Carroll, "Early American Portrait Painting," *IntSt* 86 (1927), 66–68, repro. 65; Cuthbert Lee, "The Thomas B. Clarke Collection of Early American Portraits," *American Magazine of Art* 19 (1928), 295, repro. 293; William Salisbury, "Colonial American Old Masters," *Antiquarian* 12 (1929), 49, repro. 50; Frank Jewett Mather, Charles Rufus Morey, and William James Henderson, *The American Spirit in Art* (New Haven, 1927), 6, repro.
4. By A. F. Cochrane in the *Boston Transcript*, 28 June 1930, and by Charles K. Bolton in the *Boston Transcript*, 28 January 1931.
5. Undated notes by H. M. Bland and John Hill Morgan, in NGA curatorial files.
6. NGA 1970, 172; NGA 1980, 308.
7. Notes from a course on early American painting given by William Sawitsky at the Institute of Fine Arts, New York, c. 1940, typescript in NGA curatorial files.
8. Costume report by Aileen Ribeiro, February 1988, in NGA curatorial files.

References
1932 Sherman, Frederic Fairchild. *Early American Painting.* New York and London, 1932: 6–8, pl. 1.
1970 NGA 1970: 172, repro. 173.
1980 NGA 1980: 308.

1947.17.64 (972)

Portrait of a Gentleman

c. 1695/1710
Oil on canvas, 74.5 × 64 (29¼ × 25¼)
Andrew W. Mellon Collection

Inscriptions:
Inscribed at bottom right: *Henrietta Johnston Fecit A⁰ 1718*

Technical Notes: The medium-weight canvas is plain woven; it has been mounted onto wooden composition board. The ground appears to be white. There is possibly a reddish-brown imprimatura. The composition is oval in format; the area outside the oval is painted in light brown. The painting is executed fairly thinly with virtually no impasto. The paint surface has been abraded in the darks, which are extensively repainted; a large tear in the lower right quadrant has been repaired. A fringed muslin cravat, now very abraded, has been painted over the lace cravat. The thick, natural resin varnish has discolored yellow to a moderate degree.

Provenance: (Rose M. de Forest), New York, who sold it 29 November 1926 to Thomas B. Clarke [d. 1931], New York, as a portrait of Robert Johnson by Henrietta Johnston. Sold by Clarke's executors 1935 to (M. Knoedler & Co.), New York, from whom it was purchased January 1936, as part of the Clarke collection, by The A. W. Mellon Educational and Charitable Trust, Pittsburgh.

Exhibitions: *Paintings by Early American Portrait Painters,*

Century Association, New York, 1928, no. 12. *Portraits by Early American Artists of the Seventeeth, Eighteenth and Nineteenth Centuries Collected by Thomas B. Clarke*, Philadelphia Museum of Art, 1928, unpaginated and unnumbered.

THERE IS no visual evidence to support the identification of the sitter as Robert Johnson (1677–1735), governor of South Carolina; a portrait said to be of Johnson (Dr. and Mrs. John Ward collection, Doylestown, Pennsylvania) bears no resemblance to the Gallery's picture. Nor can the provenance from Colonel John Moore of South Carolina and New York, supplied by the dealer, de Forest, be verified.

Although it has not been possible, either by chemical test or microscopic examination, to prove or disprove the authenticity of the signature,[1] Lane suspected the calligraphy of being that of Augustus de Forest.[2] Moreover, the evidence of costume suggests an earlier date for the portrait than 1718. The long and elaborately curled periwig, full over the forehead, and the lace cravat, were characteristic of English fashion in the 1690s.[3]

The attribution to Henrietta Johnston, based on what is evidently a spurious inscription, was upheld by Sherman,[4] although the artist had been known hitherto solely as a pastelist. This opinion, already challenged by Willis as early as 1927,[5] was rejected by Sawitsky, who argued that the dry, hard technique was uncharacteristic of Johnston's work,[6] and the attribution was subsequently unanimously discounted;[7] Middleton, in her monograph on Johnston, did not even mention the painting.[8] Questioned by Campbell as American in 1970,[9] the portrait was rejected by Wilmerding as such in 1980 but not reattributed.[10]

Both Ross Watson[11] and Sir Ellis Waterhouse proposed British authorship, Waterhouse suggesting an artist like Sir John Medina,[12] who settled in Edinburgh about 1693 to 1694; but Medina is far more painterly, with a strong feeling for character, and the dry, hard, sculptural modeling is closest to the style of Richard van Bleeck, a Dutch artist who first visited London in 1695, though it is not of sufficient quality for the picture to be attributed to him. The design is based on John Smith's engraving, 1695, of a portrait of William III by Kneller.

Notes

1. An examination was conducted by Francis Sullivan, resident restorer at the National Gallery, note, 17 December 1968, in NGA curatorial files.

2. James W. Lane, memorandum, 21 April 1951, in NGA curatorial files.

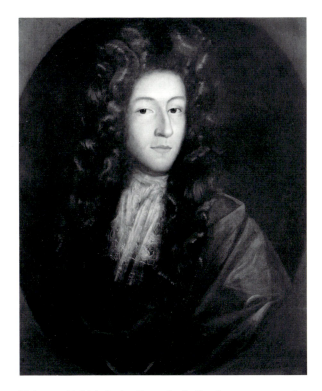

Unknown British Artist, *Portrait of a Gentleman*, 1947.17.64

3. Costume report by Aileen Ribeiro, February 1988, in NGA curatorial files.

4. Sherman 1932, 14.

5. "No one conversant with art could imagine that the same hand [responsible for the delicately colored pastels] executed the heavily painted oil portrait of the Proprietary Governor of Carolina" (Willis 1927, 13).

6. Notes from a course on early American painting given by William Sawitsky at the Institute of Fine Arts, New York, c. 1940, typescript in NGA curatorial files.

7. See William P. Campbell, memorandum, 17 April 1964, in NGA curatorial files.

8. Margaret Simons Middleton, *Henrietta Johnston of Charles Town, South Carolina, America's First Pastellist* (Columbia, S.C., 1966).

9. NGA 1970, 160.

10. NGA 1980, 308.

11. Opinion recorded in note, February 1969, in NGA curatorial files.

12. Opinion recorded in undated note, in NGA curatorial files.

References
1927 Willis, Eola. "The First Woman Painter in America." *IntSt* 87 (July 1927): 13.

1928 Willis, Eola. "Henrietta Johnston, South Carolina Pastellist." *Antiquarian* 11 (1928): 46, repro.

1932 Sherman, Frederick Fairchild. *Early American Painting*. New York and London, 1932: 14.

1970 NGA 1970: 160, repro. 161.

1980 NGA 1980: 308.

Unknown British Artist, *Portrait of a Lady*, 1947.17.39

1947.17.39 (947)

Portrait of a Lady

c. 1700/1750
Oil on canvas, 76 × 64 (29⅞ × 25¼)
Andrew W. Mellon Collection

Inscriptions:
Falsely inscribed in ink on a label pasted onto stretcher: *Ann Sinclair Crommelin A^et 34/Evert Duyckinck Pinx./G. Ver Planck*

Technical Notes: The medium-weight canvas is plain woven; it has been lined. The ground is warm light brown, composed largely of white lead, and scraped on irregularly with a knife. The painting is executed smoothly in the flesh tones and background, broadly and roughly in the costume. The paint surface is severely abraded and extensively repainted; notably, the background has been completely restored, the form, texture, and highlights of the hair are repaint, and the folds of the blue shawl are heavily reinforced. The moderately thick natural resin varnish has discolored slightly.

Provenance: (Rose M. de Forest), New York, who sold it 8 April 1922 to Thomas B. Clarke [d. 1931], New York, as a portrait of Ann Sinclair Crommelin by Evert Duyckinck III. Sold by Clarke's executors 1935 to (M. Knoedler & Co.), New York, from whom it was purchased January 1936, as part of the Clarke collection, by The A. W. Mellon Educational and Charitable Trust, Pittsburgh.

Exhibitions: *Earliest Known Portraits of Americans Painted in This Country by Painters of the Seventeenth and Eighteenth Centuries*, Century Association, New York, 1925, no. 7. *Portraits by Early American Artists of the Seventeenth, Eighteenth and Nineteenth Centuries Collected by Thomas B. Clarke*, Philadelphia Museum of Art, 1928, unpaginated and unnumbered.

THERE IS no visual evidence to support the identification of the sitter as Ann Sinclair, Mrs. Charles Crommelin (1691–1743), and the provenance from Maria Crommelin Ver Planck, daughter of the supposed sitter, supplied by the dealer, de Forest, cannot be verified. Lane and Rutledge stated that the calligraphy on the label pasted onto the stretcher was in a handwriting similar to manuscript material in the Clarke files and very similar to other inscriptions on pictures sold by de Forest; they concluded that the inscription was not genuine.[1]

The attribution to the supposed sitter's cousin, Evert Duyckinck III, based on the spurious inscription and upheld by Sherman,[2] has been unanimously discounted.[3] Sawitsky observed that the work of Evert Duyckinck III had up to the present not been identified and that no signature was known.[4] However, although Sir Ellis Waterhouse suggested that the portrait was probably Scottish,[5] no alternative attributions have been proposed. Rejected by Campbell as American in 1970, it was catalogued both by him and by Wilmerding as unknown European school.[6]

The evidence of costume supports the British authorship of the painting but provides only the vaguest clue as to date. The sitter is depicted in the antique manner, with a fringed scarf draped over the breast and fastened at the shoulder with a pearl brooch; the hair (which is in any case repainted) bears no resemblance to any style prevalent in the eighteenth century and may have been intended to reinforce this impression. This kind of dress was especially popular in England and Scotland, and continued as an artistic convention until the 1740s.[7] The modeling of the head is not undistinguished, but there are no obvious stylistic affinities.

Notes
1. James Lane and Anna Rutledge, report on the Clarke collection, 1952, quoted by William P. Campbell, memorandum, 28 June 1965, in NGA curatorial files.

2. Sherman 1932, 12.

3. See William P. Campbell, memorandum, 28 June 1965, in NGA curatorial files.

4. William Sawitsky, undated note, in NGA curatorial files.

5. Opinion recorded by William P. Campbell, note, 29 April 1975, in NGA curatorial files.

6. NGA 1970, 170; NGA 1980, 307.

7. Costume report by Aileen Ribeiro, February 1988, in NGA curatorial files.

References

1932 Sherman, Frederick Fairchild. *Early American Painting*. New York and London, 1932: 12.

1970 NGA 1970: 170, repro. 171.

1980 NGA 1980: 307.

1947.17.27 (935)

Portrait of a Lady

c. 1705/1710
Oil on canvas, 103.8 × 76.5 (40⅞ × 30⅛)
Andrew W. Mellon Collection

Inscriptions:
Falsely inscribed in ink on stretcher: *Ann Brown Hamilton showing/Effigie of Andrew her husband/Charles Bridges*

Unknown British Artist, *Portrait of a Lady*, 1947.17.27

Fig. 1. Sir Godfrey Kneller, *The Hon. Lady Mostyn*, 1705, from the mezzotint by John Smith, London, National Portrait Gallery [photo: Barnes and Webster]

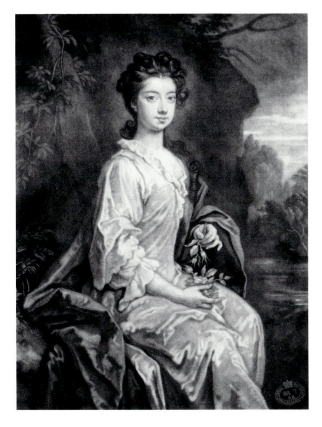

Technical Notes: The medium-weight canvas is fairly coarsely plain woven; it has been lined, but the original tacking margins survive intact. The ground is brown, thinly applied. There appears to be a light-colored, locally applied, underpainted layer beneath the dress. The painting is executed smoothly and fluidly in opaque layers, with little impasto. The original canvas is penetrated by numerous splits and tears in the lower half, and is traversed by bulges and surface deformations. The lining canvas has been torn off around the inscription. The paint surface is in good condition except for slight abrasion in the background darks. The natural resin varnish has discolored yellow to a moderate degree.

Provenance: (Rose M. de Forest), New York, who sold it 30 April 1923 to Thomas B. Clarke [d. 1931], New York, as a portrait of Anne Brown Hamilton by Charles Bridges. Sold by Clarke's executors 1935 to (M. Knoedler & Co.), New York, from whom it was purchased January 1936, as part of the Clarke collection, by The A. W. Mellon Educational and Charitable Trust, Pittsburgh.

Exhibitions: *Earliest Known Portraits of Americans by Painters of the Seventeenth, Eighteenth and Nineteenth Centuries*, Union League Club, New York, 1924, no. 19. *Portraits by Early American Artists of the Seventeenth, Eighteenth and Nineteenth Cen-*

turies Collected by Thomas B. Clarke, Philadelphia Museum of Art, 1928, unpaginated and unnumbered.

THERE IS no visual evidence to support the identification of the sitter as Anne Brown, later Mrs. Andrew Hamilton (c. 1685–1736), and no provenance—save that the portrait was purchased from the descendants of the sitter—was provided by the dealer, de Forest. The identification and attribution thus hinge on the authenticity of the inscription. The inscription is on the original canvas, and the relining canvas is probably mid-nineteenth century;[1] however, it would have been perfectly easy for a forger to have torn away part of the relining canvas and to have written the spurious inscription on the original canvas beneath. Foote stated that "No other portrait . . . which can with any assurance be attributed to Bridges, bears any such inscription."[2] Sawitsky rejected the attribution to Bridges,[3] and these authoritative opinions have received general support.[4] Art-historical judgment, and the connection with de Forest, militate strongly against the inscription being genuine. Questioned by Campbell as American in 1970,[5] the portrait was rejected by Wilmerding as such in 1980, but not reattributed.[6]

Although Burroughs had suggested an attribution to Hesselius,[7] and Ross Watson thought that the portrait was unlikely to be British on account of the light tonality and rocky background,[8] Sir Ellis Waterhouse affirmed that the work was by a provincial English painter.[9] The pose is taken from Kneller: the erect posture against a rocky background, and the positioning of the hands (though here holding a miniature and its case and not plants), are identical in reverse with John Smith's mezzotint (fig. 1) after Kneller's portrait of the Hon. Lady Mostyn, painted in 1705 (whereabouts unknown).

The hair style, swept up in waves, was characteristic of high fashion in England in the later 1690s, and continued in vogue in the 1700s. The costume is generalized and, as drapery with a life of its own, follows in the Lely tradition;[10] more bravura treatment of drapery is found in the work of Soest or in such portraits by Riley and Closterman as their Elizabeth Geers.[11]

Notes
1. According to Francis Sullivan, resident restorer at the National Gallery (James Lane and Anna Rutledge, report on the Clarke collection, 1952, quoted by William P. Campbell, memorandum, 22 June 1965, in NGA curatorial files).
2. Quoted by William P. Campbell, memorandum, 22 June 1965, in NGA curatorial files.
3. William Sawitsky, undated note, in NGA curatorial files.

4. See William P. Campbell, memorandum, 22 June 1965, in NGA curatorial files.
5. NGA 1970, 158.
6. NGA 1980, 306.
7. Alan Burroughs, note, 3 October 1939, in NGA curatorial files.
8. Unsigned note, February 1969, in NGA curatorial files.
9. Opinion recorded by William P. Campbell, note, 29 April 1975, in NGA curatorial files.
10. Costume report by Aileen Ribeiro, February 1988, in NGA curatorial files.
11. Anonymous sale, Sotheby & Co., 27 May 1987, no. 229 (by descent from the sitter).

References
1970 NGA 1970: 158, repro. 159.
1980 NGA 1980: 306.

1947.17.94 (1002)

Portrait of a Gentleman

c. 1710/1720
Oil on canvas, 76.2 × 63.5 (30 × 25)
Andrew W. Mellon Collection

Inscriptions:
Falsely inscribed at lower right: *Jo. Smibert ft., 173*[9] [the last digit not fully legible]

Technical Notes: The medium-weight canvas is plain woven; it has been lined. The ground is pale gray or beige, thinly applied. The painting is executed in smoothly blended layers in the face and hair, with unblended, drier brushwork in the drapery; there is low brushwork texture in most of the lighter areas. The background gray ends in curved forms in the upper corners, as if the painting were meant to be an oval. The "signature" was found in 1965 to be a recent addition, applied over already abraded paint and readily soluble. The contours of the face and cravat, and parts of the hair, are severely abraded; the background is slightly abraded. There is a band of overpainted losses along the bottom edge, and more recent retouching along the contour on the right side of the sitter's face, in the bottom left corner, and above the "signature." The thick, natural resin varnish has discolored to a significant degree.

Provenance: (Rose M. de Forest), New York, who sold it 13 January 1919 to Thomas B. Clarke [d. 1931], New York, as a portrait of William Shirley by John Smibert. Sold by Clarke's executors 1935 to (M. Knoedler & Co.), New York, from whom it was purchased January 1936, as part of the Clarke collection, by The A. W. Mellon Educational and Charitable Trust, Pittsburgh.

Exhibitions: *Portraits by Early American Artists of the Seventeenth, Eighteenth and Nineteenth Centuries Collected by Thomas B. Clarke*, Philadelphia Museum of Art, 1928, unpaginated

and unnumbered. *American Historical Paintings*, Golden Gate International Exposition, San Francisco, 1939, no. 21.

THE SITTER in the Gallery's picture bears no resemblance to the extant portraits of William Shirley (1693–1771), governor of Massachusetts, by Smibert and Hudson,[1] thus ruling out the identification; moreover, the provenance from William Shirley, son of the supposed sitter, supplied by the dealer, de Forest, which was regarded by Foote as open to question,[2] cannot be verified. The evidence of the costume also militates against the identification, since the short full-bottomed wig worn by the sitter is characteristic of English fashion in the 1710s;[3] by 1720 Shirley was twenty-seven, and the sitter in this portrait must be some years older.

The signature, the date on which, 173[9], is ruled out by the evidence of costume, was shown to be a forgery when a chemical test was conducted.[4] The attribution to Smibert in any case has been unanimously discounted.[5] Sawitsky thought the portrait was by an as yet unidentified Boston painter by whom several other portraits are known,[6] but both Burroughs and Foote believed the work was English and by a follower or contemporary of Kneller.[7] Questioned by Campbell as American in 1970,[8] the portrait was rejected by Wilmerding as such in 1980 but not reattributed.[9]

Sir Ellis Waterhouse concurred in the attribution to an English artist;[10] Ellen Miles has suggested an artist working in England, but of Dutch or German origin.[11] The style is closest, however, to the modeling and dour characterization of Thomas Murray (1663–1735),[12] a Scottish artist who was a pupil of John Riley, though the portrait is not of sufficiently high quality to be attributed to that artist.

Notes

1. The whereabouts of the Smibert, which was engraved in 1747, is unknown. One portrait by Hudson, painted in 1750, is in the National Portrait Gallery, Washington; another is in the State House, Boston.
2. Foote 1950, 244.
3. Costume report by Aileen Ribeiro, February 1988, in NGA curatorial files.
4. By Francis Sullivan, resident restorer at the National Gallery, recorded by Dorinda Evans, note, 17 March 1969, in NGA curatorial files.
5. William P. Campbell, memorandum, 7 December 1965, in NGA curatorial files.
6. William Sawitsky, undated note, in NGA curatorial files.
7. Alan Burroughs, note, 3 October 1939, in NGA curatorial files; Foote 1950, 244.

Unknown British Artist, *Portrait of a Gentleman*, 1947.17.94

8. NGA 1970, 162.
9. NGA 1980, 309.
10. Opinion recorded by William P. Campbell, note, 29 April 1975, in NGA curatorial files.
11. Opinion (1980) cited in undated current attribution memorandum in NGA curatorial files.
12. Compare, in particular, Murray's portrait of Edmund Halley, signed and dated 1712 (Queen's College, Oxford), engraved by John Faber, 1722.

References

1950 Foote, Henry Wilder. *John Smibert*. Cambridge, Mass., 1950: 94 n., 109, 244.
1970 NGA 1970: 162, repro. 163.
1980 NGA 1980: 309.

1947.17.49 (957)

Portrait of a Gentleman

c. 1740/1750
Oil on canvas, 127 × 101.7 (50 × 40)
Andrew W. Mellon Collection

Inscriptions:
At lower left in red paint: *R.F. Pinx/1748*.

Unknown British Artist, *Portrait of a Gentleman*, 1947.17.49

Technical Notes: The fine canvas is plain woven; it has been lined. The ground is a translucent white with additives that may be chalk with an admixture of white lead. The painting is executed in opaque, smoothly applied layers slightly thicker in the figure than in the background; the forms are broad and generalized, and there is little articulation of detail. The painting has been abraded by solvent action, most noticeably in the background and dark areas. The inscription is evidently of later date since it was painted over cracks and abrasions. There is marked craquelure, but little retouching. The thick, uneven natural resin varnish has discolored moderately.

Provenance: (Rose M. de Forest), New York, who sold it 29 September 1930 to Thomas B. Clarke [d. 1931], New York, as a portrait of Judge Foster Hutchinson by Robert Feke. Sold by Clarke's executors 1935 to (M. Knoedler & Co.), New York, from whom it was purchased January 1936, as part of the Clarke collection, by The A. W. Mellon Educational and Charitable Trust, Pittsburgh.

THERE IS no visual evidence to support the identification of the sitter as Foster Hutchinson (1724–1799), the distinguished American judge, and the provenance from the Trowbridge family of Massachusetts supplied by the dealer, de Forest, has been shown by archival research to be spurious.[1] The signature was shown to lie on top of abrasions when examined under a magnifying glass.[2]

The attribution to Robert Feke, based on the spurious inscription and upheld by Foote,[3] has been generally discounted.[4] Feke's work has greater vitality, though it can be understood why it was thought plausible in this case to add the fake inscription. Sawitsky thought the work was by a minor British painter.[5] Rejected by Campbell as American in 1970, the portrait was reattributed by him to the British school,[6] an opinion confirmed by Wilmerding.[7] Although very wooden in handling, the portrait is consciously in the mold of Thomas Hudson, the leading British portraitist of the day, as pointed out by Burroughs.[8]

The costume, notably the coat cut to meet only at the chest, suggests a date of about 1740 to 1750. The hump-backed bridge seen in the background is a typically British construction not found in the American colonies. The meaning of the letter held so prominently in the sitter's left hand can no longer be interpreted.

Notes
1. Clifford K. Shipton, letter, 6 September 1949, in NGA curatorial files.
2. Dorinda Evans, note, 9 January 1969, in NGA curatorial files.
3. Foote 1930, supplementary note, between x and xi.
4. See William P. Campbell, memorandum, 10 April 1964, in NGA curatorial files.
5. William Sawitsky, undated note, in NGA curatorial files.
6. NGA 1970, 166.
7. NGA 1980, 308.
8. Alan Burroughs, undated note, in NGA curatorial files

References
1930 Foote, Henry Wilder. *Robert Feke, Colonial Portrait Painter.* Cambridge, Mass., 1930: supplementary note between x and xi.
1970 NGA 1970: 166, repro. 167.
1980 NGA 1980: 308.

1947.17.43 (951)

Portrait of a Gentleman

c. 1750/1765 (or imitative of that period)
Oil on canvas, 75.5 × 63 (29¾ × 24¾)
Andrew W. Mellon Collection

Inscriptions:
Falsely inscribed at bottom right: *Edward Truman*

Technical Notes: The canvas is plain woven; it was lined in 1924. The paint and ground continue over the tacking edges and are severely broken at the foldovers, indicating that the picture has been reduced in format. The ground is white, fairly thickly applied. There is a warm gray imprimatura, which is used as an intermediate tone in the face. The painting is executed very thinly, in fluid, opaque paint; the handling is very direct, with forms represented by "drawn" lines of fluid paint and modeling constructed with unmodulated additions of paint. The thick, lumpy glue used in lining has caused corner draws, bulges, and buckling throughout. The paint surface has been abraded in the darks and in the background, and much of the left background has been repainted; the lower portion of the mouth and the sitter's right eyebrow, eyebrow fold, and outer corner of the eyeball have been heavily retouched. The thick, natural resin varnish has discolored yellow to a significant degree.

Provenance: (Rose M. de Forest), New York, who sold it 13 August 1930 to Thomas B. Clarke [d. 1931], New York, as a portrait of Jonathan Sewell by Edward Truman. Sold by Clarke's executors 1935 to (M. Knoedler & Co.), New York, from whom it was purchased January 1936, as part of the Clarke collection, by The A. W. Mellon Educational and Charitable Trust, Pittsburgh.

THERE IS no visual evidence to support the identification of the sitter as Jonathan Sewell (1728–1796), attorney-general of Massachusetts, and the provenance from Chambers Russell, a friend of the supposed sitter, supplied by the dealer de Forest, has been questioned,[1] and cannot be verified.

The signature was shown to be a forgery when a chemical test was conducted.[2] Portraits by Edward Truman are extremely rare. Burroughs, although accepting that Truman's style was, therefore, difficult to define, regarded the Gallery's picture as close in pattern and in the brushwork in the costume to Truman's only signed work, the portrait of Thomas Hutchinson in the Massachusetts Historical Society.[3] All other authorities have been unanimous in rejecting the attribution.[4]

Clare correctly thought that the portrait was related to the work of Arthur Devis or to the English conversation piece tradition.[5] The pose is informal and the tonality light, characteristic of English rococo painting; but the handling is stiff and awkward, and it is difficult to relate the portrait to the circle of any specific artist. Questioned by Campbell as American in 1970,[6] the portrait was rejected by Wilmerding as such in 1980 but not reattributed.[7]

The portrait seems to date to the mid-eighteenth century. The small standing collar and the cuffs *à la marinière* (cuffs in a naval style with vertical flaps edged with

Unknown British Artist, *Portrait of a Gentleman*, 1947.17.43

three or four buttons) were characteristic of English fashion in the 1750s and early 1760s. The sitter is wearing his own hair, which emphasizes the informality of the conception. Part of the dress is, however, both misunderstood and puzzling. The waistcoat, for example, intended to be double breasted, with appropriate buttons, looks as though it were single breasted; nor is the fashion characteristic of the period. The cut of the coat is strange, as are the coat buttons.[8] These discrepancies arouse suspicions about the status of the painting, which are reinforced by the design, which gives the appearance of being cut down (see also the technical notes), and by the unusual, direct technique employed by the artist. Scientific examination has not, however, revealed any evidence that would indicate that the portrait was executed later than the eighteenth century.[9]

Notes
1. By John Hill Morgan, undated note, in NGA curatorial files, and by James Lane and Anna Rutledge, report on the Clarke collection, 1952, quoted by William P. Campbell, memorandum, 24 January 1966, in NGA curatorial files.

2. By Francis Sullivan, resident restorer at the National Gallery, unsigned note, 5 December 1968, in NGA curatorial files.

3. Alan Burroughs, note, 3 October 1939, in NGA curatorial files.

4. William P. Campbell, memorandum, 24 January 1966, in NGA curatorial files.

5. Elizabeth Clare, note, 15 May 1963, in NGA curatorial files.

6. NGA 1970, 160.

7. NGA 1980, 309.

8. Costume report by Aileen Ribeiro, February 1988, in NGA curatorial files.

9. The painting was analyzed by Ellen Salzman, of the Gallery's Science Department, in February 1989, using x-ray fluorescence spectrometry; additionally, microscopic analysis of a pigment scraping from the blue coat identified natural ultramarine.

References
1970 NGA 1970: 160, repro. 161.
1980 NGA 1980: 309.

1947.17.48 (956)

Portrait of a Lady

c. 1770/1775
Oil on canvas, 93.3 × 71.8 (36¾ × 28¼)
Andrew W. Mellon Collection

Inscriptions:
Falsely inscribed upside down on left-hand page of book: *R Feke* [word illegible]/*1748*

Technical Notes: The canvas is finely plain woven; it has been lined, and there is an interlayer fabric between the two supports. The painting has been enlarged at the top with a strip of additional fabric 6.5 cm. wide. The ground is white, and is coarse and granular. The painting is executed in thin glazes in the hair, the shadows of the flesh and drapery, and the red brocade of the chair back, and in thicker, more opaque layers in the flesh tones and highlights of the costume, with slight impasto in the white fringe of the shawl. The "signature" has been shown to be false since it continues into cracks in the underlying paint film. The paint surface has been severely abraded throughout, especially in the thinly applied glazes in the shadows of the face and hands and in the hair. The abraded eyes, nose, and lips have all been reinforced, and numerous scattered losses in the head have been infilled. Some areas of the drapery have been heavily retouched, and the background has been almost completely repainted. The natural resin varnish has discolored yellow to a moderate degree.

Provenance: (Rose M. de Forest), New York, who sold it 19 September 1922 to Thomas B. Clarke [d. 1931], New York, as a portrait of Ruth Cunningham by Robert Feke. Sold by Clarke's executors in 1935 to (M. Knoedler & Co.), New York, from whom it was purchased January 1936, as part of the Clarke collection, by The A. W. Mellon Educational and Charitable Trust, Pittsburgh.

Exhibitions: *Portraits by Early American Portrait Painters*, Union League Club, New York, 1923, no. 5. *Paintings by Early American Portrait Painters*, Century Association, New York, 1926, no. 3. *Portraits by Early American Artists of the Seventeenth, Eighteenth and Nineteenth Centuries Collected by Thomas B. Clarke*, Philadelphia Museum of Art, 1928, unpaginated and unnumbered.

THE SITTER in the Gallery's picture bears no resemblance to the portrait of Ruth Cunningham, later Mrs. James Otis (1729–1789), painted by Joseph Blackburn in Boston in 1755,[1] thus ruling out the identification; moreover, the provenance from Nathaniel Cunningham of Cambridge, Massachusetts, brother of the supposed sitter, supplied by the dealer, de Forest, has been regarded with suspicion[2] and cannot be verified.

The signature was shown to be false when it was tested.[3] The attribution to Robert Feke, based on the spurious inscription and upheld in Clarke's lifetime by Sherman,[4] Foote,[5] and Bolton and Binsse,[6] has been generally dis-

Unknown British Artist, *Portrait of a Lady*, 1947.17.48

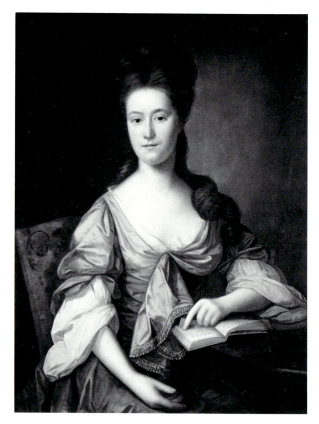

counted. Sawitsky argued that the portrait was by Matthew Pratt;[7] but the work lacks Pratt's precise definition of features. Burroughs believed that it was probably an English picture.[8] The American attribution was upheld by Wilmerding as recently as 1980.[9]

Sawitsky and Morgan, supported later by Lane and Rutledge, agreed that, on the evidence of costume, the picture must date to the 1760s.[10] However, the hair is fairly high piled, and falls in thick tresses over the shoulders, in a manner characteristic of English fashion in the early 1770s;[11] the generalized classical gown, with sleeves hitched up, is typical of the costume Reynolds adopted for many of his female portraits from about 1765.

The picture is evidently broadly in the Reynolds manner. The bland modeling of the head, and the classical draperies, are characteristic of Richard Brompton (c. 1734–1783), but are closer still to the style of Hugh Barron (1747–1791), who was apprenticed to Reynolds. Neither the empty expression of the head, nor the quality generally, suggest that the work is actually by either of these artists.

The word SPRING is legible at the top of the page the sitter is turning; the volume is evidently James Thomson's *The Seasons*, a georgic poem that was one of the most popular and influential books of the eighteenth century.

Notes

1. Last recorded in the ownership of Frances R. Porter, Washington (who deposited it on loan at the Museum of Fine Arts, Boston, 1925–1937).
2. See John Hill Morgan, undated note, in NGA curatorial files.
3. By Francis Sullivan, resident restorer at the National Gallery (William P. Campbell and Dorinda Evans, note, 17 December 1968, in NGA curatorial files).
4. Sherman 1923, 328–333.
5. Foote 1930, 74–75, 105, 137–138, 211, 213.
6. Bolton and Binsse 1930, 35.
7. Sawitsky 1942, 49.
8. Alan Burroughs, note, 3 October 1939, in NGA curatorial files.
9. NGA 1980, 287.
10. William Sawitsky, undated note; John Hill Morgan, undated note; James Lane and Anna Rutledge, report on the Clarke collection, 1952, quoted by William P. Campbell, memorandum, 2 July 1965, in NGA curatorial files. See also Sawitsky 1942, 50.
11. See, in particular, Reynolds' portrait of Ann, Duchess of Cumberland, exhibited at the Royal Academy in 1773 (Ellis K. Waterhouse, *Reynolds* [London, 1941], pl. 146).

References

1923 Sherman, Frederic F. "Four Examples of American Portraiture." *AAm* 11 (1923): 328–333, repro. 329.

1928 Lee, Cuthbert. "The Thomas B. Clarke Collection of Early American Portraits." *American Magazine of Art* 19 (1928): 300, repro. 296.

1930 Foote, Henry Wilder. *Robert Feke*. Cambridge, Mass., 1930: 74–75, 105, 137–138, 211, 213.

1930 Bolton, Theodore, and Henry Lorin Binsse. "Robert Feke, First Painter to Colonial Aristocracy." *Antiquarian* 15 (1930): 35, repro.

1942 Sawitsky, William. *Matthew Pratt 1734–1805*. New York, 1942: 48–50, pl. 13, details 42, 43.

1943 Burroughs, Alan. Review of Sawitsky's *Matthew Pratt*. *AB* 25 (1943): 280.

1980 NGA 1980: 287, repro.

1942.8.24 (577)

Robert Thew (?)

c. 1780/1790
Oil on canvas, 90 × 71 (35⅜ × 28)
Andrew W. Mellon Collection

Technical Notes: The medium-weight canvas is plain woven; it was lined between 1943 and 1944. Only the bottom tacking margin survives intact; this has been flattened and incorporated into the bottom of the picture plane. The proprietary white ground is of moderate thickness. X-radiographs show a white undermodeling in the flesh tones. The painting is fluidly executed with a restrained brushwork, texture being confined to the whites of the collar and cuff. Most of the portrait is constructed in a series of broad planes of color modified by linear areas of shading; the face and hair are handled more tightly. Overall the application is draftsmanlike rather than painterly. There is pronounced craquelure and traction crackle. The paint surface has been slightly abraded by solvent action, and the impasto slightly flattened during lining. Retouching is largely concentrated near the bottom edge; the red tablecloth is heavily overpainted and what was originally the sitter's left hand is crudely restored. The thick varnish layers, most recently a natural resin, have discolored yellow to a moderate degree.

Provenance: (Henry Graves & Co.), London, 1884, who sold it c. 1884 to (Samuel P. Avery), New York, as by Gilbert Stuart. Daniel F. Appleton, New York; by inheritance to his son, James W. Appleton, Ipswich, Massachusetts, from whom it was purchased 3 May 1921 by Thomas B. Clarke [d. 1931], New York. Sold by Clarke's executors 1935 to (M. Knoedler & Co.), New York, from whom it was purchased January 1936, as part of the Clarke collection, by The A. W. Mellon Educational and Charitable Trust, Pittsburgh.

Exhibitions: *Paintings by Early American Portrait Painters*, Union League Club, New York, 1921, no. 2. *Portraits by Early American Artists of the Seventeenth, Eighteenth and Nineteenth Centuries Collected by Thomas B. Clarke*, Philadelphia Museum of Art, 1928, unpaginated and unnumbered. *Gilbert Stuart: Portraits Lent by the National Gallery of Art*, Virginia Museum

of Fine Arts, Richmond, 1943–1944, no. 2. *The Face of American History*, Columbia Museum of Art, South Carolina, 1950, no. 11, repro. *American Portraits from the National Gallery of Art*, Atlanta Art Association, High Museum of Art, Atlanta, 1951, no. 10, repro. *Inaugural Exhibition*, Hunter Museum of Art, Chattanooga, Tennessee, 1952, unnumbered. *Early American Paintings from the Mellon Collection*, Mint Museum of Art, Charlotte, North Carolina, 1952, no cat. *Famous Americans*, Washington County Museum of Fine Arts, Hagerstown, Maryland, 1955, no. cat.

THE PORTRAIT has always been known as Robert Thew, from the evidence of an old label formerly on the back.[1] The hairstyle, natural hair with somewhat frizzed side curls, and the double-breasted frock coat, with angular lapels and large buttons sewn close together, indicate a date in the 1780s. The sitter, judging by his heavy jowls, is probably in his fifties. These observations preclude the accepted identification as Robert Thew (1758–1802), the engraver,[2] who would have been in his twenties or early thirties at the time this picture was painted. According to the registers of Patrington, Yorkshire, where there were several Thew families and where the engraver was born, a Robert Thew, son of a mercer, was baptized in

Unknown British Artist, *Robert Thew (?)*, 1942.8.24

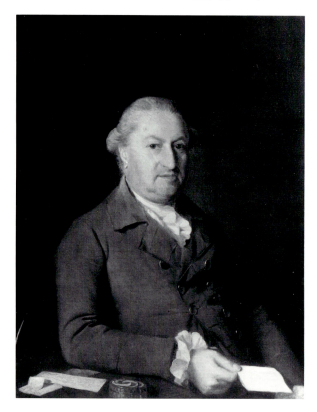

1739;[3] it is conceivable that he was the subject of the Washington picture, though age and costume would only just fit. No other portraits identified as a member of one of the Thew families are extant.

The traditional attribution to Gilbert Stuart, accepted by Park,[4] and upheld by Burroughs[5] and Sawitsky,[6] was rejected by Sir Ellis Waterhouse.[7] Watson thought the picture was Spanish or Italian,[8] but the former suggestion did not find favor with Xavier de Salas, who believed the portrait to be British.[9] Rejected by Campbell as American in 1970, the portrait was catalogued by him as unknown European school;[10] Wilmerding reattributed it to the British school.[11]

This example from the Clarke collection was imported well before the de Forest era. It is sensitively painted, and is a work of some quality. The attributes—quill pen, ink stand, and letters—suggest that the sitter, who is wearing a drab-colored coat, was an attorney or man of business.

Notes
1. The label, inscribed in ink: *ROBT THEW*, was removed when the picture was lined, and is in NGA curatorial files.
2. As was first pointed out by Dorinda Evans (memorandum, November 1968, in NGA curatorial files).
3. W. J. Peacey, then rector, letter, 6 May 1922, in NGA curatorial files.
4. Park 1926, 2: no. 833.
5. Alan Burroughs, note, 3 October 1939, in NGA curatorial files.
6. William Sawitsky, undated note, in NGA curatorial files.
7. Opinion recorded by William P. Campbell, note, 29 April 1975, in NGA curatorial files.
8. Ross Watson, note, February 1969, in NGA curatorial files.
9. Opinion recorded by William P. Campbell, note, 3 May 1976, in NGA curatorial files.
10. NGA 1970, 172.
11. NGA 1980, 309.

References
1926 Park, Lawrence. *Gilbert Stuart.* 4 vols. New York, 1926, 2: no. 833, repro.; 4: 517.
1970 NGA 1970: 172, repro. 173.
1980 NGA 1980: 308.

1954.1.7 (1191)

Portrait of a Gentleman

c. 1780/1790
Oil on canvas, oval, 37.4 × 30 (14¾ × 11¾)
Andrew W. Mellon Collection

Inscriptions:
Falsely inscribed at center left: *Henry Pelham pinx*

Technical Notes: The canvas is finely plain woven; it has been lined. The ground is white. The painting is executed in thin layers, with little modeling, and with very slight impasto in the highlights. The paint surface is severely abraded, with innumerable tiny losses and retouching throughout. The thick, natural resin varnish has discolored yellow to a significant degree.

Provenance: (Rose M. de Forest), New York, who sold it 1927 to Thomas B. Clarke [d. 1931], New York, as a portrait of John Cushing by Henry Pelham. Sold by Clarke's executors 1935 to (M. Knoedler & Co.), New York, from whom it was purchased January 1936, as part of the Clarke collection, by The A. W. Mellon Educational and Charitable Trust, Pittsburgh.

Exhibitions: *Paintings by Early American Portrait Painters*, Century Association, New York, 1928, no. 17. *Portraits by Early American Artists of the Seventeenth, Eighteenth and Nineteenth Centuries Collected by Thomas B. Clarke*, Philadelphia Museum of Art, 1928, unpaginated and unnumbered.

THERE IS no visual evidence to support the identification of the sitter as John Cushing (1695–1778), justice of the Supreme Court of Massachusetts, and the provenance from Charles Cushing, the sitter's son, supplied by the dealer, de Forest, cannot be verified. Moreover, the costume evidence indicates a date for the picture later than the sitter's death at the age of eighty-three (and the sitter in this portrait is, in any case, surely aged not more than sixty). The large brass buttons are characteristic of English fashion in the 1780s, and the short bob wig with light side curls typical of older middle-class or professional people in that decade.[1]

The attribution to Pelham, based on the signature, was upheld by Sherman,[2] but the signature was shown to be false when it was chemically tested.[3] Burroughs and Sawitsky observed that Pelham's style was known only from his miniatures, and that no examples of his oil paintings had been identified.[4] The attribution has since been unanimously discounted.[5] Questioned by Campbell as American in 1970,[6] the portrait was rejected as such by Wilmerding in 1980, but not reattributed.[7]

Lane and Rutledge suggested that the picture might be a British import,[8] and this view was supported by Sir Ellis Waterhouse.[9] The style is closest to the clarity and firmness of Nathaniel Dance, who had a good practice as a portraitist in London after his return from Rome in 1766 until he gave up painting altogether in 1782, but the modeling is harder and the pose stiffer than in his work.

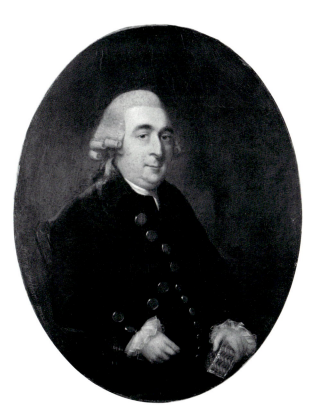

Unknown British Artist, *Portrait of a Gentleman*, 1954.1.7

Notes
1. Costume report by Aileen Ribeiro, February 1988, in NGA curatorial files.
2. Sherman 1932, 17.
3. By Francis Sullivan, resident restorer at the National Gallery, unsigned note, 13 February 1969, in NGA curatorial files.
4. Alan Burroughs, note, 3 October 1939, and William Sawitsky, undated note, in NGA curatorial files.
5. See William P. Campbell, memorandum, 10 November 1965, in NGA curatorial files.
6. NGA 1970, 162.
7. NGA 1980, 308.
8. James Lane and Anna Rutledge, report on the Clarke collection, 1952, quoted by William P. Campbell, memorandum, 10 November 1965, in NGA curatorial files.
9. Opinion recorded by William P. Campbell, note, 29 April 1975, in NGA curatorial files.

References
1932 Sherman, Frederic Fairchild. *Early American Painting*. New York and London, 1932: 17.
1970 NGA 1970: 162, repro. 163.
1980 NGA 1980: 308.

1947.17.102 (1010)

The Hon. Sir Francis Burton Conyngham

c. 1790/1795
Oil on canvas, 75.9 × 63.9 (29⅞ × 25⅛)
Andrew W. Mellon Collection

Technical Notes: The canvas is plain woven; it is unlined. The proprietary white ground is of moderate thickness. The composition is oval in format; the area outside the oval is painted in brown. The painting is executed in thin, fluid, opaque layers, blended wet into wet, with slight impasto in the reds and whites; the shading in the blue coat and the delineation of the feigned oval are accomplished with a gray glaze. There are pentimenti in the red collar, which has been shifted in position. The painting is in excellent condition. There is little loss or abrasion, and no areas of retouching. The natural resin varnish has not discolored.

Provenance: Painted for the sitter, the Hon. Sir Francis Nathaniel Pierpont Burton Conyngham [1766–1832], county Clare; by descent to his grandson William Conyngham Vandeleur Burton [1846–1919], Carrigaholt Castle, County Clare, from whose estate it was sold to (Tooth Brothers), London, from whom it was purchased 16 March 1920 by (G. S. Sedgwick) for Thomas B. Clarke [d. 1931], New York, as by Gilbert Stuart. Sold by Clarke's executors 1935 to (M. Knoedler & Co.), New York, from whom it was purchased January 1936, as part of the Clarke collection, by The A. W. Mellon Educational and Charitable Trust, Pittsburgh.

Exhibitions: *Portraits Painted in Europe by Early American Artists*, Union League Club, New York, 1922, no. 6. *Portraits by Early American Artists of the Seventeenth, Eighteenth and Nineteenth Centuries Collected by Thomas B. Clarke*, Philadelphia Museum of Art, 1928, unpaginated and unnumbered. Long-term loan to the Boyhood Home of Robert E. Lee, Alexandria, Virginia, 1968–1986.

SIR FRANCIS BURTON, twin son of Francis, 2nd Baron Conyngham, was M.P. for county Clare, Ireland, and colonel of the Clare Militia, serving as a popular lieutenant-governor of Lower Canada during the governor-generalship of Lord Dalhousie. He married in 1801 Valentina Letitia, second daughter of Nicholas, 1st Baron Clancurry.

Both the costume, a frock coat with high collar and large buttons, and the loose hairstyle, with small side curls, are characteristic of the 1780s and early 1790s. The sitter seems to be in his twenties, which would give a date in the second half of this bracket. Burton does not seem appreciably older than in the portrait of him by Gilbert

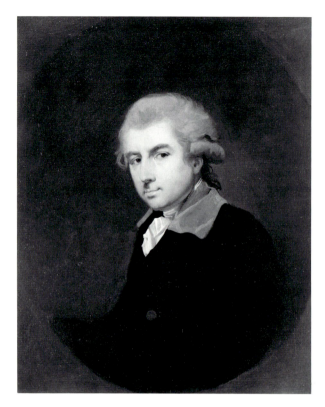

Unknown British Artist, *The Hon. Sir Francis Burton Conyngham*, 1947.17.102

Stuart in a British private collection (fig. 1), which may be linked with the statement in the Dublin *Evening Herald* in 1789 describing Stuart as "lately arrived in this metropolis" and as having painted Burton and his twin brother, Lord Conyngham.[1]

The traditional attribution to Gilbert Stuart, accepted by Park,[2] has since been unanimously rejected.[3] Sawitsky thought the work was by "a minor British painter;"[4] Watson suggested Hugh Douglas Hamilton,[5] whose work in oils is in a similarly crisp style, though less assured. Rejected by Campbell as American in 1970, the portrait was reattributed by him to the British school,[6] an opinion supported by Wilmerding in 1980.[7] It seems likely that the Washington picture is by a contemporary Irish imitator of Stuart; the style, with its linear definition of the features, is not far from his, though the right eye out of drawing (albeit occasionally found in Stuart's work) indicates a less competent hand.

Notes
1. "A Review of the Professors of the Fine Arts in This Kingdom;" quoted by William T. Whitley, *Gilbert Stuart* (Cambridge, Mass., 1932), 83. A portrait of Lord Conyngham

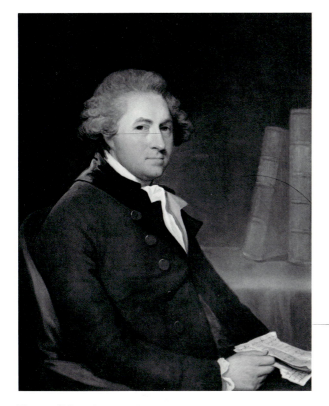

Fig. 1. Gilbert Stuart, *The Hon. Sir Francis Burton Conyngham*, probably 1789, oil on canvas, England, private collection [photo: Courtauld Institute of Art]

is in the National Gallery of Ireland, Dublin *(Illustrated Summary Catalogue of Paintings* [Dublin, 1981], no. 562, repro. 157).

2. Park 1926, 1: no. 182.

3. Alan Burroughs, note, 3 October 1939; H. M. Bland, J. H. Morgan, James Lane and Anna Rutledge, opinions cited by William P. Campbell, memorandum, 6 January 1966, in NGA curatorial files.

4. William Sawitsky, undated note, in NGA curatorial files.

5. Ross Watson to James White, 10 March 1969, in NGA curatorial files.

6. NGA 1970, 166.

7. NGA 1980, 309.

References

1926 Park, Lawrence. *Gilbert Stuart.* 4 vols. New York, 1926, 1: no. 182.

1970 NGA 1970: 166, repro. 167.

1980 NGA 1980: 309.

1976.62.1 (2704)

Mr. Tucker of Yeovil

c. 1800/1820
Oil on canvas, 91.3 × 71.4 (36 × 28⅛)
Gift of Dr. and Mrs. Henry L. Feffer

Technical Notes: The lightweight canvas is finely plain woven; it has been lined and relined. The ground is white and, although thinly applied, masks the weave of the canvas. There is a translucent reddish brown imprimatura. The painting is executed in fairly thin, fluid, semitransparent layers with more thickly applied opaque paint in the flesh tones and white collar. The painting has been slightly abraded, and along the edges the paint surface has been abraded down to the ground. There is a considerable amount of retouching in the background, in the upper right quadrant, and along the contour of the sitter's right arm. The thin natural resin varnish has discolored yellow to a significant degree.

Provenance: James H. Bingham by 1954,[1] as by George Smith of Chichester; Dr. and Mrs. Henry L. Feffer, Bethesda, Maryland, as by William Smith of Chichester.

Unknown British Artist, *Mr. Tucker of Yeovil*, 1976.62.1

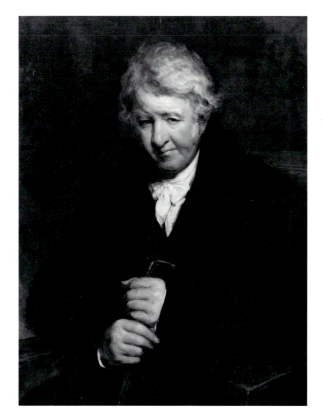

Exhibitions: *Selections from the Collection of J. H. Bingham, Esq.*, Graves Art Gallery, Sheffield, 1954, no. 42, as by George Smith of Chichester. *Pictures from the Collection of James H. Bingham, Esq.*, Brighton Art Gallery, 1954, no. 169, as by George Smith of Chichester.

NOTHING IS KNOWN about the sitter, but the identification is so circumstantial and unlikely to be invented that it may be presumed correct. The cravat tied with a bow and the coat with wide lapels stepped back to a high collar are characteristic of fashionable dress from the 1790s well into the 1810s; a middle-class countryman might be expected to appear in this dress even later.

The attribution to William Smith of Chichester (1707–1764),[2] or to his younger brother, George (1713–1776), is ruled out by the evidence of costume. Derek Rogers, when cataloguing the exhibition at Brighton, proposed Thomas Phillips, but the style is more suggestive of an artist in the circle of William Owen (1769–1825).

Phillips' similarly posed portrait of Lord Thurlow

(National Portrait Gallery, London), dating to 1806, depicts Thurlow with his hands clasped on top of his stick, but the pose in the Washington picture is more unaffected and probably reflects a posture characteristic of the sitter. The directness, and the way in which the image both fills and projects from the canvas, suggest that the portrait is by a provincial painter.

Notes
1. In the introduction to exh. cat. Brighton 1954, the Bingham collection is noted as having been formed over the previous thirty-five years.
2. Still accepted in NGA 1985, 377.

1980.61.13 (2844)

Portrait of an Unknown Family with a Terrier

c. 1825/1835
Oil on canvas, 103.3 × 80.5 (40⅝ × 31¾)
Gift of Edgar William and Bernice Chrysler Garbisch

Technical Notes: The medium-weight canvas is plain woven; it has been lined. The painting may have been cut down slightly on the left and right sides. The ground is light colored, probably white. The painting is executed in rich, opaque layers, in some passages blended wet into wet, with low impasto in the highlights. The paint surface is slightly abraded overall; a tear in the figure of the girl in the blue dress holding a basket of flowers has been repaired, and there is scattered retouching throughout. The natural resin varnish has discolored slightly.

Provenance: (Louis Lyons), New York, who sold it 1975 to Edgar William and Bernice Chrysler Garbisch.

THIS FAMILY GROUP, previously believed to be American,[1] has recently been identified as British by Ayres and Kalman, who pointed out that the view seen through the window is English:[2] the church tower, with its crenellated parapet, is that of a typically English medieval parish church. The group has not been identified, but although the family is middle class (the painter patronized is a primitive one), the presence of a Tudor ancestor on the wall indicates a respectable lineage. The emphasis on the books, flowers, and the variety of pictures on the walls, all of them with smart gilded frames, suggests a family of some cultural pretensions. The work is, however, extremely coarse and is evidently the work of a journeyman painter.

Unknown British Artist, *Portrait of an Unknown Family with a Terrier*, 1980.61.13

The dog in the foreground is in the prominent position it occupies presumably to display its breeding; it seems to be either a smooth fox terrier, a bull terrier, or a white English terrier (corroborative evidence that the picture is British, since none of these breeds is believed to have been introduced to America until the later nineteenth century[3]).

The hairstyles worn by the woman and the older girls, centrally parted hair with sausagelike side curls and the back hair brought up in a chignon, were typical of English fashion in the late 1820s and early 1830s.

Notes
1. I am indebted to Sarah Cash, NGA research assistant, American art, for the dossier she compiled on this painting.
2. James E. Ayres and Andras Kalman to Sarah Cash, 21 and 1 July 1988, in NGA curatorial files.
3. Roberta Vesley, director of the American Kennel Club Library, to Sarah Cash, 21 June 1988, in NGA curatorial files.

Unknown British Artists (?)

1947.17.86 (994)

Portrait of a Gentleman

c. 1702/1720
Oil on canvas, 115 × 92.5 (45¼ × 36⅜)
Andrew W. Mellon Collection

Inscriptions:
Falsely inscribed in ink on reverse of canvas: *John Watson/1731*

Technical Notes: The medium-weight canvas is plain woven; it has not been lined and the tacking margins survive intact. The stretcher is made of Eastern white pine, a native American species.[1] The painting is executed fairly thinly with very low impasto in the highlights. The paint surface is badly abraded, and there are many losses resulting from the weakness of the canvas, which has several tears and is extremely brittle at the corners; there is heavy retouching in the hands, along the lower part of the painting, and in the upper right corner. The thick, natural resin varnish has discolored to a significant degree.

Provenance: (Rose M. de Forest), New York, who sold it 16 January 1923 to Thomas B. Clarke [d. 1931], New York, as a portrait of Sir Peter Warren by John Watson. Sold by Clarke's executors 1935 to (M. Knoedler & Co.), New York, from whom it was purchased January 1936, as part of the Clarke collection, by The A. W. Mellon Educational and Charitable Trust, Pittsburgh.

Exhibitions: *Earliest Known Portraits of Americans by Painters of the Seventeenth, Eighteenth and Nineteenth Centuries*, Union League Club, New York, 1924, no. 1. *Earliest Known Portraits of Americans Painted in This Country by Painters of the Seventeenth and Eighteenth Centuries*, Century Association, New York, 1925, no. 13. *Portraits by Early American Artists of the Seventeenth, Eighteenth and Nineteenth Centuries Collected by Thomas B. Clarke*, Philadelphia Museum of Art, 1928, unpaginated and unnumbered.

THE SITTER in the Gallery's picture bears no resemblance to the several known portraits of Vice-Admiral Sir Peter Warren (1703–1752),[2] thus ruling out the identification; moreover, the provenance from James de Lancey of New York, brother-in-law of the supposed sitter, supplied by the dealer, de Forest, has been regarded with suspicion and cannot be verified.

The authenticity of the inscription is refuted by the costume evidence. The wig, with one end tied in a knot, is of a type known as a campaign wig, introduced at the time of the Marlborough wars; the hair rises high at the forehead, as was the fashion until about 1720. The long waistcoat with low-set pocket flaps is also typical of the 1710s.[3]

The attribution to John Watson, based on the spurious inscription and upheld by Sherman,[4] has been unanimously discounted.[5] Sawitsky observed that no oil paintings by Watson have been identified and that, of the small number of extant miniature portraits in Indian ink by him, none has anything in common, either in spirit or in style, with the Washington painting.[6] Questioned by Campbell as American in 1970,[7] the portrait was rejected as such by Wilmerding in 1980, but not reattributed.[8]

Bland thought the picture was an English import.[9] Ross Watson and Sir Ellis Waterhouse agreed that the portrait was a copy of an English portrait type, probably, according to Watson, by Kneller;[10] but Watson thought

Unknown British Artist (?), *Portrait of a Gentleman*, 1947.17.86

it was American, a view supported by the evidence of the stretcher, which is made of an American species of wood. However, the weight of evidence from an exhaustive technical examination indicates that the stretcher is not the original one.[11] The hard, sculptural modeling, rhetorical pose, and outflung hand are characteristic of the style of Richard van Bleeck, a Dutch artist who first visited London in 1695, though the handling is not of sufficiently high quality for the picture to be attributed to him.

The sitter is wearing a fitted dressing gown, known as a banyan, a popular costume for artists and writers, supposed to have originated in India.[12] The scroll of paper held in the right hand supports the view that the sitter may be a writer.

Notes
1. B. F. Kukachka, in charge of wood identification research in the United States Department of Agriculture Forest Service, to William P. Campbell, 4 June 1968, in NGA curatorial files.
2. Such as the full length by Smibert (Portsmouth Athenaeum, New Hampshire) or the three-quarter length by

Hudson, c. 1747, mezzotinted by John Faber the Younger, 1751 (National Portrait Gallery, London).
3. Costume report by Aileen Ribeiro, February 1988, in NGA curatorial files.
4. Sherman 1932, 17.
5. See William P. Campbell, memorandum, 26 January 1966, in NGA curatorial files.
6. William Sawitsky, undated note, in NGA curatorial files.
7. NGA 1970, 160.
8. NGA 1980, 309.
9. H.M. Bland, undated note, in NGA curatorial files.
10. Opinions recorded by William P. Campbell, notes, 28 February 1969 and 21 May 1975, in NGA curatorial files.
11. Ann Hoenigswald to the compiler, 14 November 1989, in NGA curatorial files.
12. See Aileen Ribeiro, *A Visual History of Costume: The Eighteenth Century* (London, 1983), 29, pl. 17.

References
1932 Sherman, Frederic Fairchild. *Early American Painting*. New York and London, 1932: 17–18, pl. 8.
1970 NGA 1970: 160, repro. 161.
1980 NGA 1980: 309.

1947.17.87 (995)

Portrait of a Gentleman

c. 1710/1730
Oil on canvas, 76.2 × 63 (30 × 24⅞)
Andrew W. Mellon Collection

Inscriptions:
Falsely inscribed at lower right: *P. Pelham pinx. 1729*

Technical Notes: The canvas is plain woven; it has been lined. The ground appears to be buff-gray, thinly applied. There is a feigned oval format in the bottom corners. The painting is executed thinly, with some texture in the face and cravat, and brushstrokes generally evident; the hair is tightly painted, with a visible dark outline around it. The painting is in good condition, with minimal retouching. The "signature" is reinforced, but the original application is consistent with the surrounding crackle pattern and may be, if not original, of close age to the painting; however, a harsh cleaning test could have caused leaching of the lower layer into local cracks to give this impression.[1] The thick, natural resin varnish has discolored yellow to a moderate degree.

Provenance: (Rose M. de Forest), New York, who sold it 16 November 1930 to Thomas B. Clarke [d. 1931], New York, as a portrait of Jonathan Law by Peter Pelham. Sold by Clarke's executors 1935 to (M. Knoedler & Co.), New York, from whom it was purchased January 1936, as part of the Clarke collection, by The A. W. Mellon Educational and Charitable Trust, Pittsburgh.

THERE IS no visual evidence to support the identification of the sitter as Jonathan Law (1674–1750), governor of Connecticut and a justice of the Supreme Court, and neither the inscription in ink on a label pasted onto the back of the stretcher[2] nor the provenance from Anne Law Hall, daughter of the supposed sitter, supplied by the dealer, de Forest, can be verified. A lineal descendant wrote to Clarke at the time of the picture's acquisition by him: "it was not known in the Law family that any portrait of the Governor was in existence."[3]

Peter Pelham, who was principally a mezzotint engraver, painted comparatively few portraits in oil. Basing their judgment on what they regarded as the key portraits by Pelham (those in the American Antiquarian Society, Worcester, Massachusetts and the Essex Institute, Salem, Massachusetts), Burroughs, Sawitsky, Lane, and Rutledge all doubted the authenticity of the Gallery's picture.[4] As a result of a chemical test it was concluded that the signature was a forgery.[5]

Burroughs suggested Gerret Duyckinck as a possible alternative attribution.[6] Sir Ellis Waterhouse thought the portrait was probably English and not unlike the work of John Smibert before he left for America in 1728.[7]

Unknown British Artist (?), *Portrait of a Gentleman*, 1947.17.87

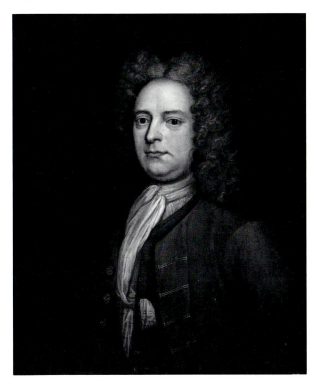

Questioned by Campbell as American in 1970,[8] the portrait was rejected by Wilmerding as such in 1980, but not reattributed.[9]

The costume is consonant with the date of the signature, 1729. The Steinkerk cravat (a cravat one or both ends of which are tucked into a buttonhole) was a style popular from the 1690s to the end of the 1720s; and the shortened full-bottomed wig was characteristic of English fashion during the 1710s and the 1720s. Both remained popular with conservative middle-class or professional people for some years afterward.[10]

The picture is coarsely painted and is evidently the work of a provincial painter; the discrepancy between the sizes of the eyes is a disturbing feature. There is nothing sufficiently distinct about the style to suggest the circle in which the painter operated. The portrait is as likely to be American as English.

Notes
1. This test was conducted in 1968; it reported that the canvas was very worn in the area and concluded that "if the signature were original, the abrasion would have passed through it," which was not the case (memorandum, 17 December 1968, in NGA curatorial files).
2. This reads: "Portrait of Governor/Jonathan Law which has/always been in the possesion [sic]/of my family in direct decent [sic]/Henry H. Peck." Henry Higgins Peck (b. 1826) of Norwich, Connecticut, was the penultimate name in the provenance supplied by de Forest.
3. Mary F. Law to Thomas B. Clarke, Santa Barbara, 5 February 1930, copy in NGA curatorial files.
4. Alan Burroughs, note, 3 October 1939; William Sawitsky, undated note; James Lane and Anna Rutledge, report on the Clarke collection, 1952, quoted by William P. Campbell, memorandum, 18 November 1965, in NGA curatorial files.
5. By Francis Sullivan, resident restorer at the National Gallery, unsigned note, 17 December 1968, in NGA curatorial files.
6. Alan Burroughs, note, 3 October 1939, in NGA curatorial files.
7. Opinion recorded by William P. Campbell, note, 29 April 1975, in NGA curatorial files.
8. NGA 1970, 160.
9. NGA 1980, 308.
10. Costume report by Aileen Ribeiro, February 1988, in NGA curatorial files.

References
1970 NGA 1970: 160, repro. 161.
1980 NGA 1980: 308.

1947.17.41 (949)

Portrait of a Lady

c. 1715/1730
Oil on canvas, 75.1 × 62.9 (29½ × 24¾)
Andrew W. Mellon Collection

Inscriptions:
Probably falsely inscribed at lower right: *Gt. Duyckinck A.D. 1699*

Technical Notes: The medium-weight canvas is coarsely plain woven; it has been lined. The ground is off-white, smoothly applied. There is a thin, warm imprimatura. The composition is painted within a gray feigned oval. The painting is executed in smooth layers, blended wet into wet, in the flesh tones, which are built up from the cool shadows to the warm highlights, with livelier, impasted handling in the highlights of the draperies. There is some abrasion in the paint surface, especially in the blue drapery, where there is extensive retouching; other retouching is minimal, except over a paint loss to the right of the sitter's head. The thick, natural resin varnish has discolored slightly.

Provenance: (Rose M. de Forest), New York, who sold it 21 April 1924 to Thomas B. Clarke [d. 1931], New York, as a portrait of Anne van Cortlandt by Gerret Duyckinck. Sold by Clarke's executors in 1935 to (M. Knoedler & Co.), New York, from whom it was purchased January 1936, as part of the Clarke collection, by The A. W. Mellon Educational and Charitable Trust, Pittsburgh.

Exhibitions: *Earliest Known Portraits of Americans Painted in This Country by Painters of the Seventeenth and Eighteenth Centuries*, Century Association, New York, 1925, no. 3. *Portraits by Early American Artists of the Seventeenth, Eighteenth and Nineteenth Centuries Collected by Thomas B. Clarke*, Philadelphia Museum of Art, 1928, unpaginated and unnumbered.

THERE IS no visual evidence to suport the identification of the sitter as Anne van Cortlandt, later Mrs. Stephen de Lancey (1676–1741), and the provenance from James de Lancey of New York, son of the supposed sitter, supplied by the dealer, de Forest, cannot be verified.

Sawitsky noted that this was the only painting bearing a signature by Gerret Duyckinck and observed that neither style nor technique accorded with the four portraits attributed to Duyckinck in the New York Historical Society; his opinion was that the signature was not authentic and the identification of the sitter doubtful.[1] The attribution has been rejected by all authorities[2] with the exception of Burroughs, who thought the signature genuine.[3] Questioned by Campbell as American in 1970,[4]

Unknown British Artist (?), *Portrait of a Lady*, 1947.17.41

the portrait was rejected by Wilmerding as such as in 1980, but not reattributed.[5]

It has not been possible, either by chemical test or microscopic examination, to prove or disprove the authenticity of the signature,[6] but the evidence of costume suggests a later date for the portrait than 1699. The informal dress, a wrapping gown in this case made of silk lined with satin in a contrasting color, is characteristic of English fashion in the second half of the 1710s and in the 1720s.[7] The portrait itself is not indisputably British rather than American, as the English taste for *déshabillé* was followed in the American colonies, and the pattern for the painting could have been copied or adapted from an English print. The head is somewhat wooden, and there are no obvious stylistic affinities; distant echoes of John Smibert may be found in the staring eyes and the handling of the drapery.

Notes
1. Notes from a course on early American painting held at the Institute of Fine Arts, New York, c. 1940, typescript in NGA curatorial files.
2. See William P. Campbell, memorandum, 30 June 1965, in NGA curatorial files.

3. Alan Burroughs, note, 3 October 1939, in NGA curatorial files.

4. NGA 1970, 158.

5. NGA 1980, 307.

6. An examination was conducted by Francis Sullivan, resident restorer at the National Gallery, in December 1968 (see undated current attribution memorandum in NGA curatorial files).

7. Costume report by Aileen Ribeiro, February 1988, in NGA curatorial files.

References

1970 NGA 1970: 158, repro. 159.
1980 NGA 1980: 307.

1947.17.88 (996)

Portrait of a Gentleman

c. 1720/1740
Oil on canvas, 76.2 × 63.2 (30 × 24⅞)
Andrew W. Mellon Collection

Inscriptions:
Falsely inscribed on reverse of lining canvas: *50 / PORTRAIT OF MY FRIEND SMIBERT / DRAWN BY P. PELHAM. / JAHLEEL BRENTON / COPIED FROM THE ORIGINAL INSCRIPTION / ON THE BACK OF THIS PICTURE BY / J. OLIVER / LINER / NEW YORK*

Technical Notes: The medium-weight canvas is plain woven; it has been lined. The ground is light brown, thinly applied. The composition is oval in format; the area outside the broad band of paint defining the oval is painted in dark brown. The painting is executed thinly and fluidly. There is retouching along the circumference of the oval and minimally in the sitter's face and hair. The natural resin varnish has discolored yellow slightly.

Provenance: (Rose M. de Forest), New York, who sold it 7 January 1922 to Thomas B. Clarke [d. 1931], New York, as a portrait of John Smibert by Peter Pelham. Sold by Clarke's executors 1935 to (M. Knoedler & Co.), New York, from whom it was purchased January 1936, as part of the Clarke collection, by The A. W. Mellon Educational and Charitable Trust, Pittsburgh.

Exhibitions: *Portraits Painted in the United States by Early American Artists*, Union League Club, New York, 1922, no. 10. *Portraits by Early American Artists of the Seventeenth, Eighteenth and Nineteenth Centuries Collected by Thomas B. Clarke*, Philadelphia Museum of Art, 1928, unpaginated and unnumbered.

FOOTE ARGUED that the portrait bears some resemblance to the only indisputable portrait of John Smibert (1688–1751), introduced into his so-called "Bermuda Group" in the Yale University Art Gallery, painted in 1729, and to the two portraits, tentatively called self-portraits, supposed to have been painted in Rome in 1728;[1] but comparison does not bear this out. Neither the inscription, allegedly copied from one on the back of the original canvas, nor the provenance from Jahleel Brenton, a friend of the supposed sitter, supplied by the dealer, de Forest, can be verified.[2]

Since the picture was erroneously believed to have been completely repainted, scholarly opinion tended to be indecisive about the attribution, which was upheld only by Sherman.[3] Burroughs, Sawitsky, Lane, and Rutledge all agreed that it was impossible to tell whether originally the portrait was by Peter Pelham.[4] Foote, however, on the basis of an x-radiograph, did not believe that the brushwork was that of Pelham.[5] Questioned by Campbell as American in 1970,[6] the portrait was rejected by Wilmerding as such in 1980, but not reattributed.[7]

No further attributions have been proposed. Sir Ellis Waterhouse was prepared to accept that the portrait might be English,[8] but Ribeiro felt that it might be either British or American.[9] The style is not sufficiently distinct to hazard a guess as to the circle in which the artist operated.

Unknown British Artist (?), *Portrait of a Gentleman*, 1947.17.88

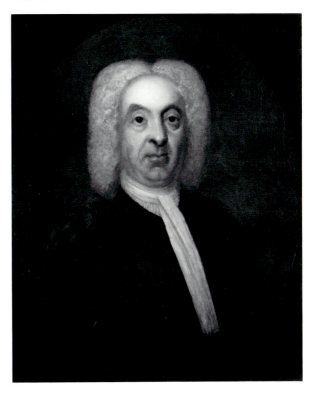

The picture may be dated fairly roughly on the evidence of the costume. The bob wig was a type of undress wig favored by the English middle and professional middle classes from the 1720s until the 1750s; the long and plain linen cravat, fashionable wear in the early decades of the eighteenth century, would have been old-fashioned by the end of the 1730s.[10]

Notes

1. Foote 1950, 235. John Hill Morgan, undated note, in NGA curatorial files, denied that the portrait bore any resemblance to Smibert's alleged self-portrait.
2. Foote 1950, 237, wrote that the pedigree "cannot be accepted as reliable, in the lack of supporting evidence."
3. Sherman 1932, 17.
4. Alan Burroughs, note, 3 October 1939; William Sawitsky, undated note; James Lane and Anna Rutledge, report on the Clarke collection, 1952, quoted by William P. Campbell, memorandum, 18 November 1965, in NGA curatorial files.
5. Foote 1950, 237.
6. NGA 1970, 160.
7. NGA 1980, 308.
8. Opinion record by William P. Campbell, note, 29 April 1975, in NGA curatorial files.
9. Costume report by Aileen Ribeiro, February 1988, in NGA curatorial files.
10. Costume report by Aileen Ribeiro, February 1988, in NGA curatorial files.

References

1928 Lee, Cuthbert. "The Thomas B. Clarke Collection of Early American Portraits." *American Magazine of Art* 19 (1928): 304, repro. 294.
1932 Sherman, Frederic Fairchild. *Early American Painting*. New York and London, 1932: 17.
1950 Foote, Henry Wilder. *John Smibert*. Cambridge, Mass., 1950: 235–237.
1970 NGA 1970: 160, repro. 161.
1980 NGA 1980: 308.

1947.17.22 (930)

Portrait of a Gentleman

c. 1726/1740
Oil on canvas, 127.2 × 101.6 (50⅛ × 40)
Andrew W. Mellon Collection

Technical Notes: The medium-weight canvas is finely plain woven; a strip of material has been added top and bottom: that at the top extremely irregular, varying from ⅝ to 1⅛ in., that at the bottom approximately 1 in. deep; the canvas has been lined. The ground is white, smoothly applied, and of moderate thickness. There is a warm gray imprimatura. The painting is executed thinly and loosely, in opaque layers, blended wet into

wet, with details of features added more crisply. The paint surface is abraded, especially in the darks, and there are numerous small losses; overpaint was removed in 1964, but the damages exposed were not compensated. The moderately thick natural resin varnish, which has discolored yellow slightly, appears to have been thinned, and to have been largely removed over the face and hands; a unifying layer of synthetic varnish was subsequently applied.

Provenance: Perhaps (Copley Gallery), Boston. (Robert C. Vose), Boston, who sold it 21 August 1930 to Thomas B. Clarke [d. 1931], New York, as a portrait of Robert Auchmuty by Joseph Badger. Sold by Clarke's executors 1935 to (M. Knoedler & Co.), New York, from whom it was purchased January 1936, as part of the Clarke collection, by The A. W. Mellon Educational and Charitable Trust, Pittsburgh.

Exhibitions: *Colonial Portraits*, Robert C. Vose Galleries, Boston, 1930, no. 6.

THE SITTER in the Gallery's picture bears little resemblance to the portrait of Robert Auchmuty (d. 1750), the Boston lawyer, which was owned by a descendant of Auchmuty in 1932;[1] moreover, the provenance from Samuel Auchmuty, son of the supposed sitter, supplied to the dealer Robert C. Vose by Rose de Forest, has been questioned[2] and cannot be verified.

The pose, the positioning of the right hand and fingers, and the placing of the background column are all derived from John Faber's engraving of 1726 after Vanderbank's portrait of Sir Isaac Newton in the possession of the Royal Society, London. Joseph Badger used Faber's print for the designs in several of his portraits,[3] and the attribution of the Gallery's picture to him was probably based on this fact. Badger's manner of painting is, however, quite distinct, and all authorities are agreed that his wooden and angular but characterful style bears no relation to the more sophisticated style of the Washington painting.[4] Burroughs suggested a possible attribution to Laurent Hübner, a German artist who seems to have worked in Boston,[5] but the picture lacks Hübner's precise definition of features; both Ross Watson[6] and Sir Ellis Waterhouse[7] agreed that the portrait was probably American. Questioned by Campbell as American in 1970,[8] the portrait was rejected as such by Wilmerding in 1980, but not reattributed.[9]

The round cuffs curving around the elbow are characteristic of English fashion in the mid 1720s and in the 1730s. The short full-bottomed wig, long, plain linen cravat, and long waistcoat are, however, all typical of slightly earlier fashion and indicate that the sitter, who is

Unknown British Artist (?), *Portrait of a Gentleman*, 1947.17.22

comparatively elderly, was probably old-fashioned in his outlook.[10]

The portrait, though somewhat stiff in posture, is softly painted and has affinities with the later style of Enoch Seeman. But there is nothing sufficiently distinct about the style to enable one to be more precise about the circle in which the painter operated. The portrait is as likely to be British as American.

Notes

1. Annette Townsend, *The Auchmuty Family of Scotland and America* (New York, 1932), 20, repro. opposite.

2. By John Hill Morgan, undated note, in NGA curatorial files.

3. See Sellers 1957, nos. 14D–14F, repros. John Faber's print is pl. 14.

4. Alan Burroughs, note, 3 October 1939, and William P. Campbell, memorandum, 21 June 1965, in NGA curatorial files.

5. Alan Burroughs, note, 3 October 1939, in NGA curatorial files.

6. Opinion recorded in unsigned note, February 1969, in NGA curatorial files.

7. Opinion recorded by William P. Campbell, note, 29 April 1975, in NGA curatorial files.

8. NGA 1970, 158.

9. NGA 1980, 306.

10. Costume report by Aileen Ribeiro, February 1988, in NGA curatorial files.

References

1957 Sellers, Charles Coleman. "Mezzotint Prototypes of Colonial Portraiture." *AQ* 20 (1957): no. 14B, repro.

1970 NGA 1970: 158, repro. 159.

1980 NGA 1980: 306.

1963.10.144 (1808)

Portrait of a Girl

c. 1730
Oil on canvas, 118.2 × 84.2 (46½ × 33⅛)
Chester Dale Collection

Technical Notes: The medium-weight canvas is plain woven; it has been lined. The white ground, consisting apparently of white lead, is smoothly applied and of moderate thickness. The

Unknown British Artist (?), *Portrait of a Girl*, 1963.10.144

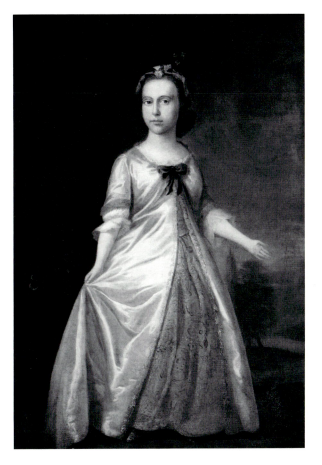

composition is laid out in flat areas of opaque, buttery paint over which the painting is executed in thin layers of rich, fluid paint, with transparent glazes for the damask patterning and to add depth of color. X-radiographs show that the head was originally more fully modeled, the cap once considerably longer on the left, and the hair somewhat shorter on the right. The paint surface is extensively abraded: much of the deep red damask pattern on the dress has been rubbed off, and portions of the thinly painted landscape are worn through. The impasto has been flattened during lining. There are two T shaped tears just above the girl's right elbow and in the bodice extending down to the waist, which have been retouched with inpainting that has now discolored. There is considerable retouching elsewhere which blends well with the paint. The residues of former varnishes have discolored deeply, and the natural resin varnish has discolored yellow to a moderate degree.

Provenance: (Ehrich Galleries), New York. Chester Dale, New York.

THE SITTER was known as Miss Warren when the picture was with Ehrich Galleries, but the identification cannot be substantiated. The girl is depicted as an adolescent, but her height suggests a youngster of about eight or ten. She is shown drawing aside her gown to reveal her richly brocaded petticoat. The costume, with round-eared cap and breast knot, suggests a date about 1730. The left arm is stiffly painted and is unrelated to the body.

The picture was attributed to Eigleton when it entered the National Gallery, but no artist of this or a similar name is recorded. The painting is distinctly primitive, and is evidently the work of a provincial or colonial painter.

1947.17.31 (939)

Portrait of a Lady

c. 1730/1750
Oil on canvas, 76.5 × 63.5 (30⅛ × 25)
Andrew W. Mellon Collection

Inscriptions:
Probably falsely inscribed on reverse of canvas in brown ink or paint: *Margaret Allen/Drawn and Colored by/Claypole Philä 1746*

Technical Notes: The canvas is fairly tightly plain woven; it is unlined, and remains on its original stretcher. The ground is light gray, thinly applied. The composition is painted within a brown feigned oval. The painting is executed in thin, fluid, opaque layers with semitransparent glazes in the shadows and some low impasto; glazes have been lost or have faded. The thick, opaque paint on the bodice fastenings may originally have been modified by dark glazes, now faded. There are few

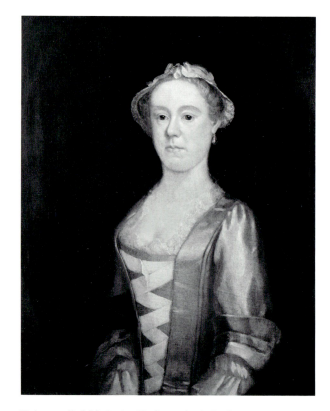

Unknown British Artist (?), *Portrait of a Lady*, 1947.17.31

losses, but the paint is abraded throughout, presumably due to overcleaning; in the face much of the paint has been abraded down to the gray ground. The natural resin varnish has not discolored.

Provenance: (Rose M. de Forest), New York, who sold it 23 November 1923 to Thomas B. Clarke [d. 1931], New York, as a portrait of Margaret Hamilton Allen by James Claypoole. Sold by Clarke's executors 1935 to (M. Knoedler & Co.), New York, from whom it was purchased January 1936, as part of the Clarke collection, by the A. W. Mellon Educational and Charitable Trust, Pittsburgh.

Exhibitions: *Portraits by Early American Artists of the Seventeenth, Eighteenth and Nineteenth Centuries Collected by Thomas B. Clarke*, Philadelphia Museum of Art, 1928, unpaginated and unnumbered.

THERE IS no visual evidence to support the identification of the sitter as Margaret Allen (died 1760), daughter of Andrew Hamilton, attorney general of Pennsylvania, and wife of William Allen, mayor of Philadelphia and chief justice of Pennsylvania; moreover, the provenance from Margaret Allen de Lancey, daughter of the supposed sitter, supplied by the dealer, de Forest, cannot be verified.

The attribution to James Claypoole, Sr., whose work has not yet been identified, upheld by Sherman,[1] has been unanimously discounted, the inscription being judged to be of a considerably later date.[2] Questioned by Campbell as American in 1970,[3] the portrait was rejected by Wilmerding as such in 1980, but not reattributed.[4]

The sitter is portrayed in a feigned oval with plain background. The pose is wooden, and the handling stiff and coarse. The style suggests a provincial or colonial painter working in the manner of George Beare or Francis Kyte. Burroughs thought the style was related to John Wollaston,[5] and Clare also tentatively suggested Wollaston;[6] but the treatment is weaker than his.

The costume, a heavy satin gown with plain robings and pleated cuffs and a stomacher with plain crisscross fastenings, worn with a round-eared cap, suggests a date between 1730 and 1750, and indicates that the sitter was of no great rank.

Notes

1. Sherman 1932, 55.
2. William Sawitsky, "The American Work of Benjamin West," *Pennsylvania Magazine of History and Biography* 20 (1938), 441, n. 12; see also William P. Campbell, memorandum, 24 June 1965, in NGA curatorial files. As Campbell pointed out (note, 29 June 1965, in NGA curatorial files), "colored" would have been spelled "coloured" at least until the nineteenth century.
3. NGA 1970, 158.
4. NGA 1980, 306.
5. Alan Burroughs, note, 3 October 1939, in NGA curatorial files.
6. Elizabeth Clare, note, 15 May 1963, in NGA curatorial files.

References

1928 Lee Cuthbert. "The Thomas B. Clarke Collection of Early American Portraits." *American Magazine of Art*, 19 (1928): 295.
1932 Sherman, Frederic Fairchild. *Early American Painting*. New York and London, 1932: 55.
1970 NGA 1970: 158, repro. 159.
1980 NGA 1980: 306.

1947.17.15 (923)

Portrait of a Gentleman

c. 1750/1770
Oil on canvas, 127.6 × 103.2 (50¼ × 40⅝)
Andrew W. Mellon Collection

Inscriptions:
Probably falsely inscribed at center left: *J. Hesselius Pincx/1768*

Technical Notes: The medium-weight canvas is coarsely plain woven; it has been lined. The ground is light gray, and is used as the middle tone in the shadows of the face. The painting is executed in thin layers which range from translucent glazes to slightly opaque paint, without impasto, in the highlights and background. The paint surface is severely abraded in the background, which has been repainted in several areas. There is considerable retouching in the right shoulder and the hair on the sitter's right side, and numerous flake losses throughout have been heavily overpainted. The contours of the coat have been reinforced. The natural resin varnish has discolored yellow to a moderate degree.

Provenance: (Rose M. de Forest), New York, who sold it 2 September 1926 to Thomas B. Clarke [d. 1931], New York, as a portrait of Thomas Johnson by John Hesselius. Sold by Clarke's executors 1935 to (M. Knoedler & Co.), New York, from whom it was purchased January 1936, as part of the Clarke collection, by The A. W. Mellon Educational and Charitable Trust, Pittsburgh.

Exhibitions: *Paintings by Early American Portrait Painters*, Century Association, New York, 1926, no. 5. *Portraits by Early American Artists of the Seventeenth, Eighteenth and Nineteenth Centuries Collected by Thomas B. Clarke*, Philadelphia Museum of Art, 1928, unpaginated and unnumbered.

THE SITTER in the Gallery's picture bears no resemblance to the portraits of Thomas Johnson (1732–1819), first governor of Maryland and a justice of the Supreme Court, by Hesselius and Charles Willson Peale,[1] thus ruling out the identification; moreover, the provenance from Benjamin Johnson, brother of the supposed sitter, supplied by the dealer, de Forest, has been contested[2] and cannot be verified.

Burroughs and Sawitsky were suspicious of the signature, which has not been tested for authenticity, but both agreed that the portrait could be by Hesselius,[3] as published by Sherman.[4] Most authorities have questioned this attribution;[5] Richard Doud, the author of a monograph on Hesselius, commented that "the drawing is not typical; form lacks his feeling for solidity at this time; lace treatment is not his—it might well be assumed that the signature is not valid."[6] As a result of these opinions the official attribution was changed in 1965, without any specific reason given, to "English School(?)."[7] Questioned by Campbell as American in 1970,[8] the portrait was rejected by Wilmerding as such in 1980, but without sustaining the attribution to the British school.[9]

No positive views have been expressed as to attribution. Ross Watson thought that the portrait was definitely not British,[10] while Ribeiro was reasonably confi-

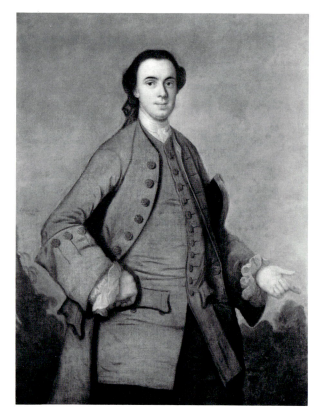

Unknown British Artist (?), *Portrait of a Gentleman*, 1947.17.15

dent that it was British. The coat cut away from the chest, large cuffs, and absence of a collar are all characteristic of English fashion in the 1750s and 1760s, the absence of a collar less so in the 1760s, and Ribeiro suggested a date in the late 1750s for the portrait.[11]

The figure fills the picture space but stands out rather awkwardly against the generalized tree forms—vaguely suggestive in handling though not in positioning of the backgrounds in portraits by Reynolds—which fill the lower part of the canvas behind the sitter.

Notes
1. Maryland Historical Society, Baltimore, and C. Burr Artz Library, Frederick, Maryland, respectively.
2. James Lane and Anna Rutledge noted in their report on the Clarke collection, 1952, that "A member of the Johnson family, Mrs. William Bevan of Buxton, Md., who is much interested in genealogy, never had heard of the portrait, nor of the people mentioned in the pedigree;" quoted by William P. Campbell, memorandum, 20 July 1965, in NGA curatorial files.
3. Alan Burroughs, note, 3 October 1939, and William Sawitsky, undated note, in NGA curatorial files.
4. Sherman 1932, 36.
5. See William P. Campbell, memorandum, 20 July 1965, in NGA curatorial files.

6. Doud 1963, 58. He included the portrait in an appendix listing the paintings he regarded as probably not by Hesselius.
7. William P. Campbell, memorandum, 20 July 1965, in NGA curatorial files.
8. NGA 1970, 158.
9. NGA 1980, 308.
10. Opinion recorded by William P. Campbell, note, 28 February 1969, in NGA curatorial files.
11. Costume report by Aileen Ribeiro, February 1988, in NGA curatorial files.

References
1932 Sherman, Frederic Fairchild. *Early American Painting*. New York and London, 1932: 36, pl. 17.
1963 Doud, Richard Keith. "John Hesselius: His Life and Work." M.A. thesis, University of Delaware, 1963: 57–58, 104 (no. 34), pl. 12.
1970 NGA 1970: 158, repro. 159.
1980 NGA 1980: 308.

1947.17.83 (991)

Portrait of a Gentleman

c. 1770/1785
Oil on canvas, 29.5 × 24.8 (11⅝ × 9¾)
Andrew W. Mellon Collection

Inscriptions:
Noted as inscribed on stretcher (there is no inscription on present stretcher): *Brig. Genl. Mordecai Gist by James Peale*

Technical Notes: The canvas is plain woven; it has been lined. The ground is buff colored. The painting is executed thinly, with little modeling and with low impasto in the highlights. The paint surface is abraded and has been extensively retouched, principally in the background. The thick, natural resin varnish has discolored yellow to a moderate degree.

Provenance: (Rose M. de Forest), New York, who sold it 15 August 1927 to Thomas B. Clarke [d. 1931], New York, as a portrait of Mordecai Gist by James Peale. Sold by Clarke's executors 1935 to (M. Knoedler & Co.), New York, from whom it was purchased January 1936, as part of the Clarke collection, by The A. W. Mellon Educational and Charitable Trust, Pittsburgh.

Exhibitions: *Paintings by Early American Portrait Painters*, Century Association, New York, 1928, no. 3. *Portraits by Early American Artists of the Seventeenth, Eighteenth and Nineteenth Centuries Collected by Thomas B. Clarke*, Philadelphia Museum of Art, 1928, unpaginated and unnumbered.

THE SITTER in the Gallery's picture bears no resemblance to the portraits of General Mordecai Gist (1743–1792) by Trumbull and Charles Willson Peale,[1] a signif-

icant feature being the eyes, light brown in the portraits of Gist, grayish blue in the Washington painting, thus ruling out the identification. Moreover, the provenance from Benjamin Rush of Philadelphia, supplied by the dealer, de Forest, cannot be verified.

The attribution to James Peale, based on the inscription and upheld by Sherman,[2] has been unanimously discounted.[3] Burroughs described Peale as a skilled miniaturist,[4] and Sawitsky characterized the Gallery's picture as "the work of a particularly untalented sign painter."[5] Questioned by Campbell as American in 1970,[6] the portrait was rejected by Wilmerding as such in 1980, but not reattributed.[7]

Sir Ellis Waterhouse believed the portrait to be English,[8] but Ribeiro argued that it was "as likely to be American as English. . . . The sitter is dressed in the informal style adopted by American men, i.e. his own hair with single side curl, cloth frock coat, and plain waistcoat."[9] The style is not sufficiently distinct to hazard a guess as to the circle in which the painter operated.

The short hair, single side curl, and narrow collar are characteristic of English fashion in the 1770s and early 1780s.

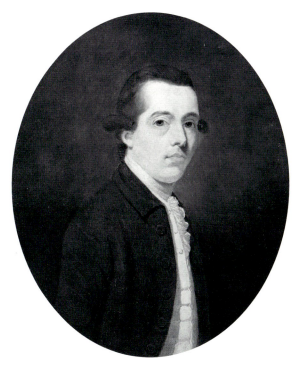

Unknown British Artist (?), *Portrait of a Gentleman*, 1947.17.83

Notes

1. The Trumbull is one of the portraits in *The Surrender of Lord Cornwallis at Yorktown* (Yale University Art Gallery, New Haven); the Peale was in the possession of Mrs. F. La Motte Smith, Westminster, Maryland, a descendant of the sitter, in 1952.

2. Sherman 1932, 64.

3. See William P. Campbell, memorandum, 16 April 1964, in NGA curatorial files.

4. Alan Burroughs, note, 3 October 1939, in NGA curatorial files.

5. William Sawitsky, undated note, in NGA curatorial files.

6. NGA 1970, 160.

7. NGA 1980, 308.

8. Opinion recorded by William P. Campbell, note, 21 May 1975, in NGA curatorial files.

9. Costume report by Aileen Ribeiro, February 1988, in NGA curatorial files.

References

1932 Sherman, Frederic Fairchild. *Early American Painting.* New York and London, 1932: 64.

1970 NGA 1970: 160, repro. 161.

1980 NGA 1980: 308.

Maria Verelst
1680 – 1744

MARIA VERELST was born in Vienna in 1680, daughter of Harman Verelst, a painter who worked successively in The Hague, Amsterdam, and Vienna, and who settled in London in 1683. She was the pupil of her uncle, the flower painter and portraitist Simon Verelst. Comparatively little of her work is recorded, but she painted small portraits on copper as well as portraits on the scale of life. She was much patronized by Scottish sitters. She also had considerable musical and intellectual attainments. She died in London in 1744.

Verelst's early style has not been charted; there exist full lengths in the Kneller baroque tradition. The earliest dated works are from the 1720s, when she was working in the manner of William Aikman and Charles Jervas. In the 1730s her style was closer to that of Hudson. She painted most of her female sitters in informal dress, with landscape backgrounds, some with Arcadian overtones and, occasionally, attributes. Her designs and poses are conventional; her modeling is firm, but her handling of drapery is somewhat primitive.

Bibliography
Waterhouse, Sir Ellis. *The Dictionary of British 18th Century Painters.* Woodbridge, 1981: 389.

1947.17.95 (1003)

Portrait of a Lady

c. 1715/1730, perhaps close to 1725
Oil on canvas, 91.4 × 71.1 (36 × 28)
Andrew W. Mellon Collection

Inscriptions:
Falsely inscribed on ledge at lower left: *Jn. Smibert. fecit.1746*

Technical Notes: The medium-weight canvas is plain woven; it has been lined. The ground is a light warm brown, thinly applied. The painting is executed very thinly, blended wet into wet, without impasto. The "signature" lies on top of a thin layer of varnish, and is easily soluble.[1] There are three horizontal tears, across the chest, below the chin, and above the head on the left side of the painting. The paint surface is extensively abraded except in the head, which was painted more thickly; there is minimal retouching in the head but elsewhere there are carelessly applied retouchings throughout. The thick natural resin varnish has discolored yellow to a significant degree.

Provenance: (Rose M. de Forest), New York, who sold it 2 July 1924 to Thomas B. Clarke [d. 1931], New York, as a portrait of Susannah de Lancey, Lady Warren, by John Smibert. Sold by Clarke's executors 1935 to (M. Knoedler & Co.), New York, from whom it was purchased January 1936, as part of the Clarke collection, by The A. W. Mellon Educational and Charitable Trust.

Exhibitions: *Earliest Known Portraits of Americans Painted in This Country by Painters of the Seventeenth and Eighteenth Centuries,* Century Association, New York, 1925, no. 4. *Portraits by Early American Artists of the Seventeenth, Eighteenth and Nineteenth Centuries Collected by Thomas B. Clarke,* Philadelphia Museum of Art, 1928, unpaginated and unnumbered.

THERE IS no visual evidence to support the identification of the sitter as Susannah de Lancey (c. 1710–1771), who married Sir Peter Warren, the future hero of Louisburg, and the provenance from James de Lancey of New York, brother of the supposed sitter, supplied by the dealer de Forest, has been described as unsatisfactory and cannot be verified.[2] Moreover, the costume depicted is earlier than 1746: the centrally fastened gown with loose-fitting sleeves reaching just below the elbow and the informal hairstyle with curls flowing over the shoulder are characteristic of English fashion in the second half of the 1710s and in the 1720s. The pose is derived from John Smith's mezzotint after Kneller's portrait of Princess Anne at Chirk Castle, Clwyd (fig. 1).[3]

The attribution to Smibert was upheld by Sherman.[4] Burroughs accepted the portrait as by one of the Smiberts, Nathaniel rather than John, although he doubted the authenticity of the signature;[5] and most authorities in the postwar period, including Campbell and Wilmerding, agreed that the work was by an American artist, probably one not as yet identified.[6] Bland alone seems to have regarded it as an English portrait of the period.[7] Later, Bland's opinion was supported by Sir Ellis Waterhouse, who thought the portrait was by some contemporary of Charles Jervas.[8]

Comparison with signed and dated portraits by Maria Verelst supports a firm attribution to this artist.[9] The slightly sculptural modeling of the features, the very per-

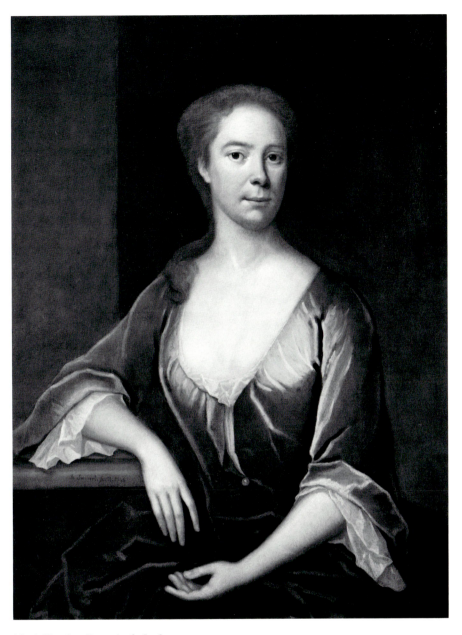

Maria Verelst, *Portrait of a Lady*, 1947.17.95

sonal treatment of the hands and open fingers, and the equally idiosyncratic emphasis on contours and highlighting of the drapery are identical with the portraits of Lady Binning (fig. 2) and Lady Murray, both dated 1725 (both Earl of Haddington, Mellerstain). The hairstyle in these portraits is the same as in the Gallery's picture, which may thus be dated similarly.

Notes
1. Report of chemical test by Francis Sullivan, resident restorer at the National Gallery (Dorinda Evans, note, 12 March 1968, in NGA curatorial files).
2. Foote 1950, 246.
3. Charles Colman Sellers, "Mezzotint Prototypes of Colonial Portraiture," *AQ* 20 (1957), fig. 18.
4. Sherman 1932, 20.
5. Alan Burroughs, note, 3 October 1939, in NGA curatorial files.

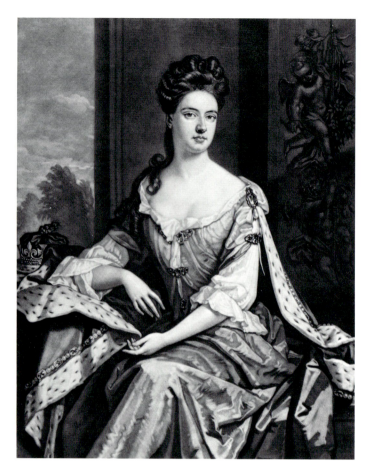

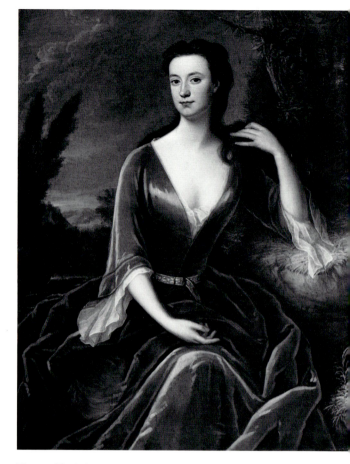

Fig. 1. Sir Godfrey Kneller, *Princess Anne of Denmark*, c. 1695, from the mezzotint by John Smith, London, National Portrait Gallery [photo: Barnes and Webster]

Fig. 2. Maria Verelst, *Rachel, Lady Binning*, inscribed 1725, oil on canvas, Berwickshire, Mellerstain [photo: Ideal Studio]

6. See William P. Campbell, memorandum, 17 December 1965, recommending a change of attribution to "American School," in NGA curatorial files; NGA 1970, 144; NGA 1980, 289.

7. H. M. Bland, undated note, in NGA curatorial files. Foote's opinion, quoted by William P. Campbell, memorandum, 17 December 1965, in NGA curatorial files, is equivocal. It was his view that most of the at least sixteen portraits to which Smibert's name was attached, offered for sale between 1917 and the 1930s, were probably imported English pictures (Foote 1950, 234–235).

8. Opinion recorded by William P. Campbell, note, 21

May 1975, in NGA curatorial files.

9. This attribution was suggested to me by my colleague, Jacob Simon.

References
1932 Sherman, Frederic Fairchild. *Early American Painting*. New York and London, 1932: 20.
1950 Foote, Henry Wilder. *John Smibert*. Cambridge, Mass., 1950: 246.
1970 NGA 1970: 144, repro. 145.
1980 NGA 1980: 289, repro.

Francis Wheatley

1747 – 1801

WHEATLEY WAS BORN in London in 1747, the son of a master tailor in Covent Garden. First placed under Daniel Fournier, a neighbor who was a drawing master, he was subsequently trained at the drawing school run by William Shipley, the founder of the (Royal) Society of Arts. He was a pupil of an unidentified Mr. Wilson, perhaps Benjamin Wilson, when, in 1762, he won the Society's premium for a drawing of the human figure. In 1763 he won a similar prize and is recorded as traveling abroad, perhaps in France and the Low Countries. In 1766 he won the Society's second prize for a landscape drawn from nature. In 1769 he entered the Royal Academy Schools as one of its first students. In 1770 he was elected a member of the Society of Artists, where he had first exhibited in 1765, becoming a director in 1774. He assisted John Hamilton Mortimer on the decoration of the ceiling of the saloon at Brocket Hall, Hertfordshire, between 1771 and 1773, and later in the decade went on sketching tours, for example to Devonshire in 1778.

Handsome, always dressed at the height of fashion, Wheatley lived extravagantly and ran into debt; in 1779, with the aid of a loan from Benjamin West which he never repaid, he went to Dublin with the wife of a fellow artist, J. A. Gresse, whom he passed off as his own. In 1783 he returned to England. Finding it difficult to reestablish himself, he applied the following year to the East India Company to practice as a portrait painter in India, but he did not go. He worked more and more for the print sellers, beginning his long association with John Boydell, for whose Shakespeare Gallery he later painted thirteen canvases. Sometime before 1788 he married the young and beautiful Clara Maria Leigh, daughter of a proctor in Doctors' Commons, St. Paul's Churchyard, with whom he had four children.

Wheatley was elected an Associate of the Royal Academy in 1790 and became a full Academician in 1791. Though he was popular and hard working, what little is known of Wheatley's prices (no account books survive) does not suggest that he was normally well paid; for example, he only received twenty guineas apiece for four small pictures for the Shakespeare Gallery. By 1793 he was again seriously in debt. For the last seven years of his life he was not only in constant financial difficulties but severely crippled by gout, the result of youthful dissipation. He died in London on 28 June 1801.

During the first half of his career Wheatley painted small-scale portraits in the style of Mortimer, in which figures—the ladies with gaily colored apparel—were informally posed and silhouetted against darker landscape backgrounds. He also produced conversation pieces influenced by Zoffany, similarly static and self-conscious, and landscapes, both in oil and watercolor, in which everyday rustic incidents were featured. His larger canvases, such as *The Irish House of Commons* (Leeds City Art Gallery), highlight his strengths and his weaknesses: a lively rococo sense of color, literal rendering and attention to detail, but lack of composition, intensity, or dramatic focus.

After his return to London in 1783, Wheatley concentrated on the work for which he is best known, sentimental scenes inspired by Greuze and the cult of *sensibilité*, mostly intended for engraving and for distribution on the French as well as the English market. He painted the celebrated canvas of John Howard visiting and relieving the miseries of a prison (Earl of Harrowby, Sandon Hall, Staffordshire), bourgeois moralities, scenes from modern literature such as the tales of Jean-François Marmontel, and fancy pictures—genre paintings in which sentiment was combined with domestic or rustic realism. His most famous works were The Cries of London, 1792–1795, a series of fourteen pictures, twelve of which were engraved in pairs. Wheatley's style was marked by sweetness rather than strength of feeling, and his figures by a decorative elegance. He continued painting portraits in his earlier manner, and executed landscapes in which the imagery of the picturesque replaced his earlier naturalism.

Wheatley's reputation declined soon after his death— the taste for Morland and farmyard realism replacing that for elegance and sentiment—and did not revive until the late Victorian vogue for eighteenth-century prints and the Edwardian cult of the eighteenth century represented by writers such as Austin Dobson.

Bibliography
Roberts, William. *F. Wheatley, R.A.* London, 1910.
Webster, Mary. *Francis Wheatley.* London, 1970.

1983.1.43 (2918)

Family Group

c. 1775/1780
Oil on canvas, 91.7 × 71.4 (36⅛ × 28⅛)
Paul Mellon Collection

Technical Notes: The medium-weight canvas is finely plain woven; it has been lined. The ground is white, probably containing white lead, smoothly and evenly applied and of moderate thickness. The painting is executed thinly and very fluidly (possibly with an admixture of resin to the oil to increase fluidity) blended wet into wet; the features and costume are articulated with finely drawn touches of rich, opaque paint, with some impasto in the white highlights. There is a slight pentimento in the positioning of the man's right knee; the girl's pink skirt can be seen beneath the paint of the breeches. There is some solvent abrasion in the darks and the impasto has been flattened during lining; there is a substantial area of retouching in the hem of the lady's apron close to the girl's skirt, and the large cracks through the man's face have been inpainted. The most recent varnish is synthetic, slightly toned with black pigment; residues of the earlier, unevenly removed natural resin varnish have discolored yellow to a significant degree.

Provenance: Lady Sarah Spencer, sixth daughter of John, 7th Duke of Marlborough, by 1891. (Anon. [Hon. Mrs. Boyle] sale, Christie, Manson & Woods, London, 7 July 1894, no. 98, as by Zoffany), bought by (P. & D. Colnaghi), London. Lady Lister (perhaps the widow of Sir Frederick Lister, 1876–1939) (sale, Sotheby & Co., London, 24 February 1960, no. 122, repro.), bought by (P. & D. Colnaghi), London, on behalf of Paul Mellon, Upperville, Virginia.

Exhibitions: *Works by the Old Masters, and by Deceased Masters of the British School*, Winter Exhibition, Royal Academy of Arts, London, 1891, no. 17, as by Zoffany. *Painting in England 1700–1850: Collection of Mr. & Mrs. Paul Mellon*, Virginia Museum of Fine Arts, Richmond, 1963, no. 265, repro., pl. 206. *Painting in England 1700–1850: From the Collection of Mr. and Mrs. Paul Mellon*, Royal Academy of Arts, London; Yale University Art Gallery, New Haven, 1964–1965, no. 221 (souvenir, repro. 78).

THE IDENTITY of the sitters is unknown. Webster has proposed a date of about 1775 to 1776;[1] though she gives no reason, this, or a slightly later date, is convincing on the evidence of costume. The high-piled hair sloping diagonally backward from the forehead and the French *dormeuse* nightcap tied under the chin with lappets, worn by the lady, who is dressed at the height of fashion in a silk Polonaise open robe with embroidered apron, suggest a date in the late 1770s, probably about 1777.[2]

The traditional attribution to Zoffany was corrected by Basil Taylor after the picture was acquired by Paul Mellon.[3] Zoffany had succeeded Arthur Devis in the 1760s as the principal exponent of the conversation piece, and a number of pictures in this genre have been mistakenly attributed to him. The crisp handling of paint, the minute attention to detail in the costume, the lovely delicate tonality, and the arrangement of the figures in a row, with a backdrop of trees behind, are all characteristic of Wheatley,[4] and the mandolin which the girl is playing was one of his favorite studio props. The figures are, however, rather larger in relation to the canvas size than was usual with Wheatley. The composition is based on simple crossing diagonals. The device of the man engaging the attention of the spectator while the others are occupied with each other is typical of the conversation piece in general.

Notes
1. Webster 1970 (see biography), 120.
2. Ribeiro 1983, 100.
3. Exh. cat. Richmond 1963, no. 265.
4. Contrast the mannered treatment of the foliage, identical with that in Wheatley's *The Browne Family* (Yale Center for British Art), with Zoffany's more painterly handling in his backdrop to *The Lavie Children* (1983.1.48).

References
1970 Webster 1970 (see biography): 25–27, fig. 30, 120 (no. 10).
1983 Ribeiro, Aileen. *A Visual History of English Costume: The Eighteenth Century*, London and New York, 1983: 100, repro. 101.

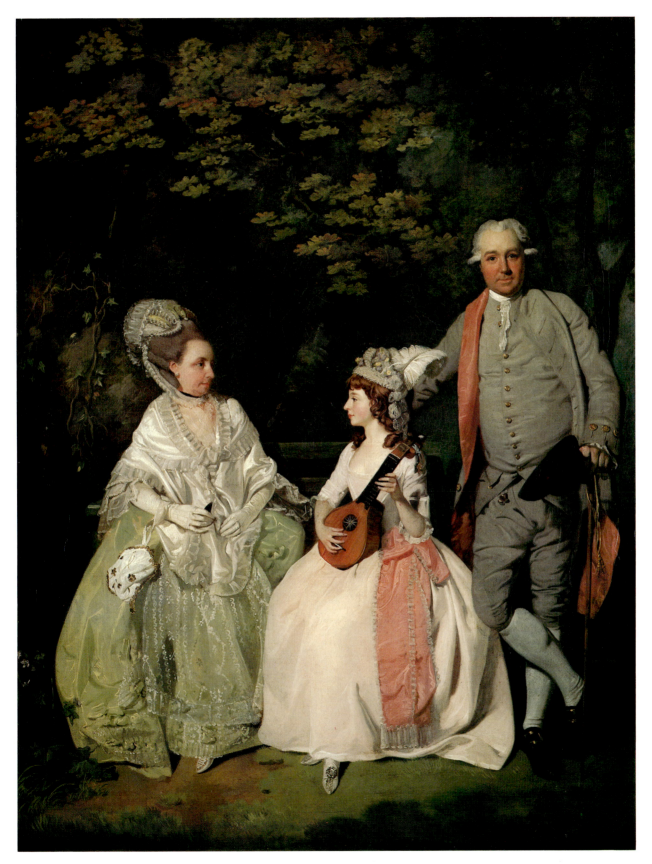

Francis Wheatley, *Family Group*, 1983.1.43

W. Wheldon, *The Two Brothers*, 1953.5.39

W. Wheldon

active 1863

NOTHING IS KNOWN of this artist beyond the signed and dated marine painting in Washington, catalogued below, which suggests that he was active in Hull. He may have been related to James H. Wheldon (1830–1895), a marine painter who lived in Hull from 1863 to 1876, works by whom are preserved in the Town Docks Museum, Hull; but he was evidently a primitive artist compared to this accomplished executant.

1953.5.39 (1245)

The Two Brothers

1863
Oil on panel, the boat in relief, 73.3 × 107 (28⅞ × 42⅛)
Gift of Edgar William and Bernice Chrysler Garbisch

Inscriptions:
Signed and dated at lower right: *PAINTED / BY W· WHELDON / 1863*

Technical Notes: The support is a solid wooden panel composed of two sections horizontally joined with metal plates; the boat in the center is a carved wooden relief, probably made of white pine. The ground is white, thinly applied. The painting is executed in layers varying from opaque masses to thin transparent glazes through which the ground is visible, in a palette of mostly earth tones; the relief appears to be executed in a similar technique. There is traction crackle in the water, which suggests the presence of bitumen. There is extensive craquelure throughout. The paint surface is heavily abraded. There is a considerable amount of discolored overpaint throughout, in at least two layers, one between the existing varnishes; the sky is almost completely reworked, as is the sail. The underlying natural resin varnish has discolored yellow to a significant degree; the overlying synthetic varnish has similarly discolored.

Provenance: Edgar William and Bernice Chrysler Garbisch, Cambridge, Maryland, by 1953.

THE SUBJECT of this work, a small fishing boat known as a coble, characteristic of the Yorkshire coast,[1] is not painted onto the panel but is a half-model that stands out in relief. The model is inscribed with the name *TWO BROTHERS*, followed by the local licence number 03S, which suggests that the coble was a pilot vessel hailing from Sunderland.[2] On the left are two white lighthouses, which may be identified as those of North Shields, at the mouth of the River Tyne,[3] about eight miles north of Sunderland. The steamer on the left bears the name *PILOT*, and the steamer to the right of the coble the name *DIAMOND;* both were Newcastle coasters, built by Hepple in Newcastle in 1859 and 1861 respectively.[4] A Royal Navy squadron is seen in the distance at the right.

The figures in the coble are not fishermen; they are depicted in ordinary dress and form a loosely grouped conversation piece, including a woman and two children. A number of models of cobles are extant among the numerous half-models with primitively painted backgrounds executed in Britain during the second half of the nineteenth century. These works were presumably commissioned by the owners or crew of the ships concerned. The figures in the Washington picture are no doubt portraits of the owners or crew of the *Two Brothers*.

Notes

1. M. V. Brewington, director of the Kendall Whaling Museum, Sharon, Massachusetts, letter, 2 October 1968, in NGA curatorial files.

2. Arthur Credland, keeper of maritime history, City of Kingston-upon-Hull Museums and Art Galleries, letter, 29 May 1987. I am indebted to Mr. Credland for help with this entry.

3. H. P. Imray, *The Lights and Tides of the World* (London, 1931), 31. The lighthouses depicted correspond to those situated on the point at North Shields, which were white towers built in 1808, 82 and 127 feet high respectively (reference kindly supplied by Paul J. O'Pecko, reference librarian, Mystic Seaport Museum, Mystic, Connecticut).

4. *Lloyd's Register of British and Foreign Shipping* (London, 1862), unpaginated, D188, P299. The correct name of the first steamer was *Pilots.*

Beatrice Godwin Whistler

1857 – 1896

BEATRICE WHISTLER[1] (née Philip) was born, probably in London, on 12 May 1857, the second daughter of John Birnie Philip, the sculptor, and Frances Black. In 1876 she married the architect Edward William Godwin, who died in 1886; they had one son, who became a sculptor. Godwin introduced Beatrice to James McNeill Whistler, with whom she studied, and for whom she posed: Whistler painted her portrait for Godwin as *Harmony in Red: Lamplight* between 1884 and 1886. In the winter of 1887/1888 Beatrice exhibited two small panel paintings at the Royal Society of British Artists.

In 1888 Beatrice married Whistler. Although she was a Gallophobe and never learned to speak French, she settled with her husband in Paris in 1892. Whistler had been proud of her as a pupil, encouraged her talent (she designed a fine and richly colored memorial window for All Saints, Orton, Cumbria, between 1891 and 1892), and was devoted to her as a wife. Beatrice, who was known as Trixie, was spirited and charming, but her health had never been good, and she died of cancer at Hampstead, London, at a comparatively early age, on 10 May 1896.

As an artist Beatrice Whistler was encouraged, but overshadowed, by her two artist husbands. Her earliest works were small portraits and delicate decorative drawings and watercolors of birds and flowers, one of which seems to be dated 1884, in which the precision of her draftsmanship was influenced by Godwin. From about 1886 she produced a number of small panels, chiefly of girls reading, with plain backgrounds, and mostly dark in tone, that were strongly influenced by Whistler; her portrait and figure drawings in chalk on brown paper of this period are almost indistinguishable from his.

Beatrice's early Whistlerian panels are rather scratchy in handling; later they became increasingly fluent and accomplished. Similarly, her later chalk drawings of nudes in various attitudes, bold and large scale, display sweeping

hatching and flowing line. Beatrice also engaged in book illustration *(Little Jiohannes)* and designs for jewelery; she was an accomplished etcher and was capable of witty caricatures.

Nearly all of the artist's work is preserved in the Beatrice Whistler Memorial Collection at the Hunterian Art Gallery, Glasgow University.

Notes

1. For the following biography I am greatly indebted to the work of Dr. Margaret MacDonald, who most generously placed her unpublished research on the artist at my disposal.

Bibliography

Pennell, Elizabeth Robins and Joseph. *The Life of James McNeill Whistler.* 2 vols. London and Philadelphia, 1908, vol. 2.

Young, Andrew McLaren, Margaret MacDonald, Robin Spencer, and Hamish Miles. *The Paintings of James McNeill Whistler.* 2 vols. New Haven and London, 1980, 1:xv, particularly 140.

MacDonald, Margaret F. "Beatrice Whistler." Unpublished article.

1943.11.8 (759)

Peach Blossom

c. 1890–1894
Oil on panel, 23.7 × 13.8 (9¼ × 5⅜)
Rosenwald Collection

Technical Notes: The support is a single piece of lightweight softwood. The ground is white, applied with sweeping brushstrokes leaving the striations clearly visible. The painting is executed very spontaneously, the figure in thick paint blended wet into wet and worked with texture, and the background with thin browns and grays through which the ground is visible. The painting is in excellent condition. Abrasion and losses are confined to the perimeter; the losses are apparently the result of adhesion of the still-wet layer to the frame. The very thinly applied natural resin varnish has not discolored.

Provenance: Probably given or bequeathed by the artist to William Webb (of James McNeill Whistler's firm of lawyers).[1] (Forbes & Paterson), London, through (Sessler Gallery), Philadelphia, from whom it was purchased 1930 by Lessing J. Rosenwald, Philadelphia.[2]

Exhibitions: *Memorial Exhibition of the Works of Mr. J. McNeill Whistler,* Copley Hall, Boston, 1904, no. 76.

THE SUBJECT, *Peach Blossom*, is identified by an old label on the back on the panel.[3] The connection between the Washington picture and the work by Beatrice Whistler included in the Whistler exhibition of 1904 as *Peach Blossom* is established by a photograph of its installation at the exhibition. The former attribution to James McNeill Whistler, still upheld by Campbell in 1970,[4] was corrected by Wilmerding in 1980.[5]

It has been suggested by MacDonald that *Peach Blossom* "may be a portrait of one of the Pettigrew sisters who often posed for Whistler."[6] The three girls were brought to London by their mother in 1884 and posed for Millais in that year. By 1891 Rose Pettigrew (born about 1876) was Whistler's most important model, and the features and hair style of *Peach Blossom* are consistent with Beatrice's etching of Rose[7] and with two of Wilson Steer's small oil sketches of her, the first dating from about 1889 to 1890, the second signed and dated 1891 (fig. 1).[8] The sitter could also be Harriet (born about 1872), who had "soft straight hair, like a burnished chestnut," but not Lilian (born about 1874), who had "most beautiful curly red gold hair" and a "long neck."[9] The young girl in the Gallery's painting must be in her mid-teens or older.

According to Sickert, the Washington picture was painted between 1880 and 1885 in James McNeill Whistler's studio at 13 Tite Street, Chelsea;[10] if the location is accepted as correct, the work would have been executed between 1881 and 1884, when Whistler was resident at this address; in 1884 Beatrice was posing to him. But in 1884 Beatrice was not working in this style, and her early Whistlerian studies of about two years later were immature, lacking the fluency and assurance of *Peach Blossom*. Moreover, this dating would rule out both Rose and Harriet Pettigrew as sitters, on grounds of age. Sickert's evidence must, therefore, be discounted, and is probably to be interpreted as authenticating the work as Whistler of a plausible period, at a time subsequent to 1904 when the picture was on the art market and had lost its correct attribution.[11]

Young suggested a date of about 1890 for the Washington painting,[12] which is broadly consonant with the development of Beatrice's style. *The Muslin Gown*, which she exhibited at the Royal Society of British Artists in the winter of 1887/1888,[13] is already accomplished and freely brushed; but, with the exception of *Woman Reading a Letter* (Hunterian Art Gallery, Glasgow), dated to about 1894, *Peach Blossom* is the most sophisticated of all her small panels. The low fringe and panneled dress worn by the sitter was characteristic of fashion in the 1880s.

This small sketch is close in crispness of handling and its broadly brushed background to Whistler's own studies

Beatrice Godwin Whistler, *Peach Blossom*, 1943.11.8

Fig. 1. Philip Wilson Steer, *Rose Pettigrew*, signed and dated 1891, oil on canvas, Ipswich Borough Museums and Galleries [photo: Browse & Darby Ltd.]

of the 1880s (fig. 2), and the title follows Whistler's practice of naming his portraits in accordance with his color harmonies.

Notes

1. Andrew McLaren Young to William P. Campbell, 4 January 1973, in NGA curatorial files. Webb certainly owned the picture by 1904, when he exhibited it at the Whistler exhibition in Boston (see exhibitions).

2. Rosenwald purchased the picture with a certificate from Sickert (MS notebook of Rosenwald's purchases of Whistler prints, 7, in NGA archives). Dr. Margaret MacDonald kindly supplied me with this reference.

3. The old label, which reads *Peach Blossom/Mr J. McNeill Whistler* seems to have been tampered with; there is an unnaturally wide gap between *Mr* and the *J*, and infrared photography suggests that the *Mr* probably originally read *Mrs*. The attribution to James McNeill Whistler resulting from the misleading *Mr* on the label was corrected by Andrew McLaren Young (William P. Campbell, memorandum, 5 April 1972, in NGA curatorial files).

Fig. 2. James McNeill Whistler, *Arrangement in Pink, Red and Purple*, probably 1885, oil on panel, Cincinnati, Cincinnati Art Museum

4. NGA 1970, 122.

5. NGA 1980, 310.

6. MacDonald, unpublished article (see biography).

7. Hunterian Art Gallery, Glasgow. Three etchings in the collection are called Rose Pettigrew, but only one is so inscribed; the other two, which show the sitter wearing a hat, are surely of a different girl.

8. R. Shaw-Kennedy sale, Christie, Manson & Woods, London, 12–13 July 1973, 2nd day, lot 274a, bought by Fine Art Society; Bruce Laughton, *Philip Wilson Steer 1860–1942* (Oxford, 1971), no. 85, pl. 88.

9. "Autobiographical typescript by Rose Pettigrew," Laughton 1971, appendix 1, 114.

10. An old photograph of the painting, in NGA curatorial files, is so inscribed by Sickert. The *o* in *1880* seems to have been altered from a *1*, which would have been correct, apparently by Sickert himself.

11. MacDonald, unpublished article (see biography).

12. William P. Campbell, memorandum, 5 April 1972, in NGA curatorial files.

13. *Impressionists and Modern Masters* [exh. cat., William Weston Gallery] (London, 1989), no. 61, repro.

Sir David Wilkie

1785 – 1841

WILKIE WAS BORN AT Cults, in Fife, on 18 November 1785, the third son of the Reverend David Wilkie, the village minister, and his third wife, Isabella Lister. He was educated at local schools in Pitlessie, Kettle, and Cupar until the age of fourteen. Ambitious to become a painter, he was sent in 1799 to the Trustees' Academy in Edinburgh, where he studied at the separate Drawing Academy newly founded by the history painter John Graham; among his fellow students were Sir William Allan and John Burnet, later the successful engraver of his works. He sold his first genre scene, *Pitlessie Fair* (1804; National Gallery of Scotland, Edinburgh), a portrait of a village teeming with incident, for twenty-five pounds, and, after a few months painting portraits in Fife and at Aberdeen, moved in 1805 to London, where he entered the Royal Academy Schools and attended Charles Bell's lectures on anatomy.

Wilkie achieved an immediate public and critical success in 1806 with his first exhibit at the Royal Academy, *The Village Politicians* (Scone Palace, Perthshire), which Lord Mansfield, to whom he had been introduced by a relative, had agreed to buy; Lord Mulgrave and Sir George Beaumont, an enthusiastic admirer, both commissioned works from him, and by 1809, his style exactly suiting the contemporary taste for highly finished Dutch cabinet pictures, he claimed to have at least forty works bespoke. He gave careful attention throughout his career to popularizing his work through engravings, from which he made a considerable profit. Wilkie was elected an Associate of the Royal Academy in 1809, and became a full Academician in 1811. *Blind Man's Bluff* (1813; Royal Collection, Buckingham Palace) marked the beginning of a lifelong friendship with the Prince Regent, whose favorite painter he became.

Wilkie traveled to Paris in 1814, in the company of Benjamin Robert Haydon, to see the art treasures pillaged by Napoleon, and was especially impressed by Rubens' Marie de Médicis series at the Luxembourg. Although in 1808 he had still been struggling to raise his prices above fifty guineas, his *Distraining for Rent* (1815; National Gallery of Scotland, Edinburgh) was bought by the British Institution for six hundred guineas. In 1816 he journeyed to the Low Countries; in 1817 he was in Scotland to study once again the life and manners of the common people, and was invited to Abbotsford by Sir Walter Scott. In 1822, after sixteen months' constant labor on the work, he exhibited the purest of all his genre scenes, *Chelsea Pensioners Reading the Gazette of the Battle of Waterloo* (Apsley House, London), commissioned by the Duke of Wellington, for which Wilkie received twelve hundred guineas. He was in Scotland again for George IV's visit to Edinburgh in 1822, and the following year was appointed King's Limner and Painter for Scotland.

Wilkie, a perfectionist, was prone to depression and mental fatigue; following a succession of bereavements and seriously strained by overwork, he suffered a severe nervous breakdown in 1825. He went to Italy in search of health, remaining there and not resuming painting

until the summer of 1827, when he traveled first to Switzerland and then to Spain; he was the first major British artist ever to visit Madrid. He returned to London in 1828, after three years abroad; liberal patronage from George IV quickly reestablished his reputation. In 1830 he succeeded Lawrence as Principal Painter to the King, a post which deflected him into portraiture when his ambition was increasingly toward history painting; in 1836 he was knighted.

Described by John Jackson, on his arrival in London, as a "raw, tall, pale, queer Scotchman,"[1] Wilkie remained unmarried and, though much loved by his fellow artists and patrons, never lost his awkwardness and strong Scottish accent. He spoke as deliberately as he painted. In 1840 he decided to visit the Holy Land to study authentic backgrounds for religious works he planned; he traveled through Holland and Germany to Constantinople, arriving in Jerusalem in February 1841. He died on board ship near Gibraltar on 1 June 1841 on his way home, and was buried at sea, an event commemorated in one of Turner's masterpieces, *Burial at Sea* (Tate Gallery, London).

Wilkie's name was identified with his anecdotal rustic genre scenes, Sir George Beaumont writing to him in 1812 that "you can never improve upon the simplicity of your first intentions."[2] These paintings of "the peculiarities of familiar life," influenced by Scottish rustic poetry, the popularity of David Allan's genre scenes, and Wilkie's knowledge of Dutch and Flemish art (initially through the medium of engravings) were characterized by an obsessively laborious preparation. Miniature lay figures, large finished drawings, and oil sketches were used to establish the grouping and lighting. "He then walks about," Constable told Farington in 1807, "looking for a person proper to be a model for completing each character in His picture, & He paints *everything from the life*."[3] Execution was piecemeal; the expressions were intensely studied, and the handling exquisite. Wilkie thought the "clear touching" of Teniers made all other pictures look misty, found Turner's workmanship abominable, and was uninterested in the antique. His determination to excel the Dutch and Flemish masters led him to develop an increasing sophistication in the lucidity and focus of his narrative and design, coupled with a greater range of emotion. He was also a skilled portraitist on a small scale.

Trapped by his own success as the "Scottish Teniers," Wilkie aspired to a higher class of painting. His years of study abroad, when he was deeply impressed by Correggio, Velázquez, Murillo, Rubens, and Rembrandt, brought about a transformation in his style. He developed a bolder, spontaneous, and more fluent technique, a new richness and depth of tone (derived partly from the use of bitumen), and a feeling for chiaroscuro. *The Defence of Saragossa* (1828; Royal Collection, Buckingham Palace) is a masterpiece of romantic panache and flowing movement based on Rubens; *General Sir David Baird Discovering the Body of the Sultan Tippoo Sahib After Storming Seringapatam* (1838; National Gallery of Scotland, Edinburgh), the largest picture he ever painted, is a night scene evincing a Rembrandtesque sense of theater and effects of light. Wilkie's later genre scenes have a greater poignancy and depth of understanding; his history pictures, which grew out of his genre painting, were remarkable for the novelty of their subjects and for the choice of private moments rather than public events. His later figure and watercolor sketches are fluent and masterly, but he was a reluctant royal portraitist, never having found it easy to catch a likeness.

Wilkie's early rustic genre paintings had a profound effect on the development of Victorian domestic genre; his protégé William Mulready was the first to be influenced by his example. Through his engravings, Wilkie was also influential on painters in Germany and America. His later style was generally deplored, and its significance was not fully recognized until the 1930s. Sir William Allan was influenced by Wilkie in his Scottish history paintings and methods of composition; John Frederick Lewis took up Wilkie's style of drawing.

Notes
1. Tom Taylor, ed., *The Autobiography and Memoirs of Benjamin Robert Haydon*, new ed., 2 vols. (London, 1926), 1: 28.
2. Sir George Beaumont to Wilkie, n.d. [1812]; quoted in Cunningham 1843, 1: 344.
3. Farington *Diary*, 8: 3164 (12 December 1807).

Bibliography
Cunningham, Allan. *The Life of Sir David Wilkie*. 3 vols. London, 1843.
Woodward, John. *Sir David Wilkie R.A.* Exh. cat., Royal Academy of Arts. London, 1958.
Irwin, David and Francina. *Scottish Painters at Home and Abroad 1700–1900*. London, 1975: 165–185.

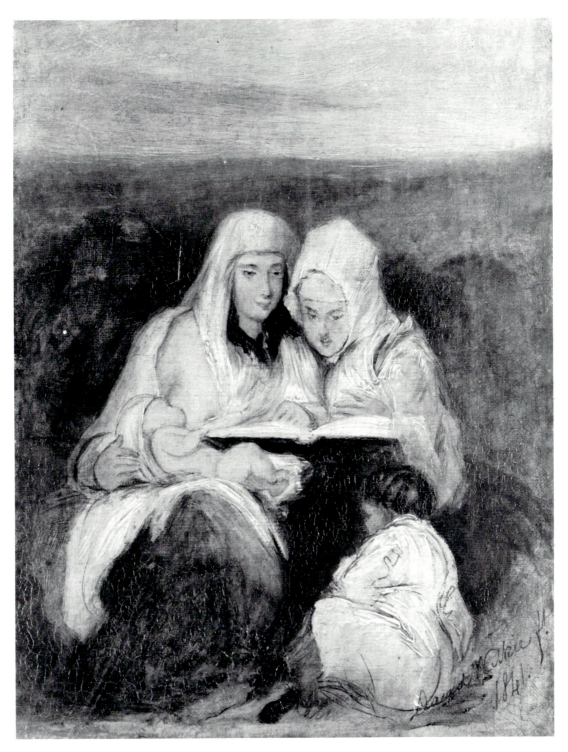

Sir David Wilkie, *The Holy Family with Saint Elizabeth and Saint John the Baptist*, 1960.6.42

Macmillan, Duncan. *Painting in Scotland: The Golden Age*. Exh. cat., Talbot Rice Art Centre, University of Edinburgh; Tate Gallery, London. Oxford, 1986: 157–185.

Chiego, William J., H. A. D. Miles, and David Blayney Brown (with contributions by Sir Ivor Batchelor, Lindsay Errington, and Arthur S. Marks). *Sir David Wilkie of Scotland (1785–1841)*. Exh. cat., North Carolina Museum of Art, Raleigh; Yale Center for British Art, New Haven. Raleigh, 1987.

1960.6.42 (1594)

The Holy Family with Saint Elizabeth and Saint John the Baptist

1841
Oil on canvas on panel, 25.7 × 19 (10⅛ × 7½)
Timken Collection

Inscriptions:
Signed and dated at bottom right: *David Wilkie f.ᵗ/1841*.

Technical Notes: The medium-weight canvas is finely plain woven; it has been adhered to a wooden panel, probably oak, which is primed with very thin white gesso; the original margins were unevenly cut at the time of the attachment. The ground is white, very thinly applied. The contours of the figures are defined in loose, fluid pencil underdrawing. The painting is executed in fluid layers ranging from thick, opaque paint— with moderate impasto in the highlights—for the draperies, to thin transparent glazes for the background. The faces may have been overpainted, as the details are weak and indistinct; the ground and paint have suffered small losses and abrasion damage along the edges where cut. The thick, perhaps slightly pigmented, natural resin varnish has discolored yellow to a significant degree.

Provenance: Frank Bulkeley Smith, Worcester, Massachusetts (sale, American Art Association, New York, 22–23 April 1920, 2nd day, no. 80, as *Camping Gypsies*, repro.). William R. Timken [d. 1949], New York; passed to his wife, Lillian S. Timken, New York [d. 1959].

THE INCLUSION OF A BOOK as the central motif in the composition militates against the accuracy of the traditional title of this work, *Camping Gypsies*. As pointed out by Ross Watson,[1] the iconography is more likely to be biblical.

Wilkie's first recorded biblical subject, a small panel of *Susanna and the Elders*, is signed and dated 1815. He painted another, larger panel, of *Bathsheba at the Bath*, in 1817, after his return from the Low Countries, and a watercolor of *Samuel in the Temple* in 1839. It was his realization that religious themes had traditionally been executed in ignorance of the Holy Land and its people, coupled with his seeing the pictures recently painted there by David Roberts, that, in spite of his by then enfeebled health, fired him with enthusiasm to travel to the Near East in 1840. Before his departure, he spoke to William Collins of "the enthusiasm he must feel in painting from a young woman and child at Bethlehem, on the very spot, as the 'motivo' for a picture of a Holy Family."[2] Wilkie arrived in the Holy Land in 1841.

As Watson suggested, the Washington picture seems to be a preliminary idea for a Holy Family with Saint Elizabeth and Saint John the Baptist; the shadowy figure of an old man, probably Saint Joseph, can be seen behind the Virgin's shoulder. Only three painted sketches for Biblical subjects done at this time have been recorded hitherto, a *Nativity*, *The Supper at Emmaus*, and *Christ before Pilate*.[3]

Wilkie habitually used panel as a support in order to give greater luminosity to his pictures; it is uncertain whether the auxiliary wooden support in the National Gallery's painting was adhered by the artist or at a later date, but the fact that it was primed with white suggests that it was attached by Wilkie himself. The heavy, discolored varnish makes the work difficult to evaluate. The figure design is compact, the background apparently very generalized.

Notes
1. Draft catalogue entry, 8 April 1969, in NGA curatorial files.
2. W. Wilkie Collins, *Memoirs of the Life of William Collins, Esq., R.A.*, 2 vols. (London, 1848), 2: 174.
3. The present locations of these works are unknown. The two last named were, respectively, with Spink & Son, London, in 1948, and P. & D. Colnaghi, London, in 1949.

Richard Wilson

1712/14 – 1782

WILSON WAS BORN in Penegoes, near Machynlleth, Montgomeryshire, between 1712 and 1714, the third son of the seven children of John Wilson, rector of Penegoes, and Alice Wynne. He received a sound classical education and, having early shown an enthusiasm for drawing, was placed in 1729 as a pupil with Thomas Wright, an indifferent portraitist and professional copyist in London, with whom he stayed for six years. Nothing is certainly known of his first eight or nine years in independent practice as a portraitist; his first recorded portrait dates from 1744. He was patronized by the Lytteltons and between 1747 and 1750 was living in the house on the south side of Covent Garden formerly occupied by Samuel Scott. He also painted landscapes of Welsh scenes and views in and around London, of which the earliest is dated 1737.

Wilson traveled to Italy in 1750 and was befriended in Venice by the British consul, Joseph Smith, and by Francesco Zuccarelli, who encouraged his propensity for landscape painting; after a year or so he went to Rome with William Lock, a young man on the Grand Tour, arriving there in January 1752. Finally persuaded by Claude Joseph Vernet to devote himself to landscape, he settled in Rome for five years or more, the sketches he made in the Alban Hills and around Naples providing him with a storehouse of ideas and compositions which laid the foundations of his later career. Lord Dartmouth gave him his most important commission, for sixty-eight large finished drawings of Italian views.

Wilson arrived back in England in 1757 or 1758 and established himself on the Great Piazza, Covent Garden; he did not resume portraiture but, according to his apprentice William Hodges, "soon attained the highest reputation"[1] in what was in the eighteenth century the less remunerative field of landscape painting. He took in a number of pupils, among them Thomas Jones and Joseph Farington. Little is known about his prices, which varied according to subject as well as size, but he is known to have been paid eighty guineas apiece for two large landscapes in 1765. He was a founding member of the Society of Artists in 1759 and of the Royal Academy of Arts in 1768, exhibiting regularly every year (with the exception of 1773) from 1760 to 1780.

A rugged and independent character unconcerned with forming connections, yet good natured and convivial, Wilson became increasingly intemperate in later years; he was forced to move several times due to straitened circumstances, and from about 1775 his practice declined noticeably. He received an income of fifty pounds a year through his appointment in 1776 as librarian of the Royal Academy in succession to Hayman. By 1781 he was described as "utterly incapable."[2] He had never married, though he seems to have had a son, and in 1781 he left London to stay with his cousin, Catherine Jones, at Colomendy, Denbighshire, where he died on 15 May 1782.

Although topography was his staple, Wilson was primarily a landscapist of a poetic inclination. He was for his period unusually responsive to the changing effects of light and atmosphere, and painted with equal sensitivity and truth of tone the clarity of Italian sunlight, twilight scenes in and around Rome, and the moisture of the Welsh valleys; skies were crucially important to him in suggesting the vibrancy of landscape and for their enveloping atmosphere. Thomas Wright, who gave the most complete account of Wilson's methods of painting, said that he "always finished the sky and distance with ultramarine; for it was his opinion that no other blue could give the beautiful effect of air."[3] He was no less sensitive to the relationships between shapes, and possessed an unerring sense of interval and accent, the classical features in his landscapes being to a large extent a formal vocabulary; he was a master of silhouette and skyline.

Wilson's handling of paint was lively and bold; even in his somewhat stiff early portraits, bland and smoothly modeled in the Hudson tradition, the delight in pigment is evident, and his style was transformed in Venice under the influence of Titian and Giovanni Battista Piazzetta. In his pre-Italian landscapes, fresh and rococo in manner, Wilson was influenced by the informality of George Lambert's more naturalistic work, and by the townscapes and low horizons of Jacob van Ruisdael; in Venice

he adopted the rich, broken handling of Zuccarelli and Giuseppe Zaïs. But it was Claude, Gaspard Dughet, and Aelbert Cuyp who inpired Wilson's mature style and whom later he regarded as the best landscape painters; Sir William Beechey recorded his comment: "Claude for air and Gaspar [sic] for composition and sentiment; you may walk in Claude's pictures and count the miles."[4] He constructed his landscapes like Claude, learned from him to use figures to underline theme or mood, achieved the grandeur in massing of Gaspard, and adopted the glow, warmth of tone, and sparkling highlights of Cuyp.

Wilson continued to paint Italian scenes after his return to England, describing a subject that sold well as "a good breeder;"[5] in these as well as in his English and Welsh views he anticipated the precepts of William Gilpin by subordinating accuracy to picturesque arrangement. In many of his country-house portraits the house is hardly more than a feature in the landscape. His finest mature landscapes are increasingly loose and atmospheric, to some extent influenced by Rubens and Philips Koninck, and in later life he more commonly painted simple, picturesque subjects.

Solkin, interpreting Wilson in sociological terms, has argued that, both in their content—down to such detail as the treatment of staffage—and in their sense of order, Wilson's landscapes "glamorised the prevailing structure of power"[6] in Britain.

Wilson had a number of pupils, including Farington, Hodges, and Jones; most of them followed his style closely. There were also many other imitators, so that his style was widely disseminated in the thirty or forty years following his death. His reputation was high, reflected in increasing prices, and copyists were active at the retrospective of his work held at the British Institution in 1814. Joseph Wright of Derby was influenced by Wilson in his later years and, in the succeeding generation, Constable, Crome, and Turner were profound admirers.

Notes
1. Constable 1953, 39.
2. Ozias Humphry to Francis Towne (unpublished letter in the Merivale papers; quoted by Constable 1953, 58).
3. Wright 1824, 20.
4. William T. Whitley, *Artists and Their Friends in England 1700–1799*, 2 vols. (London and Boston, 1928), 1: 380.
5. Wright 1824, 33.
6. Solkin 1982, 133.

Bibliography
Wright, Thomas. *Some Account of the Life of Richard Wilson, Esq. R.A.* London, 1824.
Ford, [Sir] Brinsley. *The Drawings of Richard Wilson*. London, 1951.
Constable, W.G. *Richard Wilson*. London, 1953.
Hayes, John. *Richard Wilson*. (The Masters series, no. 57.) Paulton, near Bristol, 1966.
Solkin, David. *Richard Wilson: The Landscape of Reaction*. Exh. cat., Tate Gallery, London; National Museum of Wales, Cardiff; Yale Center for British Art, New Haven. London, 1982.

1983.1.44 (2919)

Lake Albano

1762
Oil on canvas, 121.9 × 170.4 (48 × 67⅛)
Paul Mellon Collection

Inscriptions:
Signed in reverse monogram and dated at lower center: *WR. 1762*

Technical Notes: The medium-weight canvas is plain woven; it has been lined. The left edge has been folded over the non-original stretcher, obscuring approximately 2 cm. of the painted surface. Both vertical edges are extended by the addition of wooden strips approximately 1.5 cm. wide, which are painted to correspond with the adjacent original paint. The ground is off-white, thickly and smoothly applied. The painting is executed thinly and fluidly, blended wet into wet in the foreground and middle ground, leaving the ground visible; the figures are put in over the landscape with thicker paint. The landscape and sky are thickly painted, with low impasto in the highlights. The paint surface is slightly abraded, most notably on the left side of the lake; the thick paint has been slightly flattened. There is scattered retouching in the sky. There are discolored residues of an earlier natural resin varnish in the hills left and right. The overlying synthetic resin varnish has not discolored.

Provenance: Possibly Walter Spencer-Stanhope [d. 1822], Horsforth and Cannon Hall, Barnsley, Yorkshire. Simon Spencer-Stanhope [b. 1924]. (Banks Hall, Barnsley, sale, Henry Spencer and Sons, 16 September 1965, no. 229, repro.), bought by (Thos. Agnew & Sons), London, from whom it was purchased May 1966 by Paul Mellon, Upperville, Virginia.[1]

Exhibitions: *Pictures from North Country Houses*, Cannon Hall, Barnsley, 1961, no. 35.

THIS VIEW is taken from the east side of Lake Albano, with on the left Castel Gandolfo, the country residence

Richard Wilson, *Lake Albano*, 1983.1.44

of the popes, on the right Monte Cavo and the Roman villa used by the emperor Marcus Aurelius, and in the distance the Campagna and the Sabine hills. The hilly foreground, with its groups of figures, is a device often employed by Wilson to engage the spectator with a panoramic landscape.

Wilson painted a number of views of Lake Albano and its surroundings. Its natural beauty, its associations with classical antiquity, and the vista over the Campagna alike appealed to his sensibilities, sharpened as they were by his reverence for Claude. This large picture, generally unknown until it was exhibited in 1961 and therefore unrecorded in the literature, must rank as his most important painting of the area. It was executed when Wilson was at the height of his powers and reputation, in the decade after his return from Italy in 1757 or 1758, and dates to the same year as his two large views of the River Dee, now in the National Gallery, London, demonstrating his ability to work contemporaneously on English or Welsh views and on scenes derived from his memories of Italy. Certain stylistic features are, however, common to both categories of landscape: Claudean compositions, high viewpoints, an interest in silhouette, vistas in which the distance is carefully mapped out, even his vision of sun-drenched Italy. It is light that unifies the carefully balanced but detached masses of the National Gallery's picture.

A version of exactly the same size, also signed in reverse monogram and dated lower center 1762, is in an English private collection. A crude and somewhat smaller version, differing slightly in detail, formerly in the collection of Benjamin Booth (1732–1807),[2] was among the thirty-eight paintings by Wilson inherited by Booth's younger daughter, Lady Ford, and etched by Thomas Hastings between 1820 and 1824.

Notes

1. Information from Thos. Agnew & Sons, kindly supplied by Evelyn Joll.
2. Constable 1953 (see biography), 191, note to pl. 65b.

1983.1.45 (2920)

Solitude

c. 1762/1770
Oil on canvas, 142.1 × 210.1 (56 × 82¾)
Paul Mellon Collection

Technical Notes: The medium-weight canvas is plain woven; it has been lined. The ground is light gray; it is smoothly applied and masks the weave of the canvas. The painting is executed smoothly and opaquely, with thin brown and green glazes in the details of the landscape, thick textured paint in the trees, and low impasto in the highlights; the middle ground of the landscape on the right has been left unfinished, with the ground clearly visible in parts; the crude dark brown glazes in the center and right foreground, which help to establish the solid character of the forms, are original. The painting was cleaned, lined, and revarnished in London in 1973. It is in good condition. Linear cracks throughout the paint have been retouched; otherwise loss and damage are minimal. The thin natural resin varnish has not discolored.

Provenance: Perhaps (Maddox Street Gallery), London, 1828 (?). Perhaps Mr. Gray, Ilkley, Yorkshire, after whose death it was bought 1839 by (Chaplin).[1] Perhaps purchased from Chaplin c. 1839 by Andrew Fountaine [1808–1874], Narford Hall, King's Lynn, Norfolk;[2] by descent to Andrew Fountaine [b. 1918] (sale, Christie, Manson & Woods, London, 23 June 1972, no. 57, repro.), bought by (Thos. Agnew & Sons), London, for Paul Mellon, Upperville, Virginia.

THE SUBJECT corresponds with James Thomson's *The Seasons* (1730), part two, "Summer," lines 439 to 447:

> STILL let me pierce into the midnight depth
> Of yonder grove, of wildest, largest growth;
> That, high embowering in the middle air,
> Nods o'er the mount beneath. At every step,
> Solemn, and slow, the shadows blacker fall,
> And all is awful, silent gloom around.
> THESE are the haunts of Meditation, these
> The scenes where antient Bards th'inspiring breath,
> Extatic, felt; and, from this world retird.

Three hermits are shown in the grove; two are dressed as monks, the third more scantily clothed, like an anchorite, is reclining under a plinth surmounted by a broken statue of a lion, reading a book. The mood of solitude is relieved by the sunlit building in the clearing and by a view into distance on the right; the latter is closed by a bay and, beyond it, a mountain from the top of which smoke is escaping, almost certainly intended to represent the Bay of Naples and Vesuvius.[3]

The composition is organized in a series of receding planes, the foremost of which, with its mass of plants and grasses, is executed in a style characteristic of British landscape painting in the 1760s. This, the crisp delineation of the foliage, and the high quality of the handling throughout suggest that the Washington picture is a work of that decade. The trees on the left, the branches and foliage of which are spreading across the top of the canvas, are balanced by the buildup of clouds on the opposite

Richard Wilson, *Solitude*, 1983.1.45

Fig. 1. Richard Wilson, *Solitude*, from the engraving by William Woollett, 1778, London, British Museum

side of the canvas. The water on the right is given an exceptionally limpid quality by being left unfinished, the ground clearly visible through the thin paint.

Solkin has pointed out that the theme is emblematic of the notion of rural retirement.[4] He has argued, further, that the broken statue of the lion symbolizes the self-destructive nature of aggressive ferocity, a contrast to the virtuous contemplation of the hermits, which will lead to a contented old age.[5] He has suggested also that the subject (of which Wilson exhibited a version at the Society of Artists in 1762) bore an especially acute relevance for 1762, when bitter controversy raged between the hawkish mercantile City interest and the dovish country interest over the question of whether to continue the victorious Seven Years War or make peace with France and Spain.[6] This thesis is well argued, and could be applied to the smaller, enclosed versions of the subject listed below, though not to the Washington landscape, in which the setting is overtly Italian; but a polemical pictorial statement of this sort is surely quite alien to Wilson's poetic vision. Wheelock and Kreindler have proposed more plausibly that the broken statue of a lion with a globe under its paw symbolizes the inevitability of death and

decay,[7] underlining the mood of meditation.

A version almost identical in size and in details of composition is owned by M. D. G. Robinson.[8]

Solitude was evidently one of Wilson's "good breeders." Four smaller versions of it are extant. The largest, signed and dated 1762, is in the National Gallery of Ireland, Dublin, and is probably the "Landskip with hermits" exhibited at the Society of Artists in 1762, number 132. The others are all about 40-by-50 in size. One, in the Glynn Vivian Art Gallery and Museum, Swansea, is also signed and dated 1762. That formerly in the collection of Colonel M. H. Grant, London, is dated 1768; and that formerly with Dudley Wallis, London, is dated 1778.[9] An engraving in reverse by Woollett and Ellis (fig. 1), which was published in 1778 from the painting then in the possession of Robert Ledger with the lines from Thomson's *Seasons* quoted above, corresponds closely with the Dublin picture and was probably executed from it.[10] Neither the engraving nor any of these smaller versions includes the view into distance which, in the Washington picture, relieves the hermetic gloom of the subject central to Thomson's verse.

Notes

1. Descriptions of the work(s) owned by the Maddox Street Gallery and Mr. Gray quoted in Constable 1953 (see biography), 169, could apply equally well to the Washington picture and to that in the Robinson collection (see note 8).

2. Sir Geoffrey Agnew to Paul Mellon, 2 May 1972, in NGA curatorial files. It was certainly in Fountaine's possession by 1854, when it was noted in G. F. Waagen, *Treasures of Art in Great Britain*, 4 vols. (London, 1854), 3: 431.

3. It was so described in the list of pictures owned by the Maddox Street Gallery, 1828 (?): "The grand picture representing a view taken a few miles from Naples, on the *Mare Morto*, with Mount Vesuvius in the distance. One of his most capital works" (typescript in the library of the National Gallery, London).

4. Solkin 1982 (see biography), no. 101.

5. Solkin 1982 (see biography), 73.

6. Solkin 1982 (see biography), 73–74.

7. Arthur K. Wheelock, Jr., and Alice Kreindler, *British Painting in the National Gallery of Art* (Washington, D.C., 1987), 22.

8. M. D. G. Robinson sale, Christie, Manson & Woods, London, 16 April 1982, no. 60, repro., bought in; the Washington picture is described, without explanation, as "a studio product." The Robinson version, formerly in Colonel M. H. Grant's collection, is listed by Constable 1953 (see biography), 169.

9. *Illustrated Summary Catalogue of Paintings*, National Gallery of Ireland (Dublin, 1981), 180, no. 528, repro; Solkin 1982 (see biography), no. 101, repro. and color pl. 7; Constable 1953 (see biography), 169, note to pls. 28a, 28b, 29a. The version signed and dated 1768 was last recorded in the Dr. Michael Grant sale, Christie, Manson & Woods, 17 March 1967, no. 94, repro.

10. The letterpress gives 1762 as the date of the painting that was engraved, and the same date appears on the log at lower right in the print.

Joseph Wright

1734 – 1797

JOSEPH WRIGHT was born in Derby on 3 September 1734, the third son of John Wright, an attorney, and Hannah Brookes. He trained with Thomas Hudson from 1751 to 1753, returned to Derby as a portraitist, but, "not being satisfied with himself,"[1] again studied under Hudson between 1756 and 1757, forming a lasting friendship with his fellow pupil John Hamilton Mortimer. He toured the East Midlands as a portrait painter in 1760 and worked in Liverpool from 1768 to 1771; otherwise he practiced in Derby. In the mid-1760s he began painting "Candlelight" pictures, his own phrase, chiefly of scientific subjects; the most celebrated of these are *A Philosopher Giving a Lecture on the Orrery* (Derby Museum and Art Gallery) and *An Experiment on a Bird in the Air Pump* (National Gallery, London), subjects probably drawn from James Ferguson's popular lectures. He quickly achieved a high reputation in this field, in which he was an innovator. He first exhibited at the Society of Artists in 1765, showing there regularly until 1776, when he transferred to the Royal Academy. In 1773 he married Anne Swift, "a person in an inferior station of life;"[2] the couple had six children.

Wright spent nearly two years in Rome, from 1773 to 1775, where he was overwhelmed by the remains of classical antiquity and drew assiduously; on his way home he stopped only briefly in Florence, Bologna, Venice, and other centers. After a disastrous two years in Bath, where he had hoped to take the place of Gainsborough, who had left for London in 1774, Wright settled in his native Derby. He was elected an Associate of the Royal Academy in 1781 but, after being defeated by Edmund Garvey for full Academicianship in 1783 and feeling constantly dissatisfied with the way his pictures were hung, he declined election the following year and resigned as an Associate. In 1785 he followed Gainsborough's example and held his own exhibition of his works (at Robins' auction rooms in London).

Wright never obtained huge fees for his portraits: in the 1760s he charged six guineas for a head and shoulders and twelve guineas for a half-length canvas, prices which rose later only to twelve or fifteen and twenty guineas respectively; group portraits and subject pictures were priced higher according to the number of figures included, but the prices of the latter also varied according to patron. Wright was most at ease in provincial middle-class society and was in close contact with the Lunar Society (a group interested in experimental science) and with leaders of the Industrial Revolution in the Midlands, Sir Richard

Arkwright, Erasmus Darwin, Jedediah Strutt, Josiah Wedgwood, John Whitehurst, and others less well known; he was frugal, methodical, humorless, yet generous and sensitive and an accomplished musician. From early middle age he suffered from chronic ill health, which frequently incapacitated him for months. His last years were marred by a plethora of complaints, and he died in Derby on 29 August 1797.

Although Wright is best known for his candlelight scenes and industrial and other subject pictures, in which he demonstrated a wide range of imagination, he was trained as a portraitist and the bulk of his output is in this genre. He soon surpassed his master, Hudson, in his response to character, an exceptional feeling for materials, and a growing informality and inventiveness of pose which, however, owed much to the study of mezzotints and engravings; Wright's forte lay in his ability to adapt his style to the expectations of his clients and in his boldly realistic portraits of self-made men or other middle- and upper-middle-class sitters. Early captivated by the use of light in giving substance and vitality to the human form and to costume, he became absorbed by the candle-light effects of the seventeenth-century Utrecht masters and of his contemporary, Thomas Frye. He used these effects as the basis of pictorial design and to highlight the wrapt expressions of the participants in his scientific and industrial pictures of the 1760s and early 1770s, the period that marked the peak of his career. In all his work he took immense pains over the accuracy of detail, but, unlike Stubbs, who conducted his own experiments, Wright depended upon the knowledge and advice of others; he was more interested in style and effect than he was in science.

After his return from Italy, Wright abandoned his scientific and industrial scenes in favor of landscapes and literary subjects, in both of which he was characteristically innovative and unconventional. His literary scenes, for many of which he depended upon the ideas of his friend William Hayley, are evocative of the age of Rousseau and the cult of *sensibilité*, and his landscapes, at first bold and romantic—like his Vesuvian scenes—or delicate and mysterious—like his grottoes—gradually became more generalized and picturesque, smoother and softer in handling, with flat, decorative color, irrespective of whether they represented views around Rome and Naples or the Derbyshire peaks. Most of his late portraits are similarly more generalized, and subdued in color.

Wright's paintings sold well at the studio sale held after his death, in 1801. Nonetheless, since he had practised outside London, his work remained largely unknown in the nineteenth century until the exhibitions in Derby in 1870 and 1883 and at the Royal Academy in 1886. Even then he remained unfashionable, and his lack of glamor retarded appreciation of his work in the Duveen era. He had a central place in Francis Klingender's radical study, *Art and the Industrial Revolution*, published in 1947, and since then there has been a growing appreciation of his scientific and industrial painting, his feeling for light, and his position as a precursor of the romantic movement.

Notes
1. MS biography by Hannah Wright (quoted by Nicolson 1968, 1: 2, n. 2).
2. MS biography by Hannah Wright (quoted by Nicolson 1968, 1: 5).

Bibliography
Nicolson, Benedict. *Joseph Wright of Derby: Painter of Light.* 2 vols. London, 1968.
Egerton, Judy. *Wright of Derby.* Exh. cat., Tate Gallery, London; Grand Palais, Paris; The Metropolitan Museum of Art, New York. London, 1990.

1947.17.112 (1020)

Portrait of a Gentleman

c. 1760
Oil on canvas, 76.5 × 63.9 (30⅛ × 25⅛)
Andrew W. Mellon Collection

Technical Notes: The lightweight canvas is finely plain woven; it has been lined. The ground is cream colored; it is thickly applied and almost masks the weave of the canvas. The painting is executed in thin layers in the costume, thicker and more opaque paint in the flesh tones, low impasto in the highlights, and thin glazes in the background. The figure is moderately abraded; the background is severely abraded and has been heavily overpainted. There is an inverted L-shaped tear in the upper right quadrant, 16 cm. in length; areas of retouching are concentrated here and at the center of the bottom edge. The thin natural resin varnish has discolored yellow to a moderate degree.

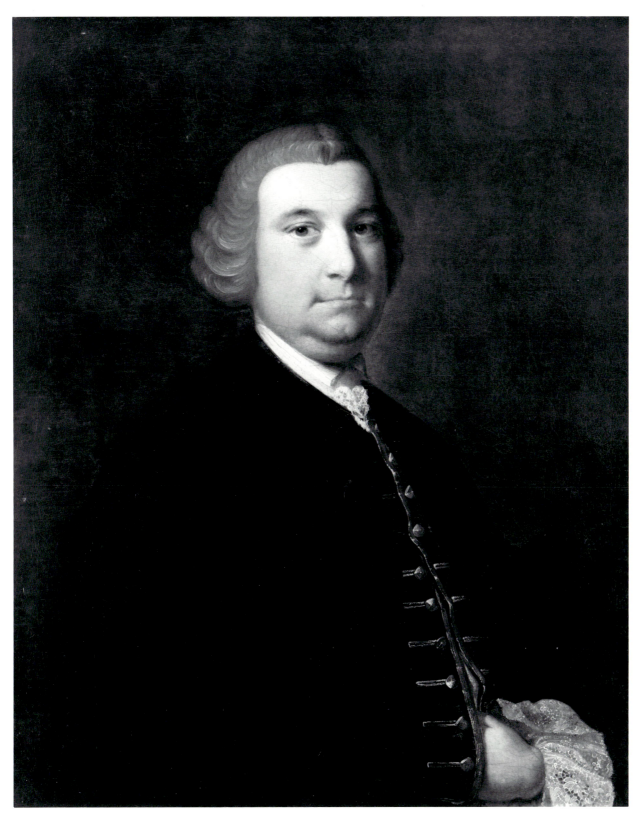

Joseph Wright, *Portrait of a Gentleman*, 1947.17.112

Provenance: Said to have been in private ownership in Georgetown, South Carolina, whence purchased by a New York dealer (perhaps Charles Henry Hart). Philipse Manor Hall Museum, Yonkers, New York, by 1910,[1] from which it was purchased, with the rest of the property, c. 1917, by C. W. Lyon, New York, who sold it 5 March 1917 to Thomas B. Clarke [d. 1931], New York. Sold by Clarke's executors 1935 to (M. Knoedler & Co.), New York, from whom it was purchased January 1936, as part of the Clarke collection, by The A. W. Mellon Educational and Charitable Trust, Pittsburgh.

Exhibitions: *Portraits Painted in the United States by Early American Artists*, Union League Club, New York, 1922, no. 11. *Portraits by Early American Artists of the Seventeenth, Eighteenth and Nineteenth Centuries Collected by Thomas B. Clarke*, Philadelphia Museum of Art, 1928, unpaginated and unnumbered. *Twelve Portraits from the Mellon Collection*, Pack Memorial Library, Asheville, North Carolina, 1949, no. 2. *The Face of American History*, Columbia Museum of Art, South Carolina, 1950, no. 19, repro. *American Portraits from the National Gallery of Art*, Atlanta Art Association, High Museum of Art, Atlanta, 1951, no. 3, repro.

THE TRADITIONAL identification of the sitter as Josias Allston (1731–1776), a planter in Georgetown, South Carolina, and uncle of Washington Allston, still accepted in 1951 when the portrait was exhibited in Atlanta, is rendered improbable by the recent identification of the artist as a British portraitist.

The portrait was variously attributed to Matthew Pratt and Henry Benbridge (by Charles X. Harris, when curator of Philipse Manor Hall Museum, and Charles Henry Hart, respectively) until its acquisition by Thomas B. Clarke, who seems to have been responsible for the attribution to Jeremiah Theüs. This and the earlier attributions have since been rejected;[2] the correct attribution to Wright of Derby was supplied, too late for inclusion in his catalogue raisonné of that artist's work, by Benedict Nicolson in 1969.[3] The smooth modeling, the lighting of the head, and the treatment of the costume (notably the minute delineation of the lace) are characteristic of Wright's style of about 1760.[4] The face is slightly masklike in character, as in the work of Wright's master, Thomas Hudson.

Notes

1. According to notes on the Clarke collection in NGA official files, Charles Henry Hart and Thomas B. Clarke were closely associated in assembling portraits for Philipse Manor Hall over a five-year period.

2. William P. Campbell, memorandum citing opinions about the different attributions, 22 January 1966, in NGA curatorial files.

3. Letter, 19 March 1969, in NGA curatorial files. The portrait was catalogued as Wright by Campbell in NGA 1970,

164, and by Wilmerding in NGA 1980, 309.

4. Compare his portraits of William Kirke, 1759–1760 (still in the family possession), and Thomas Bennett, c. 1760 (Derby Museum and Art Gallery); Nicolson 1968 (see biography), 2: pls. 19, 30.

References
1970 NGA 1970: 164, repro. 165.
1980 NGA 1980: 309.

1940.1.11 (497)

Portrait of a Gentleman

c. 1770–1773
Oil on canvas, 128 × 102 (50⅜ × 40⅛)
Andrew W. Mellon Collection

Technical Notes: The medium-to-heavyweight canvas is twill woven; it has been lined. The ground is off-white, thinly applied. The painting is mostly executed in thin, opaque layers; the costume is rendered in thicker paint applied in small strokes, the furry texture of the lapels being created by means of a stiff white paint covered with a transparent blue glaze; there is a low impasto in the leaves and highlights. The background is extensively abraded, but otherwise there is minimal paint loss. The moderately thick natural resin varnish has discolored yellow to a moderate degree.

Provenance: William Curzon [1836–1916], Lockington Hall, Derbyshire. Purchased 1916, at the dispersal of the Curzon estate, by Mrs. Claire Marion Cox, London, as Richard, Earl Howe, by John Singleton Copley; consigned by Mrs. Cox 1932 to (Hackett Galleries), New York; returned to Mrs. Cox and later consigned to (Mrs. Chambers Wood), New York, who sold it 1932 to (M. Knoedler & Co.), New York,[1] from whom it was purchased May 1936 by The A. W. Mellon Educational and Charitable Trust, Pittsburgh.

Exhibitions: Inaugural exhibition, Museum of the City of New York, 1932, no cat., as by Copley. *The Opening Exhibition*, Museum of Fine Arts, Springfield, Massachusetts, 1933, no. 1, as by Copley.

THE TRADITIONAL identification of the sitter as Admiral Earl Howe (1726–1799), plausible solely on account of a Curzon provenance,[2] is now discounted.[3] The sitter is not portrayed in naval uniform, and, unlike Howe, he has a cleft chin. He is elegantly dressed, with a felt hat and a waistcoat lined with pale blue velvet.

The traditional attribution to Copley (whose style in the 1760s had affinities with that of Wright) was first corrected in 1965 by Charles Buckley, with the support of Benedict Nicolson.[4] The use of an unconventional pose,

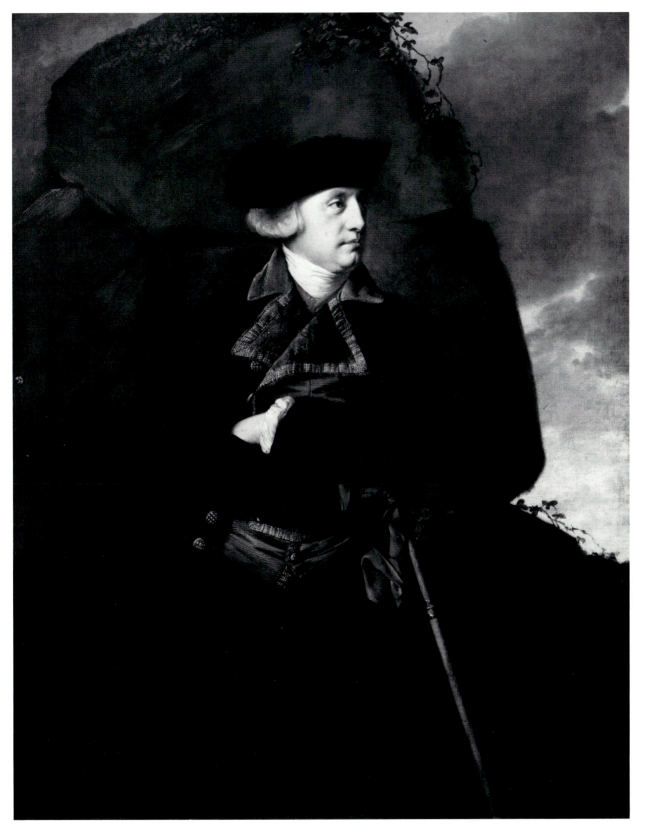

Joseph Wright, *Portrait of a Gentleman*, 1940.1.11

the delight in materials—notably the furry lapels and the soft leather gloves—the contrived lighting, and the rocky background with trailing vines are all characteristic of Wright's style. Nicolson described the portrait as a typical work of the early 1770s, the period immediately preceding the artist's Italian years (1773–1775).[5] The double-breasted waistcoat with large pointed lapels worn by the sitter was characteristic of fashion in the 1760s.

A version, rather inferior in quality and differing slightly in the arrangement of the background but identical in pose, costume, and lighting, was formerly owned by Captain R. T. Hinckes, of Foxley, Herefordshire. This portrait was then attributed to Zoffany and identified as representing the Marquis de Rinneau, sometime French ambassador in London.[6]

Notes

1. Knoedler's records give the early provenance (Elizabeth Clare to William P. Campbell, 5 November 1963, in NGA curatorial files). Clare quotes a letter from Mrs. Cox to Mrs. Wood, undated but presumably 1932, in which she states that the 1916 dispersal "was a hurried executors' sale and few persons attended it."

2. Lord Howe's eldest daughter, who became Baroness Howe after her father's death (there were no sons), married in 1787 the Hon. Penn Assheton Curzon. Their son, Richard, who succeeded his paternal grandfather as Viscount Curzon of Penn, took the name of Howe after that of Curzon and in 1821 became the 1st Earl Howe of the second creation. The portrait was said to have come from the collection of Baroness Howe, but this cannot be verified.

3. Nicolson 1968 (see biography); 1: 207.

4. William P. Campbell, memorandum, 14 June 1965, noting Buckley's verbal opinions, in NGA curatorial files. The portrait was catalogued as Wright by Campbell in NGA 1970, 166, and by Wilmerding in NGA 1980, 307.

5. Nicolson 1968 (see biography), 1: 207; compare, for example, the portrait of Sir George Cooke in Kansas City (fig. 1) of about 1770–1771 (Nicolson 1968 [see biography], 2: pl. 86).

6. Hinckes sale, Christie, Manson & Woods, London, 16 April 1937, no. 132, bought in. The evidence for this identification is unknown. No other portraits of anyone named Rinneau seem to be extant, so that the identification cannot be substantiated visually. Moreover, no one bearing the name of Rinneau, or a name remotely similar to it, is listed as ambassador, minister, or chargé d'affaires in London at any time in the eighteenth century (the official list was kindly communicated to me by Anne Lewis-Loubignac, French Embassy, London).

References

1968 Nicolson 1968 (see biography), 1: 36, 207; 2: pl. 90.
1970 NGA 1970: 166, repro. 167.
1976 Walker 1976: no. 530, color repro.
1980 NGA 1980: 307.

1983.1.46 (2921)

The Corinthian Maid

1782–1784
Oil on canvas, 106.3 × 130.8 (41⅞ × 51½)
Paul Mellon Collection

Technical Notes: The canvas appears to be finely twill woven; it has been lined, probably at the time it was sold to Paul Mellon. The ground is white, of moderate thickness. The painting is executed thinly, smoothly, and precisely, with drier, thicker highlights. There are slight pentimenti in the female figure: the upright fingers of her left hand were originally placed about 1 cm. to the right, and her right hand was further to the left; vague forms below her arms and around her profile suggest that there were also slight changes in these areas. The paint surface is slightly abraded, and has been flattened during lining. There are several large areas of discolored retouching. The thick synthetic resin varnish has discolored slightly.

Provenance: Painted for Josiah Wedgwood [1730–1795], Etruria, Staffordshire; offered by the second Josiah Wedgwood for sale by private contract, European Museum, London, 1814, no. 431, and between 1817 and 1819, no. 98. John Greaves [b. 1793], Irlam Hall, near Manchester, by 1831. Charles Meigh, Grove House, Shelton, Staffordshire (sale, Christie & Manson, London, 21–22 June 1850, 1st day, no. 108, bought in); (anon. [Meigh] sale, Christie & Manson, 18 June 1859, no. 202), bought by John Bentley [1797–1886], Birch House, near Manchester, and Portland Place, London (sale, Christie, Manson & Woods, London, 15 May 1886, no. 72), bought by (McLean).[1] William Bemrose;[2] by descent to Colonel W. Wright-Bemrose, Littleover Hill, Derby. A. Ralph Robotham, The White House, Darley Abbey, Derby, by 1947, who sold it to (Gooden & Fox), London, from whom it was purchased August 1962 by Paul Mellon, Upperville, Virginia.

Exhibitions: *Pictures, Painted by J. Wright, of Derby*, Robins, London, 1785, no. 13. *Pictures by Italian, Spanish, Flemish, Dutch and English Masters*, Royal Manchester Institution, 1831, no. 130. *Paintings by Wright of Derby 1734–1797*, Graves Galleries, London, 1910, no. 93. *Bicentenary Exhibition of Paintings by Joseph Wright*, Corporation Art Gallery, Derby, 1934, no. 35. *Joseph Wright of Derby 1734–1797*, Derby Museums and Art Gallery; Leicester Museums and Art Gallery, 1947, no. 37. *Joseph Wright of Derby*, Arts Council of Great Britain, Tate Gallery, London; Walker Art Gallery, Liverpool, 1958, no. 25, pl. xi. *Painting in England 1700–1850: Collection of Mr. and Mrs. Paul Mellon*, Virginia Museum of Fine Arts, Richmond, 1963, no. 372, repro., pl. 221. *Painting in England 1700–1850: From the Collection of Mr and Mrs Paul Mellon*, Royal Academy of Arts, London, no. 234; Yale University Art Gallery, New Haven, 1964–1965, no. 235. *Joseph Wright of Derby: A Selection of Paintings from the Collection of Mr. and Mrs. Paul Mellon*, National Gallery of Art, Washington, D.C., 1969–1970, no. 10, repro. *Pintura Británica de Hogarth a Turner*, British Council, Museo del Prado, Madrid, 1988–1989, no. 34, color

repro. *Joseph Wright of Derby*, Tate Gallery, London; Grand Palais, Paris; The Metropolitan Museum of Art, New York, 1990, no. 69, color repro.

THE SCENE DEPICTED is the legend of the origin of painting recounted by Pliny: Dibutade, the daughter of a Corinthian potter, Butades, wishing to keep a record of her lover who was about to leave the country, traced the outline of his shadow on the wall; her father then filled it in with clay, made a relief, and baked it. A kiln and vases arranged on shelves are seen in the inner room on the right, and two large vases are included in the foreground; the greyhound, asleep at the man's feet, symbolizes fidelity. The Gothic arch framing a moonlit landscape harks back to *The Alchemist* (Derby Museum and Art Gallery) of twelve years earlier, a period when Wright was still preoccupied with dramatic candlelight scenes.

The Corinthian Maid is one of the most fully documented of all Wright's works. The evolution and progress of the picture, which entailed considerable and protracted discussion with patron and friends, are described in unusual detail in the course of a correspondence with Josiah Wedgwood and with the poet William Hayley, patron and friend of a number of contemporary artists, including Blake, Flaxman, and Romney. The letters are exceptionally illuminating about the processes of artistic composition. The correspondence with Hayley illustrates Wright's characteristic dependence on outside advice and expertise and reluctance to make his own decisions.

The idea was first mooted by Wedgwood in May 1778. Wedgwood was then concerned about the introduction of his vases, "for how could such fine things be supposed to exist in the earliest infancy of the Potters Art."[3] In July 1779 Wright wrote to Wedgwood of his intention of "paying you a visit to consult you about the subject of the Maid of Corinth, or any other & to make such sketches of your apparatus as may be necessary."[4] But the proposal did not mature for another two and a half years. Then, in February 1782, Wright wrote once more to Wedgwood:

I have been employing myself in making a few historical designs, among w.ᶜʰ is the maid of Corinth, which will certainly make the best Candlelight picture I have painted. Mr. Boothby and several of my friends have seen it, & approve of it much. I take the liberty of mentioning it to you, as you sometime ago had thought of having that Subject painted. If you still continue in that Intention I shoud [sic] wish to have your thoughts upon it. It seems to me the elegant simplicity of the subject shoud [sic] be disturbed as little as

possible by other objects; an opening into another room, w.ᵗʰ some elegant vases upon a shelf, others on the ground, much kept down, would mark her fathers profession & enrich the picture without disturbing the effect, but I think I would not introduce a Furnace.[5]

Two weeks or so later Wright sent a rough sketch of the picture to his friend Hayley and invited his opinions, speaking to him first about his concern for the young man's shadow:

She by retiring a Step or two shoud [sic] conveniently see it, & it must also be evident to the Spectator. As sleep is full of motion of the head at least, the Shadow is traced upon a dark wall w.ᵗʰ a Sharp pointed instrument, w.ᶜʰ leaves the tracing white while his head was more erect, and the present Shadow agreeable to the position of the head is much lower; I think it tells the Story better, than if they coincided as it is more conspicuous. I once thought rapturous astonishment was the expression to be given to yᵉ Maid, but I now think it too violent . . . her figure . . . shou'd fall into a loose & easy swing . . . her face—I leave you to tell me what it shou'd be—the uper [sic] part of her figure will be strongly illuminated falling by gentle gradations into half Shade . . . I wish to raise his left Leg. I have done it by a vessel lying down part of a Groupe [sic] I intend there; if you have no objection to it; but it seems to want Stability. Would it [be] better if broken? Or what can be substituted that will not appear as put there for the purpose? I intend thro' an Arch showing another Room filled w.ᵗʰ elegant Earthen vessels—The Lamp will be partly concealed by a Curtain, the flame intirely—Be my *Friend* & tell me all my faults.[6]

On 9 March Wright asked Hayley to send the sketch on to Wedgwood, together with any criticisms he wished to make. The following day he wrote to Wedgwood himself, reiterating what he said to Hayley, and telling him how Boothby had suggested a tripod in place of the vase at the young man's feet and how Darwin was not in favor of any vases being shown.[7] A slightly later letter to Wedgwood raises the question of lighting: Wright was thinking of lowering the concealed source of light so as to make the shadow "more accurate."[8] Discussions inevitably slowed down the work. About ten months later the artist was writing to Hayley:

When I ask other peoples opinion, 'tis to profit by them . . . if they happen to coincide w.ᵗʰ my own I am happy, if otherwise, they stagger my opinion, & leave me undetermined whether I shall go on w.ᵗʰ the picture—I much approve Mr. Long's Idea of the female figure in the act of Drawing; the other hand up expressing a fear of waking the youth is good, & certainly tells the Story much better than mine, but I like not the thought of placing him on a Sopha, & his head raised

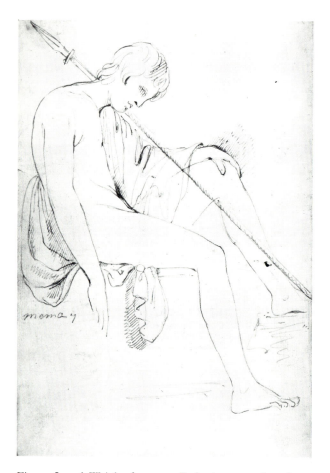

Fig. 1. Joseph Wright, f. 2 verso, *Endymion*, 1774, from the Rome sketchbook, pen and brownish-black ink, London, British Museum

w^th. an antique Bolster; here appears too much intention, when everything shou'd look like accident.[9]

Long's suggestion concerning the girl's gesture was duly incorporated.

By April 1783 Wright was sufficiently advanced to ride over to Etruria "to have the accompaniments settled,"[10] and Wedgwood sent him some vases to be introduced into the picture.[11] By October he had painted the inner room, in which he had now decided to include a

furnace, and asked Wedgwood for the "forms of the long Irons w^ch. stand about the Oven."[12] By the spring of 1784 the painting was complete. Wedgwood's one objection, that in the female figure "the naked appears too much thro' the drapery . . . the division of the posteriors appearing too plain through the drapery and its Sticking so close,"[13] was duly met by Wright: "the action she is in unfortunately makes the Drapery cling to the limbs but it is not on that account less Graecian . . . however, I will endeavour to alter it;" he would "cast a fuller drapery upon the Corinthian Maid w^ch. will conceal the Nudity, but her figure cannot be turned more in profile consistent with her employment."[14]

The Washington painting is smooth and academic in handling and somber in tonality, close in these respects to Benjamin West's neoclassical pictures of the 1760s. Irwin has suggested that its color, "its use of chrome, brown and prussian blue," derived from Poussin.[15] With its theme taken from Pliny, its classical draperies, its pose for the youth taken from an antique bas-relief of Endymion in the Capitoline Museum (fig. 1), which Wright had sketched in 1774, and with its protagonists seen in profile clearly outlined on a narrow uncluttered stage, it is Wright's most fully neoclassical work.[16] The subject, seldom illustrated before the 1770s, lent itself to such treatment, and had been painted in that decade first by one of Wright's oldest friends, John Hamilton Mortimer (this picture, now lost, was engraved in 1771), then by Alexander Runciman (fig. 2), and later by David Allan (fig. 3). Wright clearly owed something to Allan's rendering of the theme, which was painted in Rome and was engraved there in 1776, and he may have seen Runciman's; certainly he followed Runciman in painting the young man asleep, a gloss on Pliny's account by the Greek writer Athenagoras, and this may well have prompted him to choose for the pose his drawing of the sleeping Endymion. But Wright's principal influence was lit-

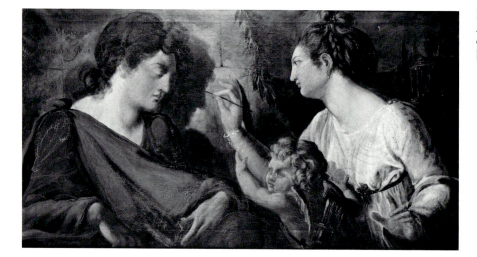

Fig. 2. Alexander Runciman, *The Origin of Painting*, signed and dated 1773, oil on canvas, Penicuik, Sir John Clerk, Bt. [photo: National Galleries of Scotland]

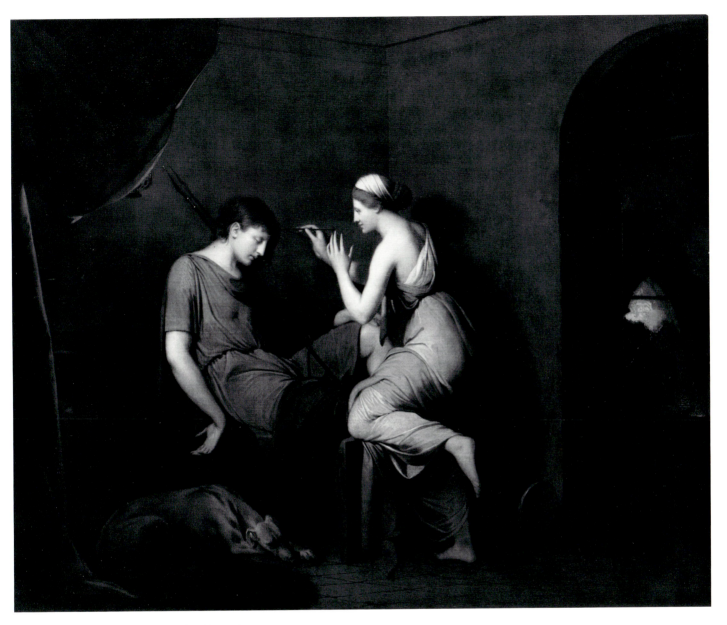

Joseph Wright, *The Corinthian Maid*, 1983.1.46

erary, not pictorial. In a letter to Hayley written some time after the completion of the picture, he gave the credit to the poet, who had expatiated on the theme in his *An Essay on Painting*, a long poem published in 1781: "Your elegant lines upon the Corinthian Maid . . . I have painted my picture from your Idea."[17] Nicolson pointed out that the three adjectives "steady, clear and even" which Hayley used in his neo-classical couplet: "Pleas'd she beheld the steady shadow fall/By the clear lamp upon the even wall," applied equally to Wright's conception.[18] It was Hayley's idea, too, that Wright should paint a companion picture, either Penelope unraveling her web or the origin of music.[19] The former subject, again one extolling the virtues of feminine fidelity, was duly executed for Wedgwood between 1783 and 1785 (fig. 4).[20]

The furnace in the inner room, for which Wedgwood had supplied information about "the long Irons," was probably intended to symbolize Wedgwood's pottery factory at Etruria.[21] Egerton has noted that the sleeping greyhound is very similar, though in reverse, to the greyhound in Stubbs' enamel painting of *Labourers*, signed

Fig. 3. David Allan, *The Origin of Painting*, signed and dated 1775, oil on panel, Edinburgh, National Gallery of Scotland

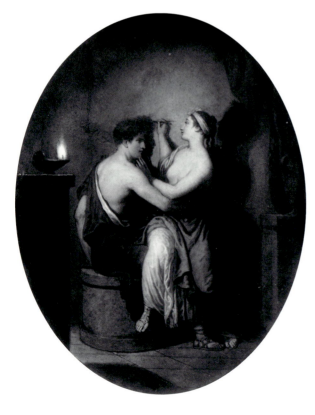

and dated 1781, which had been commissioned by Wedgwood, and which Wright would thus have known.[22]

Wright submitted his account for *The Corinthian Maid*, one hundred guineas, on 26 June 1785, at the same time as his account for the *Penelope* and two other pictures.[23]

Nicolson originally considered the Washington picture "a copy of a lost work" but, after restudying it at Yale, he concluded "that it is probably the damaged original. It still does not make a satisfactory impression."[24] Wright is known to have made versions of some of his subject pictures; nearly contemporary copies also exist. Wark considered the Gallery's painting "an extraordinarily weak performance" and observed that if it "can indeed be admitted to the canon of autograph work, then the qualitative range one must allow Wright in his replicas is very wide."[25] Cummings, enumerating specific weaknesses in anatomy and finding "no trace of Wright's delicate touch in the application of paint," concluded that the work was a copy.[26] Similar anatomical weaknesses, even the "tube-like fingers without joints, ending abruptly in startling points" of the Maid's uplifted left hand, which Cummings regards as "unlike any of the gentle, relaxed and carefully drawn hands of women by Wright himself," are, however, not uncommon in Wright's work; and, although the painting is distinctly weaker than its companion, the head and relaxed posture of the young man are accomplished enough to be acceptable as autograph Wright. Taking into account the unusually neo-classical intentions of the picture, the balance of visual evidence inclines toward the acceptance of Nicolson's revised, though cautious judgment.

A picture of this subject last recorded in the ownership of J. P. Pike in 1866[27] may have been a replica by Wright.

Notes

1. Probably Thomas McLean, London, the dealer, who dissolved his partnership in 1902 and sold his stock at Christie, Manson & Woods, 15 November 1902, 21 November 1903.

2. Author of *The Life and Works of Joseph Wright, A.R.A.* (London, 1885).

3. Wedgwood to Thomas Bentley, 5 May 1778 (Nicolson 1968 [see biography], 1: 143).

4. Wright to Wedgwood, 15 July 1779 (Nicolson 1968 [see biography], 1: 144).

5. Wright to Wedgwood, 11 February 1782 (Nicolson 1968 [see biography], 1: 145). The original design does not survive.

6. Wright to Hayley, c. late February 1782 (Nicolson 1968 [see biography], 1: 145).

7. Wright to Wedgwood, 10 March 1782 (Nicolson 1968 [see biography], 1: 145–146).

8. Wright to Wedgwood, c. March 1782 (Nicolson 1968

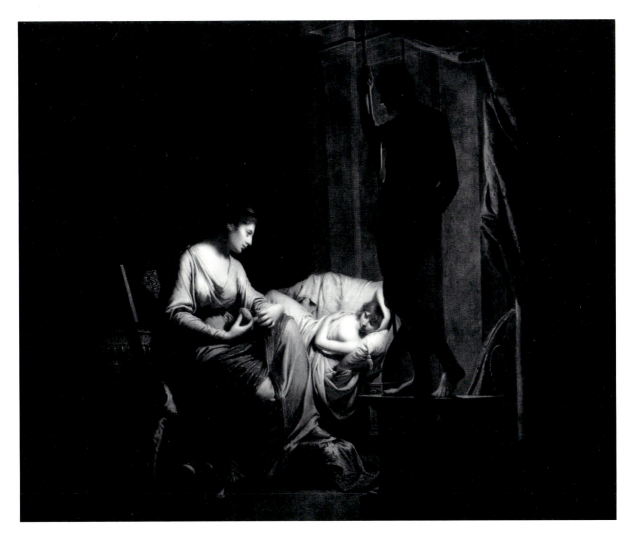

Fig. 4. Joseph Wright, *Penelope Unravelling Her Web*, 1783–1785, oil on canvas, Malibu, J. Paul Getty Museum

[see biography], 1:146).

9. Wright to Hayley, c. January 1783 (Nicolson 1968 [see biography], 1:146).

10. Wright to Wedgwood, 29 April 1783 (Nicolson 1968 [see biography], 1:146).

11. Acknowledged in Wright to Wedgwood, 29 May 1783 (Nicolson 1968 [see biography], 1:146).

12. Wright to Wedgwood, 23 October 1783 (Nicolson 1968 [see biography], 1:146).

13. Conveyed by Erasmus Darwin to Wright, c. April 1784, and Wedgwood to Wright, 29 April 1784 (Nicolson 1968 [see biography], 1:146).

14. Wright to Wedgwood, 20 April, 3 May 1784 (Nicolson 1968 [see biography], 1:146).

15. Irwin 1966, 80.

16. Nicolson 1968 (see biography), 1:65, declared that "Wright never produced another picture so uncompromisingly neo-classic."

17. Wright to Hayley, 22 December 1784 (Nicolson 1968 [see biography], 1:145). Wright catalogued the work as "From

Mr. Hayley's essay on painting," quoting ten lines of the verses, when he exhibited it in his one-man show at Robins' auction rooms in 1785.

18. Nicolson 1968 (see biography), 1:145. Rosenblum 1957, 285, observed that "one could hardly ask for a tidier list of neoclassic stylistic attributes."

19. Wright to Wedgwood, quoting Hayley, 29 May 1783 (Nicolson 1968 [see biography], 1:147).

20. Nicolson 1968 (see biography), 1: no. 225.

21. Nicolson privately to Rosenblum; Rosenblum 1957, 284, and n. 38.

22. Egerton 1990 (see biography), 134.

23. Nicolson 1968 (see biography), 1:148, n. 9. He was paid almost immediately (Wright's receipt, dated 4 July, is preserved in the Wedgwood archives at Keele University, Staffordshire; Egerton 1990 [see biography], 132).

24. Nicolson 1968 (see biography), 1:65, n. 1.

25. Wark 1970, 72.

26. Cummings 1971, 478, 481.

27. "The Origin of Portrait Painting" by Wright was lent

by J. P. Pike to the Art & Industrial Exhibition, Corn Exchange, Derby, 1866, no. 386.

References

1957 Rosenblum, Robert. "The Origin of Painting: A Problem in the Iconography of Romantic Classicism." *AB* 39 (1957): 284–285, fig. 5.

1966 Irwin, David. *English Neoclassical Art.* London, 1966: 79–80, pl. 92.

1968 Nicolson 1968 (see biography), 1: 16, 64–65, 143–149, 243, no. 224; 2: pl. 245.

1970 Wark, Robert. Review of Nicolson. *AQ* 33 (1970): 72.

1971 Cummings, Frederick. "Joseph Wright at the National Gallery." *AQ* 34 (1971): 478, 481.

1983.1.47 (2922)

Italian Landscape

1790
Oil on canvas, 103.5 × 130.4 (40¾ × 51⅜)
Paul Mellon Collection

Inscriptions:
Signed and dated at lower left: *I Wright/Pinx/1790*

Technical Notes: The canvas is plain woven; it has been lined. The ground is a smooth proprietary white. The painting is executed in a sophisticated range of techniques. The design has been blocked in with rich fluid paint; this is blended wet into wet in the sky, with thicker whites adding texture and definition. In the foreground and middle ground the base color is modified by a complex series of fluid opaque layers and glazes, with the final detail applied in bright, thick paint; in the mountains the base color of solid, opaque purplish lavender is modified by thin layers of green and bluish gray. The paint surface has been abraded in the mountain on the left side, and has been flattened during lining. There are scattered retouches in the sky. Otherwise the painting is in good condition. The moderately thick synthetic varnish has not discolored.

Provenance: Mr. Mills, Yorkshire.[1] A. J. Bentley by 1831; by descent to John Bentley [1797–1886], Birch House, near Manchester, and Portland Place, London (sale, Christie, Manson & Woods, London, 15 May 1886, no. 71), bought by F. B. Benedict Nicolson, London, until 1960. (Thos. Agnew & Sons), London, from whom it was purchased August 1960 by Paul Mellon, Upperville, Virginia.

Exhibitions: *Pictures by Italian, Spanish, Flemish, Dutch and English Masters,* Royal Manchester Institution, 1831, no. 145, as *Italian Scene—Convent of St. Cosimata* [sic]. *Painting in England, 1700–1850: Collection of Mr. & Mrs. Paul Mellon,*

Fig. 1. Joseph Wright, *Italian Landscape*, c. 1790, oil on canvas, Houston, Sarah Campbell Blaffer Foundation

Index of Subjects

Only costume discussed or described in the text is indexed. In this section, the page on which the illustration appears is given only when it differs from that of the text reference.

Index of Previous Owners and Dealers

General Index

The *General Index* includes references to all the artists and works represented in the Catalogue and those discussed in connection with them. The principal biographical reference to each artist represented in the Catalogue, and the paintings catalogued, are shown in bold.

A

Abbot, Mary (later Mrs. George Romney), 229
Abbotsford, Melrose, Scotland, 329
Abbott, Anna Maria, 3
Abbott, Revd. Lemuel, 3
Abbott, Lemuel Francis, **3–5**, 165
 Captain Robert Calder [1954.1.8], 3–5, *ill. on 5*
 Admiral Sir Robert Calder (Greenwich, London, National Maritime Museum), 4 (fig.1)
 Naval Officers, series (Greenwich, London, National Maritime Museum), 3
Abel, Carl Friedrich, 81
Aberdeen, 329 (Wilkie)
Abilgaard, Nicolai Abraham, 75
Acerbi, Giuseppe, 24
Acton, M. Adams (formerly)
 studio version of Gheeraerts, *Robert Devereux, 2nd Earl of Essex*, 114
Adair, James
 The History of the American Indians, 353
Addison, Mr., agent, Strand, London, 245
Aeschylus, 229
Agasse, Jacques-Laurent
 Lord Algernon Percy (Alnwick Castle, Duke of Northumberland), 172
Agnew, Sir Geoffrey, 182
Aikman, William
 James, 5th Duke of Hamilton, portraits of, 54
Aken, Joseph Van, 53
Albani, Francesco, 210
Alexander, John
 James, portrait of, 54
Alken, Samuel, 259
Allan, Ann (later second Mrs. John Ferneley), 72
Allan, David, 330, 346
 Sir William Hamilton (London, National Portrait Gallery), 240 note 4
 Sir William Hamilton and his Wife Catherine (Blair Castle, Perthshire, Duke of Atholl), 240 note 4
 The Origin of Painting (Edinburgh, National Gallery of Scotland), 348 (fig.3)
Allan, Sir William, 329–330
Allen, Margaret (née Hamilton), 314
Allen, William, Mayor of Philadelphia, 314

Allison, W.
 miniature, *Mrs. Paul Cobb Methuen* (Corsham Court, Lord Methuen), 88
Allston, Josias, 342
Allston, Washington, 342
Alnwick Castle, Northumberland
 portraits of *Lord Algernon Percy*: by Pompeo Batoni, Richard Cosway, Hugh Douglas Hamilton, Jacques-Laurent Agasse, Reynolds, unknown artist, 172
 portraits of *Lady Algernon Percy* (Isabella Susanna Burrell), 172
Althorp, Northamptonshire, 147
 Spencer Collection, formerly
 Gainsborough, drawing for *Mountain Landscape with a Bridge*, 98
 Gainsborough, *Rocky Landscape*, drawing, 98
 Studio version of Gheeraerts, *Robert Devereux, 2nd Earl of Essex*, 114
American Antiquarian Society, Worcester, Massachusetts
 Pelham portrait, 309
American War of Independence (Revolution), 202, 245
Amigoni, Jacopo, 120
Amsterdam, 318 (Verelst)
Amyand (later Cornewall), Sir George, Bt., 222
Anderson, David, 192
Anderson Manor, Dorset (Bullivant Collection, formerly)
 copy of Gheeraerts, *Robert Devereux, 2nd Earl of Essex*, 114
Andresen, Eva, Oslo
 Gainsborough, study for *Sea-Shore with Fishermen*, 94
Anne, Queen, 116
Anne of Denmark, Queen of James I, 111
 Kneller, portrait of, 318, 320 (fig.1)
Anthony, Mrs. Joseph, 26
Anthony, Marthe, 26
antiquarian collections, 240
Antique, the, poses from (Reynolds), 232
antique manner (dress), 294
Antiquity, classical, 339
Arkwright, Sir Richard, 339–340
Armstrong, John
 The Art of Preserving the Health, 74
Arniston House, Gorebridge, Midlothian
 Raeburn, *Gen. Francis Dundas and his Wife Playing Chess*, 195
Arnold, near Nottingham (Bonington), 19
Artists' General Benevolent Institution, 262
Art-Union, 283
Arundel, 27 (Constable)
Aske Hall, Yorkshire (Zetland Collection)
 Gainsborough (or Gainsborough Dupont), *George IV, as Prince of Wales*, 64, 66
Athenagoras, 346

Roberts, David, 332
Robertson, Andrew, 199–200
 miniature copy after Raeburn, *John Tait and his Grandson*, 200 (fig.1)
Robertson, Walter
 Mrs. William Hartigan, miniature (Charles Lull, formerly), 24
Robinson family of Cranford, 155
Robinson, Sir George, 155
 Frances Dorothea, daughter of (later Mrs. Charles Hoare), 155
 Penelope, daughter of (later Mrs. Robert Blencowe), 155
Robinson, Sir George Stamp (m. Emma Blencowe), 155
Robinson of Rokeby, Sir Thomas, 123, 127 note 4
Rockingham, Charles Watson-Wentworth, 2nd Marquess of, 258
Rockingham, Lewis Watson, 2nd Earl of, 247
rococo, 42, 116
 in Britain, 120, 121, 122, 299
Rogers, Samuel, 8
Roman Club, 147
Rome, 6 (Barker), 74, 75, 79 (Fuseli), 208 (Reynolds), 229 (Romney), 258 (Stubbs), 262, 263 (Turner), 303 (Dance), 311 (Smibert), 333 (Wilson), 339 (Wright of Derby)
 Campagna, 336
 Capitoline Museum
 bas relief, *Endymion*, 346
 Empire, fate of, 263
 landscape around, 283
 Society of Dilettanti, 147
Romney, George, 42, 75, 108, 129, 138, 176, 187, 199, 220, **229–247**, 345
 classical and other subject matter, 229
 drawing style, 229
 portrait style, 229
 portraits of Lady Hamilton, 229–230
 travels to Italy, Paris, 229
 works:
 Allegro or Mirth (Christie sale, 13 July 1984), 232
 Mrs. Alexander Blair [1942.9.77], 243–245, *ill. on 244*
 Mrs. Blair and her Daughter (not traced), 243
 Major-General Sir Archibald Campbell [1960.6.31], 245–247, *ill. on 246*
 versions of portrait of *Sir Archibald Campbell* (National Army Museum; John L. Campbell; whereabouts unknown), 245
 Mrs. Davies Davenport [1937.1.105], 237–238, *ill. on 238*
 Mr. Forbes [1954.14.1], 232–235, *ill. on 233*
 Captain Forbes (Fyvie Castle, Aberdeenshire, National Trust for Scotland), 234 (fig.2)
 Captain Alexander Forbes (New York, private collection), 234 (fig.1)
 Lady Elizabeth Hamilton (New York, Metropolitan Museum), 212
 Sir William Hamilton [1970.17.133], 239–240, *ill. on 239*

 Mrs. Paul Cobb Methuen (whereabouts unknown), 88
 Mrs. Thomas Scott Jackson [1937.1.94], 230–232, *ill. on 231*
 Mrs. Verelst (Rotherham, Yorkshire, Clifton Park Museum), 230 (fig.1)
 Lady Arabella Ward [1942.2.78], 240–243, *ill. on 241*, (x-ray on 242, fig.1)
 Miss Juliana Willoughby [1937.1.104], 235–237, *ill. on 236*, (x-ray on 235, fig.1)
Romney, John, 229
Rosa, Salvator, 6
Rosalba, *see* Carriera
Roscoe, William, 74, 80
Rossetti, William, 17
Rotherham, Yorkshire, Clifton Park Museum
 Romney, *Mrs. Verelst*, 230 (fig.1)
Rotterdam, Groote Kerk, 272
Rousseau, Jean Jacques, 176, 340
Rowlandson, Thomas, 9, 63, 72, 122, 170, 356
 Georgiana, Duchess of Devonshire, drawings of, 97 note 1
 watercolor, *Vauxhall Gardens* (London, Victoria and Albert Museum), 97 note 1
Royal Academy of Arts
 establishment of, 42, 81
 grant to Blake, 13
 members: Beechey, 10; Constable, 27; Fuseli, 74; Hoppner, 128; Lawrence, 152; Phillips, 184; Raeburn, 187; Turner, 262; Wilkie, 329; Wilson, 333; Zoffany, 355
 associates: Abbott, 3; Stubbs, 258; Wheatley, 321; Wright of Derby, 339
 presidents: Reynolds, 209, 210; Lawrence, 153
 professor, Phillips as, 184
 works exhibited at: Abbott, 3, 4; Barker, 6; Beechey, 9; Blake, 12; Von Breda, 23; Constable, 27, 33; Crome, 47; Gainsborough Dupont, 64; Ferneley, 71; Fuseli, 80; Gainsborough, 84, 94, 95, 98, 104; Herring, 114; Hoppner, 129, 130, 136; Lawrence, 156; Raeburn, 187; Reynolds, 209, 218; Singleton, 250; Stubbs, 258; Turner, 261, 264, 268, 276, 282–283, 290; Wilkie, 329
 Royal Academy Schools, 12 (Blake), 27 (Constable), 57 (Arthur William Devis), 63 (Gainsborough Dupont), 71 (Ferneley), 108 (Gardner), 128 (Hoppner), 152 (Lawrence), 176 (Morland), 184 (Phillips), 250 (Singleton), 261 (Turner), 321 (Wheatley), 329 (Wilkie)
 Turner Retrospective 1974, impact of, 263
Royal Manchester Institution, 276
Royal Scottish Academy, 139, 187
Royal Society, The, 184
(Royal) Society of British Artists, 325–326; *see also* Society of Artists, Society of British Artists
Rubens, Sir Peter Paul, 82, 98, 116, 209, 330, 334
 Marie de Médicis series (Paris, Luxembourg Palace, formerly), 329
Ruisdael, Jacob van, 6, 80, 82, 333
Runciman, Alexander, 75, 187
 The Origin of Painting (Penicuik House, Sir John Clerk,

Concordance of Old-New Titles

Artist	Accession Number	Old Title	New Title
Thomas Barker	1956.9.1	Shepherd Boys and Dog Sheltering from Storm	Shepherd Boys and Dog Sheltering from a Storm
Sir William Beechey	1961.5.1	General Sir Thomas Picton	Lieutenant-General Sir Thomas Picton
John Constable	1937.1.108	A View of Salisbury Cathedral	Salisbury Cathedral from Lower Marsh Close
Francis Cotes	1961.5.2	Miss Elizabeth Crewe	Mrs. Thomas Horne
Arthur Devis	1964.2.3	Portrait of a Gentleman Netting Game Birds	Portrait of a Gentleman Netting Partridges
Arthur Devis	1964.2.4	Conversation Piece Ashdon House	Members of the Maynard Family in the Park at Waltons
Arthur Devis	1983.1.40	Arthur Holdsworth, Thomas Taylor, and Captain Stancombe Conversing by the River Dart	Arthur Holdsworth Conversing with Thomas Taylor and Captain Stancombe by the River Dart
Thomas Gainsborough	1937.1.107	Landscape with a Bridge	Mountain Landscape with Bridge
Thomas Gainsborough	1942.9.20	Mrs. Methuen	Mrs. Paul Cobb Methuen
Thomas Gainsborough	1942.9.22	The Earl of Darnley	John, 4th Earl of Darnley
John Hoppner	1979.65.1	Lady Harriet Cunliffe	Lady Cunliffe
Attributed to John Hoppner	1956.9.3	Portrait of a Man	Portrait of a Gentleman
Style of John Hoppner	1970.17.106	Portrait of a Man	Portrait of a Gentleman
Joseph Bartholomew Kidd	1951.9.5	Sharp-Tailed Sparrow	Sharp-Tailed Finch
Attributed to George Knapton	1942.8.1	Portrait of a Man	Portrait of a Gentleman
Attributed to George Knapton	1951.7.1	A Gentleman Commoner of Merton College, Oxford	A Graduate of Merton College, Oxford
Sir Thomas Lawrence	1937.1.96	Lady Templetown and Her Son	Lady Mary Templetown and Her Eldest Son
Sir Thomas Lawrence	1942.9.37	Lady Robinson	Mrs. Robert Blencowe
Sir Thomas Lawrence	1968.6.2	Marquis of Hertford	Francis Charles Seymour-Conway, 3rd Marquess of Hertford
James Millar	1956.9.4	The Earl of Beverley	Lord Algernon Percy
James Millar	1956.9.5	The Countess of Beverley	Lady Algernon Percy
George Morland	1942.9.43	The End of the Hunt	The Death of the Fox

Artist	Accession Number	Old Title	New Title
Sir Henry Raeburn	1945.10.3	*John Johnstone of Alva, His Sister, and His Niece*	*John Johnstone, Betty Johnstone, and Miss Wedderburn*
Sir Joshua Reynolds	1942.9.75	*Lady Betty Hamilton*	*Lady Elizabeth Hamilton*
Sir Joshua Reynolds	1961.2.2	*Squire Musters*	*John Musters*
After Sir Joshua Reynolds	1942.9.76	*Nelly O'Brien*	*Miss Nelly O'Brien*
George Romney	1937.1.94	*Lady Broughton*	*Mrs. Thomas Scott Jackson*
George Romney	1937.1.104	*Miss Willoughby*	*Miss Juliana Willoughby*
George Romney	1937.1.105	*Mrs. Davenport*	*Mrs. Davies Davenport*
George Romney	1942.9.77	*Mrs. Blair*	*Mrs. Alexander Blair*
George Romney	1960.6.31	*Sir Archibald Campbell*	*Major-General Sir Archibald Campbell*
Gerard Soest	1977.63.1	*Portrait of a Woman*	*Lady Borlase*
George Stubbs	1952.9.4	*Captain Pocklington with his Wife and Sister*	*Captain Samuel Sharpe Pocklington with His Wife, Pleasance, and (?) His Sister Frances*
Joseph Mallord William Turner	1970.17.135	*Van Tromp's Shallop*	*Rotterdam Ferry-Boat*
Unknown British Artist, 17th Century	1947.17.91	*Portrait of a Man*	*Portrait of a Gentleman*
Unknown British Artist, 17th or 18th Century	1947.17.64	*Portrait of a Man*	*Portrait of a Gentleman*
Unknown British Artist, 18th Century	1947.17.43	*Portrait of a Man*	*Portrait of a Gentleman*
Unknown British Artist, 18th Century	1947.17.49	*Portrait of a Man*	*Portrait of a Gentleman*
Unknown British Artist, 18th Century	1947.17.94	*Portrait of a Man*	*Portrait of a Gentleman*
Unknown British Artist, 18th Century	1954.1.7	*Portrait of a Man*	*Portrait of a Gentleman*
Unknown British Artist (?), 18th Century	1947.17.15	*Portrait of a Man*	*Portrait of a Gentleman*
Unknown British Artist (?), 18th Century	1947.17.22	*Portrait of a Man*	*Portrait of a Gentleman*
Unknown British Artist (?), 18th Century	1947.17.83	*Portrait of a Man*	*Portrait of a Gentleman*
Unknown British Artist (?), 18th Century	1947.17.86	*Portrait of a Man*	*Portrait of a Gentleman*
Unknown British Artist (?), 18th Century	1947.17.87	*Portrait of a Man*	*Portrait of a Gentleman*
Unknown British Artist (?), 18th Century	1947.17.88	*Portrait of a Man*	*Portrait of a Gentleman*
W. Wheldon	1953.5.39	*Two Brothers*	*The Two Brothers*

Artist	Accession Number	Old Title	New Title
Sir David Wilkie	1960.6.42	*Camping Gypsies*	*The Holy Family with Saint Elizabeth and Saint John the Baptist*
Joseph Wright	1940.1.11	*Richard, Earl Howe (?)*	*Portrait of a Gentleman*
Joseph Wright	1947.17.112	*Portrait of a Man*	*Portrait of a Gentleman*

Concordance of Old-New Attributions

Old Attribution	Accession No.	New Attribution
Anonymous American, 18th Century	1947.17.95	Maria Verelst
Anonymous British, 16th Century	1947.18.1	Studio of Marcus Gheeraerts the Younger
Anonymous British, 18th Century	1947.17.102	Unknown British Artist, 18th Century
Anonymous British, 18th Century	1952.4.2	Attributed to Philip Mercier
Anonymous British, 18th Century	1954.1.11	Attributed to Henry Singleton
Anonymous British, 18th Century	1956.9.4	James Millar
Anonymous British, 18th Century	1956.9.5	James Millar
Anonymous British, 18th Century	1963.10.144	Unknown British Artist (?), 18th Century
Anonymous Unknown Nationality, 17th Century	1947.17.91	Unknown British Artist, 17th Century
Anonymous Unknown Nationality, 18th Century	1942.8.1	Attributed to George Knapton
Anonymous Unknown Nationality, 18th Century	1942.8.5	Joseph Highmore
Anonymous Unknown Nationality, 18th Century	1947.17.15	Unknown British Artist (?), 18th Century
Anonymous Unknown Nationality, 18th Century	1947.17.22	Unknown British Artist (?), 18th Century
Anonymous Unknown Nationality, 18th Century	1947.17.26	Attributed to Enoch Seeman
Anonymous Unknown Nationality, 18th Century	1947.17.27	Unknown British Artist, 18th Century
Anonymous Unknown Nationality, 18th Century	1947.17.31	Unknown British Artist (?), 18th Century
Anonymous Unknown Nationality, 18th Century	1947.17.39	Unknown British Artist, 18th Century
Anonymous Unknown Nationality, 18th Century	1947.17.41	Unknown British Artist (?), 18th Century
Anonymous Unknown Nationality, 18th Century	1947.17.43	Unknown British Artist, 18th Century
Anonymous Unknown Nationality, 18th Century	1947.17.48	Unknown British Artist, 18th Century
Anonymous Unknown Nationality, 18th Century	1947.17.49	Unknown British Artist, 18th Century
Anonymous Unknown Nationality, 18th Century	1947.17.64	Unknown British Artist, 17th or 18th Century
Anonymous Unknown Nationality, 18th Century	1947.17.86	Unknown British Artist (?), 18th Century
Anonymous Unknown Nationality, 18th Century	1947.17.87	Unknown British Artist (?), 18th Century
Anonymous Unknown Nationality, 18th Century	1947.17.88	Unknown British Artist (?), 18th Century
Anonymous Unknown Nationality, 18th Century	1947.17.94	Unknown British Artist, 18th Century
Anonymous Unknown Nationality, 18th Century	1954.1.7	Unknown British Artist, 18th Century
Anonymous Unknown Nationality, 19th Century	1942.8.24	Unknown British Artist, 18th Century
Anonymous Unknown Nationality, 19th Century	1947.17.83	Unknown British Artist (?), 18th Century
Attributed to Mather Brown	1947.17.29	Jeremiah Davison
Follower of John Crome	1942.9.14	Attributed to Joseph Paul
Studio of Thomas Gainsborough	1937.1.98	Gainsborough Dupont
John Frederick Herring	1960.6.23	Attributed to John Frederick Herring the Younger
Joseph Highmore	1951.7.1	Attributed to George Knapton
Follower of Sir Thomas Lawrence	1968.6.1	Attributed to Thomas Phillips
Sir Peter Lely	1960.6.26	Probably chiefly studio of Sir Peter Lely
Attributed to Benjamin Marshall	1970.17.125	Style of Benjamin Marshall
Sir Henry Raeburn	1954.9.1	Style of Sir Henry Raeburn
Follower of Sir Joshua Reynolds	1942.9.73	Daniel Gardner
William Smith of Chichester	1976.62.1	Unknown British Artist, 19th Century
Gerard Soest	1988.20.1	John Riley
Gilbert Stuart	1942.8.15	Carl Fredrik von Breda

Concordance of Old-New Dates

Accession Number and Old Date	New Date
1937.1.98 – 1780/1788	1781
1937.1.102 – c. 1800	1796/1811
1942.5.2 – c. 1811	c. 1811 (?)
1942.9.56 – probably c. 1790	1790
1945.10.3 – c. 1805	c. 1790/1795
1948.19.1 – c. 1795	c. 1788 – 1789, altered c. 1790
1956.9.4 – third quarter of the 18th century	c. 1777/1780
1956.9.5 – third quarter of the 18th century	c. 1777/1780
1970.17.119 – c. 1790/1797	c. 1787/1796
1970.17.120 – c. 1790/1797	1787/1796
1970.17.122 – c. 1790/1797	1787/1796
1970.17.130 – c. 1796	c. 1790/1800
1970.17.131 – c. 1806	c. 1800/1806
1977.63.1 – c. 1665	c. 1672/1675

1937.1.92	92	Thomas Gainsborough, *Mrs. Richard Brinsley Sheridan*
1937.1.93	93	Thomas Gainsborough, *Georgiana, Duchess of Devonshire*
1937.1.94	94	George Romney, *Mrs. Thomas Scott Jackson*
1937.1.95	95	Sir Joshua Reynolds, *Lady Elizabeth Delmé and Her Children*
1937.1.96	96	Sir Thomas Lawrence, *Lady Mary Templetown and Her Eldest Son*
1937.1.97	97	Sir Joshua Reynolds, *Lady Elizabeth Compton*
1937.1.98	98	Gainsborough Dupont, *George IV as Prince of Wales*
1937.1.99	99	Thomas Gainsborough, *Miss Catherine Tatton*
1937.1.100	100	Thomas Gainsborough, *Mrs. John Taylor*
1937.1.101	101	Sir Henry Raeburn, *Miss Eleanor Urquhart*
1937.1.102	102	Sir Henry Raeburn, *Colonel Francis James Scott*
1937.1.103	103	Sir Henry Raeburn, *John Tait and His Grandson*
1937.1.104	104	George Romney, *Miss Juliana Willoughby*
1937.1.105	105	George Romney, *Mrs. Davies Davenport*
1937.1.106	106	Sir Joshua Reynolds, *Lady Caroline Howard*
1937.1.107	107	Thomas Gainsborough, *Mountain Landscape with Bridge*
1937.1.108	108	John Constable, *Salisbury Cathedral from Lower Marsh Close*
1937.1.109	109	Joseph Mallord William Turner, *Mortlake Terrace*
1937.1.110	110	Joseph Mallord William Turner, *Approach to Venice*
1937.1.111	111	John Hoppner, *The Frankland Sisters*
1940.1.11	497	Joseph Wright, *Portrait of a Gentleman*
1942.5.2	553	Sir Henry Raeburn, *The Binning Children*
1942.8.1	554	Attributed to George Knapton, *Portrait of a Gentleman*
1942.8.5	558	Joseph Highmore, *Portrait of a Lady*
1942.8.15	568	Carl Fredrik von Breda, *Mrs. William Hartigan*
1942.8.24	577	Unknown British Artist, *Robert Thew (?)*
1942.9.9	605	John Constable, *The White Horse*
1942.9.10	606	John Constable, *Wivenhoe Park, Essex*
1942.9.14	610	Attributed to Joseph Paul, *Landscape with Picnickers and Donkeys by a Gate*
1942.9.20	616	Thomas Gainsborough, *Mrs. Paul Cobb Methuen*
1942.9.21	617	Thomas Gainsborough, *The Hon. Mrs. Thomas Graham*
1942.9.22	618	Thomas Gainsborough, *John, 4th Earl of Darnley*
1942.9.35	631	John Hoppner, *The Hoppner Children*
1942.9.37	633	Sir Thomas Lawrence, *Mrs. Robert Blencowe*
1942.9.43	639	George Morland, *The Death of the Fox*
1942.9.56	652	Sir Henry Raeburn, *David Anderson*
1942.9.73	669	Daniel Gardner, *The Hon. Mrs. Gray*
1942.9.74	670	Sir Joshua Reynolds, *Lady Cornewall*
1942.9.75	671	Sir Joshua Reynolds, *Lady Elizabeth Hamilton*
1942.9.76	672	After Sir Joshua Reynolds, *Miss Nelly O'Brien*
1942.9.77	673	George Romney, *Mrs. Alexander Blair*
1942.9.78	674	George Romney, *Lady Arabella Ward*
1942.9.85	681	Joseph Mallord William Turner, *Venice: The Dogana and San Giorgio Maggiore*
1942.9.86	682	Joseph Mallord William Turner, *Keelmen Heaving in Coals by Moonlight*
1942.9.87	683	Joseph Mallord William Turner, *The Junction of the Thames and the Medway*
1943.11.8	759	Beatrice Godwin Whistler, *Peach Blossom*
1943.11.11	763	William Blake, *Job and His Daughters*
1945.10.3	884	Sir Henry Raeburn, *John Johnstone, Betty Johnstone, and Miss Wedderburn*
1947.17.15	923	Unknown British Artist (?), *Portrait of a Gentleman*
1947.17.22	930	Unknown British Artist (?), *Portrait of a Gentleman*
1947.17.26	934	Attributed to Enoch Seeman, *Portrait of an Officer*
1947.17.27	935	Unknown British Artist, *Portrait of a Lady*
1947.17.29	937	Jeremiah Davison, *James, 5th Duke of Hamilton*

1947.17.31	939	Unknown British Artist (?), *Portrait of a Lady*
1947.17.39	947	Unknown British Artist, *Portrait of a Lady*
1947.17.41	949	Unknown British Artist (?), *Portrait of a Lady*
1947.17.43	951	Unknown British Artist, *Portrait of a Gentleman*
1947.17.48	956	Unknown British Artist, *Portrait of a Lady*
1947.17.49	957	Unknown British Artist, *Portrait of a Gentleman*
1947.17.64	972	Unknown British Artist, *Portrait of a Gentleman*
1947.17.83	991	Unknown British Artist (?), *Portrait of a Gentleman*
1947.17.86	994	Unknown British Artist (?), *Portrait of a Gentleman*
1947.17.87	995	Unknown British Artist (?), *Portrait of a Gentleman*
1947.17.88	996	Unknown British Artist (?), *Portrait of a Gentleman*
1947.17.91	999	Unknown British Artist, *Portrait of a Gentleman*
1947.17.94	1002	Unknown British Artist, *Portrait of a Gentleman*
1947.17.95	1003	Maria Verelst, *Portrait of a Lady*
1947.17.102	1010	Unknown British Artist, *The Hon. Sir Francis Burton Conyngham*
1947.17.112	1020	Joseph Wright, *Portrait of a Gentleman*
1947.18.1	1023	Studio of Marcus Gheeraerts the Younger, *Robert Devereux, 2nd Earl of Essex*
1948.19.1	1024	Sir Henry Raeburn, *Captain Patrick Miller*
1951.7.1	1065	Attributed to George Knapton, *A Graduate of Merton College, Oxford*
1951.9.5	1073	Joseph Bartholomew Kidd, *Sharp-Tailed Finch*
1951.9.6	1074	Joseph Bartholomew Kidd, *Black-Backed Three-Toed Woodpecker*
1951.9.7	1075	Joseph Bartholomew Kidd, *Orchard Oriole*
1951.9.8	1076	Joseph Bartholomew Kidd, *Yellow Warbler*
1951.18.1	1080	Joseph Mallord William Turner, *The Rape of Proserpine*
1952.4.2	1083	Attributed to Philip Mercier, *The Singing Party*
1952.9.4	1047	George Stubbs, *Captain Samuel Sharpe Pocklington with His Wife, Pleasance, and His Sister (?), Frances*
1953.5.39	1245	W. Wheldon, *The Two Brothers*
1954.1.7	1191	Unknown British Artist, *Portrait of a Gentleman*
1954.1.8	1192	Lemuel Francis Abbott, *Captain Robert Calder*
1954.1.11	1195	Attributed to Henry Singleton, *James Massy-Dawson (?)*
1954.9.1	1351	Style of Sir Henry Raeburn, *Miss Jean Christie*
1954.13.1	1355	William Blake, *The Last Supper*
1954.14.1	1356	George Romney, *Mr. Forbes*
1956.9.1	1448	Thomas Barker, *Shepherd Boys and Dog Sheltering from a Storm*
1956.9.3	1450	Attributed to John Hoppner, *Portrait of a Gentleman*
1956.9.4	1451	James Millar, *Lord Algernon Percy*
1956.9.5	1452	James Millar, *Lady Algernon Percy*
1959.1.1	1526	George Cuitt the Younger, *Easby Abbey, near Richmond*
1960.6.6	1558	Style of Francis Cotes, *Portrait of a Lady*
1960.6.7	1559	Style of Francis Cotes, *Portrait of a Lady*
1960.6.23	1575	Attributed to John Frederick Herring the Younger, *Horses' Heads*
1960.6.26	1578	Probably chiefly studio of Sir Peter Lely, *Barbara Villiers, Duchess of Cleveland*
1960.6.31	1583	George Romney, *Major-General Sir Archibald Campbell*
1960.6.40	1592	Joseph Mallord William Turner, *The Evening of the Deluge*
1960.6.42	1594	Sir David Wilkie, *The Holy Family with Saint Elizabeth and Saint John the Baptist*
1961.2.1	1602	Thomas Gainsborough, *Master John Heathcote*
1961.2.2	1603	Sir Joshua Reynolds, *John Musters*
1961.2.3	1604	Joseph Mallord William Turner, *The Dogana and Santa Maria della Salute, Venice*
1961.5.1	1654	Sir William Beechey, *Lieutenant-General Sir Thomas Picton*
1961.5.2	1646	Francis Cotes, *Mrs. Thomas Horne*
1961.5.3	1647	Thomas Gainsborough, *William Yelverton Davenport*
1963.10.79	1743	After Joseph Wright, *The Widow of an Indian Chief*
1963.10.144	1808	Unknown British Artist (?), *Portrait of a Girl*
1964.2.3	1911	Arthur Devis, *Portrait of a Gentleman Netting Partridges*
1964.2.4	1912	Arthur Devis, *Members of the Maynard Family in the Park at Waltons*
1968.6.1	2347	Attributed to Thomas Phillips, *Portrait of a Lady*
1968.6.2	2348	Sir Thomas Lawrence, *Francis Charles Seymour-Conway, 3rd Marquess of Hertford*

1970.17.106	2478	Style of John Hoppner, *Portrait of a Gentleman*
1970.17.110	2482	John Ferneley, *Heaton Park Races*
1970.17.119	2491	Gainsborough Dupont, *Georgiana, Duchess of Devonshire*
1970.17.120	2492	Gainsborough Dupont, *William Pitt*
1970.17.121	2493	Thomas Gainsborough, *Seashore with Fishermen*
1970.17.122	2494	Gainsborough Dupont, *Mrs. Richard Brinsley Sheridan*
1970.17.125	2497	Style of Benjamin Marshall, *Race Horse and Trainer*
1970.17.130	2502	Sir Henry Raeburn, *Mrs. George Hill*
1970.17.131	2503	Attributed to Sir Henry Raeburn, *Miss Davidson Reid*
1970.17.133	2505	George Romney, *Sir William Hamilton*
1970.17.135	2507	Joseph Mallord William Turner, *Rotterdam Ferry-Boat*
1976.62.1	2704	Unknown British Artist, *Mr. Tucker of Yeovil*
1977.63.1	2709	Gerard Soest, *Lady Borlase*
1979.65.1	2770	John Hoppner, *Lady Cunliffe*
1980.61.13	2844	Unknown British Artist, *Portrait of an Unknown Family with a Terrier*
1982.55.1	2863	Richard Parkes Bonington, *Seapiece: Off the French Coast*
1983.1.39	2914	John Crome, *Moonlight on the Yare*
1983.1.40	2915	Arthur Devis, *Arthur Holdsworth Conversing with Thomas Taylor and Captain Stancombe by the River Dart*
1983.1.41	2916	Henry Fuseli, *Oedipus Cursing His Son, Polynices*
1983.1.42	2917	William Hogarth, *A Scene from* The Beggar's Opera
1983.1.43	2918	Francis Wheatley, *Family Group*
1983.1.44	2919	Richard Wilson, *Lake Albano*
1983.1.45	2920	Richard Wilson, *Solitude*
1983.1.46	2921	Joseph Wright, *The Corinthian Maid*
1983.1.47	2922	Joseph Wright, *Italian Landscape*
1983.1.48	2923	Joseph Zoffany, *The Lavie Children*

List of Artists

Abbott, Lemuel Francis
Barker, Thomas
Beechey, Sir William
Blake, William
Bonington, Richard Parkes
Breda, Carl Fredrik von
Constable, John
Cotes, Francis
Cotes, Francis, Style of
Crome, John
Cuitt, George, the Younger
Davison, Jeremiah
Devis, Arthur
Dupont, Gainsborough
Ferneley, John
Fuseli, Henry
Gainsborough, Thomas
Gardner, Daniel
Gheeraerts, Marcus, the Younger, Studio of
Herring, John Frederick, the Younger, Attributed to
Highmore, Joseph
Hogarth, William
Hoppner, John
Hoppner, John, Attributed to
Hoppner, John, Style of
Kidd, Joseph Bartholomew
Knapton, George, Attributed to
Lawrence, Sir Thomas

Lely, Sir Peter, probably chiefly studio of
Marshall, Benjamin, Style of
Mercier, Philip, Attributed to
Millar, James
Morland, George
Paul, Joseph, Attributed to
Phillips, Thomas, Attributed to
Raeburn, Sir Henry
Raeburn, Sir Henry, Attributed to
Raeburn, Sir Henry, Style of
Reynolds, Sir Joshua
Reynolds, Sir Joshua, After
Riley, John
Romney, George
Seeman, Enoch, Attributed to
Singleton, Henry, Attributed to
Soest, Gerard
Stubbs, George
Turner, Joseph Mallord William
Verelst, Maria
Wheatley, Francis
Wheldon, W.
Whistler, Beatrice Godwin
Wilkie, Sir David
Wilson, Richard
Wright, Joseph
Wright, Joseph, After
Zoffany, Johann